The Journal of Eugène Delacroix

A selection edited with an introduction by
Hubert Wellington

Translated from the French by
Lucy Norton

Phaidon · Oxford

Phaidon Press Limited, Littlegate House,
St Ebbe's Street, Oxford, OX1 1SQ

First published 1951
Second edition (photographically reprinted) 1980

British Library Cataloguing in Publication Data
 Delacroix, Eugène
 The journal of Eugène Delacroix. – 2nd
 ed. – (Landmarks in art history).
 1. Delacroix, Eugène
 2. Painters – France – Biography
 I. Wellington, Hubert
 II. Series
 759.4 ND553.D33
 ISBN 0–7148–2105–5

Printed and bound in Great Britain
at The Pitman Press, Bath

CONTENTS

PUBLISHER'S NOTE

This volume has been photographically reprinted from the Phaidon edition published in 1951. The locations of some of the works reproduced have changed during the past thirty years; in particular the picture reproduced in Plate 20 is now in the Ordrupgaard Collection, Copenhagen, and some of the pictures listed as belonging to private owners have changed hands.

FOREWORD

The Journal of Eugène Delacroix first appeared before the public in 1893. It was compiled by Paul Flat and René Piot from hand-written copies of the diaries, and from sundry note-books and fragments. A new version was issued in 1932, the text of which had been scrupulously corrected from the original documents (now belonging to the University of Paris) by M. André Joubin, the accepted authority on the writings of Delacroix. His three volumes included considerable additional matter and contained 1,438 pages, exclusive of index.

In the present selection for English readers the reduction of this formidable text to about one-half has been achieved by omitting mention of various parties, committees and functions, of encounters with individuals whose names have now lost interest and meaning, and of some repetitive versions of ideas intended as preliminary trials for articles. Moreover, Delacroix was in the habit of copying into his diaries passages from books and current reviews he was reading: such extracts are obviously interesting as evidence of his tastes and sources of ideas, but they are not by Delacroix, and not the true Journal. So only a few characteristic examples have been kept and the same applies to the travel notes made on his journey to Morocco.

The deepest interests for artists and students will lie in the revelation of Delacroix's approach to his own work and the results of sheer technical experience. Critical judgements of this kind have been retained, but the long lists of pigments and mixtures have been necessarily curtailed. These were largely made for the use of assistants engaged on specific works, and, fascinating as they appear at first sight, are now often incomprehensible without example or demonstration by the master. Some few typical lists are included.

It is believed that nothing essential to an understanding of Delacroix's thought, or characteristic of him as a man, has been omitted from this shortened version of the Journal, while for complete detail the full French version will always be consulted.

The plates aim at illustrating the text by relevant portraits, works in progress at certain dates, and pictures by Rubens and others which are commented on in the Journal or form important sources of influence. Adequate presentation of Delacroix's vast output on the small scale of this book is of course impossible—especially in the case of the big mural decorations—but some plates have been selected to show distinctive changes of aim and style at different periods of his life. H.W.

ACKNOWLEDGEMENTS

Thanks are due to the authorities of the Metropolitan Museum, New York, and of the Phillips Gallery, Washington, for their courtesy in permitting the reproduction of paintings in their collections. The Bibliothèque d'Art et d'Archéologie (Fondation Jacques Doucet) in Paris, have kindly enabled us to reproduce a facsimile of a page from Delacroix's manuscript of the Journal.

INTRODUCTION

EUGÈNE DELACROIX is a very great name in the history of French painting: it evokes an image of the most distinguished and generously gifted figure among French artists since the Revolution. Violently attacked and enthusiastically acclaimed in his own lifetime, there was no attempt to celebrate the Centenary of his birth in 1898 by an exhibition. But Delacroix received a special kind of national homage in 1930. When the French Government decided to celebrate the Centenary of the Romantic Movement in that year, it was agreed that a comprehensive exhibition of his work in the Musée du Louvre would best symbolize all that was vital in the art inspired by that movement. Nearly nine hundred paintings, drawings and prints were displayed in the great galleries of the National Museum; this was indeed *La Gloire*—and to Delacroix, Glory was no vain or trivial word.

But Eugène Delacroix is still, as he ever was, a disturbing artist, arousing the most varied and complicated responses even in his admirers. He was an outstanding individual creator, a remarkable writer as well as painter, who transcended the Romantic Movement whose spirit he truly symbolized in his youth; an innovator with a deep sense of tradition, he was learning and growing to the end of his days.

The Journal of Delacroix has become almost as famous as his paintings. I have heard it said—and by a French artist—'I don't really care for Delacroix's pictures, but as a writer of memoirs he is great and will be remembered'. This is perverse, and one can imagine the wrath and disdain that such an attitude would have provoked in the great artist. The Journal is indeed a fascinating and unique production; no one can afford to neglect it who wishes to understand Delacroix, his psychological make-up, his struggles and difficulties, his weaknesses and his implacable will. It consists of notes, scraps, fragments, hastily set down by a man whose life quickly found its vocation and was absorbed in a prodigious output of pictures large and small; it is a by-product of that life which gains an importance of its own from the quality of mind and spirit in its author. He used it as an experimental laboratory for the discovery of himself.

The first entry made in 1822 at the age of twenty-four is revealing. He pledges himself to tell the exact truth, to be seen by no eyes but his own. He hopes to learn more in this way of his own bewildering variations of mood—partly in order to control and integrate them,

partly that he may fix on paper these flickering, changing ideas which otherwise will be carried away in the flux of time. The early pages of the Journal give plenty of evidence of sudden changes from exaltation to despair, from confidence to paralysing shyness, from excited inspiration to a longing for patience and perfection. For the root of these divisions in himself we must, I think, go back to his birth.

Eugène Delacroix was born on 26 April 1798 (that is, eighteen years after Ingres, two years later than Corot, and within a few months of Balzac), at Charenton-Saint-Maurice, near Paris. He was the fourth and youngest child in the family of Charles Delacroix who had played an active part in the French Revolution. This lawyer, who was an admirer of Rousseau and became deputy for the Marne in the National Convention of 1792, was among those who signed the death warrant of the King, and under the Directory was Minister for Foreign Affairs. When Talleyrand returned from exile Charles Delacroix was sent to Holland as Ambassador; he later became Préfet de la Gironde, and died at Bordeaux in 1805.

Eugène's mother, Victoire Œben, came of a striking family of fine craftsmen, with ancestors in Holland and Germany. Her father was cabinet-maker to the King; he carved frames for Madame la Pompadour, and worked with such famous designers as Boule and Riesener. Her step-brother was the painter H. F. Riesener, a pupil of David.

About Eugène's paternity there hangs a mystery. There were rumours current in his lifetime, though there is no sign that he was himself aware of them, that he was the son of no less a person than the brilliant, enigmatic diplomatist Maurice Talleyrand, Prince de Benevente, to whom he bore a strong facial resemblance. Their relationship is now regarded as undeniable in the light of recent researches. Such mingled hereditary strains of aristocracy and creative gifts of design might well produce an artist of exceptional character, and would go far to explain that dual nature which was so strongly marked in Delacroix—the creative artist in whom ardent imagination was combined with cool critical judgement; the brilliant talker whose caustic wit was sought for, and dreaded, in Society, who was also a tremendous worker, shunning interruption and defended by a lioness of a housekeeper; the haughty figure of scrupulous dress and manners who was the loyal and affectionate friend of intimates chosen mostly at school and in the studio of Guérin. Talleyrand's interest may also give a clue to the mysterious influence which led to the purchase by the State at successive Salons of pictures by a young artist often

accused of undermining traditions and principles, and which later brought him important commissions in spite of rebuffs from officials in the Ministry of Fine Arts.

As a boy in Paris, Eugène attended the Imperial Lycée, later known as Louis-le-Grand, where Géricault was a few years his senior. He described himself as 'one of those reasonably good scholars, who understand their work without being the models who run off with the laurels at every prize distribution'. He lived with his mother, to whom he was greatly attached, until her death in 1815. He drew dramatic compositions at school, studied music keenly, and used to visit the studio of his uncle Riesener who encouraged him to work at the École des Beaux-Arts, under Guérin, in 1816.

Guérin strikes us now as eclectic and tepid in imagination but he was one of the most accomplished painters of the French School of his time, representing the doctrines of the new Académie des Beaux-Arts, re-formed during the Revolution. The curious blend of classic with realistic outlook which had been imposed by the discipline of David was now losing both animation and interest. The master himself was nearing his end, exiled in Belgium. His most docile pupil, Girodet, a refined and cultivated classicist, was producing pictures of astonishing frigidity. Gérard, immensely successful painter of portraits under the Empire—some of them admirable—fell in with the new vogue for large pictures of history, but without enthusiasm. Gros in his generation was the one artist who could express the torrential energies of Emperor and people during the Napoleonic epic by powerful form and colour, with a bitter-flavoured realism. Delacroix was a lifelong admirer of Gros and proclaimed this in a most vigorous essay after the tragic end of the old painter. But undoubtedly the dominating enthusiasm of his youth was for Géricault, who was still occasionally painting in the Guérin studio when he himself started to work there.

'Géricault allowed me to see his "Raft of the Medusa" while he was still working on it,' he said afterwards. 'It made so tremendous an impression on me that when I came out of the studio I started running like a madman and did not stop till I reached my own room'—which illuminates the temperament of Delacroix as much as the power of Géricault. The dramatic composition of Géricault with its strong contrasts of tone and unconventional gestures stimulated Delacroix to trust his own creative impulses on a big work. In long days of concentrated labour he produced his 'Dante and Virgil in the Infernal Regions' for the Salon of 1822. With this picture he stepped at once

into his place in the new movement which first Gros and then Géricault had inaugurated. It caused an immense sensation and was greeted with laughter and derision by the public, and angry protests by many critics, but its power was recognized by others. As a member of the Jury, Gros, to whom Delacroix was then unknown either by name or in person, took the painting under his wing, had it framed by his own frame-maker and saw that it was well hung. It was quite unlike the 'Raft of the Medusa' in its poetic subject matter; it showed obvious echoes of Michelangelo in form, yet it glowed with an ardour of temperament which was felt to be a challenge to the academic rump of the David tradition. It is curious how this first bitter opposition of officialdom and the enthusiastic support of an enlightened few were to continue for the rest of his career.

In September of the same year Delacroix began his Journal while staying in the country with his brother, General Charles Delacroix. He had just received news that his Salon picture had been bought by the State and placed in the Luxembourg Galleries.

For two years he kept his Journal faithfully and we can follow his life by these notes of meetings with friends, accounts for meals and models, love affairs, technical notes on paintings seen and plans for future pictures.

He found himself dangerously celebrated with his first big picture, but an orphan with no money of his own. The considerable family estates had been disastrously lost in legal affairs in which his sister and her husband, Raymond de Verninac, had become involved. He lived hard in these days but still had the *entrée* to the high official circles in which his parents had moved, and to the *salon* of Baron Gérard, now painter to the King, through the nomination of Talleyrand. Here writers, artists and singers were to be found, in addition to politicians and the fashionable world.

We follow month by month the struggles and changes in the creation of 'The Massacre at Scio' his next important and challenging work for the Salon of 1824. On 9 November 1823, he notes 'I have again seen the sketch by Constable—an admirable, unbelievable thing', and on 24 June 1824, 'This Constable does me a world of good'. 'The Massacre at Scio' gained another sensational success, with the same accompaniment of violent criticism. Gros, who had delighted Delacroix with his comment '*Rubens châtié*' on 'Dante and Virgil', described the new picture as the massacre of painting. Certainly Delacroix had largely discarded heavy contrasts of tone and colour, after his discovery of light and atmosphere and broken greens

in Constable. Then quite suddenly the early portion of the Journal comes to an end with the entry of 5 October 1824.

It is a great loss to us that the Journal ceased before he made his visit to England in 1825. We have to get his impressions of this country from letters to his friends Pierret and Soulier. The latter had already given him lessons in English and in water-colour painting, and for a while Delacroix had shared a studio with Thales Fielding, who pressed him to come to England. Doubtless Géricault's earlier stay and his enthusiasm for English paintings—those of James Ward for example—had inclined him to follow.

Delacroix was perturbed by the immensity of London and shocked at the absence of 'all that we call architecture', but delighted with the Thames and the English countryside, and enchanted by a six-oared skiff in which he was rowed to Richmond by his friends. He made a special visit to Sir Thomas Lawrence, who received him most graciously and showed him superb drawings by the Old Masters. He also called on Etty and on Wilkie, whose sketches he found to be above all praise, but thought that like all painters he constantly spoilt them in the finishing. He renewed his acquaintance with Bonington, whom he had met about 1816 or 1817 when both were making studies at the Louvre and to whose brilliance and originality he always paid homage.

Delacroix greatly admired Reynolds and Lawrence and 'that ravishing Gainsborough' but he shrewdly criticized an English tendency to aim at the effect of old pictures at the expense of truth of lighting.

Still there is no doubt that he found great stimulus in the freshness of colour in contemporary English painting in opposition to the linear hardness, poor colour and pretentious dullness of the Academic School in France.

These influences are visible in his work of the next few years, in looser handling and richer, more glowing colour schemes—for example in the vast canvas of 'The Death of Sardanapalus' of 1827, and still more in the splendid early sketch for it. The big picture was badly received and was something of a check in his advance. But 1827 was the year in which he produced 'La Femme au Perroquet' and a group of other small nudes of delightful quality and execution. On his return to France in 1825 Delacroix plunged into the production of easel pictures large and small, with subjects from Shakespeare, Byron, Scott, and medieval history. He designed costumes and settings for Victor Hugo's drama 'Amy Robsart' and found himself hailed as the

acknowledged leader of the Romanticists in painting. Broadly speaking, this title seems fully justified and proven, but it requires some qualification and definition. In so far as Romanticism meant the expansion of contemporary painting to admit the expression of emotion, especially tragic emotion, and the choice of subjects which afforded opportunity for the display of such feelings as wonder, horror, grief, anger and the joy of combat, who indeed was so prolific and so potent as Delacroix? Baudelaire wrote: 'Delacroix was passionately in love with passion, but coldly determined to express passion as clearly as possible'—a penetrating and pregnant comment.

The Journal for 7 May 1824 reveals the state of mind in which he worked at this time. 'I have no love for reasonable painting. There is in me an old leaven, some black depth which must be appeased. If I am not quivering and excited like a serpent in the hands of a sooth-sayer I am uninspired. I must recognize this and accept it. Everything good that I have done has come to me in this way.' This seems the very heart-beat of Romanticism, but it must be balanced by Delacroix's constant insistence that the inspired vision can only be given its full intensity and force by complete technical mastery and swift execution. He complained later that he had been enrolled under the banner of Romanticism whether he would or not. 'If by my Romanticism they mean the free manifestation of my personal impressions, my effort to get away from the types eternally copied in the schools, and my dislike of academic recipes—then I admit not only that I am a Romantic but also that I have been one since I was fifteen, when I already preferred Prud'hon and Gros to Guérin and Girodet.' In other words he took his part with the rest in the battle against the neo-classics in the eighteen-twenties and thirties but was unwilling to be tied to the position of *chef d'école*. He was far too determined an individualist for this and had little in common with the sentimentalism of Ary Scheffer, the dreary *tableaux-vivants* from history of Delaroche or the bombastic side of Victor Hugo.

We get a vivid idea of Delacroix in his Romantic period from the self-portrait painted about 1829, now hanging in the Louvre. Aristocratic distinction and a rather defiant reserve are unmistakable. All who met Delacroix seem to have received the impression of intense nervous energy, and to have been struck especially by the revealing changes in his eyes which could 'sparkle and gleam like carbuncles or could become dead and remote at will'. Beneath his exquisite courtesies there lay a certain ferocity which warned the susceptible of

a nature which Théophile Gautier compared to the felines that he drew so well.

The year 1830, the symbolic year of the Romantic Movement, gave Delacroix a subject for the most stirring and characteristic of his large easel pictures. It seems to have been the result of a commission which proposed one of two battle themes, Valmy or Jemappes, but the painter turned to the history of the moment, to the fighting in the streets of Paris, and produced 'Liberty guiding the People: the 28th July 1830'. It springs in a direct line from Géricault's 'Raft of the Medusa', and his own 'Massacre at Scio', but while Géricault carried his interest in actual detail to the point of searching for survivors from the wreck as models, Delacroix felt his composition more vividly as a whole, thought of his figures and crowds as types, and dominated them by the symbolic figure of Republican Liberty which is one of his finest plastic inventions: it has the simplicity he admired so much in the antique.

Had this picture an intention of political bias? It is doubtful. True, the painter had grown up among men who had taken an active share in the French Revolution and who had later passed with perfect good faith to the Bonapartists, yet many pages of his Journal show a horror of the mob, and a grave distrust in the vague humanitarianism of his time. It would be quite in accord with his personal views to consider the Revolution as a protest against the tyranny of any Government by mediocrity. Certainly the whole picture shows an ardent sympathy with the untidy heroism of a populace struggling at odds against oppression. It may be that actual glimpses of street fighting had given him material for new dramatic poses and imagery. This superb work seems to occupy a central position in his career between the widely ranging emotional Romanticism of his early period and the disciplined pictorial experience that he was to gain from his large decorations.

It seems curious that Delacroix never visited Italy. He had longed to see Florence and Venice but difficulties were at first too great. He explored openings which might take him to Egypt. Then, in 1832, an opportunity came to be attached to a French military mission to the Sultan of Morocco, and he leapt at the chance. He went, not to study art or archaeology, but primarily as a release from the noisy, ignoble struggle for success and fame in over-civilized Paris, and to see for himself the more primitive, untrammelled life of the East. He was delighted with Tangier, and letters to his friends announce his striking discovery of the living antique—'The Greeks and Romans are here at my door, in the Arabs who wrap themselves in a white blanket and

look like Cato or Brutus, with their aristocratic bearing yet republican simplicity of manner.' He filled sketch-books and letters with notes of things seen in desert and town. In spite of his frail constitution Delacroix seems to have stood the hardships of long journeys on horseback very well, and revelled in odd hazards. He was able to see Eastern interiors at Tangier and Algiers, and it is evident that his very active intelligence absorbed much from Oriental tiles, silks and carpets in the handling of colour patterns, and in organizing close harmonies and exhilarating contrasts. His descriptions of a Jewish wedding and of a terrific fight between horses read like a catalogue of his famous pictures.

A few days in Spain gave him the sight of some pictures, and the feeling that 'Goya is throbbing in everything around me'.

He returned to Paris refreshed by six months of active life and for the rest of his career he was able to turn to his memories and sketch-books for subjects. Two years later the important painting 'Women of Algiers' showed a development of technique and colour practice which mark a new impetus—a gift from the East more important than picturesqueness of subject: there is no drama or violence here, rather the maturing of the ideas of a painter, which he said in a letter were all that he claimed.

The next year, 1833, was perhaps still more important in its eventual effect on Delacroix and the development of his talents; he was commissioned to decorate the Salon du Roi in the Chambre des Députés at the Palais Bourbon. Here was an opportunity for work on a large scale for which he hankered—the enhancing of an architectural scheme by painting in the grand manner of the masters he so greatly admired—Paul Veronese, Tintoretto and Rubens. He prepared himself seriously for this new venture, caused a wall at his cousin's country-house at Valmont to be freshly plastered, and painted four panels in some kind of tempera, possibly using lime-wash with his colours. This was a definite exercise in traditional methods of decorative painting—filling spaces with clear outline and flat colour areas without chiaroscuro, but neither the method nor the medium were actually used later by Delacroix. He needed more robustness of form, more body. Oil-colours with some admixture of wax, on canvas fixed to walls and ceilings, were used for his murals, sometimes over a distemper foundation. From now onwards the execution of decorations in public buildings, with the aid of assistants, formed the main work of his life, though not of course to the exclusion of easel pictures.

Here is a list of commissions he carried out in public buildings in Paris:

1833–7 The Salon du Roi at the Chambre des Députés, Palais Bourbon.

1838–47 The Library at the Palais Bourbon.
The Library at the Palais du Luxembourg.

1843 A large 'Pietà' at the Church of St. Denis du Saint Sacrement.

1848–50 Ceiling in the Galerie d'Apollon, at the Louvre.

1851–5 The Salon de la Paix, at the Hôtel de Ville (destroyed during the Commune in 1871).

1857–61 The Chapelle des Anges at St. Sulpice.

One would like to know how many people have taken the trouble to visit these immovable works. Most of them are impossible to judge by reproductions. The 'Pietà' at St. Denis can be seen only in a good morning light or by artificial illumination, but it is an impressive work. Fortunately the finest of them all, at the Church of St. Sulpice, is always available, and is of the greatest importance in forming an estimate of Delacroix.

In January 1847 Delacroix again took up the Journal left so abruptly in 1824. Or rather he began a new Journal for the new man that he had become. He was now close on fifty; the intervening years were the most active and productive of his life and had greatly enlarged his experience and prestige. He was coming to the end of his huge task at the Palais Bourbon where he found the painting of the domes so tiring that he had to take a complete rest after each session. In the autumn of 1846 he had suffered from a recurrence of the laryngitis which had bothered him for some years, and his letters show a growing apprehension of the flight of time and shortening of opportunity. Delacroix had always scribbled in sketch-books and on odd sheets notes of his passing thoughts, reflections on the arts, and observations of things seen, feeling that to fix such impressions might arrest them long enough for later contemplation; he had already written serious articles for the Revue de Paris. The new Journal is altogether graver in tone than that of his youth, and meditations often read like drafts for future articles, or seem intended for ultimate publication in some form. But these are interspersed with chronicles of daily events, dinner parties and conversations which make the Journal a vivid picture of cultivated society in mid-nineteenth century France. Such figures as George Sand, Alexandre Dumas, Balzac, Baudelaire,

Thiers, Berlioz, Chopin, Auber, Corot, Barye and Merimée come and go in these pages with friendly or ironical comments by the writer. House-parties and official committees are amusingly touched off. Journeys by carriage or railway invariably produced some sharp portraits of fellow-travellers, curious or uncouth characters, attractive women, unattractive children. The conversations and opinions of other people were of endless interest to Delacroix and formed food for his own ideas. According to Baudelaire he looked on conversation with misgiving, as a kind of temptation to dissipate his time and energies. To a visitor he would begin by saying, 'We won't talk this morning or only a little, a very little?' Then he might talk for three hours; he would be brilliant, subtle, but full of facts, souvenirs and anecdotes.

There was a strong streak of Byronic dandyism in Delacroix and he would recall with amusement that Bonington and he had done their best to introduce an English cut in clothes and shoes among the youth of their time. Later his reserve of manner, his expressionless countenance, his elaborate courtesy and the twenty different intonations he could give in pronouncing *mon cher monsieur* became famous—a carefully composed mask for his protection in society. This short, frail figure could dominate an assembly even in his last years as Odilon Redon testified; Redon as a youth in 1861 had shyly followed him about at a ball at the Hôtel de Ville.

In reading the Journal it is noticeable that among the fashionable salons and parties he chose those where the best musicians could be heard. Without music, or with the wrong music, he was invariably irritated, bored, or left early. Music was a passion with Delacroix, and among musicians he delighted most in Mozart, who like Shakespeare and Racine, is brought constantly into his discussions on the universal nature of art and the merits of simplicity and finish in the classics. Indeed the name of Mozart occurs more often in the Journal than that of any creative artist except Rubens. Among contemporary composers his favourites were Chopin and Rossini—but he did not care for Berlioz, or his music, rather curiously, for one might think of him as the musical counterpart of Delacroix in the Romantic Movement. But Delacroix was truly intimate with Chopin, and had a deep personal affection for him as a man; he visited him in his illness and spoke of him as 'the purest example of a true artist that I have ever known'. His sensitive portrait of Chopin, the intensely dramatic little picture of Paganini and some charming sketches of singers remain as evidence in painters' language of Delacroix's admiration and delight.

It is in his work after all, in his paintings, decorations, drawings and lithographs, that Eugène Delacroix is to be found; essays, criticisms, notebooks and Journal are subsidiary, but give us the clues.

Always he insists on imagination as the first and master quality in the great artist. What does he understand by imagination? Does he seek for the *unreal*, for the impossible or fantastic? Nothing could be further from his thought than the deliberate, symbolic *grotesquerie* of Jerome Bosch. 'Nothing is so real to me as the illusions I create with my painting. The rest is shifting sand' (Journal: 27 February 1824). This surely relates not only to the power of inventing visual renderings of a dramatic scene or a narrative from the poets—though no doubt it includes this. More profoundly these desperately real 'illusions' relate to the creative impulses of the whole man, the complex of ideas, memories, sensations, emotions stirring in him, to be expanded, intensified and ordered into shapes and colour. But the first sentence of the same note reads: 'What does please me is that I am gaining in reason and good sense without losing the faculty of being excited by beauty'. This tension between exaltation in creative imagination and a clear-headed control, this animated composure, underlies his whole work.

Was Delacroix a 'literary painter', as is so often said today—or was it yesterday? Certainly literature formed an essential part of his life, and the heightened sense of living that came to him from reading and from hearing music, he would have liked to arouse, too, by his painting. We know that it was his custom to stir his mind to activity by reading; passages from Byron, Dante and Shakespeare were favourites. He kept lists of promising subjects he had noted, and the right mood would suggest trial sketches, suggestive indications of main lines or those oval shapes he called his *noyaux* or kernels, which could be quickly combined to become figures, horses, trees or anything he wished. 'To imagine a composition is to combine elements one knows with others that spring from the inner being of the artist. Then from a well-stored memory forms are brought to an apparent reality.' Obviously this line of action from reading to design was in the nature of a dodge, a practice which was found to work, and the value of the result depended on the quality of the intelligence behind its use. The conception and organization of the great scheme for the library of the Palais Bourbon meant a rare command of fundamental brain-work, and a store of themes ranging from the Bible to the Classics. Delacroix was by no means a decorator of the kind contented to be a mere pattern-spinner. He was perfectly well aware that a picture must give a

pleasure quite distinct in its very nature from a work of literature. One of his favourite themes in the Journal is the superiority that painting holds over other arts in the spontaneous appeal of the whole, the main lines, masses and colours which 'even at a distance appeal directly to the most intimate part of the soul, transport one without words to reality by what one may call the music of the picture'. Here, as so often, Delacroix anticipates the values and the very phrases of future writers. And so with subject matter, literary or otherwise. 'Whatever his apparent subject, it is always himself that the artist paints. Subject merely exalts his inner feeling.' Delacroix sometimes took over a composition from another designer such as a Crucifixion or a Lion-Hunt from Rubens, but the result is always a Delacroix.

Nowhere perhaps do we get a more intense feeling of his personal Romanticism than from his lithographs of wild beasts, a panther bringing down a horse, a tiger struggling with a serpent, a lion devouring his prey. He loved the untamed energy of such animals and enjoyed making studies at the Jardin des Plantes, where he often met Barye. But the final prints are works of imagination, with a life and movement not to be found at the Zoo. Robaut tells us that Delacroix could produce lions and tigers from his own cat. It is a good example of his fusion of the actual and the imaginary worlds. Incidentally these prints have never been surpassed as lithographs. Delacroix was indeed endlessly alert in mind and eye for anything in nature, however minute, however large, which might help to give form and force to his imaginative vision. In his country walks he watches the drama of fly and spider, the patterned markings on a slug, and is impressed by the grandiose form of rocks at Dieppe at low tide. In towns, too, at the theatre or in the streets, observations arouse reflections of practice and principle. From his seat on an omnibus he watches contrasts of colour in the backs of bay and black horses, finds local colour strongest in the half-tones, absent in the high lights which look distinct and cold on the shiny hides. He records the effects of sunlight on a work-man stripped to the waist, seen from his window, and how vivid is the colouring in flesh compared with the inert matter of the wall.

Charles Blanc tells how Delacroix was in difficulties with the golden cloaks in 'Marino Faliero' which still looked heavy after ex-hausting all his yellows. He decided to consult Rubens and called a cab to take him to the Louvre. A burst of sunshine turned the shadows on the gravel pure violet, and at once the canary yellow of the cab looked brighter and the blacks more mauve by contrast. Here was the key to his problem, the cab was dismissed and he returned to his studio.

This in 1826 was an early perception of the influence of complementary colours which in theory and in practice fascinated him all his life. In fact Delacroix was very much *homme de métier*, craftsman as well as man of imagination. He loved the materials of his craft, 'the sight of my palette freshly set out with colours all shining in their contrasts is enough to excite my enthusiasm'.

The evolution of Delacroix's painting can be followed from the time he left Guérin's studio and achieved his own so personal style by successive advances towards light and colour. Two admirable studies from the nude model show his thorough grounding in the traditional method of painting based on four tones mixed on the palette for shadow, half-tone, light and reflected light. The two years covered by the early Journal, from 1822 to 1824, just span the distance from 'Virgil and Dante' to the 'Massacre at Scio'—a great leap—and reveal his researches and variations in style as well as temperament. He became interested in Spanish painting, perhaps through the superb portrait now in the Louvre that Goya had painted of Guillemardet, father of his great friend Félix. Delacroix got permission to copy a portrait by Velázquez; he brooded over its freedom of handling, melting yet firm, and thought that to start a subject in that way, then finish with definite contours following the exact pose of the model, would be an excellent scheme. This seems the antithesis of his mature principles, but he certainly worked on the big 'Massacre' from friends and models. The tremendous impact of Constable's landscapes in the direction of light and variety of colour is too famous to need more comment. Delacroix's admiration for Rubens, and for Lawrence, helped to form his first characteristic style—one of broadly spread masses of colour, and greater transparency. 'The Death of Sardanapalus' was not a success, but it contained portions like the nude girl drooping across the couch which were masterly in execution. So were various small nudes, the portrait of himself in the Louvre and the portrait of Baron de Schwiter, once belonging to Degas and now in the National Gallery; all of them painted about this time. One notices quite early the building up of form by small touches, hatchings of decided strokes with small sable brushes. He noted 'When I was working on the child yesterday I remembered the multitude of little touches, rather like a miniature, in the "Virgin" by Raphaël that I saw with Villot. In such things as these, where style is everything, the showy, free brushwork of Vanloo ends in accepting the "near enough". Style comes only by repeated struggles, and the big, flowing brush has to stop as soon as a happy touch comes off. I must

try to see the big gouaches of Correggio; I believe those were done with little touches.'

After the visit to Morocco in 1832, this technique becomes more apparent, the touches purer in colour; green and rose strokes are slashed side by side across a bed of more neutral flesh colour to gain additional pulsation and life. The 'Algerian Women in their Harem', painted in Paris in 1834 from memories and studies, is—or was—a complete examplar of this divided touch and the deliberate use of complementary colour contrasts. Renoir copied and admired it enormously, and as the natural heir to Delacroix's passion for colour, he expanded the practice. Alas, the colours of this masterpiece are now so dimmed that it is difficult to realize its original richness and challenge.

The big schemes of decoration meant a reorganization of method and practice for Delacroix from 1833 onwards. The arch-individualist had to train and work with assistants, some unsatisfactory, but on the whole the system suited him admirably. It appeased his need to *faire grand*. 'Small pictures get on my nerves, bore me, and big easel pictures done in the studio are as bad, they tire me out and I spoil them.' These *grandes machines* are indeed the least satisfactory of his huge output, and have suffered much from his frequent repainting and the too lavish use of bitumen and oil. He was all nerves and spirit; his recurrent fevers, migraines and dyspepsia, led to gaps in his work and struggles to complete them when feeling unfit. Now he could give his best powers of intellect and invention to conception and design, and hand over to collaborators the carrying out of preparations and underpainting, reserving his own strength for the most interesting portions and for the final repainting which was to vivify the whole. After all, this was the mode of life of Rubens and Veronese, and here his love of grandeur in scale and manner found its proper employment. The Journal shows him occupied with new problems of relating painting with architecture and ornament, with the carrying power of colours, difficulties of perspective for figures on ceilings and the concave surfaces of domes. Delacroix was not well served by the buildings allotted to him. They were mostly ill-lit and stuffy, the architectural features were oppressive, over-decorated and gilded, and one realizes in visiting them how much the taste and exigencies of his time hamper our response to his gifts today. But to bend one's mind to the study of his domes and pendentives at the Luxembourg and Bourbon Palaces is to discover designs which are invariably dignified and often splendid, and groupings such as the

presentation of Dante to Homer by Virgil which show the painter's growing power of simplification.

His assistants, Lassalle-Bordes, Planet and Andrieu in their reminiscences have given us valuable close-ups of Delacroix, of his principles and advice as he worked by their side. It was for them to lay a bed of colour without contours, carefully chosen to give the greatest support to the contrasts of pure colour which Delacroix used increasingly. He personally worked out schemes and details of colour, with all the theory and experiment he could command, he spent weeks combining tints on his palette and transferring them to pieces of canvas, with careful notes. Andrieu had whole packets of these scraps which at the sale of his effects were bought by Degas; they have since disappeared. Similar notes take up many pages of the Journal. For painters they are still fascinating to read, but without a knowledge of their quantities, and the comments of the master, they are of little or no use in practice today. Only a few examples have been kept in the present selection. It must be admitted that the names of some of the pigments—*momie, vert-chou* and *laque de gaude* for example—leave one aghast at the risk of impermanence he was willing to accept. One no longer wonders at the ruin of so many canvases.

Andrieu tells of his prodigious command of execution. Some days the master would be absolutely silent 'as a carp', at other times he would seize a prepared palette and would work as one possessed. He painted the famous group of hat and cloak in front of Jacob and the Angel in twenty-two minutes; left it for sixteen days to get hard, and gave it the final repainting in sixteen minutes. Andrieu noted the time.

Delacroix had a great respect for the knowledge and craft usages of painter-decorators and theatre painters, people like Charles Sechan whom he met at Baden in 1855. 'These people know what no one teaches us, and we have to find out only after desperate struggles.' He thought painting in distemper an excellent training and many of his own works, e.g. 'Algerian Women' and 'Sardanapalus', are in oil-colour over distemper.

There was bitter practical experience behind Delacroix's remark 'we never paint brightly enough'. It sums up the direction of his technical progress in decoration, but in his later work he went forward without hesitation. The ceiling of the Gallery of Apollo at the Louvre is a brilliant *tour de force* and the sketches for it may be compared with those of Rubens and Tiepolo for impetuous life and expressive execution. In the Chapelle des Anges at the church of St. Sulpice he achieved the finest mural painting of his time. If his earlier

decorations are burdened at times by descriptive narrative, in 'Jacob wrestling with the Angel' he finds a true balance. Without abating the dramatic force or the powerful modelling he swept figures and landscape forms into complete unity; the relationship of mass, colour, and light is not destroyed by the vigorous imaginative content.

Delacroix's reputation has rested mainly on his gift of original and expressive colour, and this was allowed in his own day even by critics who complained of his incorrectness of drawing. Undoubtedly his chief influence on the future lay in that direction and he transformed French painting by his insistence that colour is the innate and essential virtue of a picture and should be considered from the outset.

But his contemporaries did not know his drawings as we do. Over six thousand were found by his executors in his studio after his death, and we see now that they are as characteristic of the artist as his pictures. Apart from purely descriptive notes of costumes, types and accessories, he was aiming not at correctness but at expressive movement of form, it may be by many quickly repeated versions, but not by corrections of error. In his portfolios were every kind of drawing, drawings to suggest main lines of a design still taking shape in his mind, drawings done for the sake of knowledge of construction, or as records of fleeting impressions, copies of drawings and engravings from the masters, even from photographs of models—he never stopped drawing. He was allowed to take a portfolio to the houses of his friends, to drop out of the circle and continue drawing. 'Colour always occupies me, but drawing preoccupies me' was his way of putting it. That is, he rarely did a drawing as an end in itself, though he greatly admired the drawings of Ingres, especially his small portrait drawings. Ingres drew by continuous flowing contours, lines lapping more and more closely to forms, which tend to be static. Delacroix drew by the salient masses, his mind and eye working from the centre outwards. 'The contour should come last, only a very experienced eye can place it rightly.' For him relief and plasticity were essential qualities, and he found them in the drawings of Rubens, Titian, and Correggio. He said of Daumier 'he draws better than any of us, he is the only one who has the traditional sense of drawing by masses in proportionate relief'. His own system of drawing by oval shapes which resemble certain sketches by Michelangelo and Rodin, is akin to modelling, to building up in pellets from the centre. The intensity of dramatic expression in his best drawing is equal to that of his finest painting, and more concise. Compare for example the drawing of 'Jacob wrestling with the Angel' with the mural painting. The two

figures have a nerve and subtlety of touch, the Angel a spiritual majesty, and Jacob an immediacy of muscular strain in the drawing which are lost in the large wall painting, where indeed they would be inappropriate. Moreover the indication of background trees and figures, the rhythm and life of the chalk touches, have an effect which recalls Chinese painting. Similar comparisons of drawings with pictures such as 'Desdemona denounced by her father' bear out Delacroix's phrase, 'I am preoccupied with drawing'.

Fundamentally the principles of drawing, as of painting, for Delacroix spring from his longing to express life powerfully by movement and contrasts—contrasts of line, of tone, of colour. 'One must be bold to *extremity*; without daring, and even extreme daring, there is no beauty.' But there was the other Delacroix who detested eccentricity and false emphasis in all the arts, who adored order, perfection and simplicity in the Antique, in Mozart and Racine, and his finest work comes from the right tension between the two strains.

It was evidently a compelling necessity for Delacroix to express himself in words as well as paint—in conversation, in a vivid and abundant correspondence, and in full-dress articles in the *Revue des Deux Mondes*, *Revue de Paris* and *Le Moniteur*. It seems odd that among his studies of great artists he wrote nothing on Rubens, Paul Veronese or Rembrandt, whom he admired beyond all others, but readers of the Journal will know how constantly he refers to them for assistance and inspiration. Many people were surprised that instead of these he chose as subjects Raphaël, Michelangelo, and Poussin, and that these sane, balanced judgements expressed in sober prose should come from an artist notorious for the violence of his themes and the turbulence of his design. Indeed Victor Hugo and others of the Romantic group rather resented it and thought he was hedging towards the Classical. But it was surely the other side of his complex nature which found compensation in these strictly critical judgements. He gave serious attention to such work though cursing the time taken from his precious painting in order to fulfil promises to editors.

'The pen is not really my proper tool; I feel that my thoughts are genuine, and they flow freely enough, but the need for orderly planning and developing a regular sequence frightens me. Believe me, the necessity of writing a single page gives me a headache.'

The essays are interesting and at times admirable in passages which show the sensibility and experience of the practising artist, but Delacroix was not qualified to deal with Italian painting, which he knew only through the Louvre; he had never seen an Italian fresco. Serious

study of Italian art by comparison and documentation had not begun, and he had to accept traditional stories and anecdotes now discredited. No doubt the efforts of investigation and judgement cleared his mind, and the excellence of his essay on the classical Poussin reminds one that a creative artist need not confine his admiration to those of his own family or party. His contributions to reviews gathered together with odd notes on aesthetics and metaphysics form two small French volumes of literary works. The fragmentary form of these shorter pieces seems more characteristic of Delacroix's quick mind than the more deliberately composed essays. Pungent sentences take shape intuitively in the tradition of Vauvenargues, Pascal and Voltaire, and suggest a parallel with the superior vigour of sketch to finished picture which occupied him so much. Delacroix felt an urgent need for quiet and relaxation after the fatiguing work on his decorations and the strain of official and social life in Paris. From 1844 he rented, and later bought, a small cottage at Champrosay, near Fontainebleau and the forest of Sénart. Here he revelled in the opportunity for change and fresh visual experience. Some of the most delightful pages of the Journal are notes of precise details of things seen in nature and of effects of light and atmosphere. Visits to Dieppe were part of his regime against increasing ill health and yielded occasional canvases and astonishing water-colours which foreshadow the Impressionists.

After a serious illness in 1857 he was greatly shaken, and was forced to conserve all his energies for work, and hide himself even from friends. He said to Baudelaire: 'In my young days I couldn't bring myself to start work unless I could promise myself music or a dance or some pleasure for the evening. Now I can work without stopping or with no hope of reward. And I am not difficult in the matter of pleasures. After a long day's work a man finds it amusing enough to chat to the commissionaire at the corner and play a game of cards with him.'

To complete the mural paintings in the Chapelle des Anges, at Saint Sulpice, for which the walls were prepared in 1855, became the main purpose of his life. He was determined that his ripe experience and power should be realized in what might well be his last work on a grand scale. He gave up his studio on the right bank of the Seine and moved to the rue de Furstenberg so as to be near the job. Three years of incessant labour followed, broken only by sickness and visits for treatment to Baden, Plombières and Dieppe. Then a remarkable recovery of health in 1861 gave him a year without illness. He wrote

to George Sand that the old ardour for painting had returned and brought back his lost health; he felt once more like a man of thirty. The wall paintings were finished by June 1861 and exposed to view in July. The event seems to have aroused little interest and drew some rather foolish criticism. This coolness followed on a rebuff two years earlier when Delacroix sent an important group of eight pictures to the Salon of 1859. They were very roughly handled by some critics. He himself overheard scoffing remarks by a group of visitors and turned to Silvestre with the bitter comment, so often quoted, 'For thirty years now I have been thrown to the beasts'. It seemed that the old hostility and lack of understanding still existed. He did not again exhibit at the Salon.

Baudelaire was not deceived; his article on this same Salon of 1859 found its central theme in a searching analysis of the place of imagination in painting. His impressive tribute to the genius of Delacroix in a period of vicious banality drew a moving letter of thanks from the painter.

'You treat me', he wrote, 'as only the Great Dead are treated; I feel embarrassed, but you have given me great pleasure.'

After his great effort at Saint Sulpice, Delacroix returned to work in his studio. Old themes recurred—scenes from the Greek War of Independence, from Scott, from the Bible and one of his last pictures, 'Arab horses fighting in a stable', is no doubt the result of looking over the old sketch-books of his Morocco journey. Physically he had driven himself hard and no reserve of strength remained, but his ardour and enthusiasm were undimmed; his later compositions have greater breadth and simplicity than the earlier pictures, and are shorn of purely descriptive accessories; the execution is supremely expressive. There was a meaning in his confident, if nostalgic, reflection, 'I learned how to paint when neither teeth nor breath were left'.

In June 1863 the old malignant throat trouble attacked him and he retired to Champrosay to recuperate. 'If I get better,' he exclaimed, 'as I hope, I shall do some astonishing things, my brain is teeming with them,' but his weakness increased and he returned to Paris, to his house in the rue de Furstenberg. Speech became difficult but he liked his palette brought to his bedside so that he might still try fresh combinations of colour. On 3 August he dictated a long and precisely detailed will, and on 13 August he quietly ceased to breathe, attended only by his devoted housekeeper Jenny.

This remarkable woman was no ordinary servant. Jeanne-Marie le Guillou was a Breton peasant-woman who had come into his service

in 1834; he admired the courage and integrity she had shown under great hardship, and ultimately the entire control of his domestic life in Paris and at Champrosay was entrusted to her. Delacroix, so easily bored by the pompous and self-important, had a great affection for simple and natural folk. He delighted in Jenny's remarks, in her intuitive interest in his painting. Baudelaire saw Delacroix at the Louvre one Sunday expounding Assyrian Sculpture to the naïvely attentive Jenny. The Journal shows his anxiety about her health, and he called in distinguished doctors for consultations.

'She is blind devotion in person, she watches over my life and my time like a soldier on guard,' he said, and Jenny has now become an indispensable figure in the Delacroix legend. No doubt towards the end she grew suspicious and jealously kept his friends away, but it is equally certain that her devoted care for thirty years prolonged his life and made possible the prodigious amount of work he got through. He left her a modest security in money and furniture, his own portrait 'in a green Scottish waistcoat', now in the Louvre, and a superb painting of herself.

Delacroix insisted in his will that everything in his studio apart from specially named legacies should be sold by auction. Besides paintings, there was an immense accumulation of studies, projects, water-colours and drawings, a collection which he had occasionally weeded out, but had not displayed even to friends; only his assistant Andrieu had seen them. This proud and solitary artist intended that after his death they should bear witness to the thought and incessant labour that had nourished the great decorations and the easel pictures which had been so often assailed as facile improvisations. Their sale in 1864, lasting two weeks, caused a sensation. Robaut's catalogue of Delacroix's complete production gave him 'about 9,140 works' made up of 853 paintings, 1,525 pastels and water-colours, 6,629 drawings, 24 engravings, 109 lithographs, and more than 60 sketch-books; a truly prodigious output for a man hampered all his life by a delicate constitution: it was made possible only by immense will-power and nervous energy.

In the Journal we find a kind of verbal accompaniment and parallel to this feverish activity. The early portion is certainly written for no other eye than his own, nothing is withheld, cheerful or morbid. The later, and more weighty portion of the Journal, from 1847 to 1863, bears the mark of the mature artist, now an acknowledged master. Anxious to pass on his ripe experience and judgement he spent much time during periods of illness on notes for a Dictionary of the

Fine Arts which, no doubt, he intended to publish some day. They were never put into final shape and remain embedded in the Journal—pithy, wise, and exasperating in unfulfilled promise of more.

The Journal itself was not published until 1893, thirty years after the artist's death. It is only by great good fortune that it has come down to us. The strange drama that attended Delacroix's existence—three times he narrowly escaped death from accidents while still an infant—continued posthumously with the story of these fragments of his thought. It was known among his friends that Delacroix was writing some memoirs. Baudelaire makes no mention of them and almost certainly never read them, but Théodore Silvestre managed to borrow some of the note-books in 1853. When he heard of the painter's death he called to inquire about these precious books. Jenny, suspicious, distracted and sick, vowed that her master had insisted on her burning them. This was untrue: she had sent them with other odd papers to the painter Dutilleux, whom she felt she could trust. He was killed in a railway accident, but his son-in-law Robaut, who was preparing his catalogue of Delacroix's work, copied them by hand. When Jenny applied for them he returned the large note-books of the later Journal (tall oblong agendas or diaries, three days to a page, of the kind used for housekeeping accounts) but retained his copies and the odd papers. Later he sold these to Andrieu. Jenny sent the originals to the Verninac family, descendants of Eugène's sister. When the Journal was at last published, edited by MM. Paul Flat and René Piot, the text used was Robaut's copy. The note-books which had passed to Andrieu seem to have been irretrievably lost after his death. Pages torn from them appeared in bookshops in the rue de Seine, and could be bought for a few francs in the nineties. In 1924 six complete diaries and some fragments were offered to M. André Joubin, Keeper of the Art Library of Paris University, by M. David Weill, and turned out to be volumes which had been lost from the Verninac set. Those still left in the family were then presented by them to the University. With immense pertinacity and patience M. Joubin has hunted down fragments of all kinds and collated the original diaries with the copy made by Robaut, in which he found a number of misreadings. The diary for 1848 had long disappeared, traditionally said to have been left by Delacroix in a carriage when returning to Paris from Champrosay. M. Joubin's new edition, in three volumes, published in 1932, is likely to remain authoritative.

And what a fascinating record of this rich, complex nature, this life so vehemently lived, is built up by those accretions day after day, year

after year. No comments, no analyses by others can match this self-portrait in intimacy. Baudelaire's tribute written immediately after Delacroix's death is still the most profound interpretation of his spirit, it is the tribute of an equal, a poetic genius intuitively in sympathy with that of the painter. But it is inevitably personal and subjective. The vivid reporting in these diaries of things as they happened bring the man himself to life. How one would like to have heard Delacroix talk! The nearest approach to this is to read his Journal. I know of no book which interprets the life and ways of thought of a painter so closely, with an almost physical sense of presence in the studio. How right Delacroix was with his passion for making notes, feeling that they might save something of his thought from oblivion. As we consider the considerable contribution of his various writings to French literature, together with his majestic output in painting, we begin to realize why Eugène Delacroix holds his unique and irreplaceable position among the glories of French art.

We may feel that the man himself is greater than any of his works. We may even say that Delacroix was an imperfect artist; perfection, which he loved in the Classics, was one of his aims, but it was not in his nature. He was always in movement towards great works of the future—towards the unattainable. And in this he is surely a symbol of Romanticism.

Perhaps it was his conviction that there were great things still to be expressed that made his influence so pregnant for succeeding generations. Delacroix held in him the germs of Impressionism, and of Expressionism, too. Everyone knows the enthusiasm of Renoir and Cézanne for his work, and Signac's book *From Eugène Delacroix to Neo-Impressionism* is a landmark; Van Gogh, too, was inspired by his emphatic belief that colour must be judged by its contribution to the drama and expression of the subject.

There is one unifying quality in all that Delacroix did—his passionate quest for nobility, grandeur and the sublime, in art and in the lives of the great men who had formed his standards. It runs through his painting from 'Dante and Virgil' to 'Jacob and the Angel': the Journal shows it behind all the workings of his mind.

CHRONOLOGICAL TABLE

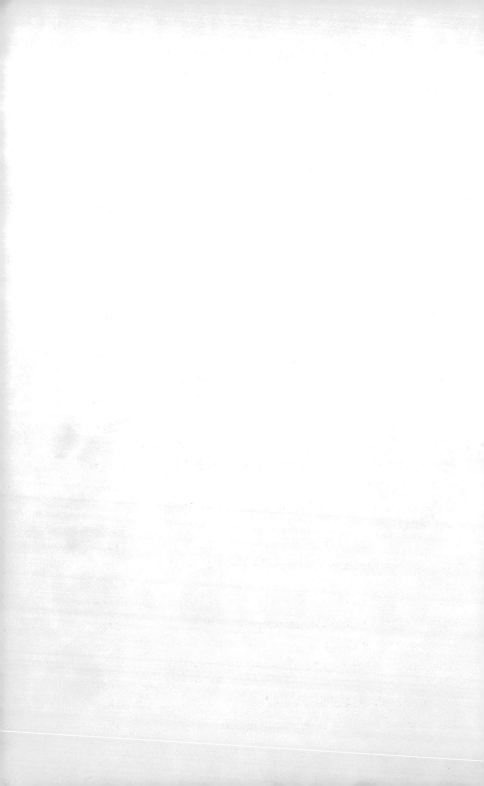

CHRONOLOGICAL TABLE
OF THE CHIEF WORKS AND EVENTS IN THE LIFE OF
FERDINAND VICTOR EUGÈNE DELACROIX

Born at Charenton-Saint-Maurice, near Paris, 26 April	1798
Entered the studio of Guérin	1815
Student of the École des Beaux-Arts, under Guérin	1816
'Dante and Virgil'	1822
Commenced the Journal	1822
'The Massacre at Scio'	1824
Visit to England, meets Sir Thomas Lawrence, and Sir David Wilkie May to September	1825
'The death of Sardanapalus'	1827
Lithographs illustrating *Faust*	1827
'The woman with a parrot', and other small nudes	1827
'Greece expiring on the ruins at Missolonghi'	1827
'Portrait of the Baron de Schwiter', National Gallery	1827
'Liberty guiding the people; The 28th July 1830'	1830
'The Battle of Nancy'	1831
Journey to Morocco and Spain January to July	1832
Decorations at the Palais Bourbon, *the Salon du Roi*	1833–7
'Women of Algiers'	1834
Decorations at the Palais Bourbon, *Library of the Chambre des Députés*	1838–47
Visited Belgium and Holland	1838
Decorations at the Palais du Luxembourg, *Library of the Senate*	1840–7
'The Justice of Trajan'	1840
'Entry of Crusaders into Constantinople'	1840
'The Shipwreck of Don Juan'	1840
'Pietà' for the Church of St. Denis du Saint Sacrement, Paris	1843
'The Sibyl, with the Golden Bough'	1845
'The Sultan of Morocco with his bodyguard'	1846

The Journal is recommenced	1847
'Christ on the Cross'	1848
'The Entombment'	1848
'Five large flower-pieces'	1849
'Apollo vanquishing the Python', ceiling in the Gallery of Apollo, Louvre	1849–51
'Salon de la Paix', Hôtel de Ville, Paris (destroyed during the Commune in 1871)	1850–53
'The Good Samaritan'	1850
'The Raising of Lazarus'	1850
'Le Lever'	1850
Visited Belgium	1850
'Christ on the Lake at Genezareth' (several versions)	1853
Visited Strasbourg and Baden	1855
At the Universal Exhibition, exhibited thirty-six pictures; made Commander of the Legion of Honour	1855
Became a member of the Institute	1857
Exhibited for the last time at the Salon	1859
'Arab horses fighting in a Stable'	1860
Decorations in the Chapelle des Anges, Saint Sulpice, 'Jacob wrestling with the Angel'; 'Heliodorus driven from the Temple'	1855–61
Died in Paris, 13 August	1863

SELECTED LIST OF BOOKS

L'Œuvre complète de Eugène Delacroix, catalogue compiled by A. Robaut, introduction by E. Chesnau, Paris, 1885.

Œuvres Littéraires de Eugène Delacroix. Paris, Crès, 2 vols. 1923.

Journal de Eugène Delacroix. Edited by André Joubin. Paris, Plon, 3 vols. 1932.

The Journal of Eugène Delacroix. English translation by Walter Pach. 1938.

Correspondance générale de Eugène Delacroix. Edited by André Joubin. Paris, Plon, 5 vols. 1936.

Delacroix by Raymond Escholier. Paris, Floury, 3 vols. 1926.

Eugène Delacroix by Charles Baudelaire. Paris, Crès, reissue 1927.

Les Palettes de Delacroix by René Piot. Paris, 1 vol. 1931.

Eugène Delacroix Drawings by Kurt Badt. Oxford, Cassirer, 1946.

Mardi Septembre 1822.

Je mets à exécution le projet formé tant de fois
d'écrire un journal. Ce que je désire le plus vivement
c'est de ne pas perdre de vue que je l'écris pour moi
seul; ... je serai donc vrai j'espère. j'en deviendrai
meilleur. Ce papier me reprochera mes variations.
je le commence dans d'heureuses dispositions ...
suis chez mon frère. il est 9 heures ou dix heures
du soir qui viennent de sonner à l'horloge du
Louroux. Je me suis assis cinq minutes ...
au clair de lune, sur le petit banc qui est devant
ma porte pour tâcher de me recueillir. mais
quoique je sois heureux aujourd'hui, je ne
retrouve point les sensations d'hier soir. c'était
pleine lune. assis sur le banc qui est contre
la maison de mon frère j'ai goûté des heures
délicieuses. après avoir été reconduire des
voisins qui avaient dîné et fait le tour de
l'étang nous rentrâmes. il lisait les journaux
moi, je puis quelques traits de Michelange

FACSIMILE OF THE BEGINNING OF THE JOURNAL
Paris, Bibliothèque d'Art et d'Archéologie
(Fondation Jacques Doucet), MS. 247

PART I

1822

Louroux,[1] *Tuesday, 3 September 1822*

I AM beginning my Journal; the Journal I have so often planned to write. My keenest wish is to remember that I am writing only for myself; this will keep me truthful, I hope, and it will do me good. These pages will reproach me for my instability. I am beginning in good spirits.

I am staying with my brother. It is evening, and the church clock in Louroux has just struck nine or ten. I am sitting for a while in the moonlight, on the little bench by the door, trying to collect my thoughts. But although I feel contented enough this evening, I cannot recapture the mood of last night. Then there was a full moon, and seated on the bench outside my brother's house I spent some hours of perfect happiness. Some friends had been dining with us, and after seeing them home we walked round the pond and came back to the house; my brother read the newspaper and I took up some of the Michelangelo engravings which I have brought with me.[2] These wonderful drawings moved me deeply and put me into a happy frame of mind. In the clear sky a big red moon was slowly climbing between the trees, and in the midst of my meditations, and just as my brother happened to be talking about love, I heard Lisette's voice in the distance. It has a sound that makes my heart beat faster and is her greatest charm, for she's not exactly pretty, yet there is something about her

[1] Le Louroux is a village in the department of Loches (Indres-et-Loire). Delacroix's elder brother, General Charles Delacroix, had a small estate there where Delacroix sometimes spent his holidays. The General, who was born in Paris in 1779, had a brilliant career in the imperial armies: aide-de-camp to Prince Eugène, wounded at the passage of the Dwina in 1815 and taken prisoner to St. Petersburg, he was promoted Field-Marshal in 1816, and retired from the army on half pay. He married the daughter of an innkeeper and fell into bad repute with his family. Eugène, however, always had a great affection for his brother.

[2] Delacroix made numerous copies and tracings of engravings of drawings by the Old Masters.

of that quality which Raphaël understood so well. The line of her arms is pure, like bronze, strong-looking yet delicate, and this girl, who is really not pretty, has a beguiling way with her, an enchanting mixture of sensuality and modesty—for instance, when she came in, a couple of days ago, whilst we were at dinner. It was Sunday, and although I don't usually care for her in her tight Sunday clothes, I found her irresistibly attractive at that moment, especially for that heavenly smile I was speaking about. Someone was telling a bawdy story; it amused her, and yet caused her to look down and sideways in embarrassment. She was quite genuinely embarrassed, for when she answered some trivial question of mine her voice trembled a little and she avoided looking at me; besides, I could see the fluttering of her breast under her kerchief. I think it was on that same evening that I kissed her, in the dark passage as we came through the house into the garden on our way back from the village. I had stayed behind with her and allowed the others to go on ahead. She kept telling me to stop, but very softly and sweetly. But it all means very little; this is not important. The thought of her will not haunt me like a violent love affair. It will be nothing but a charming memory, a flower by the wayside. Her voice reminds me of Elizabeth Salter,[1] whom I'm already beginning to forget.

On Sunday morning I had a letter from Félix[2] telling me that my picture had been hung in the Luxembourg.[3] Today is Tuesday, and I am still full of it. I must confess that it has done me a lot of good and that when I think about it the day brightens quite appreciably. At present I can think of nothing else; it has made me long to be back in Paris, where in all probability I should find nothing but concealed envy, and would soon be bored with what makes me feel triumphant now—and where there would be no Lisette, no moonlight, and none of this peaceful atmosphere.

Must try to remember all that I have planned to do in order to

[1] Elizabeth Salter was a young English girl who had been in service with Mme de Verninac, Delacroix's sister. Eugène had made love to her and had painted her portrait.

[2] Félix Guillemardet, Delacroix's intimate friend from childhood, was the son of Ferdinand Guillemardet, who was a member of the National Convention (1792–5), and a friend and colleague of Eugène's father, Charles Delacroix. He became Ambassador to Spain. Goya painted his portrait, now in the Louvre.

[3] The reference is to the picture 'Dante and Virgil', exhibited at the Salon of 1822; it was acquired by the State for 1,200 francs and hangs today in the Louvre.

keep myself busy when I get to Paris, and all the ideas I've had about subjects for pictures.

Thursday, 5 September

Went out shooting with my brother; the heat was stifling. I shot a quail as I swung round and Charles congratulated me. What is more, it was our only success, although I had three shots at rabbits.

In the evening we went to meet Lisette, who was coming to mend some shirts for me. I took advantage of being a little behind the others to kiss her; she struggled, and it vexed me because I could see she meant it seriously. When we next met I tried again, but she quickly shook me off saying that *if she wanted to* she'd be sure and let me know. Then my feelings were really hurt and I pushed her away and strolled up and down in the lane under the rising moon. I came across her once more as she was drawing water for supper, but although I felt inclined to sulk and not go back to her I finally yielded to temptation. 'Then you don't love me?'—'No!'—'Do you like anyone else?'—'I don't love anybody', or some such ridiculous answer, meaning, 'Let me alone!' This time, hurt and annoyed, I crossly let go her hand and turned my back on her. She gave a faint laugh, it was not really a laugh but the remains of her half-serious protest, but it has left a disagreeable taste. I went back to the lane and then home, pretending not to notice her. I do earnestly want to put her out of my mind. But although I'm not in love with her I feel indignant, and above all I want to make her sorry for the way she's behaved. Now that I'm writing, I feel I must give vent to my feelings. I had been meaning to see her washing the clothes tomorrow. Shall I give in? But then if I do, nothing will be ended; am I going to be such a fool as to begin all over again? I hope and trust that I shall not.

Sat up late talking to Charles. His story about the captain of the *Roquebert* who, after his arms and legs had been shot off, had himself tied to a plank and thrown into the sea—a fine subject for a picture, and a fine name to rescue from oblivion.

Nothing very important occurred yesterday, 4th. The day before was the anniversary of the death of my dear mother.[1] I began the Journal on the same day. May her spirit always be near me as I write, and may nothing I put into it cause her to blush for her son!

[1] Delacroix's mother, *née* Victoire Œben, was the daughter of Œben, the famous cabinet-maker. She died in Paris on 3 September 1814.

12 September

Uncle Riesener, with his son[1] and Henri Hugues have come to pay us a surprise visit and I'm having a very amusing time. I was immensely pleased when the news of their arrival was brought to us as we were dining with our neighbour the curé.

During the last two or three days I've made up my mind to go to M. Gros,[2] and the idea is giving me plenty to think about.

We were speaking of my father this evening. I must try to remember all the details of the anecdotes that throw light on his character: for instance, the one about his dining with the Directors in Holland, when he was surprised by rebels who were actually incited by the French government itself. He harangued the brutal, drunken soldiers with the utmost calm. One of them took aim at him, and my brother knocked the gun aside. And my father spoke to them in French—to those Dutch ruffians! The French general in league with the rebels wanted to give him an escort. He answered that he refused the protection of traitors.

His operation.[3] Entertaining his friends and the doctors to luncheon beforehand: giving the orders to his workmen. The operation was performed in five stages; after the fourth, he said: 'Well, gentlemen, here are four acts over, let us hope that the fifth may not turn it into a tragedy'.

When I return next year, I want to make a copy of my father's portrait.

Think about strengthening your principles. Remember your father, and try to overcome your flightiness. Do not be tolerant of unscrupulous people.

[1] Henri-François Riesener (1767–1828), and his son Léon Riesener (1808–78), were both painters. The former was a son of Jean-Henri Riesener, celebrated designer of furniture, who, in 1766, married as his second wife the widow of Œben, the cabinet-maker. She already had one daughter, Victoire Œben, who became the mother of Eugène Delacroix.

[2] Baron Gros (1771–1835) had noticed and strongly supported Delacroix's 'Dante and Virgil'. When congratulating the young artist he made the famous comment: 'A chastened Rubens' (*Rubens châtié*).

[3] The reference here is to the serious operation performed on Charles Delacroix in September 1797. Contemporary documents on the operation make it impossible, in medical opinion, for Charles Delacroix to have been the father of Eugène, who was born exactly seven months later.

According to Théophile Silvestre, it was rumoured in Eugène's lifetime that he was the son of Talleyrand. This is now accepted by most authorities though it cannot be regarded as certain. The varied evidence which supports the theory has been dealt with in M. Paul Jamot's book, *Le Romantisme et l'Art*.

13 September. The eve of my departure from Louroux

This evening I received a letter from Piron[1] and another from Pierret.[2] I have suddenly decided to go back to Paris; although I'm afraid that by leaving like this, without giving myself time to collect my thoughts, I shall lose some of the pleasure of looking forward to seeing my friends again. In his letter, Pierret speaks of the matter about which Félix wrote to me in his last. I feel much calmer about it all now, and to a certain extent I shall let myself be guided by circumstances. Of course I can never abandon my sister,[3] especially now that she is deserted and unhappy. I think the best thing to do is to take Félix into my confidence, and ask him to recommend some honest lawyer who will keep an eye on my brother's affairs.

Uncle Riesener and Henry left this morning. I felt sad at their going, although we shall only be separated for a short time. I've grown fond of Henry. He has a supercilious manner that makes people dislike him at first, but he's a good fellow at heart. Last night, on the eve of our separation, which my brother must have been feeling especially, we dined late and largely. I had made it up with Lisette the day before, and Charles's wife and Henry happening to be with us, we danced late into the night. I was very much embarrassed and annoyed. Henry persisted in saying coarse and filthy things to her, and in front of this woman, too, who was already more than a little tipsy etc. I've a respect for women and I couldn't say anything really obscene to them. However depraved I may think them, I cannot help blushing when I wound the modesty which, in outward appearance at least, ought never to desert them. I think, poor shy fellow, that this reserve of yours is not the way to succeed with the ladies, and perhaps that tired rake Henry is more attractive to them for that very reason.

Paris, Tuesday, 24 September

Arrived here on Sunday morning after a miserable journey on the

[1] Piron: one of Delacroix's oldest and closest friends, an official in the Post Office. Delacroix made him his executor and residuary legatee. Piron published some of Delacroix's essays and notes in 1865, dedicated to his friends.

[2] Jean-Baptiste Pierret: a school-fellow and an intimate friend.

[3] Delacroix's sister Henriette, born 1780. In 1798, the year of Eugène's birth, she married Raymond de Verninac. The settlement of their mother's estate later gave rise to difficulties between brother and sister. David painted an admirable portrait of Henriette in 1798.

outside of the coach—horribly cold, driving rain. I had been so much looking forward to seeing Paris again, but somehow, the nearer we got to it, the more depressed I became. Embraced Pierret and felt wretched. The news is the trouble. Later on I went to see my picture in the Luxembourg and came back to dine with my friend. I was very glad to see Edouard[1] again on the following day; he tells me that he is seriously studying Rubens. I am delighted to hear it. What he lacks most of all in his work is colour. I shall look forward to these studies developing his real talent and bringing him the success which I so much want to see him win. He had no luck at the Salon; it is a shame! We promised to see something of each other this winter.

Paris, 5 October

It has been a good day. Spent the evening with my great friend Edouard and explained to him my theories about the treatment of modelling; he liked my ideas.

I showed him some of Soulier's sketches.[2]

In the morning I went with Fedel to see Uncle Riesener; he has invited me to lunch with the family next Monday and I'm looking forward to it.

We all three of us then picked Rouget up at his house and went to the exhibition of prize paintings. The torso and picture by Delay, M. Gros's star pupil, have quite disgusted me with his master's methods of teaching, and to think that only yesterday I was longing to learn from him!

Uncle Riesener seemed interested and charmed by my picture. They advised me to go ahead by myself, and now I've a good mind to do so.

It is most extraordinary, I've done nothing all day but worry over the new coat which I tried on this morning; the one that fitted so badly. I find myself staring at every coat I pass in the street.

[1] Edouard Guillemardet, son of Ambassador Guillemardet, and brother of Félix; see second footnote on p. 2.

[2] Raymond Soulier, one of Delacroix's greatest friends, was then in Florence, acting as secretary to the French Minister. Educated in England, Soulier added to his income by giving English lessons, and it was in this way that he first made the acquaintance of Delacroix in 1816. Soulier also gave Delacroix lessons in water-colour, a technique then little used in France, to which Copley Fielding had introduced him in England.

Uncle Riesener has suggested taking me to see M. Gérard.[1]

Do a water-colour after Van Ostade's 'Winter Landscape', also 'The Painter in his Studio', I forget by whom; and one or two other little Flemish pictures.

Tuesday, 8 October

When we were at the Louvre, Edouard told me that he had found two studios in the same house that might suit us. Spent the day in the worst slums in the world—I was steeped in melancholy. This evening I went to see Pierret, and found a better opportunity of studying the charms of his pretty maid.

I must not feel bound to ignore something today because I rejected it in the past. Books that seem to contain nothing worthwhile when I first read them may have much to teach when read by eyes of more mature experience.

I am borne, or rather my energy is borne, in another direction. I shall be the herald of those who do great things.

There is something in me that is often stronger than my body, which is often given new heart by it. In some people this inner power seems almost non-existent, but with me it is greater than my physical strength. Without it I should die, but in the end it will burn me up— I suppose I mean my imagination, that dominates me and drives me on.

When you discover a fault in yourself, don't try to conceal it, face it squarely; stop acting a part and correct yourself. If only one's soul had nothing worse than the body to contend with! But the soul, too, has evil tendencies, and one part, the weaker yet the more divine, must be forever struggling against the other. All bodily passions are vile, but the evil passions of the soul are truly like malignant cancers; envy, etc. Cowardice is so loathsome that it must surely emanate from both body and soul.

When I have painted a fine picture I have not given expression to a thought! That is what they say. What fools people are! They would strip painting of all its advantages. A writer has to say almost everything in order to make himself understood, but in painting it is as if some mysterious bridge were set up between the spirit of the persons in the picture and the beholder. The beholder sees figures, the external

[1] Baron Gérard (1770–1857), fashionable portrait painter during the Empire, was made court-painter to Louis XVIII to whom he was introduced by Talleyrand. Delacroix was well received in Gérard's circle, which was extremely influential.

appearance of nature, but inwardly he meditates; the true thinking that is common to all men. Some give substance to it in writing, but in so doing they lose the subtle essence. Hence, grosser minds are more easily moved by writers than by painters or musicians. The art of the painter is all the nearer to man's heart because it seems to be more material. In painting, as in external nature, proper justice is done to what is finite and to what is infinite, in other words, to what the soul finds inwardly moving in objects that are known through the senses alone.

Paris, 12 October

Just returned from the *Marriage of Figaro*, full of the most heavenly sensations.

I still feel as excited as a small child. How changeable I am! A new idea can confuse my mind in a moment, and upset my firmest resolutions. From a sense of honesty I don't want to appear better than I am, but what is the use? Everyone worries far more about the least of his personal troubles than over the worst disaster that afflicts the nation as a whole.

Do what is necessary, and no more. You have been mistaken. Your imagination has led you astray.

Music often inspires me with great thoughts. I feel an intense longing to paint as I listen to it. I am afraid I lack patience. I should be a different man if I had the staying power of some of the people I know. I'm always in too much of a hurry to get results.

Charles, Piron and I dined together. Then to the Théâtre des Italiens. What a delicious thrill they give me, these women with their charms and graces! All these divine things that I can see but never possess make me feel glad and sorry at the same time.

I should like to begin studying the piano and violin again.

Today I thought with great satisfaction about the lady at the Italiens.[1]

The same night, half-past one

I have just caught a glimpse of Orion shining amid black and storm-swept clouds. At first I thought of my own insignificance compared with these worlds hanging in space. Then I thought of justice and friendship, of the divine emotions graven on the heart of man, and I

[1] The lady was Madame de Conflans, a sister of the Guillemardets.

no longer felt anything to be great in the universe, save man and his creator. I have been impressed by this idea. Can it be possible that He does not exist? But could a mere chance combination of the elements have created the virtues, reflections of an unknown grandeur! If the universe had been produced by chance, what would *conscience* mean, or *remorse*, or *devotion*? O! if only, with all the strength of your being, you could believe in that God who invented duty, all your doubts and hesitations would be resolved. For why not admit it? It is always questions of this life, fears for it or for your comfort, that disturb your fleeting days—days that would slip by peacefully enough, if at the end of your journey you saw your Heavenly Father waiting to receive you! I must leave this and go to bed, but it has been a happy dream.

I think I have made some progress in my study of horses.

Tuesday, 22 October

After I had helped Pierret home because of his lame knee, I sat down to rest for a little while. I was able to see his maid almost in half-profile—a pure, a charmingly lovely line. What a contrast this straight nose is to Pierret's wife's snub-nose! It is an old weakness of mine to think a turned-up nose one of nature's shortcomings and a straight one a compensation for many defects. In point of fact, snub-noses are ugly things. It's a matter of instinct.

As usual, my insignificant size is annoying me. I can't see my nephew without envying his good looks. I generally feel unwell. I can't talk for long.

This evening I again admired Riesener's little portrait of Félix. I should like to have painted it myself, and yet I wouldn't change what I can do for that, but I wish I had his simplicity. It always seems to me so difficult to paint the eyes—the space between the upper eyelid and the eyebrow—without making the work look laboured.

On the following day, Wednesday, I had some friends to spend the evening with me. We drank mulled wine and hot brandy.

On Sunday (the day before yesterday), I dined with Mme de Conflans, whom I'd been to consult a few days earlier. Had a most amusing time. We sang the score of *Figaro*.

I've bought *Don Juan*. I am painting a woman's portrait in exchange for her engravings. I've begun playing the violin again.

I can't prevent myself blushing, and in other ways, too, I've not enough self-control. I'm always thinking about the model's discomfort. I don't observe closely enough before beginning to paint.

Sunday, 27 October

Dear Soulier[1] is back, we met today. At first, I felt nothing but joy at seeing him again, and then I had a sudden qualm. Just as we were going up to my room I remembered that there was a wretched letter whose handwriting he would have recognized. I hesitated, and all my pleasure at his return was wrecked. I told some lie or other, pretended to have lost my key or something of the kind, and he left, promising to pick me up here this evening. We've been for a walk. I do hope that the wrong I've done him will not affect his relationship with J—. I hope to God he never finds out about this affair. And why, at this of all moments, do I have a feeling of gratified vanity? O! he'd be heartbroken if he were to hear anything. He is very busy with his music and I'm glad of it; I am looking forward to our having some good evenings together. I have often noticed how difficult it is to recapture the pleasures one has felt most vividly, in the same circumstances and with the same people; but still, I see nothing to prevent Soulier and me from repeating the happy times we spent together and which I remember so well. And yet I have a kind of foreboding; he belongs to a different world, besides, I know quite well what it is that makes me feel uncomfortable when I am closest to him; it's this business about which I've got to come to a decision, and which I want to have as little to do with as possible. I talked to M. about it yesterday—he agrees with me that there has been some trickery. He considers that we are free. I feel much less worried since I had this conversation.

When my sister was talking to Goiffon this morning, regarding the arrangement she proposes to make with her brother-in-law, she said that it would set her mind at rest about one of her brothers. *She means to thwart Charles if she can.* I won't stand this. She wants to put me at the mercy of her brother-in-law's generosity. I'll have nothing to do with it. I'd rather beg. No obligation of gratitude for me, nor any other obligation for that matter. I should find it unbearable.

Yesterday, I went with Edouard and Lopez to see Mauzaisse's studio. It is superb. The idea occurred to me that there was no need to have such a fine studio to do good painting. Perhaps I am wrong!

I am still hesitating whether or not to go and see the Lady of the Théâtre des Italiens. Every time I go there I come away in raptures.

[1] Soulier had returned from Florence. Delacroix was concerned about the situation which had arisen in his absence—his own love affair with Soulier's mistress. Her name is not known, but she evidently moved in good society, and in his Journal she is referred to as J—.

I dream about it; it is like those unobtainable joys one only recaptures in dreams—the memories of another life. The pleasure was flat enough when I had it, now it is coloured by my imagination, source of all my joys and sorrows.

I think it was on Thursday or Friday that I dined with Uncle Pascot. Didn't have much to drink; just enough to make me feel muzzy. It is a pleasant feeling, whatever the puritans may say!

1823

Paris, Tuesday, 15 April 1823

I am taking up my Journal again after a long break. I think it may be a way of calming this nervous excitement that has been worrying me for so long. I seem to be more upset than ever since Soulier returned—less master of myself. I am as nervous as a child. All my affairs are in a tangle, my money matters as well as my daily life.

I made some good resolutions today. If my memory fails, these pages may at least reproach me for forgetting them—a folly that would only serve to make me unhappy.

Spent a long time today, admiring Andrea del Sarto's 'Charity'. This painting actually moves me more than Raphaël's 'Holy Family'. Good painting exists in many different styles. What grace, nobility and strength in his children! And the woman, what a head, and what hands! I wish I had time to make a copy. It would be a reminder that in working from nature, away from the influence of the great masters, one needs a much grander style.

I really must settle down seriously to drawing horses. I shall go to some stable or other every morning; I shall go to bed early, and get up early as well.

'I thought it would be safe to see you again.[1] I hoped that you would receive me coldly, but you were too kind. What is the use of making two people wretched? I almost believed that I'd forgotten you. Whatever you may feel about him,[2] he is your friend and a friend of your family. He can see you whenever he likes.'

* * *

'I ought not to have seen you again; now everything is reawakened so far as I am concerned! You were too kind to receive me coldly.

[1] Draft of a letter addressed to J—. The first paragraph was crossed out.

[2] A reference to Soulier.

What is going to come of it all? I for one am beginning to suffer most damnably! Are we to share you between us? Whatever you may feel for someone else, he is your friend and a friend of your family. Am I to walk up and down under your window when he is with you? I had been relying on my strength of will, and now you have ruined everything. But it does not matter; since I may not see you, I shall cherish the memory of your last farewell. You, too, remember the friend who loves you.'

'What possessed you to give me such a welcome? Do you want to drive me mad again?'

Saw her again on Saturday, 10 May. I shall not write down how she received me. I shall never forget it. All this has upset me a great deal.

Now I feel perfectly calm again. I was beginning to feel the pangs of jealousy. Dined with Pierret this evening.

Today, *Friday*, 16 *May*, called on Laribe and took him the plan which I've drawn up for my picture on the history of France. Everything is happening as I foresaw. They are going to shilly-shally, to whittle down the idea and eliminate some of the competitors. I spoke to him in rather an off-hand way about it, perhaps too much so. Finally, I fell back on the promise of the commission for a church, but as if I had very little faith in the idea; he answered as if he scarcely liked to agree.

Beware of first impressions; try to have more presence of mind.

You should not be deceived by the eager promises of your best friends, by offers of help from influential people, or by the interest which men of talent seem to take in you, into thinking that there is anything real in what they say—real in the way of results, I mean. Many people are full of good intentions when they speak, but their eagerness subsides appreciably when it comes to action, like blusterers, or people who make angry scenes as women do. And you, yourself, try to be more cautious in the way you welcome people, and above all, avoid these ridiculous attentions; they're only offered on the impulse of the moment.

Cultivate a well-ordered mind, it's your only road to happiness; and to reach it, be orderly in everything, even in the smallest details.

How weak I am, how vulnerable and easily taken unawares when I come face to face with strong men, who weigh their words and are ready to act upon them! But do such people really exist? Have not I, myself, often been taken for a man with a strong will? Appearances are everything. But I must confess that I am afraid of such people, and is there anything more calamitous than being afraid? The most

resolute men are cowards when they feel unsure of themselves, and presence of mind, the best defence, only comes when one feels that there is no chance of being taken unawares because everything has been foreseen. I know that this requires immense determination, but with perseverance one is bound to make great headway.

I saw Sidonia, last Tuesday.[1] What ravishing moments! How lovely she looked lying naked on the bed! It was mostly love-making and kisses.

She is coming back on Monday.

On the following day, Wednesday, Géricault[2] came to see me. I was touched by his paying me this attention—how silly!

Evening with the Fieldings.[3]

Here is some of the nonsense which I jotted down in pencil a few days ago, while I was working on my small picture 'Phrosine and Mélidor'. This was after an account of pleasures proved which had put me into a thoroughly bad temper.

'Why did you not treat me as coldly as you feel about me? What claim have I on you? Why do you want to see me? Good God! what a thing to share! It is madness! When I left you I flattered myself that your eyes were speaking the truth. It was enough to treat me as a friend; it was the least you could do. And besides, what have I asked of you? It would have been a mean trick to come back to you in the hope of loving and of being loved. I thought my feelings were under better control. I was counting on your help. What were your eyes trying to tell me?'

'It was cruel of you to kiss me! Do you imagine that I can live with this man if I begin to love you, and that I shall be able to bear his being near you, when no doubt you will grant him everything, out of pity? That sort of pity scarcely suits a lover. My heart is not so sympathetic. I think you must despise me.'

<p align="center">* * *</p>

[1] One of the models posing for 'The Massacre at Scio'.

[2] Théodore Géricault (1791–1824) had been the most brilliant and forceful of Guérin's pupils and still visited the studio when Delacroix was working there. He was the chief formative influence on the younger painter in spirit and technique. Delacroix had posed for one of the figures in 'The Raft of the Medusa', and Géricault had passed on to Delacroix in 1820 a commission for a picture, 'The Virgin of the Sacred Heart', now in the cathedral of Ajaccio.

[3] The four brothers, Theodore, Copley, Thales and Newton Fielding were all of them painters in water-colour. Thales, with whom he shared a studio for a time in Paris, was active in persuading Delacroix to come to England in 1825.

Now I am sane again. Socrates says that flight is the best way to fight love.

I had better read *Daphnis and Chloe*; it is one of the old themes that we suffer most gladly.

Saturday, *May 1823*

I have just come in after a long walk with dear Pierret. We had a great talk about all the delightful love-affairs that keep us so busy. Just now, I can think of nothing but the exquisite figure of Mme de Puysegur's maid. I've been nodding to her in a friendly way ever since she came to live in the house. The day before yesterday, in the evening, I met her on the Boulevard as I was on my way home after paying some unsuccessful calls. She was walking arm-in-arm with another girl in her mistress's service. I was hugely tempted to tuck them both under my arm, but all kinds of stupid considerations crossed my mind, and all the time I was getting further and further away from them. I was furious with myself for being such a fool. I told myself that I ought to have seized the opportunity—talked to her a little, held her hand, and so on, or at least have done something. But her friend—two housemaids at once: I could hardly have taken them to Tortoni's to eat ices! So I walked on still faster to M. Hénin's where I learned of his return; then finally, when it was too late to overtake them, I ran after them and walked aimlessly up and down the Boulevard.

Yesterday, I went with Champmartin to make a study of dead horses. When I came home I found Fanny sitting with that nice Mme F—, the porter's wife. Sat down and chatted with them for a full hour, and then arranged things so that we went upstairs together. I felt the delicious thrill run through me that heralds a good opportunity. My foot was pressing against her foot and leg; it was delightful. When I put my foot on the first step I had no idea what I was going to say or do, but I had a presentiment that something definite was going to happen. I put my arm gently round her waist. When we reached the landing, I kissed her passionately and pressed my lips to hers; she made no attempt to push me away. She only said that she was afraid of being seen. Ought I to have gone further? But how cold words seem when one tries to describe one's feelings! I kissed her again and again and held her in my arms; then I let her go, thinking that I should see her today. Alas! it's today now, and I've been thinking of nothing else; I've seen her, but I can't make out what it is

she wants. She seems to be avoiding me, or else she's pretending not to see me. And now, this evening, at this very moment, my door is open and I'm hoping for something—I don't quite know what— something that will not happen. I foresee endless difficulties. But how sweet it would be! This is not love, the girl herself does not really enter into it, it is a strange sensation, a kind of tingling in the nerves that stirs me whenever I think about a woman. She's not even very attractive. But all the same, I shall treasure the delightful memory of her lips pressed close to mine.

I think I'll write her a little note, something that she'll have to answer, and then another; but nothing she could take seriously. I shall simply ask her, because we see each other so rarely, to let me know when I may see the portrait which she promised to show me. O foolish! foolish! how foolish to love and to want to run away! No! this is not happiness! It's better than happiness, or it's very sweet sorrow. What a miserable creature I am! And suppose I were to fall genuinely and passionately in love! My cowardly heart would not dare to choose the peace of indifference rather than the delicious, excruciating torment of a tempestuous love-affair. Flight is the only remedy, but we think there is always time to fly, and indeed, we should have to be very desperate to run away, even from misery itself.

I spent the evening with Pierret, retouching a family portrait that poor old Petit was finishing when he died. It gave me a feeling of pain to be in the humble refuge of a poor old painter, who was not without talent, and to look at the feeble work of his listless old age.

I have decided to paint scenes from the 'Massacre at Scio'[1] for the Salon. I shall go to see Cousin tomorrow.

Monday, 9 June

Why not take advantage of those antidotes to civilization, good books? They give strength and peace of mind. I cannot question what is really good, but with fanatics and schemers one must have reservations.

We are too prone to blame ourselves for being changeable when it is the object itself that has changed. Nothing is more upsetting! For instance, I have two or three, perhaps four friends, but I am forced to be a different man with each of them, or rather, to show to each the side of my nature which he understands. It is one of the saddest things in life that we can never be completely known and understood

[1] Exhibited at the Salon of 1824, and, in spite of its very mixed reception by the public, it was bought by the State for 6,000 francs. It is now in the Louvre and is the masterpiece of Delacroix's early period.

by any one man. Now I come to think of it, this is the worst evil in life, this inevitable loneliness to which our hearts are condemned. A wife who is one's equal must be the greatest blessing on earth, and I would rather she were my superior in every way than the reverse.[1]

Sunday, 9 November

Saw my beloved again; she came to the studio. I feel much calmer now, and yet most deliciously thrilled. She loves me a little (as lovers understand the word). I am sure that she has almost the same tender feeling for me that I have for her. What a strange emotion! I stroked her leg, and even dared to move up a little. At any rate, I dined with my cousin that evening, and all the time I never ceased— Dearest girl, try not to give my heart fresh torments! After she had gone I thought of so many things that I wanted to say to her. I feel that nothing more need be said about secrecy, now that it is no longer a question of making somebody unhappy. But I will not have her telling me that she loves me while she is flirting with someone else.

Heavens! how behindhand I am with everything. And Emilie,[2] poor child! She is already forgotten. I have not even mentioned her, and yet it was all very sweet.

It was last Monday that I was with her; the day on which I went to Régnier's studio and saw the Constable sketch for the second time— admirable, quite incredibly fine.[3]

10 November

I only want a woman to be frank when a man is her friend, and to be able to talk things over as two men would do. What made you come to the rue de Grenelle? It must have meant something more than a mere social call. What I hate most is uncertainty. Tell me openly, dearest, that you love us both equally. And why be ashamed of it? Are women made differently from men? Do we have any great scruples about making love to someone who charms us for the

[1] Delacroix later wrote in the margin here: 'The feelings which were bound up with the idea. This is the kind of woman with whom I would choose to pass my life: she is a good woman.'

[2] Emilie Robert, one of Delacroix's favourite models. She posed for the nude woman bound to the Pasha's horse in the 'Massacre at Scio'.

[3] It is common knowledge that the art of Constable made a deep impression on Delacroix, and caused him drastically to alter the sky and light distance of the 'Massacre at Scio'.

moment? Come now, admit your love; say that your heart is large enough to hold two friends at once, since neither of us is your lover. Then I shall not be jealous, and I think that I shall not feel guilty in possessing you. I should like to monopolize you entirely. It was heaven to hold you in my arms! And your voice sounded sincere when you said: 'How long it has been, my dear, since I saw you like this!' But am I truly never to see you again? Surely, if you were ill I might come and inquire after you? Is there no way of arranging this through your brother?

And you, my poor friend,[1] I feel sorry for you. You must be suffering a great deal. I think that I am happier than you because I am content with less. She is not blaming us in the least when she gives us up to one another: 'I put myself entirely in your hands', she said. I do hope he can stop loving her. I long for her to come next Thursday, but that will be the end; as for her, she has very calmly decided to do without me! If only she would tell me so herself, it would set my mind at rest.

The same day

'Dearest, kindest J—, I am taking advantage of my holiday to write to you, as a consolation until I see you again. Next Thursday—I'm giving it far too much thought for a man who does not intend to repeat it often. What a cruel, blissful time it will be for me, my darling! I am afraid this letter will bore you. Don't think that I am only writing to tell you my dreams—alas! so sadly and lovingly dreamed, and in this very room where I saw you yesterday, and where you were so sweet to me.' (*in all this I'm only sad because even as a friend of hers, which I most sincerely am, I am not allowed to see her*) 'I want to ask you something which I did not dwell on yesterday. Will you be kind and come here tomorrow before you see your son, and then come back afterwards? Remember that after Thursday you are going to forget all about me, and that this is all I shall have to look forward to for a long time to come. It will be easy for you to invent a headache, or to find some other excuse to get away early. I shall always be grateful to you for the time I steal from your son. May heaven make it up to him one day. I am also venturing to hope that you will be kind and arrange to give me even more of your time after you've been to the school, and that you will warn them beforehand that you are going to be away from home for part of the day. Am I not shamelessly

[1] Soulier.

indiscreet? But remember that you are going to forget all about me after Thursday. Dearest J—, why not let yourself be frank with me? Why not be friends outright with one who will always carry your dear image in his heart, and who would do anything for you? I love you so much! But do not let us dwell on all these emotions. So many strange and delicate strands of feeling are involved that I lose my head when I try to grasp them all. The heart is the only sure guide; it has never led me astray where people's feelings for me are concerned.

'Goodbye, then! Goodbye! I am counting on your kindness. Besides, you know that we have many arrangements to discuss, and I have a thousand things to tell you which I only remembered after I left you. All this will take a long time. I can see your pitying smile at my foolishness. How sad life is! There is always something to spoil what ought to be so lovely! What! suppose you were to fall ill, am I forbidden to come and inquire after you and to visit you? But there it is, it must be so. Goodbye once more, and my dearest, truest, life-long affection.'

17 December

'I have only just received your letter; I've been at home for the last day or two and have not been to the studio. J—, your memory will always be dear to me, and what you are suffering I am suffering also. I have my own troubles too, and more than one misfortune to contend with. I am worried and hard-pressed for time and money. Don't add to these evils the idea that I am indifferent to what affects you. You have been very kind in taking an interest in my affairs lately, although unsuccessfully. I should have been to see you, if I had not been afraid that at this juncture you might have thought it a mere act of courtesy, the usual social call. And here I have a friend to thank, for you may well believe that I did not wait for your letter to have news of you. Your poor child! I feel so sorry for you! My sad face would scarcely be a comfort to you. Goodbye, and my dear love to you.'

Tuesday—at midnight, 22 or 23 December

I came home full of goodwill and resigned to my fate. I have been spending the evening with Pierret and his wife in their humble little home. We accept our poverty. And really, when I complain of being poor I am not myself, I'm out of my proper sphere. To be rich you need a kind of talent in which I am wholly lacking, and if you do not possess it you need a different kind of talent to fill the gap.

We should do everything calmly and only react emotionally to great works of art or noble deeds. Work quietly and without hurrying. As soon as you begin to sweat and get excited, be careful. Slack painting is the painting of a slacker.

Tuesday, 30 December

Spent the day with Pierret. I had an appointment to go with him to an exhibition, mostly Italian paintings, but among them M. Guérin's 'Marcus Sextus'. We arrived late, thinking that this was the only painting we should want to look at and that we should find the old pictures uninteresting. But on the contrary, there were very few pictures, extremely well chosen and one outstanding, a Michelangelo cartoon. What sublime genius! How these features bear the imprint of majesty, although almost effaced by time! Once more, I felt within me the stirring of a passion for great things. We ought to steep ourselves from time to time in great and beautiful works of art.

This evening I took up my Dante again. Obviously I was never intended to paint fashionable pictures.

After leaving the gallery we went into a dyer's shop where we saw a girl with an admirable head and body, perfectly in harmony with the feeling of the lovely Italian pictures. I shall try to go back there often. There are some fine Venetian portraits. A Raphaël and a Correggio . . . Raphaël's beautiful 'Holy Family'!

A few days ago I spent the evening with Géricault. How sad it all is! He is dying; his emaciation is dreadful to see—thighs no thicker than my arms and a head like that of an ancient, dying man. I want him to live with all my heart but I dare not hope any longer. It is a frightful change! I remember coming home full of enthusiasm for his work and especially for the 'Study for the Head of a Rifleman'. I must remember that, it is outstanding. What beautiful studies! Such firmness! Such mastery! To die in the midst of all this, which he has created in the full vigour and fire of his youth. And now, he cannot even turn in his bed without assistance!

1824

Paris, Thursday, 1 January

As always, if I remember rightly, I brought nothing but a mood of blackest melancholy away from the splendid New Year's Eve party which Pierret gave for us. These serenades to the New Year and,

above all, the horns and trumpets make one feel sad about the passing of time, instead of preparing one to greet the future joyfully. This day, I mean today, is the saddest day of the year; yesterday the year was not yet over. Edouard spent the evening with us. I saw Goubaux again; we talked about our school-days . . . many of our old school-fellows have turned out badly or have been demoralized in one way or another.

Sunday, 4 January

Poor fellow! How can you do great work when you are always having to rub shoulders with everything that is vulgar. Think of the great Michelangelo. Nourish yourself with grand and austere ideas of beauty that feed the soul. You are always being lured away by foolish distractions. Seek solitude. If your life is well ordered your health will not suffer.

Here is what the great Michelangelo wrote when he was on the brink of the grave: 'Borne in a fragile bark upon a stormy sea, I complete the course of my life. I draw near that common bourne where all must go to give account of the good and evil that they have done. Ah! how clearly I perceive that this art, which was the idol and tyrant of my imagination, has plunged it in error. All is error here below. Thoughts of love, sweet and vain imaginings, what will become of you now that I approach a double death—one that is certain, the other menacing me? No, sculpture and painting cannot suffice to calm a soul that is turned towards divine love, and set aglow by heavenly fires.' (Verses at the end of his collected poems.)

Monday, 12 January

Appointment this morning with Raymond Verninac to meet M. Voutier, just back from Greece, where he has held an important post. He is returning there. M. Voutier is a fine-looking man, a Greek type. He has small, bright eyes and seems full of energy. Over and over again he has been struck with admiration for the Greek soldiers, whom he has seen overcoming their enemies and trampling them underfoot, shouting *Zito Eleutheria!* ('Long live liberty!'). During the siege of Athens, when the Greeks carried their attack to within pistol-shot of the city walls, he was so much impressed by the magnificent head of a Turk who appeared on the battlements that he prevented a soldier from shooting at him.

The massacre at Scio lasted for a month. It was at the end of the month that Captain Georges d'Ispahan with, I think, a hundred and forty men set fire to the Turkish flagship. The Captain-pacha and the senior Turkish officers perished, but the Greeks escaped safe and sound. A ship bearing the head of Balleste, the gallant French officer, as a gruesome trophy put into port at Chios on its way from Candia to Constantinople. The ship was set on fire, and the head of the heroic Balleste was buried with suitable honours.

Have been working on the 'Massacre at Scio' for a month.

Went to the Luxembourg after lunching with Raymond Verninac and M. Voutier. Came back to the studio bursting with enthusiasm, and, Hélène arriving shortly afterwards, I made a series of studies for the picture. Unfortunately, she carried away with her part of the energy I needed for my day's work.

In the evening Dimier treated us to some punch at Beauvilliers.

Last Tuesday, 6 January, I dined at the Rieseners with Jacquinot and the daughter of his brother, the colonel. Her features are not beautiful, but I am very anxious not to forget the impression of her Italian type, and especially that clear complexion—yet it is not exactly a good complexion—and the purity of the outline, I mean that decisive look, that tautness of the skin which only virgins have. It is a valuable memory to retain for painting, but already I feel the impression beginning to fade.

Today, Monday 12th, I am really beginning my picture ['The Massacre at Scio'].

Sunday, 18 January

Today, Emilie Robert.

I have been reading about an English judge who desired to live to a great age and accordingly proceeded to question every old man he met about his diet and the kind of life he led—whether his longevity had any connexion with food, alcoholic liquor, and so forth. It appears that the only thing they had in common was early rising and, above all, not dozing off once they were awake. *Most important.*

Saturday, 24 January

Today I began working on my picture again. I stopped work on it last Sunday, 18th. I had only begun a few sketches on the Monday before, or rather, on Tuesday 13th; but today I drew and painted in the head and breast, etc. of the dead woman in the foreground.

I again had *la mia chiavatura dinanzi colla mia carina Emilia*. It in no way damped my enthusiasm. You have to be young for this kind of life. Everything is now painted in, except the hand and the hair.

I was saying to Edouard this evening, that whereas most people go forward in the battle of life with the help of their reading, it so happens that what I read only confirms what I have already arrived at for myself. I have read nothing since I left school, or rather I have never read, and therefore I am astounded at the good things I find in books; I am never bored or satiated with them.

Yesterday, Friday 23rd, I was supposed to go to Taurel's in the evening, but when I left Rouget's after dinner I felt lazy and dropped into the reading-room instead, where I glanced through the life of Rossini. I read too much and made a mistake in so doing. But really, this Stendhal is insolent, supercilious when he is right, and sometimes nonsensical.

Rossini was born in 1792, the year that Mozart died.

Sunday, 25 January

Coming home with Edouard this evening I had more ideas than during all the rest of the day. People who have ideas inspire them in others. But my memory is so uncertain that I can no longer master anything; not the past, which I forget; scarcely the present, for I'm nearly always so much immersed in one thing or another that I lose sight, or fear that I shall lose sight, of what I ought to be doing; nor even the future, as I'm never sure that my time is not already disposed of. I want to set myself to learn a good deal by heart so as to improve my memory. A man with a bad memory has nothing to rely on, everything plays him false. I have already forgotten many things that I should like to have remembered from our conversation on the way home. I was telling myself that one of the sad things in our unhappy state is that we have to be constantly face to face with ourselves. This is what makes the society of pleasant people so agreeable; for a moment they almost make you believe that to some extent they are you, but we soon relapse into our unhappy isolation. Can one's greatest friend, or the dearest and best of women, never bear even part of the burden? Yes, but only for a few moments. They have their own cross to bear.

This brings me to another idea of mine, one that preceded the above. Every evening, as I said to Edouard, when I leave M. Lelièvre's,

I come home feeling like a man to whom all manner of things have happened. I end by being in a state of mental chaos that makes me utterly bewildered. I feel far more stupid, a hundred times less capable, or so I believe, of occupying myself with everyday affairs, than a peasant who has toiled all day in the fields. I said to Edouard that we become attached to our friends when they make as much progress in life as we do ourselves. The proof is that the happiest moments in our lives, the ones we remember with the greatest pleasure, would not be half so enjoyable if we were to relive them exactly as they occurred; witness those friends of our childhood whom we meet again after many years.

Today, just as I was beginning on the woman dragged along by the horse, Riesener, Henri Hugues and Rouget came to see me. Imagine how they treated *my poor creation*, which they saw in the most confused state, when only I could tell how it was going to turn out. 'Look!' I said to Edouard, 'I have to fight against poverty and my natural laziness, I have to feel enthusiastic about my work in order to earn my living, and brutes like these intrude even into my lair, nip my inspiration in the bud and measure me up with their glasses— these people who would not have cared to be Rubens!' By a stroke of luck for which I am duly thankful I now have enough presence of mind to keep at a respectful distance the doubts which their stupid criticisms used often to create. Even Pierret made a few observations, but these did not affect me in the least, because I know what has to be done. Henri was not so hard to please as the others.

After they had gone, I relieved my mind by letting off a stream of curses on mediocrity in general and then crept back into my shell.

The praise of M. Rouget, who would not have cared to be Rubens, dried me up completely. In the meantime he is going to borrow my sketch; it was a mistake to promise to let him have it. But perhaps it may be useful.

When I returned to the studio, the idea came to me of doing a girl standing in front of a table thoughtfully cutting a pen.

Monday, 26 January

I forgot to note that later on I should like to write a kind of memorandum on painting,[1] in which I could discuss the differences between the arts. How in music, for example, form predominates over matter. In painting it is just the reverse.

[1] This is the first mention of the dictionary of the Fine Arts which Delacroix was to take up in the last years of his life.

In Mme de Staël I find exactly the same method that I use to develop my own ideas about painting. This art, like music, *is higher than thought*; hence it has the advantage over literature, through its vagueness.

Tuesday, 27 January

This morning I received a letter announcing the death of Géricault. I cannot get used to the idea. Although everyone must have known that we should inevitably lose him before long, I almost felt that we could conjure death away by refusing to accept the idea. But death would not relinquish its prey, and tomorrow the earth will hide what little remains of him. What a different fate his great bodily strength and his warmth and imagination seemed to promise! Strictly speaking, he was not a friend of mine, but the tragedy cuts me to the heart. It has made me leave my work and paint out all that I have done.

Tuesday morning, 2 February[1]

Got up about seven o'clock. I ought to do this more often. Ignorant middle-class people are very lucky. Everything in nature seems simple to them; things are as they are, and that is explanation enough. And really, are not they more reasonable than the dreamers who go so far that they begin to mistrust their own minds? A friend dies. Because they believe that they understand the meaning of death, they do not add to the sorrow of mourning him the cruel anxiety of being unable to explain so natural an event. He was alive, he is alive no longer; he talked with me, we understood each other; nothing of all this remains, except this tomb. Is he lying in this cold grave, as cold as death itself? Will his spirit hover about his gravestone? And when I think of him, is it his spirit that stirs my memory? Familiarity with an idea reduces us all to the level of the common herd. After the first shock we realize 'he is dead' and the idea no longer disturbs us. Wise men and philosophers seem to be far less advanced in this than the ignorant, since the very thing that should serve them as proof is not even proved for them. I am a man. What is this *I*? What is this thing *a man*? They spend half a lifetime in verifying, and pulling to pieces bit by bit, something that has already been discovered. During the other half, they lay the foundations of an edifice that never rises above the level of the ground.

[1] Either the date or the day of the week is obviously incorrect. Several such mistakes occur in the Journal.

Friday, 20 February

Every time I look at the engravings of *Faust* I am seized with a longing to use an entirely new style of painting that would consist, so to speak, in making a literal tracing of nature. The simplest poses could be made interesting by varying the amount of foreshortening. For small pictures, one could draw in the subject and rather vaguely rub in the colour on the canvas, and then copy the exact pose from the model. I must try this method with the work that remains to be done on my picture.

Friday, 27 February

What does please me is that I am gaining in reason and good sense, without losing the thrill that beauty arouses in me. I do not want to have any illusions, but I think that I am working more calmly than before and that I have the same love for my work. One thing worries me, however. I cannot understand it but I seem to need diversions, such as meeting my friends and so on. But as regards the temptations that beset most men, I have never been much disturbed by them, and less than ever now. Who would ever believe it? The things that are most real to me are the illusions which I create with my painting. Everything else is a quicksand.

My health is not good—as temperamental as my imagination.

Monday, 1 March

I have not worked all day.

Spent a sad evening alone in a café. Went home at ten o'clock. Re-read some of my old letters, including some of Elizabeth Salter's. How strange it seems, after so long!

Wednesday, 3 March

To the Luxembourg this morning. I am astounded at Girodet's inaccuracy, especially in the young man in 'The Flood'. The man knows literally nothing about drawing.

Went to see Emilie Robert. Felt ill. Stomach-ache.

Having nothing better to do, I planned the composition of 'The Condemned in Venice' ['Marino Faliero']. Emilie dropped in for a moment and I took advantage of the opportunity; this made me feel a little better.

Work hard at your picture. Meditate on Dante. Read him again. Exert yourself continually to keep your mind on great ideas. How

shall I profit by my almost complete solitude if I have nothing but commonplace thoughts?

Today, Wednesday: Am I really such a clod? It takes a pitchfork to rouse me; I drop off to sleep when there is nothing to stimulate me.

Thursday, 4 March

Fedel came to see me at the studio and we dined together. In the evening, I went by myself to see *Moïse en Egypte*. I enjoyed it immensely. La Buonsignori reminded me of certain well-remembered features. Wonderful music! One must be alone to enjoy it to the full.

Sunday, 7 March

Fielding and Soulier came to the studio. Fielding helped me to arrange the background.

Tuesday, 16

Dined at Tautin's with Soulier and Fielding. *And after to English Brewery and drank Gin and Water.* [Written in English.]

Friday, 19 March

Splendid day at the Louvre with Edouard. The Poussins! The Rubens! And above all, Titian's 'Francis I'! Velazquez!

Afterwards looked at the Goyas in my studio with Edouard. Then saw Piron. Met Fedel. We all dined together.

A good day.

Thursday, 25 March

Went with Leblond to see some pictures; in particular the head of a woman, 'La Marchesa de Pescara' by Titian, and an admirable Velazquez, which occupies my mind to the exclusion of everything else.

Went to Saint-Cloud with Fielding and Soulier, and dined there. Evening at the Pierret's—punch.

Saturday, 27 March

Went early to the studio. Lopez. Pierret came in. Dined with him; read Horace. Longing for poetry but not because of Horace. Allegories. Meditations. Strange condition of man! Inexhaustible subject. Create, create!

Wednesday, 31 March

I must not eat much in the evening, and I must work alone. I think that going into society from time to time, or just going out and seeing people, does not do much harm to one's work and spiritual progress, in spite of what many so-called artists say to the contrary. Associating with people of that kind is far more dangerous; their conversation is always commonplace. I must go back to being alone. Moreover, I must try to live austerely, as Plato did. How can one keep one's enthusiasm concentrated on a subject when one is always at the mercy of other people and in constant need of their society? Dufresne is perfectly right; the things we experience for ourselves when we are alone are much stronger and much fresher. However pleasant it may be to communicate one's emotion to a friend there are too many fine shades of feeling to be explained, and although each probably perceives them, he does so in his own way and thus the impression is weakened for both. Since Dufresne has advised me to go to Italy alone, and to live alone once I am settled there, and since I, myself, see the need for it, why not begin now to become accustomed to the life; all the reforms I desire will spring from that? My memory will return, and so will my presence of mind, and my sense of order.

Emilie today. *Due chiavature . . . ossia una prima, poi una . . . 5 fr.*

Dufresne says about Charlet that he is not simple enough in his method of working; he makes you feel his cleverness and his processes. This is something to consider.

Thursday, 1 April

I have seen the death mask of poor Géricault. What a grand memorial! I was tempted to kiss it. His beard, his eyelashes . . . And his sublime 'Raft'. What hands and heads! I cannot express the admiration I feel.

Use short, small brushes. Beware of thin washes of oil.

I feel a longing to make a sketch of Géricault's picture ['The Raft']. I must be quick about it. What an excellent model it will be, and a precious reminder of this extraordinary man.

Sunday, 4 April

Everything tells me that I need to live a more solitary life. The loveliest and most precious moments of my life are slipping away in amusements which, in truth, bring me nothing but boredom. The possibility, or the constant expectation, of being interrupted is already

beginning to weaken what little strength I have left after wasting my time for hours the night before. When memory has nothing important to feed on, it pines and dies. My mind is continually occupied in useless scheming. Countless valuable ideas miscarry because there is no continuity in my thoughts. They burn me up and lay my mind to waste. The enemy is within my gates, in my very heart; I feel his hand everywhere. Think of the blessings that await you, not of the emptiness that drives you to seek constant distraction. Think of having peace of mind and a reliable memory, of the self-control that a well-ordered life will bring, of health not undermined by endless concessions to the passing excesses which other people's society entails, of uninterrupted work, and plenty of it.

Wednesday 7

Wednesday again! I am not progressing. But time is, and very fast, too. This morning Hélène came. O! shameful . . . I could do nothing. Am I going the same way as my brother?

Worked at the little 'Don Quixote'. In the evening, Leblond. I tried my hand at lithography. Some splendid ideas for this process. *Caricatures in the manner of Goya.*

The first and most important thing in painting is the contour. Even if all the rest were to be neglected, provided the contours were there, the painting would be strong and finished. I have more need than most to be on my guard about this matter; *think constantly about it, and always begin that way.*

It is to this that Raphaël owes his finish, and so, very often, does Géricault.

I have hurriedly re-read the whole of my Journal. I regret the gaps. I feel as though I were still master of the days I have recorded, even though they are past, whereas those not mentioned in these pages are as though they had never been.

How low have I fallen? Am I then so weak that these flimsy pages will be the only record of my life remaining to me? The future is all blackness. The past, where I have not recorded it, is the same. I grumble at having to perform this task, but why always be indignant at my weakness? Can I spend a single day without food or sleep? So much for my body. But my mind and the evolution of my soul are to be destroyed because I do not want to owe what is left of them to the necessity for writing. On the contrary, nothing is better than having some small task to perform every day.

Even one task fulfilled at regular intervals in a man's life can bring order into his life as a whole; everything else hinges upon it. By keeping a record of my experiences I live my life twice over. The past returns to me. The future is always with me.

I must begin to make drawings of some of the men of my own times. Also many medals containing nude figures.

Thursday, 8 April

I am going to be very short of money. I must work hard. Worked on the 'Don Quixote'.

Friday, 9

Instead of another fairly large picture, I should like to do several small ones, but enjoy myself painting them.

I still have about 240 francs left. Pierret owes me 20 francs.

Today: lunch, eggs and bread	o fr. 30	
Bergini	3 fr.
Belot, paints	1 fr. 50
Dinner	1 fr. 20
				Total	6 fr.	

Sunday, 11 April

At the Luxembourg: Girodet's 'Rebels of Cairo'; extremely vigorous, the grand manner; a delightful Ingres, and then my own picture ['Dante and Virgil'], which I liked very much. It has one fault that applies equally to the one I'm doing now, especially in the woman bound to the horse; it lacks vigour; there is not enough impasto. The contours are washy; they are not decisive; I must always be on the watch for this.

Worked in the studio, retouching the kneeling woman.

Saw the Velazquez, and obtained permission to copy it. It has swept me off my feet. This is what I've been searching for so long, this firm yet melting impasto. What I must chiefly remember *are the hands*. I feel that if I could combine this style of painting with bold, strong contours it would be easy to paint one or two small pictures.

Came home early, very much pleased with myself for copying the Velazquez and full of enthusiasm.

How stupid to get into the habit of reserving what one imagines to be the finest subjects for a future occasion!

As for my picture, I must leave the parts that are well painted, even though they are in a style which I have now abandoned. The next picture will at least be different even if it shows no progress.

But to return to my last comment about the absurd mania I have for doing things in which I am not vitally interested, and therefore doing them badly; the more I do such things, the more I find to do. I'm always having excellent ideas, but instead of working on them while they are still fresh in my imagination, I keep telling myself that I will do them later on—but when? Then I forget about them or, worse still, can no longer see anything interesting in ideas that seemed certain to inspire me. The trouble is, that with a roving and impressionable mind like mine, one idea drives another out of my head quicker than the changing wind alters the direction of a windmill's sails. And when I have a number of different ideas for subjects in mind at once, what am I to do? Am I to keep them in stock, so to speak, quietly waiting their turn? If I do that, no sudden inspiration will quicken them with the touch of Prometheus's breath. Must I take them out of a drawer when I want to paint a picture? That would mean the death of genius. See what is happening this very evening! For the last hour I have been hesitating between Mazeppa, Don Juan, Tasso, and hundreds of other subjects!

I believe that when one needs a subject, it is best not to hark back to the Classics and to choose something there. For really, what could be more stupid? How am I to choose between all the subjects I have remembered because they once seemed beautiful to me, now that I feel much the same about them all? The very fact that I am able to hesitate between two of them suggests lack of inspiration. What is certain, is that if I were to pick up my palette at this moment, and I am longing to do so, I should be obsessed by that lovely Velazquez. What I want to do, is to spread good, fat paint thickly on to a brown or red canvas, and therefore what I must do to find a subject is to open some book capable of giving me inspiration, and then allow myself to be guided by my mood. . . . There are certain books that should never fail, also certain engravings; Dante, Lamartine, Byron, Michelangelo.

At Drolling's this morning I saw some copies by Drolling of several fragments of figures by Michelangelo. Great Heavens! What a man! What beauty! How strange, and how very beautiful, would be a combination of the styles of Michelangelo and Velazquez! The idea came to me directly I saw the drawing. It is gentle and mellow. The forms have a softness that only heavy loading of the paint seems able

to give, and yet the contours are vigorous. Engravings after Michelangelo give one no idea of this quality. This is the very height of execution. Ingres has something of it. The spaces inside his contours are soft, and only slightly charged with details. How this would ease one's own work, especially in small paintings! I am glad I remembered this impression. Be sure not to forget these Michelangelo heads. Ask Drolling for permission to copy them. The hands are very remarkable. The great structure of the figures. The cheeks treated simply. The noses without details. In point of fact, this is what I've always been looking for! There was something of this quality in the small portrait by Géricault which was at Bertin's, a little in my portrait of Elizabeth Salter, and again a little in the portrait of my nephew. I should have arrived at it much earlier if I had seen that it could only go with very strongly marked contours. It is very evident in the standing woman in my copy of the Giorgione—the 'Landscape with nude Women'.[1] Leonardo da Vinci has something of it, and Velazquez a great deal; it is very different from Vandyke, where you notice the oil too much, and where the contours are dull and feebly stated. Giorgione has a great deal of it. There is something similar, and very attractive in the celebrated back in Géricault's picture, in the head and hand of the young man without a beard, and in the thumb of the young child sitting at the extreme end of the raft. Remember the arm of the figure which I posed for. What a joy it would be to buy, at his sale, one or two of the copies he made after the old masters! For instance, his family group after Velazquez.

Lunch	17 sous
Dinner	16 sous
Soap	1 fr. 10 sous
Sugar	7 sous
					Total		3 fr. 10 sous

Monday, 12 April

I have taken a fancy to do some lithographs of animals; tigers, for example, round the carcass of a dead beast, vultures and so on.

Dined with M. Guillemardet. Mme de Conflans came in during the evening and was charming. Wretched slacker that I am! I must admit that my life is fairly full just now, but I am apt to get into a kind of fever of excitement, which makes me very vulnerable. I

[1] The 'Concert Champêtre', at the Louvre.

thought her most attractive in her round hat with the little feathers. She seems to like me. I must remember to send her the name of the parasol shop. Tomorrow if possible.

Tuesday, 13 April

This restlessness that comes over me almost every evening! Oh sweet contentment of the philosophers, why can I not capture you? I do not complain of my lot, but I need more good sense to resign myself to the inevitable. I must never put off for a better day something that I could enjoy doing now. What I have done cannot be taken from me. And as for this ridiculous fear of doing things that are beneath my full powers . . . No, this is the very root of the evil! This is the mistake which I must correct. Vain mortal, can nothing restrain you, neither your bad memory and feeble strength, nor your unstable mind that fights against ideas as soon as you receive them? Something at the back of your mind is always saying: 'You who are withdrawn from eternity for so short a time, think how precious these moments are. Remember that your life must bring to you everything that other mortals extract from theirs.' But I know what I mean. I think that every one who has ever lived must have been tortured by this idea in some degree.

14 April

Worked on the Velazquez this morning. Began the head again, it was too big for the body. Broke off to go out to luncheon. It was a good thing I did, for afterwards I worked steadily on until half-past four. Leblond called.

Sunday, 18 April

To the studio at nine o'clock. Laure came. We continued with the portrait. It's an extraordinary thing, but although I wanted to make love to her all the time she was posing, as soon as she began to leave—rather hurriedly, as a matter of fact—I did not feel like it at all; I suppose I needed time to collect myself.

Monday, 19

Went to see Fielding, and dined at Rouget's. Then went back with him, and finished up at the café at the corner of the rue Bourbon. Returned home at a quarter-past ten.

I. DELACROIX: SELF-PORTRAIT
About 1830

II. EUGÈNE DELACROIX IN 1862
Photograph

Lunch	1 fr.	8 sous
Driver	2 fr.	12 sous
Dinner	1 fr.	2 sous
Beer		6 sous
					Total		5 fr.	8 sous

I should like to do some subjects from the Revolution; 'Bonaparte's Arrival with the Army in Egypt', for instance, or the 'Farewell at Fontainebleau'.

Tuesday, 20 April

Just returned from Leblond's. We talked a lot about Egypt; the journey costs very little. God grant that I manage to go there. I must think it over well, and see whether my dear Pierret would come too. He is the man I'd like to have with me. In the meanwhile I must try to free myself from the ties that dull my mind and injure my health. Get up early in the morning. Think about learning Arabic. I must go and see Dimier one of these days, and find out about his studies.

What can Egypt be like? Everyone is mad about it. And if it only costs as much as going to London? De Loche and Planet got there for three hundred francs. Living is cheaper out there. It would be best to go in March, and to come home in September; that would allow enough time to see Syria.

Is it living to vegetate like a fungus on a rotten trunk? I am completely immersed in the trivialities of my daily life. And besides, I must look ahead. As long as I have legs to stand on, I can hope to earn sufficient for my bodily needs. Please God! the Salon will soon bring in enough to allow me to start on my travels.

Wednesday 21

Began early on the Velazquez, but could do no work. Had luncheon and went to see Cogniet. Did a bad sketch from nature for him. I must study contours, as Fedel is doing at the studio. I might even go to the Academy to make some studies.

Sunday, 25

Why am I not a poet? But at least, let me feel as strongly as possible in all my pictures the emotion that I want to pass on to others! Allegory gives a fine range of subjects! *Blind destiny dragging away the*

suppliants, who vainly hope by their prayers to stay his inflexible arm.
I believe, and I have said so elsewhere, that it would be an excellent
thing to fire one's imagination by writing verses on a subject, rhymed
or otherwise, so as to put oneself in the mood for painting. If I could
once acquire the habit of putting all my ideas into poetry I could
manage it very easily, at least in my own way. I must try to write
some verses on Scio.

Monday, 26 April

All my days lead to the same conclusion; an infinite longing for
something which I can never have, a void which I cannot fill, an
intense desire to create by every means and to struggle as far as
possible against the flight of time and the distractions that deaden my
soul; then, almost always, there comes a kind of philosophical calm
that resigns me to suffering and raises me above petty trifles. But
here, perhaps, imagination is again leading me astray, for at the
slightest mishap it is goodbye to philosophy. I wish I could identify
my soul with that of another person.

At Perpignan's, M. Rivière was telling us about Godwin's novel,
Saint-Leon, in which he discovers the secret of making gold, and of
prolonging his life by means of an elixir. These fatal secrets are the
cause of every imaginable disaster, but in the midst of his afflictions he
finds a hidden pleasure in the strange powers that set him apart from
the rest of mankind. Alas! I have not been able to discover the secret,
and am reduced to regretting in myself the powers that were this
man's only consolation. Nature has put a barrier between the soul of
my greatest friend and myself. He feels it too. If only there were time
for me to enjoy at my leisure the ideas that come to me when I am
alone! But the law of variety makes it a mockery to expect this con-
solation. It does not take years to destroy the pure pleasures that a vivid
imagination can conjure out of every event; every passing moment
sweeps them away, or else changes their very nature. At this moment
of writing I have the beginnings of at least twenty ideas which I shall
be unable to recognize when they are written down. My thoughts
elude me. My laziness of mind, or rather my weakness, plays me
false more than any lack of skill with the pen or deficiency in words.
It is torture to have strong feelings and imagination if one's lack of
memory causes them to fade away as fast as they take shape. If only
I were a poet everything would be an inspiration to me. Try to
wrestle with your unruly memory. Would not one way of doing so

be to write poetry? For what is the truth about my position? I have the imagination; therefore the only trouble is my laziness in exploring and capturing my ideas before they escape me.

Tuesday, 27

An interesting discussion at Leblond's about geniuses and outstanding men. Dimier thinks that great passions are the source of all genius! I think that it is imagination alone or, what amounts to the same thing, a delicacy of the senses that makes some men see where others are blind, or rather, makes them see in a different way. I said that even great passions joined to imagination usually lead to a disordered mind. Dufresne made a very true remark. He said that fundamentally, what made a man outstanding was his absolutely personal way of seeing things. He extended this to include great captains, etc. and, in fact, great minds of every kind. Hence, no rules whatsoever for the greatest minds; rules are only for people who merely have talent, which can be acquired. The proof is that genius cannot be transmitted.

Wednesday, 28 April

All day long I have been feeling ill and stupidly miserable. The wise thing would be to go to bed early now that the evenings are so dull. How splendid to get to the studio at day-break!

Thursday, 29 April

Glory is no empty word to me. The sound of praise gives me real happiness. Nature has put this feeling into every heart. Those who renounce glory, or who cannot achieve it, are wise to show what they call a philosophical contempt for this illusion, the nectar of the greatest minds. Of late, men seem to have been possessed by an incomprehensible impulse to strip themselves of everything with which nature has endowed them in order to make them superior to the beasts of burden. A philosopher is a gentleman who sits down four times a day to the best meals he can possibly obtain, and who considers that virtue, glory, and noble sentiments should be indulged in only when they do not interfere with these four indispensable functions and all the rest of his little personal comforts. At this rate, a mule is a better philosopher by far, because in addition to all this he puts up with blows and hardship without complaint. Such people

seem to think that a voluntary renunciation of sublime gifts alto-
gether beyond their powers is a matter for self-congratulation.

Saturday, 1 May

Went to see Soulier; practised fencing with Fielding. Had a de-
lightful time. Dined with Fielding, then to Mme Lelièvre's house for
a little while, and afterwards rejoined the others at the little café.
Played billiards—I mean I knocked the balls about while we were
gossiping. Egypt! Egypt! General Coëtlosquet is going to arrange for
me to have Mameluke weapons. I was in a kind of frenzy of creation
at the studio this morning, and recaptured my feeling for the 'Christ',
which I have not been in the mood for. This evening, I saw for a
moment some of those lovely nudes, simple in form and modelled in
the manner of Guercino, though more solid. Small paintings are not
in my line, but I could do something of this kind.

Tuesday, 4 May

It is now the fifth month from the beginning of the year. Have I
spent the time dreaming? It has gone like a flash! I've not nearly
finished my picture. I am held up at every step. Touched up the
background today.

Yesterday, Wednesday, 5 May

Worked on the horse from about nine until two o'clock. Went
to Champmartin's where I rode Marochetti's horse. Jumped off on
the wrong side, and was nearly ridden over as I did not know how to
keep my balance when I landed. Walked home through the Luxem-
bourg feeling wonderfully free and full of well-being! Extraordinary
how human nature can always find strength to endure, or even to
benefit by every kind of circumstance—nearly always, at least.

Friday, 7 May

Bought some engravings for 5 francs in the rue des Saint-Pères:
Oriental costumes and barbaric instruments, an old lithograph of
Géricault's, the taking of the Bastille, etc. After leaving Soulier, I
lunched at the corner of the rue des Saint-Pères and the rue de
l'Université.

Pierret was at the studio when I returned. Worked on the coat of

the man in the centre. It has made the reclining man stand out better from the background. Dufresne urges me to put in local colour and to paint some of the people of the country. I must try not to break off on any account, except to finish the Velazquez. How strange the human mind is! When I first began, I think I should have been willing to work at it from the top of a church steeple, whereas now, even to think of finishing requires a real effort. And all this, simply because I have been away from it for so long. It is the same with my picture and with everything else I do. There is always a thick crust to be broken before I can give my whole heart to anything; a stubborn piece of ground, as it were, that resists the attacks of plough and hoe. But with a little perseverance the hardness suddenly gives and it becomes so rich in fruit and flowers that I am quite unable to gather them all.

The nightingale. That fleeting moment of gaiety that runs through the whole of nature. The new leaves and the lilac, and the sun made young again. During these brief moments melancholy is put to flight. If the sky becomes cloudy and overcast, it is like the delicious pouting of one's sweetheart; one knows that it will not last.

As I came home this evening I heard the nightingale; I can still hear him a long way off. Truly this song is unique, but more because of the emotions it arouses than from anything in itself. Buffon, the naturalist, goes into ecstasies over the flexibility of the throat and the varied notes of this melancholy songster of the spring, but I myself find in it monotony, that inexhaustible source of everything that makes a deep impression. Hearing it is like looking at the vast sea, one always has to wait for one more wave to break before tearing oneself away; one cannot bear to leave it. How I detest these minor poets, with their rhymes about glory and victory and nightingales and meadows! How many of them have really described what a nightingale makes one feel? But when Dante speaks of it he is as new as nature herself and that is all we hear. Yet it is all an artifice, something tricked out, a product of the intellect. How many of them have succeeded in describing love? Dante is truly the greatest of poets. You thrill with him, as though you were experiencing the thing itself. Here he is superior to Michelangelo, or rather he is different; for he too is sublime, but in another fashion; not through his truth. *Come columbe adunate alle pasture, etc. Come si sta a gracidar la rana, etc. Come il villanello, etc.* This is what I have always dreamed of, and have never been able to define. Try to be exactly this in painting. It is a unique road to follow.

But when something bores you, leave it alone. Never seek after an empty perfection. Some faults, some things which the vulgar call faults, often give vitality to a work.

My picture is beginning to develop a rhythm, a powerful spiral momentum. I must make the most of it. I must keep that good black, that happy, rather dirty quality, and those limbs which I know how to paint and few others even attempt. The mulatto will do very well. I must get fullness. Even though it loses in naturalness, it will gain in richness and beauty. If only it hangs together! O! the smile of the dying man! The look in the mother's eyes! Embraces of despair! Precious realm of painting! That silent power that speaks at first only to the eyes and then seizes and captivates every faculty of the soul! Here is your real spirit; here is your own true beauty, beautiful painting, so much insulted, so grievously misunderstood and delivered up to fools who exploit you. But there are still hearts ready to welcome you devoutly, souls who will no more be satisfied with mere phrases than with inventions and clever artifices. You have only to be seen in your masculine and simple vigour to give pleasure that is pure and absolute. I confess that I have worked logically, I, who have no love for logical painting. I see now that my turbulent mind needs activity, that it must break out and try a hundred different ways before reaching the goal towards which I am always straining. There is an old leaven working in me, some black depth that must be appeased. Unless I am writhing like a serpent in the coils of a pythoness I am cold. I must recognize this and accept it, and to do so is the greatest happiness. Everything good that I have ever done has come about in this way. No more 'Don Quixotes' and such unworthy things!

Concentrate deeply when you are at your painting and think only of Dante. In his works lie what I have always felt in myself.

Sunday, 9 May

The 8th already! I reached the studio about eight o'clock, but as Pierret had not yet arrived I went to have breakfast at the Café Voltaire.

I feel that I want to paint my own century. The life of Napoleon is teeming with suitable subjects. I have been reading some poems by a M. Belmontet, very romantic and full of pathos; perhaps that is why my imagination has been working harder than ever.

My picture is beginning to take on a different appearance; confusion is giving place to sombreness. I have been working on the man in

the centre, the seated figure for whom Pierret is posing. I am changing the plan.

Yesterday, Saturday 8

Lunched with Fielding and Soulier, then to Dimier's house to see his collection of antiquities: four magnificent alabaster vases of beautiful workmanship, and a very early sarcophagus. Remember the style of the feet of the two seated Egyptian figures which are supposed to date from the most remote antiquity.

Then to see Couturier and back to the studio, where I found Pierret. Painted the jacket of the man in the centre so that the man lying in the foreground stands out light against it. This is a great improvement.

Tuesday, 11 May

And so there will come a time when I shall no longer be agitated by thoughts and emotions, by a yearning for poetry and other effusions of all kinds. Poor Géricault! I saw him go down to the narrow home where nothing remains, not even dreams. And yet I cannot persuade myself to believe it. How I long to be a poet! But then at least, create in painting! Be bold and simple. There are so many things to do! If painting and large pictures fail, try engravings: the life of Napoleon is the epic theme of our century in all the arts. But I must hurry.

Painting—and I have said this a hundred times—has advantages which no other art possesses. Poetry is full of riches; always remember certain passages from Byron, they are an unfailing spur to your imagination; they are right for you. The end of the *Bride of Abydos*; *The Death of Selim*, his body tossed about by the waves and that hand —especially that hand—held up by the waves as they break and spend themselves upon the shore. This is sublime, and it is his alone. I feel these things as they can be rendered in painting.

Read the following anecdote in *La Pandore*, this morning. During the American war, an English officer in one of the advance posts saw an American officer riding towards him, who seemed so absent-minded and intent upon his observations that he did not perceive him, although only a short distance away. The Englishman took aim and was about to pull the trigger, but struck by the dreadful thought of shooting at a man as though he were a target he held his finger on

the trigger without firing. The American spurred his horse and galloped away. It was Washington!

Wednesday 12

Cogniet came to the studio; I think he was very much pleased with my painting. He said that he felt as though he were seeing the beginnings of a picture of the great period. And then he said how much Géricault would have liked it! The old woman whose mouth, for once, is not wide open, and the eyes with the expression not over-emphasized. The idea of the two young people in the corner, simple and moving. He seemed astonished to find that anyone was doing painting of this kind at the present time. I liked him very much, as was only natural!

Saturday, 15 May, during the course of the day

What moves men of genius, or rather, what inspires their work, is not new ideas, but their obsession with the idea that what has already been said is still not enough.

Yesterday, 14 May

This morning, as I was reading the note on Lord Byron at the beginning of the book, I again felt the insatiable longing to create. Can I be sure that this would bring me happiness? I believe, at any rate, that it would. Happy poet, happier still in having such a flexible language to clothe his imaginings! And yet French is sublime. But I should have to fight many battles with this rebellious Proteus before I could learn to tame him.

Loneliness is the torment of my soul. The more it expands among friends and in the habits and pleasures of my daily life, the more it seems to elude me and to retire into its inner fortress. A poet who lives in solitude and produces a great deal can enjoy to the full the treasures which we carry in our hearts, but which forsake us when we give ourselves to others. For when we surrender ourselves entirely to the soul it unfolds itself completely to us, and it is then that this capricious spirit grants us the greatest happiness of all, of which this note on Lord Byron speaks—I mean the joy of expressing the soul in a hundred different ways, of revealing it to others, of learning to know ourselves, and of continually displaying it in our works. This is something of which Lord Byron and Rousseau may perhaps have been unconscious. I am not speaking of mediocre people. But what is

this urge not only to write, but to publish one's work? Besides the pleasure of being praised, there is the thought of communicating with other souls capable of understanding one's own, and thus of one's work becoming a meeting place for the souls of all men. For what is the use of the approval of one's friends? It is only natural that they should understand one, and therefore their praise is of no real consequence. Living in the minds of others is what is so intoxicating. I ask myself, why be so discouraged? You can add one more to the number of those who have seen nature in their own way. What they portrayed was made new through their vision and you will renew these things once more. When they painted they expressed their souls, and now yours is demanding its turn. So why kick against the pricks? Are these demands any more absurd than the need for sleep when one's limbs and one's whole body are crying out for rest? You complain that the world has not done enough for you, but it has done no more for others. The very people who believe that everything has already been discovered and everything said, will greet your work as something new, and will close the door behind you, repeating once more that nothing remains to be said. For just as a man in the weakness of his old age believes that nature, and not himself, is degenerating, so men with commonplace minds, who have nothing to add to what has been said already, believe that nature has given only to a few—and these at the beginning of time—the power to say new and striking things. But what these immortal spirits found to express also struck the eyes of their contemporaries; yet how few were tempted to seize the new idea and hasten to sign it with their names, thus stealing the harvest from posterity. Newness is in the mind of the artist who creates, and not in the object he portrays. A writer's modesty prevents him from ranking himself with the great minds of whom he speaks. He always addresses himself, as one would expect, to one of those great luminaries, if such there be, whom nature . . .

. . . You who know that there is always something new, show it to others in the things they have hitherto failed to appreciate. Make them feel that they have never before heard the song of the nightingale, or been aware of the vastness of the sea—everything that their gross senses can perceive only when someone else takes the trouble to feel it for them. And do not let language trouble you. If you cultivate your soul it will find the means to express itself. It will invent a language of its own far better than the metre or the prose of this or that great writer. What! you say you have an original mind, and yet your flame is only kindled by reading Byron or Dante! You

mistake this fever for creative power when it is really only a desire to imitate . . . No indeed! The truth is that such men have not said a hundredth part of all there is to say. In a single one of the things which they touch upon so lightly there is more material for original geniuses than there is . . . and nature has stored away for great minds that are yet to come more new things to say about her creations than she has created objects for their enjoyment.

Tuesday, 18 May

Do you imagine that Byron could have written his powerful poems in the midst of turmoil, or that Dante was surrounded by distractions while his soul was journeying amongst the shades? Without the soul there is no continuity, nothing creative. Work is constantly interrupted, and it all comes from associating with too many people.

Thursday, 20 May

To the studio today. Settled the background. Dimier came early. Felt unwell, with headache and stomach-ache. Dined with the others at the Moulin de Beurre. I also felt unwell while I was there. Later in the evening went to the café; it was very pleasant.

Friday, 28 May

At least admire the great virtues, even if you are not strong enough to be truly virtuous yourself! Dufresne says that he is capable of devotion to all great things, but he sees the emptiness of them—that fundamentally they are nothing. I feel the reverse. I respect them, but I am too weak to practise them. My case is entirely different.

Saturday 31

To hear the *Barber of Seville* at the Odeon—very satisfying. I sat next to an old gentleman who had seen Grétry, Voltaire, Diderot, Rousseau, and so on. He once saw Voltaire paying his celebrated compliments to the ladies, in one of the salons. As he left, this old gentleman heard him remark: 'In you, I see the beginning of a century, in myself, one that is ending—the century of Voltaire'. The modest philosopher was evidently taking pains to name his century in advance, for the benefit of posterity! This gentleman was also taken by one of his friends to breakfast with Jean-Jacques in the rue

Plâtrière. They left together and walked through the Tuileries, where they came upon some children playing ball: 'There,' said Rousseau, 'that is how I should like Emile to take exercise,' and other similar remarks. But a ball belonging to one of the children happening to strike the philosopher on the leg, he flew into a violent passion and, abruptly leaving his friends, ran after the child with his cane.

Tuesday, 1 June

Dr. Bailly.[1] He has a kindly eye and a reserved manner. I caught sight of myself in the looking-glass when I arrived home and felt almost frightened at the wickedness of my face. Yet this is the man who must carry into my soul a fatal torch which, like the candles for the dead, will light only the obsequies of what was once sublime.

O lover of the muses! you who have vowed your purest blood to their worship, entreat these learned divinities to restore the clear, keen eye of youth and the lightness of an untroubled spirit. The chaste sisters have been more harmful to you than courtesans; the perfidious delights they offer, more illusory than the pleasures of the flesh. It is your soul that has crippled your understanding and caused your lack of youthfulness at twenty-five years old, your ardour that has no strength to support it. You have an imagination that embraces everything, and less memory than the humblest shopkeeper. True wisdom should consist in enjoying all things, yet we apply ourselves to dissecting and destroying everything that is good in itself, everything that has virtue, even though it be a mere illusion. Nature gives us life as one gives a toy to a little child. We want to see how it works, and we crush it between our fingers. There remains to our dull eyes that have learned to see too late, nothing but sterile dust, broken fragments that can never be rejoined. Goodness is so simple. It needs so much effort to destroy it with sophisms. And even were it true that all this goodness and beauty were nothing but heavenly gloss, a polished shell to help us to endure the rest, who can deny that it exists, at least to that extent? How strange men are, who refuse to allow themselves to enjoy the beauty of a lovely picture because the back is a worm-eaten board! All is not good, but all cannot be bad, or rather, for this very reason, all is good.

Who has ever done a selfish action without reproaching himself for it?

[1] Doctor Joseph Bailly was consulted by Delacroix, who was anxious about becoming impotent.

Friday morning, 4 June

I live in company with a body, my silent companion, constant and exacting. He it is who establishes the individuality, the mark of the weakness of our race. My spirit has wings, but my body, her brutal gaoler, is severe. He knows that though she be free it is only to be enslaved again, weakling that she is. In her prison she forgets herself and only rarely does she glimpse the pure blue of her celestial home. Unhappy fate, to yearn unceasingly for my release, I who am a spirit immured in this mean vessel of clay! You use your strength only to torment yourself in a hundred ways.

It seems to me that the body may well be the machinery that restricts the soul, which is more universal. The soul must pass through the brain as through a mill, where it is hammered and stamped with the seal of our contemptible natures. But how unbearable is the burden of this living corpse! Instead of leaping to grasp the objects of longings which she can neither appease nor define, she spends the lightning flash of life submitting to follies into which she is driven by the tyrant body. Providence played a bad joke on us when it allowed us to view the world through this ridiculous glass, whose dim and untrue lens warps all the judgements of the spirit, corrupting its natural good faith and often producing horrible results. It would be easy for me to believe in the existence of evil influences and of a hump upon our backs but to do so would be a constant sorrow, for what is the spirit apart from the mind? Men of science make a fatal mistake when they delight in cataloguing and naming objects. They invariably go too far and destroy their own case in the eyes of easy-going and fair-minded people, who believe that nature is an impenetrable mystery. I know very well that things must be given names so that we may understand one another but when once this is done they are classified, they are neither permanent species, nor . . .

Sunday, 6

The night before last, we met Dufresne who intended to leave for the country this morning.

> Early to bed and early to rise
> Makes a man healthy, wealthy and wise.
>
> Franklin.

What will become of me? I have no fortune and no aptitude for acquiring one; I am far too lazy to bestir myself about money, although at intervals I worry about the outcome of it all. When

one has money one feels no joy in possessing it, but when money is lacking one misses the enjoyments it provides. But as long as my imagination continues to be my torment and my joy what does it matter whether I am rich or poor? It is one worry, but not the worst.

As soon as a man becomes enlightened, his first duty is to be honest and unswerving. It is useless for him to attempt to stifle the virtue within him that insists on being obeyed and satisfied. What, do you suppose, are the lives of those who raise themselves above the level of the common herd? A continual struggle. A writer, for instance, must struggle against the laziness which he shares with the ordinary man when it comes to writing, because his genius demands to be heard, and it is not merely out of an empty desire for fame that he obeys, it is a matter of conscience. Let those who work coldly and calmly keep silence, for they have no conception of what it means to work under the spur of inspiration—the dread, the terror of rousing the sleeping lion whose roarings move us to the very depth of our being. To sum up: be strong, simple, and true; here is an aim for every moment of the day, and it is always useful.

There is no merit in being truthful when one is truthful by nature, or rather when one can be nothing else; it is a gift, like poetry or music. But it needs courage to be truthful after carefully considering the matter, unless a kind of pride is involved; for example, the man who says to himself, 'I am ugly', and then says, 'I am ugly', to his friends, lest they should think themselves the first to make the discovery.

Dufresne is sincere, I think, because he has come round full circle; he must have begun by having affectations when he was only partially well-informed. He is sincere now, because he sees how foolish it is to be otherwise. I suppose he always had enough intelligence to try to disguise his weaknesses. Now he prefers to have none, and will cheerfully accuse himself of weaknesses, imagining that he will not have any provided that he takes care to hide them. I have not yet been able to be as frank and open with him as I am with people whom I know better; I am still not sufficiently a friend of his to express an opinion in direct contradiction to his own, or to listen inattentively, or at least, not to pretend to be paying attention when he is speaking. If I look for the reason, I think that perhaps—and I am sure this is so—I may be afraid of appearing less intelligent than he if I disagree with him. How ridiculous! Even if one were sure of being able to impress him, is anything harder than a face with a fixed expression of insincerity?

After all he is a man; therefore, above all have some self-respect. You only respect yourself when you are open and sincere.

Wednesday, 9 June

Laure brought with her a splendid Adeline; sixteen years old, tall and well made, with a charming head. I shall do her portrait and have great hopes of it; I am thinking it over.

I have been to see the drawing by Gros at Laugier's. It is charming, but it made less impression on me than the painting. The prevailing coldness of the execution is in strange contrast with the real warmth of so much of Gros's work—it is rather flat. What is more, there is no individuality in the drawing of the various parts, the hands, feet, etc. More or less the studio formula. You feel that the draperies are arranged and the whole effect seems studied, for instance, where he puts black in the foreground, etc. At all events I am not unduly discouraged by it.

But it is very important always to make a sketch.

Monday, 14 June

Spent the morning with Fielding and Soulier. At the studio, I worked at the left-hand corner, and especially at the man on the ground. Removed the patch of white round the head.

As I left the studio about eight, this evening, I happened to meet the tall, pretty, working-girl. I followed her as far as rue de Grenelle wondering the whole time what I'd better do, and feeling almost miserable at having the chance of doing anything at all. It is always the same. Afterwards, I thought of all manner of excuses for speaking to her, but at the time I invented the most absurd objections. My determination always vanishes when it comes to action. I need a mistress to keep my flesh in proper subjection. I'm terribly worried about it, and struggle with my better self when I'm in the studio. Sometimes I long for any woman to come along. God grant that Laure comes tomorrow! And then, when a girl does come my way, I'm almost annoyed, I'd give a great deal not to have to do anything; that is my real curse. Shall I come to a decision, or simply stop being lazy? Every time I have to wait for a model, even when I'm in a great hurry, I feel delighted when she's late and tremble to hear her hand at the door. And when I leave a place where I've been the slightest bit ill at ease, I confess that I have a moment of extreme pleasure at settling down to my freedom once again. But I have moments of

boredom and depression that are certainly a severe trial to me, and I experienced some of these in my studio, this morning. I've not enough ordinary, everyday activities to escape by busying myself about some job or other. When I've no inspiration I'm bored. Some people learn to avoid boredom by setting themselves a task and carrying it out.

I was thinking today that in spite of all our squabbles, I do like Soulier very much; I understand him and he understands me. I like Leblond too, very much; and my dear old brother, I understand him very well. I wish I were richer, so that I could give him a little pleasure now and then. I must try to remember to write to him.

Tuesday, 15 June

Thil came this morning. He prefers my painting to Géricault's; personally, I like both extremely well.

Thursday, 17 June

Went to the studio at mid-day. The lady from the Italiens came to see me. I was very moved. Perpignan called, also M. Rivière. Letter from Laure. To the Italiens with Fielding, Ricciardi, Mme Mombelli and her husband. The lady was there. *I am very fond of this pretty scenery. I was looking at her incessantly.* [Written in English.]

I absolutely must make compositions of interesting subjects as soon as I think of them. I know from experience that I cannot make the best of them if I delay in working them out.

Saturday, 19

Saw Cogniet, and the picture by Géricault,[1] also the Constables. It was too much for one day. That Constable did me a world of good. Came home about five o'clock. Spent two hours in the studio. Great want of sex. I am utterly abandoned.

'May I hope, loveliest of women, to see you on Thursday? And will you forgive my not having been to call on you? I flatter myself that you will not be as harsh as you threatened, and that you cannot be so cruel as to pass my yellow door without coming in. I expect it will be in the afternoon, as before. If it's not presuming too far, may I ask you to give me a little more of your time?'

Now for the struggle! Shall I send it or not?

[1] 'The Raft of the Medusa' was put up for sale at this time.

Wednesday, 30 June

At M. Auguste's.[1] Saw some splendid paintings after the masters; costumes, and especially horses—admirable, beyond anything Géricault ever did. It would be a great advantage to have some of these horses to copy, as well as the costumes, Greek, Persian, Indian, etc.

Also saw a copy of one of Haydon's pictures. A very great talent, but as Edouard most truly said, there is a lack of any strong personal style. Drawing in the style of West. I was forgetting M. Auguste's fine studies after the Elgin Marbles. Haydon spent a great deal of time copying them, but there is no trace of it in his work . . . The lovely thighs of these men and women! Such beauty without floridness! Inaccuracies that pass unnoticed.

Spent the evening with Fielding. Had tea in the rue de la Paix.

Wednesday, 7 July

M. Auguste came to the studio today; he seemed delighted with my pictures. Felt much encouraged by his praise. Time is getting on. Tomorrow I go to his house to fetch the costumes.

Tuesday, 20 July

Have been thinking a great deal about M. Houdetot's style, and drawing. I must make a number of sketches and give myself plenty of time; this is where I most need to improve. Incidentally, I must try to get hold of some fine Poussin engravings and study them. The great thing is to avoid that infernal facility of the brush. For preference choose a medium that is hard to work, like marble— this would be something quite new. Choose stubborn material, and conquer it by patience.

August 19

Saw M. Gérard at the Louvre. Very flattering in his praise.

He invited me to dine at his country-house tomorrow.

Luncheon with Horace Vernet and Scheffer. Learned one of Horace Vernet's favourite maxims: *always finish a thing when you've got a grasp of it*. It's the only way to achieve a great volume of production.

[1] Jules-Robert Auguste (1789–1850), known as Monsieur Auguste, was an interesting figure of his period, sculptor, painter and collector, who had travelled in Greece, Egypt, and the East. Delacroix found him stimulating and encouraging, and was able to borrow arms, costumes and accessories for his own work.

Yesterday, Monday, 4 October

Went again to see the Gallery with the old master paintings. Made some studies at the riding-school and dined with M. Auguste. Saw his magnificent sketches from the Neapolitan tombs. He was speaking of the new character which one could give to religious subjects by drawing inspiration from mosaics of the time of the Emperor Constantine. Also saw at his house a drawing by Ingres after his bas-relief, and his composition 'St. Peter delivered from Prison'.

Tuesday, 5 October

Spent the day at M. de Conflans's house at Montmorency. Walked in the forest. In the evening, came home with Félix, walking one on either side of the lady. Leblond. Had a letter from Soulier this evening.

[Here the Journal stops, for no apparent reason save that the active life of the painter had become more and more absorbing. The years from 1826 to 1830 were exciting ones of full participation in the general Romantic Movement, of which Victor Hugo was the titular chief in literature. In painting there was no one in the Movement who approached Delacroix in genius, but he did not relish the restrictions and commitments of *chef d'école*, and soon tired of collaboration with Hugo.

The journey to Morocco in 1832 with Count de Mornay, Ambassador to the Sultan, resulted in quantities of sketches and notes, a selection of which were issued later. But these are in the nature of immediate travel impressions of a six months' interlude in his life, and form no portion of the Journal proper. A few extracts are included here for the light they throw on the genesis of such later pictures as 'The Jewish Wedding', or 'Horses Fighting in a Stable'.]

THE MOROCCAN JOURNEY

Tangier, 29 January 1832

The scene of the fighting horses. From the very beginning they reared up and fought with a fury that made me tremble for their riders, but magnificent for painting. I am sure that I have witnessed a scene as extraordinary and fantastic as anything that Gros or Rubens could have imagined. Then the grey got his head over the other horse's neck, and it seemed an eternity before he could be made to release his hold. Mornay managed to dismount. While he was holding it by the head, the black reared up furiously. The other went on fiercely biting it from behind. In the midst of the struggle the consul

fell off. Then they let both animals go and, still fighting, they went down to the river where they both fell in; the fight continued in the water as they tried to get out. Their legs slipped about in the slime at the edge of the river: they were all dirty and shining and wet up to their manes. After repeated blows, the grey let go his hold, and went towards the middle of the stream and the black horse came out. On the other side of the river a soldier was trying to tuck up his clothes before wading in to lead the grey out.

The quarrel between the soldier and the groom. Superb. With his heap of draperies he looked like an old woman, and yet there was something warlike about him.

As we were coming home, superb landscapes on the right, the Spanish mountains in the softest possible tones; the sea, a dark blue-green, the colour of a fig. The hedges, yellow on top because of the bamboos, green at the bottom because of the aloes.

The hobbled white horse that tried to jump on top of one of ours.

Tuesday, 21 February

The Jewish wedding.[1] Moors and Jews at the entrance. The two musicians. The violinist with his thumb in the air, the underneath part of his other hand very much in shadow, the light behind him; the *haik* on his head transparent in places; white sleeves, background in shadow. The other violinist squatting on his heels, and his *gelabia*. Blackness between them down below. The guitar-case lying on the knees of the musician; very dark towards the waist, red waistcoat, brown trimmings, blue at the back of the neck. Shadow thrown from the left arm, which is at right angles, on to the *haik* over his knee. Shirt-sleeves rolled up so as to show the arm as far as the biceps; green woodwork beside him; wart on the neck, short nose.

Beside the violinist, a pretty Jewish girl; waistcoat and sleeves, gold and purple. She stands out, half against the door, half against the wall. Nearer in the foreground, an older woman with a great deal of white about her which almost entirely conceals her. Shadows full of reflections; white in the shadows.

A pillar stands out dark against the foreground. The women on the left rise in tiers one above the other like pots of flowers. Gold and white predominate; yellow handkerchiefs. Children sitting on the ground in front.

[1] This elaborate description gives the subject-matter for 'The Jewish Wedding' shown at the Salon of 1841 and now in the Louvre.

Sitting beside the guitar player, the Jew playing the tambourine. His face is a dark silhouette hiding part of the guitarist's hand. The lower part of the head stands out sharply against the wall; one end of the *gelabia* under the guitar player. In front of him, sitting cross-legged, a young Jew holding a plate; clothes, grey. Leaning against his shoulder, a young Jewish boy about ten years old.

Against the door of the staircase, Prisciada; purplish handkerchief on her head and under the throat. Two Jews sitting on the steps, dimly visible against the door; very strong light on the noses; one Jew standing upon the staircase; cast shadow full of reflections clearly marked on the wall; reflection, pale yellow.

Above, the Jewish girls leaning over the balcony. The one on the left, bareheaded, very dark, silhouetted against the sun-lit wall. In the corner, the old Moor with a crooked beard, *haik* of some fluffy material, turban worn low on the forehead, grey beard against the white *haik*. The other Moor, shorter nose, very masculine, high turban. One foot out of his slippers, sailor's jersey, and sleeves the same.

On the ground in front, the old Jew playing the tambourine. Dirty handkerchief on his head, you can see his black skull-cap. Torn *gelabia*, also his coat, torn at the neck.

Women in the shadow near the door; many reflections.

In the evening: Costume of the Jewish girl. The shape of her pointed cap. The cries of the old women. Painting her face. The young married women holding the candle while she is being dressed. The veil thrown over her face. Girls standing on the bed.

During the day. The newly married women against the wall, their nearest relations acting as chaperons. The bride getting down from the bed. Her companions remain upon it. The red veil. The brides in their *haiks*, as they arrived. Beautiful eyes.

The arrival of the parents. Waxen torches; the two torches painted in different colours. Hubbub. Faces lit up by the flames. Moors mingling amongst them. The Jewish bride supported on both sides, with someone behind to steady the pointed cap.

Meknès, Thursday, 22 March

Audience with the Emperor.[1]

Left on horseback about nine or ten o'clock, preceded by the *Kaid* on his mule, with foot soldiers, and followed by people carrying

[1] The subject of 'The Sultan of Morocco with his Bodyguard' shown at the Salon of 1845, and now in the Museum of Toulouse. Other versions exist.

the presents. Passed in front of the mosque with the beautiful minaret, the one that we can see from the house. Little window with fine panelling.

Crossed an alley covered with bamboos, like the ones in Alcassar. Houses higher than in Tangier.

In the square opposite the great gate. The crowd beaten back with rope-ends and staves. Iron plates, studded with nails on the gate. Whitewashed half-way up.

After dismounting, we went into a second courtyard and walked between lines of soldiers. On the left, a large parade-ground with tents, soldiers and tethered horses.

After we had waited for some time, we went into the great court where we were to see the king.

Before he appeared, we heard: *Ammar Seidna!* 'Long live the Lord!' (God, understood.)

From the gateway, which is mean and without ornament, there came at short intervals small detachments of about eight or ten negro soldiers in pointed caps, who lined up to right and left, then two men carrying lances, then the king, who rode towards us and drew rein when he was quite close. Strong resemblance to Louis-Philippe but younger; thick beard, moderately dark complexion. *Burnous* of fine cloth, almost closed in front. The *haik* beneath it, worn over the upper part of the chest and almost entirely covering the thighs and legs. A string of white beads threaded on blue silk round the right arm, of which we could see very little. Silver stirrups. Yellow heel-less slippers. Saddle and harness, gold and rose-coloured. Grey horse with a hogged mane. Parasol with unpainted wooden handle and a small gold ball on top; red outside, red and green divisions underneath.

After exchanging compliments and staying longer than is usual at such receptions, he ordered Muchtar to take the letter from the King of France, and granted us the exceptional favour of allowing us to see some of his apartments. He then turned his horse and making a sign of farewell was soon lost in the crowd, to the right, among the musicians.

The carriage which appeared after him was covered in green cloth and drawn by a mule caparisoned with red; the wheels were gilded. Men were fanning it with white handkerchiefs as long as turban cloths.

Went out by the same gate and remounted our horses. Passed through a door leading into a kind of street between two high walls, with soldiers drawn up on both sides.

Tangier, 28 April

Yesterday, 27 April, a procession with a band (drums and oboes) passed under our windows. A young boy who had just finished his schooling was being ceremoniously escorted round the town. He was surrounded by singing schoolfellows, and his parents and teachers. People ran out from their shops and houses to congratulate him. He was wrapped in a *burnous*, etc.

On solemn occasions the children bring out their school tablets and gravely carry them about. The tablets are made of wood coated with clay. They write on them with reed pens and a kind of sepia ink that can be wiped out easily. The people live exactly as they did in ancient times. An outdoor life and carefully closed houses, the women withdrawn from the world, etc. The quarrel, the other day, with some sailors who wanted to go into a Moorish house. A Negro threw his slipper in their faces, etc.

Abou, the general who escorted us, was actually sitting on the door-step the other day while our kitchen boy sat on the bench. He merely leaned over a little to let us pass. There is something republican in behaving so casually. The chief men of the town squat in the sun at street-corners to talk, or perch like a row of birds in the shop of some merchant.

These people have to meet a few (and really very few) legal obligations, either foreseen or possible; some taxes, one or two punishments in given circumstances; but the whole thing is managed without all the fuss and endless detail of our modern police systems. Everything is ruled by custom and tradition. The Moor gives thanks to God for his bad food and wretched clothing; he thinks himself only too lucky to have them.

Some of their ancient popular customs on solemn occasions have a dignity that is lacking in ours. For instance, the custom for the women to visit the graves every Friday with branches, which they buy in the market place. The betrothal ceremonies with music; the presents borne behind the parents, *couscous*, sacks of corn carried on donkeys and mules, an ox, materials on cushions, etc.

It must be hard for them to understand the easy-going ways of Christians and the restlessness that sends us perpetually seeking after new ideas. We notice a thousand things in which they are lacking, but their ignorance is the foundation of their peace and happiness. Can it be that we have reached the end of what a more advanced civilization can produce?

In many ways they are closer to nature than we—their clothes, for instance and the shape of their shoes. Hence there is beauty in everything they do. But we, with our corsets, narrow shoes, and tubular clothing, are lamentable objects. We have gained science at the cost of grace.

[Delacroix returned to Paris in July 1832, refreshed and invigorated, his mind full of new projects; he received his first big commissions for decorations the following year. Then ensued a period of prodigious output, growing prestige, rivalry with Ingres and his school in the decoration of churches and public buildings, and a brilliant life in the fashionable world of the Arts.

When his most exacting work in the Libraries of the House of Deputies and the Senate was coming to an end, and he was beginning to feel the mental and physical strain of invention and execution, he turned again to the idea of a Journal. On 19 January 1847, at the age of fifty, Delacroix purchased a new, large diary and at once began to record his ruminations on aesthetic principles and practice, and his meetings with people. The sentences which describe the start of the new Journal are strikingly reminiscent of those of 1822, set down with greater ripeness and authority.]

PART II

1847

Paris, Tuesday, 19 January

Superb weather, frosty. To the Pantheon. Saw Gros's cupola. Alas! it is wretchedly thin and futile. Also Gérard's pendentives, which I had not seen before. Figures of 'Death' and 'Glory', the latter supporting Napoleon in her arms, with an unidentifiable savage kneeling in the foreground. 'France', a large, armed, female figure standing beside a tomb surrounded with crêpe hangings; prostrate mourners and a figure hovering above—the only good thing in the whole work —good in form, good action. It has managed to receive a black eye through an accident of some kind. 'Justice'; try as I may, I cannot remember a single thing about this picture. 'Death'; a female figure, either holding up or knocking down (impossible to tell which) a youngish man who seems to be making an effort to cling to a monument of uncertain character—attitude not bad. In the foreground, other prostrate figures—quite incomprehensible. The whole thing is frightful in colour. Slaty skies, tones clashing with one another all over the picture; the shine on the painting comes as a final shock and makes the whole thing unbearably thin. Gilt frame, in a style that goes very badly with the architecture and takes up far too much room compared with the painting, etc.

To the Jardin des Plantes, through a part of Paris which I did not know before. Narrow alleys, full of second-hand shops; entire families living in one small booth that serves as shop, kitchen and bedroom, all combined.

The Natural History Museum is open to the public on Tuesdays and Fridays. Elephant, rhinoceros, hippopotamus; extraordinary animals! Rubens rendered them marvellously. I had a feeling of happiness as soon as I entered the place and the further I went the stronger it grew. I felt my whole being rise above commonplaces and trivialities and the petty worries of my daily life. What an immense variety of animals and species of different shapes and functions!

And at every turn I saw what we call deformity side by side with what seems to us to be beauty and grace of form. Here were the flocks of Neptune, the seals and walruses and the huge fish with their cold eyes and foolish, open mouths; the crustacea and sea-spiders, and the turtles. Next, the loathsome family of serpents, the boa-constrictor with its tiny head and its enormous body coiled elegantly round a tree; the hideous dragon, the lizards, crocodiles and alligators, and the monstrous gavial whose jaws taper sharply and end in a curious protuberance at the nose. Then the animals nearer to our own natural scene, the countless stags, gazelle, elks, buck, goats, sheep, with cloven hoofs, antlered heads, straight horns, and horns that are twisted or coiled; the different kinds of cattle, wild oxen and bison; the camels and dromedaries, the llamas, and the vicuñas which so closely resemble them. And finally the giraffe; Levaillant's specimens are here, all patched up and pieced together; and the famous animal of 1827 himself, who was the admiration of all beholders during his lifetime and gave pleasure to thousands of idlers. He has now paid his debt to nature with a death as obscure as his entrance into the world was glorious. Here he is, at all events, as stiff and clumsy as nature made him. The other giraffes, which came into these catacombs before he did, have been set with their necks held proudly erect. They were obviously stuffed by people who had never seen the creature alive and were unable to imagine that curious forward thrust of the head that is so characteristic of the living animal.

Tigers, panthers, jaguars, lions, etc.

Why is it that these things have stirred me so much? Can it be because I have gone outside the everyday thoughts that are my world; away from the street that is my entire universe? How necessary it is to give oneself a shake from time to time; to stick one's head out of doors and try to read from the book of life that has nothing in common with cities and the works of man. No doubt about it, this excursion has done me good and has made me feel better and calmer. When I left the Museum the trees came in for their share of admiration and added their part to the pleasure of the day. I returned by the far side of the gardens, along the embankment. I walked part of the way home, and then took an omnibus.

I am writing this by my fireside, feeling very glad that I stopped to buy this note-book on my way home. I am beginning it on an auspicious day. I hope that I shall long continue to keep a record of my impressions. I shall often realize the advantage of noting down my impressions in this way; they grow deeper as one recalls them.

25 January

The immense influence that the principal lines have upon a composition. At this moment I am looking at Soutman's etchings of the 'Hunts', by Rubens, and particularly at the one of the 'Lion Hunt', in which a lioness, springing out of the background of the picture, is brought to a standstill by the spear of a horseman who is turning round in his saddle; you can see the spear bending as it pierces the breast of the furious beast. In the foreground a Moorish horseman has been overthrown; his horse, also down, has already been attacked by an enormous lion which is looking back with a hideous grimace towards another fighter lying outstretched upon the ground, who with his dying effort is plunging a long dagger into the lion's huge body. The man is pinned to the ground by one of the brute's hind legs, and it is clawing at his face in a frightful manner as it feels the thrust. The rearing horses, the rough manes and tails, the thousand details, the unbuckled shields, the twisted bridles, are all calculated to stir the imagination, and the handling is admirable. But the whole effect is one of confusion, the eye does not know where to rest; one gets the impression of a fearful conflict, but it seems as though art had not taken control sufficiently to enhance the effect of so many brilliant inventions by careful arrangement or by sacrifices.

In the 'Hippopotamus Hunt', on the other hand, the details do not demand nearly so much effort of the imagination. In the foreground of the picture there is a crocodile, which must assuredly be a masterpiece of execution in the actual painting, although the action might perhaps have been more interesting. The hippopotamus, the hero of the scene, is a formless beast which no kind of treatment could render tolerable. The action of the hounds as they hurl themselves upon it is full of energy, but Rubens has often repeated the same effect. Indeed, when one describes it the picture appears inferior to the 'Lion Hunt' in every way, but nevertheless from the manner in which the groups are arranged, or rather from the arrangement of the single group that forms almost the entire picture, our imagination receives a shock that is repeated every time we look at it; whereas in the 'Lion Hunt', our minds become as confused as the lines themselves.

The amphibious monster occupies the centre of the picture in the 'Hippopotamus Hunt'; the riders, horses and hounds are all attacking it furiously. The composition is approximately in the shape of a St. Andrew's cross with the hippopotamus in the centre. The man on the ground, who lies stretched out among the reeds under the feet of the crocodile, continues a line of light in the lower part of the picture.

This prevents the top half of the composition from having too much importance. One effect is beautiful beyond words; a great sheet of sky frames the whole of both sides of the picture—especially the left-hand side which is entirely empty—thus, the very simplicity of the contrast gives incomparable movement, variety, and unity to the whole picture.

26 January

Worked on the 'Arab Horsemen'. Dined with M. Thiers. I never know what to say to the men I meet at his house. From time to time they turn round and talk art to me when they observe how profoundly bored I am with conversation about politics, the Chamber, etc.

How chilly and tiresome is this modern fashion for dinner parties! The flunkeys bear the brunt of the whole business and do everything but put the food into one's mouth. Dinner is the last thing to be considered, it is quickly polished off like some disagreeable duty. Nothing cordial or good-natured about it. The fragile glasses—an idiotic refinement! I cannot touch my glass without making it shake and spilling half the contents over the cloth. I get away as quickly as I can.

27 January

Went to see Labbé in the evening, and afterwards Leblond. Garcia[1] was there. We talked about Diderot's views on actors. He holds that an actor must have passion, and at the same time be able to keep himself under control. I maintain that everything occurs in the actor's imagination. Diderot, who denies the actor all sensibility, does not allow enough for the power of imagination which takes its place. Everything I've heard Talma say on this subject goes to explain the combination of the two different qualities; the inspiration necessary to the actor, and the control that he must exercise over himself. Talma said that when he was on the stage he felt perfectly free to direct his inspiration and to criticize himself even when he seemed most carried away, but, he added, if at that particular moment anyone should come to tell him that his house was on fire, he would be unable to wrench himself out of his part. It is the same with every man

[1] Manuel Garcia, the musician, was a son of the celebrated singer of the same name, and a brother of Marie (La Malibran) and Pauline (Mme Viardot).

engaged on work that uses all his faculties but whose emotions are not necessarily involved.

Garcia defended the cause of sensibility and true passion, and mentioned his sister, Mme Malibran. As a proof of her great talent, he told us that she never knew beforehand how she was going to act her part; for instance, in *Romeo*, as she entered Juliet's tomb, she would sometimes stop at one of the pillars in a paroxysm of grief; at other times she would throw herself down sobbing upon the stone itself. In this way she achieved some strong effects which often seemed very true, but it also made her liable to overact and miscalculate her timing; thus she could sometimes be unbearable. I never remember seeing her *noble*. Even when she came nearest to the sublime, it was no more than what any ordinary woman might attain; in a word, she completely lacked a sense of the ideal. She was like those brilliant young people who, because of their youthful impetuosity and inexperience, are always convinced that they cannot make enough of their talent. She seemed always to be searching after new effects in her parts. When an artist takes this line there is no end to it; it was never the way of the masters. Once they had completed their studies and found the right rendering, they never varied it. This was characteristic of Mme Pasta's talent; also of Rubens and all other great artists. Apart from the fact that with other methods the mind is in a perpetual state of uncertainty, one is forced to spend one's whole life trying to solve the same problem over and over again. At the end of a performance Mme Malibran was utterly exhausted, both mentally and physically, and her brother maintained that she could not have lived long under these conditions.

I reminded him that his father, a great actor, was perfectly consistent in all his parts, in spite of appearing to be swept away by his inspiration. Garcia said that he had seen him studying different expressions in front of his mirror for the part of Othello: this is not a sign of true feeling.

Garcia told us that on one occasion (it was the moment when the unexpected return of Desdemona's father interrupts her transports of joy on learning that Othello is safe, after his duel with Roderigo), Mme Malibran was uncertain of what effect she should try to achieve and consulted Mme Naldi—wife of that Naldi who was killed by the explosion of a shell, and mother of Mme de Sparre. This lady was an excellent actress; she told Mme Malibran that when she played the part of Galatea in *Pygmalion* and had remained astonishingly motionless for as long as was necessary, she created the greatest

sensation imaginable when she made the first movement that betrayed a spark of life.

In *Mary Stuart*, Mme Malibran is led by Leicester to her rival Elizabeth. He implores her to humble herself before her enemy, to which she finally consents, falling upon her knees and making eager entreaties. But as if outraged at Elizabeth's unbending severity, Malibran would rise from her knees and give vent to a rage which, Garcia told us, was extremely effective. She used to tear her handkerchief to shreds, and even her gloves. But really, no great artist would descend to effects of this kind; they are artifices which please a fashionable audience and earn short-lived reputations for those who are rash enough to use them.

The unfortunate thing about an actor's talent is that after his death one cannot establish any comparison between him and his rivals, the men who competed with him for applause during his lifetime. All that posterity knows of an actor is the reputation which his contemporaries made for him, and our own descendants will probably place Malibran and Pasta on the same level; they may even believe that Malibran was the greater actress if they rely on the exaggerated praise of her contemporaries. When he was speaking of Mme Pasta, Garcia described her talents as cold and formal; *plastic* was the word he used. He called her *plastic*, but what he should have said was idealistic. When she was in Milan, she created an extraordinary sensation in the part of Norma, so much so, that people no longer spoke of her as *La Pasta*, but as *La Norma*. Then Mme Malibran arrived and insisted on making her debut in the same part, a piece of childishness that succeeded perfectly. Public opinion, which was at first divided, lauded her to the skies; *La Pasta* was forgotten, and it was *La Malibran* who thenceforward became *La Norma*. I have not the least difficulty in believing it. Unimaginative people, who are easy to please in matters of taste (and unfortunately they comprise the vast majority), will always prefer actresses of the type of Mme Malibran.

If painters left nothing of themselves after their deaths, so that we were obliged to rank them as we do actors according to the judgement of their contemporaries, how different their reputations would be from what posterity has made them! How many forgotten names must have created a stir in their own day, thanks to the vagaries of fashion or to the bad taste of their contemporaries! But luckily, fragile though it is, painting (and failing this, engraving) does preserve the evidence for the verdict of posterity, and thus allows the reputation of an artist of real superiority to be reassessed, even though

he may have been underestimated by the shallow judgement of contemporary public opinion, which is always attracted by flashiness and a veneer of truth.

I do not think it possible to make any satisfactory comparison between the actual techniques of an *actor* and a *painter*. The former has a moment of violent, almost passionate inspiration during which, by an act of imagination, he can put himself in the place of the character he is representing; but once his rendering has been decided, he must inevitably become colder at each successive performance. All he can do at each repetition is to give a new version of his original conception, and the further he gets from the moment when his half-realized ideal can still reach his mind, albeit somewhat confusedly, the nearer he approaches to perfection. He makes tracings, so to speak, of the original idea. A painter too, has this first, passionate glimpse of his subject, but in his case the earliest attempt at self-expression has less form than the actor's. The more talented he is, the more beauties he will add to his work by quiet study; not by conforming as closely as possible to his first conception, but by strengthening it with the warmth of his execution.

There must always be an element of improvisation in the execution of a painter, and therein lies its fundamental difference from that of the actor. A painter's execution will be beautiful only if he reserves the right to be carried away by his inspiration, to a certain extent, and to make new discoveries as his work proceeds.

29 January

If one is in the habit of working without a model—however happy the original conception—one misses those striking effects which the great masters obtained so simply, because they rendered an effect in nature—even a commonplace one—in a naïve way. And this will always be the danger; effects like those which Prud'hon and Correggio produced will never be like those of Rubens, for example. In Vandyke's little 'St. Martin' (the one which Géricault copied) there is nothing extraordinary in the composition, and yet the effect of the horse and rider is immense. This is probably due to the artist's having seen the subject in the living model. And my own little Greek ('Count Palatiano') has the same quality.

It might be argued that with the other method you get more delicate and subtle effects, even though they may not have the striking and authoritative look that at once compels admiration. The white horse

in Rubens's 'St. Benoît' would seem to have been painted wholly from imagination, yet it creates a most powerful effect.

4 February

Arrived about half-past eleven at the Chambre des Députés. As soon as I came in, I noticed Vernet's decorations on the cove of the ceiling. A whole book could be written on the appalling decadence of nineteenth-century art as exemplified by these paintings. I am not speaking only of the wretched taste and poor handling of the coloured figures, the grisailles and ornaments are equally lamentable. In the meanest village, even in Vanloo's time, they would have seemed abominable.

I was pleased to see my hemicycle again;[1] I saw at once just what was needed to restore the effect. Merely by changing the drapery of the Orpheus the whole composition has become more vigorous.

How sad it is that we reach the age of experience just as our strength begins to fail! What a cruel mockery on the part of nature is this gift of talent! It comes only after years of study have exhausted the strength needed to carry out the work.

Coming home in the omnibus, I watched the effects of half-tones on the horses' backs; that is to say on the shiny coats of the bays and blacks. They must be treated like the rest, as a mass, with a local colour lying half way between the sheen and the warm colouring. Over this preparation, a warm, transparent glaze should be enough to show the change of plane for the parts in shadow, with reflected lights. Then, on the parts that project into this half-tone colour, the high lights can be marked with bright, cold tones. This was very remarkable in the bay horse.

5 February

I have spent the whole day reading and resting in my room. Began *Monte Cristo*; it is most amusing, except for the interminable conversations which cover pages on end. However, when you've finished reading it, you've really read nothing at all.

[1] This was the hemicycle which Delacroix painted at the Chambre des Députés, with the theme of 'Orpheus bringing Civilization to Greece'. His scheme for the decoration of the Library of the Chamber included two hemicycles and five domes, and occupied him from 1838 to 1847.

7 February

Feeling unwell. Have done nothing all day. That kind fellow Fleury came to see me accompanied by a perfectly devilish child who kept touching things. He gave me his recipe for priming panels, boards and canvases: fish-glue and whitening, applied with a brush and finished with glass-paper.

8 February

An excellent day.

I began by going to the rue Taranne to see the picture of St. Just by Rubens; an admirable painting. The figures of the two bystanders are rendered in his heavy, broad style of drawing, but they have a boldness of colour and chiaroscuro that belongs only to the artist who is no longer feeling his way, and who has turned his back on rash researches and the even more foolish demands of the critics.

Then to the Chambre des Députés. Worked on the woman carrying the baby, the child on the ground, and the recumbent man above the centaur. I think I have advanced a great deal. A long spell of work, but I did not feel tired when I returned.

To make the day complete, when I arrived home I found that Mme Sand had sent to tell me of her return. I am looking forward to seeing her again.

Stayed in all the evening. It was a mistake, and I paid for it the whole of the following day. I ought to have been out at least for a short walk. Perhaps just being in the fresh air is enough to improve one's circulation. At all events, I could do nothing next day. One's stomach issues orders like a master when it is out of sorts, but like one who is most unfit to govern, for it neglects its own duties and prevents the rest of the body from functioning properly.

9 February

As a result of all this, I feel ill.

Demay called, and while he was still with me M. Haussoullier arrived. There is something priggish about these young men of the school of Ingres. They seem to think it highly meritorious to have joined the ranks of 'serious painting'. This is one of the *party* watchwords. I said to Demay that a great number of talented artists had never done anything worth while because they surrounded themselves with a mass of prejudices, or had them thrust upon them by the

fashion of the moment. It is the same with their famous word *beauty* which, everyone says, is the chief aim of the arts. But if beauty were the only aim, what would become of men like Rubens and Rembrandt and all the northern temperaments, generally speaking, who prefer other qualities? Demand purity, in other words, beauty, from an artist like Puget and farewell to his verve! This is an idea to develop. Northerners are usually less inclined in this direction. Italians prefer ornamentation. This is confirmed by their music.

To *Don Giovanni*, this evening. I had a very sorry impression of the performance. Don Juan (the actor) was wretched! Is this what they call production, this disconnected handling of an old work? But how it grows in one's memory, and how much I enjoyed thinking about it next day! What a masterpiece of Romanticism it is! And composed in 1785! The actor who played Don Juan removed his coat for his duel with the father and not knowing what attitude to assume at the end of the opera, threw himself on his knees at the feet of the Commander. I am sure that not two people in the audience noticed it.

I have been considering the amount of imagination needed by the spectator to make him worthy of hearing a work of this kind. It seemed plain to me that nearly everyone in the theatre was listening with only half an ear. This would have been no great matter had it not been that the passages most calculated to strike the imagination seemed to make no more impression on them than the rest. It takes a great deal of imagination to be vividly impressed at the theatre. The duel with the father and the entrance of the ghost must always stir a man of imagination, but the great majority of the audience appeared to see no more interest in these scenes than in the rest of the opera.

10 February

Yesterday, the 9th, I went to call on Mme Sand but she was indisposed. I saw her daughter and future son-in-law again.

It was past twelve o'clock when I left for the Palais-Bourbon. Frightful weather again; snow, frost and slush. I have to take a cab to go to my work and I spend such a long time in it that there is always a danger of picking up some illness or other. Came home early and was quite as long in the cab as I was this morning. This evening I stayed at home feeling tired and ill.

15 February

Felt unwell when I got up. Took up the sketch for the 'Entombment'

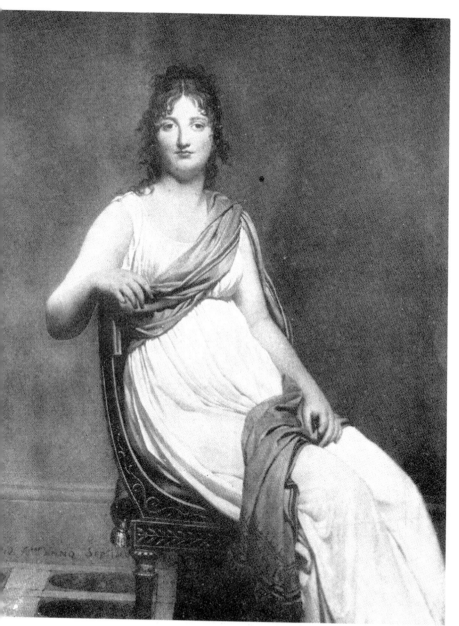

III. HENRIETTE DELACROIX, LATER MME DE VERNINAC
Painting by David

IV. A CORNER OF DELACROIX'S STUDIO
Painted by Delacroix, about 1830

once more, and became so fascinated that it drove away my dis-
order, but I paid for it that evening with a stiff neck that lasted all
through the following day. The sketch is very good. It has lost some
of its mystery, but that is the disadvantage of a methodical sketch.
With a good drawing to settle the main lines of the composition and
the placing of the figures the sketch can be done away with. It almost
becomes an unnecessary repetition of the work itself. The qualities of
the sketch are retained in the picture by leaving the details vague. For
the local colour of the Christ I used raw umber, Naples yellow and
white; over this, a few tones of black and white slipped in here and
there; shadows in a warmer tone.

The local colour of the Virgin's sleeves; a grey, rather on the red-
dish side. The lights, in Naples yellow and black.

19 February

T— very rightly says that the model drags the artist who works
from him down to his own level; a stupid fellow makes you feel a
fool. An artist of imagination strives to raise the model to the ideal of
his conception but, in spite of himself, he is drawn towards the vul-
garity that besets him on every side, and which he sees in front of his
eyes.

Saw two acts of the *Huguenots*, but where is Mozart? Where is that
combination of grace, expression and power, of inspiration and know-
ledge, comedy and terror? Out of this tormented music emerge
passages of astonishing power, but it is a feverish eloquence—flashes
of brilliance followed by chaos.

20 February

Moralists and philosophers (I mean true philosophers like Marcus
Aurelius and Jesus Christ) never talked politics, they considered their
subject only from the human standpoint. Equal rights and other such
vain imaginings were not their concern; all that they enjoined upon
mankind was resignation to fate, not to the unknown *fatum* of the
ancient world, but to the constant need to submit to the harsh decrees
of nature—a need which no one can deny and no philanthropist can
overcome. They asked nothing more of the sage than that he conform
to the laws of nature and play his part in his appointed place amidst a
general harmony. Illness, death, poverty, spiritual suffering, these are
with us always and will torment us under any form of government;
democracy or monarchy, it makes no odds.

Dined with M. Moreau.[1] Returned with Couture.[2] He reasons extraordinarily well. Strange how eager we always are to label one another's faults! Everything that Couture said of the people whom we talked about was very true and very acute, but he did not allow enough for their good qualities. Like everyone else, he only notices and analyses *qualities of execution*. He said, and I can well believe it, that he feels himself to be especially suited to work from nature, and he told me that he makes preparatory studies, so as to learn by heart the subject he wants to paint, and then sets to work on his picture with enthusiasm. From his point of view it is an excellent system. I told him how Géricault used the model—that is to say working freely and yet requiring the pose to be held exactly. We both exclaimed in admiration of Géricault's great talent. What power a great nature can draw from itself! This is a fresh argument against the foolishness of resisting one's instinct and modelling oneself upon other people.

21 February

So many callers today that I finally had to lock my door against them. Started work early on the 'Arab Comedians' because I was due to go to Franchomme's concert at two o'clock. As I was walking there, Mme Sand saw me and took me the rest of the way in her carriage. I was truly delighted to see her again; she was excellent. Angelic music. Quartet by Haydn, one of the last he wrote. Chopin said that the perfection we so much admired was the fruit of experience. He added that Mozart had no need of experience; his knowledge was always equal to his inspiration. Quintets by him, which I had already heard at Boissard's house. The *Rudolph* trio by Beethoven; commonplace passages side by side with passages of sublime beauty.

23 February

In the evening to a small reception at Alberthe's[3] house. It was a great joy to see her again, dear friend that she is. She looked quite rejuvenated in her ball-dress and was untiring the whole evening; her

[1] M. Adolphe Moreau, a stockbroker, was building up a remarkable collection of pictures, since given to the Louvre by his son M. Etienne Moreau-Nélaton. It included some very fine examples of Delacroix's work.

[2] Thomas Couture (1815–79), the painter of 'Romans of the Decadence', whose skill—and limitations—were justly appreciated by Delacroix. He showed little understanding of the latter.

[3] Alberthe de Rubempré, a cousin of Delacroix, and a fashionable beauty of the period.

daughter was also looking most attractive, she dances gracefully, especially that tiresome polka. Saw M. de Lyonne and M. de la Baume. That man never gets a day older.

26 February

Went to meet Villot[1] at an exhibition in the rue Grange-Batalière; a magnificent Titian, 'Lucretia and Tarquin', and the 'Virgin raising the Veil', by Raphaël. The Titian, clumsy and magnificent! Admirable composition of the Raphaël! I fully realized, after seeing this picture, that without any doubt he owes his greatest beauties to this quality. Audacities and inaccuracies caused by the need to conform to his personal style and the characteristic movement of his hand. Using a magnifying glass, I could see that the painting was done with small touches of the brush.

27 February

Grenier came to make a study in pastel of the 'Marcus Aurelius'. We discussed Mozart and Beethoven. He thinks that he can detect an active tendency to misanthropy and despair in Beethoven and a representation of nature that is not carried to the same lengths in other composers. We compared him with Shakespeare. Grenier did me the honour of ranking me with these unruly students of nature. It must be admitted that in spite of his divine perfection, Mozart did not disclose to us this particular horizon. Can this be because Beethoven is nearer to our own times? I think it is true to say that he reflected the modern trend of the arts more fully, inclining as he did to melancholy and to what they rightly or wrongly call Romanticism. Yet *Don Juan* is full of this feeling.

28 February

Dined with M. Thiers. I like him as much as ever and am just as much bored in his drawing-room.

At ten o'clock, I went with D'Aragon to visit Mme Sand. He told us of an exceedingly interesting book, translated by a certain M. Cazalis: *La Douloureuse Passion de Notre Seigneur*, by Sister Catherine Emmerich,

[1] Frédéric Villot (1809–75), an engraver and an early friend, who gave Delacroix instruction in the technique of etching. He was made Curator of Paintings at the Louvre in 1848. He was sharply criticized for certain restorations to pictures, but remained as Secretary-General of the Museum until his death.

a German ecstatic. I must read it. It contains extraordinary details about the Passion that were revealed to this young girl.

1 March

After breakfast, set to work again on the 'Entombment'. This was my third day on the sketch, and in spite of feeling rather unwell I have heightened the tone strongly and have brought it to a state for working on a fourth time. I'm satisfied with the sketch, but when I come to pùt in the details how am I going to preserve this impression of unity that results from very simple masses? Most painters, and I myself did so in the past, begin with the details and deal with the effect last. But however distressing it is to see the impression of simplicity in a good sketch vanish as one adds the details, there still remains far more than could be obtained with the other method.

2 March

Felt unwell. Very late in the day I made an effort to work on the background of the 'Christ'. Touched up the mountains.

One of the great advantages of a lay-in by tone and general effect, without worrying about the details, is that you need to put in only those which are absolutely essential. Beginning by completing the backgrounds, as I have done here, I have made them as simple as possible, so as to avoid their appearing overloaded beside the simple masses that still represent the figures. Conversely, when I come to finish the figures, the simplicity of the backgrounds will allow—even compel—me to put in only what is absolutely essential. Once the sketch has been brought to this stage, the right thing to do is to carry each part as far as possible, and to refrain from working over the picture as a whole, assuming of course that the effect and tone have been determined throughout. What I mean is, that when you decide to finish a particular figure among others as yet only laid in, you must be careful to keep the details simple, so as to avoid being too much out of harmony with figures that are still in the stage of a sketch. If a picture in its first lay-in satisfies your mind by its lines, colour and general effect, and you then proceed to finish it in the same way (that is, by continuing to work over it as a whole), it is plain that you will lose much of the great simplicity of impression which you achieved at the start. One's eye becomes accustomed to details, when they are introduced gradually into one figure after another, and into all at the same sitting, and the picture never seems finished. First disadvantage

of the method: the details smother the masses. Second disadvantage: the work takes much longer to do.

3 March

Today, Wednesday, repainted the rocks in the background of the 'Christ' and finished the lay-in, the Magdalen, and the naked figure in the foreground. *I wish I had applied the paint rather more thickly in this lay-in. It is incredible how time smooths out a picture; my Sibyl seems to me to have sunk into the canvas, already. It is a thing I must watch carefully.*

To the *Puritans* on Tuesday evening, with Mme de Forget. I greatly enjoyed the music. The moonlight scene at the end is superb, like everything that the designer in this theatre does. *I think he obtains his effects with very simple colours, using black and blue and perhaps umber, but they are well understood as regards the planes and the way in which one tint is placed above another. A very simple tone* was used for the terrace at the top of the ramparts, with *brilliant touches of white* to represent the lines of mortar between the stones. Tempera lends itself admirably to such simple effects because the colours do not blend together as they do in oil-painting. Several towers or castellated battlements stand out against the very simply painted sky, and are detached from one another solely through the intensity of the tone; *the reflections are well marked* and a few touches of almost pure white suffice to heighten the light passages.

4 March

Returned to the Chambre des Députés and have decided to do my own donkey-work in the future; I could always manage it perfectly well in the past and it will leave me much freer. This is the eleventh time I've been back, and the picture is now well advanced. Worked at the 'Orpheus' for the most part.

These lay-ins by tone and mass alone are really excellent for this kind of work, especially in passages such as the heads, for instance, which are prepared with a single patch of colour almost without modelling. When the tones are right the features draw themselves. The picture is growing in dignity and simplicity. I believe it's the best thing I've done in this type of work.

5 March

When I was working on the child (the one near the woman on the left, in the 'Orpheus'), I remembered the multitude of little touches

like those in a miniature, in the Virgin, by Raphaël, which I saw with Villot in the rue Grange-Batalière. In such things, where everything is sacrificed to style, the free, showy brushwork of painters like Vanloo merely leads to an acceptance of the 'near enough'. Style comes only after prolonged researches, and the big, flowing brush has to stop when the touch is a happy one. I must try to see the large gouaches by Correggio in the Louvre. I think they were done with very small touches.

In the evening, stayed at home feeling tired and miserable. Indeed, I am not grateful enough for all that providence has done for me. When I'm as tired as this I begin to despair.

6 March

After a good night's rest I went back to the studio where I recovered my good humour. I am looking at the 'Hunts', by Rubens. The one I prefer is the hippopotamus hunt; it is the fiercest. I like its heroic emphasis, I love its unfettered exaggerated forms, I adore them as much as I despise those gushing empty-headed women who swoon over fashionable pictures and M. Verdi's music.

7 March

Pierret called at half-past one, just as I was about to dress for the Conservatoire. Arrived there punctually and was alone in the box during the first item. Mme Sand had not yet put in an appearance; she only came to hear Onslow's piece which I thought extremely boring. On the whole I did not much enjoy the concert. There was only one thing I cared for, a duet for piano and 'cello by Beethoven, and I liked that only moderately well. They ended the programme with a Mozart quartet. I said to Mme Sand as we drove home that Beethoven seems to us more moving because he is a man of our own time. He is romantic in the highest degree. I dined with her; she was most charming to me. We are to go to the Luxembourg together and to the Chambre des Députés.

'The Judgement of Paris' by Raphaël, which I have been looking at in a fearfully battered print, makes an entirely new impression on me since I admired the wonderful harmonizing of lines in his 'Virgin with the Veil', in the rue Grange-Batalière. But if this interest in line were applied to all pictures it would make one blind to everything one looked at after Raphaël. In fact it does not do to think too much about this quality, for fear of throwing everything out of the window.

Have I always felt a lack of enthusiasm for Titian because he almost invariably ignores the relative charm of line?

10 March

Received a notification of the funeral of Barye's only daughter. Poor man, he is going to be very sad and lonely.

11 March

To the funeral of Barye's daughter. None of his artist friends, with whom I usually see him, was there. After the service I called on Vieillard, who is ill in bed. He is suffering from a cold in the head and still cannot get over his loss. We spent a long time discussing the eternal question of human progress, about which we have such different ideas. I talked to him about *Marcus Aurelius*, the only book that has given him any consolation since his misfortune. I also spoke to him about Barye, who is even more lonely than Vieillard; first, she was his daughter, and secondly, he certainly has fewer friends. His reserve, to say the least of it, prevents any expression of sympathy. I said that all things considered, religion, which is to say resignation, offers a better explanation of the destiny of man than any other philosophy. *Marcus Aurelius* preaches nothing else.

Perpignan told me an anecdote about old Thomas Parr, who lived to the age of a hundred and forty. A man who wished to meet him saw a decrepit old gentleman weeping and moaning, saying that he had just been beaten by his father for not having shown proper respect to his grandfather, who was Parr! Perpignan remarked with much truth that emotions wear us out quite as much as excesses, and he cited the case of a lady who expressly forbade people to talk about anything in the least likely to upset her.

I myself feel how much it tires me to talk seriously, or even to give sustained attention to someone else's thought.

12 March

After I had finished my dinner I went to call on Mme Sand. It was snowing a blizzard and I had to wade through slush to get to the rue St.-Lazare. That good-natured fellow Chopin played for us. What an enchanting talent! M. Clésinger,[1] the sculptor, was there. I did not much care for him.

[1] Auguste Clésinger, the sculptor, had married Solange, daughter of George Sand.

13 March

Gaspard Lacroix dropped in for a few minutes. He praised highly the drawing of my 'Christ' of the rue St.-Louis. It is the first time that I have been complimented on this.

Clésinger spoke to me yesterday about a statue of his, which he felt sure I should like very much on account of the *colour*. Colour, it appears, is my only sphere; I have to find it in sculpture before I can like a work or even understand it!

14 March

Gaspard Lacroix came to call for me and we went to Corot's studio. He maintains, like one or two others, and they may be right, that in spite of my desire for method I shall always be swayed by instinct. Corot is a true artist. You need to see a painter in his own studio to gain any real idea of his merit. I saw there, and appreciated quite differently, the pictures which I had already seen in the Salon, where I liked them only moderately. His large 'Baptism of Christ'[1] is full of naïve beauties. His *trees* are superb. I spoke to him about the one I am about to do in the 'Orpheus'; he told me to let myself go a little and to allow myself to take things as they come, so to speak, that is how he works most of the time. He will not allow that one can achieve beauty by taking an infinite amount of pains. Titian; Raphaël, Rubens, etc. all did their work easily. In fact they did only what they knew how to do well, but their scope was so much greater than that of other painters who can paint only landscape or flowers, for instance. But notwithstanding this facility, there is always and inevitably work to be done. Corot goes deeply into a subject; his ideas come to him and he develops them as he goes along; this is the right way to work.

Spent the evening with M. Thiers. After a short walk on the boulevard I came home feeling ill and miserable. How frightful Paris is! Why do I not realize the good things that Providence has given me? When one feels depressed everything seems dismal.

18 March

I was invited to Bertin's house this evening, but gave up the idea of going (ear-ache and sore throat).

[1] This picture had been commissioned from Corot for the church of St.-Nicolas-du-Chardonnet.

Went out about four o'clock to buy some flowers to send to J—[1]
Instead of putting me right, the walk only made me feel worse.

27 March

Left Champrosay at half-past four. Had a delicious walk in the
morning; I set out by the lane which runs along the edge of M.
Barbier's park and then took the path on the left, continuing along
the side of the hill as far as the little fountain, where I sat down to rest.
It is an enchanting spot; I shall come here as often as I can. I then went
on as far as the frog pond and home by the plain—very hot.

30 March

To the last performance at the Italiens with Mme de Forget. The
first act of *The Secret Marriage* by Cimarosa, the second act of Verdi's
Nebuchadnezzar and the second and third acts of *Othello*.

The *Marriage* seemed more divine than ever; I thought it quite
perfect. There had to be an anti-climax, of course, but what a descent
to *Nebuchadnezzar*! I left before the end.

1 April

Went to the Luxembourg at eleven o'clock with Mme Sand and
Chopin. After we had looked at the dome we went into the picture
gallery. They drove me home and I arrived back about three o'clock.
Later, I dined with them. Mme Sand was going to see Clésinger in
the evening and suggested my going with her, but I felt tired and
came straight home.

2 April

In the evening, to the Conservatoire with Mme de Forget. A
symphony by Mendelssohn, which I thought excessively boring
except for one presto passage; also one of Cherubini's lovely pieces
from the *Messe de Louis XVI*, and a symphony by Mozart which I
adored.

[1] J—. This initial does not refer here, as in 1823, to the mistress of Soulier,
'La Cara'. From 1847 onwards J—indicates Joséphine de Lavalette, a cousin of
Eugène Delacroix, whose husband, Baron de Forget, was drowned in 1836.
She was highly intelligent and became the most constant and intimate of
Eugène's women friends. M. Raymond Escholier has written of Mme de
Forget as *La Consolatrice* of Delacroix's years of maturity.

It was intensely hot and I was very tired, but I experienced something which I have never known to happen before. As I listened to the Mozart symphony, it not only seemed exquisite in every way but appeared to make all my weariness disappear. This perfection and completeness, these delicate nuances, must be the despair of all musicians who have any taste and feeling.

3 April

Went out early to call on Gautier. I thanked him for the splendid article which appeared the day before yesterday and gave me so much pleasure. He suggests my having a one-man exhibition of all the pictures I can collect together. He thinks I could do this without feeling like a charlatan, and that it would bring in some money.

To M. de Morny. Never have I seen such luxury. His pictures looked much better in his own house. There is a magnificent Watteau; I was struck by the wonderful skill it displayed. Flanders and Venice are united in this painting, but one or two of the Ruysdaels, especially a snow scene, and a very simple seascape where there is little to be seen except a grey sea and a few small boats, seemed to me the very summit of art because the art is entirely concealed. This astonishing simplicity lessened the effect of the Watteau and the Rubens; their artistry was too obvious. To have pictures like these always before one's eyes in one's own home must be the most exquisite pleasure.

25 April

Riesener said a very good thing about the exaggerated enthusiasm which some people feel for paintings by Michelangelo. I was telling him what Corot said about the stupendous superiority of his works. Riesener said, very justly, that the gigantic quality, the turgidity, the very monotony of such things is bound to crush whatever is put beside them. Antique sculpture appears shrunken and materialistic beside Indian or Byzantine images, and how much more so paintings like those by Lesueur, or even Paolo Veronese. Riesener is right when he says that we ought not to let this disturb us and that everything is good in its proper place.

26 April

Pierret came to spend part of the evening with me. It has been a good day on the whole.

He told me about his evening with Champmartin, when Dumas demonstrated Racine's feebleness, Boileau's emptiness, and the complete lack of melancholy in writers of the so-called Great Century. I undertook their defence.

Dumas never ceases to hold forth about the inevitable 'Public Square', or 'Entrance-hall to the Palace', where all the action takes place in our tragedies and in Molière's plays. He wants art without its preliminary formalities. But such so-called absurdities do not disturb anyone. What does shock one horribly is this mixture in the works of Dumas and other writers of an exaggerated realism abhorrent to the arts, and of sentiment, characters and situations of the most false and extravagant kind. Why don't they say that engravings and drawings are meaningless because they have no colour? If these men were sculptors, they would paint their statues and have them fitted with springs to enable them to walk, and believe that by so doing they were getting nearer to the truth.

27 April

Had one last look at Prud'hon's portrait of Josephine.[1] Exquisite, exquisite talent! The breast with its imperfections, the arms, the head, the dress with its tiny specks of gold, it is all sublime. The grisaille is most conspicuous and shows in almost every part of the picture.

30 April

To Souty's,[2] where I saw the picture of Susanna, which is reputed to be by Rubens. It is a very typical Jordaens, and a magnificent painting.

Souty also has a stock of modern pictures that make a very poor showing beside the Fleming. What is so depressing about these miserable canvases is that they are all completely characterless. One can see the character they are intended to have, but none of them has any distinction, with the exception of the 'Allée d'Arbres' by Rousseau which is excellent in many parts. The lower half is really first class. The darkness of the upper part must be due to some alteration in the paint; it is flaking off.

The Jordaens is a masterpiece of imitative art, broadly treated and well understood as painting. Here is a man who did the work for

[1] This portrait is now in the Louvre.

[2] Souty was a dealer in colours, father-in-law of Francis Petit, the founder of the Galerie Petit.

which he was fitted, and did it exceedingly well! But how differently men are constituted! The complete absence of ideal is disturbing, despite the excellence of the actual painting. The features, and the expression of the woman's face are vulgar beyond belief. How was it that he did not feel the need to express the poetic aspect of his subject in other ways than by the admirable contrasts of colour which make the picture a masterpiece? The grossness of the two old men, the chaste alarm of the modest young woman, her delicate forms, which one feels should appear to shun even the light of day, would all have been expressed by Prud'hon, Lesueur, or Raphaël. Here, she looks almost as though she were in collusion with the two elders, and the only spark of animation about them is the admirable colour of their heads, hands and draperies. This painting is the strongest possible proof of the impossibility of creating any high degree of unity between truth in drawing and colour, and grandeur, poetry and charm. At first I was quite bowled over by the strength and knowledge it displayed, but then I realized that it would be impossible for me to paint so forcefully or with so little imagination. I need colour, I need it as much as Jordaens, but for me it has a different purpose. And so I have become reconciled to myself, after feeling at first that here was an admirable quality that I did not possess. Jordaens's rendering and his precision are miles beyond me, or rather I am miles ahead of him. The picture has not gripped my imagination as so many other lovely pictures do; a Rubens would have moved me more, but what a difference there is between the two men! Rubens, for all his crude colour and unwieldy forms, achieves a most powerful ideal. Strength, vehemence, and brilliance absolve him from the claims of grace and charm.

2 May

Martin, my old pupil, and a perfect fool of a man, has come back from Italy quite swollen with all that he's seen, and even stupider as a result of it. A flat and boring day; no work done; an utterly empty mind.

4 May

Was unwell in the middle of the day; it felt like an attack of fever. I think I am getting these attacks at the same times as when I first had them. Went to sleep about two or three o'clock, and when I woke the fever had left me.

Aubry, the picture dealer, was here this morning. The things I saw at his gallery yesterday give me very little hope for the future of the modern school. They look on Boucher and Vanloo as the great men who should be imitated; but for all their bad taste those painters had real knowledge, whereas these pygmies, these insects I should say, of the present time have neither feeling nor the least smattering of knowledge. . . . A stupid manual dexterity is their highest aim.

J— came to fetch me at half-past five and I dined with her—a happy, peaceful evening.

7 May

I received a letter from Mme Sand. Poor woman, she writes in the kindest way, but her sad heart is much distressed. I have seen Clésinger's statue. I am afraid Planche is right; it is a daguerreotype in sculpture, except for the really brilliant handling of the marble. It is a proof of what I consider to be the weakness of the other sculptures; lack of proportion and so on. No intelligence in the lines in the figure; one cannot see it as a whole from any angle.

I enjoyed my visit to the Salon and avoided meeting anybody. I liked Couture's picture; he is a very complete artist in his own line. I do not think he will ever acquire the qualities he lacks, but on the other hand he is wholly master of what he knows. I liked his portrait of a woman.

I was not too much displeased with my own pictures, especially the 'Jewish Musicians' and the 'Boat'. Felt fairly satisfied with the 'Christ'.

9 May

To Mme Marliani's house in the evening; she tells me that Chopin has been ill. The poor fellow has been ailing for the past week, and very seriously. He is a little better now.

10 May

Called on Chopin this morning, but was not allowed to see him.

11 May

Called on Chopin about eleven o'clock.

Dined with J—. She took me to see Chopin about nine o'clock. Stayed until past midnight; Mlle de Rozières was there with her friend Herbaut.

Champrosay, Monday, 22 May

While I was sitting in the forest, this morning, I began to think of those charming allegories of the Middle Ages and the Renaissance—those cities of God and bright Elysian fields with their gracious inhabitants, etc. Was not this always the tendency in periods when belief in a higher power retained its full strength? In such times, men's souls strove ceaselessly to escape from trivial anxieties or the sufferings of their actual lives, by seeking some imaginary abode, which they embellished with everything they lacked on earth.

We also find this tendency in those unhappy periods when a sense of insecurity weighed upon mankind and curbed the flight of his imagination. In the days when he had not learned to conquer nature, and his physical needs were greater, life must have seemed even harder than it does today, causing him to dream all the more eagerly of an imaginary well-being. But in our own times, pleasure is more general, men are better housed and distances more easily crossed. It would therefore seem that in the past, as always, men's longings romanticized the lives of unhappy mortals, doomed as they are to despise whatever they possess.

26 May

Chopin called today; he leaves on Friday for Ville-d'Avray.

7 June

Adolphe Cabot, monumental mason, 106 rue de la Roquette.

Went with Jenny to Père-Lachaise to look at the graves and to see David's monument. I made an arrangement with the gardener to look after the graves of my mother, etc., for twenty francs a year, beginning from today, plus a further agreement to recut the inscription on my mother's tombstone and to clean it.

9 June

Most men's brains lie fallow for the greater part of their lives. When you consider the number of stupid, or at least of mediocre people, who seem to live only to vegetate you cannot help wondering why God gave his creatures the gifts of reason and imagination, the ability to compare and plan, etc., only to produce so little result. Laziness, ignorance, or environment turn most men into the tools of circumstance. We never realize all our capabilities. Laziness is probably the greatest obstacle to the full development of our faculties. It would

therefore seem that 'know thyself' should be the first maxim of every society in which the members all play their parts fully and to the best of their abilities.

25 June

This was the day that Grzymala came to see me, at dinner time, I think. He said several things about my painting that pleased me; in particular, that he was always struck by the *idea* rather than by the *convention* of painting; and again, that there is something ridiculous about every picture, arising out of the current fashion, etc. He never sees it in mine. Can he really be right? Might one infer that the less there is in a picture of the transitory element that usually makes for immediate success, the more it will possess of the qualities of permanence and grandeur? Develop this idea.

1 July

To the Chambre des Députés in the morning. Then to Chopin, for a session at three o'clock. He was divine. They played his trio for him with Fauchon, etc.; he then played it himself, and in a masterly manner.

10 July

Painted the Magdalen in the 'Entombment'.

Must remember the simple effect of the head. It was laid in with a very dull, grey tone. I could not make up my mind whether to put it more into shadow or to make the light passages more brilliant. Finally, I made them slightly more pronounced compared with the mass and it sufficed to cover the whole of the part in shadow with warm and reflected tones. Although the light and shadow were almost the same value, the cold tones of the light and the warm tones of the shadow were enough to give accent to the whole. We were saying when we were with Villot on the following day that it requires very little effort to produce an effect in this way. It occurs very frequently, especially out of doors. Paolo Veronese owes much of his admirable simplicity to it. A principle which Villot considers most useful and of very frequent occurrence is to make objects stand out as a darker note against those that lie behind; this is attained through the mass of the object and at the stage of the lay-in, when the local tone is settled at the beginning. I do not understand how to apply this rule as well as Villot. I must study it.

Veronese also owes much of his simplicity to the absence of details, which allows him to establish the local colour from the beginning. Painting in distemper almost forces him to do this. The simplicity of the draperies adds greatly to this quality in the rest. The vigorous contour which he draws so appropriately round his figures helps to complete the effect of simplicity in his contrasts of light and shade, and finishes and sets off the whole picture.

Unlike Titian, for example, Paolo Veronese never claimed to make a masterpiece of each picture. His skill in refraining from *doing too much* everywhere, and his apparent carelessness about the details, which gives so much simplicity, is due to the practice of *decoration*. In this type of work the artist is compelled to make many sacrifices.

This principle of the small difference in the value of shadows in relation to the lights, should be applied especially when painting *young people*, and it should be noted that the younger the subject, the more the transparency of the skin confirms this effect.

20 July

This was the day I left for Champrosay, where I have been for over a fortnight. It was on this day, or the day before, that I received Mme Sand's letter telling me of her quarrel with her daughter.

Chopin arrived just as I was lunching after having been to the Louvre, where I received a commission for a copy of the 'Corps de Garde'. He told me of a letter he'd received,[1] but since I've been back in Paris he has read me almost the whole of it. I must admit that it is an atrocious letter. Bitter passions and long-suppressed impatience are plainly discernible, with a contrast that would be almost funny if the whole affair were not so sad; from time to time she plays the woman's part and bursts into tirades which might have been taken straight from a novel, or a sermon on philosophy.

2 September

Travelled in the omnibus with two nuns; their habit made a deep impression on me as I thought of the general corruption of morals and the abandonment of all good principles. I like to see this habit which enjoins, at any rate on those who wear it, an absolute respect for the virtues—for devotion, self-respect and regard for others, even if only on the surface.

[1] No doubt this refers to the break between George Sand and Chopin.

5 September

Leroux has certainly discovered the perfect aphorism, if not the very means of saving humanity and dragging it out of the mire: 'Man is born free', he says, quoting Rousseau. No one has ever produced a more dismal piece of nonsense, no matter how great the philosopher who uttered it.

Here is the starting point of philosophy, according to these gentlemen. But in the whole of creation is there any being more of a *slave* than man? His weakness and his needs make him dependent on the elements and his fellow men. But external matters are the least of his troubles. The passions he finds within his own breast are the cruellest tyrants he has to fight, and one might add that to resist them is to go against his very nature.

Nor is he willing to submit to any kind of authority and this is where he finds Christianity particularly odious, although to my way of thinking, it is precisely this which makes it the best of all moral codes; submission to the laws of nature and resignation to the suffering of humanity are the very essence of reason (and hence, submission to the written law, whether divine or human).

18 September

The craft of the painter is the most difficult of all and it takes longest to learn. Like composing, painting requires erudition, but it also requires execution, like playing the violin.

19 September

I can distinguish poets and prose-writers among painters. The rhyme, the restraints imposed by the metre, the form that is indispensable to poetry and gives it so much vigour, are like the inner symmetry in a picture, the studied, yet inspired rhythm that governs the junction or separation of lines and spaces, the echoing notes of colour, etc. It would be easy to demonstrate this thesis, were it not that more active faculties and keener sensibilities are needed to distinguish errors, discords, and mis-statements among lines and colours, than to discover that a rhyme is faulty, or a hemistich clumsily or wrongly put together. But the beauty of poetry does not depend on exact obedience to laws, whose neglect is obvious to the most ignorant. It lies in a thousand harmonies and subtle arrangements of words and sounds which give to poetry its power and appeal directly to the imagination, just as in painting, the imagination is affected by a

happy selection of forms and a proper understanding of their relation-
ship one to another. David's picture 'Thermopylae' is, I consider, an
essay in masculine and vigorous prose. And Poussin hardly ever uses
other means to rouse our ideas than the more or less expressive ges-
tures of his figures. His landscapes seem to be more carefully thought
out, but like those other painters whom I call the prose writers in
contrast to the poets, he seems more often than not to assemble the
tones and arrange the lines of his composition at random. The poetic
or expressive idea never strikes one at first glance.

26 September

M. Cournault told me that when he was in Algiers he noticed a
workman cutting out pieces of leather or cloth to make ornaments,
and looking most carefully at the bunch of flowers which he was
using as a model. In all probability, the harmony which they know
how to obtain with colours is due simply to the observation of nature.
Orientals have always possessed this sense of colour, but neither the
Greeks nor the Romans seem to have had it to the same degree,
judging by what remains of their painting.

5 October

Villot came to see me; we discussed the process which I have used in
the figure of 'Italy'. [In the Library of the Chambre des Députés.] I
have begun to work there again for the first time since September
12th. I feel satisfied with the effect of this figure, and all day long, I
have been very pleasantly occupied with ideas and plans for paintings
connected with the work. It took me only a few seconds to paint the
small figure of the man falling forward, pierced by the arrow.

I ought to do some sketch-pictures in this way, so that they would
have the freedom and boldness of rough drafts. Small pictures get on
my nerves—they bore me; big easel pictures done in the studio are as
bad; they tire me out and I spoil them. One needs to put into huge
canvases, like the 'Battle of Ivry' by Rubens, in Florence, which
Cournault described to me, all the fire and energy which are better
reserved for murals.

The way in which I treated the figure of 'Italy' is a very satisfactory
method to use for painting figures where you wish the form to be
rendered as fully as imagination can desire, without ceasing to be full
of colour, etc.

Prud'hon's style was formed with a view to this need for going over the work again and again *without losing in frankness*. With the usual methods you always have to spoil one effect in order to obtain another. Rubens was *unrestrained* in the 'Naiads' so as to avoid losing his light and colour. *It is the same with portraiture*; if you want to obtain extreme strength of expression and character, the freedom of the touch disappears, and with it the light and the colour. By the other method one could get results very quickly and need never feel exhausted. The work can always be taken up again, because the result is almost certain.

I found wax very useful when I was painting this figure; it made the paint dry quickly and allowed me to go back over the form whenever I wished. *Copal varnish*, or . . . fulfils the same purpose, and wax might be mixed with it.

What gives paintings on white paper such delicacy and brilliance is most probably the transparency inherent in the essential whiteness of the paper. The brilliance of the Van Eycks, and later, of the pictures by Rubens, is due, no doubt, to the whiteness of their panels.

In all probability, the early Venetian painters used very white grounds. Their brown flesh seems to be nothing but simple glazes with lakes over a background that always shows through. And in the same way, in the early Flemish pictures, for example, not only the flesh, but the backgrounds, the earth, and the trees are all put in with glazes over a white ground. I must try to remember the effect of the rock behind the figure in the 'Sleeping Nymph', which I began a few days ago and worked on while Soulier and Pierret were here today (Sunday); also the ground and the background of the forest, after I had put on the glaze of *yellow lake, malachite green*, etc., over a *white* preparation with which I had covered the frightful *umber* rock that was there before.

In the early Flemish pictures on wooden panels, which were painted in the same way with glazes, the brownish colour shows through quite clearly. The difficulty is to find some suitable compensating grey to offset the gradual yellowing and the hotness of the colours.

I had some idea of all this in the sketch which I did ten years ago for the 'Women Carried off by Horsemen' [The 'Rape of the Daughters of Leucippus', now in Munich], from an engraving after Rubens; all that it lacks, as it stands, is a few grey tones. It is even possible that the backgrounds and draperies should not blend with the treatment of the flesh when it is executed in glazes over a white

ground. With any other method, the disparity between them is unendurable. When I had modelled this 'Nymph' with pure white, I found that the background of rocks behind her, for which I had used opaque tones (as in a painting laid-in with the local half-tone method), was not suitable and that what was needed was some such light background as drapery or a wall. I therefore covered the rock with *white* and later, when I decided to paint another rock in tones as transparent as I could make them, the flesh could be harmonized with this accessory; but I was forced to repaint the drapery, earth and forest background in the same way.

6 October

I should certainly gain in power and produce small pictures of current or dramatic subjects and so on, more quickly if I made tracings of them in ink, after the manner of my sketches for the Chambre des Députés, and then treated them as though they were sketches. As the proportions become greater, the arrangement on the canvas becomes more difficult. This would be a small matter if the picture were to be improved, but such is not the case. You have to take trouble over the rendering in pictures where this contributes to the effect. But this hardly ever occurs with such small subjects.

7 October

The more closely I keep to the original sketches in these small pictures the stronger they will be. It saves time and avoids tiresome researches that lead one away from the original idea. The tracing on to canvas is done with a pen. This is always the best method.

9 October

I saw a Chinese wall-paper when I was at Maigret's house with Mme de Forget. Maigret told us that we have nothing to equal their skill in producing fast colours, and he said that when he tried to make a sample of part of the pink background it turned a dreadful colour in a very short time. The wall-paper is comparatively cheap to buy. He said that all the delightful birds were done by hand, and the ornaments as well; these are whitish bamboos touched with silver, and they run over the whole surface of the paper which is a single tone of pink. The entire paper is strewn with birds, butterflies and so on, whose perfection does not come from an exact imitation of nature such as

we always use in decorations. On the contrary, although as regards their movements, graceful attitudes and contrasting colours, they are exactly like the living creatures they represent, they have been executed by a mind that has selected and summarized the objects so as to make a decoration after the style of the animals on Egyptian monuments and manuscripts.

* * *

[The following notes were written on a loose page which was found, undated, in the 1847 note-book.]

The public was certainly more enlightened in periods when great geniuses did not indulge in bombast and bad taste in order to make themselves popular.

The works that the public likes are the measure of its taste. Even talent is compelled to exaggerate effects, and to strike hard. The savage in us will always out. The most elaborate civilization cannot rid our cities of appalling crimes that would seem to belong to peoples blinded by barbarism.

And in the same way, when the human mind is left to itself, it invariably relapses into the stupidity of childhood. Men will always prefer toys to objects worthy of their admiration.

A love of simplicity cannot long endure.

The human mind is incapable of husbanding its knowledge. Tradition counts for nothing. Once a great man is eclipsed it is all over with him.

All the great problems of art were solved in the sixteenth century.

In Raphaël, perfection of drawing, grace and composition.

In Correggio, Titian, and Paolo Veronese, perfection of colour and chiaroscuro.

Then Rubens, who had already forgotten the traditions of grace and simplicity. By sheer genius he created a new ideal. This he drew from the depths of his own nature; it consisted of strength, striking effects, and expression carried to the utmost limit.

Rembrandt found his ideal in the vagueness of reverie and in sustained perfection.

[The notebook for 1848 has not been preserved. Andrieu told M. Moreau that Delacroix had left it in a cab on his way from the Gare de Lyon.]

1849

PARIS

14 January

At midday, appointment with the Commission at the Palais-Royal, to visit the various sites where the Exhibition is to be held. Appalling devastation; galleries transformed into warehouses, paymaster's offices set up, and so on. A club-room with a platform, smelling of the barracks, stale tobacco, etc. Then to the Tuileries for the same purpose, where we found the same depressing sight with this difference, that the palace no longer contains guests of the sort we found in the Palais-Royal. Signs of dilapidation, and revolting smells everywhere. The ex-King's bed with the soiled linen he had been sleeping in, and the Queen's bed in the same state. A heap of broken furniture in the theatre, jewel-boxes forced open, battered wardrobes, and so forth. Everywhere, portraits had been slashed to pieces, with the exception of those of the Prince de Joinville—why this distinction? It is hard to find any reason for it.

24 January

Meeting of the Commission at nine o'clock. It has been a good day. It reminds me of the day when I began my journal, just two years ago.

29 January

Alarms since early morning, on account of the mutiny of the *garde mobile*.

Went to see Chopin in the evening, I stayed with him until ten o'clock. The dear fellow! We talked of Mme Sand, of her strange life and extraordinary mixture of virtues and vices. All this was in reference to her *Mémoires*. Chopin says that she will never be able to write them. She has forgotten the past; she has great outbursts of feeling and then forgets very quickly. For instance, she wept for her old friend Pierret, and then never thought of him again. I was saying to Chopin that I foresaw for her an unhappy old age, but he does not think so. She never appears to feel guilty about the things for which her friends reproach her. Her health is extremely good, and may well continue to be so. Only one thing would affect her deeply, the death of Maurice, or his going wholly to the bad.

As for Chopin, his suffering prevents his taking an interest in anything, least of all in his work. I said that what with age and the unrest

of the present day, it would not be long before I, too, began to lose my enthusiasm. He said he thought that I had strength enough to resist: 'You will have the enjoyment of your talent', he said, 'in a kind of serenity that is a rare privilege, and no less valuable than the feverish search after fame'.

2 February

In the evening, I talked music with Chopin, Grzymala and Alkan. He thinks that Beethoven was obsessed by the idea of Bach. He based much of his work on Bach. Haydn, the composer whose second and third parts (that is to say the music which follows after the first themes) are the best, sometimes tried them in three or four different ways. This astonishes me. He said that Mozart also put in a great deal of hard work. No doubt he did, but not in this way. He must have been guided by his conception of the work as a whole and this would not have allowed him to change the original idea entirely.

5 February

M. Baudelaire called just as I was starting work again on the little figure of a woman in Oriental dress lying on a sofa, which I have undertaken for M. Thomas, of the rue du Bac. He told me of the difficulties which Daumier experiences in finishing.

From there, he jumped to the subject of Proudhon,[1] whom he admires and calls the idol of the people. His views seem exceedingly modern and progressive.

7 February

While I have been working on my picture, 'The Women of Algiers', I have discovered how pleasant—how necessary even—it is to paint on top of the varnish. The only thing needed is, either to find some means of preventing the varnish underneath from being attacked when the top coat of varnish is removed at some later date, or to go over the sketch with a varnish that cannot evaporate (like that which I think Desrosiers or Soehnée supply) or else to varnish with . . . in the first place, or to do the same in finishing.

9 February

Went to see Chopin immediately after dinner. He gets very indignant to see mediocrities appropriating the ideas of the masters and

[1] P. J. Proudhon, the socialist philosopher.

either ruining them, or else sickening people with the way they use them. Afterwards to Mme de Forget; spent the rest of the evening with her and stayed very late.

11 February

Met Thiers again when I was at Passy; it was rather a sour encounter, he still seems to resent my having gone against his wishes. I happened to be speaking to someone else at the time and this will certainly have upset him still more. He did not suggest my going to see him and went off rather abruptly.

14 February

Dined with the Prince-President: Poinsot, Gay-Lussac, Thiers, Molé, Royet, Jussieu, etc. Vieillard and Chabrier were also there. The President presented me to Léon Faucher.

Had a long conversation with Jussieu after dinner on the subject of flowers in connexion with my pictures; I have promised to visit him in the spring. He is going to show me the greenhouses and will arrange for me to have every opportunity to study there.

Thiers was very chilly, even more so than I had expected. I am beginning to believe what Vieillard said to me on Thursday when we were at Cerfbeer's—that he is high-minded, but has a small soul. He really ought to respect me for having had the strength of mind to oppose him over something that went against my better judgement. Well! so much the worse for him.

The Prince complimented Ingres on his fine picture 'Les Capuchins', which is actually by Granet. When Napoleon added that the picture was in his own possession, Ingres's face, as he swallowed this pill, was a perfect study!

Monday, 26 February

Dined at Bixio's with Lamartine, Mérimée, Malleville, Scribe, Meyerbeer and two Italians. It was a most amusing evening. I had never spent so much time with Lamartine before. At dinner, Mérimée egged him on to discuss Pushkin's poems, which Lamartine pretended to have read, although they have not yet been translated. He gives one the painful impression of a man who is always allowing himself to be hoaxed. He enjoys a high opinion of himself, constantly reminds people that he is responsible for everything, and seems quite unruffled

by this tacit agreement to treat him as a kind of amiable lunatic. His thick voice has something rather unsympathetic about it.

Friday, 2 March

On my way to see Chopin this evening I met Chenavard[1] and stayed talking to him for nearly two hours, part of which time we sheltered in the passage at the Opéra-Comique, where the footmen wait. He says that really great men are invariably simple and without affectations. Voltaire, for instance, was always having little fits of temper and giving vent to them in public, and he described some caricatures by a man named Hubert, showing him in all kinds of ridiculous situations. Bossuet, again, was the simplest of men and loved flirting with pious old ladies, and so forth. Every one knows about the incident when Turenne had his face slapped by his groom and about the other time, when he was seen acting as umpire in a game of bowls on the boulevard (which must have been less crowded in those days), first lending his cane to measure the distances, and finally taking a hand in the game himself.

4 March

Spent the whole day reading *Vanity Fair* in the *Revue*, abridged and translated by Chasles from the novel by Thackeray. I was fascinated by it. Let us hope that everything he writes will be translated.

5 March

Glorious sunshine. The weather has been extraordinarily mild for the past fortnight, and indeed during the whole winter, but this has not prevented my catching such a bad cold that I hesitated about going to Boissard's this evening.

However, I went in spite of it. The girl who does a mime of somnambulism was to have been there, but she did not arrive until after eleven, accompanied by Gautier, who had been to fetch her and had found her already in bed. She has a charming head and is very graceful. Her imitations of *falling asleep* were marvellous. Her twisted attitudes—quite charming—perfect for a painter.

[1] Paul Chenavard (1807–95), pupil of Ingres, a painter with lofty ideals but mediocre gifts, was preparing a scheme for the decoration of the Panthéon with a history of Humanity. Delacroix relished debates on aesthetics and ethics with this indefatigable talker, though he was irritated at times by the rigidity of his theories.

While I was waiting for her to arrive, I went with Meissonier to his studio to see his drawing of the 'Barricade'. It is horribly realistic, but although you cannot deny its accuracy, it does perhaps lack that indefinable quality which *makes a work of art out of an odious subject*. The same thing applies to his studies from nature, which are even colder than his compositions; yet he draws with a pencil that Watteau might have used for his coquettes and his delightful figures of shepherds. But in spite of this, immense ability! It is consoling and edifying to me to notice more and more the truth of what Cogniet said last year, when he saw my 'Man devoured by the Lion' hanging beside some of Mlle Bonheur's cows; namely that there is more in painting than accuracy and an exact representation of the model.

Thursday, 8 March

At Chopin's this evening there was an odd sort of fellow, a doctor or an ex-doctor, who has the greatest contempt for homeopaths of every colour and has come from Quimper to admire Chopin and to cure him of his illness. He is passionately fond of music, but his appreciation is more or less limited to Beethoven and Chopin; he does not consider Mozart to be on the same level, says that Cimarosa is an old fossil, etc. You need to come from Quimper to have such ideas and to express them so glibly; I suppose this kind of thing passes as Breton forthrightness. I hate men like this. And most of all I hate this pretence of candour that allows people to give vent to trenchant or wounding opinions. Human relationships would be impossible if this kind of outspokenness were to be considered a sufficient answer for everything. Such people really should live in the stable, where relationships are established with a pitchfork or a pair of horns; I much prefer that sort of frankness.

9 March

Prudent's concert this evening, at Pleyel's house. Overtures to the *Magic Flute* and the *Freischütz*, repeated twice over. I sat near Boissard and the lovely Aglaia, and caught another glimpse of my pretty stranger of the garden. I left my seat a little before the end to get a better view of her, or rather to see her at all, for her back was turned during the performance. I was right about her the first time, when I saw her in the distance from my window. But she is doing her hair differently and wearing ringlets, or perhaps she had altered it for that particular evening. Her features are not really pretty,

but she is the most charming creature imaginable. She reminds me a little of Mme Dalton, when she was young.

Saturday, 10 March

Saw Détrimont this morning. I was much impressed with his Albrecht Dürers—more so than I have ever been—and as I looked at his 'St. Hubert' and the 'Adam and Eve', I remarked that a true painter is one who can comprehend nature in its entirety. With Dürer, · human figures have no more perfection than the great variety of animals and trees. He is consistent in everything, that is to say, with the kind of rendering that the progress of the arts in his period required. He is an instructive painter; everything he did is worth looking at.

Détrimont also showed me a letter from my father, which I was glad to see. What struck me most among his autographs was a piece of writing by Leonardo da Vinci, with some drawings describing the ancient method of *drawing with ovals*;[1] he discovered everything. This manuscript is written backwards.

Sunday, 11 March

At half-past one, went to the St. Cecilia's Eve concert, given for the benefit of the Habeneck memorial fund. A vast concert hall and a very mixed and dirty-looking audience, in spite of its being Sunday. They will never be able to gather together a select audience of connoisseurs in a place like that.

Greatly enjoyed the divine 'Pastoral' Symphony but was somewhat distracted by the restlessness and inattention of my neighbours. The rest of the concert was given up to virtuosi, who bored and wearied me.

I ventured to say that Beethoven's pieces are usually too long, in spite of the astonishing variety with which he reintroduces the same themes. I do not remember noticing this defect when I heard the symphony before, but however that may be, it is clear to me that an artist spoils his effect when he claims one's attention for too long at a time.

Painting, among other advantages, is more discreet than music; the most gigantic picture can be seen in an instant. If its qualities, or

[1] This method of drawing by ovals, which he called *boules*, was much used by Delacroix in improvising compositions. His exposition of the practice to the painter Jean Gigoux is vividly described in the latter's book *Causeries sur les artistes de mon temps*. He claimed that Géricault learnt it from the Baron Gros.

certain portions of it, hold one's attention that is all to the good; one can enjoy it even longer than a piece of music. But if the painting seems mediocre, one has only to turn one's head away to escape boredom. When I heard the Overture to the *Magic Flute* on the day of Prudent's concert, I not only thought it ravishingly lovely but perfect in its proportions. Would it be true to say that improvements in instrumentation have made musicians more apt to fall into the temptation of drawing out their compositions, so as to introduce recurring effects that vary with each repetition?

You must never think that time spent in going to a concert is wasted, so long as one piece in the programme is worth listening to. It is the best kind of nourishment for the soul, and the business of dressing and going out to listen to music, even if it means interrupting important work, adds to the value of the pleasure. The very fact of being in an appointed place and among people who have come together with a common desire to enjoy something in one another's company, even the boredom of hearing certain pieces and certain virtuosi, all combine without our realizing it, to add to the effect of a lovely work. If that beautiful symphony had been played for me in my studio I should probably not have retained the same memory of it.

This may explain why the rich and the great are so soon bored with all their pleasures. They sit in their comfortable boxes with thick carpets under their feet, withdrawn as far as possible from the noise and bustle of a public place, the comings and goings, and the thousand petty annoyances that seem deliberately calculated to exhaust our powers of concentration. They arrange to arrive at the precise moment when the piece is beginning, and to punish them for their lack of respect for the beautiful, they usually miss half of it by arriving so late. What is worse, their habit of talking among themselves on the most trifling matters, or the sudden arrival of some intruder, destroys all their chances of quiet meditation. It is a very imperfect pleasure to listen even to the loveliest music in a box among people of fashion. A poor artist seated by himself in the pit, or with an equally attentive friend, can alone enjoy to the full the beauty of a work, and because of this he carries away with him a memory untainted by the ridiculous.

Tuesday, 13 March

The doctor came to see me at five o'clock. He rather worried me, speaking of probings, etc. I stayed at home, beside my fire.

This morning, Weill[1] took away:

'The Odalisque', and paid me	200 fr.
'The Chess-Players'	200 fr.
'The Man devoured by a Lion'	500 fr.
(Lefebvre) 'Christ at the Foot of the Cross'	200 fr.
(Thomas) 'Christ on the Mount of Olives'—small	100 fr.
'Turkish Woman'	100 fr.
(Bouquet) 'Hamlet and the Rat Scene'	100 fr.
(Weill) 'Berlichingen writing his Memoirs'	100 fr.
(Lefebvre) Sketch, repetition of 'The Entombment'	200 fr.
(Lefebvre) 'Odalisque'	150 fr.
'Scourging of Christ'	150 fr.

Wednesday, 30 March

I have allowed several days to pass without writing; a thing I always regret. Saw that enchantress Mme Potocka[2] this evening, at Chopin's house. I had heard her sing twice before, and thought that I had never met with anything more perfect, especially the first time, when it was dusk and the black velvet dress she was wearing, the arrangement of her hair, in fact everything about her, judging by what I could see, made me think she must be as ravishingly beautiful as her movements were certainly graceful. Mme Kalergi[3] appeared first on one of the earlier occasions; she did not play very sympathetically, but she really is exceedingly beautiful when she raises her eyes as she plays, like a Magdalen by Guido Reni or Rubens.

Monday, 2 April

It was on this evening or on the previous Saturday that I went with Mme de Forget to the President's box to hear *Athalie*.

I do not care for Rachel in all her parts; but how I admired that High Priest! What a conception! How extravagant it would seem

[1] Weill, Lefebvre, Thomas, Bouquet were all picture dealers. It is interesting to note that Delacroix was now over fifty and the eleven pictures on his list were sold by him for 2,000 francs.

[2] Countess Delphine de Potocka, whom Delacroix calls 'The enchantress', was one of the most beautiful women of the period. Chopin delighted in her singing, even in the last days of his illness.

[3] Mme Marie Kalergi, another of the circle of devoted admirers around Chopin and another great beauty, is said to have inspired Théophile Gautier's poem, *A symphony in White*.

now, and how right for that orderly, confident society which knew
Racine in the flesh and made him what he was! This wild enthusiasm
and wordy fanaticism, when throats are cut and men are overthrown
cold-bloodedly and without conviction, does not suit the present day.
During the scene with the confidant, Nathan is altogether too in-
genuous in the speech: '*Je suis un coquin, je suis un être abominable*'.
Here Racine departs from the truth, but he is positively sublime when
Nathan leaves in a state of agitation to escape the curses of the High
Priest and, unconscious of what he is doing or where he is going,
bends his steps towards the sanctuary he has profaned, and whose very
existence torments his mind.

Wednesday, 4 April

This was the day of Véron's[1] dinner-party. I felt thoroughly tired
before I set out, but recovered as soon as I got there, and enjoyed
myself. He lives in amazing luxury; great apartments hung with
magnificent brocade, including the ceilings. There was superb silver
and an orchestra playing during dinner. Incidentally, this is a Gothic
practice that does not improve the meal and interrupts the conversa-
tion that should season it.

Rachel was there, also M. Molé, the Duke of Osuna, General
Rullière, Armand Bertin, and M. Fould, who sat near me and was most
civil. Rachel is exceedingly witty, very fine in every way. It would
have been extraordinarily difficult for any man, born and brought up
as she was, to become what she now is quite naturally. Later in the
evening I had a chat with Rullière about *Athalie*, etc. He was very
agreeable.

Had a long discussion with Armand Bertin about music. We also
talked of Racine and Shakespeare. He says that, do what we will, in
this country we always come back to the idea of the beautiful which
our nation has accepted once and for all. I believe he is right; we shall
never make good Shakespearians. The English are all Shakespeare—
he virtually made them everything they are!

Thursday, 5 April

To Mme de Forget in the evening; she read me part of the speech
which Barbès delivered before his judges. You can see in these people's

[1] Dr. Véron, founder of *La Revue de Paris*, whom Delacroix had known as a
young man, included some lively comments on the painter in his *Mémoires
d'un bourgeois de Paris*. Delacroix considered them superficial and unreliable.

speeches all the falseness and pomposity with which their poor silly heads are filled. It is always so with these cheap scribblers; they are the plague of the century, ready to sacrifice an entire nation with the utmost calm in order to satisfy the ravings of a sick brain.

He says that the goal is everything. No doubt that universal suffrage stood for something, and it certainly established the Chamber, but both the Chamber and the provisional government that preceded it were also the result, or so they believe, of a kind of general wish of the whole nation; yet Barbès did not feel it his duty to support all this. On the contrary, he seems to have considered it as something to be overthrown as soon as it began to depart from the goal on which he had set his heart, although he unfortunately neglected to tell us what this goal was. And so he prefers prison and a dark cell to the pain of standing helplessly by to witness this impious deviation from the supreme end to which humanity must inevitably come—according to the sublime aspirations of Barbès.

In the speech which Blanqui[1] made a few days earlier, the argument was adorned with poetic similes in the modern style. He spoke of the abyss which must be crossed by the Revolution in order to pass from the old ideas to the new. Our all too feeble leap was not enough to carry us over the fatal chasm where the future lies in danger of drowning—although it cannot for one moment stay the flow of Blanqui's rhetoric. His style is full of difficulties, broken threads, or pomposities, but to utter the great, simple truths and to impress them upon men's minds, there is no need to borrow the style of Victor Hugo, who never came within a hundred miles of truth and simplicity.

Saturday, 7 April

Went with Chopin for his drive at about half-past three. I was glad to be of service to him although I was feeling tired. The Champs-Élysées, l'Arc de l'Étoile, the bottle of quinquinà wine, being stopped at the city gate, etc.

We talked of music and it seemed to cheer him. I asked him to explain what it is that gives the impression of logic in music. He made me understand the meaning of harmony and counterpoint; how in music, the fugue corresponds to pure logic, and that to be well versed in the fugue is to understand the elements of all reason and development in music. I thought how happy I should have been to study

[1] Barbès and Blanqui, socialist orators, were being tried for conspiracy in the disorders of 1848.

these things, the despair of commonplace musicians. It gave me some idea of the pleasure which true philosophers find in science. The fact of the matter is, that true science is not what we usually mean by that word—not, that is to say, a part of knowledge quite separate from art. No, science, as regarded and demonstrated by a man like Chopin, is art itself, but on the other hand, art is not what the vulgar believe it to be, a vague inspiration coming from nowhere, moving at random, and portraying merely the picturesque, external side of things. It is pure reason, embellished by genius, but following a set course and bound by higher laws. And here I come back to the difference between Mozart and Beethoven. As Chopin said to me, 'Where Beethoven is obscure and appears to be lacking in unity, it is not, as people allege, from a rather wild originality—the quality which they admire in him—it is because he turns his back on eternal principles'. Mozart never does this. Each part has its own movement which, although it harmonizes with the rest, makes its own song and follows it perfectly. This is what is meant by counterpoint, '*punto contrapunto*'. He added that it was usual to learn harmony before counterpoint, that is to say, to learn the succession of notes that leads to the harmonies. In Berlioz's music, the harmonies are set down and he fills in the intervals as best he can.

Those men, who are so taken up with style that they put it before everything else, prefer to be stupid rather than not to *appear serious*. Apply this to Ingres and his school.

Wednesday, 11 April

I think it was this evening that I met Mme Potocka again at Chopin's house. She sang as beautifully as ever. Parts of the Nocturnes and piano music by Chopin and, among other things, the *Moulin de Nohant*, which she had arranged as an *O Salutaris*. This was most successful. I told her what I sincerely believe to be true, that in music and, as I suppose, in all the arts, as soon as the style and character of a work (that is to say, the serious part of it) becomes apparent, all the rest disappears. I like her much better when she sings 'The Willow Song' from *Othello* than these charming little Neapolitan airs. She tried *Le Lac*, by Lamartine, the one with Niedermeyer's vulgar and pretentious setting. I've had this cursed tune on the brain for the last two days.

Thursday, 12 April

To Edouard Bertin's where I met Amaury Duval, Mottez and

Orsel.[1] These fellows swear by fresco, and use the names of the
Italian Primitives as though they belonged to intimate friends. They
talk of true and false fresco, *al tempera*, and so on. Came home very
tired; I had to force myself to go there.

Saturday, 14 April

To see Chopin in the evening; I found him in a state of collapse,
scarcely breathing. After a time, my being there seemed to do him
good. He said that boredom was the worst evil he had to suffer, and I
asked him whether before he fell ill he had not known the unbearable
sense of emptiness that I sometimes feel. He said he could always find
some occupation or other, and that having something to do, however
trivial, filled in the time and dispersed the vapours. Real grief is some-
thing quite different.

Sunday, 22 April

Felt tired after last night, and stayed at home. About one o'clock
M. Poujade came; he was quite interesting, but stayed too long and
tired me. Then Leblond called. I was glad to see him in spite of feeling
tired; he is a man I genuinely like. One so rarely has the company of a
friend that it is worth all manner of pleasures and makes up for many
irritations.

To Chopin after dinner. He is another man it does one's heart good
to be with, and one's mind as well, needless to say. We talked about
the people I have met at his house, Mme Kalergi, etc. He had dragged
himself out to see the first performance of Meyerbeer's *Le Prophète*.
His horror at that rhapsody!

Monday, 23 April

From all the signs that have been staring us in the face during the
past year, I believe it is safe to say that all progress must lead, not to
further progress, but finally to the negation of progress, a return to the
point of departure. The history of the human race is proof of it. But
the blind belief of both this generation and the last in modern ideas
and the coming of a new era, which is to herald a complete change for
mankind (although to my mind, a change in man's destiny must be
foreshadowed by a change in his very nature)—this curious belief, for
which there is no justification in history—remains our only security

[1] Amaury Duval and Mottez were pupils of Ingres, Orsel a French painter of
pre-Raphaelite style. All of them executed mural paintings in churches.

for the future triumphs and revolutions which are so much desired by the human race. Is it not very clear that progress, that is to say, the onward march of all things, good as well as evil, has brought our civilization to the brink of an abyss into which it may very possibly fall, giving place to utter barbarism? And the reason for this, the sole reason, is it not to be found in the law that dominates all others here below, the need for change in some form or other? We must change. *Nil in eodem statu permanet.* What the wisdom of the ancients discovered before making so many experiments must necessarily be accepted by us, and we must submit to it. What is now perishing with us will doubtless take new shape, or will continue to exist elsewhere for some time unknown.

This monstrous work, *Le Prophète*, which the author probably imagines to be a great advance, is the very abasement of art. Meyerbeer seems to have felt a pressing need to do something better or different from what had been done before, in other words to change, and this has caused him to lose sight of the eternal laws of taste and logic which govern the Arts. Men like Berlioz and Hugo and other would-be reformers have not yet managed to abolish all the ideas of which we have been speaking, but they have led people to believe in the possibility of doing something other than what is true and reasonable; and it is the same in politics. Leaving the well-trodden path inevitably means a return to the infancy of society, and after a succession of reforms, a state of savagery must necessarily be the result of the changes.

Mozart said: 'Violent passions should never be expressed to the point where they arouse disgust. Even when describing horrible events, music should never offend our ears and cease to be music.' (*Revue des Deux Mondes*, 15 March 1849, p. 892.)

Sunday, 20 May

Received a letter from the Minister of the Interior confirming the commission for Saint-Sulpice. I had already been to thank Varcollier a few days ago, at his house in the rue Mont-Thabor.

Friday, 1 June

To the Louvre. I was very much impressed, especially by the Gros and, above all, by the 'Battle of Eylau'. I like everything about it at present. It has more mastery than 'The Plague in Jaffa', and the execution is freer.

Greatly admired the Rubens in the long gallery.[1] The figure of the 'Weeping Victory' in the last picture but one! How marvellously this figure detaches itself from the others, even though the legs seem to have been painted by another hand than Rubens's. They show carefulness, but the sublime weeping head and the folded arm—all this displays the work of genius itself.

I thought the 'Nereids' seemed more beautiful than ever. Only complete freedom and the greatest audacity can produce such impressions on me.

Saw 'The Resurrection' by Carracci; its coldness and dullness made me realize how beautiful this subject is. The angel rolling away the stone with eyes that flash like lightning; Christ in splendour rising from the bowels of death, and soldiers lying prostrate on every side.

Saturday, 2 June

Mme de Quérelles tells me that she has seen my small 'Arab Horseman' at the gilder's—the one galloping up on the chestnut horse. She described her impressions; exactly what I myself had felt looking at those sublime Rubens! It's most extraordinary to find this in a society woman. She maintains that painting, when it has this quality of natural vitality, carries her away like music and makes her heart beat faster—or so she says. She repeated it with every possible emphasis.

Tuesday, 5 June

Left for Champrosay at eight in the evening. Arrived very late, and found everything in the garden neglected; fetched water from the little spring to make soda-water with the new machine I have brought with me.

Champrosay, Wednesday, 6 June

Dined with Mme Villot who sent me an invitation earlier in the day. I did not know she was in Champrosay; it was a pleasant surprise. After dinner we strolled in the garden and went up to the drawing-room to finish the evening.

[1] The cycle of pictures of the 'Life of Marie de Médicis', by Rubens, was frequently consulted by Delacroix as exemplars of painting. The nereid splashing in the water in the 'Landing of Marie at Marseilles' was copied by him, and he took his assistant, Andrieu, to study the iridescent colour of the flying drops of water.

Sunday, 24 June

A bad mood, this morning. Made an attempt at a sketch for a 'Samson and Delilah'; kept to white chalk.

This afternoon I entered the forest by the entrance on the Marquis's side; I had not been in this part since last year. I took it into my head to collect a bunch of wild flowers and scrambled about amongst the undergrowth at the cost of pricked fingers and badly torn clothes. It was an enchanting walk. In the morning it had been thundery and oppressive, but by the afternoon the quality of the heat had changed and the setting sun lent to everything a gaiety which I never used to see in the evening light. I find that, as I grow older, I am becoming less susceptible to those feelings of deepest melancholy that used to come over me when I looked at nature, and I congratulated myself on this as I walked along. What then have I lost with the loss of my youth? . . . A few illusions that certainly brought me great happiness at times, but which, from this very fact, resulted in equal bitterness.

As we grow older we are forced to realize that almost everything wears a mask, but we gradually become less resentful of deceptive appearances and grow accustomed to making the best of what we see.

Sunday, 15 July

Wrote to Peisse about his article of 8 June:

'I hardly like to say that everything you write is very just and very true, since I am the one to reap the benefit. What you say about colour and its function has never received much attention before. Criticism, like many other things, is apt to be confined to what has already been said, and never leaves the beaten track. This famous quality, the beautiful, which some see in a curved line and others in a straight, all are determined to see in line alone. But here am I, sitting at my window, looking at the most beautiful countryside imaginable and the idea of a line does not enter into my head. The larks are singing, the river is sparkling with a thousand diamonds, I can hear the rustle of the leaves, but where are any lines to produce such exquisite sensations? These people refuse to see proportion and harmony unless they are enclosed by lines. For them, all the rest is chaos, and a pair of compasses the only arbiter. Forgive this passionate criticism of my critics, and please observe that I very humbly take shelter behind the great names you have quoted and pay them an even higher tribute of admiration than is customary. Indeed Rubens draws; indeed Correggio draws. Not one of these men has broken with the ideal.

Without the ideal there is neither painting, nor drawing, nor colour. But worse than having no ideal is to have that second-hand one which these people learn at the École, and which is enough to make one hate their models. But since several volumes might be written on the subject, I shall stop here and thank you once more for all the pleasure you have given me, etc.'

Paris, 11 August

At about half-past nine I took a cab and went to call on Villot. Found only his wife at home. She was lying on her sofa as usual, doing needlework. She was looking exceedingly handsome, with exquisite flowers on the little table at her side. I waited for Villot until eleven o'clock.

Rouen, Thursday, 3 October

Putting off my departure until today has meant my losing the opportunity of seeing my 'Trajan'. When I reached the Museum I found it half covered by scaffolding that is being put up for the exhibition of Norman painters. If I had kept to my original plan I should have been able to see it in comfort.

I cannot remember ever being so much pleased with one of my pictures when I have come across it in a gallery long after I have forgotten it. Unfortunately, one of the most interesting parts, probably the most interesting of all, was hidden; the woman who is kneeling at the feet of the Emperor. But what I did manage to see of the picture struck me as having so much depth and vigour that everything else, without exception, was put in the shade. Curiously enough, the picture appeared brilliant, although it is mostly dark in tone.

Saturday, 6 October

Went out late to see the Cathedral, which does not come within miles of the effect produced by Saint-Ouen; I mean the interior, of course, for the front and side views are very fine. The façade is a magnificent pile, pleasing irregularities, etc. The *Portail des Libraires* is equally fine, but what I found most moving were the two tombs in the chapel at the far end, especially that of M. de Brézé. It is all exceedingly good, particularly the statue. It combines the good qualities of the antique with something of the spirit of our own times and the grace of the Renaissance. The shoulder-blades and arm and

the leg and feet are all beyond praise in style and execution. I liked the other tomb very much, but there is something odd about the general effect; this may be due to the placing of the two figures which look as though they had been posed there quite casually. I thought the figure of the cardinal extraordinarily fine; in style it can only be compared with the best of Raphaël, the drapery, head, etc.

Saint-Maclou: superb glass, carved doors, etc. The frontage on to the street is much improved by so many buildings having been cleared away. A few years ago they cut a new road through here, leading down to the port.

At Yvetot I had a disappointment. Took a cab and was late in getting to Valmont.[1] The great avenue leading to the castle has gone. I was deeply moved at the idea of going back to a place which I used to be so fond of. But everything has changed for the worse . . . the road is different, etc.

Valmont, the following day, Sunday 7

Went into the rain-soaked garden: I was not too much disillusioned. It is astonishing how the trees have grown; they somehow make it seem more melancholy than in the old days, but here and there they look really sublime. The hill on the left, seen from below before you come to the little waterfall, the ivy-clad trees near the bridge. Unfortunately, although the ivy looks so well twined round the trunks, it is strangling the trees and will kill them before long.

After lunch visited the chapel with Bornot and Gaultron. It is now raining and we are confined to the house.

Had a pain before dinner. I have not been feeling at all well since I arrived in Rouen. We went out in spite of the rain and climbed the hill towards Augerville. The roads have been enormously improved.

Next day it rained so hard and continuously that it was impossible to go out. There were people for dinner; the curé, a chubby little man, who sat smiling and sucking his teeth the whole time and never uttered a word: the postmistress, a pleasant sort of woman, and that nice Mme d'Argent. Billiards and so forth.

Tuesday, 9 October

How sad it is that man can never enjoy all the powers of which his nature is capable at the same time, and that we only come into full

[1] The Abbey of Valmont, near Fécamp, was the property of a cousin of Delacroix, M. Bornot.

possession of our various faculties at different stages in our lives! These thoughts were suggested by a passage from Montesquieu which I came across the other day, where he says that as soon as a man's mind reaches maturity his bodily powers begin to fail.

It also occurs to me that as we grow older the sharpness of some of our impressions tends to become blurred, especially those relating to physical sensations. When I first arrived—and still more so, now that I have been here for several days—I noticed that I was not experiencing those strong emotions of joy and melancholy which I used to feel at Valmont, and which were such precious memories. I shall probably leave without the same regrets. As regards my mind, I have more self-confidence than I had at the time of which I am speaking; my powers of assembling and expressing my thoughts are far greater, my intellect has developed, but my soul has lost some of its sensitiveness and elasticity. Why, after all, should man escape the fate of every other living creature? When we pick the delicious fruit have we any right to demand to smell the perfume of the blossom at the same time? The exquisite delicacy of the sensibility of youth is needed to bring about confidence and maturity of mind. Perhaps, and I sincerely believe this to be true, really great men are those who, when their minds have reached full maturity, can still retain some of the warmth in their impressions that is characteristic of youth.

Spent the morning reading Montesquieu.

To Fécamp about two o'clock; the sea was magnificent. Lovely views of the valley. After dinner we talked politics.

During the last day or two I have been examining and comparing the pictures in my cousin's drawing-room. I think that I have discovered what distinguishes a painting that is merely simple and unpretentious from one that possesses lasting qualities. In short, I have often wondered why the extreme facility and boldness of touch in Rubens's work never disturbs me, but in paintings by men like Vanloo (and I include modern painters as well as his contemporaries) it merely seems an odious form of technique. Fundamentally, I am perfectly well aware that this facility in the work of the great master is not the chief quality, that it is only the means and not the end, and that the reverse is true of mediocre painters. I was glad to have this opinion confirmed when I compared the portrait of my old aunt with Uncle Riesener's paintings. Although the work of a beginner, it already shows a sureness and a grasp of essentials—even a quality of touch in the rendering, which struck Gaultron himself. I mention this only because I find it reassuring. He spoke of vigorous handling, etc.

Lovely weather: we've been to Saint-Pierre, on the other side of the valley.

On our way we passed through Augerville where I came so many years ago with my dear mother, my sister and nephew, and my cousin; all now departed! The little house is still standing and you can still see the sea, which will be there long after the house has disappeared.

We went down to the sea by a little path on the right which was unfamiliar to me. There was the loveliest stretch of greensward imaginable, sloping gently downwards, from the top of which we had a view of a vast expanse of sea. I am always deeply stirred by the great line of the sea, all blue or green or rose-coloured—that indefinable colour of a vast ocean. The intermittent sound reaches one from far away and this, with the smell of the ozone, is actually intoxicating.

I have just noticed that the fine thoughts filling these last pages have quite prevented my saying anything about our first expedition to Fécamp; I forget which day it was, but the weather was very different. There was a rough sea breaking magnificently against the pier, and we saw two small ships get under way.

Today, however, there is a perfect calm and I love it like this, when it is all sparkling and flashing in the path of the sun, which lends gaiety to the majestic sheet of water.

We then went to see the curé's house, where old M. Hebert used to live. It is certainly rather gloomy; a man living there by himself could hardly help turning into a fossil.

They are pulling down the charming old church to make way for a new one. We were all indignant about it.

Wednesday, 10 October

At Cany, on the following day. Some of the woods beside the road have gone, but this has not yet spoiled the view of the house. I have never enjoyed this enchanting place so much. I must try to remember those masses of trees; the avenues, or rather glades, continuing along the side of the hill above the lower roads and giving an effect of trees piled one above the other. The park is full of magnificent trees, their branches touching the ground; I particularly noticed the plane tree on the right as you come to the end of the park. The beauty of the fountains. Came home by way of Ourville. Magnificent view as we climbed the hill out of Cany; tones of *cobalt* visible in the green masses of the background in contrast to the vivid green and occasional gold tones in the foreground.

Saturday, 13 October

Spent the morning finishing Montesquieu's *Arsace et Isménie*. All the author's talent cannot disguise the triteness of these boring adventures, these love-affairs with their everlasting fidelity. I think that fashion and perhaps a feeling for truth have condemned this kind of thing to oblivion.

Idled about until dinner-time. Had a nap in my room and went for a turn in the park at dusk. In that light, the park with its huge trees took on an almost lugubrious air; I felt that if only these effects could be rendered in a painting it would make the finest landscape I had ever seen. I could think of nothing to compare with it. The forest of columns formed by the trunks of the pines, the old walnut tree as one goes up the hill, etc.

Monday, 15 October

A lovely day; we went to Grandes-Dalles. The same road as far as Sassetot, only we kept to the left. I admired the church door at the cemetery. It is obviously an imaginative work by a craftsman of taste, and goes to show that this quality is part of the very texture of an art for which the text-books give ready-made proportions; a method that can only engender works devoid of all character. Made a drawing. The tide was still out.

Tuesday, 16 October

Before luncheon, I went out by myself along the road to Fécamp. I had intended to climb up into the little wood on the left and to stroll through the charming meadows where the pine trees are, but I was always being stopped by hedges or fences.

The common people, who will always be the majority, make a mistake in thinking that great estates are useless. It is the poor who benefit by them, and the profits they gain do not impoverish the rich who let them take advantage of the little windfalls which they find on their estates. My good cousin's easy-going ways were a great blessing to the poor people who collected ferns and firewood on his land. But when small tradesmen grow rich, they shut themselves up at home and fence off their approaches, with the result that the poor are entirely excluded and cannot even enjoy those ludicrous privileges which the Republican Government has given them.

On the way back I crossed the valley near the mill that stands by the river, at the place where you cross by the wooden bridge.

I saw the path behind the laundry where we used to go for so many walks.

Bornot reminded me that this was where I kissed the mason's little wife, the one who was so sweet, and who used to come up to the house now and then to pay her respects to my old cousin.

Thursday, 18 October

A beautiful morning. Went into the garden to make a drawing of the tree-masses; the morning sun gives lovely effects from there.

We left for Fécamp at about two o'clock in order to see the famous *Trou au Chien*. To have given this vulgar nickname to one of the most beautiful sights in the district shows what little imagination and feeling for poetry we possess as a nation. We arrived too early and I stayed for a long while on the jetty. The sea was well worth studying.

As soon as the tide was far enough out, we set off on our expedition. It is very hard to describe all I saw, and unfortunately my memory is far too poor to remind me of it with any exactness. We had some difficulty in reaching the pillars at first as the tide was still too high. They appear to be of Roman architecture and support the side of the cliff, leaving an opening underneath; then there are two magnificent, many-tiered amphitheatres, one of them far larger than the other. I think it was here that I saw the deep grotto looking like the cave of Amphitrite. Lastly, the great arch through which you can see yet another amphitheatre with those mushroom-like projections, placed side by side, like the refuges for wild beasts in a Roman circus. We stopped at this point, seeing other interesting objects in the distance which appeared to us less fine, although from near at hand we probably should have thought them well worth admiring. Beneath the great arch the ground seemed to be furrowed by the wheels of chariots, like the ruined streets of some ancient city. The soil is the white limestone of which the cliffs are almost entirely formed, although some places above the rocks are brown, like umber, some are intensely green, and a few are ochrous. The loose stones lying on the ground are generally white, but otherwise very dark. Little springs gushed out under our feet and flowed into the sea.

Came home very quickly. It was after sunset.

Saturday, 20 October

It was after lunch that I learned of the death of poor Chopin. Strangely enough, I had a presentiment of it before I got up this morning. I have now had such premonitions on several occasions.

What a loss he will be! What miserable rascals are left to clutter the earth, yet that fine soul is extinguished!

I took a turn in the garden. Farewell to this lovely place with its truly exquisite charm, a charm which the owners of the manor seem to appreciate very little, for in the midst of all this beauty, my good cousin talks of nothing but repairing broken walls or the quarrels of the municipal council. As a result, I spend the greater part of the time silent and uncomfortable.

Monday, 22 October

In the *Description de Paris et de ses Édifices*, published by Legrand et Landon in 1808, I read this morning the horrifying list of treasures and historic monuments that disappeared from the churches during the Revolution. It might be interesting to write something on this subject with a view to demonstrating the most obvious results of revolutions.

Paris, Wednesday, 24 October

Left at nine o'clock with Bornot, by the old road to Ypreville, in the most perfect weather.

Reached Rouen at one o'clock, and made the whole journey to Paris without travelling companions. Before we reached Rouen, a very pretty girl got in with an elderly man; I enjoyed looking at her for the short time she was in the carriage. I was not feeling too well; I had had no appetite for luncheon and this persisted throughout the day so I ate nothing at all, which made me feel wretched. However, the banks of the Seine with those great rocks that lie alongside the road from Pont-de-l'Arche to beyond Vernon; those smooth, rounded hillocks that are so marked a characteristic of the whole region, etc. Mantes, Meulan, Aperçu, Vaux, etc.

In a miserable mood when I reached home, partly brought on by my sick headache. Had to wait a long time for the luggage. Found Jenny waiting for me. I was not sorry to hand myself over to her care.

Undated

Idled away the next few days. Paid a few calls.

Saw Mme Marliani, who had written to me. She has been spending a month at Nohant, and fell ill while she was there. Mme Sand is depressed and bored. She now has a craze for dominoes and scolds poor Charlotte dreadfully for not appreciating the fine points of this

sublime game. They also get up charades in which she takes part. The costumes keep her busy.

Clésinger, whom I had met in the street, sent his wife to take me to see his statue for the tomb of Chopin. Rather to my surprise I thought it entirely satisfactory; I feel that I should probably have done something of the kind myself. On the other hand, the bust is not a success. I disliked the other busts of men which I saw there. Solange tells me that he is making an attempt to change his style.

1850

Paris, Friday, 25 January

It has occurred to me that artists who have a sufficiently vigorous style are most to be excused from exact imitation, Michelangelo, for example. When they reach a certain point, they more than make up in independence and audacity for what they lose in literal truth.

30 January

I was saying to Pradier that I am in the habit of eating a large meal in the evening because I cannot break off my work for lunch, and that I have to force myself to go for a walk afterwards in order to digest it. He said: 'When you have an old carriage, you don't take it on long journeys, you lay it up and use it only when necessary, and then simply for light work.'

(I remembered this, on February 20th; it has helped me to overcome the worry and upset of making arrangements for my trip to Belgium.)

Came home at two in the morning, very tired. This is the first time I've forgotten the lesson that I have just received.

31 January

Poor Beyle[1] once wrote to me: 'Neglect nothing that can *make you great*'.

Thursday, 7 February

Dined with Ed. Bertin. Delsarte took me up on the subject of religion; he found in me soil that was well prepared, but he really is

[1] Stendhal (Henri Beyle) died in 1842. Delacroix had not taken to him at first but later they became great friends. Stendhal was among the first to appreciate the genius of Delacroix, whom he called 'a pupil of Tintoret' as early as 1824.

a fanatic. He considers Mozart a corrupting influence and much prefers the older masters, including Rameau.

At a concert, the other day, Hecquet told me of a well-known critic who refers to Mozart as the first of the second-rate composers.

At this concert and at the following one, I compared the two Beethoven overtures with the overture to the *Magic Flute*, and to so many others by Mozart; in the latter, what an assemblage of every quality that art and genius can combine to produce perfection! And in the former, what strange, undisciplined inspiration!

Friday, 8 February

When one is beginning to work out the scale of a picture it would be a good idea to settle on some light object in which the tones and value were exactly taken from nature, a handkerchief, for instance, or a piece of material. Ciceri advised me to do this some years ago.

11 February

Chenavard was saying at dinner, that he disliked Raphaël because he found him an impersonal painter, meaning that he completely changed his style when other strong personalities made a deep impression upon him. Michelangelo, Correggio, Rembrandt, etc., are quite the reverse.

13 February

Called on Princess Marcelline about three o'clock; I was much impressed by the Chopin pieces which she played for me. Nothing commonplace, perfect composition. It would be difficult to find anything more finished. He is nearer to Mozart than anyone and, like Mozart, his melodies run so smoothly as to seem almost inevitable.

14 February

I am beginning to feel a violent dislike for people like Schubert, the dreamers like Chateaubriand (this began a long while ago), Lamartine, etc. Why will nothing of theirs endure? Because it is utterly untrue. Does a lover gaze at the moon when he is holding his mistress in his arms? It may be an excellent plan when one begins to grow tired of her! Lovers do not weep together, they make no hymns to infinity, and very few descriptions. The hours of true enchantment pass so swiftly, and they are not spent like that. The sentiments in the *Meditations* are false, as they are also in *Raphaël*, by the same author.

These vague yearnings, this chronic melancholy, describe no real human being; it is the school of sickly sentiment and a very poor advertisement for it. Yet women pretend to be infatuated with all this nonsense. It must surely be out of modesty, for they know perfectly well what to believe about the real issue in love. They praise the writers of odes and invocations, but attract and deliberately seek out healthy men who are responsive to their charms.

Mme P[otocka] called today, with her sister Princess de B[eauvau]. She at once noticed the nudes, the 'Femme Impertinente' and the 'Femme qui se peigne':[1] 'What is it that you artists, all you men, find so attractive in this?' she said. 'What makes it more interesting to you than any other object in its nude or crude state; an apple, for instance?'

Tuesday, 19 February

Went to hear Berlioz. The *Leonora* overture seemed as confused as before and from this I conclude that it is bad: full of brilliant passages no doubt, but without unity. And the same applies to the Berlioz. It's an appalling din, a kind of heroic hotch-potch.

The beautiful is to be found only once in any given period. So much the worse for those geniuses who miss the crucial moment, for in periods of decadence only the most independent have a chance of survival. They cannot lead their public back to the good taste of former times because no one would understand it, but there are lightning flashes in their work which tell us what they would have been in a time of simplicity. During those long centuries when the beautiful is forgotten, mediocrity is even duller than in those periods when the taste for what is simple and true seems as though it were in the air and all the world able to profit by it. At such times, dull artists either set themselves deliberately to exaggerate the lapses of the more gifted, which gives rise to that special form of dullness called turgidity; or else they make old-fashioned imitations of the beauties of the good period—the last word in insipidity. They go back even further, and borrow the naïvety of the artists who preceded the good periods, pretending to despise that perfection which is the natural aim of all the arts.

The arts have their childhood, their manhood and decay. Some powerful geniuses have appeared too early on the scene, others came

[1] Two small nudes: the second is the picture usually known as 'Le Lever' or 'Morning Toilette', painted in 1850.

too late, but among both groups we find outstanding achievements. Primitive talents can no more reach perfection than those which appear in times of decadence. One might name forty musicians of the time of Mozart and Cimarosa who seem to belong to the same family and whose works contain, in varying degrees, all the conditions of perfection. But from that time onwards, not all the genius of men like Rossini and Beethoven could save their work from being *mannered*. Mannerism can make an artist popular with a public that is surfeited and therefore eager for something new; but it is also mannerism that so quickly dates the work of artists who, even though they may be inspired, are themselves made dupes of the false originality which they introduced into their art. At such times, the public will often turn back to masterpieces which they had forgotten and take new pleasure in the inexhaustible charm of beauty.

I really must write down my thoughts on the Gothic style; the above would fall into place quite naturally.

Sunday, 24 February

In the evening to Cimarosa's divine *Secret Marriage* with Mme de Forget. Such perfection is rarely found among the works of man.

What De Piles has done for painters only, might be revised to cover all the fine works that survive in human memory. I have been going into the subject and find, to mention only music, that I have in succession preferred Mozart to Rossini, then to Weber, and now to Beethoven, and always from the point of view of perfection. But when I went to the *Secret Marriage* I found, not a higher state of perfection, but perfection itself. No other musician has this symmetry, this expressiveness and sense of the appropriate, this gaiety and tenderness and, above all, this all-pervading leaven that enhances the other qualities—incomparable elegance; elegance in expressing tender sentiments, elegance in humour, elegance in the gentle pathos that characterizes the opera.

It is difficult to say where Mozart falls short of the idea that I have now formed of Cimarosa. It may be something peculiar to my own nature that gives me this bias—and yet to reason in such a way would be to destroy all standards of good taste and true beauty, it would mean that personal inclinations were the measure of beauty and taste. I have even dared to admit to myself that Voltaire seems to me to have his unpleasant side, very discouraging for one who loves his admirable wit—I mean the abuse that he makes of it. For indeed, this

arbiter of taste, this exquisite critic sometimes descends to making petty effects; he has elegance, but all too often he is merely witty, and this epithet is a devastating criticism. The great authors of the preceding century were simpler, less mannered.

At four o'clock I went to see the exhibition of studies by Rousseau,[1] which I liked immensely. Shown together, these pictures will give some idea of his talent, which the public is far from appreciating and has been, for the twenty years during which he was prevented from exhibiting.

Tuesday, 26 February

I have just discovered something that will scarcely be believed; namely, that Beauvais Cathedral was left unfinished and lacks a nave. The cathedral is a mixture of Gothic and sixteenth-century styles of architecture, but they are seriously discussing whether the missing nave is to be rebuilt in the same style as the rest of the cathedral or in that of the thirteenth century, the style favoured by present-day antiquarians. In this way, they propose to give a lesson in manners to the sixteenth-century illiterates who were so unfortunate as not to have been born three centuries earlier.

Wednesday, 27 February

Worked on the sketch for Saint-Sulpice which I have to submit to the Préfecture.

About three o'clock I went to see Cavé, who was so badly bitten by his dog that he has been in danger of losing his nose and jaw. The *Constitutionel* published a paragraph saying that nothing was saved but his nose, since when his friends have been arriving one after the other to find out what actually was left of the poor man. He has now written to the paper to beg for mercy.

Sunday, 3 March

To the *Union Musicale*: Symphony in F, by Beethoven; most spirited and effective; then Gluck's overture to *Iphigenia in Aulis* with the whole of the introduction, the airs for Agamemnon, and the chorus for the entrance of Clytemnestra.

The overture is a masterpiece: it has elegance, simplicity, tenderness and, above all, strength. But to be quite honest, although these qualities are most striking, one becomes somewhat wearied by its monotony. After Mozart and Rossini it sounds a little too much like plainsong

[1] Théodore Rousseau (1812–67), of Barbizon.

for a nineteenth-century listener. The double-basses with their re-entries pursue one like the trumpets in Berlioz.

They played the overture to the *Magic Flute* immediately after-wards; this is truly a masterpiece. Hearing this piece of music coming after the Gluck I was suddenly struck by the following idea. This is where Mozart discovered the art, and in this overture, we see the step forward which it caused him to take. Mozart is undoubtedly the creator—I will not say of modern art, since none is being produced at the present time—but of art carried to its highest point, beyond which no further perfection is possible.

Monday, 11 March

To Mme Jaubert's in the evening to see the Persian portraits and drawings. I felt moved to quote Voltaire's remarks which run some-thing like this: 'There are vast territories where taste has never penetrated; those eastern countries in which society is non-existent, where women are degraded, etc. In such countries all art is at a standstill'.

In these drawings there is no perspective, no feeling for what is truly painting; that is to say there is a certain illusion of relief and so on, but the figures are immobile, their attitudes clumsy, etc. We also saw a portfolio of drawings by a M. Laurens, who has travelled in these countries.

One thing that struck me particularly was the character of the Persian architecture. In spite of being in the Arab style, it is entirely characteristic of the country. The shapes of the domes and the pointed arches, the detail of the capitals and all the ornamentation is original, whereas, if you travel across Europe today, every piece of architecture from Cadiz to St. Petersburg looks as though it had come out of the same workshop. Our architects have only one idea in their heads, to return to the primitive purity of *Greek art*. I am not speaking of the craziest among them, the ones who attempt the same thing in the Gothic style. Every thirty years or so, some purists make the dis-covery that their immediate predecessors failed in their appreciation of this exquisite imitation of the antique. For instance, Percier and Fontaine in their day thought that they had fixed the style forever. We can see the relics of it in some of the clocks made about forty years ago, and appraise it for what it really is, arid, mean, and wholly lacking in the qualities of the antique.

Modern architects have found the recipe for these qualities in the monuments of Greece. They seem to believe that they are the first

people who ever looked at them and, as a result, the Parthenon is made responsible for all their follies. When I was in Bordeaux five years ago, I found Parthenons in all directions; barracks, churches, fountains, everything was derived from it. And painters pay the same homage to the sculptures of Phidias. It is no use even speaking to them of Roman antique art, or of Greek art before or after Phidias.

16 March

Mme Cavé has been reading me some chapters of her book on drawing. Its originality and simplicity are delightful. I was very glad to see her again and enjoyed our talk.

Friday, 22 March

In one of Voltaire's letters, where he refers to Diderot's *Père de Famille*, he complains that everything vanishes, everything degenerates; he is comparing his century with that of Louis XIV. Voltaire is right. The different styles in the arts are becoming confused with one another, miniature and genre painting are replacing clear-cut styles and are being preferred to simplicity and broad effects. I would add, that here Voltaire is already complaining of bad taste, yet he lived on the verge of the great century and was in many ways worthy of belonging to it. Since then, the taste for simplicity (which is nothing other than beauty) has disappeared. How can modern philosophers, who have written so much that is fine on the gradual development of mankind, reconcile in their theories this decadence in the arts with the progress of our political institutions? Without going into the question of whether this progress is really as beneficial as we imagine, it cannot be denied that human dignity has been enhanced, at least by statute. But is this the first time in history that men have perceived that they are something more than animals, and have therefore refused to allow themselves to be ruled? This so-called modern progress in our political system is therefore nothing but a stage in evolution, a chance happening at this particular moment in time, and we are just as liable to embrace despotism tomorrow with all the fury that we have employed in breaking loose from restraints.

Monday, 8 April

This morning I ought to have been at the meeting to adjudicate on the picture restorations, but I had to go back to bed and have been feeling ill all day.

I sent for the doctor, but it turned out to be nothing more than a temporary indisposition, so I only had to consult him about my cold. We talked about the news of the day, and then about his work. The poor man never has a moment's rest. I feel very thankful when I compare our lives. The whole of his time that is not taken up with patients, operations, etc., is given to lectures and examinations and other work at the hospital. He says that he often feels very stale and tired in consequence. It killed Depuytrien at a comparatively early age. This seems to be the inevitable fate of all doctors who put their whole heart into their work.

I ought really to consider this when I begin to pity myself.

Monday, 22 April

M. Meneval's funeral. Isabey, who was sitting next me, said that he disapproved of the use of colour in architecture. You are always coming across tones that make features recede where they ought to project, and vice versa. The shadows cast by the projections should be enough to define the ornamentation. This was said during the service with our eyes on the paintings and architecture of Notre-Dame de Lorette, where everything is misconceived—one might almost say nonsensical. Isabey was also critical of gold backgrounds to paintings, and rightly. They destroy all sense of projection in the figures and put every effect of painting out of tune by becoming the most prominent feature in the picture, thus depriving it of the background that should be intended to set it off as a whole.

Champrosay, Friday, 26 April

Left for Champrosay at half-past eleven. I am enchanted to be back again. The most delicious feeling of all is the perfect freedom I enjoy here. I cannot be hunted down by tiresome people, although they are so persistent that even this has happened once or twice. The garden was beautifully tidy, and everything went off very well.

Saturday, 27 April

I fall asleep every evening in the most disgraceful way, and even during the day-time, occasionally. When one is afraid to read very much, the great danger of life in the country is boredom and the mood of melancholy which nature always inspires.

I am never conscious of it when I am working, but this time, I am resolved to do absolutely nothing and to give myself a complete rest

from the rather exacting work of arranging the composition of my ceiling.

Sunday, 28 April

Went for a long walk in the forest this morning. I took the little lane that runs across the Marquis's land and stopped to look at the inscriptions on the park wall. Every year the weather and the ravages of time obliterate a little more of them, until now they are almost illegible. I cannot help feeling touched every time I pass—and I often go there on purpose—by the complaints and fond affection of that poor lover! He seems so convinced of the eternal nature of his love for his Celestine. Heaven only knows what became of her or of his love, for that matter. But which of us has not known that state of youthful rapture when one never had a moment's peace and rejoiced in the torments?

I walked on as far as the frog-pond and home by the lane along the side of the hill.

Went into Candas's field to help the maid pick dandelions.

Monday, 29 April

This morning, and yesterday evening as well, I went for a stroll in the deserted and overgrown garden of the poor gendarmes. Their neat little rows of cabbages, and the vines and fruit trees, which must have been a consolation to them and some small help in their poverty, have almost disappeared, ruined by passers-by, the wind, and other accidents of various kinds. The wind has blown the shutters to and fro until all the window panes have been broken, and it is fast becoming a refuge for birds and other wild creatures.

Tuesday, 30 April

Went out about nine o'clock. Along the Marquis's lane, and then on as far as the Hermitage, opposite which I found an immense clearing where the trees had been cut down. Each year I feel heartbroken to find that part of the forest has disappeared, and always one of the loveliest parts, where the trees were thickest and most ancient. There used to be a charming little shady path just here.

Branched off to the right as far as the Prieur oak. It was there that I saw a procession of ants moving along the path in a way which I challenge any naturalist to explain. The entire tribe seemed to be moving in formation as if they were emigrating, with a few worker-ants

going along the column in the opposite direction. Where could they have been going? We are all shut up together higgledy-piggledy, animals, men, and plants, in this vast box that they call the universe. We claim to be able to read the stars and to make conjectures about the past and the future, which are both beyond the range of our vision, and yet we understand nothing of the things in front of our eyes. All these living creatures, permanently separate and incomprehensible to one another.

Wednesday, 1 May

On the power of thought and imagination with which man is gifted. Fatal gifts.

It clearly matters very little to nature whether man has a mind or not. The proper man is the savage, he is in tune with nature as she really is. No sooner does man sharpen his wits, enlarge his ideas and his manner of expressing them, and develop his needs, than he finds nature frustrating him at every turn. He has to be continually at war with her, and she on her side does not remain inactive. If man ceases for a moment from his self-imposed task nature reclaims her rights, invading, undermining, destroying or disfiguring all his work. She seems to grow impatient at having to tolerate the masterpieces of his imagination and the work of his hands.

For what do the Parthenon, or St. Peter's in Rome, or so many other miracles of art signify to the march of the seasons, or to the courses of the stars, the rivers and the winds? An earthquake, or the lava from a volcano can destroy them in the twinkling of an eye; the birds nest in their ruins, and the wild beasts drag the bones of their founders from the open graves. But when he gives rein to the savage instincts that lie at the very root of his nature, does not man himself conspire with the elements to destroy works of beauty? And like the Fury that lies in wait for Sisyphus as he rolls his stone up the mountain, does not barbarism return periodically to overthrow and destroy, to bring the night after too bright a day? And this—whatever it may be—that has given to man an intelligence greater than the beasts, does it not seem to delight in punishing him for possessing it?

What then is the use of so much genius, such great exertions? Does living in tune with nature mean existing in squalor? Must we swim the rivers for want of boats and bridges, live on acorns in the woods, or hunt the deer and buffalo with bows and arrows in order to preserve a stunted existence far less useful than that of an oak tree, which does at least provide shelter and food for other living creatures? Is

this what Rousseau meant when he outlawed the arts and sciences on the ground that they were corrupt? Is everything that derives from man's intelligence a snare, a disaster, or a sign of corruption? But if this is so, why does not Rousseau blame the savage for painting and ornamenting his rude bow, or decorating with feathers the apron with which he hides his nakedness? And why should he seek to hide it from his fellow men? Is not this also too elevated a sentiment for such a brute to feel, mere machine that he is for living, sleeping and digesting?

Tuesday, 7 May

Why not keep a small note-book for isolated ideas that come to me complete in themselves, and are therefore difficult to link up with others? Is it absolutely necessary for a book to follow all the rules? After all Montaigne wrote by fits and starts—such works are often the most interesting. For besides all the effort needed by the author to follow and develop the thread of his idea, there is also the reader's labour to be considered. He is apt to open a book for his recreation and to find himself gradually committed, almost in honour bound to puzzle out, understand, and remember much that he would infinitely prefer to forget, in order that at the end of his task he may profitably have followed all the paths along which his author has been pleased to lead him.

Wednesday, 8 May

Worked all morning without much enthusiasm; I was not feeling well and ate nothing until dinner-time.

About three o'clock I decided to force myself to go to Froment. I greatly enjoyed the walk although I saw nothing of the park, except the part which lies between the gate to the high road and the green-house. However, on my way I passed two or three magnolias, a few of them still in flower. I had no idea what a show they made; the really astonishing profusion of enormous flowers with the leaves only just beginning to show, the delicious scent, the ground strewn with fallen petals; it brought me to a standstill, delighted. In front of the greenhouse there were red rhododendrons and a huge camellia.

Came home through Ris, and stopped on the way to buy some tarts. It was looking exquisite from the bridge as I came up the hill, the spring foliage, and the effects of the cloud shadows passing over it all. When I got home I did a kind of *pastel* drawing of the *effect of sunlight*, with an eye to my ceiling.

Saturday, 11 May

I've decided to put off indefinitely my plan for leaving today.

I feel as happy as a child at the beginning of the holidays now that I have made this sudden decision to stay on here. How weak men are, how easily they change their feelings and resolutions! Last night I was in a mood of blackest melancholy. As I came home in the evening I did nothing but imagine disasters of every kind, yet this morning, the sight of the fields and the sun, and the thought of putting off for a little longer the frightful racket of Paris, has sent my spirits sky-high. Happy or unhappy, I'm always at one extreme or the other!

Monday, 13 May

Spent the day alone, but I have not been bored. Jenny and the maid went to Paris this morning and only got back at six o'clock.

I was just getting my dinner when they arrived, wet through with this frightful rain that has hardly ceased all day.

I have enjoyed the complete solitude and quiet of today.

14 May

It was on this day, or on the following one, that I went to see Mme Quantinet. I stayed chatting with her for a long time. She played a little for me and sang the air from *Zarastro*.

'The outcome of independence is solitude.' She quoted this extract from Benjamin Constant's *Adolphe*. Alas, the only alternative is the choice between being teased and harassed throughout the whole of one's life, like a man bound up with family ties, or being deserted by everybody and everything because one has been unwilling to submit to the least constraint; the alternative, I repeat, is inevitable. Some men have their lives made a burden to them by the domination of a shrew, or suffer the whims of the coquette with whom they've joined their fate. At the end of their lives they do not even have the consolation of knowing that this fellow creature will be there to close their eyes or to bring them their gruel—this woman, who might at least have served to comfort them in their last moments. Women always leave you or die at the very time when they could be a help by preventing your feeling lonely. If you have had any children, they will have caused you endless worry during their childhood and adolescence, and will have deserted you long since. You therefore almost inevitably fall into a state of terrible solitude, in which the remainder of your life and sufferings draws to a close.

Friday, 17 May

A long walk in the forest on the Draveil side; then took the avenue that runs the whole way round.

That was where I saw the fight between the spider and a strange sort of fly. I saw them both coming towards me; the fly, on its back, fighting desperately and striking furious blows, until after a short struggle the spider died under its attacks. When the fly had sucked the body, it proceeded to drag it off with incredible speed and fury, pulling it backwards over blades of grass and other obstacles. I watched this miniature Homeric duel with a good deal of excitement, feeling like Jupiter watching the fight between Hector and Achilles. And moreover, there was a kind of retributive justice in witnessing this victory of a fly over a spider. One has seen the opposite happen so often. The fly was black, and very long, with red marks on its body.

Saturday, 18 May

I took my dear Jenny for a stroll in the forest, about one o'clock. I was truly delighted to see her expansive pleasure in the charming scene that was looking so green and fresh. I made her take a long rest and she walked home without difficulty. We went as far as the Antin oak. As we crossed Lamouroux's enclosure, she said sadly, 'Must I always see you badly off, living in a way not worthy of your position? Am I never going to see you with a place of your own, somewhere like this, where you could settle down and make improvements?' She is perfectly right. In this way I am like Diderot, who believed that he was destined to spend his whole life in a hovel and thought he must be at death's door when he found himself established, by Catherine's generosity, in a fine apartment with magnificent furniture. But the fact of the matter is that I like living in a modest sort of way. I loathe and detest show and ostentation; things do not appeal to me when they are new; I like old houses and old furniture; I like the place where I live and the things that I use to speak to me of all they have been and seen, and of the people and events that they have known.

Thursday, 23 May

About five o'clock, I went for a walk as far as the avenue that leads to the hermitage. The weather was delightful, although rather warm. I found myself revelling in that delicious time of evening, which does not seem to make me feel so sad as it used to do. I've found an

adorable little path leading off the Great Avenue into some delight-fully hidden places. I couldn't help thinking of the lady with the variegated dressing-gown.

There was wonderful moonlight this evening in my little garden. Walked about until very late. I felt as though I could never sufficiently enjoy the gentle light on the willows, the sound of the little fountain, and the delicious scent of the plants which seem to give out all their hidden treasures at such times.

Paris, Saturday, 8 June

It is now more than a fortnight and I've written nothing! I returned from Champrosay exactly fifteen days ago. Jenny has gone back today to find the Mayor's spectacles and return them to him.

As I considered the composition for the ceiling (I only began to like it yesterday, after I had made the alterations to the sky with pastel), it struck me that a good picture is like a good dish. It is made of exactly the same ingredients as a bad one—the artist does everything! How many magnificent compositions would be worthless without a pinch of salt from the hand of the great cook! In Rubens, the power of this, *whatever it may be*, is astounding; it is incredible what his temperament, his *vis poetica* can add to a composition without seeming to change it. Yet it is only a turn of his style, it is the way he does it that matters, what he works on is comparatively unimportant.

The *new* is very old; you might even say that it is the oldest thing of all.

For the priming on the wall of the church: linseed oil and no other, boiling; white lead, not zinc white, which won't stick. Yellow ochre would be most suitable.

Friday, 14 June

An architect who truly fulfils every condition of his art seems to me to be a phoenix far rarer than a great painter, a great poet, or a great musician. And the reason is perfectly clear, it lies in the abso-lutely essential harmony between common sense and great inspiration. The practical details that form the starting-point for an architect, details which are the very root of his work, must take precedence over ornamentation, yet he is no artist unless he can supply an orna-mentation suitable to the *practical* ideal that is his theme. I use the word *suitable*, because even when he has established in every possible way the exact relationship of his plan to the purposes for which the

building is intended, he can only ornament it in a certain manner. He is not free to be lavish or restrained in the use of ornamentation, for this must be as appropriate to the plan as the plan is to the practical purpose of the building. The sacrifices which painters and poets make for the sake of elegance, charm, and effect upon the imagination, excuse them for occasional faults in exact logic. The only liberties an architect can allow himself may perhaps be likened to those which a great writer takes when he invents, as it were, his own language; when, for example, he takes expressions in everyday use and by giving them a special twist changes them into something new. In the same way an architect, by a calculated yet inspired use of a form of ornamentation that is the common property of every other architect, can give it astonishing freshness and realize the type of the beautiful which rightly belongs to his art. When an architect of genius copies some great building of antiquity he knows how to modify it so as to make it original; his rendering will make it right for its new position, and he will observe in the distances and proportions such order as will make it seem entirely new. Ordinary architects are able only to make literal copies, with the result that they add to this humiliating evidence of their own lack of ability, a failure even to imitate successfully. For although they may copy their model exactly down to the smallest detail, it can never be under precisely the same conditions as the one they have imitated. They are not only incapable of inventing a beautiful thing, but they also spoil for us the fine original, which we are astonished to find appearing flat and insignificant because of their treatment.

Architects who do not set out to make complete and meticulously exact imitations work, as it were, at random. The rules teach that certain parts should be ornamented and they therefore ornament them regardless of the character of the building or of its surroundings.

Brussels,[1] *Saturday, 6 July*

At eight o'clock, left for Brussels with Jenny; by a quarter to five we had arrived. This really makes one feel tempted to travel.

[1] Delacroix had made one previous journey to Belgium in September 1838, before beginning his great decorations at the Palais Bourbon. He was then accompanied by the charming Elisa Boulanger—later Mme Cavé—who had a passing caprice for the artist and carried him off on a dashing visit to see the works of Rubens, but left him suddenly at The Hague. Later Delacroix wrote an article on her book, *Le Dessin sans Maître*.

Brussels, Sunday, 7 July

In the morning, to Saint-Gudule.

Magnificent stained-glass windows. I have put down in my note-book the ideas they suggested. [This note-book is missing.]

In the Chapel of the Virgin the seventeenth-century windows are in the style of a chastened Rubens. Execution very fine. An attempt has been made to use colour as in a painting, but although this has been most skilfully handled, it is an argument in favour of the stained glass of the previous century. A bias, and some formula for sim-plifying is absolutely necessary.

I heard some very good music while I was looking at the windows in the Chapel of the Virgin and among other things, children's voices singing Chopin's favourite psalm, 'Judah the Conqueror', with organ accompaniment, etc. For a moment I stood entranced. This could be used as an argument against excessive modernization of the Gregorian chant or, more especially, against the anathema so stupidly pronounced on the attempts of modern composers to appeal to the imagination in church.

To the Museum today, but so late that I was not able to stay as long as I should have liked. The Rubens are magnificent; the 'Road to Calvary', the 'Christ the Avenger', all of them indeed, in their different degrees, impressed me more than the pictures I afterwards saw in Antwerp. I think that this may have been partly due to their being shown in the same gallery and hung close together.

Went to a small theatre in the evening: *L'Homme gris. Le Sous-préfet s'amuse*. I laughed a great deal.

Antwerp, Monday, 8 July

Left for Antwerp at eight o'clock.

The pictures in the Museum are very badly hung. The old arrange-ment made a far better effect. The Rubens pictures lose greatly by being dispersed. However, I never did feel that they had the kind of superiority that kills everything else. I preferred the '[Last Communion of] Saint Francis' this time, a picture I used not to care for so much, and I also greatly enjoyed the 'Christ on the knees of the Eternal Father',[1] which must be of the same period. I see by the catalogue that Rubens painted the 'St. Francis' when he was forty or forty-two years old.

[1] Actually, 'Lamentations over the body of Christ' dated 1614. It is not the Eternal Father, but St. John who is supporting the Body.

Before leaving, I looked at the 'Scourging of Christ', from the church of Saint Paul—a masterpiece of genius if ever there was one. It is slightly marred by the big executioner on the left. It really requires an incredible degree of sublimity for this ridiculous figure not to ruin the whole picture. On the other hand, there is one figure, a negro or mulatto standing on the left among the executioners and scarcely visible, that is worthy of the rest of the work. The blood-streaked back, the head, so wonderfully expressive of the fever of suffering, the one arm that can be seen, are all indescribably beautiful.

Brussels, Tuesday, 9 July 1850

I had planned to leave, but have given myself another day. Spent a long while in the Museum where it was horribly cold in spite of its being July.

The 'Calvary' and the 'Saint Liéven' are the very summit of Rubens's mastery.

I think the 'Adoration of the Magi' superior to the one in Antwerp, but there is a certain dryness about it when you compare it with the other two. You can detect no *sacrifices* whatsoever, whereas it is the art of *calculated lapses* that raises my two favourites, the pictures I have just been speaking of, to such a pitch of excellence—the feet and the hand of Christ are barely hinted at. To these must be added the 'Christ the Avenger'. In passion and verve the brush can go no further. The 'Assumption', a little dry: the 'Glory' seems to me unsuccessful, I cannot help thinking that there have been accidents. There is a lovely 'Virgin Crowned', on the right, as you go in. Strong effect, but not nearly as much freedom as in the finest works. The clouds are carried almost to the point of blackness. This fiend of a man allows himself every liberty. His determination to make the flesh brilliant at any cost forces him to overstate the contrasts.

Also went on Tuesday, at about two o'clock, to see the Duke of Arenburg's pictures; a fine Rembrandt, 'Tobias healing his Father'. Also a sketch by Rubens, drawn very coarsely with the brush, and one or two figures in colour, an allegory after the manner of the one in Van Thulden's book.

Even when he is painting on a background that has been rubbed in with a kind of grisaille, he often indicates the light passages with white. He usually begins with a local colour of middle tone, using very little impasto. It is on top of this middle tone, at least so I believe, that he places the lights and the dark passages. I particularly noticed this local half-tint when I was looking at the 'Calvary'. The flesh tints of

the two thieves are very different, without apparent effort. It is plain that he rounds or models the figures in this local tone with light and shade before putting in the strong accents. I think that his slighter pictures, like this one and the 'St. Benedict', which is rather similar, must have been done in this way. In his drier manner each part was treated more or less separately. Must try to remember the hands of the St. Veronica; the linen entirely grey; the hands of the Virgin beside her, sublimely negligent. The two thieves are sublime in every respect. The pallor, and the terrified expression of the old rascal in the foreground.

In the 'St. Francis[1] hiding the World with his Robe', extraordinary simplicity of execution. The grey of the lay-in is visible throughout the whole picture. A very light local tone for the flesh, and a few touches of slightly heavier impasto in the light passages.

I must often think of my study of the 'Woman in Bed', the one I began about a month ago; the modelling was already established in the local tone, without accents of light and shade. I made this discovery for myself a long while ago when I was doing a study of a reclining nude, using Caroline as model. My instinct used to guide me in those early days.

Wednesday, 10 July

Left Brussels. Delightful country between Liége and Verviers. Passed Aix-la-Chapelle without being able to go into the town. How long it is since I came here with my dear mother, my sister, and poor Charles! We were both children then. For quite a long time I was able to see the Louisberg where we used to go to fly our kites with Leroux, my mother's cook. Where are they all now?

A short time before, we had changed into Prussian carriages, which are much narrower and less comfortable than the Belgian ones. A very dull road as far as Cologne. We arrived in a steady downpour. Stayed in the Hôtel de Hollande, overlooking the Rhine, with a fine view so far as I could judge through the mist and rain. Felt depressed by the strange jargon and the sight of foreign uniforms. The Rhine wine at dinner made me feel more reconciled to my situation, but unhappily I had the worst bed in the world, even though this is supposed to be one of the best hotels.

Thursday, 11 July

Left by boat at half-past five in the morning in pouring rain.

[1] In the 'Intercession of the Virgin and St. Francis to avert the divine anger'.

Fearful bother over getting on board; the luggage, etc. The evening before, when we arrived in Cologne, we had an endless wait at the customs.

The journey was rather pleasant on the whole. After Bonn, on both banks of the river, and especially on the right, we had fine views of the mountains which are a little spoilt by cultivation. As we passed by, we noticed the famous 'Seven Mountains' of the German legends.

Arrived in Coblenz about one o'clock and went on to Ems, where the difficulties of finding somewhere to stay kept me busy until five or six o'clock. In the end, I found temporary lodging for Jenny and myself in a sort of attic, for tonight and tomorrow. This is only for the time being, but it is quite tolerably comfortable. The next day (today, that is), after seeing the doctor, whom I rather liked and who will persist in calling me M. Sainte-Croix, I developed a slight headache which grew worse as the day went on. Managed to cure myself by starvation.

Ems, Saturday, 13 July

Drank my first glass of water.

In the afternoon I went for a short walk over the bridge and up the hill and looked at the cemetery and the church. It is quite charming, and yet life here seems very insipid. Is all this not intended to give one a certain amount of pleasure, or am I becoming less susceptible than I used to be? I don't know how I shall manage to fill in the time. I've brought no engravings with me and no books, except l'Homme de Cour and the extracts from Voltaire... Perhaps I shall be able to find a library.

Sunday, 14

Today, Sunday, I can say that I am once more master of my soul, hence this is the first day on which I've been able to take an interest in my surroundings. It really is a charming place. I went for a walk on the other side of the river this afternoon in a very good humour. When I got there, I sat upon a bench and began to jot down in my note-book the kind of reflections that I am writing here. I have been saying to myself, and I cannot say it too often for my happiness and peace of mind (they are one and the same) that I must and can live only through the mind; the food it needs is more necessary to my life than bodily food.

Why was it that I lived so fully on that particular day? (*I am writing two days later.*) Because I had a great many ideas that are miles away from me now. The secret of having no worries—at least where I am concerned—is to have plenty of ideas. Therefore I cannot afford to let slip any means of encouraging them. Good books have this effect, and especially certain books. Health is the first consideration, but even when one is feeling dull and tired these particular books can renew the source from which my imagination flows.

A delightful walk. To live materialistically is not to live. For the three or four days since I arrived here I have been busy trying to find somewhere to live, chasing after the doctor, and getting glasses of water from the spring. I have been nothing but a machine, I have not been living—not in possession of my intellect. This is an exceedingly beautiful place and yet it makes no appeal to me. I go for walks that should give me intense enjoyment and they are nothing but empty spaces in which I wander aimlessly about. What a disgrace to my immortal soul! My whole life is spent in quarrelling with my landlord in order to get a bed fit to sleep in, or in exasperation with the Germans for being guilty of the crime of not being French, that is to say of not understanding the language of a man who has dropped among them from out of the clouds, and who cannot make out a word of their jargon. The majority of human beings live lives of this kind, but as most are ignorant of the life of the mind they feel no deprivation in the limbo where they vegetate, more akin to the animals than to men.

Thursday, 18 July

'In painting, and especially in portraiture,' says Mme Cavé in her treatise, 'mind speaks to mind, and not knowledge to knowledge.' This observation, which may be more profound than she knows herself, is an indictment of pedantry in execution. I have said to myself over and over again that painting, i.e. the material process which we call painting, is no more than the pretext, the bridge between the mind of the artist and that of the beholder. Cold accuracy is not art. Skilful invention, when it is *pleasing* or *expressive*, is art itself. The so-called conscientiousness of the great majority of painters is nothing but perfection in the art of *boring*. If it were possible, these fellows would labour with equal care over the backs of their pictures. It might be interesting to write a treatise on all the falsities that can be added together to make a truth.

Sunday, 21 July

Today I began to work seriously at the article on Mme Cavé's book.

I decided to drink the water before dinner and it suits me much better. After my last glass, about five o'clock, I went back to those charming meadows beside the Lahn, crossed the bridge and took the path to the left. I was full of ideas inspired by the work I had been doing. It all seemed so easy. I think I could have done the whole article in one breath if I'd had the strength to write for long enough.

I am writing this on the following day, that is on Monday, and my splendid fire is damped. One ought to be able to summon up inspiration at will as Lord Byron did. Perhaps I am wrong to envy him in this, since I have the same faculty in painting, but whether it is that literature is not my element, or that I have not yet managed to make it so, I do not become so quickly inspired when I see the paper covered with little black marks as when I look at one of my pictures—or just my palette. The very sight of my palette, freshly set out with the colours in their contrasts is enough to fire my enthusiasm. But I am certain that if I were to write more often I should develop the same facility with the pen. All that I need is a little perseverance. Once the machine gets going I find it just as easy to write as to paint and oddly enough I don't need to go over what I have done as often. If it were merely a question of tacking one thought on to another I should be armed much sooner and ready for battle but there is the sequence to be considered, the plan of the work to be observed, and the worry of not getting mixed up in the middle of one's sentences. This is where the great difficulty lies, and it is this that checks the free flow of one's ideas. Your picture you can see at a single glance but in a manuscript you do not see the whole page, that is to say your mind cannot take it in as a whole. It takes uncommon strength of mind to embrace the work as a whole and to carry it, with suitable extravagance or moderation, through developments that follow one after the other. Lord Byron said that when he wrote he never knew what was going to come next and that he did not much bother about it. But his poetry is usually in the style that I should call *exclamatory*, nearer to the form of the ode than to the narrative poem, and he was therefore able to give free rein to his fancy.

The historian's task appears to me to be the most difficult of all because he needs to give unceasing attention to a hundred and one things at the same time, and must preserve through quotations, precise recitals of events, and facts that are only relatively important, the

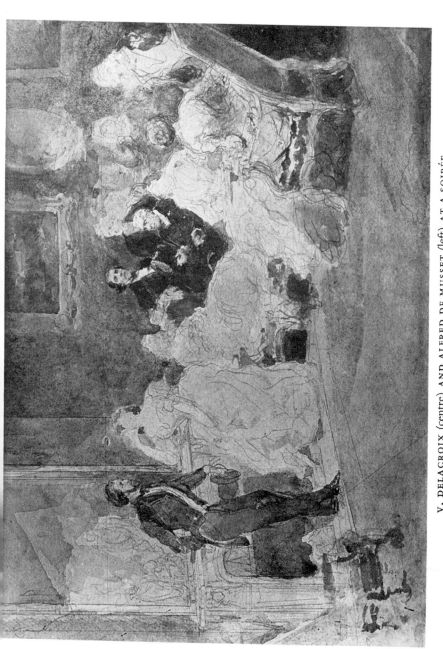

V. DELACROIX (centre) AND ALFRED DE MUSSET (left) AT A SOIRÉE

Water-colour by Lami

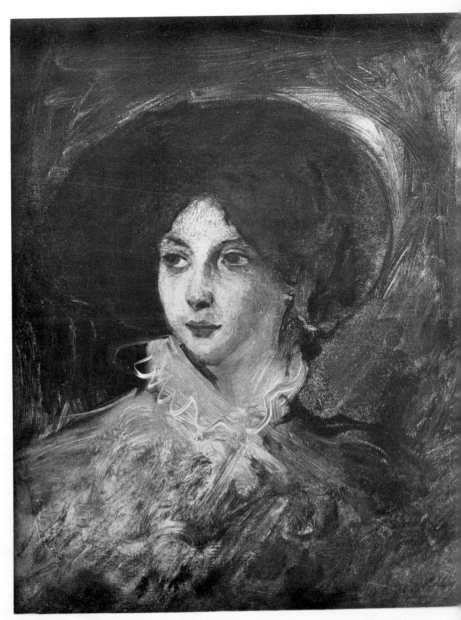

VI. DELACROIX: PORTRAIT OF MME DALTON, A FRENCH DANCER

enthusiasm that gives life to his story and makes it something more than an extract from the newspapers.

Experience is absolutely necessary in order to learn all that may be done with one's own instrument of expression, and more especially to avoid what should not even be attempted. When a man is immature he plunges into all kinds of senseless experiments, and by attempting to force his art to yield more than it either can or should concede, he fails to reach even a small degree of superiority within the bounds of what is possible. We must not forget that language (and here I'm speaking of language in every art) is an imperfect instrument. Great writers supplement its deficiency by the characteristic turn which they give to their phrases. Experience alone can give even to the most talented artist the confidence that he has done everything that could possibly be done. Only fools and weaklings torture themselves by trying to achieve the impossible.

And yet we need to be very bold. Without daring, without extreme daring even, there is no beauty. Jenny remarked when I was reading the passage from Lord Byron in which he praises gin as his Hippocrene, that this was because it made him bold. I think that what she says is true, however humiliating it may be for the great number of fine minds who discover in the bottle the *adjuventum* of talent that helps them to scale the rugged heights of art. We must therefore be almost *beyond ourselves*, if we are to achieve all that we are capable of! Happy are they who, like Voltaire and other great men, can reach a state of inspiration on fresh water and a plain diet!

Sunday, 4 August

Left Ems at about seven o'clock. A delightful road; the little carriage allowed us to admire the scenery as we drove along. The banks of the Lahn are charming. The castle at Lahneck, a ruin overhanging a precipice. We lunched at Coblenz.

Reached Mainz in a bad temper. Dined very well at the Hôtel du Rhin and had a good night in beds that for the first time were passably comfortable. I got up in the night to admire the moonlight on the Rhine, a truly wonderful sight; the stars, the crescent moon, etc.

Cologne, Monday, 5 August

A morning as lovely as the night before; the sun was full in our faces and quite dazzling. We left at half-past seven. Did the journey very quickly and passed by everything I'd seen the day before,

but in a different light. Arrived early in Coblenz. After Coblenz I rested in the cabin, to recover from yesterday's journey and to avoid the heat.

Reached Cologne before four o'clock. Found it decked out for a holiday with every imaginable German flag. They were firing cannon on the Rhine, etc. Hôtel du Rhin; not as comfortable as Mainz. Went out sight-seeing at about five o'clock; the town reminds me very much of Aix-la-Chapelle. Very lively and interesting. Wandered about the streets in terrific heat.

Tried to find my 'St. Peter'. After many vain inquiries, I was helped out of my difficulty by a colleague, a house-painter who, brush in hand, and as it were doffing his cap at the sound of Rubens's name (which everybody knows in this place, down to the very children and shopkeepers), put me on my way as best he could. A rather mean-looking church with a cloister in front, full of small stations of the Cross, a Calvary, etc. The people seem exceedingly devout. After paying my fifteen *silbergroschen*, or one florin, or two francs, I was allowed to see the famous 'St. Peter', which has an unspeakably bad copy on the back. The Saint himself is magnificent; the other figures look to me as though they'd merely been put in to accompany him, and were probably composed and imagined as an afterthought; they could hardly be more feeble but, even so, they are full of vitality. In a word, I saw all I wanted to see in one visit. Yet I still remember with admiration the legs and torso and the head, they are as fine as they possibly could be, but the composition does not grip one.

Very tired as I came back through the streets, but recovered my good humour by dinner-time.

Tuesday, 6 August

At Cologne. I had intended to go on to Brussels or Malines during the day but was forced to put it off until ten o'clock on account of the time-table.

Took the guide to see the Cathedral. They'll never finish this unfortunate edifice, which seems doomed to be cluttered up for ever with scaffolding and workmen's huts. When they felt they must add the missing spires to Saint-Ouen, in Rouen, they managed to get on perfectly well without all this paraphernalia, but Cologne Cathedral is in a peculiarly unfinished state; the nave is not even roofed over. That is what they ought to finish; the great door would entail a

colossal amount of work, and the one or two poor devils whom you see and hear chipping away in this great barracks of a place would not get through a tenth part of it in a hundred years, even supposing they were paid for their labours.

What has been done is magnificent. You have an impression of grandeur that reminded me of the cathedral in Seville. The choir and transepts have been finished for a long time. They have been amusing themselves with gilding the capitals in the choir and painting them red. The little pendentives are filled with figures of angels in would-be Raphaëlesque style; they make a very poor showing.

The more I see of these attempts to restore Gothic churches, and especially to paint them, the more convinced I become that the less they are painted the more beautiful they are. It's no use people telling me that they were painted originally. I can see they were since traces of colour remain, but I still think that we ought to leave them in the condition to which time has brought them; their bareness is sufficient ornament. The architecture can be seen to full effect, whereas all the attempts that we make, we men of another age, to illuminate these beautiful structures, merely cover them with a travesty of the original and make everything look pretentious, false, and odious. The windows which the King of Bavaria has given to Cologne are another wretched example of the work of our modern schools; they are full of the kind of talent possessed by men like Ingres and Flandrin. The more this sort of thing is intended to resemble Gothic, the more it turns to tawdriness and to the trivial, neo-christian painting of the modern experts. What lunacy, and what a terrible pity it is that this present craze, which might be practised harmlessly enough in our small exhibition halls, should be used to degrade beautiful works of art like these churches!

As I was leaving I looked at the Jesuit church. Here you have the exact opposite of what we are doing today. Instead of amusing themselves by imitating the constructions of another age they did the best they could, blending Gothic with Renaissance (and every other style for that matter) and from this mixture artists who were really artists were able to create a delightful unity. In such churches one is dazzled by the wealth of treasures, the marble statues, and the tombs that cover the walls and lie beneath one's feet.

Arrived in Malines about six o'clock. A good little hotel, the Saint-Jacques, and a good supper that quite set me up again. Great men, when they write their memoirs, never say enough about the influence of a good dinner upon their state of mind. I'm very much down to

earth in this respect—always provided that my digestion does not wreck the favourable effect which Ceres or Bacchus has produced. But even so, would it not be true to say that all the time one is dining and perhaps for some time afterwards, one's brain sees things in a different light? This is a grave question, and humiliating for the people who believe, or would like to believe, that they are something more than mere men. This inspiration born of the bottle takes us further than we could go without its help. We might just as well resign ourselves to it, for not only is it a fact but a very agreeable one into the bargain.

Malines, 7 August

There is a Vandyke in the Cathedral, a 'Christ between the two Thieves', which I thought extremely feeble. It is a very large picture. The blackish-brown tone of the shadows makes it very gloomy.

In the church of Sainte-Marie, Rubens's 'Miraculous Draught of Fishes', with the side pieces including the shutters: on one side, St. Peter standing full face, the keys above him; on the other, St. Andrew clothed in dark colours and already scarcely visible on account of mildew—like the 'Draught of Fishes' itself, which is beginning to lose its colour. Of all painters, Rubens has most to lose by such discolouration. His invariable custom of rendering the flesh tones lighter than the rest makes his figures seem like ghosts when the backgrounds have darkened. He is obliged to paint these on the dark side in order to bring out the flesh tones.

Malines, Thursday, 8 August

It was raining when I arrived. I am staying with the good lady who keeps the Auberge des Trois Rois, a shabby little inn for commercial travellers.

I began by going to see the picture;[1] I noticed at once that, however much they may pretend that it has suffered very little, the smooth, yellow look is due to restoration. Beneath it, on the altar, there are some sketches by Rubens representing St. Roch.

Left again at three o'clock, in the company of three remarkably cheerful priests. They seem quite at home in this country and look happy and self-assured, as we never see men of their cloth look in France.

[1] The picture was 'Saint Roch', patron of the plague-stricken.

Malines, Friday, 9 August

In the morning went the round of the churches again. The 'Draught of Fishes' seemed to me far more beautiful than when I first saw it, and the 'St. Peter' and 'St. Andrew' on the shutters are admirable.

Went by the ramparts, in the loveliest weather imaginable, to the Church of St. Peter and St. Paul, an exceedingly fine church in the style of Louis XIV, very rich—the richest in the town. Rows of pictures representing miracles performed by the Jesuits and other religious bodies, not particularly interesting, but quite effective against the walls and among the architecture. Painters busy repainting the pillars. They never cease repainting in this part of the world.

Went back to Saint-Rombaut to have another look at the Vandyke; I liked it rather better than before.

Came back tired. I have been trying to do too much, so as to leave time for some drawings. Rested for about an hour and then went with Jenny to the church of Saint-Jean where I drew for two or three hours. Bought some copper pots.

Went out again in the evening by the city gate, which stands at the end of our road. I made the discovery this morning; it looked most picturesque in the evening light.

Antwerp, Saturday, 10 August

Saturday morning, left for Antwerp. Felt slack and was in two minds about going, but as will be seen I had every reason to congratulate myself on my strength of mind.

Started at seven o'clock. Lunched at the Grand Laboureur. English tourists everywhere!

Cathedral: the picture over the altar. Other churches.

Then to the Museum. Made a sketch of one of the Cranachs. Admired the 'Souls in Purgatory', it is in Rubens's best manner. I could hardly bear to drag myself away from the picture of the 'Trinity', the 'Saint Francis', the 'Holy Family', etc. And then a young man who was making a copy of the great 'Christ on the Cross'[1] lent me his ladder and I was able to see the picture in different light. It is of his finest period; the half-tint in the underpainting is evidently used to give the modelling, and the bold touches of light and shade are laid into quite thick impasto, especially in the lights. How strange that I never noticed until now the extent to which Rubens proceeds by means of half-tone, especially in his finest works! His sketches

[1] This is the picture known as the 'Coup de lance' painted in 1620.

ought to have put me on the track. In contrast to what they say about Titian, he first lays in the tone of his figures which appear dark against the light tone. It also explains how, when he afterwards comes to put in the background, and in his urgent need to obtain his effect, he deliberately sets out to render the flesh tones exaggeratedly brilliant by making the background dark. The head of the Christ and that of the soldier descending the ladder, the legs of the Christ and of the crucified thief are very strongly coloured in the preparation, and the lights are placed only in small areas. The Magdalen is remarkable for the following quality: you can see quite plainly that the eyes, the eyelashes, the eyebrows, and the corners of the mouth are drawn on top of the underpainting, and while the paint was still wet, I think, contrary to Paolo Veronese's usual practice.

I must also remember the 'Souls in Purgatory'. The round modelling in the half-tone is obvious in the figures in the lower part of the picture, also the brush-strokes with which he has later drawn the features. The sketch must have been very good to have allowed him to proceed with the picture itself by this method, and with such perfect assurance. Always use the sketch to feel your way, and go ahead confidently when it comes to executing the picture.

In the evening, after dinner, started out in brilliant sunshine to pay my call on Braekeleer.[1] As I went up the road, I saw two magnificent Flemish horses, a chestnut and a black.

At last I have seen the famous 'Raising of the Cross':[2] I was most deeply moved! In many ways it is akin to Géricault's 'Raft'. The artist is still young and trying to please the pedants. Full of Michelangelo. Extraordinary impasto. Dryness that approaches Mauzaisse[3] in some parts, and yet manages never to be disturbing. The treatment of the hair is very dry in the curly heads, in the old man with the red face and white hair, for instance, who is lifting up the cross on the right-hand side at the bottom of the picture, the dog, etc. This is not prepared in the half-tone. In the panel on the right-hand side you can see passages with heavily loaded underpainting, such as I often use myself, and the glaze laid on over them—especially the arm of the Roman soldier holding the staff, and the crucified thieves. This is even more probable in the left-hand panel although the finish conceals it.

[1] F. de Braekeleer, historical painter, was Keeper of the Antwerp Museum.

[2] The picture was painted in 1610-11, i.e. soon after Rubens had returned from Italy at the age of thirty-three.

[3] J. B. Mauzaisse (1783-1844) was an academic painter of battle-pieces.

The colour has gone from the flesh, where the light passages have become yellow and the shadows black. The folds in the drapery have been studied with an eye to style; the arrangement of the hair has been carefully thought out. More freedom in the central picture, although his touch is still somewhat academic, but wholly free and reverting to his natural style in the panel with the horse, which is superior to everything else. Seeing this picture has raised Géricault in my estimation, for he divined this particular force, and his work is in no way inferior to this. Although in the 'Raising of the Cross' the actual painting may be less masterly, it must be acknowledged that it creates an impression at once more gigantic and more elevating than that of Rubens's later masterpieces. He was infused and permeated with sublime works; it cannot be said that he imitated. There was that side to his genius among many others. How different from the Carracci! When you think of them it is very evident that Rubens was no imitator; he was always Rubens.

All this will be useful for my ceiling.[1] When I began it I had the same feeling. Did I perhaps owe something to other masters besides Rubens? Painters of each generation in turn have been exalted and lifted beyond themselves by the study of Michelangelo.

For the grand style it is essential to have the drawing established in advance. When a picture is built up by the half-tone method the contour comes last, this gives greater reality but also a softer quality, and possibly less character.

Finished the evening with M. Leys,[2] another painter, and a collector. They brought me back to my hotel, the Pays-Bas.

Sunday, 11 August

In Antwerp. Braekeleer called to fetch me about ten o'clock to have another look at the Rubens pictures that are being restored. His ceaseless chatter spoiled my second visit; he was at my elbow the whole time talking of nothing but himself. The impression I had yesterday evening at dusk was the right one.

After I'd been with him to call on the collector, who had invited me to see his pictures the day before, I felt so tired that I went back to my hotel and slept, instead of going back to the Museum where I could have completed the observations I made yesterday. I stayed

[1] The ceiling of the Gallery of Apollo, at the Louvre, recently commissioned.

[2] Henri Leys, a distinguished Belgian painter.

idly indoors listening to the bells, which I always love to hear, and waited for dinner-time.

Made drawings from memory of all the things that had impressed me during my expedition to Antwerp.

Paris, Wednesday, 14 August

Left Brussels at nine o'clock. A rather tiring day. Arrived in Paris about six.

I feel as though I'd been away for three months.

Tuesday, 17 September

Laurens tells me that Ziegler is making a great number of daguerreotypes, including some of nude men. I must ask him to lend them to me.

Monday, 23 September

Preparation for the figures in the picture: begin with a good outline; when Andrieu has laid on the colour and has begun to *model* his figure, give him fresh coaching in this preliminary stage, and try to make him capable of carrying it through without help. This will make my own retouching easier. We shall have to keep the outline in the tracing, and even improve it before it is used, so that we can make a new tracing on top of the underpainting if the drawing should be lost.

We must follow the methods of preparation used by decorators throughout the work, especially for the distant figures, which must be modelled with flat tints as we did in the cartoon: give them shape by means of the shadows, ignoring the lights, so to speak.

Looking at Paolo Veronese's 'Susanna' [in the Louvre], I noticed how simply he handles the light and shade even in the foreground. In a vast composition like the ceiling this is even mor important. In the 'Susanna', the breast seems to be painted in a single tone, and is in full light. The contours too, are very pronounced—another way of obtaining clarity at a distance. I had the same experience with the cartoon after tracing an almost childish contour without accent round the figures.

Sunday, 29 September

Mme Cavé came to read me part of her treatise on water-colour; it is full of delightful things.

Looking at the sketch of Rubens's 'Christ bearing the Cross' (the one I coloured from memory), I said to myself: this is the way to lay in a picture—that is to say in a key which, although rather below its value in light, is sufficiently intense to establish the colour areas in their right relationship—then later, on top of this, let oneself go, putting in lights and accents with all the fancy and verve one can command. It would be a means of preserving the animation until the end when one most needs it, instead of expending it earlier to no purpose, as usually happens and especially with me.

In Vandyke's pictures (I am not speaking of his portraits), you notice that he was not always bold enough to go over this under-painting where the half-tone becomes rather too dominating, with vigour and inspiration. The two conceptions that Mme Cavé was describing to me, that of colour as *colour* and of light as *light*, must be reconciled in one operation. If you allow the light and the breadth of plane to dominate unduly it leads to an absence of half-tints, and consequently to loss of colour; to err in the other direction is espec-ially damaging in large compositions, such as ceilings, etc., which are intended to be seen at a distance. Paolo Veronese surpasses Rubens in the simplicity of his local colour areas and his broad treatment of light. (Remember the 'Susanna and the Elders' in the Louvre; it is a lesson to meditate on.) In order to prevent it from appearing to lack colour when the light is so broadly spread, Paolo Veronese greatly strengthens his local colour.

Wednesday, 16 October

On pictorial licence. The most sublime effects of every master are often the result of *pictorial licence*; for example, the lack of finish in Rembrandt's work, the exaggeration in Rubens. Mediocre painters never have sufficient daring, they never get beyond themselves. Method cannot supply a rule for everything, it can only lead everyone to a certain point. Why have no great artists ever attempted to break down this mass of prejudice? They were probably frightened by the magnitude of the task and therefore abandoned the mob to their foolish ideas.

Champrosay, Saturday, 19 October

Villot maintains that every cold will yield to starvation and a day in bed. I think he must mean a cold in its first stages. I am writing at Champrosay; we had been for a walk the day before, and had had a long discussion about painting.

3 November

Rubens frankly lays the grey half-tone at the edge of the shadow between his local colour for the flesh and his transparent rub-in. With him, this colour in middle tone predominates all the time. Paolo Veronese lays on flat the half-tint of the flesh and that of the shadow. (I have noticed from my own experience that by this procedure alone one gets an astonishing amount of illusion.) He finds it sufficient to bind the two together with a greyer tone, applied in certain places where the underlying preparation is dry. And in the same way, he lightly touches in the strong transparent grey tone which edges the shadow on the side where it is grey.

Titian probably never knew how he was going to finish a picture, and Rembrandt must often have been in the same state. His extravagantly vigorous brush-strokes were less the result of planned execution than of feeling his way with repeated touches.

During this same walk, Villot and I noticed some extraordinary effects. It was sunset; the *chrome* and *lake* tones were most brilliant on the side where it was light and the shadows were extraordinarily blue and cold. And in the same way, the shadows thrown by the trees, which were all yellow (*terre d'Italie, brownish red*) and directly lit by the sun's rays, stood out against part of the grey clouds which were verging on blue. It would seem that the warmer the lighter tones, the more nature exaggerates the contrasting grey, for example, the half-tints in Arabs and people with bronzed complexions. What made this effect appear so vivid in the landscape was precisely this law of contrast.

I noticed the same phenomenon at sunset, yesterday evening (13 November), it is more brilliant and striking than at midday, only because the contrasts are sharper. The grey of the clouds in the evening verges on *blue*; the clear parts of the sky are bright *yellow* or orange. The general rule is, *the greater the contrast, the more brilliant the effect.*

Wednesday, 27 November

Spent the morning with Guillemardet. He has given me M. Dupin's recipe for quickly finding words with which to express one's thoughts: never worry about the phrasing when you are turning the subject over in your head; concentrate on the matter, and make sure that you have got it thoroughly into your mind, then, when you begin to speak, the words will look after themselves.

1851

Thursday, 2 January

The Oval of the ceiling in Saint-Sulpice:[1]

<div align="center">

5 metres = 15 ft. 4 in.

3 ,, = 12 ft.

</div>

[The entries for April and May have been selected as examples of the immense care given by Delacroix to the choice of his pigments, their use and orderly position on his palettes. In this instance they relate to figures in 'Apollo triumphing over the Python' in the Louvre ceiling.]

Tuesday, 29 April

For the children in the picture of the 'Python': after sketching and massing-in the whole with cool, light tints and half-tints at the same time, I began modelling with rather dry paint, putting in the light passages with a very thick impasto of *white* with a touch of *vermilion*.

Rubbed in over the shadows the mixed tone of *vermilion, Prussian blue* and *white*; this must overlap the edges of the shadow so as to produce the bluish half-tone, and in order to get the reflected light you must overlay it with the tone of *white* and *vermilion* mixed with *antimony* or *cadmium*, but *antimony* makes it cooler. When you go over this reflection again, which it is better to do when the paint is dry, you must add the above-mentioned tint of *Prussian blue* to the *antimony*.

Tones for retouching: strong accents in the shadows, or for contours; use a decided brown with *vermilion* and *cobalt*. This is an excellent tone to use for picking up the drawing with colour in subjects with fresh complexions.

When it comes to finishing the light passages, paint over them lightly with a half-fluid pigment, so as to blend the *white* high light with the general mass.

When I was retouching the Venus, which was too yellow, I scumbled almost every part, and especially the shadows, with *yellow lake* and *red lake*. For the reflected lights in the shadows laid on top of this scumbling I used *antimony* with *Prussian blue, vermilion* and *white*. This gives a tone of remarkable quality. For the warmer reflections in delicate skins use *cadmium*, instead of *antimony*. This latter colour is also very satisfactory when used with *Cassel earth* and *white*.

[1] Delacroix was beginning to think of the Chapelle des Anges at St. Sulpice, but he was chiefly occupied by the Salon de la Paix at the Hôtel de Ville and the ceiling in the Galerie d'Apollon at the Louvre.

This preparation of *Prussian blue, vermilion,* and *white* can also be used for flesh where the half-tint is violet, as for example, in the pastel I did of Mme Cavé. Where the half-tint is green, on the other hand, the preparation should be composed of *raw umber* and *white,* or some other greenish tone.

Terre verte can also be very useful. Where the undercoat turned out to be too red in one of the children a simple glaze of *terre verte* was most successful.

I used another and brighter green tone in the Nymph to contrast with the *Prussian blue* tint: *vermilion, white, viridian, Naples yellow.*

The Nymph: I scumbled the whole of this with some *yellow lake* and *red lake* over a rubbed-in preparation that was already almost the right tone. Then I indicated the chief accents on the edges of the shadows with *cobalt* and *vermilion* or, even better perhaps, with *Cassel earth,* a *low-toned white,* and *vermilion* (an excellent tone for the edges of shadows, or for background passages which may be rendered warm or cool, as desired). Next, I placed the half-tone of *Prussian blue, vermilion,* and *white* equally near to the shadow and the light, so that although it gave a warm tone to the shadow, or a golden tone to the light passage, it also blended with the lights in the flesh tones, which were suitably varied.

The green tone in some places in the shadows was made with *viridian* and *Naples yellow,* and was used in other parts too, such as the half-tones in the light passages. The rosy passages in the flesh have to be retouched with this half-tone, for example in the 'Child with the Trident', where it was done with *terre verte* and scumbled over almost the entire undercoat—a flesh tone that was already light and brilliant.

The flesh tones, adding to and blending with these scumblings of *terre verte,* produced the rosy half-tone.

In the Nymph, I used a very fine flesh tone, brilliant and vigorous, made with *vermilion, white,* and *dark chrome yellow,* with *viridian* and *Naples yellow.*

The Red Horse. The light passages laid over a half-tone undercoat for the dark chestnut horse were almost flesh-coloured, but slightly more brilliant, and in streaks. The metal plates on the harness: a stronger and fairly warm half-tone tinged with *burnt Italian earth, brownish-red,* and even *vermilion,* edging the light passages quite sharply wherever they came in contact with them. Some brown passages of *burnt Italian earth* and *mummy,* suitably modified with *Cassel earth* and *white,* and very dark, so as to make a violet-grey, were laid on in the shadows over an umber half-tone. The reflected

lights on the parts turned towards the sky, very decided, with *Prussian blue*, *vermilion*, and *white*.

For repainting the *arm of the Minerva*: I indicated the shadows with *lake* and *yellow lake* in a very solid impasto over the old flesh-coloured ground, with perhaps a touch of *terre verte*. Tints of green and violet were laid crudely here and there on the light part, not blending with it, but keeping the form. These tones were fairly dark in value so as to form the edge of the shadow.

Tuesday, 13 May

A very beautiful violet for flesh: the tint made of *lake* and *vermilion* mixed, without being too well blended, with the tone of delicate *viridian*, *terre verte* and *white* (these are set next to one another on the palette which I last used for the 'Python').

The underpainting for the 'Femme Impertinente' was made with a very thick impasto and in a very warm and above all, a very red tint. On this I laid a glaze of *terre verte* with perhaps a little *white*. This produced the half-tone of iridescent opal-grey, and over it I very simply touched in the lights with the extremely good tone of *Cassel earth*, *white* and a little *vermilion*, followed by a few orange tones, strong in places. All this was still merely an underpainting, but an exceedingly subtle one. The half-tone was entirely flesh colour.

Friday, 6 June

Yesterday was the *Opening of the galleries at the Louvre*. Deeply impressed by Lesueur's decorations, which did not prevent my realizing how much force colour can add to expressiveness. I should be inclined to say that colour is a very much more mysterious, and perhaps a greater force than is generally supposed; it functions, so to speak, without our being aware of it. I am even convinced that a great deal of Lesueur's charm is due to his colour. He possesses the art, which Poussin so entirely lacked, of giving unity to everything he portrays. A single figure by him is a perfect harmony of line and effect, and when many figures are assembled in one picture everything is brought into harmony. At the same time, it is open to argument that if he had had to paint the Queen on horseback, the one of which Rubens made so magnificent a picture, he would not have been able to make such a strong appeal to our imaginations with so uninspiring a subject. Only the imagination of a colourist could have carried it off with such a flourish; the horse, for instance, and the shadow on the hind leg that links it up with the cloak.

Poussin loses a great deal by being shown near Lesueur. He has no feeling for the muse of Grace, and harmony in line, colour and effect is another quality, or rather a whole collection of most valuable qualities, in which he is entirely lacking. His conceptions are powerful, he carries accuracy to the utmost limit of what is possible, but his work never contains those omissions, those sacrifices made for the sake of relaxation and enjoyment, which give serenity to the effect and allow our eyes to travel easily over the composition. There is a sense of strain in his Roman and religious subjects and he is equally tense in his 'Bacchanalia'; his fauns and satyrs are a little too serious, too respectable, and his nymphs are really extraordinarily chaste for creatures of mythology. They are exceedingly beautiful individuals but have nothing supernatural or mythological about them. Poussin was never able to paint the head of Christ, or the body either for that matter—that body which should express so much tenderness, and the head that must be eloquent of the divine grace and pity for the sufferings of mankind. He was thinking far more of Jupiter, or even Apollo, when he painted his Christs. And he was equally unsuccessful in his treatment of the Virgin; he seems to have had no conception of the holiness and mystery surrounding her personality. His infant Jesus appears to hold no interest for the men who kneel to adore His divine grace, or even for the animals which the Gospel tells us were present at the birth of the Holy Child. The ox and the ass are missing from the group around the manger, where God is born in the straw that forms their own bed, and the uncouth appearance of the shepherds who have come to worship is rather heightened by a hint of figures from the antique; the robes of the Magi are as stiff and bare of ornament as though they had been carved out of marble. I miss the jewel-encrusted robes of silk and velvet, borne by slaves and dragging over the stable floor at the feet of the Master of all nature, who has been revealed to them by a supernatural power. Where are the dromedaries, the incense, all the pomps that make such a marvellous contrast in the humble refuge?

I am sure that Lesueur never used Poussin's method of arranging the effect of his pictures with the help of small models lit by studio lighting. This so-called conscientiousness makes Poussin's pictures intensely arid. His figures look as though they had been cut out, and seem to have no connexion with one another; hence the lapses, the absence of unity in his work and the lack of fusion—qualities which you find in Lesueur and in all the colourists. Raphaël also suffers from this lack of fusion, but in his case it comes from his

practice of conscientiously drawing each figure in the nude before he draped it.[1]

Although one has to keep in mind every part of the figure so as not to lose the proportions when they are hidden by drapery, I cannot think that this is a good method to follow in every case, but Raphaël seems to have conformed to it scrupulously, judging by the studies that are still in existence. I feel convinced that Rembrandt would never have achieved his power of representing character by a significant play of gestures, or those strong effects that make his scenes so truly representative of nature, if he had bound himself down to this studio method. Perhaps they will discover that Rembrandt is a far greater painter than Raphaël.

This piece of blasphemy will make every good academician's hair stand on end, and I set it down without having come to any final decision on the subject. The older I grow the more certain I become in my own mind that *truth* is the rarest and most beautiful of all qualities. It is possible, however, that Rembrandt may not quite have had Raphaël's nobility of mind.

It may well be, however, that where Raphaël expressed this grandeur in his lines and in the majesty of each of his figures, Rembrandt expressed it in his mysterious conception of his subjects and the profound simplicity of their gestures and expression. And although one may prefer the note of majesty in Raphaël which echoes, as it were, the grandeur of some of his subjects, I think that without being torn to pieces by people of taste (and here I mean people whose taste is genuine and sincere) one might say that the great Dutchman was more of a natural painter than Perugino's studious pupil.

Saturday, 14 June

The way in which the dead bodies are handled in the picture of the 'Python' is my true execution, the one best suited to my temperament. I should not paint like this if I painted from nature, and the freedom I gain compensates for the absence of the model. Remember the difference in character between this and the other parts of my picture.

11 August[1]

'I am sorry to hear that you are bored. You have so many ways of making the time pass pleasantly, yet you will not enjoy the

[1] This is a copy of a letter to Mme de Forget. Delacroix often copied into his Journal letters (and especially those to his favourite correspondent) which summed up his recent thoughts and experiences.

opportunities within your reach, which providence grants to so few in our present state of civilization. You are right in saying that I am lucky to be able to practise an art that amuses and genuinely interests me, but what a price we have to pay to acquire a talent that so often is mediocre and uncertain, although, as you rightly say, it is sometimes a consolation to us! . . . And all the troubles and vexations that go with it, which we never tell a hundredth part of! You must realize that you are one of the small group for whom we worker bees destroy ourselves; it is to give you pleasure that we turn yellow and get stomach-ache . . . You have nothing to do but to admire and, what is far more agreeable, to criticize us, and you can do this with an infinitely better chance of good digestion because you are able to rest and take exercise whenever you please . . . You move about, and then you rest. Even shop-assistants spend thirty years of their lives working like slaves only because they hope to be able to retire one day. But you have already reached the haven towards which we slaves are striving with all our mental and bodily strength; you, at any rate, are free from journalists and jealousy. Have you an enemy? . . . Invite him to dinner and use the opportunity to make him amuse you.'

'Come now, my dear, try to take a more cheerful view of your life. Think what so many unfortunates have to put up with. Far from giving dinner-parties and having too much money and too many pleasures, they cannot even supply their bare necessities. And above all, go and look at the sea. There you have the certain cure for boredom, a sight of which one can never grow weary.'

1852

Wednesday, 21 January

Have you seen what they are doing to the Pont Neuf? It is certainly going to live up to its name now, for it has no connexion with the old bridge, the one we've seen all our lives, and which was so familiar that there used to be a saying, *as well-known as the Pont Neuf*. Now this will have to be given up like so many other illusions.

26 January

Went to Mousseaux, where the sublime tapestries of the 'Life of Achilles', by Rubens, are being sold.[1] His large pictures, and indeed

[1] This refers to a sale of tapestries from the estate of Louis-Philippe. The catalogue was drawn up by Viollet le Duc. The tapestries fetched ridiculous prices and all trace of them has been lost.

his pictures in general, are not usually so full of inaccuracies but they do not have this incomparable zest. Here he is not *feeling his way* and above all, he is not *making improvements*. When he tries to chasten his style he loses this feeling of vitality and freedom that gives unity and movement to the composition. The upturned head of Hector is beyond comparison in expression and even in colour. It is astonishing how well these tapestries have kept the feeling of colour in spite of their being faded, and especially when you realize that they must have been done from very lightly coloured cartoons.

'The tripods brought before Achilles; and Briseis, whom the elders are restoring to him.' How the moderns would have spread themselves on this subject, with ultra-refinements and secondary themes! Rubens, like Homer, goes straight to the point . . . It is the most striking feature of these cartoons.

'Achilles diving into the River Styx': the body hidden by the water and the little legs waving above it . . . The old woman holding the torch, and the background, which is quite superb. Charon, the souls in torment, etc.

'Achilles discovered by Ulysses': the gesture of Ulysses exulting over the success of his stratagem and pointing out Achilles to a confederate at his side.

Remember the decorations on these tapestries, the children with the garlands, the figures framing the composition on both sides, and especially the emblems in the centre of the base of each tapestry which distinguish the different subjects. For example, the amazingly vigorous cock-fight beneath the 'Death of Hector', 'Cerberus' lying asleep under 'The Styx', and the roaring lion under the 'Wrath of Achilles'.

In this last tapestry Agamemnon is superb, seated on his throne, half-indignant, half-fearful. On one side the old men come forward to arrest Achilles; on the other, Achilles draws his sword but is held back by Minerva, who clutches him roughly by the hair—all just as Homer describes it.

'Achilles riding on Charon': this seemed to me ludicrous. Achilles looks as though he were in a riding-school, like an equestrian portrait of a horseman of Rubens's own time.

'The Death of Achilles': Achilles sinks down upon the altar where he has been sacrificing; an old man is supporting him; the arrow has transfixed his heel. Paris stands in the doorway of the temple with a ridiculous little bow in his hand, and above him Apollo points out Achilles with a gesture that avenges the whole Trojan war. It is

completely un-French in sentiment—nothing could be more so. Everything else, even the Italian things seemed cold beside it.

I hope to be able to go again.

Monday, 27 January

Went back today to see the tapestries. I was feeling unwell, which prevented me from making the most of the opportunity, but I did manage to do some drawings. I was just as deeply impressed and had the same difficulty in dragging myself away.

Impossible to imagine anything finer than the 'Agamemnon'. How simple it is! That magnificent head, with its expression of mingled dread and indignation, but with indignation predominating! The old man looking at Achilles and taking him by the hand as though to soothe him. The unforgettable head of the dying Hector. In every respect this is one of the truest and most expressive pieces of painting that I know. The beard is simple and beautifully modelled. It makes one shudder to see the way the spear has pierced him, its deadly point deep into his breast. This is Homer and more than Homer; the poet can reveal his Hector only to the mind, but here I see him with my eyes. This is when painting is supreme, when the image that the painter displays before our eyes not only satisfies the imagination but gives the subject a permanent setting and surpasses the original conception.

Briseis is delightful, a mixture of shyness and joy. Achilles, separated from her by the men setting down the tripods, feels an ever-increasing longing to take her in his arms, and the old man who steps forward bowing to present her to Achilles seems half-ashamed, half-anxious to ingratiate himself. In 'Achilles Discovered', the group of maidens is wonderfully fine; they seem torn between a longing to play with the jewels and dresses, and surprise at seeing Achilles, free once more with his helmet on his head. Delightful legs. I have already mentioned Achilles's incomparable gesture; his eyes sparkle with intelligence and vitality. The 'Death of Achilles' is full of such beauties. When you come to study it more closely in order to make a drawing, you are astounded by the knowledge it displays. It is his understanding of planes that raises Rubens above all these would-be draughtsmen. When they manage to hit on the planes it always seems a stroke of luck, but Rubens, even in his wildest flights, never misses. One splendid figure, full of truth and energy, is the garlanded acolyte who supports the wounded Achilles as he sinks to the ground; he turns towards the murderer with a mournful look, as if to say: 'How could

you dare to slay Achilles?' There is even something tender in his glance which might be directed towards Apollo who, standing relentlessly over Paris, and almost clinging to him, points with an angry gesture to the spot at which he must aim. Vulcan is one of the most perfect and most finished of the figures; the head is truly characteristic of the God, also the huge breadth of the great body. The Cyclops bearing the anvil, and the two assistants hammering upon it, the Triton receiving the dreadful helmet at the hands of a winged child, are all masterpieces of imagination and composition!

The way in which the work has been planned, and certain exaggerated forms, show that Rubens was working like a craftsman practising the trade he knew and not for ever trying to improve upon it. The flow of his thought was uninterrupted because he was dealing with something that he understood. He clothed his thoughts in images that were always readily accessible to him, translating the sublime ideas that came to him in such variety into forms which superficial people call monotonous, not to mention their other complaints. But a profound thinker who has delved deeply into the secrets of art is not disturbed by such 'monotony' for a continual return to the same forms shows the imprint of a great master; it is also the instinctive action of a wise and practised hand. It is this which gives the impression that the compositions were produced smoothly and easily, a feeling that adds greatly to the power of the work.

Sunday, 1 February

Pierret tells me that these beautiful tapestries have been sold for two hundred francs apiece. Some of them, from the Gobelin workshop, were very fine indeed, with backgrounds of gold thread. They have been bought by a coppersmith to melt down for the metal.

Monday, 2 February

Mme Sand came to see me about four o'clock . . . Ever since she returned to Paris I have been reproaching myself for not having been to call on her. She is not at all well, and besides the liver complaint, she now has the same kind of asthma that poor Chopin used to suffer from.

We were discussing the people who were so great and proud a short while ago, and who now seem suddenly to have come to a tacit agreement to grovel and make themselves inconspicuous.[1] In the twinkling

[1] Delacroix and George Sand were discussing the people who were seeking pardon from Louis Napoleon, the Prince-President, after opposing him at the Coup d'État of 2 December 1851.

of an eye, all these irresponsible braggarts have turned into arrant cowards. However, we have not yet quite descended to the level of Napoleon's Marshals in 1814, but only because there has been no opportunity for it. It is the greatest disgrace in history.

Wednesday, 4 February

Mocquart, in his pompous way, has been giving us the latest details about Géricault. He spoke of Mustapha's[1] presence at the funeral and gave a vivid description of the poor Arab's grief, saying that he lay prostrate on the ground, burying his face against the tomb. The truth is that he did nothing of the kind, but stood some distance apart, although this did not prevent his being a very touching sight for everybody present.

Saturday, 7 February

As I was leaving Saint-Germain l'Auxerrois I met Victor Cousin[2] on the quay, on his way to Passy. I happened to be going to the Ministry where I had an appointment with Romieu, so I walked with him across the Tuileries and along the river as far as the Barrière des Bonshommes. There followed a long conversation during which he kept me amused with stories of the private lives of several mutual acquaintances: 'We all know', he said, 'about Thiers's wit and intelligence, but see him at the conference table controlling affairs of State and he is beneath contempt.' Guizot[3] is the same, and even more heartless than Thiers. He gave me a very poor idea of him. Perhaps I shall go and call on him at the Sorbonne.

Sunday, 6 February

Halévy[4] says that we ought to keep a record every day of the things that we see and hear. He has made several attempts, as I have myself, but has always been discouraged by the gaps that inevitably occur in a journal, either because one is too busy or too forgetful to write it up.

[1] Mustapha, one of Géricault's favourite models.

[2] Victor Cousin, philosopher, writer, Professor at the Sorbonne.

[3] Guizot (1787–1874). After the fall of the monarchy, this statesman had retired into private life, but was then trying to unify the remnants of the two fallen royal dynasties.

Thiers, arrested in December, was expelled from France, and was living in exile. Delacroix, who owed much to his early influence, had for some time grown cool towards him.

[4] Fromental Halévy, musician, composer of *La Juive*.

Tuesday, 10 February

M. Chevallier's reception in the rue de Rivoli. Magnificent apartments on the first floor, hideous pictures on the walls, splendid bookcases, which like the books themselves are never opened. No taste whatsoever. I met Mme de Ségalas, who reminded me that we had not met since that time at Mme O'Reilly's in 1832 or 1833. It was then, or at Nodier's earlier in the evening, that I first saw Balzac. He was dressed in a blue coat, I think, with a black waistcoat, at least I remember that there was something wrong about his clothes and that he was already beginning to show gaps in his teeth. He was a rising man in those days.

Sunday, 15 February

At the Saint-Cecilia concert: Mozart's Symphony in G minor. I must confess I was a little bored. I greatly enjoyed the beginning, but I rather think that this was merely because it *was* the beginning, and that it had no connexion with the real merits of the piece.

The overture and a finale from *Oberon*. The fantastical spirit in this work by one of Mozart's worthiest successors gains by coming after the same quality in the divine Master and by being in a more modern form. It has not yet become so hackneyed and plagiarized by every musician in the last sixty years. 'The Chorus of Gauls', by Gounod, gives every appearance of being a fine work, but you need to hear a piece of music several times before coming to a decision, and a composer must have established his position, or at least made his style comprehensible, by a fairly large number of works. It sometimes happens that pedantic instrumentation, or a taste for archaisms, give a false impression of austerity and simplicity to the work of unknown composers. Sometimes, too, a musician's uncontrolled enthusiasm supported by cleverly arranged reminiscences and a brilliant use of instruments may be mistaken for the work of an ardent genius carried away by his ideas and capable of greater things. This was so with Berlioz, and the former could be applied to Mendelssohn. Both composers are lacking in ideas and both do their utmost to conceal this vital defect by every trick that memory or intelligence can suggest.

Very few musicians have been unable to invent a certain number of striking themes. When these appear in a composer's early works they give a favourable idea of his imaginative ability, but such fleeting inspirations are all too often followed by long passages of appalling

dullness. They bear no relationship to the wonderful fluency of the great masters who so often lavish their happiest ideas on mere accompaniments. They have not the wealth of that inexhaustible, ever-flowing stream that supplies an artist's every need and prevents his having to waste his time in an endless search after the best interpretation, or hesitating between different forms of the same idea. Such freedom and wealth of ideas is the surest sign of superiority in every art. Raphaël and Rubens never had to search for ideas, they came of their own volition, and often too many at a time. The difficulty for these artists was certainly not in giving birth to ideas, but in rendering them in the best possible way through their execution.

Friday, 20 February

Dined with the Villots. These continual dinner-parties are a great nuisance. It is becoming more and more fashionable to dine in the Russian way, with the table covered with sweets and sugar biscuits through all the courses and an immense arrangement of flowers in the centre, but never a scrap of the kind of food that a hungry man expects to see when he sits down to dinner. The waiting is lamentable; the footmen hand round whatever dishes they happen to fancy, which usually means anything they do not want to keep for themselves. People seem to find it all very agreeable, but it is farewell to pleasure and farewell to the agreeable pastime of dining well! You leave the table feeling only half-satisfied and spend the rest of the evening regretting the bachelor supper you missed having by your own fireside. The wretched woman has plunged into fashionable life, which means that she is perpetually surrounded by the most boring and futile people.

I left before the music in order to call on Didot, my colleague on the Municipal Council.[1] It was dry and cold out of doors and the walk did me good. When I arrived at his house, I found the same mob of stupid people, worse music, and bad pictures on the walls—except one, a nude man by Albrecht Dürer which held my attention the whole evening.

This unexpected discovery, and Delsarte's singing at Bertin's the night before, made me reflect that there is a great deal to be said for going into society, exhausting though it is and futile though it may appear at the time. On the other hand, if I had stayed at home I should

[1] Delacroix, through his links with the Bonapartist world, had been appointed a member of the Municipal Council after the Coup d'État in December 1851. He took his duties very conscientiously.

not have been tired, nor should I have had to suffer any of these petty
annoyances, which were probably increased by the society of trivial
and tiresome people—pleasures which the average man looks forward
to in fashionable drawing-rooms.

Saturday, 21 February

To the Jardin d'Hiver in the evening, where I escorted Mme de
Forget to the 9th Arrondissement Ball, to which I'd paid a subscrip-
tion. The same thing happened as on the two preceding evenings; I
did not at all want to go when I was dressing, but enjoyed myself
when I got there. I was enchanted by the exotic trees—some of them
enormous—lit up by the electrical illuminations; the fountains and
the sound of splashing water made it perfectly delightful. Two swans
were swimming about in one of the basins among the water-plants
beneath the spray of a fountain forty or fifty feet high. I was even
greatly amused by the ball itself, the vulgar orchestra, the dashing
bowing of the fiddlers, the drums and cornets, and the zest of the
little shop-assistants fluttering about in their fine clothes. I am sure
that only in Paris can one get such a thrill from this kind of thing.
Mme de Forget did not share my pleasure, having been rash enough
to risk a new dress of rose-pink Turkish silk on the asphalt pavement
among the stamping feet of this very mixed crowd. I fear it lost some
of its freshness. Mme Sand, Maurice, Lambert, and Manceau had been
dining with me. It made a strange impression to see these young men
with that poor unfortunate woman.

Monday, 23 February

Painters who are not colourists practise illumination, not painting.
Unless you are deliberately setting out to do a monochrome or
camaïeu painting in the proper sense of the word, you must consider
colour as one of the most essential factors, together with chiaroscuro,
proportion, and perspective. Proportion applies as well to sculpture
as to painting; perspective determines the contour; chiaroscuro gives
relief by the arrangement of lights and shadows in relation to the
background; colour gives the semblance of life, etc.

A sculptor does not begin with the contour; he builds up an ap-
pearance of the object with his material; it begins by being rough,
but shows from the very outset the actual relief and solidity that are
the chief characteristics of sculpture. The colourists, by whom I mean
those artists who unite all the factors of painting, must establish

everything that is proper and necessary to their art at once, from the start of the work. And just as the sculptor masses-in his work with clay or marble or stone, so the colourist must mass-in colour, and his sketch, like the sculptor's, must render at the same time proportion, perspective, colour and effect.

In painting, the contour is a matter of idea and convention just as it is in sculpture, and should arise naturally out of a proper arrangement of the essential parts. In the early stages of preparation, when the effect, which includes the perspective, is united with colour, the work approximates more or less closely to its ultimate appearance according to the ability of the artist, but even in the first stage of all, it will unmistakably contain the germ of all that is to come after.

Wednesday, 25 February

Commonplace people have an answer for everything and nothing ever surprises them. They try to look as though they knew what you were about to say better than you did yourself, and when it is their turn to speak, they repeat with great assurance something that they have heard other people say, as though it were their own invention.

It almost goes without saying that such people are usually bursting with the kind of information that anyone can get hold of. Nothing prevents their making complete fools of themselves except their natural shrewdness and whatever modicum of common sense they happen to possess. I can think of endless examples that show how widespread this ridiculous behaviour is. As I said before, the only difference between such fools is in the degree of their folly. And naturally, they all go about looking efficient and superior.

Thursday, 26 February

Reception at Mlle Rachel's. She was extremely charming to me. I met Musset[1] again, and remarked to him that nations have good taste only in the things they do well. For instance, the French are only good at what can be spoken or read; they never had any taste in painting or music. French painting is stylish and pretty-pretty . . . Great masters like Lesueur and Lebrun never inspired a school. Style is the quality which they find most attractive and it is much the same with music.

[1] Alfred de Musset admired Delacroix greatly but the painter does not seem to have cared much for the poetry of de Musset.

Monday, 1 March

The man who brings our coal and wood is a bit of a wag and a great chatterbox. When he asked for a tip the other day saying that he had a great many children to feed, Jenny said: 'Well why did you have so many?' and he answered: 'It was my wife who had them.' A perfect example of Gallic humour . . . He said something equally pungent a year ago, but I forget what it was . . .

Monday, 8 March

I have been having another look at Géricault's lithograph of the fighting horses. Close relationship with Michelangelo. The same power, the same precision, and in spite of the impression of strength and action, a slight feeling of rigidity, probably because of his intensive study of details.

Since last Thursday, I have been pestered to death every day with this jury. When I get home, in the evening, I feel as though I'd been for a ten-mile walk.

Monday, 5 April

I have been to Saint-Sulpice, to lay in one of the four pendentives.

As I was taking my evening stroll, and just before being nearly drowned in a sudden storm, I met Varcollier in the rue Mont-Thabor. He is horrified at Lehmann's small colour-patterns in the Hôtel de Ville and wants me to set myself up as denouncer and avenger of his crimes. I said it would mean getting too angry, and that in any case, the numerous misdeeds of this kind ought to have been put a stop to long ago. I mentioned some of the things his own friends have been doing.

On the following day, Tuesday 6th, I went into Saint-Germain on my way home from Saint-Sulpice and looked at the Gothic daubs with which they have been plastering the walls of this poor unfortunate church. It confirmed what I was saying to Varcollier; I would rather have Lehmann's fantasies than the forgeries of Baltard, Flandrin and Co.

Thursday, 29 April

Goubaux came to see me today. We discussed the slovenly way in which classical plays are produced. No theatrical producer would stand it for a moment in a modern play performed on the Boulevards. The actors at the Français have got into the habit of chanting

their speeches like children reciting a lesson. Goubaux gave me an illustration of this from the opening scene of *Iphigenia*, the speech: '*Oui, c'est Agamemnon,*' etc. He remembers seeing Saint-Prix—an actor who was generally considered to have talent, and one who knew the great tradition—calmly get up from his couch in one corner of the stage, walk across to waken Arcas and say all in one breath: '*Oui c'est Agamemnon,*' etc. But Racine's intentions are so obvious! The '*oui*' at the beginning of the speech is clearly there to echo the surprise which the attendant must show at being wakened before daybreak—and wakened by whom? By his master, his King, the King of Kings. Does not the answer also show that this King, this father, has spent long hours in anxious watching before coming to his confidant to obtain relief by speaking of his trouble? He must have turned and tossed upon his bed long before making up his mind to rise. In his preoccupation, which seems to continue throughout the speech, he does not even answer the question of his faithful friend. He talks to himself, and his agitation is betrayed by that glance into the future: '*Heureux qui, satisfait,*' etc.

'*Oui, c'est Agamemnon . . .*' echoes Arcas's surprise. These words should be punctuated by gestures, not strung out like a row of beads or like a man reading something out of a book. Actors are lazy people, who never even consider whether any improvement could be made in their rendering. I am convinced that they follow the beaten track without having the slightest conception of the treasures of expression contained in so many great works.

Goubaux was saying that Talma[1] told him that he made a practice of *noting down* all his inflections, quite apart from the pronunciation of the words. This acted as a guiding thread which prevented him from losing his way when he felt less inspired. Once he had memorized the rhythm, as it were, he could not break out of the circle of intonations which it formed without the risk of losing his way, of being carried away too far, or on a wrong track.

Wednesday, 5 May

A picture should be laid-in as if one were looking at the subject on a grey day, with no sunlight or clear-cut shadows. Fundamentally, lights and shadows do not exist. Every object presents a colour mass, having different reflections on all sides. Suppose a ray of sunshine

[1] Talma (1763–1826), famous tragic actor admired by Napoleon. He brought back a more natural style to the conventional declamation of tragedy.

should suddenly light up the objects in this open-air scene under grey light, you will then have what are called lights and shadows but they will be pure accidents. This, strange as it may appear, is a profound truth and contains the whole meaning of colour in painting. How extraordinary that it should have been understood by so few of the great painters, even among those who are generally regarded as colourists![1]

Champrosay, Thursday, 6 May

(I am writing this with my back to the fence, at the foot of the great oak in the avenue to the Hermitage.)

As I was walking along the Soisy road, about four o'clock, to give myself an appetite, I came upon a trail of water in the dust that looked as though it had been sprinkled from the spout of a funnel. It reminded me of observations which I made some time ago in other places on the geometric laws governing such phenomena, which are generally supposed to be accidental.

Take, for instance, the furrows in fine sand scooped out by the sea, which you can see on the beach at Dieppe, where I noticed them last year, just as I did when I was in Tangier. In their irregularities, these furrows showed the return of similar forms, but whether by the action of the water or the nature of the sand which received the imprints they seemed to take on a different appearance according to the locality. Thus at Dieppe, where the marks took the form of stretches of water on very fine sand broken up here and there or enclosed by small rocks, they gave a very good representation of the waves of the sea. If one had copied them in the proper colouring they would have given an idea of that movement of the waves which is so difficult to capture. At Tangier, on the other hand, where there is a flat beach, the receding tide left upon the sand the imprint of small furrows, so closely resembling the stripes on a tiger's skin that they might have been mistaken for the object itself. The trail of water that I found yesterday on the road to Soisy looked exactly like the branches of certain trees after the leaves have fallen; the wide trail formed by the main branch and the little twigs interlaced in all directions were produced by the criss-cross splashes.

I have a horror of the usual run of scientists. I have said elsewhere

[1] The problem of coloured reflections was one of the great issues among painters, a major difference for example between Delacroix and Ingres. This note of May 1852 heralds the coming doctrine of Impressionism.

that they jostle one another in the ante-room of the sanctuary where nature hides her secrets, always hoping that the cleverest among them will push open the door. When, as I read the other day, the famous Danish, Norwegian, or German astronomer Borzebilocoquantius discovered a new star with his telescope, scientists proudly recorded the new arrival, but no telescope has been invented to show them the relationship between objects.

Scientists ought to live in the country where they are close to nature, but they prefer to gather round baize-covered tables in academies and institutes and to chatter about things which everybody knows as well as they do. In the forests and on the mountain tops there are natural laws to be observed, and you cannot take a step without finding something to wonder at.

The world of animals, vegetables and insects is proper food for the student who wants to record the diverse laws that govern all such creatures. But these gentlemen do not consider such simple observations worthy of their talents, they like to go further, and work out systems in the depth of the offices which they call their observatories. And besides, they have to frequent the drawing-rooms and win *crosses* and *pensions*; the science which teaches how to gain such things seems to them worth all the rest put together.

Writers who have ideas but lack the skill to arrange them are comparable to the Barbarian generals who led hosts of Persians or Huns into battle and allowed them to fight haphazard, without order or united effort, and hence without success; bad writers are just as often to be found among those who have ideas as among those who have none.

A delicious walk while they were tidying my rooms. The forest was in its most smiling mood and a thousand different thoughts came into my mind as I wandered about. At every step I disturbed some springtime tryst, and the noise of my feet frightened the poor birds, who flew away, and always in pairs. O! these birds and dogs and rabbits! These humble professors of good sense, all of them silent, all submissive to the eternal decrees, how far superior they are to our cold and empty knowledge! Springtime is the awakening of Nature, it opens the door to love. New leaves are sprouting, new creatures are being born to people this new world. I feel far more awake to science here than in a town. And yet these fools (the scientists) live in their laboratories and imagine them to be the sanctuary of Nature. They have skeletons and dried grasses sent to them by post instead of going out to see them bathed in dew.

Friday, 7 May

Spent the morning at the Jardin des Plantes. I have renewed my ticket. Stood among the crowd in the sunshine, drawing the lions.

When I first got there I felt very tired and sat down to sleep on a chair in the sun.

Wednesday, 12 May

Part of a letter I have written to Pierret: reflections on interruptions to my work during the past week.

'. . . It doesn't do to leave one's work, that is why time and nature, and indeed everything that labours slowly and ceaselessly, produces such good results, but we, whose work is constantly being interrupted, never spin the same thread from beginning to end. Before I left Paris I was producing the work of M. Delacroix, as he was a fortnight ago, now I am about to begin the work of the present M. Delacroix. I shall have to pick up the stitches and the knitting will be either tighter or looser than it was before.'

Dieppe, Monday, 6 September

Left for Dieppe at eight o'clock; arrived at Mantes at nine, and at Rouen at about a quarter past ten. The rest of the journey took much longer as we did not go direct.

Arrived in Dieppe at one o'clock and put up at the Hôtel de Londres. I have been given the room I hoped for, with the view over the port. This is delightful; it will be a great distraction.

For the rest of that day, which I spent mostly on the pier, I could not get rid of a sense of utter boredom. At seven o'clock I dined alone, next to some people whom I had already met on the pier and disliked from the moment I saw them—my dislike increased as the wretched meal progressed. Uncouth sportsmen, would-be men of the world, there's nothing more unpleasant.

Travelling in the train as far as Rouen there was a big, bearded man, a very likeable fellow, who told me most interesting things about the German emigrants, and especially about some of the colonies which they have established in various parts of southern Russia, which he had been visiting. These people are mostly descended from the Hussites, who became the Moravian Brotherhood. They live as a community, but are not Communists as the word was understood in France during the recent troubles. Only the land is held in common, and probably also the tools to work it, since each man

owes a debt of labour to the community. Some of their industries grow richer than others because each manages its own savings with more or less thrift and ability. A man may employ a substitute to do his share of the communal work. They call themselves the Meronites or Menonites.

Saturday, 11 September

When I woke up I could see from my bed that it was almost high tide in the harbour and that the masts of the ships were swaying about more than usual. I therefore concluded that the sea must be looking wonderful, and hurried down to the pier where, for close on four hours, I enjoyed the most magnificent spectacle.

The young woman in the hotel, who says she feels lonely, was looking very handsome when I saw her on the pier; black is certainly more becoming to her, it makes her look less second-rate. She really can be quite beautiful at times and I was rather intrigued by her, especially when she went down to the beach and found how delightful it was to let the ripples wet her feet. I had thought her rather commonplace at dinner. The poor girl is throwing hooks out in all directions and to the best of her ability; all her oglings and simperings are directed to the task of catching a husband, that elusive fish which is not to be found in the sea. She has an irritating father ... for a long time I thought he was dumb but since he has begun to talk (which, I must admit, he does very seldom) he has sunk even lower in my estimation. Before this, only his outward appearance was unattractive.

In the afternoon the tide was low and I was able to walk far out across the dry sand. I felt the most delicious pleasure at being by the sea. All the same, I think that the recollection of the things we enjoy is their greatest attraction, the memories they evoke in our hearts and minds, and especially in our hearts. I'm always thinking about Bataille, and about Valmont as it was when I first went there so many years ago ... Regrets for past times, the charm of my early years, the freshness of first impressions, have more effect on me than the scene itself. And the smell of the sea, especially at low tide—which is perhaps its keenest charm—has an almost incredible power to take me back among those beloved people and those precious times that are gone forever.

Sunday, 12 September

I met Mme Sheppard on the pier and she has invited me to dine tomorrow. I managed to elude the young woman, who is becoming

thoroughly tiresome. She and her party spoiled my evening again yesterday; it is impossible to avoid them on the pier . . . Really, I am the biggest fool in the world, I only want to be polite and considerate to people but I must give the impression of meaning something more, for they hang on to me and I don't know how to get rid of them. In the evening I went into the harbour-master's office at the invitation of Possoz, who seems very much at home there; it was high tide, and the waves were breaking with splendid fury.

Since I came here, I have been learning pretty thoroughly the truth of the saying that too much liberty leads to boredom. One needs solitude and one needs amusement. I was dreading meeting Possoz but his company has turned out to be quite a resource at various times, and the same applies to Mme Sheppard—for a little while. If I had not had Dumas and his *Balsamo*[1] to fall back on I should have been on my way home to Paris before now; these interruptions to my solitude take up most of my time, and I'm far from regretting the hours I've spent in day-dreaming.

Monday, 13 September

How can you be so stupid?—to give yourself a sore throat by arguing with fools! You spend an entire evening in a discussion with inanity in petticoats—and on *God* of all things, and *terrestrial justice*, and *good* and *evil* and *progress*!

Before going out this morning, I wrote to Mme de Forget: 'Try to take action so as to avoid suffering. If there is anything you can do to lessen your boredom or discomfort, do it immediately without thinking twice about it. It all sounds so easy. Here is a trivial example: my clothes were uncomfortable when I started out, but I went on because I was too lazy to go back and change; I can think of endless others. If only I could apply the rule to ordinary, everyday affairs as well as to important matters it would give me the buoyancy and poise that are the best means of preventing boredom. You increase your self-respect when you feel you've done everything you ought to have done, and if there is nothing else to enjoy, there remains that chief of pleasures, the feeling of being pleased with oneself. A man gets an immense amount of satisfaction from the knowledge of having done good work and of having made the best use of his day, and when I am in this state I find that I thoroughly enjoy my rest and even the

[1] Delacroix was reading *Joseph Balsamo*, a novel by Alexandre Dumas, an old friend, but an author on whom he lavished few compliments as a rule.

mildest forms of recreation. I can even be with boring people and feel no regrets. The memory of the work I've done stays with me and prevents my being bored or melancholy.'

Tuesday, 14 September

My last day in Dieppe. It has not been the pleasantest; I had a sore throat from talking too much the evening before. As soon as I had finished my packing I went down to Le Pollet in order to avoid meeting people I knew. A ship had just been launched, and I watched them tow it into harbour. When I returned I felt cross and miserable. Towards three o'clock I went down to take my last look at the sea. It was perfectly calm and I have seldom seen it more lovely; I could hardly bear to tear myself away. I spent the whole time on the beach and didn't go near the pier all day. How passionately one clings to things when one is about to leave them.

The sketch I made from memory was of this sea: golden sky, boats waiting for the tide to return to harbour.

Paris, 15 September

When they asked Sophocles in his old age whether he regretted the pleasures of love, he answered: 'Love? I am as thankful to be rid of it as of a savage and ill-tempered master.'

Monday, 20 September

On architecture. It is itself the ideal, for everything in architecture is idealized by men. Even the straight line is man's invention; it exists nowhere in nature. Lions seek out their lairs, wolves and wild boars find shelter in the depth of the forest, and although some animals build their habitations, they are guided only by instinct, they have no idea of adapting or embellishing their homes. When men build houses they imitate the caves and the airy vaults of the forest, and in periods when the arts are carried to perfection, they produce masterpieces of architecture. In every period contemporary taste and new inventions bring changes that bear witness to the freedom of taste.

Architecture, unlike sculpture and painting, takes nothing directly from nature, and here it resembles the art of music—unless it be claimed that just as music recalls the noises of the outside world, so architecture echoes the dens of animals, the caves and the forest. But this is never direct imitation as we understand the word when we speak of the two arts that copy the exact forms to be found in nature.

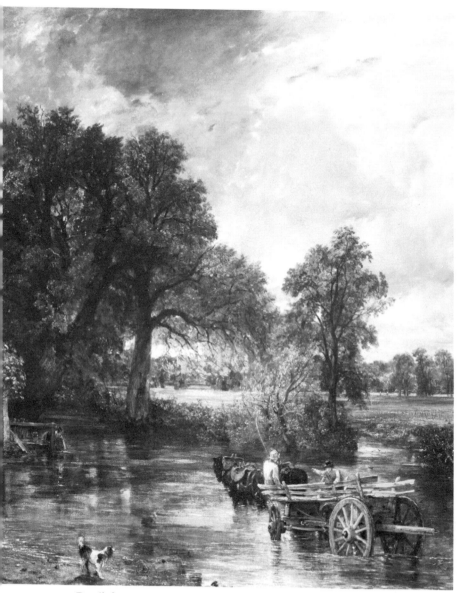

VII. Detail from Constable's 'Haywain', which Delacroix saw at the
Paris Salon in 1823

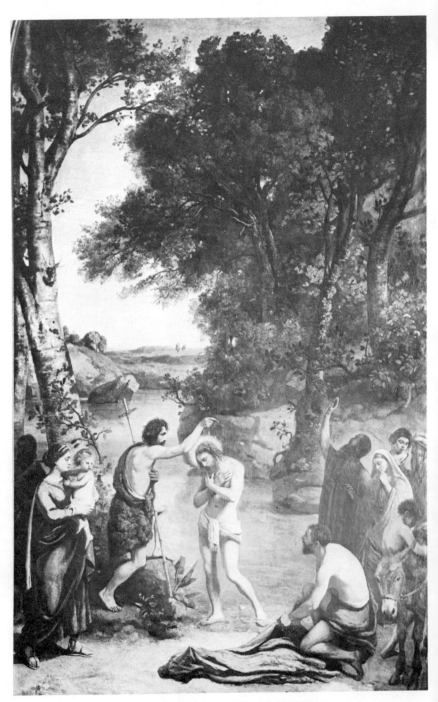

VIII. COROT: BAPTISM OF CHRIST

Tuesday, 28 September

This was the last day on which I was able to work before I fell ill. Villot dropped in out of the clouds and I enjoyed his visit, but after this Tuesday I developed a sore throat and felt so tired that I had to take to my bed. I had been heightening the general tone of my picture, which seemed to me to be becoming too dark in places.

Saturday, 2 October

All this time I have been ill, but in spite of the North wind I've been going out every evening to keep up my strength. Today, on Jenny's advice (she practically took me by the shoulders and pushed me out of the house), I walked out in the middle of the day, along the road to Saint-Ouen and Saint-Denis; I was tired when I came home, but felt a little better, I think. The sight of the hills at Sannois and Corneille brought back many happy memories of the past, and when I saw the omnibus that goes from Paris to Saint-Denis and back I thought how pleasant it would be to go out there sometimes for a walk. I have an intense longing to go into the country, and here I am tied down by this illness.

I have been reading the *Mémoires de Balsamo*, in the evenings. The mixture of brilliant passages with the everlasting effect of melodrama sometimes makes one want to throw the book out of the window, but at other times one becomes so curious to know what is going to happen next that one cannot put it down the whole evening. You cannot help admiring the vitality and imagination of these remarkable books, but it is impossible to class the author as an artist. They lack all sense of modesty and are addressed to a shameless and unbridled century.

Saturday, 9 October

I was saying to Andrieu that you can become master of a subject only if you are prepared to devote to it the necessary patience. A young man risks everything by making a wild rush at his picture. You need maturity to be able to paint.

Monday, 11 October

When my figures in the 'Earth' were too red I put in some high lights with Naples yellow, and although this appears to be going against the natural effect which I feel consists in making the high lights grey or violet, I noticed that the flesh immediately became

luminous, all of which goes to prove that Rubens was right. One thing is certain: if you make the flesh red or purplish and use high lights composed of similar tints, you no longer get any contrast and consequently there is uniformity of tone. And if in addition to this the half-tones are violet, as I am rather apt to make them, it necessarily follows that the whole picture becomes reddish. In that case it is absolutely essential to add more *green* in the half-tones. As regards the golden high light, I cannot explain why, but it is very satisfactory, Rubens uses it everywhere . . . The 'Kermesse' is full of it.

Tuesday, 12 October

Today I saw Mme Rachel in *Cinna*; Beauvallet is not bad as Augustus, especially towards the end of the play. This actor is still improving, yet his face is beginning to show wrinkles and his hair is probably white—although Augustus's wig prevented my being sure of this.

If a man who has been a bad or at best a second-rate actor all his life—or at any rate during his youth, the age of his strength and passion—can become passable or even excellent when he has neither teeth nor breath left, shall not the same be true for the other arts? Do I not write better now than I used to do? These days, no sooner do I take up my pen than ideas come flocking into my mind just as before; not only that, but sequence and proportion, those matters which I used to have such difficulty with in the past, come to me quite naturally and at the time when I am thinking out what I want to say.

Surely it must be the same with painting. Otherwise, why is it that nowadays I never know a moment's boredom when I have a brush in my hand, and feel that if only I had enough strength I should never stop painting, except to eat and sleep? I remember that in the past, at the age when an artist's enthusiasm and imaginative powers are supposed to be at their height, I lacked the experience to profit by these fine qualities and was halted at every step and often discouraged. Nature plays a bad joke on us when she places us in this situation as we begin to grow old. We become completely mature, our imagination is as fresh and active as ever, especially now that age has stilled the mad, impetuous passions of our youth, but we no longer have the same strength; our senses begin to wear out and are more in need of rest than activity. Yet, with all these drawbacks, what consolation we derive from work. I feel so thankful not to have to seek for happiness, as I used to understand the word. What tyranny this weakness of my

body has delivered me from! Painting used to be the least of my pre-
occupations. Therefore we must do the best we can, and if nature
refuses to allow us to work for more than a certain length of time we
must not ill-treat her, but be thankful for what she still leaves us. We
must be less eager in the pursuit of praises that are as empty as the
wind, and enjoy work for its own sake, and for those delightful
hours when we have the deep satisfaction of realizing that our rest has
been earned by a healthy tiredness that keeps our souls in good repair.
This in its turn affects the body and prevents the rust of the years from
tarnishing the nobler sentiments.

Monday, 18 October

All these last days, I have been working with intense concentration
before sending off my paintings, which are being fixed [on to the
wall] tomorrow; I have been at my pictures for seven, eight, and
sometimes nine hours at a stretch.

I think my system of having only one meal a day certainly suits me
much better.

Tuesday, 19 October

They have begun the work of fixing my paintings at the Hôtel de
Ville. I shall be there regularly every day, from now onwards. I shall
scarcely be able to begin retouching before Saturday or Sunday. I
have set a strong guard upon the door of my hall, and Haro sent away
the Prefect, who quite approves of my decision to lock myself in;
this has enabled me to extend the ban to everybody at his express
orders.

I think this room is the darkest of them all and I am beginning to
feel rather anxious about it, especially about the effect of the back-
grounds to the ceiling panels, which will have to be lightened, I think.

Wednesday, 20 October

This morning I had all the scaffolding removed, and felt easier in
my mind when I was able to see the work as a whole. All my calcula-
tions about the proportions and charm of the whole composition
have been justified, and I am delighted with this aspect of the work.
The darknesses are the result of the poor lighting in the hall and were
impossible to foresee to this extent. They can be easily corrected, I
hope.

Friday, 22 October

As I was leaving my hall, about ten o'clock last night, I ran into the Prefect who insisted on walking round with me in front of all those wretched paintings. He then knocked over a wooden frame which fell on my leg and gave me a nasty gash. It does not seem very bad today, but I am worried for fear it should delay me in finishing my work for the Salon.

23 October

Saw M. Cazenave this morning. I have been working at retouching the ceiling all these last few days and alternating between pleasure and boredom. There is an immense amount to be done, but as long as I'm not ill I shall manage it somehow.

On the difference between the geniuses of France and Italy in the arts. At the time of the Renaissance, France was the equal of Italy in elegance and style. How has it come about that this detestable style, this flabby *Carracciesque* manner has gained the upper hand? Unfortunately, at that time painting had not yet been born.[1] All that remains of the period is the sculpture of Jean Goujon. Moreover, it must be remembered that the French genius has a distinct bias towards sculpture, for there have been sculptors in nearly every period and that art has always been more advanced in France than the art of painting, if we except Poussin and Lesueur. When these two great painters appeared, there no longer remained any trace of the great Italian schools—I mean of those schools where naturalness was united to the most profound knowledge. The great schools which came after Raphaël were nothing but academies for the teaching of recipes. Such were the models which Lesueur and Poussin saw predominating in their time, and they themselves were influenced by prevailing fashions and habits, despite that admiration for the antique, which is especially characteristic of them and of all the creators of the Galerie d'Apollon.

I prefer the society of things to that of men. Men are always irritating—affectations, etc. The work is more valuable than the man. Corneille may have been insufferable, and Cousin, too, Poinsot, etc. In a man's work there is a gravity which he himself does not possess. Perhaps Poussin is the man whom one feels to be most present in his work. Productions which are laboured, etc.

[1] It was the accepted opinion in the time of Delacroix that the French School began with Simon Vouet (1590–1649). The French Primitives of the fifteenth century were as yet unknown to the public.

Monday, 1 November

To write learned papers on the arts, to grade and classify them, to make summaries and devise systems for teaching them systematically is a mistake, a waste of time, a false and useless idea. The ablest man can do no more for others than he does for himself, namely, to make notes and observe when nature shows him objects of interest. Such a man is continually changing his point of view. Opinions must be modified from time to time; we never know a master well enough to speak finally and absolutely about him.

If a man of talent wishes to write down his thoughts on the arts, he had better express them in the order in which they come to him. He should not be afraid of contradicting himself; there is more fruit to be harvested from a rich profusion of ideas, however contradictory, than from the neat, constricted, clipped pattern of a work in which a writer has concentrated upon the form . . . When Poussin, in a capricious mood, said that Raphaël was an ass compared with the antique, he knew what he was saying; he was simply comparing Raphaël's drawing and anatomical knowledge with that of the ancients, and he had a good case to prove that Raphaël was ignorant compared with them.

In a different connexion, he might equally well have said that Raphaël did not know as much as he, Poussin . . . But before these paintings, where grace and elegance are so marvellously united, where knowledge and the instinct for composition are carried to a point which no other artist has ever reached, Raphaël would have appeared to him what in very truth he is, superior even to the ancients in many aspects of his art, and especially in those qualities which were entirely denied to Poussin.

Raphaël's invention, by this I mean his drawing and colour, is as good as it can be, not that I mean it is bad, but compared with the marvels produced by Titian, Correggio, and the Flemish painters, it is of minor importance, and so it had to be. It might have been much more so without seriously detracting from those qualities which place Raphaël, not only in the first rank of artists, but superior to them all, ancient and modern alike, for the qualities in which he excels. I would even go so far as to say that these qualities would have been diminished by a more profound study of the science of anatomy, or of effect and the handling of the brush. You might almost say the same of Poussin himself, when you consider the qualities in which he excels. His disregard for colour and the rather dry precision of his touch, especially in paintings in his best manner, tend to heighten the impression of character or expression.

Tuesday, 17 November

Man is a social animal who dislikes his fellow men. Explain this idiosyncrasy: the more intimately a man lives with another human being as foolish as himself, the more he appears to wish to harm this unfortunate individual; domestic bliss. Two friends, who enjoy meeting once a week and miss one another when they are parted, conceive the strongest aversion for each other if circumstances, such as a voyage, compel them to live together for any length of time.

I spent only a very short time at the Hôtel de Ville as I was feeling exceedingly unwell, and I walked the whole way home, but this valiant effort was not successful, although I might perhaps have felt even worse had I not attempted it. However that may be, ever since then, I have had this illness which has set me back a great deal, and has caused me to meditate long and earnestly on the foolishness of slaving to death and then imperilling a whole work through a ridiculous pride in finishing on an appointed day.

Thursday, 25 November

My first walk with Jenny outside the gates, an excellent cure for mind and body. Instead of finding the cold tiring and unbearable, as I usually do, it invigorated me. I am delighted to find that it has done me so much good.

Friday, 26 November

Went for a long walk with Jenny on the outer boulevards, Monceau, the Barrière de Courcelles and the Place d'Europe, then across the vast plain where we nearly lost ourselves; all this is very good for me. I ought to go out every day, before dinner, and dress, and see my friends, and get away from the atmosphere of the studio.

Remember Montesquieu, who never allowed himself to become overtired after he had devoted a reasonable time to writing. This is a faculty denied to the young; it is one we learn by experience and it makes work easier and more systematic.

Saturday, 27 November

They have decided to cover up my ceilings and paintings with paper and to open the room to the public: I am delighted to hear of the arrangement. Now I shall be able to go back to the work at my leisure.

I have been going through all the sketches which I used in the course of the work. How many there are with which I felt eminently satisfied when I began, and that seem weak, inadequate, or badly composed now that the paintings have been carried out! I cannot tell myself too often that it requires an immense amount of labour to bring a picture to the last degree of expressiveness of which it is capable. The more frequently I reconsider it, the more it gains in expression . . . There is no doubt that the touch has to disappear, and that skill in execution must no longer be the chief merit of the work. Yet how often it happens that after putting in all this dogged work, which has meant examining the idea again and again from every point of view, I find that my hand obeys me more quickly and surely when it comes to giving the necessary lightness to the final touches!

Undated

Remember that *grey* is the enemy of all painting. Paintings almost invariably appear greyer than they actually are because they are hung at an oblique angle to the light. For example, the portraits of women, in the Louvre, by Rubens [Anne of Austria and Helen Fourment with a chain], which allow the underlying panel to be seen; Van Eyck and others.

This suggests a way of avoiding long hours spent in retouching: make up your mind before beginning the work. To do this, you must try to be completely satisfied with the figures painted in without a background, it is then easier to keep the background in place at a later stage.

It is absolutely essential that the half-tints in a picture (that is to say all the tones, generally speaking) should be exaggerated. You can safely wager that the picture will be hung with the light falling obliquely on to it and therefore, what is true from one point of view only—when it is facing the light—will inevitably be grey and false when seen from any other angle. Rubens exaggerated, and so did Titian; Veronese sometimes appears grey because he searches too hard for the truth.

Rubens painted his figures first, and afterwards put in the background; he did this in such a way as to make the figures stand out. He must have painted on white grounds. As a matter of fact, the local colour ought to be transparent; although only a half-tint, it imitates in the beginning the transparent effect of the blood showing beneath the skin. Note that in his sketches, the light passages in the accessories are always painted and almost finished over a simple rub-in.

1853

Paris, 2 January

Colour is nothing unless it is appropriate to the subject and in-
creases the effect of the picture through the power of the imagination.
Let men like Boucher and Vanloo use light and charming tones, etc.

Monday, 10 January

It often happens that I feel ill in the morning, or that I imagine I am
feeling ill until the moment when I begin to work; I admit that boring
work might not have the same effect, but is any work too dull to
fix the attention of the man who gives himself up to it? I was saying to
Trousseau[1] that I am not like those musicians who spend their time
abusing music, etc. He said that he was passionately devoted to his
profession, which is one of the most disgusting that a man can follow.
He is a man who loves pleasure, therefore he must enjoy his comfort
and yet everyday, at this time of the year, his alarum-clock rouses him
early and sends him hurrying off to his hospital to change dressings
and feel pulses and what is worse, to do this for people with disgusting
illnesses, in the foul atmosphere where he spends his mornings.

15 January

Left hand of Talma: prepared this with deep, reddish, and as yet
unbroken tones. When this undercoating had been dry for some
time, I applied over it a very transparent glaze with *reddish-brown*
and *white*, and *raw umber*, *Prussian blue*, and *white*—this immediately
gave an exceedingly subtle half-tint for flesh. When the warm
shadows and high lights had been put in with suitable tones the effect
was complete. (Could be successfully applied to every undercoating
prepared after the manner of Titian with *Sienna* or *brownish-red* tones,
etc., for instance, the little 'Andromeda'.)

27 January

I find it much less difficult to write than to paint my pictures. I need
to pay far less attention to composition in order to be fully satisfied
with something I am writing than when I want to satisfy myself fully
in painting. Without realizing it, we spend our lives practising the art
of expressing our ideas in words, for when a man is considering how
best to ask a favour, to rid himself of a bore, or to melt the heart of a

[1] Dr. Armand Trousseau, a distinguished physician.

proud lady, he is unconsciously studying the art of literature. We write letters every day that require our whole attention and sometimes our entire future depends on them. Thus a superior man will always write well, especially when he is dealing with a subject which he understands. That is why women write as well as the greatest men. It is the only art that women with small talents can practise . . . They have to contrive, to know how to be charming and tender, to touch people's hearts, to receive and dismiss them. Women's presence of mind and their extreme lucidity in certain circumstances make them marvellously well adapted to this art. The proof is that since they are not remarkable for any great powers of imagination they are past-mistresses in the art of giving expression to trifles. A letter—some little note which requires no great labour in the composition—in such things they are triumphantly successful.

Friday, 18 March

After the meeting of the Council,[1] I saw Rubens's admirable 'Saint Just'. When I tried to recall it next day by means of a sketch from the engraving, I was able to confirm that Rubens's smooth and finished execution—one in which there are no sharply contrasting planes—is produced by the use of a fine pointed brush instead of a flat one. This method tends to give a rounder execution, like that of Rubens, and at the same time it more quickly gives a sense of finish. Moreover, when using panels, pointed brushes are almost a necessity, the smooth and rather soft touch leaves less roughness in the surface of the paint. With ordinary sables and flat brushes you tend to get a hardness, a difficulty in blending the colours that is almost unavoidable; the tracks of the brush leave grooves that are impossible to conceal.

Sunday, 27 March

To those partisans who believe exclusively in form and contour.

Sculptors are your superiors. When they have established the form they have fulfilled every condition of their art yet, like the partisans of contour, they also study the nobility of forms and composition. You do no modelling, because you do not understand chiaroscuro, which only exists when you exactly fix the relationship of light and shade. With your slate-coloured skies and dull, flat flesh-tones you

[1] The meeting of the Municipal Council where Delacroix wasted so much of his time.

cannot produce an effect of projection. As for colour, which is a part of painting, you pretend to despise it, and no wonder . . .

Monday, 28 March

To Andrieu:

'I do not deserve as much credit for hard work as you might imagine; it is the greatest pleasure I can give myself . . . When I am at my easel I forget all the worries and cares that beset mankind. In this world the chief thing is to defeat boredom and sorrow, and I am sure that the man who chooses an occupation like painting out of all the possible forms of recreation, will find attractions that the ordinary run of pleasure does not afford. One of its greatest charms is to remember the time spent in painting, after the work is done. Recollection is not usually the best part of a pleasure, more often than not one is left with a sense of regret—and sometimes even worse. Therefore, work all you can; therein lies the whole of philosophy and the best way of organizing one's life.'

1 April

The memory of that enchanting music (Rossini's *Semiramis*) is still filling my mind with quiet satisfaction and gentle thoughts, on this, the following day, 1 April. All that remains in my mind is the impression of the sublime in which the work abounds. When I am in the theatre the padding, the obviousness of the plot, and the actor's mannerisms combine to dull the impression, but once away from actors and theatre, memory blends the general effect into a harmony and divine passages return to fill me with pleasure and remind me of my lost youth.

Something which no one guessed when Rossini appeared and for which, amid so much criticism, they forgot to attack him, was the extent of his romanticism. He broke with the ancient formulae that, until his time, had been illustrated by the greatest composers. It is only in Rossini that you find those moving introductions, those passages, often so swift, yet capable of summarizing a whole situation and free of all conventions. It is a marked characteristic of his talent and the only one to be proof against imitation. He is not a colourist in the style of Rubens—here I am still speaking of those mysterious passages, for elsewhere he is cruder or more conventional, and then he does resemble a Fleming—but throughout the whole of his work there is an Italianate grace, and even an abuse of it.

Sunday, 3 April

I am still working to finish my pictures for the Salon, and the other small pictures for which people are asking me. People have never been so eager for my work. It seems that my paintings are a recent discovery.

Monday, 4 April

Went to call on Mme de Rubempré[1] this evening, in her new house. I am delighted with it, it will be perfectly charming and I am glad for my old friend's sake. She is enchanted with her curios and furniture, and says that her servants are all perfection. She remarked, indeed we both did, that happiness always comes too late. It is like the little vogue for my pictures; after despising me for so long, the patrons are going to make my fortune.

Wednesday, 13 April

One always has to spoil a picture a little in order to finish it. The last touches, which are given to bring the different parts into harmony, take away from the freshness. It has to appear in public shorn of all those happy negligences which an artist delights in. I compare these murderous retouchings to the boring *ritornellos* that end every melody and the insignificant passages which a composer must place between interesting parts of his work so as to lead on from one theme to another, or display them to advantage. At the same time, retouchings are not so harmful as one might suppose, so long as the picture is well thought out and executed with real feeling. By effacing the separate touches (the first as well as the last), time restores to the picture its final unity.

Friday, 15 April

To the exhibition of paintings by Courbet.[2] I was amazed at the strength and relief of his principal picture—but what a picture! what

[1] Delacroix's cousine Alberthe, an elegant and much sought-after lady. She was the Mme Azur of Stendhal's *Souvenir d'Egotisme*.

[2] The first meeting between Delacroix and Courbet, the rising star. Delacroix, although he could appreciate Courbet's talent, could not like the man himself. In fact he was horrified by him as he was by Balzac, and for the same reasons. They were geniuses of a profoundly different nature. The principal picture, here referred to, is the celebrated 'Baigneuses', now in the Museum at Montpellier. The picture created a scandal.

a subject to choose! The vulgarity of the forms would not signify, the vulgarity and futility of the idea is what is so abominable, and even that might pass if only the idea (such as it is) had been made clear! But what are the two figures supposed to mean? A fat woman, back-view, and completely naked except for a carelessly painted rag over the lower part of the buttocks, is stepping out of a little puddle scarcely deep enough for a foot-bath. She is making some meaning-less gesture, and another woman, presumably her maid, is sitting on the ground taking off her shoes and stockings. You see the stockings; one of them, I think, is only half-removed. There seems to be some exchange of thought between the two figures, but it is quite unin-telligible. The landscape is extraordinarily vigorous, but Courbet has merely enlarged a study that can be seen near his picture; it seems evident that the figures were put in afterwards, without any con-nexion with their surroundings. This links up with the question of harmony between the accessories and the principal object, a harmony lacking in the majority of the great painters. It is not, however, the greatest weakness of Courbet. There is also a 'Woman asleep at the Spinning-wheel' that shows the same qualities of vigour and imita-tion. The spinning-wheel and distaff—admirable; the dress and arm-chair—heavy and ungraceful. In the 'Two Wrestlers', the action is weak, proving the artist's lack of inventive ability. The background kills the figures. A strip, at least three feet wide, needs to be cut off all round.

O Rossini! O Mozart! O inspired genius in every art, you who draw from things only so much as you need to reveal them to our minds! What would you say before such pictures? O Semiramis! O entry of the priests to crown Ninias!

Saturday, 16 April

They brought Millet to my studio this morning. He spoke of Michelangelo and the Bible which, he says, is almost the only book he reads. This explains the rather pretentious look of his peasants. More-over, he is a peasant himself and boasts of it. He belongs to that con-stellation or crew of bearded artists who made the revolution of 1848 or encouraged it, thinking, apparently, that it would bring equality of talent as well as equality of wealth. But Millet himself seems to me to be above this level, and the small number of rather similar paint-ings by him which I have seen show a deep, if pretentious, feeling struggling to reveal itself through an execution that is either dry or confused.

Wednesday, 20 April

To Princess Marcelline's house.[1] Arrived in time to hear some of the music. Found Mme Potocka there, looking extremely handsome. Came home with Grzymala; we talked of Chopin. He said that Chopin's improvisations were far more daring than his finished compositions. They probably take the place of the sketch for a picture compared with the finished work. No! one does not spoil a painting by finishing! Perhaps there may be less scope for imagination once the work has been sketched out. You receive a different impression from a building under construction where the details are not yet shown, than from the same building when it has received its full complement of ornamentation and finish. It is the same with ruins, which appear all the more impressive because of the missing portions; their details are worn away or defaced and, as with buildings under construction, you see only rudiments and vague suggestions of mouldings and ornamentation. A finished building encloses the imagination within a circle and prevents it from straying beyond its limits. Perhaps the only reason why the sketch for a work gives so much pleasure is that each beholder can finish it as he chooses. Artists gifted with very strong feeling, when they consider and admire even a great work, are apt to criticize it not only for the faults it actually possesses, but also for the way in which it differs from their own feeling. When Correggio made his famous remark: '*Anch' io son pittore*', he meant, 'This is a fine painting, but I should have put something into it that is not here'. Thus an artist does not spoil a picture by finishing it, but when he abandons the vagueness of the sketch he reveals his personality more fully, thereby displaying the full scope of his talent, but also its limitations.

Thursday, 21 April

To the sale of Decamps's pictures . . . I was deeply impressed at seeing several works or sketches which gave me a higher opinion of his talent than I had had before. The drawing of 'Christ before Pilate', the 'Job', the small 'Miraculous Draught of Fishes', one or two landscapes, etc. When you take a pen to describe such expressive things you feel at once how impossible it is to give any

[1] Princess Marcelline Czartoriska and Countess Potocka were famous in the fashionable world for their beauty and with Count Grzymala and some others formed the inner group of Chopin's admirers. The Princess was a favourite pupil.

idea of them in words, so strong are the boundaries which separate the different fields in the arts.

The same evening: the Mozart trio for viola, piano and clarinet; I delighted in some passages, but the rest seemed to me monotonous. When I say that works like this can give only a few moments' pleasure I certainly do not mean that the fault always lies in the work, and, where Mozart is concerned, I am sure that I am the one to blame. In the first place, some forms have become antiquated; they have been hackneyed and spoiled by the composers who came after him, a thing that is bound to destroy the freshness of any work. Indeed, it is astonishing that some parts should have contrived to remain so delightful after such a long time (time moves fast with artistic fashions), and after so much good and bad music has been based on this enchanting model. Another reason why a work by Mozart does not grip us with the feeling of sheer novelty that we find in Beethoven or Weber is that, in the first place, the latter are our contemporaries, and in the second, they have not the perfection of their illustrious predecessor. This is exactly the effect which I was discussing on the preceding page —the effect of the sketch compared with that of the finished work; the ruins of a great building, for example, or its rudimentary stages, compared with the same building at its completion. Mozart is superior to all others in the art of carrying his ideas through to their conclusion. The beauties of Racine do not shine beside the great writers who sometimes lapse into bad taste or spoil their effects; yet this seeming lack of brilliance in the poet and the musician is the very quality that consecrates them for ever in the admiration of their fellow-men and raises them to the greatest heights.

After such men (or on a level with them if you prefer) come those whose works actually show considerable lapses, defects which perhaps render them unequal, but do not detract from the impression they produce except in so far as certain parts are only relatively successful. Rubens is full of such lapses or hasty work. The superb 'Flagellation' at Antwerp for instance, with the ridiculous executioners; also the 'Martyrdom of Saint Peter' in Cologne, which has the same drawback—the principal figure admirable, and all the others bad.

Considered in one way, Rossini belongs to this group. After the first novelty, when people are willing to accept almost anything from an artist, as they did with Rossini, and the subsequent period of boredom and reaction when they see almost nothing but his faults, comes a time when distance consecrates his beauties and makes the spectator indifferent to his shortcomings. This is what I experienced with *Semiramis*.

26 April

During the ball at the Tuileries last night, we were discussing the marriage of an august personage. I said to Redon that one of the greatest weaknesses in the French character is that everyone lacks a sense of duty, and that this may have been chiefly responsible for the long list of catastrophes and defeats in our history. No one in France is punctual for appointments or considers himself absolutely bound by his word; hence the elasticity of conscience which you find in any number of people. We think that our duty lies in anything that pleases or benefits us. In England, on the other hand, where they are not so easily carried away by the impulse of the moment, every individual feels the need for a sense of duty. At the Battle of Trafalgar, Nelson did not speak to his sailors of glory and posterity, he simply said in his signal, 'England expects that every man will do his duty'.

When I left Boilay's house tonight, at half-past twelve, I rushed off to the Théâtre des Italiens to have an ice as all the cafés were closed. I finally managed to get one at the café in the Passage de l'Opéra on the boulevard, where I met M. Chevandier, who walked home with me. Among other remarks about Decamps, he told me that he finds it impossible to work from a model when he is painting his pictures—also, and this seems to me a result of the same characteristic, that he is exceedingly timid when he works from life. You must have complete freedom of imagination when you are painting a picture. The living model, compared with the figure which you have created and harmonized with the rest of the composition, is apt to confuse you and to introduce a foreign element into the ensemble of the picture.

Thursday morning, 28 April

You need to make a host of *sacrifices* in order to give painting its full value, and I think I do make a great many, but I cannot stand it when an artist shows his hand too much in his pictures. Yet many exceedingly fine things have been conceived by exaggerating the emotional effect: Rembrandt's pictures are an example of this—also the work of our own Decamps. Such exaggeration comes naturally to them and is not at all disturbing in their work. I am thinking about this as I look at my portrait of M. Bruyas;[1] Rembrandt would only have shown the

[1] Now in the Montpellier Gallery, presented by Alfred Bruyas, with the rest of his collection.

head, the hands and clothes he would scarcely have indicated. I do not say that I prefer the method that allows every object to be seen according to its importance, for I have an immense admiration for the Rembrandts, but I feel it would be clumsy if I were to attempt such effects. Here, I am in sympathy with the Italians. Paolo Veronese is the *ne plus ultra* of rendering in every part of a picture, and so is Rubens. In subjects where pathos is required the latter may perhaps have an advantage over the glorious Paolo, for he knows how to focus attention on the principal subject and increase the force of the expression by using certain exaggerations. On the other hand there is something artificial in the method and we are just as conscious of it, if not more so, as we are of Rembrandt's sacrifices and the vagueness which he uses so noticeably in less important passages. Where my own work is concerned, neither method satisfies me. My aim, and I think I have often achieved it, is to keep the means unnoticeable and yet to stress the interest in a suitable way; this, once again, can be obtained only by sacrifices, but they must be made in a manner infinitely more subtle than Rembrandt's if they are to satisfy me.

At the moment I cannot recall among the great painters any absolute model of the perfection I require. Poussin never sought it and did not want it; he planted his figures side by side, like statues—did this come from his habit (according to what they say) of making small models so as to get the shadows correctly? But although he may have gained this advantage, I should be more grateful to him if he had obtained a more closely linked relationship among his figures, even if it had meant less accuracy in the observation of the effect. Paolo Veronese is infinitely more harmonious (here I am speaking only of the general effect), but in his pictures the interest is scattered. For one thing, concentration of interest is less necessary in compositions like his, which are often conversation pieces—episodic subjects. In paintings where there are fewer figures his effects are apt to be somewhat trite and conventional. He distributes the light more or less uniformly and here, as with Rubens and many other great painters, we find a constant repetition of certain habits of execution. No doubt the great number of commissions that these artists received led them to use such conventions. They were craftsmen to a far greater extent than we imagine, and thought of themselves as such. Artists of the fifteenth century painted saddles, banners, and shields, as did the makers of stained glass windows, and this profession was merged with that of the painter, just as today it is merged with that of house-painting.

It is the glory of the two great French painters, Poussin and Lesueur,

that they made successful attempts to break away from such common-places. Not only did they revert to the simplicity of the Flemish and Italian primitive schools, where frankness of expression was never spoiled by habits of execution, but they opened up entirely new fields for the future. And although they were immediately followed by decadent schools, where tyranny of tradition, and especially the custom of going to Italy to study contemporary masters, soon stifled the urge to study the truth, the two great masters prepared the way for the modern schools that have broken with convention and have gone to the very source to find the effect on the imagination that belongs to the realm of painting. If later schools have not followed exactly in the footsteps of these great men, they have at least recognized their passionate protest against academic conventions, and hence against bad taste. David, Gros, and Prud'hon, whatever differences we may notice in their styles, kept their eyes fixed upon the two fathers of French art; in short, they upheld the independence of the artist in the face of tradition by teaching him to respect whatever is useful in it, and at the same to have the courage to stand by his own feeling and to prefer it above all else.

Poussin's biographers, and there have been many, have not sufficiently considered him as one of the greatest innovators. The style of painting with which he grew up, and against which he protested in his works, covered the whole realm of the arts and in spite of his long career its influence survived him. The decadent schools in Italy joined hands with the schools of Lebrun and Jouvenet, and later, with men like Vanloo and their successors. Lesueur and Poussin did not stem this torrent. When Poussin arrived in Italy he found the Carracci and their followers lauded to the skies—*dictators of glory*. No artist's education was considered complete without the visit to Italy, but this did not mean a study of such true models as the Antique, or the sixteenth-century masters. The Carracci and their pupils had the monopoly of fame, and had become dictators of glory, that is to say they praised only what resembled their own work and used all the authority of their position as the leaders of the reigning fashion to plot against anything that tended to break out of the ordinary rut. Domenichino, himself a product of this school, but one who was led by the sincerity of his genius to seek for truth of expression and effect, became a target for universal hatred and persecution. They even went so far as to threaten his life, and the jealous fury of his enemies forced him to live in hiding, so that he almost entirely disappeared. This great painter, who combined that true humility which is almost

inseparable from great talent with a gentle and melancholy nature, was probably brought to an early death by the universal conspiracy against him.

When this relentless war was at its height, with every man's hand turned against one who offered no defence, not even through his works, Poussin, still unknown and outside the cliques . . .

This independence of all convention is very marked in Poussin—in his landscapes, etc. As a scrupulous and poetic observer of history and the emotions of the human heart, Poussin is unique! . . .

Friday, 29 April

Returned to the Salon with E. Lami to make some inquiries, then on to see Decamps, whose studio was in utter confusion. He showed me some admirable things, including the enlarged version of his 'Job', intended for the Ministry; it is quite as fine as the small one and I think that he has carried it further. He also showed me a 'Good Samaritan at the Inn'. In the foreground, the sick man is being carried into the inn, the horses that bore him and his benefactor are being led away, the servants have their heads out of the window, in fact, all the characteristic details. The effect of sunlight is always the same and always delightful. This never-failing power of creating an impression with monotonous repetition is one of the great privileges of genius. Another picture sketched in the same style, 'Interior of an Italian Pottery'. On the easel, a large work, the 'Flight of Lot', which I did not much care for. Lastly, a charming little sketch, for an 'Agony in the Garden', hundreds of figures, delightful effect.

Sunday, 1 May

This evening M. and Mme Moncey took me to call on M. Gentil, where I saw the lovely Mariette Lablache,[1] and listened to some rather good music—but chiefly, I looked at the lovely Mariette. She outshone everyone around her, like a goddess among ordinary mortals. The northerners seemed very puny beside her southern splendour. Came home very late, and I left before the end.

Monday, 2 May

Boissard tells me that he met Rossini in Florence, where he is dreadfully bored.

[1] Mariette Lablache, later Baronne de Caters, was a daughter of Lablache the famous singer.

Dined at Pierret's house, with Riesener, his friend Lassus, Feuillet, and Durieu. I came away with a miserable feeling that these fellows secretly dislike me; it persisted throughout the following day and I was only able to forget it while I was working. There is a good deal of ill-feeling underlying all this, which they do not always take the trouble to hide . . . Nowadays I feel isolated among these old friends! They cannot forgive me for a number of things—first and foremost, for the greater advantages that fortune has given me.

. . . I find myself agreeing with Voltaire; I have always detested people who made it their business to collect and repeat anecdotes, especially anecdotes about current events, which were precisely those that used to annoy Voltaire. Poor Beyle made a mistake in stuffing himself with them and it is one of Mérimée's weaknesses—one reason why I find him so boring. Anecdotes must sometimes come into a conversation, but to be interested in nothing else is simply curio collecting. And that is another group I detest; the collectors who sicken one of beautiful things by showing them in such profusion and disorder that it tires the eyes to look at them, instead of allowing a few pieces to stand out by careful selection and by showing them in a becoming light.

Tuesday, 4 May

Nieuwerkerke invited me to the Louvre to hear a lecture on art, or on the progress of art, given by a certain M. Ravaisson. Great gathering of artists, semi-artists, priests and women. After waiting politely for Princesse Mathilde to arrive, with another long pause for M. Fould, the professor began in a shaky voice and a slight Gascon accent. You need to come from Gascony to be so certain of everything and to give a lecture like this one—in any case, I could only hear half of it. It was pure neo-christianity. The Beautiful is to be found at one period only (a period situated, almost exclusively, between the thirteenth and fifteenth centuries); Giotto and, I think, Perugino are its culminating points; Raphaël shows a falling off after his early work; about half the Antique is praiseworthy, but we must hate it when it becomes obscene—he reproached it with the abuses that were made of it in the eighteenth century. The Saturnalia of Boucher and Voltaire who, according to the professor, showed a distinct preference for immodest paintings, ought to be enough to make us hate all that side of the Antique, the satyrs, the hunted nymphs, all the erotic subjects that are unhappily inseparable from it. No artist can be great without the friendship of a hero, or of some great mind of a different

kind. Phidias is so great only because of his friendship with Pericles . . . Without Dante, Giotto would not have amounted to anything. What an extraordinary idea of friendship! He began by saying that Aristotle puts either at the head or at the end of his treatise on aesthetics, a statement to the effect that all the finest arguments on the Beautiful never have and never will help anyone to discover it. Everybody must have wondered what good the professor thought he was doing. After describing Voltaire's opinions on the arts he haled poor Baron de S . . . before his tribunal, who could have given him some good answers if he had had the opportunity. The wretched Baron, according to the professor, expects the modern advent of the Beautiful only when government by two chambers has gone the rounds of Europe, and the Garde Nationale is established in every country. This was the biggest joke of the evening, and caused an explosion of 'vestry' laughter—the kind peculiar to the clergy, whose black cassocks could be seen here and there in this very mixed audience.

After the first part of the lecture, of which the above is a very faint summary, I slipped away, perhaps rather disgracefully, but I was encouraged by seeing one or two other people who, like myself, felt that they had been sufficiently edified on the subject of the Beautiful.

From there I walked round to see Rivet in marvellous weather and feeling exceedingly glad to be able to stretch my legs after being cooped up for so long.

Champrosay, Sunday 8 May

All day long, I have been trying to straighten out my article on Poussin. I begin to see that there is only one way to finish it—if I ever do—and that is to give up even thinking about painting until it is done. This infernal business takes much more concentration than I usually give to painting, and yet I write very easily; I often fill whole pages without having to alter anything. I even seem to remember putting down in this note-book that writing came more easily to me than my own work. My trouble is that I have to confine the article to a certain length in which I'm obliged to cover a great many different subjects. I need a method to co-ordinate the different sections and to arrange them in proper order, especially since I have made a great many notes, so as to remember everything that I want to bring into the article.

It seems as though there is nothing for it but to concentrate steadily on the work. I dare not even think of painting, for fear of sending the whole thing to blazes! I do nothing but dream of articles like those

in the *Spectator*:[1] quite short, three or four pages perhaps or even less, on the first subject that comes to mind. I swear that my brain could turn them out *ad lib.*, as though from an inexhaustible mine.

Monday, 9 May

I have been at Champrosay since Saturday. I go for solitary walks in the forest until they have done my room and I am able to get back to the famous article. Seeing the Antin oak at a distance, looking so ordinary that I did not recognize it at first, I remembered something that I wrote in my Journal about a fortnight ago, on the effect of the sketch compared with the finished work. I said that the sketch for a picture, the early stages of a great building, a ruin, in fact every work of imagination of which portions are missing, must have a stronger effect on the mind in proportion to what our imaginations have to supply in order to gain an impression of the work. What is more, flawless works like those by Racine or Mozart do not at first sight make so much impression as those by less accurate or even careless geniuses, whose outstanding passages seem all the finer because they occur beside others that are undistinguished, or frankly bad.

As I stand beneath this fine and beautifully proportioned tree (the Antin oak) I find fresh evidence to support this idea. When one is far enough away to see it as a whole, it does not seem particularly big, but when I stand beneath its branches the impression is completely changed. Now that I only see the trunk (which I am almost touching) and the springing of the great limbs, outstretched overhead like the huge arms of some giant of the forest, I am astounded at the grandeur of its details. In short, I feel it to be great and even terrifying in its greatness.

Is disproportion one of the conditions that compel admiration? If Mozart, Cimarosa, and Racine are less striking because of the perfect proportion in their works, do not Shakespeare, Michelangelo and Beethoven owe something of their effect to the opposite quality? That, at any rate, is my opinion.

The Antique is never surprising, never gives this gigantic and extravagant effect. We feel at ease with its admirable creations; only after reflection do we see them grow and take their unrivalled position on the heights. Michelangelo astounds us and fills us with a sense of awe (which is one kind of admiration), but before long we notice

[1] Delacroix admired Addison's *Spectator*, and enjoyed copying extracts into his notebook.

disturbing incongruities caused in his case by hasty work, either be-
cause he attacked it with so much passion, or because of the weariness
that must have overcome him at the end of an impossible task.

This weariness is evident in his statues, as we should realize for
ourselves even if historians did not take care to tell us that he was
often disgusted with his work when it came to finishing, because (so
they say) he found it impossible to realize his sublime conceptions.
It is easy to see from parts that are left in the rough—feet still buried
in the block, for example, and material for other parts lacking—that
the fault of the work lies in its conception and execution, rather than
in the extraordinary demands of a genius who was made to reach the
heights and stopped short before he was satisfied. It is more probable
his conception was vague, and he counted too much on the inspira-
tion of the moment to develop his thought. If he often broke off in
despair, it is because he was actually incapable of carrying the work
any further.

Monday, 10 May

In the morning, I struggled with the Poussin . . . Sometimes I feel
inclined to throw the whole thing up, sometimes I go at it in a kind of
fury. Today has not been so bad for the poor unfortunate article.

I made a start by setting it out clearly on to large sheets of foolscap
and dividing the principal headings into paragraphs; then, at midday,
I went out, feeling very pleased with myself and with my courage
in attacking my article in this way.

It was heavenly in the forest. The sun was shining, it was warm but
not too hot and as I came into the clearings, the air was deliciously
scented by the grasses and moss. I went down a little out-of-the-way
path near the corner of the Marquis's wall, hoping that it would lead
me into the one which runs uphill from the road to join the path to
the Prieur oak, but in spite of fighting my way through brambles
and undergrowth I failed to reach it. I came home by an easier but
very much overgrown track through part of the forest which I think
adjoins the Marquis's house. On the way I sat down by his park wall,
but on the side opposite to the entrance to the forest, and made a
sketch of an oak tree, so as to verify the arrangement of the branches.

When I reached home I began to read the Journal. It's not up to
much regarded as a piece of literature but I don't find it boring,
and that is the main thing. About four o'clock, instead of going out
again, I tried my hand as a glass-painter and painted an old piece of
plate glass.

In the evening I walked towards Soisy down a little lane and discovered some lonely and rather charming places; I made love to a delightful Angora cat which followed me and allowed itself to be petted.

Thursday, 12 May

I've put in a lot of work on this damned article. I've set out everything I want to say, in pencil, as clearly as I can, on large sheets of foolscap. I'm beginning to think that there is a good deal to be said for Pascal's plan of writing down each thought on a separate sheet of paper, especially for someone like myself who has had no time to learn to be an author. All the headings and sub-headings could then be spread out like a game of patience which would make it easier to decide their proper order. Physical fitness and comfort have more effect on the mind than one imagines; some positions may be more favourable to thought than others; they say, for example, that Bacon used to hop about on one leg when he composed his essays; that ideas came to Mozart, Rossini, and Voltaire when they were in bed, and to Rousseau, I think, while he was walking in the country.

Friday, 13 May

Made an attempt at the article, but after I'd written a few lines to use as a heading for Part 1 (I want to do it in two parts, the first biographical, and the second a review of his talent and works), I developed a bad mood and spent the rest of the morning reading and sleeping. Then, in perfect weather, such as we've not been having lately, I took Jenny for a long walk in the forest. We followed the Hermitage avenue as far as the foot of the great oak, where we sat down to rest; we had already been into the Hermitage, part of which is for sale. This is just the sort of country-house I'd like to have! The garden is charming—really only a kitchen garden and full of old trees that have seeded themselves everywhere. The old gnarled trees, twisted by the years, still bear a profusion of splendid fruit and flowers among buildings that have been ruined, not by time, but by the hand of man. How sad it makes one feel to see this cruel scene, wrought by the blind rage for destruction that has marked the periods of our quarrels. Destroy! uproot! burn! Fanatics of liberty can do this as well as religious fanatics, and this is where both begin when they are let loose, but there the savage impulse ends . . . To build up

something lasting, to mark the journey through life by something other than by ruins is what the blind mob never learns. Then I remarked how works that owe their existence to a spirit of continuity, that are conceived with the idea of permanence, and executed with proper care, bear the mark of strength even in their ruins, which seem almost impossible to obliterate entirely. The ancient corporations, and especially the monasteries, must have thought themselves eternal, for they built to last for centuries. The ruins of the old walls put to shame the jerry-built additions of later years. There is something gigantic about their proportions compared with those of the buildings which private individuals are putting up before our eyes every day.

I reflected that it is much the same with works of art and certainly with sculpture, where the clumsiest restoration cannot hide what remains of the original work. And even in painting, fragile though it is and sometimes quite ruined by incompetent retouching, the composition, the character of the work, and a certain ineffaceable stamp of genius will show the hand and conception of a great artist.

Saturday, 14 May

Spent a long morning copying out my notes for the biographical part of the Poussin article. There are very few days when I can settle down to it with any enthusiasm; sometimes I loathe the very thought of it. However I persevere, and hope to get it finished one day; it provides an excuse for staying on here a little longer.

In the evening I went down to the river and walked along the bank towards the bridge. I love the grandeur of this stretch of water, and its peacefulness. I had never seen it looking so picturesque. Towards sunset, it reminded me of the colours of a Ziem. Afterwards I took a few turns in the garden, the soft moonlight blending with the fading daylight.

For a few moments during my solitary walk I felt completely happy. I realized more than ever before, as I walked by the river, that this feeling of melancholy which the sight of nature engenders is a necessity of our existence. This vague feeling, which every man has probably imagined to be unique to himself, finds its echo in all sensitive natures. Modern artists are wrong only when they allow it too important a role in their compositions. The originators of the style are the Northern poets, and especially the English; in their countries everything inclines to reverie—calmer temperaments, and nature in a sterner mood.

Monday, 16 May

Girardin still firmly believes in the coming of the Millennium, and one of the ways of bringing this about, one which he loves to dwell on, is the mechanical ploughing on a vast scale of the whole of France. He believes that it will add greatly to men's happiness if they are relieved of work. He pretends to think that all those unhappy creatures who now snatch a living from the soil (painfully, I admit, but feeling nevertheless that their energies and patience are well employed) will be happy and contented when the ground that was their home, where their children were born and their fathers buried, is no more than a factory exploited by the great arms of a machine and yielding up most of its produce to the unclean hands of God-less speculators. Will the steam-engine stop at the doors of churches and cemeteries? Will Frenchmen returning to their homes after many years be reduced to asking where their villages stood, and where the sites of their fathers' graves? Villages will become as useless as every-thing else. Countrymen who cultivate the soil need to live on the spot where their care is wanted every moment of the day, but new towns will have to be built to house the idle, disinherited crowds who will no longer have work to do in the fields, and great barracks must be constructed where they can live crowded higgledy-piggledy together. And when they are settled side-by-side, the Fleming and the man from Marseilles, and the Norman next to the Alsatian, what will they find to occupy them? They will have nothing to do but read the newspapers, not to learn whether the harvest has been good in their district, their own beloved fields, or to discover the prospects of selling their corn and oats and grapes at a good price, but to see whether the price of stock in the Universal Estates Company is going up or down. They will own paper instead of land! They will go to billiard-saloons to gamble away pieces of paper with their unknown neighbours, people with different languages and customs. And when they are finally ruined will they have even the chance that remained to them when hail had destroyed the fruit or crops—the chance to mend their fortunes by patience and hard work, or at least to draw some consolation from the fields which they watered so freely with their sweat, or the hope of better years to come?

O shameful philanthropists! O philosophers, without heart or imagination! Do you think that man is a machine like the rest of your machines? You deprive him of his most sacred rights on the pretext of saving him from work which you pretend to consider beneath his dignity, but which is, in fact, the very law of his existence, that law

which not only lays upon him the obligation to create his own resources against hunger, but raises him in his own eyes and occupies the short years of his life in a way that is almost holy! O wretched journalists, you scribblers and schemers! Instead of trying to turn mankind into a mere herd of animals, leave them their true inheritance, their love and devotion for the soil! And then when new invasions threaten what they still call their country, they will rise up joyfully to defend it. Men will no more fight to defend the ownership of machines than those poor Russians, poor regimented serfs, would work for their masters and Emperor when they came here to avenge their quarrels. Alas! poor peasants! Poor villagers! The false doctrines they have taught you are already bearing too much fruit! If the machines are not yet on the land they are already at work in your deluded minds. Your ideas of equal ownership, of leisure, and even of constant amusement are realized in these shameful schemes. Countrymen are already scrambling to leave agricultural work on the slenderest of hopes and rushing to the towns where they find nothing but disappointment. Once there, they finally pervert the feeling of self-respect that love of one's work inspires, and the more they are fed by the machines, the more they become degraded! A noble sight in this best of centuries, these human cattle, fattened by the philosophers!

Thursday, 19 May

A walk in the afternoon with Jenny by the entrance to the gardens, and a lovely view looking over towards Corbeil: great clouds on the horizon, with the sun shining full upon them. We stopped to admire the little spring near the wash-house and the great poplars, and then came home to dinner together.

To the Jardin des Plantes in a very bad mood. For a moment, I thought it was going to rain and almost decided to go home as soon as the meeting was over. However, when I arrived at the Hôtel de Ville I found that the meeting was cancelled, so I had lunch in the town and feeling rather better, walked to the Jardin des Plantes where I made some studies of lions and trees for the picture of Rinaldo [and Armida]. It was unpleasantly hot and the crowd was most annoying. I finally left at about a quarter to two and came home along the river.

I always love the view of the river and its banks as I come home. Beside the river I feel as though I were casting off my chains. I seem to leave all my troubles behind when I cross this piece of water.

While I was lunching I read Peisse's article, in which he reviews the Salon as a whole and inquires into the trend of modern art. He is quite right in seeing a tendency towards the *picturesque* which he considers to be a sign of inferiority. Yes, if it were only a question of arranging lines and colours to create a visual effect an arabesque would do as well, but when you add to a composition already interesting on account of its subject, an arrangement of lines that heightens the impression, a chiaroscuro that grips the imagination, and a colour scheme suited to the characters, you have solved a more difficult problem and, moreover, you are moving on a higher plane. Like a musician, you are adapting to a simple melody the wealth of harmony and its mutations. Peisse calls this tendency *musical*, and he uses the word in a derogatory sense; personally, I think it as praiseworthy as any other.

He has taken his theories about the arts from his friend Chenavard, who considers music an inferior art. Chenavard has the typically French mind which needs ideas that can be expressed in words; when it comes to ideas which language is incapable of describing, he banishes them from the realm of art. But even admitting that drawing is everything, it is clearly not merely a question of form, pure and simple. There may be either grace or vulgarity in this contour, which is all that he demands, and a line drawn by Raphaël will have a different charm from one drawn by Chenavard. Is there anything vaguer or more impossible to describe than such an impression? Must we establish degrees of nobility among our feelings? This is what the doctrinaire and hopelessly frigid Chenavard is attempting to do. He puts literature in the front rank, painting second, and music only third. There might be something in this theory if any one of these arts were capable of containing the other two, or of replacing them. But if you were to describe a painting or a symphony in words, you might easily give a general idea, from which a reader could gather as much as he was able, but you could give him no real understanding of it, because words themselves are not exact. What is intended for the eyes must be seen; what is intended for the ears must be heard. What has been written as a speech will have far more effect when it comes from the lips of an orator than when it is simply read. A great actor will transform a passage by his delivery . . . But I have said enough . . .

Fould advises me to have my reflections and comments published as they stand, and I think that this plan will suit me better than writing articles as such. It means that I shall have to write each one out separately on a different sheet of paper and file them as I go along. In this way, I shall be able to revise one or two whenever I have a spare

moment and after a time I shall have accumulated a bundle of speci-
mens, like a botanist who puts into a box the grasses and plants which
he gathers in a hundred different places and with as many different
sensations.

Saturday, 21 May

This was the day when Pierret and Riesener came.

Worked all the morning at pastels of the lions and trees, which I
had drawn the day before in the Jardin des Plantes. Went to meet
them at about a quarter past two; I brought them back to the house,
and we then went into the forest. Riesener again began to criticize my
search after a certain finish in my small pictures which, he considers,
makes them lose a great deal compared with what I get in the sketch,
or with a swifter way of painting and a first attempt. He may be
right and again, he may be wrong; Pierret said, probably for the sake
of argument, that things must be done as the painter feels them, and
that the interest of the picture overrides all such questions of touch
and frankness.

After dinner they looked at the photographs which Durieu has
been kind enough to send me. I persuaded them to try an experiment
that I made quite by chance a couple of days ago. After examining the
photographs of nude models, some of whom were poor physical
specimens, with parts of the body over-developed—not very beau-
tiful to look at—I showed them some engravings by Marcantonio.
We felt repelled, indeed almost disgusted, by the inaccuracy, man-
nerism, and lack of naturalness, in spite of the excellence of the style.
It is his only admirable quality, but we were incapable of admiring it
at that particular moment. As a matter of fact, if some genius were
to use daguerreotype as it should be used he could reach untold
heights. Above all, when you look at these engravings, the admitted
masterpieces of the Italian School that have exhausted the admiration
of every painter, you realize the truth of Poussin's remark that 'com-
pared with the Antique, Raphaël was an ass'. Up to the present, this
machine-made art has done us nothing but harm: it spoils the master-
pieces for us, without being able to satisfy us completely.

Tuesday, 24 May

Spent the whole day by myself; Jenny and Julie went to Paris to
fetch the wine. Worked all the morning, and arranged my papers in
great good spirits. About two o'clock I began to feel tired and walked

across the fields towards Soisy. I went farther than usual, but still not
as far as the great avenue; like Robinson Crusoe, I am busy exploring
the interior, and shall end by knowing all the country within reach
of my legs.

As I was sitting down to a cold supper Jenny returned. My meal
was arranged differently, and I had a much better time of it. That
night I was enraptured by the stars. How quiet it was! How much
nature accomplishes in this majestic silence! What a racket we make,
who are doomed to cease and leave no trace behind!

Sunday, 29 May

These last few days have slipped by very quickly, partly in work,
and partly in going for walks, but not so much the latter as it has been
raining. Sometimes I long to throw Poussin out of the window;
sometimes I go at him in a kind of frenzy, sometimes in a more
reasonable way.

There are few people whose society I cannot enjoy, very few who
give me no return for my pains when I try to make myself pleasant to
them. Try as I may to remember the dullest people I know, it still
seems to me that simply by wishing to be on the best possible terms
with them, whatever warmth they possess (and I'm thinking of the
coldest and most cantankerous among them) rises to the surface in
response to mine and encourages my good humour. If one forgets
such people quickly, if their memory does not arouse the smallest
spark of feeling, one should not feel ungrateful or believe them to be
more interesting than they really are. Like two metals, any two
human bodies that are passive when they are apart may throw out a
few sparks when they come into contact. Separate them, and they very
properly relapse into their former state of insensibility.

When I think of Pierret and Riesener and do not see them, I am
passive, like metal. But when I am with them, after the first few
moments needed to break the ice, I react in the old way—I begin to
thaw as soon as I am near them. Perhaps they too are surprised to
find themselves softening, but I'll wager that I feel the shock of this
small spark of memory longer than they do. No motives of self-
interest separate me from them. When I dream of people who are
my enemies, people whom I hate the very sight of when I am awake,
I think them charming and talk to them as though they were my
friends, I feel quite surprised to find them so pleasant. Then I say to
myself, in all the innocence of sleep, that I have never appreciated
them or been fair to them and I vow that I will go and see them and

learn to know them better. Do I divine their good qualities when I am dreaming, or does my ill-nature—if I'm really as malicious as they—prevent my seeing anything but their faults when I am awake, or is it simply that I am a better man when I am asleep?

Tuesday, 31 May

Rain and fog all day long. I did not leave my room and made the best of a bad day by working at my article.

Went out while it was still daylight and walked along the road to Soisy in excellent spirits. Fog and bad weather do not make one melancholy. When night descends upon the soul, that is the time when everything seems dismal and unendurable; it is not enough to have no real cause for sadness, the state of one's health can change everything. The squalid process of digestion is the grand arbiter of our moods.

Wednesday, 1 June

When I opened the studio window this morning in the same misty weather, I felt almost dizzy with the scent of the rain-drenched garden and the flowers that are still lovely, although bent and battered by the rain. What pleasure the townsman misses, the wretched clerks and lawyers breathing the stale smell of their dusty papers or the mud of that unspeakable Paris! What a compensation for the countryman, the agricultural labourers! There is no perfume like the smell of damp earth and trees! How penetrating is this strong scent of the forest, how quickly it brings back to me the pure and lovely memories of early childhood and the feelings that come from the depth of my soul! O beloved places where I once saw you, dear friends whom I can see no more: delightful days that I used to enjoy so much and that are now gone forever! How often has the sight of the green leaves and the scent of the woods roused such memories, the very sanctuary and holy of holies, to which the spirit flies to take refuge, if it can, from the cares of our daily lives! And this affection that comforts me, the only thing remaining to me that is capable of stirring my heart as in the past, how much longer will fate allow me to enjoy it?

Sunday, 5 June[1]

The last few days have been much alike. I have been working and

[1] This leaf, which includes a sketch, is the only one remaining of the original note-book of 1853: it is now in the Louvre. M. Moreau-Nelaton told M. Joubin that he bought it from a bookshop in the rue de Seine.

have nearly finished the article. About three o'clock I usually go out and have been as far as the Hermitage avenue more than once. Exquisite view, the garden of Armide. The fresh green and the leaves, which are now their full size, lend a superb grace and richness to the foliage. The dominant note is a rounded luxuriance. The tree trunks are ornamented with leaves. The walnut tree, yellowish in tone against patches of bluish distance. The whole scene has a look of magic and fairyland.

In the evening after dinner, I went out in the twilight, and instead of going to Barbier's, walked along the road to Soisy. There was a bright star over the great poplars by the roadside. It was deliciously cool.

Yesterday, I took Jenny for a walk before dinner; it was delightful to see her pleasure, ill though she is.

Monday, 6 June

The weather was so perfect this morning when I opened my window that it made me hate the very idea of burying myself among my papers. I saw two swallows settle on the garden path and noticed how slowly they moved and how they waddled; they used their wings to cross a space only two feet wide. Nature blessed them with long wings but she did not make them nimble on their feet.

The view from my window is charming every moment of the day, I can hardly bear to tear myself away from it. The scent of the leaves and flowers in the garden adds all the more to my pleasure.

Tuesday, 7 June

Finished the article.

I think that I shall really leave here tomorrow. I am enjoying it perhaps rather less than before, not because I have been here too long, but because I have been putting off my departure. When I think of the sadness that follows every pleasure, I often wonder if we can ever be truly happy in a world where everything comes to an end. This dread of time passing and of the nothingness to come spoils every pleasure.

Paris, Saturday, 11 June

Started work at last and in pretty good spirits. I was beginning to think that I should never paint again. Finished the 'Man shoeing the Horse'.

Sunday, 26 June

The Poussin article appeared this morning [in the *Moniteur*]. Only yesterday I was writing to Mérimée that I'd had no news of it, and when I was at dinner this evening they sent the proofs round in a hurry for me to correct.

Put in a day's work at the Hôtel de Ville and came home on foot. I stopped a long time in Saint-Eustache to hear Vespers, and for a few moments I understood the pleasure that people get from religion . . . I saw the officials of the church passing backwards and forwards, the cripple who gives you holy water, muffled up like a figure from a picture by Rembrandt, and the priest in his ceremonial cope and canon's hood.

Wednesday, 29 June

Exquisite music at the house of charming Princess Marcelline. I especially remember Mozart's *Fantasia*, a serious work, verging on the terrible, and with a title too light for its character; also a sonata by Beethoven which I already knew—but admirable. I really liked it exceedingly, especially the mournful imaginative passages. Beethoven is always melancholy. Mozart is a modern too; I mean by this that like the other men of his time he is not afraid of touching on the sad side of things. French gaiety demands that only charming subjects be dealt with and banishes from conversation and the arts anything likely to sadden us or to remind us of our unhappy condition. But Mozart adds exactly the right touch of gentle melancholy to the serene and easy elegance of a mind that is happy in seeing the pleasant side as well as the sad.

Friday, 8 July

Dined with Véron, whom I met on the boulevard a few days ago. He congratulated me on the Poussin article. I have collected quite a number of compliments up to date. Will they repay me for all the bother I have had in writing it?

Véron asked me for some notes on myself and some of my friends to use for his Memoirs.

Wednesday, 28 September

Seven o'clock in the morning, while I am dressing: We do not realize the extent to which mediocrity abounds. Lefuel,[1] Baltard, I can

[1] Hector Lefuel and Victor Baltard were architects, the latter in charge of the restoration of Saint-Germain-des-Prés.

think of many others, men with great positions in the arts, the government and the army—in fact in every profession. People like these are everywhere blocking the machinery which men of talent have set in motion. The best men are naturally innovators. They arrive to find stupidity and mediocrity in control and apparent in everything that is being done. The first impulse of the better men is to reform, to try new methods, so as to break away from so much sameness and futility. But if they finally succeed in gaining the upper hand over routine methods, they in their turn have to deal with the incompetents, men who seem to take pride in carrying their natural stupidity to the utmost limits and spoil everything they handle. After the first impulse driving the innovators to break out of the rut, there is nearly always a second, which comes at the end of their careers warning them to check the rash impulse before it goes too far, and ruins their inventions by exaggeration. They then take to praising what they themselves rebelled at, as they see the tragic misuse being made of the new ideas they cast upon the world. Perhaps a motive of self-interest creeps in at this point, prompting them to dictate to their contemporaries to the extent of allowing no one else to question what they consider deserves criticism. And at this stage they too become mediocre because this bias causes them to take up absurd positions, unworthy of the reputations which they won in the past.

Champrosay, Thursday, 6 October

Left for Champrosay, at eleven o'clock.

I have now been in pain for more than a week. I caught cold in the ear during my expedition to the Jardin des Plantes last Sunday and have had earache ever since. When I arrived, I felt that I could truly say, like Tancred, what I always say when I come back to Champrosay: 'With what delight I see this place again!'

The weather was unusually lovely before dinner, and I went for a long walk in the forest, which did not improve the state of my shoes and trousers. I started out by the avenue leading to the Prieur oak, but turned off half-way down the track that goes into the middle of the forest to meet the main road, where it crosses the Hermitage avenue. As I came home to my own hermitage, I had the most delicious sensation of privacy and freedom. I felt it strongly on the following day, and so it will continue, I hope, all the time that I am here.

Saturday, 8 October

Here I must write down my adventures in the forest. When I had finished work, I set off at about half-past one and crossed into the *Grand Senart* before I realized what was happening. Fould is repairing the pheasantry and has been amusing himself by having all the finger-posts repainted, so I wandered about for nearly five hours in the boggy part of the forest, wading through thick slimy mud, without knowing where I was going. At last, at the most difficult place, I met a labourer who showed me the way, and I came home by Soisy, rather tired, but devoutly thankful at not having to spend a night in the forest.

Monday, 10 October

To compile a *Dictionary of the Fine-Arts and of Painting*.[1] This would be an attractive theme. Each item could be tackled separately.

Authorities are the ruination of great talents, and form almost the entire talent of mediocrities. They are the leading strings with which everyone learns to walk at the beginning of their careers, but they almost always leave a permanent mark. People like Ingres never get them out of their systems and never take a step without invoking their help. It is as though they wished to eat bread and milk all their lives.

Wednesday, 12 October

Dined with Mme Barbier. Mme Villot returned in the evening. Perhaps rather imprudently, I said something about regretting the restorations to the pictures in the Louvre; but when I saw how warmly she defended her husband's skill I did not dwell too long on the subject of the large Veronese which that miserable Villot has destroyed by his attentions.[2] Villot's skill is probably the only quality that she does admire in him and she makes the most of it, as indeed she should. She told me, as a matter of fact, that not a single brushstroke is applied in the restorations unless M. Villot has taken up the palette himself. A fine recommendation, one can well imagine!

Today I worked rather slackly, but made good progress with the

[1] Throughout the latter part of his life Delacroix was taken up with the idea of compiling this dictionary.

[2] The restorations which Villot made of some of the pictures in the Louvre aroused such violent criticism that he was obliged to resign his post as Curator of Paintings in 1860, and he was given a purely administrative appointment as secretary of the Louvre.

small Saint Anne.[1] Repainting the background from the trees which I drew a few days ago at the edge of the forest, near Draveil, has completely changed the picture. This little piece of nature, caught in the act so to speak, but fitting in with the rest, has given it character. In the same way I have gained in freshness and a firm simplicity by repainting the figures in Mme Sand's picture from the sketches I did from life when I was at Nohant.

On the use of the model. It is a question of effect and of how to obtain it when working from a model or from nature in general; true effect is the rarest thing to find in most pictures where the model plays a prominent role. The model seems to draw all the interest to itself so that nothing of the painter remains. When an artist is very learned and very intelligent the use of a model, if properly understood, allows details to be suppressed which a painter who works from his imagination always includes too lavishly for fear of leaving out something important. This fear prevents him from treating really characteristic details freely and from showing them in their full light. Shadows, for example, always have too much detail in the painting one does from imagination, especially in trees, draperies, etc.

Rubens is a remarkable illustration of the abuse of details. His painting, which is dominated by the imagination, is everywhere superabundant, the accessories are too much worked out. His pictures are like public meetings where everybody talks at once. And yet, if you compare this exuberant manner, not with the dryness and poverty of modern painting, but with really fine pictures where nature has been imitated with restraint and great accuracy, you feel at once that the true painter is one whose imagination speaks before everything else.

When Jenny and I were walking in the forest yesterday and I was praising the forest painting of Diaz, she remarked with her great good sense: 'Exact imitation is always colder than the original'. It is perfectly true! Conscientiousness over showing only what is seen in nature always makes a painter colder than the nature he believes he is imitating, and for that matter nature is by no means invariably interesting from the point of view of the effect of the whole ensemble . . . Even though each detail taken separately has a perfection which I call inimitable, collectively, they rarely produce an effect equal to what a great artist obtains from his feeling for the whole scene and its composition. This is what I meant when I said, a short while ago, that although the use of a model can add something striking to a picture, it can

[1] In a picture of 'The Education of the Virgin', begun at Nohant and intended for George Sand.

happen only with extremely intelligent artists; in other words, the only painters who really benefit by consulting a model are those who can produce their effect without one.

What happens then with subjects that contain a great element of pathos? See how Rubens triumphs over every other painter in such subjects! See how the frankness of his execution, result of the freedom with which he imitates, increases the effect that he wishes to produce upon our minds! Take a subject of this kind: the scene round the bed-side of a dying woman, for example; seize and render the entire scene in a photograph, if such a thing be possible—it will be spoiled in a thousand ways. The reason is that according to the liveliness of your imagination you will find the subject more or less beautiful; you will be more or less the poet in that scene where you are also an actor; you see only what is interesting, whereas the camera records everything.

I make the above remarks and reaffirm all my earlier observations on the need for a great deal of intelligence in using the imagination, as I look at the sketches which I made at Nohant for the 'Saint Anne'. The first sketch, which I did from nature, seems unbearable when I look at the second, although this is really almost a tracing of the earlier one. But my intentions are shown more clearly in it, useless details have been eliminated, and I have introduced the degree of elegance which I felt was needed to render a true impression of the subject.

It is therefore far more important for an artist to come near to the ideal which he carries in his mind, and which is characteristic of him, than to be content with recording, however strongly, any transitory ideal that nature may offer—and she does offer such aspects; but once again, it is only certain men who see them and not the average man, which is a proof that the beautiful is created by the artist's imagination precisely because he follows the bent of his own genius.

This process of idealization happens almost without my realizing it whenever I make a tracing of a composition that comes out of my head. The second version is always corrected and brought closer to the ideal. This is an apparent contradiction but it explains how an over-detailed execution, like that of Rubens for instance, need not detract from the effect on the imagination. The execution is applied to a theme that has been realized in imagination; therefore the superabundance of details that slip in as a result of imperfect memory cannot destroy the far more interesting simplicity that was present in the first exposi-tion of the idea. And as we have already seen in the case of Rubens, the frankness of the execution more than compensates for the dis-advantage caused by the superabundance of details. If therefore you

can introduce into a composition of this kind a passage that has been carefully painted from the model, and can do this without creating utter discord, you will have accomplished the greatest feat of all, that of harmonizing what seems irreconcilable. You will have introduced reality into a dream, and united two different arts. Indeed, the art of the truly idealistic painter is as different from that of the cold copyist as are the eloquent orations in *Phèdre* from the love-letters of some little chorus-girl. The majority of painters who are so scrupulous in their use of the model spend most of their time putting faithful copies into dull and ill-digested compositions. They believe that they have accomplished everything when they reproduce heads, hands, and accessories in slavish imitation of nature without any relationship with one another.

On the imitation of nature. This important matter is the starting point of every school and one on which they differ widely as soon as they begin to explain it. The whole question seems to come to this: is the purpose of imitation to please the imagination, or is it merely intended to obey the demands of a strange kind of conscience which allows an artist to be satisfied with himself when he has copied the model before his eyes as faithfully as possible?

Monday, 17 October

After spending the day working (and sleeping, too, as I strongly suspect), I walked out in the direction of Choisy. The roads were soaking. As I was coming home I met Baÿvet. He is as much behind the times as I am. There he was going the round of his improvements and splashing along in the mud just like me. His clothes were so ancient that his servant would not have taken them as a gift, and he had his trousers rolled up to the knee to keep them out of the mud. People used to dress like this when they wanted to be at ease at home or in the country, but nowadays X . . . and Y . . . and the other empty-headed young fops would be most embarrassed at being seen wearing the kind of get-up in which poor old Baÿvet strolls about, comfortably conscious of his hundred thousand francs a year.

When I open my window every morning, and especially when the sun shines, I feel a keen sense of pleasure; there is an ever-increasing charm in the peace and tranquillity of the country for a man who is growing old. I think it is the right place for me. Towns can offer nothing comparable with this, their restless activity suits only the young and foolish.

On imitation and the use of the model, continued. Jean-Jacques was right when he said that the joys of liberty are best described from a prison cell, and that the way to paint a fine landscape is to live in a stuffy town where one's only glimpse of the sky is through an attic window above the chimney-pots. When a landscape is in front of my eyes and I am surrounded by trees and pleasant places my own landscape becomes heavy—too much worked; possibly truer in details, but out of harmony with the subject. When Courbet painted the background of the woman bathing, he copied it faithfully from a study which I saw hanging near his easel. Nothing could be colder; it is like a piece of mosaic. I began to make something tolerable of my African journey only when I had forgotten the trivial details and remembered nothing but the striking and poetic side of the subject. Up to that time, I had been haunted by this passion for accuracy that most people mistake for truth.

In spite of the bad roads, I took my poor dear Jenny for a little walk in the forest through the Baÿvet estate. I am very glad that she seems in better health now. What a lot of sound common sense there is in this child of nature, such wisdom in her oddest prejudices!

My instinct hardly ever deceives me; only a short time ago I was writing in this note-book about the abundance of mediocre people; but what degrees there are in mediocrity! And here is one from the lowest category of all (I mean among people who pride themselves on doing intellectual work)! He [Véron] serves to show the true value of the leaders—men like Dumas, for instance, whom they are talking so much about. By the side of Véron, Dumas appears to be a great man, and I have no doubt that this is his own opinion, but what does he or any other modern writer amount to, compared with a prodigy like Voltaire? Compared with that marvellous combination of lucidity, brillance, and simplicity, what becomes of all this confused chatter, these endless strings of sentences and volumes bestrewn with good things and bad, without restraint, order, or moderation, and with no consideration for the reader's common sense? Dumas is mediocre because of the way in which he uses his talents, and yet these are above the average. These writers are all alike. Even poor Aurore [George Sand] shares the same faults among her other valuable qualities. Neither of them works, but not because they are idle. They do not know how to work, that is to say, they cannot prune, condense, summarize, and pull their work into shape. The need to write for so much a line will be fatal to stronger talents than theirs. They accumulate capital from the volumes they pile up; it is impossible to make masterpieces today.

Thursday, 20 October

How I adore painting! The mere memory of certain pictures gives me a thrill that stirs me to the depths of my soul—even when I do not see them; like those rare and interesting memories which we recapture at long intervals in our lives especially from early childhood.

On the way home from Froment yesterday, where I was very bored, I stopped at Mme Villot's house to return her umbrella. She was at home with Mme Picard, who was speaking of her husband's pictures. Thereupon, Mme V. . . remembered some of the paintings by Rubens which she had seen at Windsor. She spoke of a huge equestrian portrait, one of those great figures of the past in full armour, with a young man standing beside him. I felt as though I were actually seeing it. I know much of what Rubens has done and I think I know all that he is capable of doing, but the mere recollection of this picture by a very ordinary little woman (who when she actually saw it, certainly did not experience the thrill which I feel in just imagining it) has revived for me the great images of those pictures that impressed me so deeply when I saw them as a young man in Paris at the Musée Napoléon, and on my two journeys to Belgium.

Glory to that Homer of painting, the father of warmth and enthusiasm in the art where he puts all others in the shade, not, perhaps, because of his perfection in any one direction, but because of that hidden force—that life and spirit—which he put into everything he did. How strange it is: the picture that perhaps made the strongest impression on me, the 'Raising of the Cross' in Antwerp, is not the one where his own peculiar and incomparable qualities shine out most strongly. . . It is neither by the colour, nor by the delicacy nor the boldness of the execution that this painting surpasses the others, but, strangely enough, it is because of those Italian qualities that do not delight me so much in the work of Italian painters. Here I think it only right to say that I have had exactly the same feeling before Gros's battle pictures and the 'Raft of the Medusa', especially when I saw the latter half-finished. There is something sublime in all these works which is partly due to the great size of the figures. The same pictures on a smaller scale would, I am sure, have had an entirely different effect. In both Rubens's picture and in Géricault's, there is an indescribable flavour of the style of Michelangelo which adds still further to the impression produced by the size of the figures, and gives them an awe-inspiring quality. Proportion counts for a great deal in the absolute power of a picture. As I was saying, it is not only that these pictures would rank among the ordinary works of the

master if they had been executed on a smaller scale, but that even life-size, they would fall short of this effect of the sublime. The proof is that an engraving after Rubens's picture does not have at all the same effect.

I must admit, however, that proportion is not everything, for many of Rubens's pictures in which the figures are very large do not give this kind of feeling—to me, the most elevated of all—nor is it solely due to a more Italian quality of style, for pictures by Gros which show no trace of it, and are entirely his own, have this power of projecting me into that spiritual state which I consider to be the strongest emotion that the art of painting can inspire. The impressions that the arts produce on sensitive natures are a curious mystery; when you try to describe them they seem confused but each time you experience them, if only in recollection, they are strong and clear. I firmly believe that we always mingle something of ourselves in the emotions that seem to arise out of objects that impress us. And I think it probable that these things delight me so much only because they echo feelings that are also my own. If, although so different, they give me the same degree of pleasure, it must be because I recognize in myself the source of the kind of effect they produce.

The type of emotion peculiar to painting is, so to speak, tangible; poetry and music cannot give rise to it. In painting you enjoy the actual representation of objects as though you were really seeing them and at the same time you are warmed and carried away by the meaning which these images contain for the mind. The figures and objects in the picture, which to one part of your intelligence seem to be the actual things themselves, are like a solid bridge to support your imagination as it probes the deep, mysterious emotions, of which these forms are, so to speak, the hieroglyph, but a hieroglyph far more eloquent than any cold representation, the mere equivalent of a printed symbol. In this sense the art of painting is sublime if you compare it with the art of writing wherein the thought reaches the mind only by means of printed letters arranged in a given order. It is a far more complicated art, if you like, since the symbol is nothing and the thought appears to be everything, but it is a thousand times more expressive when you consider that independently of idea, the visible sign, the eloquent hieroglyph itself which has no value for the mind in the work of an author, becomes in the painter's hands a source of the most intense pleasure—that pleasure which we gain from seeing beauty, proportion, contrast, and harmony of colour in the things around us, in everything which our eyes love to contemplate in the

outside world, and which is the satisfaction of one of the profoundest needs of our nature.

Many people will think the art of writing superior to painting precisely because of this simpler means of expression. Such people have never taken pleasure in considering a hand, an arm, or a torso from the antique or by Puget; they appreciate sculpture even less than they do painting, and are strangely mistaken if they imagine that when they have written down the words *foot* or *hand* they have inspired me with an emotion comparable to what I feel when I see a beautiful foot or a beautiful hand. The arts are not algebra, where abbreviation of the figures contributes to the success of the problem. To be successful in the arts is not a matter of summarizing but of amplifying where it is possible, and of prolonging the sensation by every means. What is the theatre but clear evidence of man's need to experience the greatest possible number of emotions at once? It brings together all the arts in order that the effect of each may be enhanced. Miming, costume, and the beauty of the actor enhance the effect of words that are spoken or sung, and the representation of the scene where the action takes place adds still further to all these different impressions.

What I have been saying about the *power of painting* now becomes clear. If it has to record but a single moment it is capable of concentrating the *effect* of that moment. The painter is far more master of what he wants to express than the poet or musician who are in the hands of interpreters; even though his memory may have a smaller range to work on, he produces an effect that is a perfect unity and one which is capable of giving complete satisfaction. Moreover, the painter's work does not suffer so much from variations in the manner in which it is understood in different periods. Fashions change, and the bias of the moment may cause a different value to be set upon his work, but ultimately it is always the same, it remains what the artist intended it to be, whereas this cannot be said of the art of the theatre, which has to pass through the hands of interpreters. When the artist's mind is not there to guide the actors or singers the performance no longer corresponds to his original intention; the accent disappears, and with it, the most subtle part of the work is lost. Happy indeed is the author whose work is not mutilated, an insult to which he is exposed even during his lifetime. Even the change of an actor alters the whole character of a work.

Monday, 24 October

Worked until nearly four o'clock; I was out of doors scarcely an

hour, but enjoyed it intensely. Went down the little lane by Barbier's garden and stopped to admire the great trees near the banks of the Seine; many delightful views of Champrosay Hill, etc. At times like this one feels how weak the art of writing is; with a paint-brush, I could make the whole world feel what I have seen, a written description would reveal it to no one.

Tuesday, 25 October

I have hardly written at all these last few days, because there has been too much to write. My time is so taken up with work and with going for occasional walks that if I settle down to write for too long at a stretch I no longer feel the same enthusiasm for my work.

Spent the whole morning working on the little 'Saint Anne', with short interruptions for strolls in the garden. I adore this little kitchen garden, with the yellowing grapes and the tomatoes along the wall, and the soft sunlight playing over everything. It fills me with secret joy, a feeling of well-being such as we have when our bodies are in perfect health. But all this is fleeting; I have been in this delicious state of mind a hundred times during the three weeks I have spent here.

I feel that we need some special mark to remind us of each of such perfect moments; for this sun, shedding the last beams of the year on to the fruit and flowers; for this lovely river which, yesterday and again today, I watched flowing by so peacefully, reflecting the sunset sky; for the poetic solitude of Trousseau's place, and for the stars, which I see sparkling overhead like diamonds during my evening walks, or through the trees by the road-side.

Wednesday, 26 October

The *Spectator* speaks of what it calls *geniuses of the first rank*, such as Pindar, Homer and the Bible—a confusion of sublime and imperfect things—Shakespeare, etc.; and then of those in whom it sees more artistry: Virgil, Plato, etc.

Query: Is there really more to marvel at in Shakespeare, who interlards passages of amazing truth to nature with interminable and tasteless conversation, than in Virgil and Racine where all these things appear in their proper place and are suitably expressed?

What would be the use of the most beautiful and finished style if it were applied to vulgar and formless ideas? Among the above-mentioned geniuses, the first are like those scapegraces to whom much is forgiven because of their occasional good impulses. Here we come

back, as always, to the question of which I have spoken before: the finished work compared with the sketch—the great edifice when only the large guiding lines are visible and before the finishing and co-ordinating of the various parts has given it a more settled appearance and therefore limited the effect on our imagination, a faculty that enjoys vagueness, expands freely, and embraces vast objects at the slightest hint. Furthermore, in the matter of the sketch as compared with the final appearance of the great building, the imagination cannot conceive anything very different from the appearance of the finished object, whereas in the work of geniuses such as Pindar, for instance, we sometimes stumble on enormities side-by-side with the finest conceptions. Corneille is full of such contrasts, and so is Shakespeare. We never find such things in Mozart, nor in Racine, Virgil, or Ariosto. These geniuses give continuous delight to the mind, and while we enjoy the spectacle of the passion of Phèdre or Dido, we cannot but feel grateful to the poet for so exquisitely polishing the casket in which he encloses the thoughts that move us so deeply. The author has taken proper care to brush away every obstacle that might obstruct the path he wishes us to tread, or blur the vista which he unfolds before our eyes.

If geniuses like Homer and Shakespeare display such disagreeable sides of their talent, what shall we say of the careless and unrestrained imitators of this style? The *Spectator* is right to denounce them, for there is nothing more odious; of all forms of imitation it is the stupidest and most clumsy. I did not say that the *Spectator* praises men like Homer and Shakespeare primarily as *original geniuses*; this would be matter for a further inquiry, comparing them with men like Mozart and Ariosto, who seem to me no less original although their work is so even.

There is nothing more dangerous for the young than this kind of unevenness, for they are always tempted to admire what is gigantic, rather than what is reasonable. A florid, inaccurate style seems to them to be the height of genius and moreover, it is extremely easy to imitate. We do not realize sufficiently that even the greatest talents only do what they can; when their style is weak or florid it means that their inspiration was unable to follow them, or rather that they were not able to capture and confine it within proper limits. Instead of mastering their subject, they were mastered by their enthusiasm or, shall we say, by an inability to subdue their ideas. Mozart could say of himself, though he would probably have said it less pompously: *Je suis maître de moi, comme de l'univers.* Mounted high upon

the chariot of his improvisation, like Apollo at the summit of his career, from start to finish he firmly grasps the reins of his coursers and sheds his light everywhere. This is what Corneille and others like him can never do in their erratic leaping course, for they astonish us as much by their sudden descents as by the flights of genius that carry them to the heights of the sublime.

We must not be too tolerant of what are called negligences in the work of original geniuses. It is best to speak of these as lapses; they could not have done other than they did. Sometimes they toiled and sweated over passages that are very weak or even disturbing. This would seem to have occurred frequently with Beethoven, whose manuscripts are as full of corrections as Ariosto's. It must often happen that beauties come unsought to such men without their pondering over them, and that, on the contrary, they spend much time in lessening the effect by pointless repetition and misplaced amplification.

Thursday, 27 October

Impossible to work! . . . Is it a bad mood, or the idea of leaving tomorrow?

Went for stroll in the garden and then stood for a long time under the poplars at Baÿvet; they delight me beyond words, especially the white poplars when they are beginning to turn yellow. I lay down on the ground to see them silhouetted against the blue sky with their leaves blowing off in the wind and falling all about me. And once again, the pleasure they gave me belonged to my memories—to the recollection of seeing such things at a time when I was surrounded by the people I loved. This feeling accompanies all our pleasure in the spectacle of nature; I felt it last year in Dieppe when I was looking at the sea, and now again here. I could scarcely bear to tear myself away from the sight of the clear water under the willow trees and above all, from the great poplar and the white poplars.

When I came back to the garden, I helped them to finish picking our grapes. The sun was hot, but it gave me a great sense of well-being.

I do not feel too sad at leaving here to take up my life and work in Paris, but I've not grown tired of this place. I think I could enjoy spending much more time in such a peaceful solitude without any diversions, as they are called. While I was lying under the poplars, I could see in the distance, over the top of the hedge at Baÿvet, the hats and faces of smart people driving along the Soisy road in their

carriages, which were invisible to me because of the hedge. They were engaged in pleasure-seeking at the houses of mutual acquaintances, showing off their horses and carriages and joining in those vapid conversations which fashionable people enjoy. They leave their homes but they cannot escape from themselves, and it is in themselves that this hatred for all forms of real recreation lies, and this implacable idleness that prevents their creating true pleasures.

Friday, 28 October

Got up as usual this morning, but full of the idea that I had nothing but my packing to do I again rejoiced in the pleasure of doing nothing at all.

After walking up and down the studio for some time and looking at my paintings, I threw myself into the armchair by the fire, stuck my nose into the *Nouvelles Russes*, and read two of them, the *Fatalist*, and *Dombrowski*, which I greatly enjoyed.[1] Apart from details about customs that are new to us, I suspect them to be lacking in originality. You might as well be reading some of Mérimée's short stories, and as the Russian stories are modern it is quite probable that the author was familiar with Mérimée's work. The rather spurious style gives one a curious kind of pleasure, unlike what we get from reading the great writers. There is an extraordinary feeling of reality about them, the quality that took everyone by surprise in Walter Scott's novels when they first appeared, but no one with real taste can consider them finished. Compare Voltaire's novels, *Don Quixote*, or *Gil-Blas*. In them you never have the sense of being present at actual events, such as you might get from reading the account of an eye-witness; you feel the hand of the artist—and you should feel it—just as you should see a frame round every picture. But in these Russian stories, after descriptions of various details which are astonishing because they seem so ingenuous (the exceedingly odd names of the characters, for instance, and the foreign customs), you see that all it amounts to is a more or less romantic fable and this destroys all the illusion. Instead of giving a true picture and calling it Damon or Alcestis, you write a novel like every other novel and it seems all the more ordinary because the studied attempt at illusion is brought to bear on minor details alone. The whole of Walter Scott's work is like this. The appearance of novelty was a greater contribution to his success than all his

[1] The *Nouvelles Russes* were translated into French by Louis Viardot in 1845. *The Fatalist* is by Lermontov and *Dombrowski* by Pushkin.

imagination, and what makes his books date today, and ranks them lower than the famous books I have mentioned, is precisely this violation of truth in the details.

Paris, Sunday, 30 October

Retouched the pictures that people have been asking for. I am going to be so busy that I shall have to interrupt these notes, and I regret it, for they fix something that passes so quickly, the thoughts and doings of my daily life which give me comfort or encouragement when I come back to them later.

Friday, 4 November

I have been going back to the Hôtel de Ville every day this week, correcting and retouching the work with the greatest enthusiasm.

Monday, 14 November

Although I was still in pain—or rather to see whether the fresh air would do me good after a morning spent in idling and reading some short stories by P . . . (which I enjoyed very much, and thought rather moving)—I went to the Hôtel de Ville about two o'clock, stopping on the way to buy the scarf and blue waistcoat with Jenny.

I walked nearly the whole way, including coming home through the Faubourg Saint-Germain to buy some gloves. I also bought an engraving by Piranesi: a large interior of a church, very striking. As I went past the Tour Saint-Jacques I saw some men digging up a great quantity of bones that were still in their original position.[1] How our minds love scenes of this kind, we never have enough of them. As I passed Hetzel's office, Silvestre[2] buttonholed me and made me go in with him.

Tuesday, 15 November

Have had stomach trouble for the past week, and have done nothing. This morning I feel better and am still enjoying a delicious feeling of idleness, as though to make up for my regret at wasting

[1] The opening up of the rue de Rivoli had led to the clearing of the Tour Saint-Jacques and the demolition of some of the surrounding houses. The bones were dug up from the cemetery which used to be near the old church of Saint-Jacques de la Boucherie.

[2] Théophile Silvestre (1823–84), writer and art critic, and a great admirer of Delacroix.

time. I am surrounded by my old note-books; I notice that in the later ones my eternal complaint against the boredeom and melancholy which I used to feel in the past becomes progressively rarer. If middle age is really giving me more gaiety and peace of mind it will be a genuine compensation for the advantages it makes me lose.

I read in the note-book for 1849 that during one of my frequent visits to poor Chopin, at the time when his illness was already terribly advanced, he told me that suffering prevented his taking an interest in anything and, least of all, in his work. I said that what with advancing age and the unrest of the present time it would not be long before I too would begin to lose my enthusiasm. He said that he thought I had strength enough to resist: 'You will have the enjoyment of your talent,' he said, 'in a kind of serenity that is a rare privilege and no less valuable than the feverish search after fame.'

Thursday, 17 November

Dear Alberthe sent me a ticket for *Cenerentola*. I had a delightful evening, my head was full of ideas which were stimulated by the music and the spectacle on the stage.

When I was in the theatre, I noticed that in satin dresses the actual tone of the material can only be seen immediately beside the high light; it is the same with a horse's hide.

As I listened to this enchanting little opera, with its exquisite passages, and the music which I already knew by heart, I noticed the lack of interest in the expressions of all these bored people who only came to be fashionable, or to hear Mme Alboni. The rest of the performance seems so much useless trimming to them, and they can hardly sit through it without yawning. I on the other hand enjoyed everything. I said to myself: 'Tonight they are playing for me, I am here quite alone, and some magician has had the charming idea of putting the ghosts of an audience around me lest the thought of solitude lessen my pleasure. It is for me that they have painted the scenery and designed the costumes, and as for the music, I alone am hearing it.'

Saturday, 19 November

At Gihaut's, this evening, I was looking at some photographs of works by Marcantonio in the Delessert collection. Must we really go on admiring as perfect these incoherent and inaccurate images, which are not all of them the work of the engraver? I remember how much

I disliked them when I was in the country last Spring, and compared them with photographs taken from life.

Among others I looked at the 'Feast in the House of Simon',[1] an engraving that has been reproduced and is highly esteemed. Could anything be colder than the action? The Magdalen has been planted squarely in front of the Christ, literally drying his feet with great ribbons hanging from her head, which the engraver gives us for hair. None of the unction that such a subject requires! No trace of the wanton repenting her riches and offering her beauty at the feet of Christ, who ought surely to be making some acknowledgement to her or at the very least looking at her with kindly indulgence. The spectators are as cold and dull as the principal figures. They stand some distance apart, as if so extraordinary a scene would not have caused them to draw closer together, or to form a group, in order to gain a better view and communicate their thoughts. The gesture of one of the figures near the Christ is pointless and absurd; he appears to be encircling the table with an arm that is larger than the table itself, and this totally unnecessary distortion in the most conspicuous place increases the absurdity of the rest of the picture. Compare this dull rendering of the most moving subject in the gospel, so rich in tender and lofty sentiments and picturesque contrasts arising out of the different natures brought into contact—this lovely creature in all the radiance of her youth and health and these old and middle-aged men, before whom she does not fear to humble her beauty and confess her sins. Compare this, I say, with what the divine Raphaël has done and with what Rubens has made of this same subject. He did not miss a single characteristic feature. The scene takes place in the home of a rich man with many servants around the table; the Christ, in the most conspicuous place, is befittingly serene; the Magdalen, carried away by her feelings, trails in the dust her brocaded robes, her veils and jewels, while her golden hair streaming over her shoulders and spread in disorder over the feet of the Christ is no vain and uninteresting accessory. The vase of perfumes is the richest that Rubens could imagine—nothing can be too beautiful or too rich to be laid at the feet of this Master of creation who has become an indulgent master to our errors and our weaknesses. And can the spectators watch unmoved the sight of such beauty prostrate and in tears, such shoulders, such a throat, and the soft upward gaze of such bright eyes? They are talking and

[1] The 'Feast in the House of Simon' engraved by Marcantonio from a picture by Rubens; the original plate was damaged and proofs are often very bad.

pointing to each other, looking on at the scene with animated gestures, some with an air of wonder and respect, others, their surprise tinged with a touch of malice. . . This is nature and here is the painter! We accept everything that tradition tells us is sacred, we see through the eyes of others; artists are the first to be caught and are greater dupes than the less intelligent public, who accept what the arts offer them in each period like bread from the baker's shop. What would you say of the pious imbeciles who stupidly copy the lapses of the painter of Urbino and praise them as sublime beauties? Or of those poor wretches who, unmoved by any feeling whatsoever, cling to questionable or absurd sides of the greatest talents and imitate them unceasingly, not understanding that such weak or careless passages are the unfortunate accompaniment of beauties to which they can never attain?

Sunday, 20 November

Rubens is not simple, because he is not laboured.

Went to see dear Alberthe, whom I found sitting without a fire in her great alchemist's chamber, dressed in one of the strange costumes that make her look like a sorceress. She always had a fancy for these necromancer's trappings, even at a time when her beauty was her most genuine enchantment. I still remember her room with its black hangings and symbols of mourning, her black velvet dress and the red turban wound round her head, all the various details which, together with the admiring circle which she seemed to keep at a distance, made me temporarily lose my head. Where is poor Tony now? Where is poor Beyle? Now she is mad on table-turning[1] and told me some incredible tales about it. It seems that the spirits inhabit the tables and that you can sometimes call up the spirit of Napoleon, or of Haydn, among many others (I quote the two she mentioned), and compel them to answer at your pleasure! How everything is improving to be sure! Even these tables are progressing! In the beginning they used to rap out a certain number of knocks which stood for 'yes' or 'no', a person's age, or the day of the month when some event would take place. But now they are being specially manufactured with a wooden pointer in the centre which swings round a circle of the letters of the alphabet picking out one here and there and choosing them,

[1] During this winter of 1853 there was a perfect mania for table-turning. Even the *Institut* became excited about it. Delacroix appears to have been sceptical.

needless to say, with great aptness and deliberation so as to spell out whole sentences—wonderfully profound, after the manner of the oracles! They have even advanced beyond this already quite remarkable stage in their education. You now hold a little board in your hand with a pencil attached and when armed with this instrument you press on to the inspired table, the pencil writes words and even whole discourses of its own volition. She spoke of fat manuscripts written by the tables, which will doubtless make the fortune of people whose style is sufficiently flowing to give substance to so much spirit. A cheap way of becoming a great man.

Tuesday, 22 November

Do not feel like work. Went to the Louvre about three o'clock. Vividly impressed by the Italian drawings of the fifteenth and the beginning of the sixteenth centuries. Head of a nun, dead or dying, by Vanni. A drawing by Signorelli of nude men. Small torso, front view, early Florentine school. Drawings by Leonardo da Vinci. For the first time I noticed the drawings by Carracci for the *grisailles* of the Farnese Palace; the cleverness in them overrides the feeling, technique and style have carried the artist away in spite of himself, he knows too much about these matters and, since he no longer studies, he no longer discovers anything new or interesting. This is the danger of progress in the arts, and it is inevitable. It is the same with all this school. Head of Christ and other heads by Guido where, in spite of the expression, his great cleverness with the pencil is even more astonishing. What then are we to say of the modern schools who concentrate on this deceptive cleverness and try to acquire it? In the Leonardo drawings, especially, one cannot see the touch, all that reaches our minds is the feeling. I still remember a time, and not so very long ago, when I was constantly nagging at myself for being unable to attain to the skill in execution which, unfortunately, the schools teach the best minds to consider the last word in art. I have always had a tendency to imitate naïvely using simple methods, and I used to envy the easy brush and coquettish touch of artists like Bonington. This man was full of feeling but he was carried away by his skill, and this very sacrifice of the noblest qualities to a fatal facility has caused his work to sink in our estimation and has set upon it the imprint of weakness—as has happened with the work of men like Vanloo.

Yesterday's visit to the Louvre gave me a great deal to think of, it would be a good thing to repeat from time to time.

Thursday, 24 November

Went for a walk this evening in the Galerie Vivienne, where I stopped at a bookshop to look at some photographs. I was attracted by a photograph of the 'Raising of the Cross', by Rubens, which interested me greatly; the inaccuracies are more apparent when they are no longer saved by execution and colour.

The sight of this masterpiece, or rather the recollection of my feeling when I actually saw it [in Antwerp], kept me happily employed for the rest of the evening. By way of contrast, I thought of the drawings by Carracci which I was looking at the day before yesterday. I have seen drawings by Rubens for this picture; they are certainly not conscientious—he shows more of himself in them than of the model which he had before his eyes—but such is the power of the hidden force belonging to artists like Rubens, that the characteristic feeling of the artist dominates everything and compels the attention of the beholder. At first sight his forms seem as ordinary as Carracci's but they are far more significant. Carracci had great intelligence, great talent, great ability—I speak only of what I have seen—but none of the quality that sweeps you off your feet and causes unforgettable emotions!

Friday, 25 November 1853

That terrible Dumas, who never leaves his prey, came to hunt me out at midnight with an empty note-book in his hand. God only knows what he intends to do with all the details that I have been fool enough to give him! I quite like him, but we are not of the same clay and we are not striving towards the same goal. His public is not mine; one of us must be crazy. He left the first numbers of his journal with me, they are delightful reading.

Saturday, 26 November

In the evening, to hear *Lucrezia Borgia*; I enjoyed it from beginning to end, even more than I did *Cenerentola*. Music, acting, scenery, costumes, everything interested me. That evening, I atoned for the wrong I have been doing to the unfortunate Donizetti, now dead, and to whom I render full justice, herein, alas! imitating the common run of humanity, and even the best of them. We are always unfair to contemporary talent. I was delighted with the chorus of men in dominoes in the enchanting moonlight scene with the garden staircase. Memories of Meyerbeer are mingled with all this Italianate

elegance and they blend very happily into the rest of the music. I particularly liked the next aria, which Mario[1] sang exquisitely—another wrong atoned for, I now think him delightful. It is like suddenly falling in love with a person to whom you thought you were indifferent after seeing them every day for several years.

Monday, 28 November

First performance of *Mauprat*. All Mme Sand's plays have the same construction, or lack of it. The start is always stimulating and full of promise, but the middle of the play drags along in what she imagines to be the development of the various characters; it is really nothing but a means of elaborating the plot.

This play seems to me to be like all the others; from the second act to the end—and there are six acts—the action does not move a single step forward. The hero, a character past praying for, is told in every conceivable tone of voice that people love him, but he never emerges from a state of despair, anger and inanity. It is exactly the same as in the *Pressoir*.

Poor woman! She suffers from some natural handicap that prevents her from writing good plays. Judged as a play, this thing is worse than the thinnest melodrama but it contains some delightful epigrams, and that is where her real talent lies. Her virtuous peasants are intolerably boring, and there are a couple of them in *Mauprat*. Her nobleman is virtuous, the heroine beyond reproach, the hero's rival full of sensibility and moderation when it comes to taking action against his enemy, even the passionate young hero has a kind heart! There is a poor little dog which causes the most absurd situations. Mme Sand lacks a sense of the theatre, just as she lacks good taste in her novels. Her writing is not suitable for French people although she writes exceedingly good French; yet the public taste is not hard to please in these days. It's like Dumas, who is always trampling over everything and going about with his buttons undone, as though he were above caring for what everyone else is accustomed to respect. She certainly has great talent, but is even less aware of what suits her than most writers. Am I being unjust again? I am fond of her, but I must say that I don't think her work will last. She has no taste.

It was past one in the morning by the time I reached home. I met my old friend Ricourt at the theatre and had a long conversation with

[1] Mario, one of the most famous of Italian singers, began his theatrical career in 1838.

him. I find that he still remembers the sketch of the 'Satyr caught in the Nets'. He spoke of what I used to be in those far off days. He remembers the green coat,[1] my long hair, and my passion for Shakespeare, novelties, etc.

Wednesday, 30 November

Dined with Princess Marcelline. Mozart's duet for double-bass and piano.

What a life I am leading! Such were my thoughts as I listened to the exquisite music and especially to the Mozart, where everything breathes the peace of a well-ordered age. At my time of life, the turmoil of violent passions no longer disturbs the delicious sensations that works of art give me. I don't know what it means to have to deal with official papers and cope with boring tasks, as most men do. Instead of thinking about business, I think only of Rubens or Mozart; my chief concern for a whole week is the memory of an aria, or of a picture. I go to my work as other men hurry to their mistress and when I stop, I take with me into the solitude of my home, or abroad when I go in search of distractions, a delightful memory that bears no relation to the lover's uneasy pleasure.

Wednesday, 7 December

Dull dinner-party at Casenave's house. Found myself sitting opposite Bethmont. He's a man with a very smooth tongue. For all his mild eyes, he settled poor Véron properly after dinner; all very amusing, but really exceedingly malicious—rounding on him all the time with the most charming manner imaginable. There is something parsonical about the way he talks, and even in his bearing. You naturally notice the studied eloquence of the lawyer in everything he says, but there's a hesitation over his choice of words which would seem to suggest that his mind is not entirely obedient, in spite of all the training he must have given it in his life-long experience of public speaking. I remember that Vieillard once said in all innocence, contrasting him with some of his colleagues who were fiery or intolerant republicans: 'What a charming fellow he is! So gentle!' I also remember disliking him on sight when I first met him with M. N...., who was not as critical as I. He had a way of looking at one without saying anything and of answering with reservations, that gave me an

[1] This refers to the green waistcoat in the self-portrait now in the Louvre which Delacroix left to Jenny le Guillou.

impression of him which I have been able to confirm on the two or
three occasions when I've met him since. I thought he seemed much
affected at the death of poor Wilson; he appeared to me to be shed-
ding genuine tears. What can I conclude from this? Have I made an
error of judgement? Not at all! He is like everyone else, a compound
of strange and inexplicable contrasts, and this is what the writers of
novels and plays will never understand; they make their characters
all of a piece. But people are not like that. There may be ten different
people in one man, and sometimes all ten appear within a single hour.

Thursday, 8 December

I was invited to call on Mlle Brohan,[1] but after coming in from my
walk in this keen but delightful weather, I remained at home when I
ought to have been at her house, and read the second article which
Dumas has written about me. He makes me appear like the hero of a
novel. Ten years ago I should have rushed off to hug him for his kind-
ness, for in those days I thought a lot of the good opinion of the fair
sex, which now I utterly despise, though not without occasionally
looking back with pleasure to the time when I thought everything
about them was charming. Today I see only one charm in them, and
it's no longer of any use to me. Common sense more than age is re-
sponsible for making me change my views, it is the tyrant who rules
everything else!

When the Brohan first appeared she was quite enchanting! What
eyes she had! What teeth! What a complexion! When I saw her again
at Véron's two or three years ago she had aged a good deal, but she
still retained a certain amount of charm. She is exceedingly witty but
strives a little too much after effect. I remember that she kissed me as
we left the dining-room that evening; it was because of something
they had said about me—I think there was some question of a por-
trait. All through dinner, Houssaye, who was directing her at the
time (though not her conscience, since he was also her lover), looked
green with jealousy—very comical to see in a theatrical manager
who, one might imagine, would be well accustomed to the ways of
the female section of the ranting, singing, croaking, bawling flock of
which he is shepherd.

I did not go, this evening, for fear of meeting too many of those
compromising faces that make me want to fly to the opposite ends of
the earth.

[1] Augustine Brohan left the stage in 1842, after brilliant successes at the
Théâtre-Français and the Vaudeville.

14 December

Pierret and I dined with Riesener. That evening I stayed in the studio and made a charcoal drawing after a Renaissance torso in order to experiment with the fixative which Riesener uses. The wretched man is drowning in his everlasting Niobes. He's always scheming to make money out of small pictures. He's finished! He's beginning to say: 'It's too late now', like all lazy people who have been in the habit of saying confidently, 'I've got plenty of time'. His wife's attitude to me was very comical. There was a distinct atmosphere at the beginning of our conversation arising out of some hatred, or from some unknown grudge which she seems to be harbouring against me in the depth of her little heart. She gazed fixedly at me and shot out tart remarks that would have upset anyone less determined to be good-tempered. I answered as she spoke to me but less crossly, and she gradually calmed down; by the end of the evening she was sweetness itself.[1]

It had begun to freeze in the afternoon and when I came home with Pierret there was a wonderful moon. When we reached the Champs Elysées, I reminded him that at the very same spot, more than thirty years ago, and at about the same time, we were coming back together from Saint-Germain where we'd been to see Soulier's mother —on foot, if you please, and in Arctic weather. Could it really be the same Pierret that I was arm in arm with? Our friendship used to be so warm! How cold it is now!

Saturday, 24 December

Dined with Buloz, Meyerbeer, Cousin and Rémusat: an amusing party. Babinet came in during the evening. I was talking to Cousin about the discouragement which artists feel, not so much when they find their energy flagging, as when the public begins to grow tired of them, which always happens sooner or later. He said it is because they no longer feel passionately about their work, and he is perfectly right. I told Rémusat that I am always called at dawn, and that even at this time of year I hurry off to my work through frost and snow with the greatest pleasure and enthusiasm. 'How splendid that is!' he said, 'How lucky you are!' It is profoundly true.

[1] Delacroix's friendship with the Rieseners had grown cooler from the time when Jenny had taken her special place in Delacroix's life. Jenny had once been a servant of the Pierrets. Now his friends resented the influential position she held with Delacroix as well as her attitude towards themselves.

Walked home, and went into Saint-Roch to hear the midnight mass. I do not know whether it was because of the crowd or the lights or the solemnity of it all, but the pictures seemed to me colder and more insipid than ever. How rare talent is! What a lot of energy is spent in making a mess of canvases, and yet what finer opportunity could any man have than religious subjects such as these! I only wanted one touch, just one single spark of feeling and deep emotion from all these pictures which have been so patiently and even skilfully executed by many different hands and schools—a touch which I feel I could have given almost unconsciously. They seemed worse than usual at that rather solemn moment, but on the other hand how something really fine would have thrilled me! I have had this experience before whenever I have looked at a fine painting in a church while religious music was being played; indeed, the music need not be particularly well chosen to produce the effect, perhaps because it appeals to a different part of the imagination, a part that is more easily captivated. I remember seeing in circumstances like these, and with intense pleasure, a copy of Prud'hon's *Christ* at Saint-Philippe du Roule; I think it was at M. de Beauharnais's funeral. I am sure that this composition, which is not above criticism, never looked better. The emotional part seemed to rise up from the picture and to reach me on the wings of the music. The ancients realized something of this and put it into practice. There is a story about a great painter of antiquity who, when he showed his pictures to an audience, arranged for music to be played of a sort calculated to put them into the right frame of mind for the subject of the painting. I remember my delight when I was painting in Saint-Denis du Saint-Sacrement and used to hear the music at the services; Sunday was a feast day twice over and I always had a good session. The best head in my picture of 'Dante' was brushed in with tremendous speed and excitement while Pierret was reading me a canto from Dante, one which I knew already, but to which his voice gave an energy that quite electrified me. The head is that of the man facing you in the background, the one trying to climb into the boat, who has thrown his arm over the gunwale.

At dinner they were talking about *local colour*. Meyerbeer said, quite rightly, that it depends on something indescribable which has nothing to do with accurate observation of habits and customs: 'Who has more of it than Schiller,' he said, 'than Schiller in his *William Tell*? And yet he never went to Switzerland.' Meyerbeer is a past master of this kind of thing: the *Huguenots*, *Robert*, etc. Cousin could not see the slightest trace of local colour in Racine, whom he does not

care for, but considers that Corneille, whom he's crazy about, is full of it. I said what I thought of Racine, and what must be said of him, namely that he is too perfect and that this very perfection, combined with the absence of lapses and dissonances in his work, deprives his style of the pungency which we find in works that are full of beauties and faults at the same time. Experts are more shrewd in their criticisms than other people, but they become very excited over technical matters. Painters worry over nothing else. Interest, subject matter, even pictorial qualities amount to nothing beside virtues of technique, I mean academic technique.

Rereading what I have been saying about Meyerbeer and *local colour*, it occurs to me that he makes too much of it. If he had written *William Tell*, he would have wanted us to recognize Switzerland and Swiss emotions in the most trifling duet. Rossini, on the other hand, brushed in the broad outline of a few landscapes where you can almost smell the air of the mountains, or rather you can sense the melancholy that grips the soul when face to face with the great spectacles of nature, and on to this wide background he flung men, passions, grace, and elegance. Racine did the same. Who cares if his Achilles is a Frenchman? Who ever saw the Greek Achilles? And who, in any language but Greek, would dare to make him speak as Homer did? 'What tongue will you use?' asks Pancrace of Sganarelle. 'Why, the one I have in my mouth, of course!' You can speak only with your tongue, but also, only in the spirit of your own times. Those who hear you must be able to understand you and above all, you must understand yourself. Make a Greek of Achilles! Great heavens! Do you suppose that even Homer did that? He created an Achilles for the people of his own time. The men who knew the real Achilles had been dead long since. He must have been more like a Red Indian than the Achilles whom Homer gives us, and probably ate raw the sheep and oxen, which the poet makes him knock on the head and spit with his own hands. Homer surrounds him with a style of living that came from the poet's own imagination; the tripods and tents and ships are just what Homer saw about him in the world in which he lived. Those ridiculous little ships in which the Greeks sailed to lay siege to Troy! The entire fleet would have had to surrender to the fishing flotilla that puts out of Fécamp or Dieppe to fish for herrings. It has been the special weakness of poets and artists of the present time to believe that they made a great discovery with the invention of local colour. The English led the way and we followed them. We had to make our own attempt to attack the masterpieces of man's creation.

Friday, 30 December

Someone was saying about the 'Venus'[1] that when you looked at it you saw the whole thing at once. I was struck by this remark. As a matter of fact, this is the quality that should predominate over everything else. All the rest should come later.

1854

Paris, undated

Fragments of a dictionary, etc. Very short articles on celebrated artists, introduced as a digression, dealing with some point that has occurred or with some quality specially characteristic of them.[2]

The Beautiful implies a combination of many different qualities. Strength alone, without elegance, etc., is not beauty. In a single word, the broadest definition would be Harmony.

4 January

Evening party at the Tuileries. I came home feeling even sadder than after poor Visconti's funeral. The faces of these rogues and worthless women make me sick; their flunkeys' souls hidden under their embroidered uniforms!

17 January

Men of letters pretend to believe that music and painting please the ear and eye in the same way that eating and drinking affect the palate.

25 January

This evening at Princess Marcelline's soirée Sauzet was speaking about Mozart; he said that Mozart left a note-book in which he noted down everything he composed: it seems that there were days and weeks, even months during which he did nothing, but that when he began to work again his output was stupendous—the amount of work he sometimes produced in a single day!

[1] The 'Venus' was a figure forming part of the architectural decorations of the Salon de la Paix, at the Hôtel de Ville.

[2] Delacroix was hesitating over the form to be given to his reflections on art: essays or newspaper articles, or a dictionary. The idea of a dictionary attracted him especially. He was never to carry it fully into effect.

29 January

This morning Riesener took the trouble to come out in this appalling rain and mud in order to tell me that my ceiling had been a complete fiasco, last night. What a good-natured fellow he is! What a kind cousin! When he found that I received his remarks very coldy (seeing that *I think the ceiling is good*) he went off without accomplishing his purpose. He was full of concern at having taken my good humour too much for granted; his face grew longer and greener every moment, as he visualized commissions for pictures and ceilings flying away.

11 March

A long interruption of my poor Journal; I feel very sad about it. These trifles, written down at random, seem all that remain to me of my daily life as it slips away. My wretched memory makes them essential to me. Since the beginning of the year the steady work required to finish at the Hôtel de Ville has been absorbing me too much, and since I finished there—nearly a month ago now—my eyes have been troubling me and I have been afraid to read and write.[1]

23 March

Literature. Everybody's art, one learns it unconsciously.

Commissions. At the last meeting,[2] I was struck by the amount that has to be submitted to experts. Memorandum on this subject: everything they do on Commissions is unfinished and disconnected. At this meeting the artists voted solidly together; they had right on their side; the others had no clear ideas, they only dimly understood what it was all about.

This does not mean that if I were in power I should hand over questions of art, for example, to commissions of artists. Commissions should be purely consultative and the able men who preside over them should go their own way after hearing what the others have to say. When artists are collected together, men who are all of one trade, they each take up their own narrow point of view, but when they are opposed by incompetent people they see the solid, general advantages and succeed in making them equally clear to others.

This is an argument against republics. You will object that some of them were illustrious; I think the cause of this lies in the spirit of

[1] Delacroix had contracted a disease of the retina through working on his ceiling in a very dark room at the Hôtel de Ville.

[2] The reference is to the Commission for the Universal Exhibition of 1855.

tradition that survived in certain organized bodies of men entrusted with the management of affairs. The most celebrated republics were governed by an aristocracy. Provided that a nobleman is intelligent he will understand his country's interests as well as the man in the street, but whereas the latter is a member of no particular body, the nobleman is what he is only by virtue of tradition and an instinct for conservation, which renders his country all the more dear to him because he is placed at its head by the very institutions which he is called upon to defend. Venice, Rome, England, etc., are good examples.

The people will only recover a feeling of national solidarity when they find themselves directly opposed by the interests of foreign nations. The artists on the Commission who vote like one man against the manufacturers are just the same. If you were to send a delegation from the English lower classes to a European congress (I mean from the men who form the opposition in their own country and demand reform and progress) they would be Englishmen first and last against Germans, Frenchmen, etc., and uphold to the very letter the English privileges that give England her strength, and which instinct tells them is the source of her power.

24 March

At half-past two, meeting of the Industrial Commission. Discussion on the ruling about the exhibition of works produced since the beginning of the century. With Mérimée's help, I successfully fought against this proposal and it was ruled out. Ingres was lamentable; he has a completely warped mind; he can see only one point of view. It's the same in his painting: no logic whatsoever, and no imagination: 'Stratonice', 'Angélique', the 'Vow of Louis XIII', his recent ceiling with 'France' and 'The Monster'.

26 March

Concert of the *Saint Cecilia Society*. I really only listened to the 'Eroïca' Symphony. I thought the first part of it admirable. The Andante is perhaps the most tragic and the most sublime thing that Beethoven ever wrote, but only as far as the end of the first half. It was followed by the *Marche du Sacre*, by Cherubini, which I enjoyed. As for the *Preciosa*, either the heat of the room, or perhaps the brioche which I had eaten beforehand, paralysed my immortal soul, for I slept soundly through the whole thing !

As I listened to the first piece, I thought of the different ways in which musicians seek to obtain unity in their works. Repetition of the theme is the method they usually consider to be most effective and it is also the one that comes most easily to mediocrities. Although this kind of repetition can be extremely satisfying to mind and ear, when it is used too often it seems a matter of minor interest or rather, a mere artifice. Are our memories so bad that we cannot establish a connexion between the different parts of a piece of music unless the principal idea is restated almost *ad nauseam*? In a letter, or in a piece of poetry or prose, there is a chain of argument, an entirety, arising out of the birth of one idea from another and not from the repetition of a single phrase which becomes, as it were, the essential point of the composition. In this respect, musicians are like those preachers who repeat the text of their sermon over and over again, and work it into every paragraph.

As I said before, such repetitions of the principal theme can be a source of pleasure when they are properly used, but they are more likely to fatigue the ear than to give a sense of unity, unless this appears naturally by the help of those true means to which only genius holds the key. The human mind is such an imperfect instrument, so hard to concentrate, that even those most sensitive to the arts feel a kind of uneasiness when faced with a really fine work—a difficulty in enjoying it completely—which cannot be overcome by cheap ways of procuring an artificial unity, such as the repetition of the theme in a piece of music, for instance, or the concentration of the effect in a painting. Such devices are paltry little tricks, which the average artist learns to achieve very easily and uses just as freely. It would seem that a picture should be able to satisfy the need for unity more fully and easily than a musical composition because you have the impression of seeing it all at once, but unless it is well composed it will be no more successful than a piece of music. Indeed, I would add that even though it exhibited a unity of effect carried to the highest degree of perfection it would not be completely satisfying to the soul for that reason alone. The feeling that a picture inspires in us must return to our memory when we no longer have it before our eyes, and then it is that the impression of unity will predominate—provided that it does really possess that quality. Only then can the mind grasp an impression of the whole composition, or become aware of its lapses and incongruities. The observations I have been making about music have made me realize more clearly than ever before, what bad judges professional artists are of their own particular art, unless they can combine it with

a superiority of mind or a delicacy of perception that cannot be acquired merely by playing an instrument or by using a paint-brush. All that professionals know of an art is the rut along which they have laboured and the examples which the *Schools* hold up for admiration. They are never impressed by original qualities in a work of art, and indeed, are far more likely to abuse them; in short, the *intellectual* side escapes them entirely and since, unhappily, they form by far the largest body of judges, they can mislead public taste for a time and even delay the proper appreciation of fine works of art. Hence the contempt which the best minds feel for the narrow and superficial taste that usually prevails in schools and academies. Hence the return to so-called *scholarly techniques* that satisfy none of the needs of the spirit and, by their continual repetition of fashionable commonplaces, can even spoil the effect of certain genuine masterpieces and cause them to appear dated.

Fine works of art would never become dated if they contained nothing but genuine feeling. The language of the emotions and the impulses of the human heart never change; what invariably causes a work to date, and sometimes ends by obliterating its really fine qualities, is the use of technical devices that were within the scope of every artist at the time the work was executed. On the other hand, what usually makes for the material success of most works of art is, I am sure, the use of certain fashionable embellishments of secondary importance compared with the main idea. Those, who by a miracle were able to dispense with such accessories, have either been appreciated very late and with great difficulty, or else by later generations, who are indifferent to the charm of these particular conventions.

4 *April*

On the difference between literature and painting with regard to the *effect that can be produced by the rough sketch of an idea*; in other words, on the impossibility, in literature, of making a sketch that will convey an idea to the mind, and of the strength with which an idea can be stated in a painter's rough sketch, or in his first draft. Music must be like literature, and I think that this difference between drawing and the other arts comes from the fact that in the latter, ideas are developed in succession, whereas the whole impression of a pictorial composition can be summed up in three or four lines.

Even when a piece of music or literature is complete as regards the general composition, which is supposed to convey the impression, a lack of finish in the details is a greater drawback than it would be in a

sculpture or a painting. In short, in music and literature the *near enough* is unbearable, or rather, you cannot have what we call the *indication*, or the *sketch*; whereas in painting, a fine indication, or a sketch infused with great feeling can be equal in expression to the most finished production.

7 April

Concert at the Princess's. It was unbearably hot, and there was an equally unbearable smell of dead rat. The concert was also very long. They began with the best work, and although this inevitably spoiled us for the rest of the concert we were able to enjoy to the full, and without being tired, that lovely symphony in C, by Mozart—poor Chopin, you realize his weaknesses after hearing something like this. The dear Princess persists in playing his important pieces and in this she is encouraged by her musicians who, being *professionals*, know nothing about the matter. There is not much inspiration in these compositions. One must allow that the structure, invention, and perfection are all in Mozart. At Boissard's house, Barbereau said to me, after hearing that lovely quartet of which I shall speak later, that his ideas are even simpler and more frankly stated than Haydn's; it is when you recall his music afterwards that you fully appreciate him. Barbereau attributes this very largely to knowledge, not forgetting inspiration; he said that knowledge allows a composer to profit by his ideas.

Champrosay, 12 April

Left for Champrosay. It began to rain just as we were leaving Paris. This really phenomenal drought has now lasted for six weeks and is beginning to affect the farmers.

In the evening I went for a walk with Jenny in the direction of Draveil. The moonlight was enchanting. The weather seems to have quite cleared up.

I brought with me the end of Silvestre's article on me. I think it very satisfactory. We poor artists are lost unless people take notice of us! He puts me under the heading of those artists who prefer *the judgement of posterity to that of their own period.*

13 April

The finest morning in the world, and the most heavenly sensation when I opened my window. The sense of peace and freedom which I have when I'm here is inexpressibly soothing! And besides, I'm letting my beard grow, and have almost taken to wearing sabots!

Worked on the 'Women Bathing' all the morning, and from time to time strolled into the garden or out into the country.

Towards three o'clock, I went for a short walk in the forest; I set out by the avenue leading to the Prieur oak and came back by the great avenue crossing the Hermitage road, and finally along the latter and home in the shade of the farmyard wall. Not many ideas, but a feeling of happiness; satisfied with myself and with my work.

Found two beautiful hawk's feathers.

17 April

In the morning, while I was at work, I received an invitation to a party at the Élysée Palace for the same evening. I left at four o'clock.

Felt tired by the journey to Paris, and profoundly bored at having to attend this grind. I came away with the usual feeling of bitterness and contempt for myself at being mixed up with these scoundrels. They had illuminated the garden with coloured lanterns and Bengal lights, it all looked very pretty. That is what these people call beauty! An April morning leaves them unmoved.

Left next day without seeing anyone. Spent an hour looking at animals in the Jardin des Plantes, but they were lazy and did not give me much chance of studying them; in any case, it was excessively hot.

23 April

Took up the 'Clorinde' again; I think that I have arrived at an entirely different effect reverting to the original idea, which I had gradually been losing. Unfortunately, it often happens that either the execution, or some difficulty, or even some quite minor consideration, causes one to deviate from the original intention. The first idea, the sketch—the egg or embryo of the idea, so to speak—is nearly always far from complete; everything is there, if you like, but this everything has to be released, which simply means joining up the various parts. The precise quality that renders the sketch the highest expression of the idea is not the suppression of details, but their subordination to the great sweeping lines that come before everything else in making the impression. The greatest difficulty therefore, when it comes to tackling the picture, is this subordination of details which, nevertheless, make up the composition and are the very warp and weft of the picture itself.

If I am not mistaken, even the greatest artists have had tremendous struggles in overcoming this, the most serious difficulty of all. Here, it

IX. HOLMAN HUNT: STRAYED SHEEP

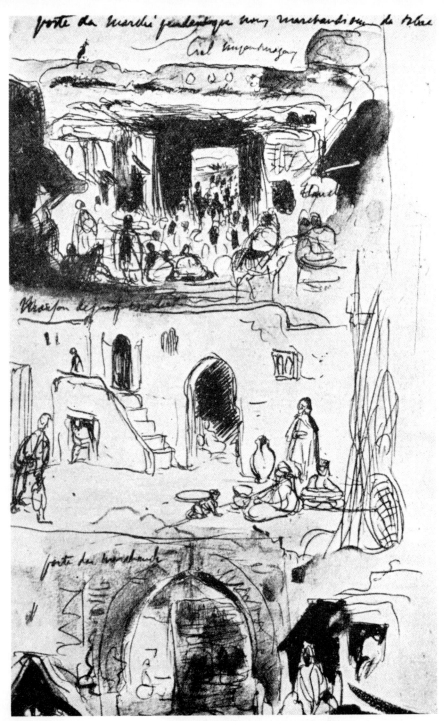

x. Leaf from Delacroix's Moroccan Sketchbook, 1832

becomes even more obvious that the disadvantage of giving too much interest to details by grace of charm in execution is that at a later stage you bitterly regret having to sacrifice them when they spoil the whole effect. This is where the specialists in light and witty touches, those people who go in for expressive heads and brilliant torsos, meet with defeat where they are accustomed to triumph. A picture built up bit by bit with pieces of *patchwork*, each separate piece carefully finished and neatly placed beside the rest, will look like a masterpiece and the very height of skill as long as it is unfinished; as long, that is to say, as the ground is not covered, for to painters who complete every detail as they place it on the canvas, finishing means covering the whole of that canvas. As you watch a work of this type proceeding so smoothly, and those details that seem all the more interesting because you have nothing else to admire, you involuntarily feel a rather empty astonishment, but when the last touch has been added, when the architect of this agglomeration of separate details has placed the topmost pinnacle of his motley edifice in position and has said his final word, you see nothing but blanks or overcrowding, an assemblage without order of any kind. The interest given to each separate object is lost in the general confusion, and an execution that seemed precise and suitable becomes dryness itself because of the total absence of *sacrifices*. Can we expect from this almost accidental putting together of details that have no essential connexion, that swift keen impression, that original sketch giving the impression of an ideal, which the artist is supposed to have glimpsed or fixed in the first moment of his inspiration? With the great masters, the sketch is no dream or remote vision; it is something much more than a collection of scarcely distinguishable outlines. Great artists alone are clear about what they set out to do, and what is so hard for them is to keep to the first pure expression throughout the execution of the work, whether this be prolonged or rapid. Can a mediocre artist, wholly occupied with questions of technique, ever achieve this result by means of a highly skilful handling of details which obscure the idea instead of bringing it to light? It is unbelievable how vague the majority of artists are about the elementary rules of composition. Why indeed should they worry over the problem of retaining through their *execution* an idea which they never even possessed?

24 April

I here affirm my preference for short, concise books that do not tire the reader, because they have not tired their authors, etc.

27 April

Went out early. I find that this plan suits me at present and that I work more easily in the afternoon if I have my exercise in the morning. This was impossible for me in the old days.

I spent some time on my way home studying the foliage of trees. There are plenty of lime trees and they come out before the oaks. It is easier to observe the principle of construction with this type of leaf.

It was very pleasant coming home. Studying the trees by the roadside has helped me to tone up the picture of the 'Lion Hunters' which had got into a bad state yesterday when I was in an irritable mood, although it was going well the day before. I was seized with a kind of frenzy of inspiration, just as I was the other day when I began to work on the 'Clorinde' again; there were not many alterations to make, but the picture had suddenly got into that flat and dreary state which invariably betrays a lack of enthusiasm. I'm sorry for people who work calmly and coldly. I think that all they do must inevitably be cold and calm and must plunge the beholder into an even worse state of coldness and calmness. Some people congratulate themselves on this calm composure and absence of emotion; they call it mastering their inspiration.

It was very late when I went to bed and I had a delicious sensation of the cool of the evening, the open windows, and the sparkling song of a nightingale. If it were possible to convey this song to the mind through the medium of the eyes, I should compare it to the twinkling of stars seen through the trees on a beautiful night; these notes, so light, or vivid, or flutelike, or full of unbelievable energy coming from so small a throat, seem to me like those fires, now sparkling, now faintly veiled, that are scattered like celestial diamonds over the great vault of the night. When these two sensations are combined, as so often happens at this time of year, the feeling of solitude and coolness, with the scent of the flowers and, above all, of the woods—a scent that always seems more intense in the evening—it is one of those spiritual feasts to which we are rarely bidden in this imperfect universe.

28 April

I have been thinking of the freshness of memories and of their power to lend enchantment to the distant past, and I have been marvelling at the way in which our minds involuntarily suppress and brush aside anything that spoiled the charm of those happy moments when we were actually living them. I have been comparing this kind

of idealization, for such it is, with the effect that great works of art have on the imagination. A great painter concentrates the interest by suppressing details that are useless, offensive, or foolish; his mighty hand orders and prescribes, adding to or taking away from the objects in his pictures, and treating them as his own creatures; he ranges freely throughout his kingdom and gives you a feast of his own choosing, whereas, with a second-rate artist, you feel that he is master of nothing; he wields no authority over his accumulation of borrowed materials. Indeed, what possible order can he establish in a work where everything dominates him? All that he can do is to invent timidly and to copy slavishly and therefore, instead of suppressing the uglier aspects as one's imagination does, he gives them equal, if not greater importance by the slavishness of his imitation, so that everything in his work becomes confused and insipid. If, among this hotchpotch of other people's ideas, some degree of interest or even of charm should appear because of the personal inspiration he may have put into the work, I liken it to real life and to the flashes of pleasure and disgust that go to compose it. And just as in the patchwork compositions of my semi-artists the good is smothered by the bad, so in our lives, we scarcely notice the moments of happiness, spoilt as they are by our continual anxieties.

Can any man say with certainty that he was happy at a particular moment of time which he remembers as being delightful? Remembering it certainly makes him happy, because he realizes how happy he could have been, but at the actual moment when the alleged happiness was occurring, did he really feel happy? He was like a man owning a piece of ground in which, unknown to himself, a treasure lay buried. You would not call such a man rich, neither would I call happy the man who is so without realizing it, or without knowing the extent of his happiness.

29 April

Took up work again on my picture of 'The Women Bathing'.

Since coming here I am beginning to understand the *principle* of the trees better, although the leaves are not yet fully out. They must be modelled with a coloured reflection, as in treating flesh; the method seems even more suitable in their case. The reflection should not be entirely a reflection. When you are finishing you must increase the reflection in places where it appears necessary, and when you paint on top of light or grey passages the transition is less abrupt. I notice that one should always model with masses that turn, as one would in

objects not composed of an infinity of small parts, such as leaves. But as the latter are extremely transparent, the tone of the reflection plays an important part in their treatment.
Note:

(1) The general tone, which is neither entirely *reflection*, nor *shadow*, nor yet *light*, but is *almost everywhere transparent*.

(2) The edge is colder and darker; this will mark the passage from the reflection into the *light*, which must be indicated in the lay-in.

(3) The leaves that lie wholly in the shadow cast from those above, which it is best merely to indicate.

(4) The *matt passages in the light*, which must be painted in last.

You must always argue it out in this way and above all, bear in mind the direction from which the light is coming. If it comes from behind the tree, the latter will be almost entirely reflection. It will present the appearance of a mass of reflection in which a few touches of *matt tone* are scarcely visible; if, on the other hand, the light comes from behind the beholder, i.e. facing the tree, the branches on the other side of the trunk instead of receiving reflected light will be massed in a *shadow* tone that is unbroken and *completely flat*. To sum up, the flatter the different tones are laid on, the more lightness the tree will have.

The more I think about colour, the more convinced I become that this reflected half-tint is the principle that must predominate, because it is this that gives the true tone, the tone that constitutes the value, the thing that matters in giving life and character to the object. Light, to which the schools teach us to attach equal importance and which they place on the canvas at the same time as the half-tint and shadow, is really only an accident. Without grasping this principle, one cannot understand true colour, I mean the colour that gives the feeling of thickness and depth and of that essential difference that distinguishes one object from another.

10 May

A dull morning and I was in a bad humour at the Hôtel de Ville.

As I was leaving I went to see Ingres's hall.[1] The proportions of his

[1] This was the Salon de l'Empereur at the Hôtel de Ville. Ingres had decorated the ceiling with a painting of the 'Apotheosis of Napoleon I'. The design was founded on an antique cameo. Delacroix referred to it in the Journal on 24 March 1854 as 'The Monster'.

ceiling are really shocking, he has forgotten to allow for the fore-shortening which the perspective of the ceiling gives to the figures. The whole lower part of the picture is unbearably empty and so is the vast expanse of flat blue, in which his horses (also flat) are swimming about, with his naked emperor and the chariot floating around in air. It has the most discordant effect on the mind as well as the eye. He has never done anything weaker than the figures in the panels; the man's clumsiness overrides all his other qualities. Pretentiousness, clumsiness, and a certain suavity in the details, which are charming in spite of (or perhaps because of) their affectation—this, I think, is about all that will remain for our descendants.

I have been to look at my Salon.[1] It did not tally with my recollection of it in the least. I could not regain any of my impressions, it all looked very garish.

20 May

Left for Augerville, with Berryer,[2] Batta, and M. Hennequin. Felt sad at leaving. Judging by the way everything makes me feel depressed these days, I think I must be growing younger! Health may have something to do with it. I enjoyed the journey, especially after Étampes, where we changed to a carriage and drove the last fifteen or twenty miles quietly trotting through the countryside as we used to do in the old days. There was rather a lot of dust owing to the great heat, but it was real country, the kind you do not see around Paris. It reminded me of when I was young and of the good times we used to have: Berry and Touraine are very like this.

It was delightful when we arrived. This is an old house which Berryer has restored, full of the ancient things I am so fond of. I know nothing more enchanting than an old country house. In towns people have lost touch with the old-fashioned way of living; but here, old portraits, old panelling, turrets, pointed roofs, everything, even down to the very smell of the old house, warms the heart and imagination. I found some old prints tucked away that used to amuse us when we were children; they must have been new then. There is a room that was once used by the great Condé, where some paintings in distemper still exist; they are amazingly fresh, the burnished gilding does not seem to have suffered at all.

[1] The Salon de la Paix at the Hôtel de Ville.

[2] Pierre-Antoine Berryer, a famous advocate, was a second cousin of Delacroix. His country house-parties at Augerville, about forty miles from Paris, became a favourite relaxation for the painter.

Berryer, the kindest and most liberal of hosts, showed us everything. He has a fish-hatchery in the park and a vast amount of water, wonderful stables and a magnificent bull. You have to go a long way from Paris to find anything to compare with this; I get none of these impressions at Champrosay.

21 May

The Bishop of Orléans[1] arrived this afternoon to hold a confirmation service. He is a fine-looking man, very distinguished, with a pleasant wit.

Berryer and the rest of the party went to Mass this morning, and when they returned I felt a little ashamed at not having followed their example. I went for a walk along the river almost to the point where it leaves the estate. I noticed how the house is framed in trees and on my way back made a sketch of the corner of the house and the side of the courtyard.

It was between four and five o'clock when the Bishop arrived. We had a clerical dinner with a M. de Rocheplate, or de Rocheville, one of Berryer's neighbours. I like the Bishop immensely. I sometimes think that I must be made of wax; I melt so easily when I am at the theatre, or with a person who has something imposing and interesting about him. I talked about original sin in a way that must have given the gentleman a good idea of my convictions. The evening went off very well.

22 May

After the confirmation and Monsignor's exhortation we stayed in the cemetery to watch the blessing of the graves; it was a moving scene. The Bishop, robed and bareheaded, with the Cross in one hand and the aspergillum in the other, strode between the humble graves, sprinkling holy water right and left. Religion is beautiful when it is like this. In church, the Bishop's words of consolation and advice went straight home to the simple peasants, prisoners of hard necessity, with their sunburnt faces tanned from working in the fields. As he came back the mothers presented their children for his blessing.

Luncheon at half-past twelve or one o'clock, which the poor fasting priests—and we ourselves, for that matter—needed very badly. At half-past one the ladies arrived, but no Princess Czartoriska! I felt very disappointed.

[1] Mgr Dupanloup had just been elected to the Académie Française.

23 May

Torrential rain, a real deluge. The Princess was supposed to be coming today, but it was hardly likely in this frightful weather! However, come she did in spite of it, and was ready for everything, no pretence of being tired, no airs and graces. We took the ladies for a long walk. Perhaps the Princess was a little bored at having to do the round of the whole estate, but she took my arm in the kindest way and I did not have a dull moment. She has a temperament like mine; she likes to make herself pleasant to everybody.

25 May

Saw two copies of the English *Punch*. Must try to get hold of it in Paris; some of the caricatures are exceedingly well drawn.

27 May

Before luncheon I made some drawings of the young horses, and some sketches of the imaginary figures I had seen in the rocks. While I was drawing I remembered Beyle's advice: 'Neglect nothing that can make you great'.

Paris, Monday, 5 June

Spent the evening with Mme de Forget; young d'Ideville tells me that my pictures are selling very well. The little 'Saint George', the one he calls a 'Perseus' and which I sold to Thomas for four hundred francs, fetched two thousand at public auction. Beugniet asked the same amount for the small 'Christ' which he originally bought for five hundred—the Jews always make the profits in the long run.

7 June

To a meeting of the Industrial Commission [of the World Fair]. They had arranged the meeting in order to find out which of us wished to go to London for the opening of the Crystal Palace. In spite of Lord Cowley's presence and his pressing invitation, only two members were found willing to go. The rest of us declined when we were asked. The English have again produced one of those miracles which they accomplish with what seems to us astonishing ease, thanks to the money they can raise at any given moment and their cool instinct for business, which we imagine we can imitate. They always get the better of us and always will unless we change our natures. Our

own Exhibition and the site chosen for it are wretched, but we never do this kind of thing well. The Americans, who have the same coolness and energy as the English in practical matters, are already beginning to surpass them.

8 June

This morning I heard, almost simultaneously, of the deaths of Pierret and Raisson.

Dear Pierret, his death will leave by far the greatest blank in my life, and I shall miss my old friend Raisson too. He has left his family badly off, but that is the result of his wife's vanity; she always would insist on trying to act the *lady* instead of earning money and making her daughters learn a trade.

25 June

To Saint Sulpice to see the work that Andrieu has been tracing; everything fits in beautifully, and I think that all is going very well; at any rate, it is an excellent start.

From time to time, I rather enjoy going to parties that take me away from home. I think they are a relaxation and a good tonic. Incidentally, I have been out for two Sundays running and have lunched out on both occasions—I, who can usually eat nothing during the day, even at home in my studio! I was astonished to notice the same thing when I was staying with Berryer. Amusement and conversation, and taking one's mind out of its usual rut have a good effect upon the constitution.

27 June

Dined at the Rieseners' with Vieillard.

Today, I have almost finished the 'Arab Horseman and the Tiger', for Weill. Arnoux called. He says that the 'Massacre' has not been improved by removing the varnish, and I can quite believe it even without seeing the picture. It will have lost transparency in the shadows, just as the Veronese did when it was treated; it is almost impossible to avoid this happening. Haro says that he takes off the varnish by washing instead of by rubbing with his fingers. If he can do this, he will have overcome a great difficulty. In the meantime, he has spoiled the portraits of my two brothers when they were children, by Uncle Riesener.

29 June

To Boissard's house at two o'clock, for some music. They have not yet mastered the Beethoven of the last period. I was asking Barbereau if he had really fathomed the last quartets; he said that you still needed a magnifying glass to appreciate everything in them, and that you probably always would need one. The first violin said they were magnificent but that some passages still seemed obscure. I was bold enough to suggest that something that remained obscure to everyone, and particularly to the violinists, might well have been obscure to the composer himself. However, let us not pronounce judgement yet. It is always safe to bet on genius.

30 June

To Saint-Sulpice, where the work is making good progress. My heart always begins to beat faster when I find myself face to face with a great wall waiting to be painted.

1 July

Worked all day without interruption. Wonderful sensation of peace and solitude and of the deep happiness they bring. No one is more sociable than I. No sooner am I with people whom I like—even mere acquaintances, provided there is nothing irritating about them —than I am carried away by the pleasure of being cordial. I find myself behaving as though such people were my friends and I go more than half way to meet them. I desire to please them, to make them think well of me. This peculiarity must often have given people a wrong idea of my character. Nothing looks so much like deceit and flattery as the desire to be on friendly terms with people, and yet it is simply a natural inclination. I think my nervous, irritable constitution is at the bottom of the strange longing for solitude that seems so much at variance with my wish to be sociable, which I carry to almost absurd lengths. I like, for example, to be liked by the tradesman who delivers a piece of furniture to my door. I want every man whom I chance to meet to go away feeling satisfied, whether he is a peasant or someone of importance and yet, coupled with this desire to be pleasant and to get on well with people, I have an almost foolish pride that makes me avoid any one who might be of use to me, for fear of being suspected of flattery. The fear of having my solitude interrupted usually comes when I am alone in my studio, because there I am at my real work, which is painting; I have no other.

Nothing else is of the least importance to me. I think that this dread, which also haunts me when I go for my solitary walks, comes as a result of my longing to be as friendly as possible when I'm with my fellow creatures. My nervous temperament makes me dread the exhaustion that follows upon such cordial encounters. I am like the Gascon who said when he went into battle: 'I tremble as I think of the dangers to which my courage is going to expose me'.

5 July

When I came home my eyes happened to light on Rubens's picture of 'Lot', of which I've made a small copy. I am surprised at the coldness of the composition and the lack of interest, apart from his talent for painting figures. It is really not until Rembrandt that you see the beginning of that harmony between the details and the principal subject which I consider to be one of the most important, if not the most important element in a picture. It might be possible to draw a comparison between the great masters on this subject.

19 July

Andrieu tells me that weather that is good for the vines is just the reverse of what is needed for the corn; for the latter, you need cool, clear weather, but for the grapes it must be stiflingly hot—sirocco and mistral. Add the above to my reflections on *necessary evils*.

It is not in nature alone that one finds these apparent contradictions which seem to satisfy one need at the expense of another. We ourselves are a mass of contradictions, hesitations, and cross-purposes that can make our situation at any given time either miserable or happy. The situation remains the same, it is we who change. We yearn for a particular state of happiness and when we obtain it we no longer care about it. We often find that the last state—the very condition for which we have been longing—is worse than the first.

Human beings are so strangely constructed that they often find consolation and even happiness in misfortune (for instance, when one is unjustly persecuted, the comfort of knowing that one deserves a better fate), but it far more often happens that a man will be bored by prosperity and even think himself supremely miserable.

Men scarcely ever base their happiness on the real blessings of life. They almost invariably believe that it lies in the gratification of vanity, in the foolish pleasure of attracting attention and consequently of bringing down envy upon themselves. But even in this vain pursuit

they rarely gain their object, for no sooner do they succeed in holding the centre of the stage than they aspire to rise still higher. As they mount, so do their ambitions, and they envy others as much as they themselves are envied. As for true happiness, they draw further and further away from it; the blessings of peace of mind, and independence based on modest and easily satisfied aspirations are denied to them. Their time is at every man's command and they waste their lives in futile occupations. So long as such men can feel the dignity of wearing ermine and silken robes, and provided that the wind of favour blows in their direction and supports them, they will wear themselves out among dusty papers, gladly devoting themselves to other people's business. To be a Minister of State or a President is a risky position, for it not only endangers a man's peace of mind but his reputation as well, and puts his character to a severe test. Unless he can rely upon his conscience, he will come to grief amidst the ever-increasing dangers to which he is exposed.

21 July

Accidents which are looked upon as dreadful misfortunes in certain countries make no impression in others, and public opinion attaches honour and disgrace to the most contrary things. An Arab, for example, cannot endure the idea that a stranger should see his wife's face even by accident, and therefore Arab women make it a point of honour to conceal their faces with the greatest care. They would be quite ready to lift their skirts and bare the rest of their bodies in order to keep their faces veiled.

How many men have longed for death as a refuge and a blessing, that same death, which is looked on with universal horror and is commonly considered to be the one incurable misfortune—which makes it a cause of fairly constant affliction in most people's lives! Yet even if death is to be regarded as a misfortune, should we not try to grow accustomed to the idea of this necessary solution, our liberation from the other evils of which we complain and that are evils indeed, since we can feel them; whereas in death, which is the end, there is neither consciousness nor feeling?

22 July

Arnoux called. He says that Corot likes my ceiling very much. He also told me of favourable comments by other people.

28 July

I have been thinking of Voltaire's novels, of the tragedies of Racine, and of thousands upon thousands of other masterpieces. Can we believe that such things are done merely that in every generation men may ask whether there is anything fresh to divert them in the way of literature? Is not this incredible output of masterpieces, produced for the human herd by the greatest minds and the most sublime geniuses, enough to terrify the more sensitive portion of our unhappy race? Will the insatiable search after novelty never give anyone the idea of seeing whether the old masterpieces are not newer and fresher than the rhapsodies that pander to our idleness, and which we prefer to the masterpieces? Were these miracles of imagination and wit, of reason, gaiety, or pathos, produced by geniuses at a cost of such immense labour and sleepless nights, and rewarded, so rarely alas, by meagre praise when they first appeared—were these great works, I say, created only to lapse, after a brief appearance and a few eulogies, into the dust of libraries and the unproductive, almost dishonouring esteem of so-called savants and antiquaries? Shall college pedants tug at our sleeves and remind us that Racine is at least simple, that La Fontaine saw as much in nature as Lamartine, and that Lesage portrayed men as they really are? Are the leaders of our present civilization, these ordinary schoolmasters, who have been raised to be ministers or shepherds of the people because they once had a quarter of an hour of *inspiration according to present-day standards*, the men who are to make a new literature? New indeed! A fine sort of novelty!

29 July

On portrait painting. On landscape, as an accompaniment to the subject. *On the contempt of the moderns* for this factor of interest. On the ignorance of almost all the great masters as regards the effect that could be drawn from it. For example Rubens, who painted landscape exceedingly well, never troubled to put it into the right relationship with his figures so as to make them more striking—striking to the mind I mean, for so far as the eye is concerned, his backgrounds are usually calculated to exaggerate the colour of the figures by means of contrast. The landscapes of Titian, Rembrandt, and Poussin are generally in harmony with the figures. With Rembrandt indeed— and this is perfection itself—the background and figures are one. The interest is everywhere, nothing is separate, it is like some lovely natural scene where everything combines to please. Watteau's trees

are painted *according to a formula*; they are always alike and remind one more of theatrical scenery than of forest trees. A painting by Watteau placed beside a Ruysdaël or an Ostade loses a great deal. Its artificiality jumps to the eye. One very quickly tires of the convention it offers, whereas one finds it hard to tear oneself away from the Flemish pictures.

The majority of the masters developed the habit (slavishly imitated by their schools) of exaggerating the darkness of the background to their portraits. They thought by so doing to render the heads more interesting. But such obscure backgrounds, when we see them behind lighted figures, deprive the portraits of the simplicity that should be their chief characteristic. The objects supposed to be in relief are shown in extraordinary conditions, for it is surely unnatural for an illuminated face to stand out against a very dark background—an unlighted one, that is to say. The light that falls upon the figure must logically also reach the wall or tapestry against which the figure is placed. Thus, unless we are to imagine that the face stands out accidentally against an intensely dark piece of drapery (but this would rarely occur), or against the entrance to some cave or cellar where the light never penetrates (a still rarer event), such a method will always appear artificial.

Simplicity is the quality that gives to portraits their principal charm. I do not consider as portraits those where an attempt is made to idealize the features of some celebrated man whom the artist has never seen, with the help of likenesses that have been handed down to posterity; in representations of this kind it is right to use the imagination. True portraits are those which we make of our own contemporaries; we like to see them on canvas as they are when we see them in the flesh, even if they happen to be illustrious personages. Indeed, with the latter, complete truth in a portrait is its greatest attraction. When famous men are out of sight we enjoy glorifying their images, as we do the qualities that distinguish them, but when the image is fixed and before our eyes, we find intense pleasure in comparing the reality with the figure that we have imagined. We love to see the man behind the hero.

Exaggerating the darkness of the background makes a strongly lighted face stand out well, if required, but such strong light is apt to be crude; in other words, it is an exceptional effect that we see before us rather than a natural object. When figures are so strangely detached from their backgrounds they seem more like ghosts than men. The effect is only too likely to occur of its own accord as the colours

darken in the course of time. The dark colours become even darker in relation to the light colours, which retain their value better, especially if the paintings have frequently had the varnish removed and have then been revarnished. Varnish sticks to the dark parts of a picture and is not easily detached so that the dark parts gradually become more intense until a background that appeared only moderately dark when the picture was painted will in course of time become sheer obscurity. When we copy a Titian or a Rembrandt we believe that we are keeping the same relationship between lights and shadows as the master's, but actually we are piously reproducing the work of time, or rather its ravages. The great artists would be most painfully surprised if they could see the smoke-blackened daubs that the pictures which they originally painted have become. The background of Rubens's 'Descent from the Cross', for example, must always have had a very dark sky, although one which the artist could imagine when he represented the scene, but it has now become so dark that one cannot distinguish a single detail.

We are sometimes astonished that nothing remains of the painting of antiquity. We ought, rather, to be surprised at finding a few traces of it in the third-rate scrawls that still decorate walls at Herculaneum. Here conditions were slightly more favourable to their preservation, because being painted upon walls, they were not exposed to so many risks as the pictures which the great masters painted upon canvas and panels, and which were far more liable to accidents because they could be carried about. We should be even less surprised at their destruction if we reflected that most of the pictures produced since the Renaissance—that is to say, comparatively recently—are already unrecognizable, and that a great number have already perished from a thousand different causes. Such causes will now be multiplied, thanks to the increase in sharp practice and knavery in every branch of the art, whether it be adulteration of the materials that go to make up the colours, oils and varnishes, or substitution by the manufacturers of cotton for hemp in canvases and of poor quality boards for the well-seasoned wood formerly used for panels. Clumsy restorations only finish the work of destruction. Many people imagine that they do a great deal for paintings when they have them restored. They appear to think that pictures are like houses that can be repaired and still remain houses, like all those other things, in fact, which time destroys, but which we contrive to preserve for our use by constantly repairing and replastering. Women who know how to make-up can sometimes disguise their wrinkles so as to appear younger than they

really are, but a picture is something totally different. Each so-called restoration is an injury far more to be regretted than the ravages of time, for the result is not a restored picture, but a different picture by the hand of the miserable dauber who substitutes himself for the author of the original who has disappeared under his retouching. Restorations to sculpture are less destructive.

3 August

Appointment in the morning with the Abbé Coquant to ask his permission to work (at Saint-Sulpice) on Sundays. It becomes more and more impossible. The Emperor, the Empress, and Monsignor, all seem to be conspiring together to prevent a poor painter from committing sacrilege by giving free rein, on Sundays as well as on weekdays, to the ideas which he brings out of his brain to the glory of God. And yet I used to prefer working in churches on Sunday; the music of the services was an inspiration to me; I did a great deal of work in Saint-Denis du Saint-Sacrement at such times.

4 August

Read an article in the *Indépendence Belge* on a translation of Dante's *Inferno*, by a certain M. Ratisbonne. This is the first time that a modern writer has dared to give a judgement on the great barbarian. The author says that the *Inferno* is not a poem, that is to say, not what Aristotle calls a unity—a work having a beginning, a middle and a conclusion. He says that there might as well be ten or twenty cantos instead of thirty-three; that it has no central interest; that it consists merely in separate episodes tacked on to one another, sometimes brilliant, as in the descriptions of the torments, but more often fantastic than striking; that there are no degrees of horror in the episodes and that the various punishments and tortures bear no relation to the crimes of the damned souls. What the article omits to say is that the translator, by his eccentric choice of language, still further increases the strangeness of some of Dante's imaginings, yet, although he criticizes certain uncouth expressions, he seems to approve this system of translating word for word, and of dogging the poet's footsteps through every verse or triplet.

How should an author appear anything but uncouth under such absurd and pretentious handling? Why add to the already difficult task of trying to render into a language adapted to the needs of modern life, whose whole spirit and idiom is different, the work of an ancient author, largely unintelligible to his own countrymen, a

poet, concise, epigrammatic, obscure, and possibly incomprehensible even to himself? I think that the work of translation as most translators understand it, that is to say into a living language acceptable to the people for whom it is intended, is hard enough already. To attempt to enter into the genius of another language, especially when it is a question of expressing the ideas of an entirely different period, is a *tour de force* which I consider almost useless to attempt. M. Ratisbonne's translation murders the French language and grates upon our ears; he succeeds in giving us neither the spirit nor the harmony of Dante's poem, and consequently no true sense of the meaning. He must be ranked with Viardot, and those other translators who turn Cervantes into Spanish-French, and write English-French when they are translating Shakespeare.

5 *August*

Every original talent goes through the same stages in its development as art does in its various evolutions, namely, timidity and dryness at the beginning, and breadth or carelessness of details at the end.

Nature is amazingly logical. When I was in Trouville I made a drawing of some fragments of rock the irregularities of which were so proportioned as to give the impression of a huge cliff when I had set them down on paper; it only needed some suitable object to establish the scale of size. At this very moment, I am writing beside a large ant-hill formed at the foot of a tree, partly with the help of irregularities in the ground, and partly by the patient labour of the ants. Here are gentle slopes and projections overhanging miniature gorges, through which the inhabitants hurry to and fro, as intent upon their business as the minute population of some tiny country which one's imagination can enlarge in an instant. If it is only a mole-hill that I am looking at, I can see if I choose, thanks to the miniature scale of the inhabitants, a vast stretch of country broken up with precipitous crags and steep inclines. A lump of coal or a piece of flint may show in reduced proportions the forms of enormous masses of rock.

I noticed the same thing when I was in Dieppe. Among the rocks that are covered by the sea at high tide I could see bays and inlets, beetling crags overhanging deep gorges, winding valleys, in fact all the natural features which we find in the world around us. It is the same with the waves which are themselves divided into smaller waves and then subdivided into ripples, each showing the same accidents of light and the same design. The huge billows in certain parts of the sea, off the Cape for example where they are said to be sometimes more

than a mile long, are composed of millions of smaller waves, the greater number of which are no bigger than the ripples in the basin of my garden fountain.

When I have been drawing trees, I have often noticed that each separate branch is a miniature tree in itself; in order to see it as such one would only need the leaves to be in proportion.

Shun evil men even when they are agreeable, instructive, or fascinating. How curious that some unconscious attraction, as much as chance, often brings us into contact with perverse people. This impulse must be checked since we cannot avoid the risk of chance meetings.

9 August

I have been reading an article in the *Revue*, by Saint-Marc Girardin, on Rousseau's *Lettre sur les Spectacles*. The author argues at great length the question of whether or not the theatre is a bad influence. I think that it is, but not more so than other diversions. Everything that we invent to distract us from the contemplation of our wretchedness and the cares of our daily lives tends to turn our minds towards matters which are more or less forbidden by strict morality. You create interest only by displaying the passions and the disturbances which they cause, and that is scarcely the way to inspire men with virtue and resignation. Our arts are nothing but incitements to passion. All the nude women in pictures, all the amorous ladies in novels or plays, all the deceived husbands and protectors are anything but encouragements to chastity and family life. Rousseau would have been a hundred times more shocked by our modern theatre and romances, for in the past, with very few exceptions, the novel and the theatre both described passions whose triumph or defeat more or less upheld the cause of morality. Adultery was rarely portrayed in the theatre (*Phèdre, La Mère Coupable*): love was a thwarted passion, but one whose aims were legitimate according to our ideas of moral conduct; it was poles apart from the romantic eccentricities which form the usual plot of modern drama and the food for idle minds. What possible seeds of virtue or even of morality can these Anthonys and Lelias and the rest plant in our hearts, when there is nothing to choose between them for extravagance and cynicism?

11 August

Compare the relative advantages of the life of the intellectual with that of the man who is no thinker—a country gentleman, for instance, born to the abundance of his manor and estates, who spends his

life in hunting and shooting and in visiting his friends, and the man whose life is given over to pleasures of the mind, who is modern, who reads and produces, and lives by his self-esteem. How can the latter's rare delights, his love of beautiful things, be compared with those of the other man? Unfortunately, he knows only too well what he lacks, for in the midst of the emptiness which he sometimes feels in his abstract happiness he is keenly aware of the joy he would gain from a life in the country, surrounded by his family in an old house on an ancient estate that perhaps belonged to his fathers before him. On the other hand, the man who is a countryman first and last has gross pleasures; he drinks, and lives on gossip and tittle-tattle, and does not know how to appreciate the noble and genuinely happy side of his life.

(Put the above among the other papers dealing with conflicting opinions on the reasons for unhappiness: chapter on necessary evils.)

For the countryman, whose only way of avoiding boredom when he comes home from hunting is to sleep like his dogs, the real misfortune is sickness and pain, even as it is for the philosopher who sighs for the joys of a country life. When they are in pain neither thinks of his life as being unhappy, and whether they suffer from boredom or from actual ills, both have the same horror of death—in other words of release from their boredom or suffering.

Custom dulls the edge of all our sensations: the petty irritations of family life, etc. Mme Sand ought to be happy, but I happen to know that she is not.

The happy man is one who is contented with the surface of things. I admire and envy people like Berryer who never seem to go deeply into anything—you give me something, I take it, it is not worth worrying over—who are always attentive to the demands of society, careful of conventions and appearances, and who are satisfied with that.

How often have I tried to look into people's hearts, solely in order to find out what real happiness lay beneath their satisfied countenances. How can these sons of Adam who are heirs to the same troubles as myself, these Halévys and Gautiers, weighed down with debt and constantly harried by the demands of their families or their vanity, how do they manage to appear so calm and smiling amidst their troubles? It can only be that they deliberately delude themselves, shutting their eyes to the dangerous reefs through which they steer their desperate course and on which some day they must inevitably be shipwrecked.

13 August

Lay figure at Lefranc's for 350 francs. Rue des Fossés-Saint-Germain, 23. Find out whether he lets them out on hire and if it is less expensive. Ask Andrieu to see about it.

17 August

Left for Dieppe at nine o'clock in the morning. Fearful difficulties in getting started; great relief when we were finally off.

I am sitting next to a great strapping fellow who looks like a Fleming but is wearing the most faultless travelling outfit; English felt hat, tightly buttoned gloves, superb walking-stick. He is reading the paper in a rather condescending fashion and from time to time throws a word to the man opposite. This man is plainly but neatly dressed in black; he seems to be reading his paper with attention and I take him to be an able man. The great dandy has just asked him about the place where he is going to live. 'It's a terrible hole,' he says, 'You'll be bored to death.' I conclude therefore that he is hard to please, another sign of superiority.

After both had exhausted their newspapers, which no doubt prevented their even glancing at the landscape through which we were travelling and which was giving me intense pleasure, they began a conversation. The man in black asked the man with the cuffs and walking-stick what had happened to So-and-so, and whether he'd seen him lately. So-and-so appeared to be a butcher. They then began to talk shop, and I discovered that my supposed intellectual, the scholar or professor, kept a draper's and milliner's shop in one of the suburbs and that his wife ran a smaller shop in the rue Saint-Honoré. The conversation became quite animated on the subject of shawls and cretonne . . . Everything at once became clear; I began to recognize in the features and build of my affluent butcher with his fashionable clothes, the strapping fellow who coolly bleeds a calf and cuts up the meat; the other fellow's jokes, and the mean expression in his little eyes, which disappeared into his head as he gave his inane laugh, fitted in perfectly with the gestures of a tradesman who spends his time measuring out material. Now I was no longer surprised that they paid so little attention to the scenery . . . They both left us at Rouen.

18 August

Today, I dined again at the Hôtel du Géant; I have found lodgings at 6 Quai Duquesne. The view from the window is enchanting. I

think we made a good bargain in arranging to pay a hundred and twenty francs for the month.

My poor Jenny, her destiny seems to be as firmly settled as my own (it has never been otherwise), but it is not what her goodness deserves. No nobler and more loyal nature has ever been put to such cruel tests. Heaven grant that she may have at least some happiness and less bitter suffering, to make up for the years of poverty she has endured so cheerfully and with such generous intentions!

23 August

I think it was this morning that I took Jenny, who is feeling much better for these outings, for a brisk walk along the top of the cliff towards the baths. It was then that I noticed the rocks at sea level and so much enjoyed seeing them flooded by the tide.

About four o'clock, I walked with Jenny towards Le Pollet. We went into the new church. It is built in the Italian style that modern architects are so fond of. It gives an impression of utter bareness; what these fellows imagine to be stark simplicity was merely barbarism to the men who invented this style of architecture. It might suit the Protestants who have a horror of the pomps and ceremonies of Rome, but these great bare walls and mean little windows enclose a faint light that is out of keeping with Catholicism, especially in this country where it is dark for three parts of the year. I cannot protest enough at the stupidity of architects and I *make no exceptions*. Each whim of fashion in every century becomes like a sacrament to them. They seem to think that only their predecessors were free to invent what they pleased for the decoration of their homes. They allow themselves to produce nothing that they cannot find ready-made somewhere else, and sanctioned by their text-books. Beavers will invent a new way of building dams before architects accept a new method or a new style in their art which, incidentally, is more a matter of convention than the others and should therefore allow more scope for invention and variation.

24 August

As I was coming back from Le Pollet before dinner today I came upon a poor old horse lying upon the ground, as I thought dead. In fact it was dying, and I began to quarrel with a great lout who was trying to beat it on to its legs again. To my great surprise the wretched animal managed to take a few steps when it got up although it was

clearly in great pain. I saw it again the following day (Friday) and at
about the same time; it was then standing, with flies covering its scars
and eyes, sucking what little blood remained in it. I resolutely sat
down in the middle of the road and made several drawings. All this,
occurring in the carriage-drive along the river Arques, created great
astonishment among the elegant passers-by, who wondered what
interest there could possibly be in the poor old screw which they saw
me drawing.

25 August

During my walk this morning I spent a long time studying the sea.
The sun was behind me and thus the face of the waves as they lifted
towards me was yellow; the side turned towards the horizon re-
flected the colour of the sky. Cloud shadows passing over all this
made delightful effects; in the distance where the sea was blue and
green, the shadows appeared purple, and a golden and purple tone
extended over the nearer part as well, where the shadow covered it.
The waves were like agate. In the places in shadow you get the same
relationship of yellow waves, looking towards the sun, and of blue
and metallic patches reflecting the sky.

Here I am copying a letter to Mme de Forget which relates to the
above.

'I have been very slow in writing to you, but I have been tossing
about from one set of lodgings to another before finally settling down;
however, here I am at last, and on the sea front. I can see the port and
the hills towards Arques; it is a charming view and so varied that it
provides me with endless amusement when I don't go out. I live my
usual life, seeing nobody and avoiding the places where I should be
likely to meet tiresome people. When I first arrived I ran into several
acquaintances and we promised, even swore, to meet every day, but
as I never set foot in the establishment where everyone forgathers
I have great hopes of never meeting them. I have my usual resources
for banishing boredom when I've nothing to do; I've borrowed one
of Dumas's novels and it sometimes makes me forget to go down to
look at the sea. Since yesterday the sea has been superb, the wind has
risen and there are going to be magnificent waves. I am sorry that you
should have ended your holiday just as I am beginning mine, but you
enjoy Paris more than I do. When I'm away from town I feel more
of a man; in Paris I'm merely a *gentleman*. There, all one sees are
ladies and gentlemen, dolls in other words; here there are sailors and
labourers, fishermen and soldiers.

'I have become an extraordinarily good cook. They have a cooking-stove like yours in these lodgings, and I have developed a passion for everything that comes from it. As for the fish and the oysters, and the lobsters and crabs, they are incomparably delicious. In Paris, you eat dish-water in comparison. As you will gather, I am wallowing in materialism; everything tastes good here, even the cider. However, I do occasionally feel bored at having no continuous work. The small drawings which I do now and then are not enough to keep my mind occupied and at such times I take up a novel or go down to the jetty and watch the ships putting in and out of harbour.

'This is the kind of life that I shall be leading for some time to come; I shall probably make a few excursions, but my headquarters will continue to be the Quai Duquesne. One has to drive out the demons as best one can in this devilish life which we have been given for no good reason that I can see, and it so easily becomes bitter if we don't present a firm front to boredom and worry. In short, one has to shake up one's mind and body from time to time; they begin to rend each other if we stagnate in an idleness that is really only torpor. The best way is to make a complete change from rest to work and vice versa, then both seem equally pleasant and health-giving. A man overburdened by exacting work must be dreadfully miserable, but someone who is obliged to amuse himself all the time cannot find happiness or even peace of mind in recreation; he knows that he is fighting boredom and it has him by the throat, the bogy is there as well as the pleasure and is always looking over his shoulder. Don't imagine, my dear, that I am free from the attacks of this terrible enemy because I have fixed hours of work. I am sure that people with a certain cast of mind need inconceivable energy never to be bored, and we must learn to use our will-power to banish the listlessness that we are constantly liable to fall into. The pleasure I feel at this very moment in writing to you at such length is a proof that when I have the strength I seize every opportunity to occupy my mind, even down to discussing the boredom which I so much want to exorcize. All my life, I have found that free time hangs heavily on my hands, and I think this is largely due to the pleasure I have almost always found in work itself. Perhaps the real or supposed pleasures that come after cannot make a big enough contrast with the fatigue of my work—a fatigue that tries most men very severely. I can perfectly imagine the joy which the great mass of men overwhelmed by tedious work must feel in their recreations, and I am not speaking only of the poor who work for their daily bread, but also of lawyers and other men in

offices, up to their necks in official papers and busy all day long over affairs that do not concern them. It is true that the majority of such people are not tormented by their imaginations, they may even find their mechanical occupations as good a way of filling up their time as any other. The stupider they are, the less they are unhappy.

'I end by consoling myself with this last axiom, that it is because I have a mind that I am bored; not just now, however, when I am engaged in writing to you. On the contrary, I have enjoyed this half-hour thinking of you, my dear, and talking to you in my own way of this subject that interests everybody. Perhaps these ideas will give you five minutes' pleasure when you read them, especially if they serve to remind you of the sincere affection that I feel for you.'

26 August

In the evening as I was walking by the shore I ran across Chenavard; I had not expected to meet him there. I felt glad to see him; his conversation will be a great resource to me. He came with me to Mme Sheppard's house, where I spent the evening and was exceedingly bored.

I left about half-past ten and walked as far as the Customs house on the quay trying to shake off the effect of the insipidity of the evening. I saw some of those English steamboats that are so wretchedly designed, and felt great indignation against nations that care only for one quality—speed. Let them go to the devil and the quicker the better with their machines, and all their improvements that merely turn men themselves into machines!

27 August

They are going to launch a large vessel called a clipper at noon today. Another of these American inventions to make people go faster and faster. When they have managed to get travellers comfortably seated inside a cannon so that they can be shot off like bullets in any given direction civilization will doubtless have taken a great step forward. We are making rapid strides towards that happy time when space will have been abolished; but they will never abolish boredom, especially when you consider the ever increasing need for some occupation to fill in our time, part of which, at least, used to be spent in travelling.

30 August

A heavenly morning; I went out alone and climbed the hill behind

the castle, up a little winding road and through a small copse of beech trees planted on the slope of the hill in rows of five, in the Norman way. I sat down in a field where the corn had just been reaped, and made a sketch of the castle and the view—not that it was particularly interesting, but so as to retain the memory of this exquisite moment. The scent of the fields and the newly cut corn, the song of the birds and the purity of the air put me into one of those moods when I can remember nothing but the days when I was young and my soul was easily stirred by such delicious sensations. I think that nowadays I can almost coax myself into being happy merely by remembering how happy I used to be in similar circumstances.

31 August

Had an endless conversation with Chenavard this evening as we walked on the beach and along the streets. He told me of the difficulty which Michelangelo used to experience in working, and quoted a saying of his. Benedetto Varchi said to him: 'Signor Buonarroti, avete il cervello di Giove'. He is supposed to have answered: 'Si, vuole il martello di Vulcano per farne uscire qualche cosa'. At one period he burned a large number of studies and sketches so as to leave no trace of the effort it cost him to produce his works, which he altered over and over again like a man writing verses. He often made his carvings from drawings, and his sculpture bears witness to this procedure. He used to say that good sculpture never looks like painting, and that on the contrary, good painting is the kind that looks like sculpture.

This was the day when Chenavard talked to me again about his famous theory of decadence. He is far too dogmatic. And what is more, he fails to assess estimable qualities at their true value. Although he says that the men living two hundred years ago are not on the same level as those who lived three hundred years ago, and that our own contemporaries are not the equals of the artists of the past fifty or a hundred years, I consider that Gros, David, Prud'hon, Géricault, and Charlet are admirable men of the quality of Titian and Raphaël. I also think that I myself have done some scraps of painting which these gentlemen would not despise, and that I have had one or two ideas that would have been new to them.

1 September

Got up early yesterday and the day before, and went down on to the beach with Jenny.

Worked all day. Sat at my window before dinner drawing boats.

In the evening I put Chenavard off; I was feeling tired after his tirade of yesterday. Either deliberately or unconsciously he manages to reduce one's spirits like a surgeon practising bleeding and dissection. What is beautiful is beautiful, no matter what the period or for whom it is intended.

2 September

When all is said and done scholars can do no more than find in nature what is already there. A pedant's personality plays no part in his work, but it is very different with the artist. It is the imprint which he sets upon his work that makes it the work of an artist—of an inventor, in other words. The scholar discovers the ingredients, so to speak, but the artist takes ingredients that have no value in the place where they are, composes them and invents a unity, in short, he creates. He has the power of striking men's imagination by the sight of his creations and he does this in a manner characteristic of himself. He summarizes and elucidates for the average man, who can only dimly think and feel, in the presence of nature, the sensations which such things arouse in us.

3 September

Went down to the pier in the morning. Saw two brigs, one of them from Nantes, getting under way: as a study, this interested me a good deal. I am going through a complete course in yards, pulleys, etc., so as to find out how the rigging fits together; it will probably be quite useless but I've always wanted to understand the mechanism and besides, there is nothing so picturesque. My observations have certainly been rather superficial, but they have led me to see how clumsy all this apparatus still is, and the heaviness and inefficiency of all the masts and spars; there had been no change for the last two hundred years until the coming of steam, which changed everything. Those two poor ships were dragged out of port with the help of every conceivable kind of machinery for towing, and reached the open sea without being able to make any progress of their own accord. I drew them first as they lay motionless and when I left them, tired of waiting, they were still in the same position.

6 September

In the morning I abandoned the jetty and took the path which climbs up to the left behind the castle as far as the cemetery; before

reaching it there was a most delightful effect at the top of the ravine which we crossed the other day. The little path on the far side was lit up in the rays of the morning sun and disappeared into the shadow of the beech trees. Went into the cemetery. It is less repulsive than that ghastly Père-Lachaise, less formal and inane, altogether less middle class. Forgotten graves lie buried beneath the grass, clumps of roses and clematis make the air fragrant in this abode of death; for the rest, perfect solitude, the ultimate harmony with the purpose of this place and the inevitable end of all who lie herein—that is to say, silence and forgetfulness.

7 September

Coming home to Saint-Jacques, I saw a poster announcing that the mountain singers would sing the Mass today: I came exactly at the right moment and was as much surprised as delighted.

These men are all peasants from the Pyrénées with magnificent voices; they appear to have no music and no one to beat time for them, but I think that an elderly man with grey hair who remained seated was probably their conductor. They sang unaccompanied. I could not resist following them when we left the church and complimenting them on their performance. Most of the men had serious expressions. I thought the children very moving. Boys' voices are far more piercingly sweet than the voices of women which I've always thought shrill and lacking in expression, and there seemed something almost holy about these innocent artists of eight or ten years old. Their pure voices rising up to God out of bodies as yet scarcely developed, and from souls that have not yet been sullied, must carry straight to the steps of His throne and plead to His eternal goodness for our weaknesses and our sorry passions.

It was a very moving scene for a simple fellow like myself to witness. These young men and children dressed alike in their poor clothes, gathered in a circle, and watching each other's faces as they sang without written music. I sometimes regretted that there was no accompaniment. It was partly the fault of the music which was beautiful in itself in the graceful Italian manner, but some of the pieces were too long and too complicated for unaccompanied singing and for these very simple artists, who seemed to sing by inspiration alone. All the same it left a deep impression, and reminded me exactly of a bas-relief of singers by Lucca della Robbia, even down to the blue blouses fastened by a belt which they all wore. These poor people have sung in real concerts at the *Établissement*. I should be sorry

to hear them singing popular tunes, probably tricked out in their Sunday best for this damnable modern music which the public demands at such places.

I have been reading that dull book *Eugénie Grandet*. Works of this kind do not stand the test of time; the muddle and lack of skill which are incurable defects of the author's talent will relegate all such things to the scrap-heap of the centuries. No restraint about it, no unity, no proportions.

Went to look up Chenavard; we kept away from the beach on account of the wind and walked through the streets to the quay of the farthest dock, where we stayed in the moonlight until eleven o'clock.

I felt his sympathy and regard for me. He is unhappy; he feels that he has wasted his talents. Philosophy is a hollow diet; it pretends to give men self-knowledge but does not increase their resignation to the inevitable evils, the contradictions and defects in their natures. It seems to me that besides the habit of deeper reflection on the subject of life and human nature, being a philosopher should imply taking things as they come and making the best we can of our lives and passions. But it appears not to be so! These dreamers are as restless as everyone else. It would seem as though their meditation on the mind of man (a thing more to be pitied than admired) deprived them of the serenity that often comes to those who are harnessed to work that is more practical and to my mind better worthy of their efforts. I asked the poor fellow, whom one really cannot help admiring, what he was doing in Dieppe, why he was returning to Germany and Italy and why he had gone there in the first place. I also asked him what he was escaping from, and what he hoped to gain from all these comings and goings. A man who is beginning to have doubts will only doubt the more when he has seen everything.

Chenavard thinks that I am happy, and he is right; what is more, now that I have seen how miserable he is, I consider myself much happier still. His devastating doctrine of the inevitable decay of the arts may well be true, but we must not allow ourselves even to think of it.

When we were walking on the wooden pier that evening, I said to Chenavard that genius ranks according to taste. It is purely a matter of taste that La Fontaine, Molière, Racine and Ariosto are considered superior to men like Shakespeare and Michelangelo. I admit that it still remains to be seen whether strength and originality carried beyond a certain point do not compel our admiration despite everything. But here again we return to a debatable point, a question of personal taste.

I adore Rubens, Michelangelo, etc., and yet I was saying to Cousin that I believed the fault of Racine lay in his very perfection. He is not considered beautiful because he is actually too beautiful. Perfect beauty implies perfect simplicity, a quality that at first sight does not arouse the emotions which we feel before gigantic works, objects whose very disproportion constitutes an element of beauty. Are works of this kind, whether in nature or art, actually more beautiful? Assuredly not, but they are capable of making a deeper impression. Who would dare to say that Corneille is more beautiful because parts of his work are coarse and slipshod? Rather, we must say that the work of men of his kind contains passages so strong that we forget their faults, and our minds become accustomed to them; never let us say that Racine or Mozart are tamer because beauty is to be found in every part of their work, where it forms the warp, the very tissue of the fabric itself. I have said elsewhere that sublime geniuses whose works are full of outstanding passages are like those scapegraces whom women adore; they are so many prodigals, in whom we are thankful to discover a few redeeming qualities to make up for their general misbehaviour. But what shall we say of Ariosto, who is all perfection, who unites all imagery, all shades of feeling, comedy and tragedy, tenderness and restraint? But I must stop.

8 September

As Mérimée says, a perfect work should need no notes. I feel inclined to add that if a work is really well written, and above all well reasoned, it should not require even paragraphs. If the ideas arise one out of another and the style is well-knit, there should be no need for breaks until the thought which forms the kernel of the subject has been fully developed. Montaigne is a supreme example of the need for *genius* in *this particular case*.

After luncheon I set to work with great enthusiasm to draw the carts passing along the road, with their teams of four horses and the very picturesque harness. Afterwards I made a large-scale drawing of the whole fore-part of the ship lying under my window. When one's mind is refreshed by work, a sense of happiness pervades one's whole being.

In this happy mood I went down to the jetty, and came back along the seafront to the Cours Bourbon to dine with Chenavard. I thought that we were going to have a good dinner and an enjoyable talk. But the food was abominable and my companion did not make things any better with his gloomy forebodings.

I am beginning to think that the same fate that decides everything, according to Chenavard, also prevents the possibility of any intimate friendship between us. One day I feel drawn towards him and the next, I am reminded of the unpleasant side of his character.

I left him at ten o'clock at the Salt Pits and walked down to the pier in an attempt to shake off this obsession. Saw a fine brig coming into harbour by moonlight, in a fairly rough sea. It was a fine sight and I turned round and followed her; the moon was in front of me, and there were wonderful effects on the water and on the great mass of the ship with its rigging standing out against the night sky.

That infernal fellow Chenavard never praises anything that is not beyond our reach. Kant and Plato, those were men indeed! They were almost gods! But if I mention a contemporary, someone whom we can reach, he immediately tears him into shreds and forces me to help in dissecting him until we have left nothing intact. He is right in saying that he has no faculty for admiration; he makes it quite obvious. Chenavard is an interesting man but at the same time he repels me. Is it possible for perfect virtue and perfect honesty to be repellent? Can a sensitive spirit dwell in a sordid body? If he picks up a drawing to examine it, he handles it carelessly and puts his fingers all over the paper as though it were a thing of no account.

I believe this disregard for objects that need careful handling is a kind of affectation, and that in spite of his efforts to conceal it, his apparent contempt for common decency masks an inner revolt in the proud soul of this cynic. His mind must have suffered some deep hurt. Perhaps he hates himself because he feels that he is a failure and there-fore tries to delude himself into thinking that everyone else is a failure too. He is talented in all manner of ways, and it is all dead. He draws and composes, and people are coldly just to him; it is the most they can do. It is astonishing to hear him talk and to realize how much he knows and what he could add to other people's ideas. He doesn't care for painting and admits it. But why not write? Why not edit some book or other? He feels himself to be capable of doing this and says that he has sometimes made a success of it, but he acknowledges that it costs him too much effort to express his ideas. This excuse betrays his weakness. Why doesn't he do as Rousseau did, whom he so much admires? He unquestionably had something to say, and said it exceedingly well, in spite of his difficulty in expressing himself, a matter which he used almost to boast about.

Have I written all this under the influence of an unusually bad impression of him? Not at all, I like him, I'm almost fond of him and

should like to think him more amiable, but in the end I always come back to the ideas which I have expressed here.

12 September

In the morning the tide was out when I went on to the pier; the sea did not look very attractive. I noticed a good subject for a picture, a dinghy bringing fish ashore from a small ship that could be seen in the distance; the men were landing on the shoulders of others who were standing in the sea; they were bringing in baskets of fish to a group of women. The dinghy was first dragged up on to the beach by two or three little cabin-boys and was then launched again with oars upright, the morning sun streaming down on the whole scene.

Went out late in the evening—we did not dine until six because we had trouble with the famous stove. Strolled about in the main street and looked at the shop windows, a thing I never do in Paris. I enjoyed everything. Happening to see the door open as I passed Saint-Rémy, I went inside and was rewarded by the most imposing sight imaginable—a dark and lofty church lit here and there by half a dozen smoking candles. I challenge the opponents of *vagueness* to produce an impression comparable to this with their precise, clearly defined lines. If we are to classify our feelings, as Chenavard does, in order of nobility, we might as easily plump for an architectural drawing as for one by Rembrandt.

I left the church enchanted but much pre-occupied by the problem of rendering, not so much the feeling, as the complication of lines and perspective, the projection of shadows and so forth, which made such a magnificent picture out of what I had just seen.

After dinner, I went into Saint-Jacques where they were holding a service. The priest was thoughtfully reciting the Stations of the Cross from the pulpit. He was interrupted at regular intervals by the choir intoning a canticle which was repeated by the entire congregation. The priest, with the Cross-bearer and choir, then knelt to pray at each Station, and at the end of the service offered the Crucifix or Paten to be kissed by the people. There is a good subject for a picture in this final act, seen from behind the altar.

15 September

David once said to a man who wearied him with his talk of processes, methods, etc.: 'I knew all that before I knew anything at all.'

How strange painting is, it delights us with representations of objects that are not pleasing in themselves!

17 September

Chenavard called at about eleven. He opened his mind very sincerely to me (at least, so I think) on the contrast between the credit he feels he deserves, and which I genuinely acknowledge, and the low opinion which he thinks people have of him. He knows that he is unpopular; people reproach him for being extremely hard on others when he shows no particular sign of talent or activity on his own account. He thinks, as I do, that his lack of self-confidence, and the discouragement which he admits to feeling, are the reasons for his comparative failure—he gives up far too quickly. How can he expect people to be as interested in him as they are in men who not only have the gift of a fine mind, but the determination and energy required to bring them to the front rank? He does not consider Géricault a master; he feels him to be somewhat stunted. *He was a brilliant young man* and Chenavard does not believe that he would ever have become more than that. He gives many good reasons for his opinion, such as the pictorial insignificance of Géricault's work, and the way in which posed figures and details predominate although the painting is strongly handled.

(Six months later, on 24 March 1855. Feeling in an idle mood before the Exhibition, I have been re-reading the above passage concerning Géricault. I was looking at some lithographs by him yesterday, of horses, etc., and even lions. Everything about them is cold, in spite of the masterly way in which he has handled the details. There is no unity about them; every one of these horses is badly put together in one way or another, parts of them either too small or ill-connected; not a single background has the smallest relationship with the subject.)

A rather miserable dinner. However, when I went down to the beach, I was compensated by seeing the setting sun amidst banks of ominous-looking red and gold clouds. These were reflected in the sea, which was dark wherever it did not catch the reflection. I stood motionless for more than half an hour on the very edge of the waves, never growing tired of their fury, of the foam and the backwash and the crash of the rolling pebbles.

20 September

We have been to Eu. I was supremely happy for two or three hours after we started, delighting in the smallest details of nature, just as I used to do when I was young. Spent the journey writing down my

impressions in spite of the jolting of the carriage. I did not much enjoy Eu, apart from a feeling of freedom and well-being before we visited the church. Tombs of the Counts of Eu. Guns hung over the churchwarden's pew.

We visited the Château. I cannot find words to express my disgust at the appallingly bad taste of this place. The paintings, architecture, and decorations, even the very posts surrounding the courtyard are mean and hideous. The garden is as wretched as everything else. The view from the Château over the church, with its bleak restorations and its narrow entrance set between offices and outbuildings, offends against all decency and common sense. God forgive the poor king, who was so admirable in many ways, for his taste in art. The influence of Fontaine and the taste of the Academy, Picot, etc., can be seen everywhere.

Whilst I was looking at the tombs at Eu I noticed that the head-dress of one of the Countesses was exactly like those of the women at Tréport, apart from the quality of the material and the pearls. They wear a kind of forage cap, but very graceful. The whole costume of the Tréport women is charming; a plain bodice with a double skirt, the under-skirt showing below the top one, the sleeves worn wide to the elbow. The women walk loosely and easily, like the Jewish women in Tangier.

21 September

Stayed indoors until rather late, and sat at my window drawing the fishing boats as they came into harbour. When I went out at about one o'clock I drew a boat which they were burning on the other side of the bridge, and then continued my walk with a great sense of happiness. I feel as though I could spend my whole life idling in this delightful fashion. Before dinner I made a drawing behind the altar at Saint-Jacques.

The world was not made for man. Man is the master of nature and is mastered by it. He is the only living creature who not only resists, but overcomes the laws of nature and extends his authority by energy and force of will. But to say that the universe was made for man is a very different matter. All man's constructions are as transitory as himself; time overthrows his buildings and blocks his canals, it reduces his knowledge to nothing and obliterates the very names of his nations. Where is Carthage now? Where is Nineveh? They say that each generation inherits from those that have gone before; if this were so there would be no limit to man's improvements or to his power of

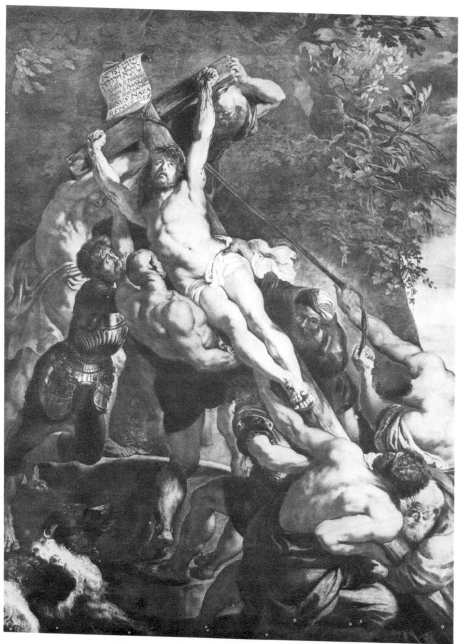

XI. RUBENS: THE RAISING OF THE CROSS
1610–11

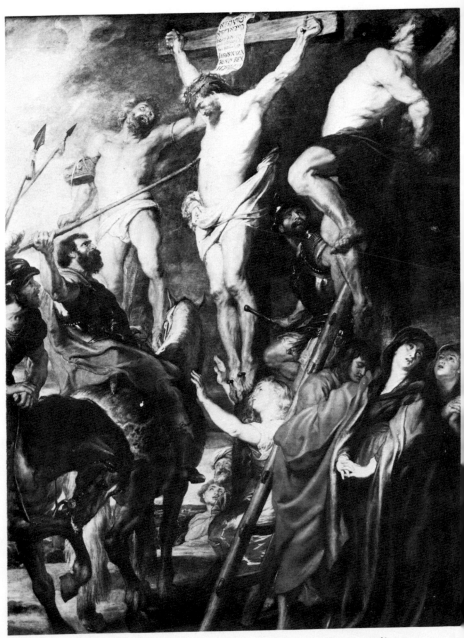

XII. RUBENS: CHRIST ON THE CROSS ('LE COUP DE LANCE')
1620

reaching perfection. But he is very far from receiving intact that storehouse of knowledge which the centuries have piled up before him; he may perfect some inventions, but in others, he lags behind the originators, and a great many inventions have been lost entirely. What he gains on the one hand, he loses on the other. I have no need to point out how harmful to morality, and even to health, many of his so-called improvements have been. Some, by removing or reducing the need for exertion and hard work, have diminished our patience to endure evils, and the energy that was given us to overcome them. Others again, by increasing luxury and an appearance of well-being, have fatally affected the health of generations to come and have brought about a general decline in morals. We borrow from nature such poisons as tobacco and opium and make them the instruments of our gross pleasures, and we are punished by loss of energy and the degradation of our minds. Entire nations have been reduced to a form of slavery by immoderate use of stimulants and strong drink. No sooner do nations reach a certain stage of civilization than they find themselves growing weaker, especially in their standards of courage and morality. This general loss of energy, which is probably a result of the increase in pleasure and easy living, brings them to swift degeneration and to the neglect of the tradition that was their safeguard —their standard of national honour. In such circumstances it is hard for a nation to resist conquest. There will always be peoples ready to enrich themselves at the expense of degenerate nations, either because they are essentially barbarous, or because they still retain their courage and spirit of adventure. This easily foreseeable catastrophe sometimes turns out to be a source of new life to the conquered peoples. It purifies the air like a storm or a hurricane and brings fresh seed to an exhausted land. Sometimes a new civilization rises from the ruins, but centuries must pass before the arts of peace can flourish again. Those arts which in their turn are destined to lead to softer ways of living and the corruption of moral standards bring about once more the eternal succession of greatness and misery, proof of man's weakness, but also of the astounding power of his genius.

22 September

Drew some boats that were moored alongside the jetty. From the pier the sea was looking wonderful. I saw a number of fishing-smacks sailing in and out of the harbour, a pretty English yacht, a schooner, etc.

Came back late and slept after luncheon. After dinner, I did a small water-colour of an English brig and the fishing boats that have been run up on to the mud at Le Pollet, opposite my window. Then I went for a walk along the jetty; the tide was out and I was almost the only person there.

23 September

On silence and the silent arts.

Silence is always impressive: even fools look respectable when they are silent. In business and other human relationships, men who are wise enough to be silent at the proper time owe much of their success to this faculty. But nothing is harder than such restraint for men who are dominated by their imagination. Men with subtle minds who are quick to see every side of a question find it hard to refrain from expressing what they think. Rash suggestions, wild promises, witticisms about dangerous or powerful people, confidences made on the spur of the moment, one could draw up a long list of the difficulties and dangers arising out of such indiscretions.

On the other hand, everything is to be gained by listening. You know what you wish to say to the other man, your mind is full of it, but you cannot know what he has to say to you; he may have something new to tell you, or remind you of something which you have forgotten.

But how is it possible to resist giving a favourable idea of one's mind to a man who seems surprised and pleased to hear what one is saying? Fools are far more easily carried away by the empty pleasure of listening to their own voices because they are incapable of profiting by serious and instructive conversation, and because they are less interested in informing their hearers than in dazzling them with their brilliance. Fools feel self-satisfied after a conversation from which their only reward for all the boredom they have caused is the contempt of sensible men. Reticence in a fool is the first sign of wisdom.

I confess my preference for the silent arts, those mute things which Poussin used to say that he professed. Words are tactless, they interrupt one's peace, demand attention, and provoke discussion. Painting and sculpture seem more serious; you have to seek them out. Books on the other hand are importunate, they follow you about, you find them everywhere. You have to turn the pages, follow the argument and continue to the end before you can pass judgement. How often have we not regretted the time and trouble spent on some second-rate

book for the sake of extricating a few ideas scattered here and there amidst its pages! Reading any book that is not entirely frivolous means having to work; it causes a certain amount of fatigue. The author seems to wrestle against criticism. He argues, and one can argue with him in return.

The works of painters and sculptors, on the other hand, are all of one piece, like the works of nature. The author does not appear in them, is not in touch with us like the writer or orator. He offers, as it were, a tangible reality, yet one that is full of mystery. He does not need to lure us into giving him our attention, for the good passages in his work can be seen at once. If it is unbearably mediocre we have only to turn away our eyes, whereas a masterpiece holds us, in spite of ourselves, rapt in contemplation which only an irresistible charm can induce. Moreover, its silent charm has the same power, and even seems to increase each time we look at the work.

Books are different. Their beauties are not sufficiently detached to excite the same pleasure continuously. They are too much inter-mingled with passages which cannot be so interesting because of the need for links and transitions. Although we stimulate our ideas by reading good books—and that is one of the first claims of such reading —we involuntarily merge them with those of the author; his images cannot be so striking as to prevent our forming a picture of our own as well as the one which he creates for us. There can be no better proof of this than our dislike for long books. An ode or a fable has the virtues of a picture and can be taken in at once. What tragedy does not end by becoming wearisome, and how much more so, a work like *Émile*, or *L'Esprit des Lois*?

26 September

Left Dieppe. In the morning I went down to take my leave of the jetty. Did a sketch of the beach and the castle. The weather was marvellous, and the sea calm and blue.

Found Chenavard at the railway station; he has been in Dieppe all this time, either ill or busy; he said that he thought I had left.

Arrived at five o'clock. Find that I dislike Paris as much as ever.

2 October

Varcollier goes out of his way to be charming to me and I am touched by his attentions; unfortunately, I no longer feel the emotion which I used to call friendship to the same degree, and it is rather late

to revive it now. *Only one person* in the world truly makes my heart beat, all the rest quickly weary me and leave no impression when they are gone.

4 *October*

I discovered early in life that a certain amount of money is indispensable to a man in my position. To have a great deal would be as much of a nuisance as to have none, but a moderate degree of comfort is necessary to maintain one's dignity and self-respect. That is what I have learned to appreciate and it is absolutely necessary, far more so than the small luxuries which one can purchase if one is well-to-do. The immediate advantages of an independent income are peace of mind, and freedom from worry and from these wretched expediencies to which one is driven by financial embarrassment. You need to be very prudent to reach and maintain this essential standard of security. You must steadily fix your eyes on the need for serenity, and the freedom from material cares that will allow you to devote yourself to high endeavours and prevent your mind and spirit from degenerating.

These reflections are the result of a conversation with Riesener, who called on me after dinner this evening, and of what he told me about the Pierrets. His own circumstances do not seem much better, or his future prospects, for that matter. All his life, he has acted as though he were slightly crazy; there is a basis of common sense in his mind, but he never allows it to appear in his conduct.

Speaking of common sense brings me to my visit to Chenavard this morning. Here is another man who seems full of common sense when he is talking and arguing, or comparing and making deductions, but his own compositions and the partiality of his judgements contradict this seeming wisdom. He likes Michelangelo and Rousseau, but geniuses of their type and certain others of very imposing quality are particularly admired by the young. Men like Racine and Voltaire are admired by riper minds, to whom they make an ever-increasing appeal.

The only explanation I can give for the different opinions about authors that we hold at different ages, is the lack of reason and clear thinking that goes side by side with the many great qualities of florid writers. Rousseau has something unnatural about him; you feel a sense of strain in his work which points to a mind struggling between insincerity and truth. I maintain that in truly great men there is not

one particle of falsity. Falsity, bad taste, lack of true reason—different names for the same thing.

Titian! Now there is a man who seems made to be enjoyed by those who are growing old; I confess that when I had a great admiration for Michelangelo and Lord Byron I never appreciated Titian. It is not, I believe, by the depth of his expression, nor by his great understanding of the subject that he moves one, but by his simplicity and his total absence of affectation. In his art the painterly qualities are carried to the highest possible degree. Whatever he does is done thoroughly and completely; when he paints eyes, for instance, they see, they are quickened by the fire of life; life and logic abound in every part of his work. Rubens is entirely different and has a different kind of imagination, but he really knows how to paint men. Both artists lose their sense of proportion only when they imitate Michelangelo and affect a grandeur that is really nothing but turgidity and usually smothers their true qualities.

The claim which Chenavard makes for his beloved Michelangelo is that he painted man before everything else, but I say that he painted only muscles and poses, in which, contrary to general opinion, knowledge is not the dominant factor. The least of the artists of antiquity was infinitely more knowledgeable than the whole of the work of Michelangelo, who never understood human passions and feelings. When he did an arm or a leg he seems to have thought of nothing but the particular arm or leg that he happened to be working on, and not at all of its relationship, I do not say to the action of the picture as a whole, but even to the movement of the figure to which it belonged.

Some passages, it must be admitted, are treated in this manner with the deliberate intention of stirring our emotions independently of the rest of the work. Herein lies the glory of Michelangelo; he can give a sensation of grandeur and even of the terrible in a single limb. And in a different style, Puget has the same characteristic. You can spend an entire day looking at an arm by Puget, and that same arm will be part of a statue that is mediocre, taken as a whole. What is the secret of this kind of admiration? But this is something which I cannot undertake to explain.

We talked about the rules of composition. I said to Chenavard that absolute truth can give an impression contrary to truth, or at least contrary to that relative truth at which art must aim. Now that I come to consider the matter thoroughly, I see that it is perfectly logical to exaggerate the important passages intended to create the chief impression, in order to make them suitably outstanding,

because it is to them that the mind of the beholder must be directed. Regarding our subject, 'Mirabeau and the Protest of Versailles',[1] I said that Mirabeau and the Assembly should be on one side of the composition and the King's envoy quite alone on the other. Chenavard's composition shows arranged and balanced groups, varied attitudes, men talking naturally among themselves, just as it might have occurred at the time. His sketch is well planned for size and follows the material laws of composition, but the mind gets no conception of the protest of the National Assembly against M. de Brézé. That emotion, animating an entire assembly as though it were one man, must be authoritatively expressed. Reason demands that Mirabeau should be at the head of the group and that the others should throng behind him, attentive to all that is happening. All minds, including that of the beholder, are fixed on what is taking place. At the time, no doubt, Mirabeau was not in the position which would make him the centre of the picture, and perhaps M. de Brézé's arrival was not announced in such a way as to bring the whole Assembly into a single group facing and, as it were, ranged against him, but the painter has no other way of expressing the idea of resistance. It is absolutely essential to isolate the figure of de Brézé. He must certainly have arrived with attendants and followers, but he must go forward alone, leaving them at a distance. Chenavard commits the incredible blunder of showing them arriving on one side of the picture, while de Brézé, coming in on the other, is lost in the group of his antagonists. In this highly topical scene, with the throne on one side and the people on the other, he haphazardly places Mirabeau on the same side as the throne over which—another mistake—workmen are climbing to take down the draperies. The throne ought to have been shown as isolated and abandoned as it then was, morally speaking, by the people and by public opinion; above all, the Assembly should be standing facing the throne.

5 October

To be surrounded by papers that talk to one, I mean drawings, sketches, and memoranda, to read two acts of *Britannicus* and feel more amazed each time at such perfection, to hope—I dare not say to be sure—of remaining undisturbed, to have a little work to do, or

[1] Both Delacroix and Chenavard painted pictures for an open competition organized by the Government in 1831. The subject was 'Mirabeau delivering a vehement protest on behalf of the Assembly against a declaration from Louis XVI presented by the Marquis de Dreux-Brézé at Versailles in 1789'.

a great deal, but above all to feel secure in one's solitude; herein lies a form of happiness that often seems to me more desirable than any other. At such times I can enjoy myself to the full; I have nothing to hurry me, nothing to tempt me outside a circle of study, where content with little (*little*, I mean, *of what the average person calls enjoyment*), but aspiring to the greatest things by inward contemplation or by looking at the masterpieces of all time, I feel neither crushed by the burden of time, nor terrified by the swiftness of its passing. Such are the pleasures of the mind, an exquisite mixture of peace and excitement that physical passion can never give.

Champrosay, 12 October

Worked in a frenzy of enthusiasm until past three o'clock. I could not bear to tear myself away. Pushed forward with the grisaille of the 'Moorish Horseman mounting his Horse', the 'Fight between the Lion and the Tiger', and the small 'Algerian woman with the Greyhound': have also put some colour on the cartoon of 'Hamlet killing Polonius'.

After so long a spell of work, it is a real delight to go for a walk. The weather is still very good. I must try to make up my mind to enjoy the country only from my window in the mornings; going out, even for the shortest walk, seems to distract me too much and condemns me to boredom for the rest of the day, because I find it so hard to recover my enthusiasm for work.

Went down to the river and had another look at the view of Trousseau's place, which I have been doing on cardboard; it is not the same thing at all. The landscape I want is not the landscape rendered with absolute truth; do we ever find this absolute truth in the work of the landscape painters who have painted truthfully, and yet have remained in the ranks of the great artists? It would seem as though nothing could equal the truth of the Flemish painters, and yet how much the artist appears in the work of this school! Painters who simply reproduce their studies never give the beholder a living sense of nature. He is moved because he sees nature through the eye of his memory while he looks at your picture. Your picture must already have been beautified, idealized, if you are not to seem inferior to the conception of nature formed by the ideal, which memory thrusts willy-nilly into all our recollections.

In the evening, we had a wonderful capon cooked with enough garlic to put a whole company of British Grenadiers to flight. Afterwards, Jenny le Guillou and I went for a walk.

We talked about Chenavard's assertion that talents are worth less in a bad period. But what I should have been in the time of Raphaël, that I am today. What Chenavard is today, that is to say dazzled by the gigantic element in the work of Michelangelo, he would certainly have been in Michelangelo's own lifetime. Rubens is none the less Rubens for having appeared a hundred years later than the immortals of Italy, and if anyone should exist today of the stature of Rubens or any other of the masters, he will be all the greater. He will adorn his century by his independent effort instead of being one of a group of talents all contributing to its brilliance. As for success in his own lifetime, this may well be doubtful; his circle of admirers may be limited, but one of these, lost in the crowd, may be as much moved as those who hailed Raphaël and Michelangelo. What is made for men will always find men ready to esteem it at its true value.

15 October

I have made it a rule never to allow myself to finish a picture unless the effect and the tone have been completely caught, and I find this plan very successful. I am always going back over my work, redrawing and correcting, and always in the light of *what I feel is needed at that particular moment*; indeed, it would be stupid to do otherwise. What I felt yesterday can be no guide for me today. I do not know how other men work, this is the only method for me. When everything has been carried forward in this way there is no difficulty about finishing, especially when one uses tones that at once fit in with those already set down. Without this, the freshness of the execution is lost and one spoils the liveliness of sensitive touches; proceeding in this way, the touches seem scarcely to have been modified.

Before repainting, any passages of thick paint must be scraped down.

21 October

In Racine the different parts are nearly always perfectly conceived. He thought everything out and never resorted to padding: Burrhus, a leading role if ever there was one, and Narcisse also. Britannicus, the simple, fiery, rash Britannicus; Junie, so loving, but delicate; so prudent in her love, but prudent only for the sake of her lover. I will say nothing of Nero and Agrippina, because with two such parts in a play or even one, played by a tolerably good actor, you go away feeling satisfied. You feel that you have been seeing a play by Racine even

if, because of bad acting, you may have missed those fine shades of meaning which are the essence of Racine.

In some plays the principal character on whom the whole action pivots is sacrificed and the part given to a minor actor. Is any role comparable to Agamemnon? The ambition and warmth in his character, the different attitudes which he adopts towards his wife, in short his perpetual vacillations, cannot be ascribed to a lack of feeling that would destroy the sympathy of the audience, but to a plot brilliantly contrived to test a great character. I am not saying that the part of Achilles, usually played by the leading actor, is inferior to that of Agamemnon; it is inevitably a great part, but not the centre of interest. Clytemnestra, Achilles, and Iphigenia are all impressive characters because of their passions and their parts in the play, but to a certain degree they are mere instruments working upon Agamemnon to urge and drive him in different directions.

How many people think of such things when they go to the play? And I would ask those capable of such reflections whether or not it is the actors' performances that make them conscious of such varied impressions.

Augerville, 30 October

Mme de Caen was looking her best at dinner this evening; I have to take a tight grip on my heart when she is near, but only when she wears full evening dress and shows her arms and shoulders. I become very reasonable next morning when she wears ordinary clothes. She came to look at the paintings in my bedroom this morning and then, without any hesitation, took me through her dressing-room to see the ones in her own room. I felt secure about my virtue, however, because I found myself thinking of other times when this bedroom and dressing-room housed the exquisite Marcelline who, I suspect, possesses no such breasts and arms, but has a way of pleasing by some quality of her own—her wit perhaps, or the mischief in her eyes, the qualities that make her so impossible to forget.

2 November

I was much impressed by the Requiem Mass. I thought of all that religion has to offer to the imagination, and at the same time of its appeal to man's deepest feelings. *Blessed are the meek, blessed are the peacemakers*: what other religion has ever made gentleness, resignation and simple goodness the sole aim of man's existence. *Beati pauperes*

spiritu: Christ promised heaven to the poor in spirit, that is, to the simple-hearted; this utterance is not so much intended to humble our pride in the human mind as to show us that a simple heart is better than a brilliant intellect.

Champrosay, 7 November

Arrived at Champrosay before three. My good Jenny was waiting for me at the station. I was shocked to see how ill she looked. However, it is not as bad as I thought; she had been worrying at not hearing from me for so long.

9 November

I stayed longer than I had intended with my cousin Berryer, who is as charming to me as ever. In his delightful house I am surrounded by pleasant people who give me no chance to be bored, but nevertheless, I feel that such delicious idleness is dangerous for a man who wishes to withdraw from the world. When the time comes to return to work and a quiet life one finds that one has changed, and it is not so easy to take up the daily routine again.

17 November

Burnt sienna must be considered as a primary *orange-colour*. Mixed with *Prussian-blue* and *white* it gives a very subtle grey. *Yellow lake* and *burnt sienna* take off the crudeness of pure *burnt sienna* and give it incomparable brilliance. Excellent for warming flesh-tones when they have been prepared too grey.

Paris, 21 November

Avoid using *black*; prepare dark tones with fresh, transparent colours: either *lake*, or *cobalt*, or *yellow lake*, or *raw*, or *burnt sienna*. When I had made the coffee-coloured horse too light, I found that I improved it by touching up the shadows again, especially with green, decisive tones. Remember this example.

25 November

My days are spent in working and I am glad to bury myself in my studies. What a happy, happy distraction! This lovely feeling of serenity which the passions can never give! Unfortunately I am neglecting all my other affairs; I have not written one letter or paid a single call.

19 December

Dined with Mme de la Grange: Berryer and the Princess were present. Mme de Caen came in during the evening: black dress and green ribbons, which suited her to perfection. Great talk with Marcelline on the most intimate subjects. It's the oddest situation, but really most amusing and it all helps to pass the time.

1855

Paris, 20 January

To Viardot's house, where his wife sang some of Gluck's music most admirably. Even Chenavard, the philosopher, stopped saying that music was the lowest form of art! I told him that the libretto of the opera is exceedingly well done. You need the broad clear-cut divisions. The verses are adapted from Racine and therefore appear somewhat battered, but they have a far more powerful effect when put to music.

To Tattet's house on the following day (Sunday). Membrée sang pieces of his own composition. The air from the *Étudiants* would be bad even if it were set to the loveliest music. It is a short opera without recitative, in other words the story and the singing are combined. This is an exhausting method because you cannot concentrate on either music or story if you are trying to follow both at once—another proof that it is a mistake to break the *laws* laid down from the beginning to govern all the arts. Say what you choose in recitative, but let only passion sing, and in words which I can guess before you utter them.

Never let the attention be divided. Fine verse has its place in a spoken tragedy; in opera, music should be everything.

Chenavard admitted without any pressing on my part that nothing can compare with the emotion which music inspires. It is capable of expressing the finest gradations of light and shade. Surely the gods who find our earthly food too coarse must live exclusively on music. For its eternal honour we ought to reverse Figaro's remark, 'Whatever we cannot sing, we speak'. A Frenchman should repeat what Beaumarchais says.

What places music higher than the other arts (with many reservations in favour of painting precisely because it resembles music in so many ways), is that although completely in a convention of its own,

it is also a complete language. All we need do is to enter into its kingdom.

30 January

To the house of Mme de la Grange. I unfortunately arrived too early—that is to say at ten o'clock. Who would ever believe that ten o'clock at night is unwarrantably early in Paris? I found old Rambuteau[1] there, who has lost his sight. When he heard who I was, he said he was sorry that they had not told him of my presence at Mme de Blocqueville's when I first dined there. He said that he would have liked to tell me how much he had always admired my pictures. The old ruffian! All the time he was Prefect, he never said a word to me except to warn me not to ruin his church of Saint-Denis du Saint-Sacrement. They had originally offered Robert-Fleury the commission for this thirteen-foot picture, at 6,000 francs, but he did not feel inclined to accept it and suggested that I should do it instead, of course with the consent of the directors. Varcollier, who at that time knew neither myself nor my pictures as well as he does now, rather contemptuously consented to this exchange of artists; but I always understood that the Prefect was more difficult, owing to his lack of confidence in my meagre talents.

In adversity people regain all the virtues which they lose in prosperity.

Which reminds me that when I saw Thiers again after his short exile, he deplored the niggardly commissions which I had been given. From the way he spoke, I ought to have had everything, and been magnificently rewarded.

2 February

Dined with Mme de Forget, and then on to Mme Cerfbeer's house where the atmosphere was stifling. I talked to Pontecoulant and his wife. He said with a good deal of truth that the taking of Sebastopol would prove to be an insurmountable barrier to peace, and that the Emperor did not re-establish the kingdom of Poland in 1812 because he was unwilling to destroy all chance of ending the war. He was quite convinced that Russia would never relinquish her claims on Poland and would always make it a first object of her national ambitions, like the possession of the Crimea, her *open sesame* to the East.

[1] Le comte de Rambuteau had been Prefect of the Department of the Seine.

When I left I went for a delicious stroll along the boulevard, drinking in the cool evening air as though it were something rare and precious. I asked myself, and with good reason, why men shut themselves up in stuffy rooms instead of walking about in the open air which costs them nothing.

5 February

In the evening I called on Thiers, and stayed a long time. He took me into a corner and talked war to me; he played havoc with my ideas on strategy.

When I left—and it was very late—I went on to Halévy's house,[1] where the heat from the stove was suffocating. His wretched wife has crammed his house with bric-à-brac and old furniture, and this new craze will end by driving him into a lunatic asylum. He has changed and looks much older, like a man who is being dragged along against his will. How can he possibly do serious work in all this confusion? His new position at the Academy must take up a great deal of his time, and make it more and more difficult for him to find the peace and quiet he needs for his work.

Left that inferno as quickly as possible. The breath of the streets seemed positively delicious.

6 February

Dined with the Princess. I still find her very attractive; she was wearing a most unmanageable dress, the material so magnificent that it looked as though it were made of twenty yards of shining armour. This absurd mass of material makes all the women look like barrels.

Went to see Fould for a few minutes after dinner and returned in time to hear the Princess with Franchomme, but for me the real pleasure of the evening was listening to the two or three pieces by Chopin which she played for me before I called on the Minister.

While we were at dinner Grzymala asserted that Mme Sand had accepted money from Meyerbeer for the articles she wrote in praise of him. I cannot believe it and I protested. The poor woman needs money badly; she has written too much and she has written for money, but I do not believe for one moment that she has descended so low as to become a literary hack.

[1] Fromental Halévy (1799–1862), the composer; he had been appointed Permanent Secretary to the Académie des Beaux-Arts in 1854.

7 February

Dined with the celebrated Comtesse de Païva.[1] I disliked the appalling display of wealth. A curious set of people. From an evening like this one brings home no memories whatsoever; one feels slightly heavier next morning and that's about all.

5 March

The day of the dear Princess's concert. The Chopin concerto was not very effective. They will persist in playing it instead of his delightful short pieces. The poor Princess and her piano were quite lost in that large theatre. When Mme Viardot[2] sang Chopin's mazurkas arranged for the voice, as a prelude, you felt that you were listening to an artist. That is what Delaroche said, who was sitting near the place to which I withdrew after giving up my seat to the de Vaufreland ladies.

The short fragment of the Haydn symphony which I heard yesterday delighted me as much as I was bored by all the rest of the concert. The time has come when I can no longer consent to lend my ears or my attention to anything that is not truly excellent.

14 March

I have been very unwell for quite a long time: my stomach has been behaving temperamentally, and everything else depends upon it. I usually get attacks in the middle of the day, but I am sometimes able to manage a sitting during the evening. I get up very early.

15 March

Dined with Bertin. Delsarte tells me that Mozart stole outrageously from Galuppi, in the same way I suppose, that Molière stole from anybody anywhere, if he found something worth taking. I said that *what was Mozart* had not been stolen from Galuppi, or from anyone else for that matter. He ranks Lully above everybody, even above Gluck whom, however, he greatly admires. He sang some little old-fashioned popular airs which were charming, sung with the perfect taste with which he rendered them. I pointed out to him that music by the great composers, which he does not care for, would be just as

[1] A celebrated demi-mondaine of the Second Empire.

[2] Pauline Viardot, née Garcia, was the sister of Marie Garcia, known as la Malibran: both were famous singers.

effective, and possibly more so, if he would take the trouble to sing it with equal care. He also sang the lovely air from *Telasco* and I was charmed by it, as I always am.

We must overlook the peculiarities of certain artists and not allow them to lessen our admiration for their talent. Delsarte behaves like a lunatic. These wild schemes of his for increasing the happiness of the human race, his latest persevering effort to become a homoeopathic doctor and finally this absurd, exclusive preference for old music, which goes with the rest of his eccentric behaviour, put him on a par with Ingres who acts like a child, or so they tell me, and whose likes and dislikes are equally absurd. There is something lacking in such people. Neither Mozart, Molière, nor Racine would have had such ridiculous preferences and aversions, consequently the *common sense* of these men was on a level with their *genius*, or rather it was *their genius itself*.

The stupid public are forsaking Rossini for Gluck, just as they formerly threw over Gluck for Rossini; a sixteenth-century air is considered better than anything by Cimarosa. It is all very well for the mass of stupid people who, because they have neither taste nor discernment, are always having to find something new to get excited over, but it is quite incomprehensible when men who know about these things, artists or near-artists—people whom we credit with being superior—are so cowardly as to lend themselves to such absurdities.

16 March

This was the day on which I was taken ill and was compelled to give up all my work for a fairly long time.

22 March

M. Janmot called on me this morning. When we were talking about good lay-ins, he told me that Ingres says: 'You only finish on what is finished already'.

Saturday, 24 March

When I consider the pleasure it gives me to read in my little note-books the thoughts of my earlier days, or merely to read reminders of what I did on a particular day, the people I met, for instance, or the places I visited, it ought to cure my laziness and encourage me to write more often. Shall I ever be able to go on with it in my present

state of listlessness as I see the time that is left to me to finish my pictures slipping away? Feel very depressed at the unfriendliness of the people at the Exhibition when it is a question of their being able to render me any service. I still like to do what I can for people, and as I cannot gain much from the friendship of others I try to exist on the memory of my own feelings, but I feel very lonely, and it troubles me still more when I think of the future. Why have things gone so badly for me? It is because at certain times I cannot stand the least opposition. I like any number of people and am glad to see them, but they must come at exactly the right moment, and since there is no magician to foretell the proper time for meetings they nearly always occur inopportunely.

I was about to go out yesterday, in spite of feeling so weak, when Chenavard called. His visit annoyed me. I had told him that I was ill when I wrote to introduce M. Janmot. As soon as he had done praising my two pictures he came to his criticisms, and a slight uneasiness became apparent. He wants franker effects, he would like to see the old pictures with their black shadows again. I expect he is quite sincere about this. The arrival of young Armstrong[1] drove him away. The latter told me about Turner, who left a hundred thousand pounds sterling to found a retreat for old and infirm artists. He used to live like a miser with one old servant and I remember that the only time he came to see me, when I was living on the Quai Voltaire, I was not particularly impressed; he looked like an English farmer with his rough black coat and heavy boots, and his cold, hard expression.

Haro called on me at about half-past five. He tells me that they have made a different arrangement about the panel which had been promised to me at the Exhibition. They have now given it to Ingres. Chennevières,[2] who was all over me the other day, could not seem to remember that the gentlemen had given a decision in my favour about this particular place. I shall go and see the Minister about it today, Saturday.

25 March

Yesterday, Saturday, still unwell, but a little better than I have been feeling lately. I am still reading Dumas's novel, *Nanon de Lartiques*, and

[1] Thomas Armstrong, English painter, was a fellow student in Paris of Poynter, du Maurier and Whistler, the group which figures in the novel *Trilby*. Later he became Director of Art at South Kensington Museum.

[2] Philippe de Chennevières was at that time Inspector of Museums, and one of the organizers of the Exhibition of 1855.

falling asleep over it at intervals. It begins very well and then as usual there are dull passages, either pompous or badly thought out. At this stage, I don't quite see how he is going to bring in the would-be dramatic and passionate interludes which he introduces into all his novels, even the comic ones.

This mixture of comedy and pathos is undoubtedly in poor taste. You must know where you are and where you are being led. We Frenchmen, who have been used to thinking of the arts in this way for so long, would find it very difficult to get any idea of the opposite effect, like that in Shakespeare's plays for instance, without a good knowledge of English literature. It is hard for us to imagine a joke coming from the mouth of the High Priest or Athalie, or even the faintest attempt at a colloquialism. Comedy generally portrays passions that are extremely serious to those who feel them, but tend to provoke laughter rather than a sense of tragedy in others.

I think Chasles was right in our conversation about Shakespeare, of which I have made a note in one of the diaries: 'Properly speaking,' he said, 'he is neither a tragic nor a comic writer. His art is unique, and it is as much psychology as poetry. He does not set out to portray Ambition, Jealousy, or Consummate Villainy, but one particular jealous or ambitious man, not so much a type, as a human being with all his characteristic lights and shades. Macbeth, Othello or Iago are anything but types; their characteristics, or rather their individuality, make them seem like real people, but give us no absolute idea of their passions. Shakespeare has such a strong sense of realism that he forces us to accept his characters as though they were people we knew personally. Hence, the colloquialisms which he introduces into their speeches do not disturb us any more than such things do when we hear them uttered by the people about us, who are not on a stage, but are alternately glad and sorry, or even made to seem ridiculous, by the various situations that occur in real life. In the same way, irrelevancies that would shock us in our own theatre do not disturb us when we find them in Shakespeare. Thus, in the midst of all his troubles and schemes for revenge, Hamlet jokes with Polonius and the students and amuses himself with instructing the actors who are brought before him to perform a bad tragedy. Moreover, there is a powerful surge of life throughout the play, an onward movement as it were, a development of passions and events which, however irregular according to our ideas, gives it a quality of unity that becomes established in our minds as we think it over afterwards. For if this supreme quality were lacking, plays containing all the

drawbacks which we have been discussing would never have deserved to retain the admiration of the ages. A hidden thread of logic, an imperceptible order, runs through this agglomeration of details. Where one would expect to find nothing but a shapeless mountain, one discovers distinct phases, considered reliefs, and always continuity and reason.'

Poor Dumas, whom I'm so fond of, probably imagines himself to be another Shakespeare, but the details he gives us are not so powerful, and his work does not leave us with this strong sense of unity. The different phases are ill balanced. He seems to imprison the comedy—the thing he does best—in certain portions of his books, and then suddenly thrusts you into the middle of a sentimental love story, where the same characters who made you laugh a short while ago become pompous and maudlin. How could anyone recognize the three joyous musketeers of the beginning of the novel in these creatures of melodrama, entangled in the exploits of a certain Milady and her ceremonial trial and execution in a raging storm at the dead of night? This is also Mme Sand's besetting sin. When you finish one of her novels your ideas about the characters are in utter confusion. For instance, some of them begin by amusing you with their high spirits and end by making you weep over their virtue and their devotion to others, or else hold forth like minor prophets. I could quote any number of her characters who disappoint the reader in this way.

31 March

I am feeling better and have begun to work again. The Princess came to see my pictures about four o'clock, and has invited me to hear Gounod on Monday. She was wearing a dreadfully unbecoming green shawl and still managed to look charming. The mind has great influence in a love affair. It would be easy to fall in love with this woman, yet she is no longer young and not at all pretty, and she hasn't even a good complexion. What a strange sentiment it is! I suppose the idea of possession is always at the root of it, but possessing what, when a woman is not pretty? Surely not her body, when it has no charm? But if it is her mind that one is in love with, one can enjoy that without possessing her unattractive body; hundreds of pretty women don't amuse me at all. The desire to monopolize a woman entirely once she has moved our hearts is perhaps curiosity—a powerful driving force in love-affairs—or possibly the illusion that one is probing deeper into the secrets of her mind and soul. All these feelings

combine to form a single emotion, and it may well be that where our eyes see nothing but an outwardly unattractive object, we are instinctively driven forward by certain charms that respond to something in our inner natures. The expression in a woman's eyes is enough to captivate us.

2 May

This evening, to the house of that boring woman Païva. What a set! What conversation! There are young men with and without beards, gay young sparks of forty-five or so, German dukes and barons, journalists, and new faces every time! Amaury Duval was there. At first I did not dare to open my mouth to anyone else, I was quite petrified by the futility and dullness of it all. Poor old Dumas thinks himself in high society. They all worship the ground he walks on and since he can get a first-rate dinner there once a week and what is more, bring his young woman along with him—and, moreover, since they consult him about the cooking and even ask him to decide whether or not to dismiss the chef—he has become a fixture, like Mondor in the salons of the Ancien Régime. He yawns most of the time and falls asleep when people are talking to him, but he is a good fellow for all that.

When I left that pest-house at about half-past eleven it was a positive joy to breathe the air of the streets. I walked about for an hour, but felt very morose and dissatisfied with myself. I turned over in my mind all kinds of unpleasant ideas and imagined myself having to face all the problems of existence—especially the one that forms the basis of all such meditations—the eternal round of solitude, boredom, inertia, companionship with or without ties, perpetual bad temper, and once again a longing for solitude. Inference: remain in solitude without undergoing the other trials since a quiet life is what you most desire, even though this should mean a form of self-annihilation.

15 May

The doctor called for the seventh time. Opening day of the Exhibition.[1] Afterwards, rather imprudently, I went to the exhibition

[1] This was the Universal Exhibition of 1855, held at the Palais de l'Industrie. Special rooms were allotted to Delacroix and to Ingres. Delacroix's exhibition of forty-two canvases included some of his finest works, lent by the Louvre, the Museums of Nancy, Lille, Rouen, Versailles, by private collectors, and by the artist himself.

of paintings with Dauzats, who walked back with me as far as my door. It was very cold in the gallery. Saw the Ingres exhibition: highly ridiculous, the complete expression of an incomplete mind! There is a sense of strain and pretentiousness about everything, not one spark of naturalness.[1]

22 May

Dumas sent round this morning to ask when I should be at home and I made an appointment with him for two o'clock. He wants notes on various things which it is perfectly unnecessary for the public to know, how I set about my painting for instance, my ideas on colour, etc. He asked if he might dine with me and so prolong the interview, and I jumped at the opportunity of having an amusing time. Then he went off on some errand or other and came back after seven o'clock, just as I was dying of hunger and about to begin dinner without him.

Afterwards we took a cab to pick up a young woman whom he is protecting and went on to see the Italian tragedy and comedy. There is only one possible reason for seeing a show like this—to improve one's Italian. Nothing could have been more boring.

Dumas told me that he was in the middle of a lawsuit which should secure his future: something in the nature of 800,000 francs to begin with, and more to follow. The poor fellow is beginning to be bored with writing day and night and never having a penny to spend. 'I've done with them,' he said, 'I shall leave them a couple of half-finished novels and go away. I shall travel, and when I come back again we shall see whether they have been able to find an Alcides to complete these two, unfinished contracts.' Like Ulysses, he is quite certain that he is leaving behind him a bow which no one else can bend. In the meanwhile, he does not feel in any way older and, indeed, he behaves like a young man in many ways. He has several mistresses and manages to exhaust them; for instance, the girl we took to the theatre wanted to cry off; she said that she would die of heart failure at the rate he was going. Kind old Dumas pays her a fatherly call every day, looks after the housekeeping accounts and doesn't bother about how she amuses herself! Lucky man! How pleasant to be so casual! He deserves to die like a hero on the battlefield, without having to know the miseries of old age, the hopeless poverty and neglect.

He told me that living with his two children was like living alone, They go about their own affairs and leave him to find what comfort

[1] As so often with Delacroix the first impression was passionate and violent. A few days later, on 1 June, he was less harsh, more impartial.

he may with his Isabelle. On the other hand Mme Cavé said to me next day that his daughter was complaining of having to live with a father who sent his mistresses to call on her and was never at home himself. It's a strange world.

26 May

In the evening, Nieuwerkerke[1] took me to the first of Prince Napoleon's soirées. What a crowd! Such odd-looking people! Republicans like Barye, Rousseau, and Français, among Royalists and Orléanists, all crowding together and rubbing shoulders with one another. There were some charming women among whom was Mme Barbier, looking extraordinarily handsome. I left early and went to have an ice at the Café de Foy; (at the Prince's they were disgusting).

Could not get to sleep when I went to bed, so as soon as it began to grow light I got up and went for a walk, which set me right again. I was able to enjoy that solemn moment when nature recovers her strength, and Royalists and Republicans alike lie wrapped in the slumber that is common to all men.

1 June

At the meeting of the Council, which is still being held in the Salle des Cariatides, the question arose about tickets for the ball. I made a stand against the rule of giving them only to personal friends. It is fascinating to see how all these grocers, bad painters, paper merchants, and the rest of these well-to-do people think themselves better bred and better company than some cobbler or tailor who might be let in by mistake, and whom they would dread to appear in the same room with. I told them that French society was entirely made up of shoe-makers and grocers in these days and that they would do better not to examine it too closely.

Afterwards I went again to the Exhibition. Ingres's section seemed to me much better than the first time I saw it and I very willingly acknowledge his many fine qualities.

Saw Alberthe again that evening, she is always as nice as possible to me. For a long time they could talk of nothing but an enormous dog that seemed to fill the entire room and which they never ceased admiring. I hate having to spend a lot of time over episodic creatures like *dogs* and *children* who are of interest to no one except their parents and owners, and the people who bring them into the world.

[1] Le comte de Nieuwerkerke was Director of Fine Arts.

Champrosay, 3 June

Left for Champrosay at half-past one. It was raining, as usual, but the weather looks better this evening.

4 June

As soon as I got up I began to unpack my canvases and prepare my palette. Did a great deal of work today, my first day at Champrosay.

Went for a walk before dinner along the path by the wall of the Baÿvet estate, and noticed that you can still see traces of the charcoal inscription. Each year, I take a melancholy interest in seeing how much more the lamentations of the poor lover have been effaced. The fragile inscription has probably lasted longer than the feelings which prompted it; even the fellow who wrote it and his beloved Celestine may long ago have disappeared.

Paris, 7 June

I have been to Paris for the banquet given in honour of the Lord Mayor at the Hôtel de Ville; for want of proper information I unfortunately missed the ceremony in the morning which, they tell me, was extremely dignified—the presentation by the Lord Mayor of the Corporation of London's address to the Municipality of Paris. The costumes of the Lord Mayor and Aldermen were well worth seeing.

At eleven o'clock I left in the Lyons omnibus, escorted by Julie. As soon as I arrived I went to the Jardin des Plantes in spite of the oppressive heat: there are two fine lions and some cubs. I was almost dying of heat as I stood and watched them, but I managed to observe that generally speaking, the light tone noticeable beneath the stomach, under the paws, etc., is merged more softly into the rest than I usually make it. I am apt to exaggerate the white. The colour of the ears is brown, but only on the outside.

I enjoyed the evening enormously. The banquet given in the Salle des Fêtes was splendid, the chandeliers made a wonderful effect. Found myself sitting next to an unfortunate Englishman who could not speak one word of French; I have nearly forgotten my English, and was hunting about for every word. We both pretended to understand what the other was saying and neither of us said very much.

11 June

To Paris again, for the ball at the Hôtel de Ville. I thought the new

arrangement of the courtyard most successful, but it will be disastrous in the daytime as it cuts off light and air from part of the Hôtel de Ville.

Caught in a sudden downpour as I came home, about half-past eleven. As luck would have it the carriage was half open, but there was a kind of leather apron which protected my beautiful white trousers.

15 June

I have been reading extracts from Mme Sand's *Histoire de sa Vie*, which is appearing in *La Presse*. Today, she speaks of her friendship with Balzac. Poor woman, she has to pay her tribute to everyone, but I must say that she expresses remarkable admiration for him in this work, which is being published during her lifetime and is addressed to her own contemporaries. One of the many drawbacks of this undertaking of hers is that she has to consider the feelings of all the present-day celebrities because she is still alive and might be accused of jealousy. She talks a great deal of the fatherly affection which Latouche feels for her, and of how she and Arago are like brother and sister. What an undertaking, especially for someone in her position, to try to write about herself, when the need for publishing during her lifetime prevents her from being frank (the only quality that could make the book interesting)—frank not only about herself, but about all the famous people whose portraits she wishes to leave to posterity. She has been rash enough to speak of her theory of novel-writing and of the *need for an ideal* (her favourite expression), which consists in representing people *as they ought to be*. She says that Balzac encourages her in this attempt and himself proposes to portray them *as they really are*, a claim which he considers he has more than justified.

17 June

When I was getting up on Sunday, I thought of the peculiar charm of the English school of painting. The little that I've seen of it dwells in my memory. Over there, they have a real delicacy of perception and skill that outweighs any tendency to imitate the past, which does occur now and then, as it does in our own dreary school. With us, delicacy is the rarest of qualities; all our work looks as though it were done with clumsy tools and, what is worse, by dull and common-place minds. If you except Meissonier, Decamps, and one or two others, and some of Ingres's early pictures, the rest is all trivial, feeble,

cold, and lifeless. You have only to look at that stupid, boring paper, *L'Illustration*, which our trumpery artists botch together, and compare it with its counterpart published in England, to get an idea of how vulgar, spiritless, and wishy-washy most of our productions are. They call this country the land of draughtsmanship, although in actual fact we do not show a trace of it, even in our most pretentious pictures. Whereas, in these little English drawings, almost every object is treated with the interest it deserves; landscapes, seascapes, conversation- and battle-pieces, all are charming, all well carried out and, best of all, they are drawn. I do not know anyone in France to compare with Leslie and Grant and the rest of the school. It originated in Wilkie and Hogarth and has a dash of the ease and flexibility given to it forty years ago by Lawrence and his associates, who excelled by their grace and lightness of touch.

If you consider another phase of English painting, something quite new to them, I mean what people call the *Dry School* which reverts to the Flemish primitives, you discover beneath its apparently reminiscent quality and its aridity of treatment, a feeling for truth towards what is real and characteristic in detail. What sincerity they have managed to get into their would-be imitations of old pictures! For example, compare the 'Order of Release', by Hunt[1] or Millais (I've forgotten which), with our primitives and Byzantines, who are so obstinately engrossed by questions of style that they keep their eyes rigidly fixed on the images of another age and extract from them nothing but their stiffness, without adding new qualities of their own. The crowd of hopeless mediocrities is enormous. There is not one who shows a vestige of truth, the truth that comes from the heart, not one painting like this child asleep in its mother's arms, whose silky baby hair and sleeping state are so truthful (in every particular, even down to the redness of the legs and feet), and are expressed with such remarkable observation and above all, with feeling. Look at the work of men like Delaroche, Janmot and Flandrin—so much for the grand style! How much of the actual man who painted them comes out in pictures like theirs? How much of Giulio Romano has been seized by

[1] Delacroix was praising the English Pre-Raphaelites at the expense of Ingres and his followers.

'The Order of Release,' with its sleeping child, is of course by Sir John Millais. Holman Hunt showed three pictures at the Universal Exhibition of 1855 including 'The Strayed Sheep' now in the Tate Gallery, which Delacroix mentions with enthusiasm on 30 June. His admiration for truth of observation in details is particularly interesting in view of his usual dislike of realistic painting and his own desire for unity of effect.

one of these fellows, or Perugino, or even Ingres, his own master, by another! Running through the work of all of them is a pretence at gravity and a claim to be a great artist—to serious art, as Delaroche calls it!

Leys,[1] the Flemish painter, also seems to me very interesting, but for all his appearance of having a more independent execution, he has not the facility of the English painters. I notice a straining after effect, a certain mannerism in his work which makes me doubt his sincerity; the rest of the Flemish paintings are not up to his level.

Gautier has written several articles on the English school, in fact he began with it, and I do him the credit of believing that he shows this marked preference for foreigners out of good taste and not out of flattery for the *Moniteur*, as Delamarre maintains. Yet it was not his observations that gave me the clue to the feelings which I have expressed here. He should have had the courage to demonstrate the beauties of the English school by comparing them with paintings by French artists considered to have similar qualities, but I can find nothing of this in his articles. What he does is to take a painting and describe it in his own way; he makes a charming thing of it, but that is not true criticism. So long as he can find words to stimulate his readers, or dazzle them with that interplay of phrase that he so obviously delights in and that often sweeps us along with him, Gautier is satisfied. And provided he can bring in allusions to Spain and Turkey, the Alhambra or the Almeida of Constantinople, he feels that he has achieved his aim as an author-connoisseur, and that, I think, is about as high as he aspires. When he comes to the French painters he will do the same for them as he has done for the English. In this sort of criticism there is neither instruction nor philosophy.

Last year, he made his analysis of Janmot's very interesting pictures in exactly the same way. He gave me no idea of the man's really remarkable personality which is smothered under the smart and vulgar tone of the article. How interesting it would be if a discerning critic were to compare these paintings with all their faults of execution, with the English pictures which are equally unaffected in style but so different in inspiration! Janmot has looked at Raphaël and Perugino in the same way that the Englishmen have looked at Van Eyck, Wilkie, Hogarth, and others; both have managed to retain their originality after making their studies. In Janmot's work there is a strange flavour of Dante. When I look at it I am reminded of the

[1] The Baron Henri Leys, whom Delacroix had met in Belgium, was one of the leaders of the Flemish Romantic School.

angels of the Purgatorio: I like his robes, green as the grass in May, and those heads, evolved out of his dreams or inspirations, that seem like recollections of another world. An unaffected artist like this will never receive a tithe of the credit he deserves, for unfortunately, the crudeness of his execution makes him exceedingly hard to place. He speaks a language which no one else can use; it is hardly even a language, but I can perceive his ideas through all the confusion and naïve crudeness of his rendering. His is a talent unique of its kind in this country and century; the teaching of his master Ingres, which has so often resulted in mere technical imitation by disciples with no ideas of their own, has been incapable of giving skill in execution to this artist of natural talent who still cannot get away from leading-strings, and who will go through life like a newly hatched bird, dragging bits of egg-shell after him.

Dined with Halévy: Mme Ristori, Janin and Laurent Jan were there among others.

Ristori is a big woman with a cold expression, you would never think her capable of possessing such talent. Her little husband looks more like her eldest son; he's either a marquis or a Roman prince.

Laurent Jan was as usual pretty aggravating, with his smart way of trying to be witty by taking the opposite view to every reasonable opinion. Nothing stops him once he gets started. Janin, on the other hand was completely silent and I was sorry, because I like his form of humour. Halévy was equally dumb. Yet, in spite of my dislike of his continual sallies and repartee, and his noisy talk which makes one silent and depressed, I was glad to see Laurent Jan again. When one reaches my age, there is no greater pleasure than that of being with intelligent people who understand everything, even at the merest hint. He was saying to the little fair-haired Roman prince, who happened to be sitting next to him at table, that the Paris by whose judgement reputations are made is composed of about five hundred intelligent people who do the thinking for the great mass of two-legged animals who live in it, but are Parisians in name only. It is good to be with a man like this who thinks for himself and, best of all, forms his own opinions, even if you have to bicker with him during the quarter of an hour, or even the day that you spend in his company. When I compare the company on Sunday with that at the Parchappes on the day before, I gladly allow my Laurent Jan his affectations, and remember nothing but the originality of his conversation and the artist quality that makes him such a valuable person.

People who pride themselves on belonging to good society have no idea that they are missing what good society really means—the pleasures of conversation. When they have exhausted the weather and gossiped about their friends and neighbours, they have nothing but whist to carry them through the long hours which they spend sitting opposite to one another. However, it is probably less of a deprivation to them, because they have no idea of the pleasures I was speaking of. Wit is rare, and those who possess it in this so-called good society either end by putting up with boredom out of empty pride, or become as stupid as the rest. What is one to think of a man like Berryer, for example, whose only recreation after his tiring work is the company of society people, who seem each more tiresome than the last—if possible. He is an extraordinary man, very difficult to understand, especially when you first meet him. Actually, he is a lawyer first and last; the man has been completely swallowed up by his profession; he is just the same in society as in his office or in court, and he puts up with boredom for the same reason that he wears his gown, for the good of the cause. Some people in society are capable of enjoying themselves as artists do—I use this word because it seems to sum up what I mean—they take great trouble to collect artists round them, and find real pleasure in their conversation.

The Princess is like that; when she has seen her fashionable friends, she has small at-homes at which she likes to receive painters and musicians.

19 June

This evening I received Eugène de Forget's letter telling me of the death of Mme de Lavalette.[1]

Paris, 20 June

Left at half-past six. I told the driver to go straight to Mme de Forget's, as I did not know the time of the funeral. I found her very much upset. I told her it did not seem to me suitable to hold the service in a little church that is really only a kind of annexe. But neither she nor Eugène, to whom I also spoke about it, seemed able

[1] Mme la Comtesse de Lavalette, mother of Joséphine and grandmother of Eugène de Forget, had been the heroine of a famous episode after the fall of Napoleon in 1815. At great personal risk she contrived the escape of her husband from prison where he was awaiting execution for assisting the Emperor to reach France from his exile in Elba. Broken in health she lived in her daughter's care in semi-seclusion.

to grasp how necessary it was that this public tribute should be a ceremonial occasion of some importance. Actually, it was so little of a public affair that I felt ashamed at the lack of feeling and the off-hand manner of the people present.

As the service was not to be held until noon I went home until it was time to leave. In the middle of the church service or rather, towards the end of it, M. de Montebello, the Emperor's aide-de-camp arrived, not in a state carriage, and in undress uniform. This last touch was so flagrant that he seems to have felt obliged to make his excuses to Eugène, saying that he had been delayed. I think it is true that the Emperor was not properly notified; Mme de Lavalette's daughter or her grandson were responsible for sending the notification and it may possibly not have been made at all. Even fewer people accompanied the body to the cemetery and not one of them was a former friend of M. de Lavalette. I cursed myself at the time, and am still cursing myself for not having had the courage to speak out there and then, and say what every man of feeling must have been thinking. But to tell the truth, it would have been almost impossible before that audience of frigid and even totally indifferent people; only a lawyer could have found inspiration at such a moment.

People's memories are very short, and events are forgotten as quickly as the people who take part in them. Not one of the people whom I told in the last few days that I had been to Paris for the funeral of Mme de Lavalette had the slightest idea of whom I was speaking. And yet how much might have been said of this woman who for the past forty years has been dead to the world, a stately ghost, living in the poverty to which we had seen her reduced!

I went back to see my own graves[1] and found that they were being well looked after, but seized with the mad idea that I might be able to escape and return to my peaceful home on the same day, and even get there early, I did not allow myself enough time to see the graves of my dear aunt and my friend Chopin.

I accordingly hurried back to the studio so as to leave again as soon as possible, but when I arrived there, I found a letter from Guille-mardet[2] saying that he was accompanying his mother to her last resting place on the following day. After that I ceased to worry about wasting time and gave up all thought of Champrosay.

I was half-dead with exhaustion. These upsets and interruptions

[1] Delacroix's mother and his aunt Riesener were buried at Père-Lachaise.

[2] Edouard Guillemardet, a friend since childhood. His brother Félix, Delacroix's more intimate friend, had died in 1840.

wear me out, but I suppose they are good for me. The forced activity gets on my nerves, but it keeps my life and circulation active. Slept soundly until seven o'clock. I think it was hunger that finally woke me, and I went out to dine at the English restaurant in the rue Grange-Batalière and then to smoke and drink my coffee in the café at the corner of the rue Montmartre. There I enjoyed myself lazily, with a kind of philosophical pleasure in watching the life of the sordid little place, the men playing dominoes and all the vulgar details of that crowd of automata, the smokers, beer-swillers and waiters. I could even picture to myself the pleasure which people derive from reaching self-forgetfulness to the point of degradation in such surroundings. I came home with a mind as serene as when I set out, not thinking much about anything. I had managed to shut a door between the emotions of the morning and those which I had to face the following day. It was incredibly cold and after a couple of turns on the boulevard I went home and returned to my bed.

Champrosay, 21 June

Got up before six o'clock. As I had taken no one with me to Paris I had to do everything for myself, and being so busy has made me much more tired.

Arrived in Passy shortly before nine o'clock, saw poor Caroline[1] and embraced her. It was a sad ceremony, but there was something more moving about it than any Paris funeral. The atmosphere there is fatal to all real feelings. The whole business of the funeral procession, the priests performing the service and the rest of it, turn a dignified ceremony into something commonplace. In Passy, only half an hour away from that pestilential Paris, everything was different, the procession, the service, the very expressions on the faces of the people taking part were different. It was all decent and serious, even down to the attitudes of the people looking on from their windows.

I went into the vestry to witness the death certificate with Edouard, my excellent friend, her admirable son. When he had signed the register he added the words *her son* after his name, then I signed and it seemed to me that I almost had a right to follow his example. I think that in his generosity the same thought occurred to him, for as we went back to our places he said with the most heart-rending expression: '*You know, old man, you are Félix here!*' Those were his very words.

[1] The sister of Félix and Edouard Guillemardet.

Champrosay, 30 June

At nine o'clock I went to the meeting of the Jury. I met Cockerell[1] again, and Taylor, both of them old acquaintances. Stayed there until midday looking at the paintings by those Englishmen whom I admire so much. I am really astounded by Hunt's sheep.

Contrary to my usual custom, I made a very good luncheon off a slice of ham and a jug of Bavarian beer. I felt perfectly happy and quite free and light-hearted as I sat out of doors under the trellis of the vulgar little café, watching the few idlers who come to this bleak Exhibition.

Went home about two o'clock, put my things together and hurried to catch the Lyons train. I arrived at Champrosay, still in great good spirits and with a tremendous appetite into the bargain.

Augerville, 13 July

Went out this morning in fine sunny weather and, near the stone bridge, made a sketch of the river vanishing into the distance, with a picturesque group of trees in the foreground. I then walked on very happily as far as the rocks, where, whatever she may say to the contrary, I was haunted by the memory of M . . .

I noticed new types among the rocks, formed like people and animals, some are more clearly defined than others. I even drew a kind of wild boar and an elephant, as well as several centaurs and heads of bulls. This is a wonderful place for discovering fantastic animals; these strange forms have a most plausible likeness to living creatures. What an extraordinary coincidence! What whim of nature decided the formation of this crag, the only one of its kind in the district?

14 July

Berryer left at six o'clock in the morning to go and argue a case in Paris. He imagined that he would be back in time for dinner, or at the latest, at nine in the evening. But to our huge surprise he turned up a little after seven as we were sitting at table and was able to finish dinner with us. I had suggested to the ladies that we should put it off for a little while.

[1] Charles Robert Cockerell (1788–1864), the English architect and archaeologist, known for his excavations at the temples of Aegina and Phigalea in Greece, and for his works on Greek architecture.

It really was an astonishing feat. He got to Paris and the Palais de Justice at half-past eleven and went into court immediately, where he spoke for two hours and a half. He then left his junior to listen to his opponent's plea and take any notes that were necessary. He changed at the Palais de Justice, left Paris and came straight home. He had taken some slices of bread and galantine in his pocket when he left the house, but he met some people on the train and had to keep up a conversation with them, so that he was unable to eat anything and was forced to make up for it between the station and the Palais de Justice.

We were a family party after dinner and drank our coffee on the terrace. I could see how happy he was after a day like this to be back in the country among his flowers and trees, most of which he has planted himself. This is true happiness!

15 July

In the morning I went for a walk in the direction of the rocks. On a path higher up I came upon an unfortunate beetle struggling with some ants that were bent on its destruction. I stood watching it for some time as it overthrew the enemies it was dragging after it. But each leg was pinioned by two or three worker ants mercilessly clinging to it, and it finally succumbed when they attacked it by the antennae, which were often completely covered with ants. I went away for a little while, and came back to find it motionless and utterly defeated. I moved it about a little, but death had come at last. It seemed to me that the ants were trying to drag it away to their ant-hill, but I could not see it anywhere, so I left the scene of the tragedy for a time, and settled down for a nap in the little pavilion with the copper dome. At the end of half an hour I returned to my ants, but to my great surprise could find no trace, either of them or of the beetle.

16 July

We have been trying to work out the music of *La Gazza*,[1] but my head was still so full of *Don Giovanni* after hearing it the other day that I had no admiration to spare for Rossini's masterpiece. I realized once again that one must take works of art as a whole and, above all,

[1] *La Gazza Ladra*, the opera by Rossini. They had a great deal of music at Augerville.

not make comparisons between them. The passages which Rossini treats so carelessly do not diminish the impression that his music leaves on our memories. In *La Gazza*, the father, the daughter, the trial, and indeed the whole opera is alive. The Princess's miserable fiddlers, who swear by Mozart, do not understand him any more than they do Rossini. The vital part of his work, the secret force that is the whole essence of Shakespeare, does not exist as far as they are concerned. They must have counterpoint and the Alexandrine; all they admire in Mozart is his regularity.

Paris, 3 August

Went to the Exhibition, where I noticed the fountain that spouts artificial flowers.

I think all these machines are very depressing. I hate these contrivances that look as though they were producing remarkable effects entirely on their own volition.

Afterwards I went to the Courbet exhibition.[1] He has reduced the price of admission to ten sous. I stayed there alone for nearly an hour and discovered a masterpiece in the picture which they rejected; I could scarcely bear to tear myself away. He has made enormous strides, and yet this picture has taught me to appreciate his 'Enterrement'. In this picture the figures are all on top of one another and the composition is not well arranged, but some of the details are superb, for instance, the priests, the choir-boys, the weeping women, the vessel for Holy Water, etc. In the later picture ('The Studio') the planes are well understood, there is atmosphere, and in some passages the execution is really remarkable, especially the thighs and hips of the nude model and the breasts—also the woman in the foreground with the shawl. The only fault is that the picture, as he has painted it, seems to contain an ambiguity. It looks as though there were a *real sky* in the middle of a painting. They have rejected one of the most remarkable works of our time, but Courbet is not the man to be discouraged by a little thing like that.

I dined at the Exhibition, sitting between Mercey and Mérimée. The former agrees with me about Courbet, the latter does not care for Michelangelo!

[1] Courbet's two important pictures 'The Studio' and 'Funeral at Ornans' had been refused by the Jury. He challenged their judgement with a private exhibition of his work nearby. Although Delacroix disliked the man and had severely criticized his realist theories, he now acknowledged his remarkable gifts.

Odious modern music sung by those choruses which are so much in fashion nowadays.

15 August

Lunched at the Hôtel de Ville and afterwards to hear the *Te Deum*. I received a fairly strong impression of the crowd in their multi-coloured dresses and embroidered coats. The music, the bishop, in fact the whole service is intended to appeal to the emotions. The church, as always, seemed to me one of the least well adapted to elevate and impress. Afterwards to the Emperor's reception. Came home feeling tired. In the evening I went out alone and had a most delightful walk. I enjoyed the illuminations, I think this is the first time I have not felt irritated by being in a crowd.

Letter to Mme de Forget:

'You ask me where one can find happiness in this world. After many experiments, I have convinced myself that it rests entirely in feeling satisfied with oneself. The passions can never make us happy, we always want the impossible, and are never content with what we have. I suppose that some people, blessed with unfailingly virtuous natures, possess a good deal of the contentment that I think of as being a condition of happiness, but for myself, since I'm not good enough to be self-satisfied, I make up for it by the real satisfaction that work can give. Work does afford a genuine sense of well-being and increases one's indifference to pleasures that are pleasures in name only, the amusements that society people have to be content with. And there, my dear, you have my small philosophy and it's a certainty, especially when I'm feeling well. At the same time, it should not prevent us from snatching such little diversions as may come our way from time to time; an occasional love-affair, a beautiful countryside, travel, such things leave enchanting memories, and you think of them when you are far away and can no longer enjoy them. They make a little store of happiness against whatever the future may bring.

'And so I spend my days working, except for interruptions caused by the time which just now I have to give to festivities in progress, or to those about to take place. But even these disturbances do not bother me much. They rest my mind and although tiring in other ways it is a different kind of fatigue from painting. I wear my full dress for the *Te Deum* services, I attend banquets and enjoy myself as much with fools as with intelligent people. Everyone is alike in a crowd, they are all actuated by one idea, to elbow themselves to the

front over the bodies of their neighbours. The scene is full of interest for a philosopher who has not yet turned his back on all the vanities.

'I sincerely hope this letter is long enough for you, I am writing while still under the effect of my official visits of yesterday. Now we are waiting for the Queen of England, which will give me other subjects for meditation. And, by the way, I've ordered a new pair of knee-breeches, the most important event of the week.'

18 August

Arrival of the Queen of England.[1] I left the church[2] about three o'clock to go home. Not a cab to be found! Paris seems to have gone mad today. The streets are full of processions of workmen's guilds, bands of market women, and young girls dressed in white, all carrying banners and jostling one another to give her a good reception. Actually, no one saw anything as the Queen arrived during the night. I was sorry for the sake of all these good people who had put their whole hearts into their welcome.

25 August

Went to Versailles this evening, there were illuminations in front of the Palace. I had been looking forward to seeing 'The Battle of Aboukir', by Gros, again but I was disappointed with it. It is extremely crude in colour and the jumble of men and horses is really rather inexcusable.

Came home alone by the light of a wonderful moon. I took the Saint-Cloud road and was reminded of happy times in my life between 1826 and 1830. The E . . . s, and A . . . s, and J . . . s, etc.[3]

26 August

Had a visit from that attractive woman the Princess of Wittgenstein[4] and her daughter, the one for whom Liszt commissioned a drawing: I am to see her again, and dine with them on Tuesday.

[1] Queen Victoria, accompanied by Prince Albert, arrived at the Gare de Strasbourg (Gare de l'Est) and drove across Paris to Saint-Cloud where she resided.

[2] The church of Saint Sulpice, where Delacroix was working.

[3] He is probably referring to his models of the Sardanapalus period, Emilie Robert, Adeline, Juliette, etc.

[4] The intimate friend and admirer of Liszt, who was considering marriage with her in about 1861.

27 August

I have struck a bad patch. I went back to the church after an interval of nearly a week, but am finding it difficult to work: there is no break in this appalling heat.

30 August

Soulier[1] wrote to say that he would be coming to Paris during September or at the end of August, and I asked him to dinner this evening. I then wrote to invite Villot, but he refused as he's unwell, also to Riesener and Schwiter.[2] It was a gay party and I was pleased.

That morning I had done a great deal of work at the church, inspired by the music and chanting. There was a special service at eight o'clock and the music put me into an exalted mood, very favourable for painting.

31 August

Called on Schwiter. When I was looking at his work, also the portrait of West, by Lawrence, and some engravings after Reynolds, I was struck by the unfortunate influence that any kind of mannerism has upon painting. The Englishmen, and especially Lawrence, have copied blindly from their grandfather Reynolds, without realizing the extent to which he distorted the truth. Such liberties have helped to give his paintings a kind of originality, but they are by no means always justifiable. Exaggeration for the sake of effect and, indeed, the utterly false effects which result therefrom, has decided the style of all his disciples and gives the whole school an appearance of artificiality which its other fine qualities cannot redeem. Thus, the head of West is brilliantly lit, but the accompanying details, the clothes, a curtain, etc., have no share in the light whatsoever. In short, there is no reason in it; therefore it is false, and the whole picture is mannered. A head by Vandyke or Rubens, put beside a thing like that would make it look very commonplace.

True superiority, as I have already said somewhere in these brief memoranda, admits of no eccentricity. Rubens is carried away by his

[1] Edouard Soulier, his old friend, was living in the country, at Saint-Mammés.

[2] Baron Louis Schwiter, painter, another old friend of Delacroix, and later one of his executors. His portrait by Delacroix once belonged to Degas and is now in the National Gallery in London.

inspiration and allows himself exaggerations in keeping with the idea, but they are always founded on nature.

The so-called geniuses of the present day are nothing but the ghosts of earlier writers, painters, and musicians. Full of affectations and absurdity, their bad taste matches their pretentiousness; their ideas are invariably foggy and they carry into their own behaviour the eccentric manner which they imagine to be a sign of genius. It would have been impossible for Racine or Mozart, Michelangelo or Rubens, to have made themselves ridiculous in this way. The greatest genius is simply a superlatively rational human-being. English painters of the school of Reynolds believed that they were imitating the great Flemish and Italian colourists. When they painted pictures that looked as though they were blackened by smoke, they imagined that they were doing vigorous painting; thus they imitated the darkness which time brings to every picture and more especially, that false brilliance that comes from repeated revarnishings—an operation that darkens some parts of a painting and gives to others an intensity of light that was not the intention of its creator. Such unfortunate deteriorations have led them to believe—as is shown by this portrait of West—that it is possible for a head to be extremely brilliant and for the clothing to receive no light whatever; also that backgrounds can be in complete darkness when the objects in front of them are in the light—a theory that is flagrantly untrue.

10 September

Left for Croze by the eight o'clock express.[1] A very fast journey as far as Argenton but, from there onwards, every kind of misadventure. When I arrived at Argenton I stood over my luggage for an hour in the mud and pouring rain before getting into a dreadful little conveyance, in which I had an unspeakable journey between a child that constantly relieved itself and three women who were sick.

I went on to Limoges, but was almost tempted to turn back and go home again, inventing the best excuse I could think of.

Croze, 11 September

Arrived at Limoges about eleven o'clock and established myself for the day in the Hôtel du Grand Perigord. Had luncheon, which I

[1] The Château de Croze, in the department of the Lot, between Brive and Souillac, belonged to the de Verninac family, who were connected with Delacroix through his sister Henriette.

badly needed after that unspeakable journey, and went out to see the sights—the museum, the church of Saint-Pierre, the cathedral, and Saint-Michel. The cathedral is unfinished, the nave is missing; most of the churches in this part of France are dark and gloomy. Fell asleep in the cathedral and also in Saint-Michel, near the museum, which I reached last. These two little naps set me up again completely, and I went off and had a shave at the barber's, getting back to the Hôtel at about half-past four. Super-excellent mushrooms, a variety we never see in Paris!

Left for Brive at six o'clock. *Tête à tête* in the carriage with a sergeant of police, a very good fellow—fine head. He left me about nine o'clock. Had quite a good night, sometimes dozing a little, and sometimes watching the extraordinary landscape through which I was travelling, by the light of the oil lamps on the coupé. Uzerche, etc., which I am sorry not to have seen in daylight.

As I looked at the really extraordinary objects I was passing, I thought of *the little world* which men carry about inside their heads. People who say that you can learn everything by education are fools, not excepting the great philosophers who uphold this theory. However strange and unexpected the prospect before our eyes, it never seems to take us wholly by surprise; there is an echo within ourselves answering each new impression. Either we must already have seen something resembling it elsewhere, or else our brains are prepared in advance with every possible combination of shapes and forms. Thus, when we rediscover them in this transitory world, we simply reopen a pigeon-hole in our minds. How otherwise can we explain the astounding power of the imagination and, as final proof, the fact that this incredible power is, relatively speaking, infinitely stronger in childhood? When I was a child and a young man I not only had as much imagination as I possess today, but what I saw made a deeper impression on me without causing me greater surprise, and gave me incomparably more pleasure. Whence could I have received all these impressions at so early an age?

12 September

Arrived in Brive at ten o'clock and left again immediately. François came to meet me.

I went for a walk with François along grassy rides, through orchards and fig-trees. I love this part of the country, it is full of pleasant memories. Mme de Verninac seems pleased to see me, and calls me by my first name. François's wife is a nice woman.

13, 14, 15 September

Every day except Sunday, the day of my departure, I led much the same kind of life. Remained alone until luncheon, according to my usual custom. On the 15th, the day before yesterday, I spent part of the time drawing the mountains from my bedroom window. After luncheon, and in the hottest part of the day, I made a drawing in the delightful valley where François has planted the poplars. I love this place. When I came back up the hill, I felt positively grilled by the sun, which always seems to make me tired for the rest of the day. I delighted in picking a few peaches and figs, they are delicious eaten like this. Needless to say, I felt as though I were committing a crime!

How shall I find words to describe my pleasure in this countryside? It is a mixture of all the sensations that are lovely and pleasant to our hearts and imaginations. It makes me think of those places where I had so much quiet happiness when I was young; I think of old friends as well, of my brother, dear Charles, and of my sister. In this part of the country, which is so near the South, it almost seems to me, in my present state of loneliness, as though I were back again with the dear people in Touraine and the Charente; the districts which are so lovely to me, so very dear to my heart.

Périgueux, 16 September

At seven o'clock left for Brive with François and Dussol. On the way we met the doctor-masseur, and then François's maid and her charming sister, the one whom I had seen standing ragged and barefoot near the horses on the day we went to the races at Turenne. This time she was very smartly dressed and was going into Brive to shop for her wedding, which is to be in a week's time. Her husband will be a lucky fellow for a little while. She is that most delicate and attractive type, the blonde, armed with all the special, incomparable charms of her type. I realized it the first time I saw her.

We travelled through a rich and smiling countryside as far as Périgueux, but the air was heavy with the heat and the scorching wind.

Reached Périgueux about sundown, side by side with the daintiest little creature imaginable, who was given me as a travelling companion in the miserable little box on wheels in which I did the last stage before the town. Crossed the pretty little town under transparencies and illuminations to celebrate the good news from Sevastopol.

To the office to inquire about seats on the coach. I find that I shall have to change my plans. I have to go to Montmoreau to take the

train, and to travel with the mails by way of Ribérac in a kind of gig, dining at the Hôtel de France, opposite to the coach station. A pretty moderate meal served by a damsel of captivating if somewhat mature charm, did marvels for me, and the effect of it was not entirely spoiled by the company of some commercial travellers, whose conversation is always the same mixture of nonsense and ineptness. I had already met a party of these fellows when I was lunching in Brive, on my way to Croze.

Whilst I was paying my 3 fr. 50 to the landlady for my dinner in Périgueux I had time to admire the fashionable rotundity of her dress, and the magnificent get-up in which she passed in and out of the yard into the kitchen and dining-room. I left the inn delighted with everything I had seen and not least, with the beauty of the women in this part of the country; they are the most attractive creatures imaginable. I walked about the main street until quite late, watching the crowds of sightseers of every description, the pedlars, strolling musicians, and street-hawkers with their lottery tickets and quack medicines. I even found a *real beauty* among them, charm united to grace and innocence, which you rarely see in the North and never in Paris.

I finally left about nine o'clock, I think. The arrangements which had seemed quite impossible at first, ended by turning out rather well, and my greatcoat was splendid. Squeezed into a corner of the gig, wrapped up like a parcel, and buttoned well above my eyes for fear of catching cold, I ended by falling into a stupor and reached Ribérac about two in the morning.

We drove through empty streets where a few candles were still burning to mark the celebrations. I went into this stable that calls itself an inn, took a bedroom, flung myself fully dressed upon the bed, and slept soundly until five o'clock.

Montmoreau, 17 September

Left for Montmoreau feeling very cheerful. Rose early, and found myself perched high in the coupé between a young soldier and a good Périgourdin who told us about his wine, etc. I was charmed with everything I saw; this beautiful, rich countryside looked indescribably attractive in the sunrise. The country was so like my own dear forest that it revived other delicious memories. I began to imagine that I was with Charles and Albert once again, going out shooting in the early dew among the woods and vineyards, as we used to do in the

old days. No words to describe such tender memories! The very force of such feelings ends by dulling my senses and making me exhausted, or rather, insensitive.

Between Ribérac and Montmoreau, I noticed that the vines were grown clinging to trees, or to posts, in the Italian way. It is very pretty and picturesque and would look well in a painting, but my neighbour, the soldier, a fine young fellow who has returned somewhat disillusioned from the Crimea, where his feet were frost-bitten, told me that this was not the best method, not so much for the effect on the vines themselves but because it keeps the sun off the crops grown around them. This young infantryman also said that the English are *parade-ground soldiers who give up far too soon*, in spite of their reputation for doggedness. Perhaps, like good allies, we are behaving to them, as regards their courage, as people treat misers when they try to extract something from them by praising their generosity.

Paris, 18 September

I had intended to go on to Strasbourg this morning, but I felt so tired that I spent the day in bed, or rather lying upon it. I went out only once, to dine at the little Belgian restaurant in the rue de Provence, then I came back in time to fasten my bags and left again at eight in the evening. I could not sleep during the journey. There was a family party, including a baby in arms, with its wet-nurse in Alsatian costume, and a small boy who kicked me ceaselessly.

Strasbourg, 19 September

Arrived about eight o'clock and set out on foot for my cousin's house,[1] following a man with my luggage on a hand-cart along the quays and the river. I found the cousins at breakfast; they were delighted to see me, and I to see them. Then I felt tired and fell asleep on the drawing-room sofa; dinner, which followed next, and far too soon, only increased the exhaustion I have been feeling for the past few days.

20 September

While I was having luncheon with the cousins—again too early—Schuler, the engraver, called; I used to know him at Guérin's when I

[1] Delacroix was greatly attached to this family. His first cousin, Victorine Pascot, had married M. Lamey, a judge.

was finishing my time there. We went together to see the superb Correggio belonging to M. Simonis,[1] 'Venus disarming Cupid'; I did not realize how good it was at first, and very much regret that I am only now writing of the impression it made on me—three weeks later. Knowledge, grace, balance of lines, charm of colour, and boldness of execution are all united in this charming picture. At the time, some harsh outlines disturbed me, but I have since realized that they are perfectly justified by the need to make certain parts stand out decisively.

We then went to the museum in the Town Hall, where I found a rather good copy of my 'Dante' by a young man named Brion, who has done some good pictures of Alsatian subjects.

Baden, 25 September

Arrived in Baden about four o'clock. Fine mountains in the distance, almost melting into the horizon. I've scarcely arrived, and as usual everything seems dismal; I am sure I'm going to be bored.

I did a water-colour of the mountains from my bedroom window. When I went out I ran into Séchan,[2] and shortly afterwards, into Mme Kalergi. I am torn between the necessity for going out with Séchan—a matter of conscience—and my instinctive desire not to move.

Baden, on arrival, 25 September

Yesterday, when I was in Strasbourg, I saw the tomb of Maréchal de Saxe,[3] in Saint Thomas's church; it is a perfect example of the particular defect that I have been considering lately. The figures are brilliantly executed but they almost give one a fright, so closely are they copied from the living model. The Hercules, although it is of the school of Puget and inspired by him, has none of the divine afflatus, nor the daring, none, I venture to say, of the semi-imperfections that you find everywhere in the work of the master. The proportions are exceedingly accurate, every part is correct in its planes and the flesh

[1] This picture may have been a copy of the one in the National Gallery, London. 'Mercury instructing Cupid, before Venus'.

[2] Charles Séchan (1803–74), a decorative painter. He was in charge of the decorations at the casino in Baden.

[3] By Pigalle.

is treated with great feeling, but the pose is dull. This is a sorrowful Italian organ-grinder, not the son of Alcmene; he happens to be here, but you feel that he might equally well be anywhere else. The 'Mourning France' confronts death with a very accurate expression of grief, but it is the portrait of an ordinary Parisian woman, and the figure of 'Death'—subject for an ideal figure if ever there was one— is merely an articulated skeleton, such as you find in every studio. The sculptor has flung a large sheet over it, which he has carefully imitated in order to make you very exactly aware of the hollows and projections of the bones beneath the drapery, or where they lie un- covered. Our rude forefathers represented symbolic figures very differently in the simple-minded allegories of the Gothic period.

I still remember the little figure of 'Death' that used to strike the hours on the old clock on the church at Strasbourg—the one I saw in the store-room with the rest of the set, the old man, the youth, etc. It was a terrible object, but not merely hideous. All the awk- wardnesses and errors of proportion in these figures of angels and devils made one's imagination grasp what the artists were trying to achieve.

I have said nothing about the tomb as regards unity of effect or style because it is totally devoid of any such quality. The mind does not know where to begin with these scattered figures, broken flags, and prostrate animals. And yet what a subject for the imagination of a true artist; the mere description of it is enough! The armed warrior going to his death, grasping the baton of a marshal of France; the figure of the France whom he served throwing herself between him and the implacable monster about to seize him; the trophies of his victories, now merely the empty trappings of his tomb; the emblems of conquered powers, the eagle, the lion, and the dying leopard!

I am still thinking about the tomb as I look out of my window here in Baden, on the 25th of September, and here again, I notice how closely Shakespeare resembles the unity of external nature. This view, for instance, in spite of its multitude of separate details, seems never- theless to make a single, unified impression on the mind. The moun- tains through which I travelled on my way to Baden seem to rise in simple majestic lines as I see them from a distance; from near at hand they no longer look like mountains, but like bare patches of rock with fields and trees, single or in groups, and the works of man, the roads, houses, and so forth, each object holding our attention in turn.

This unity, which the genius of Shakespeare manages to create through all his irregularities, is a quality entirely his own.

27 September

At six o'clock called on Mme Kalergi as she had asked me to do. She talked a great deal about Wagner[1] and is ridiculously infatuated with him, just as she was with the Republic. This fellow Wagner wishes to revolutionize music and he is convinced that he is right. He suppresses many of the musical conventions believing that they are not based on any law of necessity.

Went out fairly early and in spite of the raw cold took a long walk by the avenue leading to Lichtenthal. Charming views. As I was on my way back I met Winterhalter,[2] he is not a bad fellow, but a terrible bore. He insisted on our having a glass of beer together, and I went along with him.

28 September

Started out early for the convent at Lichtenthal without even troubling to take an overcoat. A delicious, early morning walk. In the chapel of the convent I had the heavenly surprise of hearing the chanting of the nuns just as I was leaving; you could not find such a thing in the whole of France—not in a hundred years. I was saying to Mme Kalergi, a tremendous supporter of the Germans, that in Germany music has its roots in the soil, so to speak, whereas with us it is an artificial growth.

A large Christ in painted wood, very expressive and terrifying, hangs sideways just under the eyes of the poor nuns when they kneel in their gallery.

How expressive they were, those pure, resonant voices! What singing, what simple harmony! The voice proceeds from the temperament rather than the soul, and theirs seemed to me to betray repressed longings—at least, so I imagined. I came away enraptured with it all.

Walked as far as Eberstein under a hot sun, discussing politics, art, and so forth. The castle was like all the other big German houses, pseudo-Gothic, ornamentation in every known style and everything hideous and clumsily arranged. Clumsiness is the muse who usually stands at the elbow of German artists. A kind of semi-clumsiness is almost the only charm of their women.

[1] Richard Wagner, born in 1813, was still completely unknown in France, although he had already written *The Flying Dutchman*, *Tannhäuser*, *Lohengrin*, and in this year, 1855, *Tristan and Isolde*.

[2] François-Xavier Winterhalter was the fashionable portrait painter of the Royal and aristocratic families of Europe.

Strasbourg, 29 September

Spent part of the day drawing in the Cathedral museum. On my first visit I was attracted by works of the fifteenth century and the beginning of the Renaissance. At first I did not care for the somewhat stiff and rather Gothic statues of the earlier period, but I did justice to them the following day and the day after, for I spent three whole days drawing enthusiastically in spite of the cold, the poor lighting, and the difficulty of finding a place to work. On the first day I drew the statue, supposed to be by Erwin[1]—you find Erwin everywhere here, like Rubens in Antwerp, or Caesar in every circle of grass that even remotely resembles a camp. The head and hands are superb, but the draperies are fussy, routine work.

30 September

Went back to the museum in spite of its being Sunday and immediately attacked the thirteenth- and fourteenth-century figures of angels. The Foolish Virgins and the bas-reliefs are still somewhat primitive in their proportions, but full of grace or strength. I was greatly impressed by the emotional power. *Knowledge* is almost always fatal to it. Great manual skill, or even a greater knowledge of anatomy and proportions immediately allows an artist to take liberties, he no longer reflects the image with the same simplicity. Methods which give him facility in rendering and the possibility of taking short cuts, lead him astray and draw him into mannerisms. Schools teach scarcely anything else, for what master can impart his own personal sentiment? All that can be gained from him are his *recipes*. The student's natural inclination to adopt as quickly as possible his master's facility of execution—which is the fruit of long experience—corrupts his art and, so to speak, merely grafts one tree upon another of a different species. Some artistic temperaments are strong enough to absorb and take advantage of everything. In spite of being brought up in ways that would not have come naturally to them, they find their own path through the mazes of other men's precepts and examples. They benefit by what is good, and although they sometimes bear the mark of a particular school, they develop into artists like Rubens, Titian or Raphaël. It is absolutely essential that at some moment in their careers, artists should learn not to despise everything that does not come from their own inspiration, but to strip themselves

[1] Erwin de Steinbach (1240–1318), architect and sculptor, who is said to have completed the façade of Strasbourg Cathedral.

of the almost always blind fanaticism which prompts us all to imitate the great masters and to swear by them alone. One should say to oneself: 'this method is good for Rubens, this for Raphaël, and this for Titian or Michelangelo. What they did is their own affair; nothing binds me to either method.' One must learn to be grateful for what one discovers for oneself; a handful of *naïve inspiration* is preferable to everything else. They say that Molière closed his Plautus and Terence one day and remarked to his friends: 'I have had enough of such models; from now onwards I look within and around myself'.

1 October

I am becoming more and more fascinated by the *primitives*. In some of the heads, for instance the old man with the long beard and long draperies and the two gigantic statues of an abbot and a king in the courtyard, I notice how well they understood the processes of antique art. I am drawing only by the planes, in the manner of our medals after the antique. I feel that by studying these models of a period that was generally supposed to be barbarous—notably by myself—and finding that they are full of the qualities that stamp great works of art, I am striking off the last of the chains that bound me and confirming my idea that the beautiful is everywhere, and that each artist not only sees it in his own way but is absolutely bound to render it in his own style.

Where are the Greek types here, the regular features that we have become accustomed to accept as the invariable type of *the beautiful*? These heads are those of the men and women whom the artist saw around him. Would anyone deny the connexion between the impulse that leads us to love a woman who attracts us, and that which makes us admire beauty in a work of art? If we are so constructed as to find the kind of attractions that make us fall in love with a charming woman, how can we explain the fact that these same features, these same charms, can leave us unmoved when we find them expressed in a picture or statue? Shall we say that as we cannot help loving, we fall in love with whatever comes our way, however imperfect, for want of something better? The conclusion would seem to be that our love should increase in exact proportion to our mistress's resemblance to Niobe or Venus, but we meet women formed like goddesses who do not compel us to love them at all.

It is not only by having regular features that women attract us, for some who are blessed in this way mean nothing to us. The kind of

charm that makes us fall in love lies in a thousand different qualities, and the word charm explains everything.

That evening we went out to bid farewell to the beauties of Strasbourg and to see the Promenade des Contades. I wish I had learned to know it earlier, and I regret not having made one or two sketches.

Dieppe, 3 October

I cannot express my pleasure in seeing Jenny again. Poor dear woman! Her little face was looking thin, but her eyes sparkled with pleasure at having someone to talk to again; I walked back with her in spite of the rain. For the next few days, and probably for the whole time I am in Dieppe, I shall be under the spell of this reunion with the only creature in the world who gives me her whole heart without reserve.

4 October

I have not been bored for a single moment. I spend the time looking out of my window and walking about my room. The boats come in and out of the harbour, complete freedom, no boring or unfriendly faces, the same view that I had last year, and I have not read a line.

I am still devoured by a passion for learning, but not like so many fools for learning things that are useless to me. Some people, for instance, who will never make musicians learn to become experts in counterpoint, others study Hebrew or Chaldean, and decipher hieroglyphs or the cuneiform inscriptions on the palace of Semiramis. Poor Villot cannot drag anything out of his own sterile mind, but he has adorned himself with the most varied pieces of information— and the most useless. He likes to think himself superior to exceptional and eminent men who are distinguished only in their own subjects. I renounced such pedantic satisfactions long ago. When I left school, I too wanted to know everything; I attended lectures and thought of becoming a philosopher like Cousin, another poet who made great efforts to be a scholar. I also went to construe Marcus Aurelius in Greek with the late Professor Thurot, at the Collège de France; today, however, I know too much to wish to learn anything outside my own sphere, but I am insatiable for any knowledge that can enlarge my mind, and I remember, because of a natural inclination to follow it, the advice which Beyle gave me in one of his letters: 'Neglect nothing that can make you great'.

5 October

I spend hours without books or newspapers. I look through the drawings which I have brought with me and passionately, never growing weary, I study photographs of nude men—this human body, this admirable poem, from which I am learning to read—and I learn far more by looking than the inventions of any scribbler could teach me.

8 October

Now I have finally caught cold: I have felt it coming on from being in this chilly room, and from sitting half-dressed at the open window in the mornings.

9 October

I get up late, I don't shave and I'm not going out; I've made them give me a fire; I am trying to check this cold while it's still in its infancy. It is delightful I must say, to come all the way to Dieppe and stay in one's bedroom, but luckily my imagination never ceases travelling; I go from my engravings to this little note-book. Indeed, is not it as good as travel to have such a lively scene beneath one's windows? Here I can indulge my natural taste for bodily rest and *withdrawment*, if one can use such a word; rain and dull weather only add to my pleasure and help me to justify my dislike for exercise. About four o'clock I had a view of a very fine rainbow with a clarity of detail that astonished me, and which I've never seen described. The bow was perfectly traced in the sky, and its colours could be seen clearly in front of the houses surrounding the harbour and the trees forming the boundary of the view of the hill on the right, above the salt-marshes, where part of the river Arques flows into the sea; thus I did not see the phenomenon from a great distance, I could almost touch it, in a manner of speaking. The houses are only about a hundred feet away. There must therefore be particles of mist imperceptible to the eye, and yet sufficiently dense to catch the colours of the prism.

10 October

So much pleasant idling will end by bringing back my terrible enemy boredom, and with it the longing for my brushes and canvas. I often think of them, I ought to have brought them with me. It strikes me more forcibly even than last year, as I watch the scenes in

this seaside town, the ships, and the interesting types of people, that not enough has been made of such subjects. Even ships do not play a large enough part in marine paintings. I should like to see them the heroines of the piece—I adore them; they give me an impression of strength and grace and picturesqueness, and the more dishevelled they look, the more beautiful I think them. Marine painters render them very inadequately; as long as they keep the proportions correct, and the rigging conforms to the principles of navigation, they think they've done all that is required of them, and they put in the rest with their eyes shut, as it were, like architects marking off the columns and principal ornamentation on a plan. What I require is accuracy for the sake of the imagination. Their ropes are mere lines, drawn in hastily and *according to formula*; they are put there simply as reminders and seem to serve no real purpose. Colour and form must combine to get the effect I require. My kind of accuracy, on the other hand, would consist in strongly sketching in only the principal objects, but in such a way as to show their essential functions in relation to the figures in the picture. As for the rest, I look for the same qualities in marine paintings as I do in any other kind of subject. Even the greatest masters treat accessories too casually; if you render your figures with great care and neglect their accessories, you bring the mind down to questions of technique, of hurried and impatient handling, or a measure of skill sufficient only to hint roughly at details which complete the truth of the figures, weapons, materials, backgrounds, land formations, and so on . . .

11 October

Went down early to the pier. The sea was very fine; a great many ships and fishing-boats were already in harbour and I saw several others come in. I stood there in the wind and rain for two or three hours.

Felt tired for the rest of the day and stayed indoors in complete, and not unpleasant, idleness. This grey, rainy weather encourages my indolence.

In the evening, after a short nap, I went down to the pier to meet Jenny. There was a tremendous sea running, and I could hardly stand upright. Two fishing-boats whizzed past me like arrows, the first one making me jump; they had lit the lamps on board. Something could be made of these night effects. Remember the great banks of cloud over Le Pollet and the brilliant clusters of stars in the clear spaces.

13 October

Wrote to Mme de Forget:

'I too was glad to see the South once more; not indeed Provence, nor Languedoc, but Périgord and Angoulême, the districts I loved in my boyhood, and which are like the real South in so many ways. I relived memories of those happy times, and was reminded of many dear friends who have now departed. One thing upset me a little, I discovered that the climate does not suit me—at least not in one important respect—the heat and sun tire me and are bad for my health; it made me feel quite ill, even at a time of year when the discomfort is not usually very great. Normandy suits me far better, and Dieppe is enchanting just now; you never meet a soul, and I find the sea more and more fascinating. I am still extremely damp even as I write to you which, you will think, ought to be enough to complete the happiness of a man who is frightened of a little sun.

'When we meet we will tell one another all our adventures. I've already described some of the things that happened during the first part of my journey. If you must travel, you must be ready to put up with many discomforts, and sometimes one has fits of ridiculous rage, comical enough to think back on, but pretty desperate when they occur.

'I am going back to my life in Paris, which has its own discomforts although, rightly or wrongly, I have philosophically removed a good many of them, thanks to being more independent, or more unsociable —qualities or faults that are becoming second nature to me.'

Paris, 14 October

Left for Paris at midday. Went down to the pier in the morning while they were packing. I was delighted when I arrived in Dieppe and yet I am glad to be leaving. How strange it is, no sooner had I put off the day of my departure than I had a great desire to hurry back to Paris. I am longing to begin work. This travelling about, the constant change of scene and different sensations, quickens all one's senses. It is easier to resist the deadly torpor of boredom if one varies one's life.

From Dieppe to Rouen I travelled with three Englishmen, all of them young and, since I was in a first-class carriage, all you would suppose comfortably off. They were very badly dressed, especially one who was really dirty, his clothes were even torn. I do not understand this complete contrast with their former habits; I noticed the same thing on my trip to Baden and Strasbourg. A day or two later,

when I was making my examination of the pictures, I met our vice-president, Lord Elcho, and even his clothes were not particularly clean; the excellent Cockerell, who walked to the Place Louis XI with me the other day, was wearing a very vulgar cravat. The English have changed entirely and we, on the other hand, have adopted many of their former habits.

At the meeting of the jury the other day Horace Vernet told me of the approaches which he had been making to Ingres, who wrote to refuse his medal because he felt deeply insulted at being placed after Vernet, and still more outraged (according to what I am told by people above suspicion) at the insolence of the special jury on painting in placing him on the same line as myself in the preliminary classification of the candidates.

Augerville, 7 November

Left for Augerville. By following Berryer's instructions I arrived at the station at half-past eight instead of at half-past nine; but I was not in the least bored. I am better at waiting about than I used to be. When I'm by myself I'm very happy and have learned to rely less on outside amusements, such as reading, to fill in the time. Even in the old days I never understood how people could read on a journey. When are they ever alone with themselves? What use can they make of their minds if they never seek them out?

What have I done in the past month? I have been busy with the Jury. I have seen plenty of toadying and have yielded to the temptation of obliging one or two poor devils. I must try to remember how angry M. Français became when, after consistently voting the highest award for Corot, he discovered to his indignation that they had completely forgotten him and had left no room for him on the list. Dauzats and I did manage to remember him and gave our votes for him, and we were the only people who did so.

Paris, 16 November

Dear Guillemardet[1] came to congratulate me, and Villot called while he was here. He began to tell me his version of the story of the cancellation of Meissonier's medal of honour. I could not help

[1] Delacroix was receiving visits of congratulation: he had been awarded one of the Grand Medals of Honour at the Universal Exhibition of 1855, and had been made *Commandeur de la Légion d'honneur* by the State.

stopping him in the middle of his tirade against these shocking scoundrels, as he calls them.

24 November

How I have been neglecting my poor note-books! When I am in Paris, I am too busy to write, even in snatches. For the past four or five days I have shut myself up in an attempt to get rid, if possible, of this miserable cold. It is a good excuse to give to myself and others for not going out.

25 November

Nothing can overcome the bias of the reigning fashion. In the days of Lebrun and David, when students used to be sent to Rome they were advised to study only Guido; nowadays *the Beautiful* is supposed to lie in reproducing the technique of the old frescoes, but students need only consider the academic side. These two methods, that seem so much opposed to one another, have in common what will always be the watchword of all the schools: namely, copy the technique of this school, or that. To draw upon the imagination in order to find a way of rendering nature and its effects, and then to render them according to one's own temperament are 'vain imaginings, profitless studies' that never lead students to the *Prix de Rome* or the *Institut*: all they have to do is to imitate the execution of Guido or Raphaël, according to which one happens to be in fashion.

11 December

I have been looking at some of Géricault's lithographs and have been struck by the invariable lack of unity. Unity absent from the composition in general, absent from each separate figure and from every horse. The horses are never modelled in the mass; each detail is added to the rest, and altogether they make an incoherent whole. Just the opposite of what I notice in my 'Entombment' (belonging to Count de Geloës), which I have in front of me at this moment. Here the details are, generally speaking, mediocre and scarcely bear close inspection, but on the other hand, the general effect inspires an emotion that astonishes even myself. You cannot tear yourself away from it, and no single detail seems to call for special admiration or distract your attention from the whole. The perfection of this kind of art lies in creating a simultaneous effect. If effects in painting were produced as they are in literature (which is simply a series of pictures

following one after another) there might be some justification for allowing the details to stand out in relief.

Re-reading the above, in December 1856, I am reminded of what Chenavard was saying, in Dieppe, two years ago; namely, that he did not consider Géricault a master because he had no unity. This is Chenavard's crucial test for the title of Master in Painting. He refuses it even to Meissonier.

1856

Paris, 8 January

Dined with Guérin and several other doctors this evening. Ricord, very gay and amusing but too cynical, as people who practise his art so often are. The flippant way they talk of our illnesses, serious as well as trivial, is really . . .

10 January

Called on Rossini, then went to Ségalas's *soirée*, where the Prefect [Baron Haussman] was unusually affable. He told endless stories, including several in which he showed up to great advantage. His main theme was his firmness and courage in the most critical situations; I needed only to bow from time to time in polite agreement.

Earlier in the evening, when I was at Rossini's house, I enjoyed watching this rare artist; I seemed to see him surrounded with a kind of halo. I like watching him. This is a new Rossini.

12 January

(The Prefect's dinner-party.) Instead of dining at the Prefect's I went with Mme Sand to see her play *Favilla*. An excellent plot which the poor woman has not been able to develop satisfactorily. I begin to be afraid that she will never manage to write a good play, in spite of her many fine qualities. She kills her good situations because *she can never grasp the central interest*. She has no idea of what is lacking. Her obstinacy in pursuing a gift that, judging from her failures, seems to have been denied to her, must place her in an inferior rank, however little we like to think so. It is very rare for great talents not to be swayed almost irresistibly towards the subjects that are their own particular province. This above all is what experience should teach

them. Young men may be mistaken in their vocation for a time, but not talents that have been matured by practice in a particular style.

13 January

While we were at dinner Mérimée was speaking of Dumas; he has a great opinion of him and prefers him to Walter Scott. Perhaps he improves as he grows older; perhaps he is so free with his praise because he is afraid of making enemies.

14 January

The Second Monday dinner. Trousseau said, very rightly, that doctors are artists. Like painters and poets they have a scientific side, but this can only produce the ordinary run of doctors and artists. Inspiration, a natural genius for the profession, is what produces the great man.

15 January

Magnificent concert by Mme Viardot, the aria from *Armide*. I enjoyed hearing Ernst, the violinist. Telefsen tells me that he gave a very poor performance at the Princess's, but I must admit that once a certain degree of excellence has been reached I cannot detect much difference between the various executions. When I spoke of my re-collections of Paganini he said that beyond all doubt he was an incomparable artist. The difficulties and the so-called *tours de force* in his works still make most of them impossible for even the most brilliant violinists. Here is the true inventor, the man with a natural genius for his art. I thought of many artists in painting, architecture, and the other arts who are just the reverse.

17 January

At Mme Viardot's house. She again sang the new air from *Armide*: *Sauvez-moi de l'amour!*

Berlioz behaved abominably,[1] exclaiming all the time against the trills and grace-notes characteristic of Italian music which he considers barbarous and in execrable taste. He will not even allow them in older composers like Handel, and really lets himself go against the flourishes in the great aria of Donna Anna.

[1] Berlioz, worn out by financial and family worries, was in a highly nervous condition at this time.

18 January

In the morning I went to see my old friend Guillemardet. He handed me a packet of letters which I had written to Félix, long ago. It is easy to see how many long years it takes for the mind to develop its true character. He said that even in these early letters he could recognize the man I have since become. All that I can see, apart from a certain amount of vivacity, is that I had more bad taste and impertinence than brains—but it was bound to be so. The strange discord between the strength of our minds and the weakening of our bodies as we grow older always seems to me a contradiction of the laws of nature. Should we see in this a warning that we ought to turn towards the things of the mind when our bodies and senses begin to fail? It is, at any rate, some compensation for growing old, but how we must guard against letting ourselves go at those deceptive moments when we think we can be young again—or at least act as though we were. If we fall into that trap we are done for.

19 January

Dined with Doucet. Came home with Dumas who told me about his love-affair with a *virgin*, widow of one husband and still intact *with* her second!

Whilst they were playing baccarat at Doucet's house, Augier, whom I like very much, was saying how important it is for an artist not to attempt to earn too much money and consequently not to be obliged to spend it on purely frivolous things. He thinks that an artist should live in simple surroundings. Mme Doucet said that having to give dinner-parties at three or four hundred francs a head often prevented people with small incomes from asking three or four friends to take pot-luck at a cost of fifty francs. What is more, she lives in a tiny ground-floor apartment in the rue du Bac, with low ceilings, but furnished with every conceivable modern luxury and contrivance; gilding, damask, useless little bits of furniture, etc.

21 February

On masterpieces.

Without *the masterpiece* there is no great artist; yet artists who have produced only one masterpiece in their lifetime are not great on the evidence of that single achievement. Such masterpieces are generally the productions of young men. Sometimes a burst of precocious energy, an emotional as much as a mental exaltation,

produces a flash of extraordinary brilliance, but the promise shown in an artist's early works needs to be confirmed by those of his maturity, the age of true power. However, where there is real power this nearly always happens.

25 February

Admirable article by Gautier on the death of Heine in today's *Moniteur*.

I wrote to him as follows: 'My dear Gautier, your funeral oration was a masterpiece and I cannot resist writing to offer you my congratulations. It has made an unforgettable impression on me and will become part of my collection of famous *excerptae*. Can it be, alas! that your art, that possesses so many resources denied to ours, is under certain conditions more fugitive than a fragile painting? What will become of four exquisite pages, published in a newspaper between a list of meritorious actions performed in the eighty-six departments of France and the review of some musical comedy of the day before yesterday? Why did they not notify one or two of the men who genuinely care for true and great genius? I did not even know that poor Heine was dead; I should have liked to have stood by the bier on which such brilliance and wit was borne away and to have felt what you yourself expressed so beautifully. I send you this small tribute, less indeed for the obligation that I certainly owe you, than for the sake of the sad, the gentle pleasure that your article has given me. Your sincere friend.'

6 April

For the past few days I have been reading Baudelaire's translations from Edgar Poe with great interest. In these truly *extraordinary*—I mean *extra-human*—conceptions, there is the fascination of the fantastic which may be an attribute of some temperaments from the North or elsewhere, but which is certainly not in the nature of Frenchmen like ourselves. Such people only care about what is beyond nature, or extra-natural, but the rest of us cannot lose our balance to such a degree; we must have some foundation of reason in all our vagaries. At the most, I can understand a man's making one excursion of this kind, but all Poe's tales are alike. I am sure that any German would feel at home with them. Although he displays a remarkable talent in these conceptions, I believe that it is inferior to one which consists in depicting the truth.

I admit that one does not get such a thrill from reading *Gil Blas* and Ariosto, if therefore it is merely a question of varying our pleasures, this kind of literature has its merits and keeps our imaginations alive, but you cannot take it in large doses, and Poe's obsession with horror, or impossibility made to seem possible, is something that runs quite contrary to our mentality. We should not allow ourselves to believe that writers like Poe have more imagination than those who are content with describing things as they really are. It is surely easier to invent striking situations in this way than to tread the beaten track which intelligent minds have followed throughout the centuries.

9 April

While I was on my way to Saint-Sulpice yesterday, I began to think of writing something about the inevitable course that all art must follow as it becomes increasingly sophisticated. The idea first came to me yesterday at the Princess's, when we were listening to the compositions by Mozart which Gounod reviewed, and it was confirmed when I heard Mme Viardot sing the aria from *Figaro* at Mme d'Haussonville's this evening. Bertin said that the music was too sophisticated and that the impression was carried beyond the limits acceptable to popular taste. This is not right. In periods like ours the public develops a love for details because modern works of art make people accustomed to look for subtleties everywhere. And contrary to what Bertin says, if you wish to please public taste, this is not the moment to paint on broad sweeping lines; this should be reserved for those infinitely rare minds who rise above the level of public demand, and still draw their nourishment from beauty as it was understood in the great periods of art; in short, for those who still love beauty, that is to say, simplicity.

Yet we need pictures painted on broad sweeping lines. Works of art have this quality in primitive periods. The root of my idea is the need to belong to one's own period. I remember that Voltaire makes his Huron exclaim: *Greek tragedies are good for Greeks*, and he is perfectly right. Hence the absurdity of trying to swim against the stream and of producing archaisms. Compared with Corneille, Racine appears sophisticated, but how much more sophisticated we have become since the time of Racine. Walter Scott, and Rousseau before him, set themselves to probe the finer shades of human sentiments and the vague melancholy whose existence the old writers scarcely recognized. Modern authors are no longer content merely to write of

human sentiments; they describe external appearances and analyse everything.

In music, the perfecting of some instruments and the invention of others brings the temptation to experiment further with sound imitations. Before long we shall have learned to imitate the sound of the sea, the wind and a waterfall. Last year Mme Ristori, in *La Pia*, gave a rendering of the death rattle of one of the characters in a very accurate but singularly repulsive manner. Objects which, as Boileau used to say, ought to be *offered to the ears* and *hidden out of sight* now belong to the realm of art; in the theatre, for instance, costumes and scenery are perfected as a matter of course. It is even becoming evident that this is not entirely bad taste. We have to elaborate everything to satisfy all the senses. Before long we shall perform symphonies and show fine pictures at the same time in order to complete the impression.

As much as twenty years ago they were making structural decorations on the stage at the Opera in an attempt at realism, in the operas *La Juive* and *Gustave*, for instance. In the first of these productions there were real statues and other accessories on the stage, objects which are usually conveyed by paintings. In *Gustave*, actual crags were used, artificial ones it is true, but made from solid blocks. And thus, from a love of illusion they reached the point of destroying it entirely. It is obvious that when real columns or statues are put on the stage in conditions under which one usually sees painted scenery, with the lights coming from all directions, they lose all their effect. This was the period when they took to wearing real armour, etc., on the stage, and so by continual improvements they reverted to the infancy of the art. When children play at acting they use real branches for trees, and so they must have done in those periods when the theatre was first developed. We are told that Shakespeare's plays were generally performed in barns and that no great trouble was taken over the production. The constant changes of scene which, incidentally, seem the sign of a decadent art rather than of one which is progressing, were shown by placards with the inscription: 'A Forest', 'A Prison', and so on. Within this conventional setting the onlooker's imagination was free to follow the actions of the various characters who were animated by passions drawn from nature, and that was enough for him. So-called innovations are gratefully seized on as an excuse for poverty of invention and in the same way, the long descriptive passages that so overburden modern novels are a sign of sterility, for it is obviously easier to describe a dress or the outward appearance of an object than

to trace the subtle development of a character or portray the emotions of the heart.

14 April

Delivered since November:

Copy of the 'Greek Horseman' . . .	1,200 fr.
'Chlorinde'	2,000 fr.
'The Lions', small scale	2,000 fr.
'Greek Horseman and Turk' (Tedesco) . .	1,600 fr.
Small 'Moorish Horseman' (Barye) . . .	300 fr.
'Hamlet and Polonius'	1,000 fr.
	8,100 fr.

Sold a month ago, 'Marino Faliero'[1] . . . 12,000 fr.

16 April

On the need for sophistication in decadent periods.

The greatest minds cannot escape it. People think that they are discovering a new form of art when they introduce details where the ancients used none. The English and the Germans have always urged us along this road. Shakespeare is intensely sophisticated. When with his deep perception he portrayed emotions which the early writers ignored or did not even realize the existence of, he revealed a little world of sentiments which, albeit confusedly, have been common to men of every age but seemed doomed never to reach the light or to be analysed until some specially gifted genius carried his torch into the dark corners of the soul. It seems that a writer ought to be tremendously learned, but we know how easy it is to be deceived and how much reality lies beneath a show of universal knowledge.

6 May

In the evening I read aloud several scenes from *Athalie* to Jenny.

12 May

One finds that one never has enough learning. The drawing of Ingres—Decamp's bottles of fat oil and clear oil—Not one false note in the work of men of feeling—Before you begin, study unceasingly,

[1] This picture was painted in 1826 and shown at the 1855 Exhibition. It is now in the Wallace Collection.

but once started, make mistakes if you must but you must execute freely.

30 May

'In beauty of face no maiden ever equalled her . . . yet her features were not of that regular mould which we have been falsely taught to worship in the classical labours of the heathen: "*There is no exquisite beauty*", says Bacon, Lord Verulam, truly speaking of all the forms of beauty, "without some *strangeness in the proportions*".' (Edgar Allan Poe, *Ligeia*.)

When I came home I continued my reading of Edgar Allan Poe. His work revives that sense of the mysterious which I used to be so much concerned with in my painting, and which I threw off, I believe, by working *in situ* on allegorical subjects, etc. Baudelaire says in his preface that my painting reminds him of Poe's feeling for a strange ideal that finds enjoyment in the terrible. He is quite right, but the incoherence and obscurity that Poe mingles with his conceptions do not suit my ideas. His metaphysics and researches into the soul and the life to come are most remarkable, they give one a lot to think about. Van Kirch's description of the soul in a mesmeric sleep is a strange, profound piece of writing, very haunting. There is something monotonous in the way Poe tells all his tales, and, as a matter of fact, the lurid glow with which he surrounds his dim but terrifying figures is the whole secret of the charm of this remarkable and highly original poet and philosopher.

6 June

After leaving the Hôtel de Ville yesterday, I went to see the great Agricultural Exhibition. It has gone to everyone's head; people are full of admiration for the marvellous new inventions, the machines for cultivating the land, and the animals from various countries brought together in friendly rivalry by people of all nations. Every little shopkeeper leaves the exhibition thankful for having been born into so excellent a century. For my own part, I felt unutterably wretched in that extraordinary agglomeration—those poor animals, unable to make out what the stupid crowd wanted of them, or to recognize the keepers who have been allotted them at random. As for the peasants who have accompanied their beasts, they remain near their charges, casting anxious glances at the idle spectators, ready to forestall the insults and impertinences that are not spared them.

Ordinary common sense should have been enough to convince the people concerned of the uselessness of this assemblage before ever the scheme was put into operation. The mere sight of these animals with their different shapes and characteristics should have made it obvious that it would be futile to try to transplant them, or to cut them off from the natural environment in which they have developed. Nature has decided that cows shall be small in Brittany and big in Scotland. Was it really necessary to collect them into one place, and from so far away . . . innocents like these?

When I first came into the exhibition of machinery for ploughing and sowing and reaping, I felt as though I were in an arsenal looking at the engines of war, for this is how I picture ballistas and catapults; rough instruments bristling with iron spikes, chariots armed with scythes and sharp-pointed blades—surely these are engines of Mars, not of fair Ceres.

Poor deluded people, there will be no happiness for you in release from work! See these idle loafers who seem overburdened with the weight of time and have no idea what to do with their leisure which these machines will increase still further. In other times, travelling was a distraction for them, it took them out of their usual rut; they saw new countries and new customs and for a time escaped the boredom that dogs their footsteps and weighs so heavily upon them. Nowadays they are carried so swiftly from place to place that they have no time to see anything; they mark off the stages of their journeys by names of railway stations which look exactly alike, and when they've crossed the whole of Europe they feel as though they have never left these dull stations which appear to follow them everywhere, like their own idleness and incapacity for enjoyment. It will not be long before they discover that the costumes and strange customs which they crossed the earth to see are the same all over the world.

Soon we shall be unable to go five miles without coming across those fiendish contraptions, railway trains. Fields and mountains will be ploughed up by their tracks: we shall pass one another like the birds as they fly through the air. We shall no longer travel for the sake of sightseeing, but arrive at one place only as a means of going somewhere else. People will journey backwards and forwards from the Bourse in Paris to the stock exchange in St. Petersburg, for business will have its claims on everyone when the harvest no longer has to be reaped by hand or the land watched over and enriched by careful attention. This thirst for riches, which brings so little happiness, will turn us into a world of stockbrokers. They say that, according to the physicians,

this fever is as necessary to the life of communities as actual fever is to the human body during the course of certain illnesses. But what is this new disease, unknown to past civilizations that astonished the world by their great and useful works, their conquests in the realm of high ideas and the true riches which they employed to add to the magnificence of the state and to increase the self-esteem of the nation? Why do they not make use of this unrelenting activity to dig great canals and drain off the disastrous floods which we read of with so much dismay? The Egyptians did this when they disciplined the waters of the Nile and set up the Pyramids against the encroachments of the desert, and the Romans did the same when they covered the ancient world with their bridges and triumphal arches.

But who will build a barrier against man's evil impulses? What hand will force his wicked passions to keep within bounds? Where are the people who will raise a barrier against covetousness and envy, or against the slander that, unchecked by indifferent or impotent legal systems, wrecks the reputations of honest men? When will they control the Press—that other merciless machine? When will the honour and reputation of men who are upright or eminent, and are therefore envied, no longer be the target for malicious slander from every nonentity?

10 June

Among the great geniuses there were undoubtedly some fiery spirits who were undisciplined even when they thought themselves to be restrained, because they blindly obeyed their instinct, which must surely sometimes have been at fault. For example, Michelangelo, Shakespeare, Puget; such men did not govern their inspiration, but were themselves ruled by it. Corneille is one of the most outstanding examples; he falls from the greatest heights to writing abominable trash. But to make up for it, these men are the pioneers, they are great eternal monuments, unformed at times, but towering above deserts and elaborate civilizations alike. For such civilizations they provide the starting point and the standard of criticism by reason of the eternal character of their fine qualities.

It is equally undeniable that there were other sublime geniuses who both obeyed and controlled their inspiration. Men like Virgil and Racine, for instance, never showed unpardonable lapses; they entered upon a road which had been cleared by giants; they left behind the

unformed crags, the too rash attempts, and possess over men's hearts a more complete dominion.

When the geniuses whom I first described try to reform themselves and to work systematically, they become frigid and fall below their level, or rather, remain beside it, whereas those of the second category hold their imagination in check. They reform their ideas and change their course at will, and never fall into inconsistencies or disturbing errors.

14 June

I sat next to Auber at dinner at the Hôtel de Ville. He told me that although his life had been a happy one, he would not wish to live it again because of all its vexations and bitterness. I thought this the more remarkable because Auber is a complete voluptuary, and even at his age can enjoy the company of a woman. It would seem therefore, that the sovereign blessing is tranquillity. Why not then begin early and put tranquillity above everything else? If man is bound to discover sooner or later that a state of calm is best of all, why not determine to lead the kind of life that induces it, mitigated now and then perhaps, by one or two of those little pleasures that are not like the terrible upheavals of a serious love-affair? But how watchful one has to be if one is to protect oneself when they become dangerous!

8 August

The finest works of art are those that express the pure fantasy of the artist. Hence the inferiority of the French school in sculpture and painting, where precedence is always given to studying the model instead of expressing the feeling that dominates the artist. Frenchmen in every period have relapsed into styles or academic enthusiasms and have been satisfied with this approach, which is supposed to be the only true one and is in reality the most false of all. Their love for reason in everything has made them . . .

16 August

Worked in the church [Saint Sulpice]—am feeling rather weary; I have now put in fifteen working days there at a stretch.

Dined with Schwiter in the rue Montorgueil; the poor fellow can talk of nothing but his grand friends. I fear that he may have some disappointments. I am very fond of him.

26 August

Made a new start today on the picture of Jacob at Saint Sulpice. Got through a great deal of work during the day; I heightened the tone of the whole group, etc. The lay-in was very successful.

27 August

I live like a hermit and each day is like the next. Every day except Sundays I work at Saint Sulpice, and I see no one.

Paris, 7 September

There is a man making parquet-flooring in the gallery opposite to my window; he works stripped to the waist. Comparing the colour of his skin with the outside wall of the house, I noticed how brilliant the half-tints of the flesh are against those of lifeless matter. I observed the same thing the day before yesterday in the Place Saint-Sulpice, where a small urchin had climbed up one of the statues of the fountain in full sunlight: dull orange in the lights, the most brilliant violets for the transitional passages into the shadow, and golden reflections in the shadows thrown up from the ground. The orange and violet were alternately predominant or else were mixed together. The golden tint had some green in it. It is only in the open air and especially in sunlight, that flesh takes on its true colour. When a man puts his head out of a window he looks quite different from what he does inside a room; hence the futility of making studies in a studio, you deliberately set yourself to render that false colour.

I noticed the singer at the window of the house opposite this morning (11 September); that's what gave me the idea of writing the above.

Ante, 1 October

Left at seven o'clock for Ante.[1]

4 October

A marvellous morning. We sat out-of-doors after luncheon, reading La Fontaine's fables and enjoying the most heavenly sunshine.

[1] The home of his cousin, Commandant Delacroix, in the department of La Meuse.

5 October

The difficulties of translation.

After we came in, I read some translations from Dante and other writers and realized how hard it is to adapt our matter-of-fact language to the translation of a very naïve poet like Dante. The demands of the rhyme or the need to *save* some commonplace word forces the translator to use roundabout phrases that are most irritating to read. Yet La Fontaine, whose fables we read yesterday afternoon, is just as naïve and even more ornate, and yet manages to say everything without redundant elaboration and without periphrasis. Say only what needs to be said: this is the quality which one must unite with elegance. We then read some Horace who has the same elegance of style and the same strength. No true poet lacks these qualities.

We spent the evening sitting round the dining-room table at a meal which seemed to last a very long time. To the great, and quite justifiable, annoyance of my cousin, a swarm of relations arrived as we were finishing dinner; everything had to be heated up again and we were forced to squeeze together and to sit with our elbows pressed tight to our sides, while we watched them fall upon their food.

Went for a walk by the light of the stars, which were shining superbly.

Paris, 9 October

Painted two views of my cousin's place from memory, in oils. In the evening I learned from Boissard of poor Chassériau's death.

10 October

Funeral of Chassériau. I met Dauzats there and young Moreau,[1] the painter. I rather liked him. Came back from the church with Émile Lassalle.

Augerville, 11 October

Left for Fontainebleau at seven o'clock and arrived in Augerville about one.

[1] Gustave Moreau was then twenty-eight and he became famous later as a highly personal symbolist and teacher. As the master of Rouault and of Matisse his presence with Delacroix at the funeral of Chassériau is an interesting link between Romanticism and the present day.

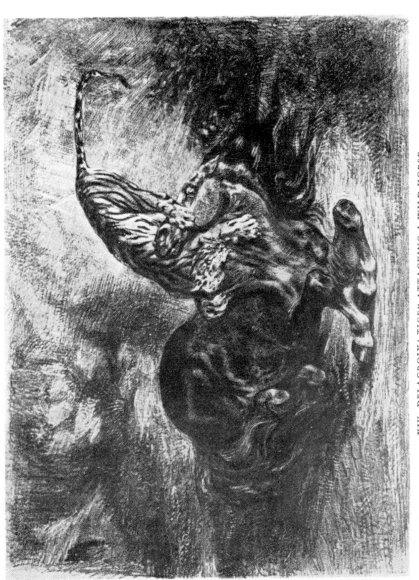

XIV. DELACROIX: TIGER ATTACKING A WILD HORSE
Lithograph, 1828

12 October

For enjoyment to be perfect, one needs memory to complete it and unfortunately, we cannot both enjoy and remember a pleasure at the same time. That would be to add the ideal to the real. Memory isolates the delightful moment, or creates the necessary illusion.

As I stand by this wood the song of a thrush awakens memories of other delightful moments and the recollection of them gives me more pleasure than I felt at the actual time.

To be satisfied with oneself is the greatest enjoyment of all and in a sense that is not so indirect as it might appear, one likes to be satisfied with other people's opinions about oneself. Some people derive this feeling from a sense of virtue, but others from external advantages that make people envious.

I am admiring the countless little spiders' webs that have suddenly appeared because the morning mist has made them heavy with moisture. What a multitude of flies and other insects must find their way into these nets to feed the spinners, and how many millions more must go to satisfy the appetites of the birds!

15 October

I came upon a slug spotted like a jaguar, with broad rings upon its back and sides, turning into single spots on the head and near the stomach, where it was lighter in tone, as in quadrupeds.

19 October

Every evening, I stroll up and down in front of the house while the gentlemen are enjoying their interminable billiards. There was exquisite moonlight at the beginning of the week. We had an almost total eclipse of the moon; it turned that blood-colour which we read of in poetry, and which Berryer said he'd never seen before. It is very much the same as with Pariset and Hippocrates. Great men see what the vulgar never see, that is why they are great. What they have discovered and often shouted from the housetops is disregarded or misunderstood by those to whom they speak, until time, or more often some other man of their own stamp, rediscovers the phenomenon and points it out to the crowd.

I wish I could remember whether Virgil, in his description of the storm, makes the sky revolve above the heads of the sailors as I saw it turn when I was on my way to Tangier. In that sudden squall, when

the night-sky was cloudless, the motion of the ship made it seem as though the moon and stars were performing a vast, continuous turning movement.

Champrosay, 21 October

Left Augerville with Berryer and Cadillan. Marvellous weather. I still have an inexhaustible appetite for nature and a faculty for receiving impressions such as one usually possesses only when one is young. I think that most men do not understand these feelings. They say: 'It is a fine day!' 'What big trees!' but it gives them no particular pleasure, no exquisite sensation of living a poem.

I travelled with them from Étampes to Jusigny. A most lovely woman was in the carriage, a strange, rare beauty, made to be painted. Even my neighbours were impressed; one of them, who in many respects has a fine mind, is very French in the way I have been describing. Next day I made a drawing of the beautiful creature from memory.

Arrived at Champrosay about two o'clock. Jenny had not received my letter warning her of my arrival.

General Parchappe called to ask me to dinner with Pelissier on the following day. Today I refused Mme Barbier's invitation.

The dinner I ate and my stupidity in going to bed almost directly afterwards have made me ill for the last two days.

22 October

Felt ill and miserable all day. Dragged myself to the General's dinner party, but Pelissier was not there. Ate nothing but a little of the roast.

23 October

Felt seedy all day, but managed to put in some work on the 'Arab saddling his Horse'.

About three o'clock I took my poor Jenny for a walk in the forest; she enjoyed it so much. I developed a splitting headache and was sick after we came home. Went to bed without supper.

Mérimée was dining with Barbier, but I could not manage to get there although I wanted to consult him about etiquette at the Fontainebleau receptions.

24 October

Felt better and ate a little luncheon. Went for a short stroll in my slippers as far as Baÿvet's fountain, and had a light supper which did me good.

6 November

Funeral of that poor, miserable Delaroche.[1] Stood in the church porch for an hour in piercing cold, and left before the service as I felt chilled to the bone.

22 November

Thierry called when I was at luncheon, to talk about the next election at the Institute.

7 December

Must try to remember the splendid subject which I mentioned before; *Noah and his family sacrificing after the Flood*—animals scattering over the face of the earth, birds in the air, the monsters which God in His wisdom condemned lying half-buried beneath the mud, the branches of the trees, still heavy with the weight of the waters, pulling themselves up towards the sky.

M. Mesnard tells me he thinks that the concentration of the eye and brain on colour greatly adds to the fatigue caused by painting. The truth is, I have to be feeling very well to be able to paint. This is not so necessary with writing; ideas come to me even when I'm ill, and as long as I can manage to hold a pen I can write, but it is different when I'm at my easel, with a paint-brush in my hand.

9 December

Didn't feel in the mood and yet I managed to put in some good work on the 'St. John the Baptist', intended for Robert, of Sèvres.

Went for a long walk, from four until six o'clock. I am enjoying being in Paris. From the Place Louis XV I crossed the Tuileries and came home by the Rue de la Paix. The lovely garden is quite deserted now. How it reminds me of my youth!

Called on Thiers in the evening. Only Roger was there. I saw the portrait by Delaroche, a feeble piece of work, no character or execution.

[1] Paul Delaroche had been a constant source of irritation to Delacroix by the poverty of imagination and colour shown in his laborious pictures of historical subjects. Ironically enough, Delacroix was elected in January to the chair at the Institute left vacant by Delaroche's death; his own severe illness at the time seems to have begun with the intense cold he felt at the funeral.

People can write sensible, logical, even interesting things, and yet not write good literature, and it is the same in painting. He also showed me a full-length Flemish portrait of a man in black. This was admirable, and will always give pleasure through its *execution*.

12 December

Mozart writes in a letter where he deals with the theory that music can express all the passions, all pain, all kinds of suffering: 'Nevertheless, the passions, whether violent or not, must never be expressed to the point of arousing disgust, and music even in situations of the greatest horror, *must never pain the ear*, *but must flatter and charm, and consequently remain music*'.

16 December

I most stupidly caught cold today.

Drove to Mme de Forget's house in an open carriage to see her ceiling, then to Andrieu, and finally to call on Galimard, who astonished and disgusted me by telling me of all the little tricks and ruses that are being set in motion to prevent my election [to the Institute].

29 December

Once, when he was with a party of friends, someone asked Voltaire to tell a story about a thief. 'Gentlemen,' he said, 'there was a certain tax-collector—Good Heavens, I cannot remember the rest of it!' He had a great store of philosophy and detachment, and that's not a thing to blame him for.

31 December

In the article on Charlet.[1] Some talents come into the world fully armed and prepared. The kind of pleasure which men of experience find in their work must have existed since the beginning of time. I mean a sense of mastery, sureness of touch going hand in hand with clear ideas. Bonington had it, but especially in his hand. His hand was so skilled that it ran ahead of his ideas. He altered his pictures because he had such facility that everything he put on canvas was charming. Yet the details did not always hold together, and his tentative efforts to get back the general effect sometimes caused him to abandon a

[1] *Charlet, sa Vie, ses Lettres*, by Colonel de la Combe, had just appeared. In 1862, Delacroix published an article on Charlet in the *Revue des Deux Mondes*. Here he is jotting down some ideas for later use.

picture after he had begun it. Note that another element, colour, enters into this type of improvisation, and that this does not occur in Charlet's work.

1857

Paris, 1 January[1]

Poussin's definition of the beautiful—that which gives delight. After examining the pedantic modern definitions, for example the splendour of the good, that beauty is regularity, or whatever most resembles Raphaël or the Antique, and other such absurdities, I have found for myself, and without much difficulty, the definition which I now discover in Voltaire—article on 'Aristotle, the Poetics', in the *Dictionnaire Philosophique*. Here he quotes Pascal's inept reflection that we do not speak of *geometric* or *medicinal beauty*, and that we are wrong to speak of *poetic beauty*, because the aims of geometry and medicine are known, whereas no one knows what model in nature must be imitated to produce the particular pleasure that is the object of poetry. To this Voltaire replies, 'One feels how lamentable this passage from Pascal is. Everybody knows that there is nothing beautiful in a dose of physic or the properties of a triangle and that *we only call something beautiful when it awakens feelings of pleasure and admiration in our soul and senses.*'

On Titian. In praise of Titian. We praise contemporaries whose status is not yet established, and praise often goes to those who least deserve it. But to praise Titian! They will tell me that I am like the pious lawyer who drew up the famous *Memorandum in favour of God . . .*

He is beyond all praise of mine . . . his great shade . . .

It really seems as though the men of the sixteenth century had left little for us to do; they were the first to tread the road and seem to have reached the summit in every form of art, yet we have seen other talents bringing something fresh to each of these art-forms. These talents, appearing in times that have been less and less favourable to great endeavours, daring, new ideas, and simplicity, were fortunate, if you like, and so did not fail to please their own century which, though less favoured, was equally hungry for enjoyment.

[1] January 1857 was a critical period for Delacroix. The chill noted in December, but neglected, led to a serious laryngitis which forced him to remain indoors for three months. He wrote letters to Ingres and to other Academicians excusing himself for his inability to pay the traditional visits expected from candidates for a chair. Unable to work in his studio he took up his critical notes and reading.

Titian may be regarded as the creator of landscape painting. He brought to it the same breadth of treatment that he gave to the rendering of figures and draperies.

We stand amazed at the power and fertility, the universality of these men of the sixteenth century. Think of the miserable little pictures which we produce to match our mean little dwellings. Think of the disappearance of the great patrons, whose palaces for generations on end were the homes of fine works of art which the families who owned them regarded as titles to nobility, and the guilds of merchants, who commissioned works in a way that would terrify present-day monarchs, from artists great enough to accomplish every task.

Less than a hundred years later Poussin was painting nothing but small pictures.

We must give up even trying to imagine what the Titians must have been in their first freshness.

We see these admirable works with the varnishes and accidents of three hundred years, and after repairs more harmful to them than the original damage . . .

3 January

How civilization, as we understand it, dulls our natural feelings! Hector says to Ajax (*Iliad*, VII) as he leaves the fight: 'Already night draws near, and we must all obey the night which sets a limit to the work of men'.

5 January

No one can deny that with Raphaël elegance takes precedence over naturalness, and that this elegance frequently degenerates into mannerism. I fully realize that he has charm, the indefinable quality . . . It is like Rossini: *Ah! si dei mali amici.*—Expression, but elegance before all else.

If we lived to be a hundred and twenty we should end by preferring Titian above everyone. He is not a young man's painter. He is the least mannered and consequently the most varied of artists. Mannered talents have but one bias, one usage only. They are more apt to follow the impulse of the hand than to control it. Those that are less mannered must be more varied, for they continually respond to genuine emotion. The artist must express this emotion in his work; embellishments and vain displays of facility and skill do not come into his mind, on the contrary, he despises everything that does not lead to a more vital expression of his thought.

Some men have natural taste, but it increases and becomes more refined as they grow older. Young men are all for what is eccentric, artificial, and bombastic. Do not mistake for coldness what I call taste. When I speak of taste, I mean a lucidity of mind that distinguishes in a flash what is worthy of admiration from mere tinsel. In a word, good taste is maturity of mind.

Titian originated that breadth of handling that broke sharply away from the dryness of his predecessors and is the very perfection of painting. Painters who deliberately cultivate this dryness of the Primitives (a quality quite natural to schools that were still finding their way, and emerging from almost barbaric beginnings) are like grown men imitating the speech and gestures of childhood in an attempt to appear ingenuous. This breadth of Titian's is the final aim of painting, and is as far removed from the dryness of the primitives as from the monstrous abuse of touch, and the soft slickness of painters in decadent periods. The Antique has this quality. I am re-reading the expressions of admiration of some of Titian's own contemporaries. There is something incredible about their eulogies, but indeed, what must these stupendous works have been when they showed no trace of carelessness in any part and when, on the contrary, the delicacy of the touch, the harmony, the truth and inconceivable brilliance of the colours could be seen in all the beauty of their first freshness, before they had lost anything through age or unavoidable accidents! In an instructive dialogue on the painters of this period Aretino mentions with admiration a number of Titian's works and ends with the words: 'But I must restrain myself and pass lightly over my praise, because I am his friend, and because one must be absolutely blind not to see the sun'.

He says afterwards something that I might use as a foreword: 'Therefore our Titian is divine, without his equal in painting, etc.' He adds: 'Let us say in conclusion that, although there have been several excellent painters before the present day, these three, Michelangelo, Raphaël, and Titian, deserve and hold the foremost place'.

I quite realize that to call a man a colourist is considered more of a disadvantage than a recommendation by modern schools which regard the study of drawing as a virtue in itself and are willing to sacrifice everything to it. It would appear that colourists are solely concerned with the inferior, the more mundane aspects of painting, that fine drawing is infinitely finer when combined with a depressing colour-scheme, and that colour merely serves to distract attention from more sublime qualities that can very easily stand without the

support of its prestige. This might be called the *abstract* side of painting in which the contour is the prime object. Apart from colour, such a conception subordinates other essential factors of painting, for example the right distribution of effect, and even composition itself.

The school that sets out to imitate ancient frescoes in oil-painting is guilty of a strange misconception. The disadvantages of fresco technique with regard to colour, and the difficulties it presents in practice to a timid talent, demand from the painter a lightness and sureness, etc. . . .

On the other hand, oil-painting leads to a perfection of rendering which is the very opposite of this painting with great sweeping lines; everything must be in harmony, the magic of backgrounds, etc. . . .

It [fresco] is a form of drawing better suited to go with great architectural lines than to express the delicacy and richness of objects.

Thus Titian, whose rendering is so superb in spite of his broad treatment of details, concerned himself very little with fresco. And Paolo Veronese himself did very few, although he might seem better suited to the technique because of the even greater breadth of his handling and the character of the scenes he loved to paint.

I must add that in the hey-day of fresco, that is to say during the early days of the Renaissance when it was preferred to every other style, painting was not yet mistress of all the means it has since learned to command. When oil-painting had made such marvels of illusion possible in the realms of colour and effect, fresco was little practised and almost entirely abandoned.

I do not deny that in painting, the reign of the grand, the epic style, if I may call it so, began to decline at the same period, but geniuses like Michelangelo and Raphaël are rare. The technique of fresco, which they rendered illustrious and used for their sublime conceptions, was bound to perish in less daring hands. But genius can use the most varied means with equal success, and oil-painting when controlled by the brush of a Rubens, has rivalled the most celebrated frescoes in strength and breadth of handling in spite of its different technique. Even within the limits of the Venetian school where Titian held the light, that admirable master's great pictures, those of Veronese, and even of Tintoretto are examples of verve allied to power as fine as the most celebrated frescoes; they simply show another side of painting. The perfecting of the material means may have entailed some loss of simplicity, but it also revealed new sources of effect, variety, richness, etc.

These changes are such as time and new inventions inevitably bring about, and it is childish to try to swim against the stream of time and seek in the primitive masters . . .

Fresco is more liable to injury in our climate. Even in the South it is very difficult to preserve. It fades and becomes detached from the wall.

Most books on art are written by people who are not practising artists, hence so many wrong ideas and judgements arrived at capriciously, or through prejudice. I firmly believe that any man who has received a liberal education is qualified to speak sensibly of a book, but by no means of a painting or a piece of sculpture.

10 January

Long-winded passages are a major defect in any book. Walter Scott, all modern writers, etc. What would you say of a picture that contained more space and figures than were necessary?

Voltaire says in the preface to the *Temple du Goût*: 'All books are too long for me'.

Sunday, 11 January[1]

PLAN FOR A DICTIONARY OF THE FINE ARTS. A SMALL PHILOSOPHICAL DICTIONARY OF THE FINE ARTS. A SHORT DICTIONARY OF THE FINE ARTS. EXTRACT FROM A PHILO- SOPHICAL DICTIONARY OF THE FINE ARTS OF PAINTING AND SCULPTURE.

Fresco. The masters who excelled in fresco have been given great credit for the boldness of their handling, which enabled them to paint and finish in one operation, etc. But every fresco was retouched in tempera.

Technique (execution).

French. The French style in the bad sense of the word. French school of sculpture. See what I say about the tomb of M. de Brézé, 6 October 1849.

Model (the posed model). Use of the model.

Effect. Chiaroscuro.

[1] Delacroix was at last elected to the Academy on 10 January 1857, after seven previous failures. The next day he began work on his Dictionary. He was ill, deprived of voice, and unable to teach. But he felt that he had ideas and experience worth preserving, and looking back over his diaries, compiled these notes, experimenting with various titles. The dictionary was never completed.

Accessories. Details. Draperies. Palette.

Oil-painting.

Charm.

Contour. Should come last, contrary to the usual practice. Only a very experienced eye can place it accurately.

Brushwork. Fine brushwork. Reynolds used to say that a painter should draw with his brush.

Colour. Colour scheme, importance of.

Colours. (Materials) used in painting.

Drawing. From the centre or from the contour.

The Beautiful. Definitions by Poussin and Voltaire. What the latter says about Pascal.

Simplicity. Examples of simplicity, the final achievement in art, the Antique, etc.

Antique. The Parthenon (the marbles of the Parthenon) or Phidias; the modern craze for this style at the expense of other periods of the antique. Roman antique.

Academies. What Voltaire says of them, that they have never produced the greatest men.

Shadows. Accurately speaking there are no such things as shadows. There are only reflections. Importance of defining the edges of shadows. Always too strong. Note-book for 1847, June 10th. The younger the model, the lighter the shadows will be.

Half-tints. Tempera renders them more easily.

Local colour. (Importance of local colour.)

Perspective or *drawing*.

Sculpture. Modern sculpture. Difficulties of modern sculpture after the antique. French sculpture.

Master. One who teaches.

Master. One who executes with mastery.

Taste. Applicable to all the arts.

Flemish (Dutch) painters.

Method. (Does such a thing exist in drawing and painting, etc.?)

Tradition. (Continuous until the time of David.)

Masters. Exaggerated respect for the artists to whom this name has been given.

Pupils. (Difference between ancient and modern customs with regard to pupils.)

Technique. (To be demonstrated palette in hand.) How little light is thrown on this subject in the text-books. Inordinate admiration for spurious technique in the bad schools. Importance of true technique in bringing works to a high state of perfection. The most perfect technique is to be found in the works of the greatest masters: Rubens, Titian, Veronese, the Dutch painters; the special care they took in grinding colours, in primings and preparations, in drying the different layers of paint. (See panels.) The tradition entirely lost in modern painting. Hence bad results, neglect of preparations, canvases, brushes, execrable oils, carelessness on the part of the artist.

David was responsible for this carelessness, because he affected to despise material means.

Considered from a different angle David is wholly materialistic. You always find this respect for the model and lay-figure in painters of the type of Vanloo.

Varnishes. (Their deadly effects.) Sparing use made of them on old paintings. Quote passages from Oudry.

Varnishes should be a kind of protective armour to the picture, as well as a means of bringing out its brilliance.

Boucher and Vanloo. Their school. Manner, and the abandonment of all research and naturalness. Remarkable methods of execution. Relics of tradition.

Watteau. Held in great contempt under David, and later restored into honour. Admirable execution. His fantasy cannot stand comparison with the Flemish painters. Beside Ostade, Van de Velde, etc., he appears merely theatrical. He understands how to interrelate the different parts of a picture.

13 January

Daguerreotype.

Photography.

Illusion, deceptive likeness to appearances. This term, which is usually only applied to painting, would serve equally well for some forms of literature.

Foreshortening. There is always a certain amount of foreshortening, even in figures standing perfectly erect with the arms at the sides. The arts of foreshortening (or perspective) and drawing are one and

the same. Some schools have evaded them, seeming actually to believe that the problem would not arise because they did not have to deal with extreme foreshortening. In the profile of a head, the eye, fore-head, etc., are all foreshortened, and so is the rest of the head.

Frames, Mounts. Can have a good or bad influence on the effect of the picture. Lavish use of gold at the present time. Their shape in relation to the character of the picture.

Light, the point of brilliance or high light. Why is the true tone of the object always to be seen beside the high light? Because the point of light only appears on parts where the light strikes directly, i.e. on those parts which do not turn away from the light. In a rounded object such as an ovoid this does not occur because it all recedes from the light.

The more highly polished the object, the less one is able to see the true colour; it literally becomes a mirror reflecting surrounding colours.

Vagueness. In one of my little blue note-books there is a quotation from Obermann on vagueness. The church of Saint-Jacques at Dieppe[1] in the evening. Painting is vaguer than poetry in spite of the definite appearance it presents to the eyes. One of its greatest charms.

Cohesion. The effect of atmosphere and reflections that brings objects of the most incongruous colours into one whole.

First lay-in. The free play it gives to imagination.

Talent. Talent or genius, and the possession of talent without genius. For talent, see observations in one of the little blue note-books. See also note on the miniature world which a man carries about inside his head. Note-book for 11 September 1855.

Reflections. Every reflection contains green, and the edge of every shadow contains violet.

Criticism. Inadequacy of most criticism. Its comparative uselessness. Criticism follows the works of the mind as the shadow follows the body.

Proportion. The Parthenon perfect; the Madeleine bad. Grétry used to say that it was possible to make a melody one's own property by altering the time to suit the occasion, as one alters the character of a

[1] Delacroix had been greatly impressed by effects of declining light when on a visit to Dieppe, noted in the Journal of 12 September 1854, and referred to more than once.

monument, etc. When the proportions are too perfect it detracts from a sense of the *sublime*.

Backgrounds. Art of painting backgrounds.

Skies.

Atmosphere. Aerial perspective, surrounding atmosphere.

Style. On the art of writing. Great men write well. A man is never wordy when he says something that needs saying.

Sketch. The best sketch is one that sets the artist's mind at rest about the outcome of his picture.

Distance. To give objects distance one usually makes them more grey: it is a question of touch, etc. Also, use the colours flat.

Landscape.

Horses, animals. Should not be treated with the accuracy of a zoological drawing, especially when the painting or sculpture is in the grand manner. Géricault displays too much learning. Rubens and Gros are superior. Barye's lions, poor. The Antique is the model to be followed here, as in everything else.

Youthful subjects. I have said elsewhere that they have lighter shadows. In the note-book for 1852 I find the remarks which I made to Andrieu when I was painting the Venus at the Hôtel de Ville; there is something tremulous, indefinite about them like the shimmer that rises off the ground on a hot summer day. Rubens, with his very positive style, makes his women and children older than they should be.

Grey and Earth colours. Grey is the enemy of all painting. Painting nearly always looks greyer than it actually is, on account of being placed slantwise under the light. Banish all earth colours.

Proportions. In arts like literature and music it is essential to establish the chief proportions between the different parts of the work. Beethoven's pieces are too long. He wearies one by spending too much time on one idea.

Albrecht Dürer. The true painter is familiar with the whole of nature. People, animals, landscape, treated with the same perfection. Rubens belongs to this class.

Accessories. If you are careless in your treatment of accessories, you draw attention to questions of craftsmanship, impatient handling, etc.

Dramatic Art. Shakespeare's example leads us to the false belief that comedy and tragedy can be mingled in the same work. Shakespeare's art is of his own creating, etc.

The mixture of comedy and tragedy in parts of many modern French novels is unbearable.

Cohesion. Art of binding together the different parts of the picture by means of effect, colour, line, reflections, etc.

Lines. Lines of the composition. Combining and contrasting them, yet avoiding stiffness.

Touch. [i.e. the brush-stroke.] Many masters have avoided showing the touch, thinking, no doubt, that by so doing they were coming closer to nature, where there is of course no such thing. Touch is merely one of several means that contribute towards rendering a thought in painting. No doubt it is possible to paint a very beautiful picture in which touch is not apparent, but it is childish to imagine that in so doing you are getting closer to nature; you might as well construct actual reliefs in colour upon the picture, on the pretext that all bodies have projection! Every art has its accepted methods of execution, and it is a very imperfect critic who cannot read these indications of the artist's thought. The proof is that vulgar taste will always prefer the smoothest pictures where the touch is least visible, and will prefer them for this very reason. Moreover, where the work of a true master is concerned, everything depends on the beholder standing at a proper distance to look at the picture. At a certain distance touch blends into the whole effect, but gives an accent to the painting which the blending of colours alone cannot produce. On the other hand, if you look closely at a highly finished work you will still find traces of touch, accents, etc. . . . Thus it would seem that a sketch in which the touch is good can never give so much pleasure as a very highly finished picture, I mean a picture where touch is not stressed, for in many pictures touch is completely absent, although they are very far from being finished. (See under the heading *finishing.*) The FINISH (what the finish of a picture consists of).

When *touch* is judiciously handled it can be used to stress the different planes of an object more suitably. The planes are brought forward when the touch is strongly marked, and vice versa.

Even in small pictures touch is not at all unpleasant. One may well prefer a Teniers to a Mieris or a Van der Werff.

And what of those masters who accentuate contours dryly, and at the same time avoid using touch? Contour and touch are equally absent in nature. In every art we are always obliged to return to the accepted means of expression, the conventional language of the art. What is a black-and-white drawing but a convention to which the

beholder has become so accustomed that with his mind's eye he sees a complete equivalent in the translation from nature?

It is the same with engraving. Nothing special is needed in the way of eyesight to see the multitude of fine strokes crossed this way and that to produce the effect desired by the engraver. Here are touches more or less ingeniously placed, sometimes spaced out to allow full play to the paper, sometimes crowded together so as to deaden the tint and to give an appearance of continuity. Although no use is made of the magic of colour, such touches are capable of rendering, not only for the physical sense of sight but also for the eye of the spirit, the whole wealth of nature through a convention, one which has been discovered and hallowed by love of the art. They can render the bloom on a young girl's cheek, an old man's wrinkles, the softness of cloth, the transparency of water, the distance of skies and mountains. If we are tempted to argue that touch is absent in certain pictures by the great masters we should not forget that it is flattened by the effect of time.

Many painters who take the greatest possible pains to avoid showing touch on the pretext that it does not exist in nature, exaggerate contours although these also are non-existent. They seek thus to bring a quality of precision into their work, but it remains unreal to any but the dull eyes of semi-connoisseurs. They even make this clumsy method an excuse for avoiding the proper expression of relief, although it is the enemy to all illusion, for a contour too evenly and unduly emphasized neutralizes relief by bringing forward those parts which are actually furthest from the eye in every object, that is to say the outlines.

With many painters, this tendency to over-emphasize the contours is due to an excessive admiration for the old frescoes. But in this type of painting the demands of the medium force the artist to trace his contours firmly (see *Fresco*). In any case, you have to use broad sweeping lines in fresco-painting, as you do in painting on glass, where the medium requires more conventional handling than oil-painting. The artist seeks to charm, not so much by the effect of colour, as by a broad disposition of lines and their harmony with those of the surrounding architecture.

Sculpture has its convention just as *painting* and *engraving* have theirs. We are not disturbed by the coldness which would seem bound to result from the uniform colour of the materials employed, whether marble, wood, stone, ivory, etc. The absence of colour in the eyes, hair, etc., is no bar to the form of expression belonging to this art,

and neither the isolation of figures carved and modelled in the round and unrelated to any background, nor the very different convention of bas-reliefs is any disadvantage.

Touch is required even in sculpture. The disposition or exaggeration of certain hollows can increase the effect, for example, the holes which sculptors bore in parts of the hair and accessories instead of making a continuous incised line, serve to soften what would otherwise appear too hard when seen from a distance, and give lightness and suppleness—especially to curly hair, where the waves are not too conventionally arranged.

From the way in which touch is used in architectural ornamentation, we see the amount of lightness and illusion it can produce. In the modern style, such ornamentation is hollowed out to a uniform depth in order to appear irreproachably correct when seen from near at hand; seen from a distance, as it needs must be, it looks merely cold and even completely lacking in effect. But in the Antique we are amazed by the daring and aptness with which these studied expedients, these touches, properly so-called, were used to exaggerate the form in keeping with the effect, or to soften the crudeness of certain contours in order to connect the different parts of the work.

Schools. What they chiefly offer: the imitation of a fashionable technique.

Decadence. Since the height of their perfection in the sixteenth century the arts have shown a steady decline. The cause lies rather in the changes that have occurred in thought and manners than in any rarity of great artists, for these were not lacking in the seventeenth, eighteenth or nineteenth centuries. The absence of popular taste, the gradual enrichment of the middle classes, the increasingly autocratic sway of sterile criticism (whose special task appears to be the encouragement of mediocrity and the discouragement of genius) the tendency of men with good brains to study the popular sciences, the growth in material knowledge which frightens away works of the imagination—a combination of all these things has inevitably condemned the arts to be increasingly at the mercy of changing fashions and to lose all nobility and elevation.

There comes a definite point in every civilization when it is given to human intelligence to display its full power. In this brief moment, like a flash of lightning in a dark and cloudy sky, there seems scarcely any interval between the first dawning of the brilliant light and the last gleam of its splendour. The night which follows may be more or less dark, but there is no possibility of a return to the light. It would

need a rebirth of morals and manners to bring one about in the arts. This point occurs between two states of barbarism, one caused by ignorance, the other (for which there is far less hope of remedy), by the excess and abuse of knowledge.

Sea, Seascapes. As a rule, marine artists do not paint the sea well. One might apply the same criticism to them as to landscape painters. They try to display too much knowledge, they make portraits of waves, just as landscape-painters do of trees, earth, mountains, etc. They are not sufficiently concerned with the effect on the imagination which, by the multiplicity of details—too minutely described even when they are true—is distracted from the main theme, the vastness or depth which the art is capable of expressing.

Interest. The art of concentrating the interest on essential points. One must not show everything. This seems difficult in painting, where the mind is only able to imagine what the eye perceives. A poet does not find it hard to sacrifice minor issues or to pass over them in silence. The art of the painter consists in drawing attention only to what is essential, yet at the same time . . .

Classical. Which works come most naturally under this heading? Clearly those which seem destined to serve as models, as a standard in all their parts. I would readily apply the term classical to all well-ordered works which satisfy the mind, not only by an accurate, noble, or lively rendering of sentiments and objects, but also by their unity and logical arrangement; in short, by all those qualities which enhance the impression by creating a final simplicity.

By this reckoning Shakespeare would not be classical, that is to say, not a model to be imitated in his methods and system. The admirable parts of his work cannot conceal and make acceptable his tedious passages, his continual play on words and irrelevant descriptions. In any case, his art is entirely his own.

For his contemporaries, Racine was a Romantic, but for every age he is classical, that is to say, he is faultless.

Respect for tradition is nothing more than obedience to the laws of taste, without which no tradition would be lasting, etc.

The School of David has been wrongly described as the highest type of classical school in spite of the fact that it was based on imitation of the Antique. It is precisely this often quite unintelligent and narrow-minded imitation which deprives the school of the chief *characteristic* of antique art, its quality of permanence. Instead of penetrating the spirit of the Antique and connecting it with the study of

nature, etc., one sees that David echoed a period when there was a vogue for antique art.

Although the word classical implies beauties of a very lofty order, you may say that there are many very beautiful works to which it cannot properly be applied. Many people cannot separate the idea of coldness from the idea of what is classical. It is true that a large number of artists imagine themselves to be classical because they are cold, and for a similar reason there are some who believe that they have warmth because people call them Romantics. True warmth consists in the power to move the beholder.

Subject. Importance of the subject. Mythological subjects always new. Modern subjects difficult to treat on account of the absence of the nude and the wretchedness of modern costume. The originality of the painter gives novelty to his subject. Painting does not always need a subject. Géricault's painting of arms and legs.

Knowledge. On the need for an artist to have knowledge. How such knowledge can be acquired independently of ordinary practical experience.

People talk a great deal of the painter's need to be universal. We are told that he should study history, the poets, and even geography. This is all far from useless, but no more indispensable to him than to any other man who wishes to enrich his mind. The painter has enough to do to be learned in his own art, and no matter how able or diligent he may be, he can never master it completely. The cultivation of a true eye and a sure touch, the art of carrying a picture on from the first sketch to the finish and many other matters, all of the first importance, require unremitting study and a lifetime of practice. Very few artists, and here I speak of those who really deserve the name, fail to become aware as they reach the middle or decline of their careers, that time is too short to learn all they lack, or to begin over again a bad or unfinished education.

Rubens was more than fifty years old when he was sent on his mission to the king of Spain, yet he spent his free time in copying the superb Italian originals that can still be seen in Madrid. In his youth he did an enormous amount of copying. This practice of copying, entirely neglected by modern schools, was the source of his immense knowledge.

Flesh. Its predominance with the colourists. Even more essential in modern subjects which offer few opportunities for the nude.

Copies, copying. Herein lay the education of most of the great masters. They first learned their master's style as an apprentice is

taught how to make a knife, without seeking to show their own originality. Afterwards, they copied everything they could lay hands on among the works of past or contemporary artists. Painting, in the beginning, was a trade like any other. Some men became picture-makers as others became glaziers or carpenters. Painters painted shields, saddles and banners. The primitive painter was more of a craftsman than we are; he learned his trade superlatively well before he thought of letting himself go. The reverse is true today.

Preface . . . The alphabetical order adopted by the author has led him to give the title of Dictionary to this series of memoranda. Properly speaking, the title would only be suitable to a book which gave as completely as possible a detailed description of all the different processes of the arts. Would it be possible for any one man to possess the knowledge necessary for such a task? Assuredly it would not.

These are memoranda jotted down in the form that seemed most convenient to the author having regard to the distribution of his time, part of which is given to other work. Perhaps, too, he has yielded to his insuperable laziness at the thought of embarking on the composition of a book. A dictionary is not a book but an instrument, a tool for making books, or other things. When the material is thus divided into articles it can be expanded or contracted to suit the author's wishes, and sometimes to suit his laziness. In this way he can avoid the transitional passages, the labour of linking together the various sections of the work, and the problem of arranging them in proper order.

Although the author professes a great respect for books, properly so-called, he—like many other readers—has often found it difficult to give due attention to all the deductions and sequences of a book, even when it is well written and compiled. You see a picture at a glance, at least so far as the general effect and principal parts are concerned, but to a painter accustomed to receiving an impression so favourable to the understanding of the work, a book seems like some great edifice, whose appearance is often an indication of its contents. Once he has entered, he must give equal attention to the succession of rooms contained in the building that he is visiting, not forgetting those which he has left behind him, nor neglecting to look ahead from what he already knows so as to form the impression that will be his at the end of his journey.

It has been said that rivers are moving roads. One might equally well say that books are portions of moving pictures following one after the other, so that it is impossible to take them all in at once. To

grasp the thread that binds them together the reader needs almost as much intelligence as the author. If the work is one of fantasy, and addressed to the imagination alone, the labour of giving attention can become a pleasure; a well-written history produces the same effect upon the mind, for the sequence of events and their consequences form a natural chain which the mind follows without difficulty. But this can scarcely be true of a didactic work. Since the virtue of such a work lies in its usefulness, the reader must closely apply his mind in order to master all the different parts and extract their meaning. The more easily he grasps its doctrine, the more fruitful his reading will be. Can there be anything simpler, or better calculated to discourage rhetoric than this method of dividing up the material?

Although the author is himself a working artist and knows all that long practice aided by much special study can teach him about his profession, he will not dwell as much as might be expected on that side of art which seems the whole of art to many mediocre artists, but without which art could not exist. He will thus seem to trespass on the domain of the critics who doubtless believe that they do not need to practise an art in order to rise to the height of theorizing about it.

He proposes to treat of philosophical rather than of technical matters. This may seem strange in a painter writing on the arts. Many sciolists have written on the philosophy of art. It would seem as though they regarded their profound ignorance of technical matters as a special qualification, being convinced that the practising artist's concern with this vital part of every art debars him from aesthetic speculations.

It would almost seem that they imagined a profound ignorance of technical matters to be an added reason for rising to purely meta-physical considerations; in other words, preoccupation with their craft must render professional artists unfit to rise to heights forbidden to those outside the realm of aesthetics and pure speculation.

Is there any art in which execution follows more closely upon imagination? In painting and poetry *the form is one with the conception*, etc., etc. Some people read for instruction, others for amusement.

Men of genius could never agree in the task of making a dictionary; on the other hand, if each of them were to contribute a collection of his special observations, what a dictionary could be compiled of such material!

In this form repetition is inevitable. So much the better! The same things said in a different way have often . . . etc.

Friday, 23 January

NOTES FOR A DICTIONARY OF THE FINE ARTS:

Flesh colour. Flesh is its true colour only in the open air: the effect I noticed in the urchins climbing the statues of the fountain in the Place Saint-Sulpice, also in the man planing wood in the gallery opposite my window. In the latter, how strongly coloured the half-tints of the flesh were, compared with lifeless objects. (Note-book for 1856, 7 September.)

Execution. I have come across the following passage in Voltaire's *Questions Encyclopédiques,* the article on *History,* which might serve as an epigraph for a dictionary of the Fine Arts: 'The history of the arts is perhaps the most profitable of all histories when it adds a description of technical methods and practice to a knowledge of invention and progress in the arts'.

25 January

Lithography, etching, engraving of medals, impasto, scumbling, glazing.

Engraving. Engraving is a dying art, but its decline is not due solely to the technical processes that are superseding it, nor to photography, nor to lithography—the latter, an easier and more economical technique, but one which cannot replace it satisfactorily.

The earliest engravings are probably the most expressive. Men like Lucas van Leyden, Albrecht Dürer and Marcantonio were true engravers, that is to say, they sought above all to render the spirit of the painter whose work they wished to reproduce. When they reproduced their own creations, many of these men of genius quite naturally gave free rein to their feeling without concerning themselves with translating an impression foreign to the work; others, when they set themselves to render the work of another artist, carefully avoided making their own brilliance felt by displaying a skill which would only have distracted the beholder's attention from the impression of the original work.

The perfection of the tool, which is to say the material means of rendering, has begun.

Engraving is an actual translation, that is to say, it is the art of transposing an idea from one art to another, as the translator of a book written in a foreign language transposes it into his own. The engraver's foreign language, and this is where he shows his skill, does not consist merely in imitating the effects of painting through the medium of his own art which is, as it were, a different language. He

has, if I may so describe it, his own personal language that marks his work with its characteristic stamp, and even in a faithful translation allows his personal feeling to appear.

Fresco. It would be wrong to suppose that this method is more difficult than painting in oils because it needs to be done in a single operation. The fresco-painter demands less of himself materially speaking, and knows that the beholder will not require from him any of those niceties which in oil-painting can be obtained only by using an elaborate technique. He arranges that his preparatory work shall make the final stage as brief as possible. How can he possibly bring the least unity into a work that is put together like a mosaic—and even worse than that, seeing that each portion differs in tone while he is painting it—in other words, into work which he puts together by portions lying adjacent to one another, without being able to harmonize what he is working on today with what he did the day before (unless he makes an exact note of the general effect before beginning the work)? This is the function of the cartoon or drawing, in which the painter makes a preliminary study of the lines and effects, and even of the very colour he wishes to render. What is more, we must not take too literally all that they say of the marvellous facility with which the fresco-painters overcame their difficulties. There is scarcely a fragment of fresco where the painter was sufficiently satisfied with his work to dispense with retouching. There are many retouchings on the most celebrated works, and after all, what does it matter whether a work has been executed with facility or not? What does matter is that it should produce all the effect that we have a right to expect. But to the detriment of fresco, it must be admitted that such retouchings, added later in a kind of tempera, and sometimes even in oil, are apt in course of time to stand out from the rest of the work and tend to cause a lack of soundness.

As years go by fresco becomes increasingly dull and faded until after a century or more, it is hard to tell what it may have been, and what are the changes which time has produced. These changes are the reverse of those that damage oil-paintings. In oil-paintings, blackness and the effect of darkness is caused by the carbonization of the oil, but even more by the dirt of varnishes. On the other hand, fresco, which has lime as its base, is subject to appreciable attenuation of the colours because of humidity in the atmosphere or in the places where it is applied. Every painter who has worked in fresco has observed the whitish skin, like a grey film, that forms from day to day over the surface of the colours in their different jars. The effect

is more pronounced on a large surface of the same tint and ultimately appears on the painting itself, forming a veil over it as it were, and tending in course of time to throw it out of harmony; for since this attenuation occurs chiefly in colours containing a large proportion of lime, it follows that those which contain less remain more brilliant, and by their relative crudeness bring about an effect that was not the intention of the painter.

It is easy to infer from the disadvantage I have just mentioned that fresco is not suited to our climate where the air contains a great deal of humidity, but warm climates are equally injurious to it for another and perhaps more vital reason. One of the greatest drawbacks to this type of painting is the difficulty of making the preparation adhere to the wall (this passage should be preceded by a short explanation of the process of fresco). In the south, the extreme dryness is an enemy impossible to overcome. Every fresco tends in the end to become detached from the wall to which it is applied; this is its usual and almost inevitable fate.

Fresco is not suited to damp climates.

It is different from that of the ancients.

Lay-in. It is hard to say how a man like Titian, for example, set about his lay-in. The touch is so difficult to see in his work, the hand of the craftsman so completely concealed, that the steps he took to arrive at such perfection remain a mystery. There still exist underpaintings from pictures by Titian but they give different indications; some are simple grisailles, others are built up, with broad touches in almost crude tones; this is what he used to call making the bed of the picture. (Incidentally, this is what David and his school particularly lack.) But I do not think that any of these underpaintings can give us the clue to the methods which Titian used in order to bring them to that always consistent style so remarkable in his finished works, in spite of their very different starting points.

Correggio's execution presents approximately the same problem, although the somewhat *ivoried* tint of his pictures and the softness of the contrasts would seem to suggest that he nearly always began with a grisaille. Discuss Prud'hon, and the school of David. In this school, the lay-in is practically non-existent, for you cannot give this name to mere scumbles that are hardly more than slightly clearer definitions of the drawing, and are then entirely covered over by the painting.

Woe betide the artist who finishes parts of his lay-in too quickly. He needs great sureness if he is not to be tempted to alter them when the other parts are brought to the same degree of finish, etc.

Thought. (*First thoughts.*) The first main outlines with which a skilful master indicates his thought contain the germ of every characteristic that the work will ultimately possess. Raphaël, Rembrandt, Poussin (I purposely mention these painters because they excelled above all by the quality of their thought), flung a few swift lines upon the paper, not one of which appears unimportant. To the intelligent eye the life of the picture is already apparent everywhere, and nothing in the subsequent development of the theme, vague though it appears, will deviate from this conception, which is already complete although it has scarcely unfolded itself to the light.

Some talented artists in the first dawning of their thought do not show such vivacity, nor above all, such lucidity. These painters need execution in order to reach the imagination of the beholder. They usually rely a great deal on imitation. The presence of the model is necessary to their performance. They take a different road to reach one of the perfections of art.

If you remove from artists like Titian, Murillo, or Vandyke the astonishing perfection of their imitation of living nature—the execution that causes both art and artist to be forgotten—you find nothing in the idea of the subject or its arrangement but a theme that often lacks all interest for the mind, although the master-magician knew full well how to exalt it by the poetry of his colour and the marvellous skill of his brush. The astounding effect of relief, the harmonies of subtle gradations, the light and atmosphere, all the wonders of illusion will be lavished on this theme which seems so arid and uninteresting in the sketch.

Only imagine what may have been the first idea for the admirable picture of the Pilgrims at Emmaus by Paolo Veronese; nothing could be colder than the arrangement on the canvas, which is rendered even more frigid by figures who have no part to play in the scene. I refer to the family of the donor (whose presence can only be explained by the most curious convention), the little girls in their brocade dresses playing with the dog in the most conspicuous part of the picture, and the many other objects (costumes, architecture, etc.) that go against all probability.

And now consider Rembrandt's sketch[1] for this subject—a favourite one with him, and which he treated several times. He brings before our eyes the flash of light that dazzled the disciples when the divine Master became transfigured as He broke the bread. The scene is

[1] Rembrandt's etching of this subject is evidently discussed here—not his famous painting at the Louvre.

empty, no intruders witness the miraculous apparition. Profound amazement, reverence and terror are expressed in these lines flung on to the copper in response to the artist's feeling, which does not require the magic of colour to stir us.

I see Mars or Bellona in their fury in the first stroke of Rubens's brush upon his sketch; the Furies brandish their lurid torches, the gods of peace rush forward weeping to prevent them or flee at their approach, the arts, the architecture in ruins, the flames of the conflagration. In these brief outlines my mind seems to run ahead of my eye and to seize the artist's thought almost before he gives it shape. Rubens traces the first idea of his subject with his brush, as Raphaël or Poussin do with pen or pencil.

The Sublime. Effect of vagueness in the churches in Dieppe at night, on the sea; the spectacle on a lovely night.

The Terrible. The sensation of *the Terrible* and still more, that of *the Horrible*, cannot be endured for long. It is the same with *the Supernatural*. I have been reading the story of a shipwreck by Edgar Allan Poe, where the survivors remain in the most horrible and desperate situation for fifty pages on end—nothing could be more boring. Here we have an example of foreign bad taste. The English, German, and other non-Latin peoples, have no literature because they have no idea of taste or proportion. They can bore you to tears with the most interesting plots. Even *Clarissa*, which appeared at a time when there was a reflection of French manners in England, could only have been conceived on the other side of the Channel. Walter Scott and Cooper are far worse offenders, they drown one beneath a flood of detail that takes away all the interest.

The Terrible is a natural gift in the arts, like charm. Artists who attempt to express this sensation without having a natural bent for it are even more absurd than those who try to assume a levity not in their natures. I have spoken elsewhere of the figure which Pigalle conceived to represent Death on the tomb of Maréchal de Saxe. That was surely the right place for *the Terrible*. Only Shakespeare knew how to make ghosts speak.

Michelangelo. Antique masks, etc., Géricault.

The Terrible is like *the Sublime*, it must never be abused.

Curiously enough, *the Sublime* is generally achieved through want of proportion.

In one of the note-books (9 May 1853) I mention that the Antin Oak looks unimpressive from a distance because its shape is symmetrical and because the mass of foliage is in proportion to the trunk and

the spread of the branches, but when I stood beneath the branches and could see only portions of the tree unrelated to the whole, I experienced a sensation of *the Sublime*.

Mozart and Racine seem natural; they are less overwhelming than Shakespeare and Michelangelo.

Unity. From Obermann: 'Unity, without which no work can be beautiful, etc.' To which I add that only man produces works without unity. Nature, on the contrary, etc. Nature creates unity even in the parts of a whole.

The Model. Slavish attachment to the model in David. I contrast him with Géricault who also imitated, but with more freedom, and brought greater intensity to his imitation.

Preparation. There is every indication that the preparations of the early Flemish schools were uniform. Rubens always conformed to them, and in this respect he followed his masters' methods absolutely. The groundwork was light, and because these schools almost invariably used wooden panels, it was also smooth. Soft, round brushes were used in preference to stiff brushes until the last years of these schools. (Explain the difference.)

Effect on the imagination. What Byron says: 'Campbell's poems smell too strong of the lamp. He is never satisfied with what he has done; he spoils his finest efforts by trying to finish them too much; all that was brilliant in the first attempt is lost. It is the same with poetry as with pictures. They must not be too finished; the great art is the effect, no matter how it is produced.'

'*In painting, and especially in portraiture,*' writes Mme Cavé in her delightful book, '*mind speaks to mind and not knowledge to knowledge.*' This observation, which may be more profound than she knows herself, is an indictment of pedantry in execution. I have said to myself a hundred times that materially speaking, painting is nothing but a bridge set up between the mind of the artist and that of the beholder. Cold accuracy is not art; skilful artifice, when it is pleasing and expressive, is art itself. The so-called conscientiousness of the great majority of painters is nothing but perfection laboriously applied to the art of being boring.

One must not forget that language (here I mean language in all the arts) is always imperfect. Great writers supplement this deficiency by giving a characteristic twist to everyday speech. Experience and above all, confidence in his powers, gives a talented artist the assurance of having done all that can be done. Only fools and weaklings torment themselves in a vain attempt to achieve the impossible. The

superior man knows when to stop; he knows when he has done all that is possible.

Without daring, without extreme daring even, there is no beauty. Lord Byron praised gin as his Hippocrene, because it made him bold. We must therefore be almost beyond ourselves if we are to achieve all that we are capable of doing. A strange phenomenon this, and not very elevating either to our natures or to our opinion of all those clever people who have discovered the key to their talent in the bottle.

Happy are they who, like Voltaire and other great men, can reach a state of inspiration on fresh water and plain living.

Church Music. Lord Byron said that he intended to write a poem on Job. 'But,' said he, 'I found it too sublime; there is no poetry to compare with it.' I would say the same about simple church music, etc.

Cohesion. When we look at the objects around us, whether in a landscape or an interior, we notice that between each of them there is a kind of connexion produced by the surrounding envelope of air and the various reflections which, as it were, cause each separate object to be part of a general harmony. This is a charm which painting seems unable to dispense with, and yet the majority of painters and even some of the great masters paid little attention to it. By far the greater number seem not even to have observed in nature this essential harmony that establishes in a painting a unity which lines alone would be unable to create, in spite of the most skilful arrangement. It seems almost superfluous to add that painters who were not primarily interested in effect and colour disregarded it completely. What is even more surprising is that it was neglected by many of the great colourists, which could only have been a result of their lack of sensitivity to this quality.

Michelangelo. You may say that if Michelangelo's style has been one of the causes of the general decline in taste, the study of his art has exalted each generation of painters in turn and lifted them beyond themselves. Rubens imitated him, but in the way that only he could imitate. He was infused and permeated with sublime works, and felt drawn to them by what he had within his own nature. What a difference between this kind of imitation and that of the Carracci!

'To be *successful* in an art, one must cultivate it throughout one's lifetime.' (Voltaire's discourse on tragedy, preceding his Brutus.) After living in England for a long time he had grown unaccustomed to his own language; it took him some time to get into the way of it again; so necessary is it to keep in practice. And this was Voltaire!

All my notes, excepting those which relate to the Dictionary, must be arranged so as to form a consecutive work, by placing passages of the same kind next one another and linking them with scarcely perceptible transitions. Therefore none of the notes must be detached and published separately. For instance, I must put together all my notes on the spectacle of nature, etc.

Dialogues would allow me great freedom with the use of the first person, smooth transitions, contradictions, etc. Extracts from a correspondence would serve the same purpose. Letters from two friends, one sad, the other gay; the two sides of life. Letters and critical observations.

Homer. Rubens is more Homeric than some of the ancients. He had a similar genius; the spirit is everything. There is nothing Homeric about Ingres except his pretensions. He makes tracings of outward appearances. Rubens is a Homer, painting the spirit and indifferent to its dress, or rather, dressing it in the garments of his own period. He is more Homeric than Virgil because it is in his nature to be so.

Polished objects. They seem by their very nature to produce the effect most suitable for their rendering because their lights are much more brilliant and their dark parts much darker than in objects with a dull surface. They are true mirrors. In places where strong light does not strike them they reflect the dark parts with extreme intensity. I have said elsewhere that the actual local colour of the object is always to be found beside the most brilliant point; this applies to glossy materials and the skins of animals as well as to polished metal.

It is sometimes almost impossible to tell what colour the object actually is, in ovoids or spheres, for instance, where all the planes turn away from the light and only a single point faces the light and receives the high light.

Execution. Good, or rather true execution is one that fulfils the thought by means of an apparently materialistic technical skill without which it would be incomplete; this is the case with great poetry. Great ideas can be expressed prosaically. David's execution is cold; it would be enough to chill loftier and more vital ideas than any he possessed. True execution, on the other hand, redeems the idea from any element of feebleness or commonplace.

Imagination. This is the paramount quality for an artist, and no less essential for an art lover. I cannot conceive a man buying pictures and being devoid of imagination; his vanity would need to be insensate. However, strange as it may seem, the great majority of people are devoid of imagination. Not only do they lack the keen, penetrating

imagination which would allow them to see objects in a vivid way—which would lead them, as it were, to the very root of things—but they are equally incapable of any clear understanding of works in which imagination predominates.

Advocates of that truism of the sensualists, *nil est in intellectu quod non fuerit prius in sensu*, may pretend that imagination is nothing more than a form of memory, but they are bound to acknowledge that although all men have sensation and memory, very few possess the imagination which they claim to be composed of those two elements. With an artist, imagination does not merely consist in conjuring up a vision of various objects, it combines them for the purpose which he has in mind; it makes pictures, images that he arranges as he pleases. Where then is the acquired experience that can develop this faculty of composition?

Impasto. The real aim of execution lies in getting the utmost effect from the particular qualities offered by the material means employed. Every process has its own advantages and drawbacks. Speaking only of execution in oil-painting, which is the most perfect technique and the most abundant in resources, it is important to study how it has been handled by the various schools and to consider what advantages may be derived from their different styles. But before going into the details of any one of these styles it is necessary to grasp it *a priori.*

The advantages of oil-painting, which the great masters brought to perfection in different ways, are: (1) Dark tones retain the same intensity as at the time of execution which is not the case with tempera, fresco or water-colour, that is to say, it is not the case in any form of painting where water is the only means of dissolving the colours, for when the water evaporates, it leaves them far weaker in tone; oil also has the advantage of keeping the colours moist so that they can be blended. (2) The option of using either a thin rub-in or impasto, as seems most expedient, which immensely improves the rendering of opaque or transparent passages. (3) The possibility of going back over the painting at your pleasure, not only without injury to it but on the contrary, increasing the strength of the effect or diminishing the crudeness of the tones. (4) The facility which the artist gains in handling his brush, etc., because the colours remain fluid for a considerable length of time.

Many drawbacks, such as the effect of time on varnishes and the need to wait before retouching.

Here it is necessary to consider the contrast between impasto and glazing, so that this contrast may be felt even after successive

varnishings have produced their effect, which is always to make the picture smooth, etc.

Dust. Dust colour is the most universal half-tint. It is, in fact, a combination of every tone. The tones of the palette mixed together always give a dust-tone of greater or less intensity.

Interest, interesting. To bring interest into a work must be the chief aim of every artist; he can only achieve it by uniting many different qualities. An interesting subject cannot succeed in interesting the beholder when it is clumsily handled. On the other hand, subjects which seem least interesting may catch the interest and charm the beholder when treated by experienced hands and graced by the breath of inspiration.

A kind of instinct teaches the superior artist to find where the chief interest of his composition should lie. The art of grouping, the art of ordering the lighting appropriately, or of colouring brilliantly or soberly, the art of sacrificing or of multiplying the possibilities of the effect, and a whole host of other qualities belonging to the great artist are needed to awaken interest, and all contribute to it in some degree. The exact truth of the forms, or their exaggeration, the profusion or moderation of details, the uniting or dispersal of the masses, in a word all the resources of art are like a keyboard under the hand of the artist, from some notes of which he draws chosen sounds whilst others he allows to lie dormant.

The main source of interest comes from the soul of the artist, and flows into the soul of the beholder in an irresistible way. Not that every interesting work strikes all its beholders with equal force merely because each of them is supposed to possess a soul; only people gifted with feeling and imagination are capable of being moved. These two faculties are equally indispensable to the beholder and the artist, although in different proportions.

Mannered talents cannot awaken true interest; they can excite curiosity, flatter a momentary whim, or appeal to passions that have nothing in common with art. But since the principal characteristic of mannerism is a lack of sincerity both in feeling and conception, these mannered talents cannot touch our imagination, which is simply a kind of mirror where nature is reflected as she really is; thus giving us, through a powerful form of memory, the sight of things which the soul alone enjoys.

The great masters are almost the only artists who excite interest, but they do so by different means according to the particular bent of their genius. It would be absurd to expect from a painter like Rubens

the form of interest which Leonardo or Raphaël knows how to arouse by such details as hands and heads, in which correctness and expression are united. It is equally useless to require from Leonardo and Raphaël the great combined effects, the animation and breadth that commend themselves in the works of Rubens, that most brilliant of painters. Rembrandt's 'Tobias' is not to be recommended for the same qualities as certain similar pictures by Titian, in which the perfection of the details in no way spoils the beauty of the general effect, but which do not convey to our imagination the emotion—the actual spiritual uneasiness, which is inspired by the naïvety and nervous energy of the figures, and by the strange profundity of certain effects in the work of Rembrandt.

David maintained that merit consisted in making a faithful copy of the model but improving it with the help of fragments of the antique to redeem its vulgarity. Correggio, on the other hand, took only a glance at nature so as to avoid falling into enormities. All his charm, everything in him that tells of power and the force of genius comes from his imagination, and raises an echo in imaginations capable of understanding him.

The schools, one after another, see perfection in a single virtue. They condemn everything that is condemned by the fashionable masters. Today drawing is the fashion, and furthermore, only one kind of drawing. The drawing of David, as shown by the school which he founded, is no longer true drawing.

Eclecticism in the Arts. This pedantic word, which philosophers of the present century have introduced into the language, is not ill-suited to the moderate aspirations of certain schools. One might say that *eclecticism* is the particular banner of the French in the arts of drawing and music. The Germans and Italians had clear-cut qualities in their arts, some of which were mutually antipathetic; the French, in every age, seem to have attempted to reconcile such extremes by softening what appeared discordant. Thus their works are less striking. They are addressed more to the intellect than to the emotions. In music and painting they are inferior to all other schools through their practice of injecting into their work, in small doses, a collection of qualities which other schools find incompatible, but which the French temperament contrives to harmonize.

Sensitivity. Sympathetic feeling works miracles. Through it, an engraving or a lithograph produces the effect of the actual painting on our imaginations. In Charlet's 'Grenadier' I can feel the tone through his pencil touch; in a word, I want nothing more than what

I see. It almost seems to me that colouring, that is to say painting, would disturb me and spoil the effect of the whole.

It is the intelligent touch that summarizes; and offers an equivalent of feeling.

Originality. Does it consist in being the first to invent certain new ideas and striking effects?

Schools. Founding a school. Some mediocrities, or at least some artists of minor importance, have been able to *found a school*, whereas other very great men have never had this privilege, if such it be. Eighty years ago men like Vanloo were producing prize-winners for the Prix de Rome, and their style had absolute sway. Then there arose a genius who had imbibed their principles, and was to become famous by entirely different ones. One may say that David renewed the art of painting, but the credit was not due solely to his originality. Several attempts had already been made, by Mengs amongst others. The discovery of the paintings at Herculaneum had inspired many artists to admire and imitate the Antique. David, mentally more vigorous than inventive, more a sectarian than an artist, and full of the new ideas in politics that were breaking out everywhere and which led to an exclusive admiration for the ancients especially in political matters, summarized them in the arts, and . . . The nerveless, artificial style of the followers of Vanloo had had its day. It was nothing but mannerism, utterly empty of ideas, etc.

Coming to maturity a hundred-and-sixty years earlier, when the school of Lebrun was at the height of its power, a genius of far greater originality than David was not so fortunate. All the genius of Puget, all his verve, all the strength that had its source in inspiration from nature was unable to collect a following in competition with men like Coysevox and Coustou and the rest of that school, which though very eminent in itself, was already tinged with mannerism and the academic spirit.

Sophistication. On sophistication in periods of decadence.

On Execution and its importance. The tragedy of the pictures by David and his school is that they lack that precious quality without which all the rest is imperfect and almost useless. One can admire fine drawing in them, and sometimes, a well-ordered composition as in Gérard, grandeur, fire and pathos as in Girodet, or true aesthetic taste as in David himself—for example the 'Sabine Women'; but the charm which the craftsman's hand can add to all these merits is absent from their works and therefore they must be ranked lower than those by the great, acknowledged masters. The only painter of this period

XV. COURBET: THE PAINTER'S STUDIO

XVI. 'HOMMAGE À DELACROIX'

with an execution equal to his conception was Prud'hon, who charms with the sort of painting some people call material, but which, whatever they may say, is wholly a matter of feeling—as much a question of the ideal as the conception itself, which it should necessarily complete. It is as though the skin were lacking in this kind of painting.

The Modern Style (in literature). The modern style is bad. Everywhere there is over-indulgence in sentimentality and the picturesque. When an admiral writes of his naval campaigns he does so in the style of a novelist, almost of a humanitarian. Everything is long-drawn-out and poetical. Writers try to appear moved and full of conviction, and they wrongly believe that their constant dithyrambs will win over the reader and give him a great opinion of them as authors and especially of their goodness of heart. Memoirs and even histories are odious. Philosophy and the sciences, everything written on these subjects is tinged with this false colouring, this borrowed style. I am sorry for our contemporaries; posterity will not look to the works they leave behind them for models of sincerity, and especially not their self-portraits. Even Thiers's admirable history has not escaped the imprint of this maudlin style, always ready to pause for a wail over the ambitions of a conqueror, the inclemency of the weather, or the sufferings of humanity. It is all sermons or elegies. Nothing masculine . . . , which gives it the effect of being a mere convention, because it is either all out of place or else too diffuse, and because everything is pedantically declaimed instead of being told in a simple way.

Execution. We have already said that good execution is of the greatest importance. We might almost go so far as to say that if not everything, it is the one means of bringing the rest to light and giving it full value. Schools in decadent periods have considered it mainly a question of dexterity; a certain rather off-hand manner of expression that is sometimes called frankness, fine brushwork, etc.

It is certain that after the great masters of the sixteenth century there was a change in the material execution of painting. The painting now current in the studios, a direct painting which must be finished touch by touch and cannot easily be gone over a second time, has replaced executions which were purely a matter of feeling and were carried out by each master in his own way, or rather in the way that his instinct suggested, following the bent of his genius.

You certainly cannot paint a Titian with the methods that Rubens used. Stippling, etc. The Raphaël which I saw in the rue Grange-Batalière was done with small brush strokes . . . A painter of the school

of Carracci would have thought it beneath his dignity to paint with such minuteness. How much more so men of later and more corrupt schools like that of Vanloo.

Colour. On its superiority or, if you prefer, its exquisiteness as regards the effect on the imagination. On colour in Lesueur.

Imitation. The name Arts of Imitation is used particularly to describe painting and sculpture; the other arts, like music and poetry, do not imitate nature directly, although their object is to appeal to the imagination through the emotions.

On the Antique and Dutch schools. It may seem surprising to find included under the same heading productions that are so different in appearance; different in time they certainly are, but less different than is generally supposed in the style and spirit in which they were conceived.

Antique. Where does that special quality come from, that perfect taste only to be found in antique art? Perhaps from the fact that we compare it with all that has been done in supposed imitation of it.

But indeed, what can be compared with the Antique among the most perfect things that have been produced in the various styles?

I cannot find anything lacking in Virgil or Horace, but I know exactly what I should like to find in our own great writers, and also what I should prefer not to find. Perhaps, because I belong to the same community of civilization—if I dare to call it so—as these authors, I have a more thorough knowledge of them and above all, I understand them better and realize the contrast between what they did and what they wished to achieve. A Roman might have shown me blemishes and faults in Horace and Virgil which I am unable to perceive.

But above all, it is in everything that remains to us of the plastic arts of antiquity that we find this quality of taste and judgement carried to the height of perfection. In literature we stand comparison with the ancients; in the arts, never!

Titian is one of those who approach most nearly to the spirit of the Antique. He belongs to the same family as the Dutch painters, and in this sense is akin to the Antique. He understands how to work from nature, that is why we always recognize in his pictures a type of the True, therefore one that is not fugitive like that which comes from an artist's imagination, and of which we tire more quickly because of the imitators of his style.

One might say that there is a seed of madness in all the others. Titian alone has good sense, is master of himself, of his execution,

and of his facility, which he never allows to dominate him and which he never parades.

We imagine that we imitate the Antique by taking it literally, making caricatures of the draperies, etc.

Titian and the Flemish painters catch the spirit of the Antique and are not mere imitators of its outward forms.

The Antique does not sacrifice to charm, like Raphaël and Correggio and the majority of the painters of the Renaissance. It has no affectation either of strength or of the unexpected, as in Michelangelo. It never sinks to the poor quality of parts of Puget's work, nor to his all-too-natural naturalness, etc.

In the work of all these painters certain elements have become antiquated; there is nothing of this in the Antique. With the moderns there is always excess; in antique art, always the same moderation, and the same sustained strength.

Those who see Titian simply as the greatest of the colourists make a grave error. He is that certainly, but at the same time he is the first of draughtsmen (if by drawing, we understand drawing from nature, and not that in which the artist's imagination plays a greater part than imitation). Not that Titian's imagination was in any way servile; to perceive this we have only to compare his drawing with that of painters who set themselves to render nature exactly, for example in the schools of Bologna and Spain.

One may say that with the Italians style is of paramount importance. But I do not mean to imply that all Italian painters have a grand or even an agreeable style, I mean that they are all inclined to exuberance in what one might call *their style*, whether one likes it or not. By this I mean that Michelangelo makes as much abuse of his style as Bernini and Pietro da Cortona do of theirs, apart from the loftiness or vulgarity of their respective styles. In short, their personal manner, what they believe they are adding, or do unconsciously add, to nature, dismisses all idea of imitation but spoils the truth and naïvety of the expression. This precious naïvety is scarcely ever to be found in the Italians after the time of Titian, who himself managed to preserve it in the midst of his contemporaries' surrender to the temptation of mannerism, which may aim more or less at the sublime, but very soon becomes ridiculous in the hands of imitators.

Here another painter should be mentioned and placed on a level with Titian if one regards truth united to the ideal as the paramount quality: I mean Paolo Veronese. He is freer than Titian, but less finished. They both have the tranquillity, the calm temperament

that itself indicates a master mind. Paolo would seem to be the more learned of the two, less bound to the model and therefore more independent in his execution. On the other hand, Titian's scrupulousness in no way tends to make him cold: I refer especially to coldness in the execution, which itself is sufficient to give warmth to a picture, for both artists are less concerned with expression than most of the great painters. That rarest of qualities, that animated composure, if I may call it so, no doubt excludes emotional effects. Here again are characteristics which they share in common with the Antique, where the external plastic form takes precedence over expression. The introduction of Christianity is usually given as an explanation of the strange revolution that occurred in the arts during the Middle Ages, and brought about the predominance of expression. Christian mysticism, brooding over everything, and the custom for artists to paint almost exclusively religious subjects, whose chief appeal was to the soul, undoubtedly favoured this general tendency towards expressiveness. The inevitable result in modern times has been a greater degree of imperfection in the plastic qualities. The ancients do not display any of the exaggerations or the inaccuracies of such men as Michelangelo, Puget, or Correggio, but, on the other hand, the lovely calmness of their beautiful countenances does nothing to awaken that part of the imagination which the moderns excite in so many ways. The sombre turbulence of Michelangelo, that indefinable quality of mystery and grandeur that lends passion to the least of his works, Correggio's gentle, pervasive grace and irresistible charm, the profound expressiveness and the fire of Rubens, the vagueness, the magic, and the expressive drawing of Rembrandt—all this belongs to us, and the ancients had no inkling of it.

Rossini is a striking example of the passion for pleasing—for exaggerated elegance. Consequently, his school is unendurable!

4 February

Could be used as part of the preface to the Dictionary.

I should like to contribute towards the teaching of a better way to read great books. They say that in Athens many more people were judges of the Fine Arts than in our modern society. The excellent taste of the works of antiquity confirms this opinion.

In Rome, as in Athens, the same man would be lawyer, soldier, scholar, inspector of public games, senator and magistrate, and his

education would be equal to all these activities. Such a man could scarcely fail to be a good judge in any branch of learning, at the stage it had reached at the time. Whereas with us, a lawyer is simply a lawyer and is usually unacquainted with subjects outside the range of his profession. It is no use asking a colonel of cavalry, for example, to judge a picture; at best he will be a good judge of horseflesh and will greatly deplore the fact that Rubens's horses are not like the English and Limousin animals, which he sees every day with his regiment, or on the racecourse.

As a result, the artist who worked for such an enlightened public was ashamed to descend to ways of making an effect which the public taste would have disapproved. The sense of taste perished among the ancients, not as fashion changes—a thing that is always happening with us, and for no valid reason—but along with their customs and institutions when it became imperative to please Barbarian conquerors (such as the Romans were in relation to the Greeks). Above all, taste became corrupted when public virtue disappeared and citizens lost the urge that moves men to high endeavours. I do not mean by this the virtue common to all citizens and inclining them to do what is right, but only that simple respect for morality that drives vice into hiding. It is difficult to imagine men like Phidias and Apelles under the reign of the appalling tyrants of the Late Empire and amidst the spiritual degradation that follows when the arts become the willing tools of infamy. Beauty can never flourish, and still less can truth, under a government of spies and rascals. If these inestimable treasures are still anywhere to be found, it is in the noble protests of such writers as Seneca and Tacitus. Lighter charms and gentle descriptive passages give place to indignation and stoical resignation.

Is there then a necessary connexion between the *good* and the *beautiful*? Can a debased society enjoy lofty things of any kind? Probably not; moreover, in our present state of society, with our hide-bound customs and mean little pleasures, the beautiful can only occur by accident, and this accident never assumes sufficient importance to change public taste and bring back the majority to an appreciation of beauty. Afterwards comes the night and barbarism.

It would seem that there are undoubtedly some periods when the beautiful seems to flourish more naturally than in others, and nations which seem specially gifted with certain qualities of the mind, just as certain countries and climates encourage the growth of the beautiful.

25 February

Casanova says somewhere, 'The comforts of peace are far better than the charms of love, but no one thinks so when he is in love'.

Thursday, 5 March

As I was having luncheon today, two pictures ascribed to Géricault were brought me to give an opinion on. The small one is a very indifferent copy; costumes of Roman beggars. The other (a No. 12 canvas, approximately) is an amphitheatre subject; arms, feet, etc., also dead bodies; it is admirable in strength and relief, with those careless lapses so characteristic of the painter's style, and which further increase its value.

When I set it beside the portrait by David, it took on even greater emphasis. You can see in it everything that David has always lacked, that power of the picturesque, that vigorousness and daring, which is to painting what the *vis comica* is to the art of the theatre. David's painting is all too even, the head is no more interesting than the draperies or the seat.

His complete subjection to the posed model is one of the causes of this coldness, but it would be more reasonable to think that the coldness lay in his own nature. It was impossible for him to discover anything beyond what was offered to him through the imperfect medium of the little piece of nature before his eyes, and he seems to have been satisfied when he had imitated it well. His audacity consisted wholly in placing beside it fragments cast from the Antique, such as a foot, or a leg, and in bringing his living model as near as possible to the ready-made ideal of beauty displayed by the plaster cast.

The fragment by Géricault is truly sublime; it more than ever proves that *there is neither serpent nor horrible monster, etc.*, and is the best possible argument in favour of the Beautiful, as it should be understood. The lapses do not in any way mar the beauty of this piece of painting. Beside the foot—which is very precisely stated and has more resemblance to nature, except that it is coloured by the artist's personal ideal—there is a hand in which the planes are soft, almost as though they were painted from imagination, in the style of the figures which he used to paint in the studio; yet this hand does not spoil the rest; the power of the style uplifts it to the level of the other parts. This kind of excellence bears the closest relationship to that of Michelangelo, in whose work inaccuracies did no harm whatsoever.

I have greatly enjoyed reading in my note-book for January 1852 the description of those tapestries by Rubens which I saw at Mousseaux, where they were being sold by order of the executors of Louis-Philippe. I must refer to these notes whenever I want to write about Rubens, or to give myself a real enthusiasm for painting. I still have a vivid recollection of those admirable works. While I was reading my description of them, I had the idea of doing all the subjects from memory (a series of this kind with a different design would be a fine theme). Devéria simply must find me the engravings.

Here I must put down something which should be entered under one day of last month, when I was still very weak and did not feel much inclined to write in this note-book: I mean the sad impression of Thiers's character which I received from something that M.C.B. said when he came to see me. He described him as the most selfish and unfeeling of men, grasping, incapable of affection, in fact the reverse of what I had believed him to be. Were I convinced that all this is true it would be one of the greatest disappointments of my life. Gratitude in the first place, and the affection I have always felt for him make me unwilling to believe it. I know that although he always receives me kindly, he never seeks me out, and the petty resentment he showed when I opposed him (as it was my duty to do) over his wild scheme for restoring the Louvre—a scheme which was partly executed in accordance with his absurd ideas—somewhat spoiled my idea of him at the time of that adventure. However, since that time, I have always found him as he used to be and with the same charm of manner that makes him so attractive.

Monday, 16 March

In an article on Virgil (too long, as usual) Thierry of the *Moniteur*, after discussing the modern preference for unsophisticated works, primitives, etc., such as Homer, goes on to ask whether Virgil coming thirty or forty centuries after would have been able to produce an *Iliad*. He adds:

'Even though the ancients will always be our masters, do not let us despise those of their disciples who vainly strive to equal them. It is a great advantage to be first; you take the best without even having to select; you can be simple without knowing what simplicity is; you are concise, because there is no need to fill gaps or to surpass someone else's standard; you stop in time, because no rivalry tempts you to go too far . . . Do we not often mistake the absence of art for its

culmination? If the development of art merely leads to the production of artists of ever-diminishing stature, I may be forgiven for feeling deep compassion for periods which cannot do without its elaborate labours. I ask that we be not too much made the dupes of one great word, simplicity, and that we avoid taking simplicity for our watchword at periods when this is no longer possible.'

This is the theme of all the modern pedants. Chenavard sees nothing beyond what has already been accomplished. Delaroche used to bristle when anyone mentioned Roman antiquities; Phidias was first with him, as Michelangelo is with Chenavard. And yet, Chenavard includes Rubens in his famous heptarchy. He admires Rubens and uses him to crush the unfortunate attempts of our own contemporaries. Yet Rubens appeared in a period of comparative decadence; how can they place him on a level with Michelangelo in an order of this kind? He was great in a different way.

This much-vaunted simplicity which Thierry discusses often results, in literature, from the unsophisticated language of primitive poetry; in other words, it is less a matter of the actual thought than of the way in which the thought is clothed. Many people, especially now, when they believe that a language can be invigorated and renewed at will, as a man is shaved when his beard grows too long, prefer Corneille to Racine merely because his language is less polished. The same thing holds good for Michelangelo and Rubens. The technique of fresco, which was Michelangelo's medium, forces the painter into greater simplicity of means and effect; the result, even irrespective of the artist's talent, and simply because of the limitations of the medium itself, is a certain grandeur and the necessity to forgo details. Rubens, using a different process, discovers different effects which satisfy us for other reasons. As Montesquieu very truly remarks: *Two commonplace beauties destroy one another, two great beauties enhance each other.* A masterpiece by Rubens will lose nothing by being hung beside a masterpiece by Michelangelo. If, however, you study each work separately, you will probably find yourself entirely absorbed by the one you are looking at, in so far as you are capable of being impressed. A sensitive nature is easily dominated and carried away by the *beautiful*; you will be wholly possessed by the one which is before your eyes at the time.

You must use methods familiar to the times in which you live, otherwise you will not be understood, and you will not live. This language of another age, which you desire to use in speaking to men of your own times, will always be an artificial medium, and those

who come after you, as they compare this borrowed manner of yours with works of the period when it was the only manner known and understood, and therefore used with mastery, will condemn you as inferior, a sentence which you will already have pronounced upon yourself.

Tuesday, 17 March

Yesterday, I went out with Jenny for the first time.[1] The sun was shining. I gave up the idea of walking towards the Place d'Europe as the wind was coming from that direction. Instead, I went down the hill and came home through the streets. I was tired, but the walk did me good.

Wednesday, 18 March

It is now three days since I began going out and I feel much better for it. Yesterday I drove with Jenny to the Tuileries. We went from the swing-bridge as far as the gate of the rue de Rivoli.

I must try to remember the ideas suggested to me by the contrast between the statues of the 'Tiber' and the 'Nile', copies after the Antique, and the groups of flowers and nymphs of the time of Louis XIV—the disconnectedness of the latter, and the majestic unity of the former. I notice everywhere the same contrast between what the Antique was, and what the modern is.

Thursday, 26 March

Called on Haro to discuss the possibility of making a studio at his place. We talked of it a week ago, but I think he is not very enthusiastic about the idea, and only wishes to be obliging. He spoke of the great expense involved; it is not a practical proposition.

When I was on my way to Haro's house, the sight of some young men in the street caused me to make several reflections very uncharacteristic of most men when they are growing old. Youth, which seems to be the happiest time of our lives, does not excite my envy in the slightest degree; at most, I envy the bodily strength that makes it possible to tackle great works but I do not envy at all the pleasures that accompany it. What I should like—and of course, this is just as impossible as to grow young again—would be to stay at my present age, and to have long enjoyment of the advantages it gives to a mind

[1] The first time since his serious illness began in December 1856.

which has grown, I will not say disillusioned, but genuinely reasonable. But this is no more possible than the other.

Champrosay, 9 May

Left for Champrosay at a quarter-past one. Torrents of rain as we arrived, I was soaked, and so was Jenny. We stopped for a few moments to look at our old garden, which has been opened up and quite ruined by all that Candas is doing. I saw the little spring; they only use it now for washing clothes; it is a mess of dirty water and soapsuds. The cherry trees I planted have grown enormous, and you can still see traces of the paths I laid down. It made me feel more sentimental than sad, as I remembered all the years I spent there. I still love this part of the country. I get very fond of the places where I live; I feel about them as though they were living creatures.

11 May

Went for a long walk into the country this morning, I could not bear to tear myself away from the green grass and the sunshine.

After I came back I did a great deal of work on the article on the Beautiful, and continued until it was time for dinner.

In the evening, I went for a stroll in the garden, and out into the country.

Felt tired and depressed when I went to bed.

12 May

One should always read with a pen in one's hand. There's never a day passes that I do not find something worth making a note of, even in the worst newspaper.

I am greatly enjoying being in this delightful place. It is an exquisite pleasure to open my window in the morning.

14 May

The real primitives are the men of original talent. If every man of talent bears within himself a special type, a new vision, what is the use of a school that continually refers back to the types of antiquity, since these types were themselves simply the expression of individual natures, such as appear in every period.

Rossini said to B . . . : 'I catch glimpses of something different, which I shall never accomplish. If I were to find a young man of

genius I could set him on an entirely new path, and poor Rossini would be left behind.'

15 May

At Champrosay, in the grassy avenue.

You might compare the first draft of a writer's or painter's work with platoon firing, when a couple of hundred musket-shots are let off in the heat of battle and only two or three find their mark; sometimes two or three hundred shots are fired at the same moment and not one strikes the enemy.

Sometimes similar geniuses appear in different periods. The intrinsic character does not differ in such men of talent, only the art forms of the times in which they live give them variety. Rubens, etc.

It was not the climate that produced Homer and Praxiteles. You might search the length and breadth of Greece and the islands today without discovering a poet or a sculptor. On the other hand, in Flanders, and at a period nearer our own times, nature gave birth to the Homer of painting.

There are privileged periods; there are also climates where man has fewer needs, etc.; but such influences are not enough.

Manners and customs have a more effective influence than climate. No doubt that among peoples to whom nature is kindly . . . but in the absence of certain moral values, etc. A nation must have self-respect to be nice in matters of taste and to curb its poets and orators. Nations who manage their politics in terms of blows and pistol-shots have no more literature than those who used to delight in gladiatorial combat.

16 May

Jenny has gone to Paris. I am sitting at the place where the old chestnut tree was uprooted near the Hermitage.

Dear Chopin used to get very indignant with the school that ascribed a large part of the charm of music to sheer quality of tone. He spoke as a pianist.

Voltaire defines the *beautiful* as that which should delight the mind and senses. A musical theme can speak to the imagination on an instrument that has only one means of charming the ear, but a combination of instruments possessing different tone qualities adds force to the impression. Otherwise what would be the point of using a flute on some occasions and a trumpet on others? A flute suggests

lovers' meetings, a trumpet, the triumphal return of a warrior, and so on. And even with the piano itself, why use muffled or brilliant tones at different times, if not to intensify the expression of the composer's idea? Where instrumental colour replaces the idea it is bad, and yet you must admit that independently of the expression, certain contrasts of sound do give pleasure to the senses.

It is the same with painting; a simple outline is less expressive and gives less pleasure than a drawing in which the lights and shadows are rendered. And the latter is less expressive than a picture, provided that the picture is brought to the degree of harmony where drawing and colour combine to form a single effect. Do not forget the painter of ancient times who used to have a trumpet fanfare sounded behind an arras when he was showing the portrait of a warrior.

Monday, 18 May

I have begun to paint at last, after more than four and a half months of enforced idleness. I began with the 'Saint John and Herodias', which I am doing for Robert, at Sèvres. Worked at it all the morning and enjoyed myself.

Walked in the forest in the middle of the day in spite of the heat, and managed to take up my palette before dinner even after this rather tiring excursion. In the evening I went for a stroll with Jenny into the garden and the little meadow by the Baÿvet woods. Mme de Forget writes every day to give me news of poor Vieillard's condition.

20 May

After dinner I went into the forest with my poor Jenny. I am still more grieved at my poor friend Vieillard's death, when I think that I may lose this other friend who means so much more to me.

24 May

Went to meet Jenny in the evening, in the little wood at Baÿvet. The nightingales were trying to outsing each other in Barbier's wood. Reflections of every kind in this place. Saw a grey horse and a black one on the river bank reflected in the water; they went off at a canter ahead of their driver in order to get back to the river.

Walked into the country, crossing the road and through the fields on the other side as far as the cross-roads. I walked too far. Either I've not yet regained my strength, or else I'm not as strong as I used to be.

Tuesday, 2 June

I went to Paris, on tenter-hooks to know whether M. Bégin[1] would give me possession of the house so that we can begin the alterations.

My first anxiety was to meet him or his wife, and I cursed the driver for going slowly. However I finally got there and saw the lady, who had good news for me. I then rushed off in a great state of excitement to find Haro. But I found more trouble there; the builders are being diabolical; some of them are utterly unreliable, and the rest are either lazy or too expensive. And that is the least of it; Haro told me about the fearful complications of the plan, which is causing an immense amount of worry. However he has almost set my mind at rest, at least I think so, by suggesting the possibility of getting compensation in proportion to the length of my lease.

On the whole it was not such a bad day, except that I was very tired. I had arranged for Joseph to do the shopping while I ate my luncheon in the little café at the corner of the rue de la Roche-foucauld. I stayed there more than an hour so as to give him plenty of time, but when I came back he had done scarcely anything, with the result that he had to be out just when I most needed him, and I was forced to wait about doing nothing, as I could not hunt for what I needed in my studio when he was away.

He finally came back, but by then we had barely enough time left to make our preparations for leaving. However I managed it some-how, and sent him out to get a hackney carriage. At the end of half an hour he came back saying that he could not find one; he was dead set on taking a cab. I cursed him and flew into a rage, and he managed to collect one by some means or other. The whole way to the station I was urging the driver to hurry, I don't think I could have been more desperate if my life had depended on it. Thanks to my shouts and entreaties we arrived just as they were starting, and once I was settled into my seat I felt completely and childishly delighted. I forgot all my troubles, enjoyed everything I saw, and continued in this mood throughout the evening. But before the night was over I was back with the worst of my worries, made all the greater by darkness and solitude. I woke after my first sleep and for a long time lay a prey to every imaginable kind of anxiety.

I forgot to say that I saw Ingres when I was at Haro's, he was most polite and cordial.

[1] Dr. Bégin was tenant of the suite of rooms which Delacroix was to occupy at 6 rue de Furstenberg.

26 June. In Paris

On the sublime, and on perfection. These two words may appear almost synonymous. *Sublime* means everything that is most elevated; *perfect*, that which is most complete, most finished. *Perficere*, to realize completely, to crown the work. *Sublimis*, that which is highest, which reaches to the skies.

Some men of talent can only breathe in the highest altitudes and on the peaks. Michelangelo appears like one who would have been stifled in the lower regions of art. We must attribute to this consistent and unbroken strength the authority which he has exercised over the imagination of all artists. Titian stands in exact contrast with him.

Lord Byron says somewhere: 'Campbell's works smell too strong of the lamp, he destroys all traces of his first draft'. But Byron himself, goes over his poetry again and again with the greatest care. Whatever other people may say of his facility, he tells us himself that he sometimes wrote as much as two hundred lines at a sitting, and afterwards reduced them to twenty.

Our own writers, who take improvisation for their muse, will find it hard to reach perfection. They hope to be saved by such lucky accidents as improvisation occasionally brings and to meet the *sublime* by chance, and I say good luck to them.

Ought one to say that the best way of discovering the *sublime* is to polish one's work less? When people say that Racine is perfect and Corneille is sublime, do they not appear to mean that the one is less elaborate than the other? One thing is certain, in Corneille's work it is perfectly clear when he is being sublime. Racine too, is often sublime, and quite as frequently as Corneille, but the texture of his work is so even that the most sublime passages are linked to one another by imperceptible transitions. He does not flash out like lightning against the darkness of the night. The sustained warmth of his style, and the truth of the sentiments seem to come easily to him, and reveal their stupendous quality only when one penetrates deeper into an art that is profound and supremely confident of its power.

Sunday, 28 June

First visit to the doctor. He seemed to me to be absent-minded, and more occupied with his own affairs than with my fever. He could not remember what he had prescribed for me.

Strasbourg, Tuesday, 28 July

Left for Strasbourg at seven o'clock. Pleasant journey through a fine countryside; oppressively hot in the middle of the day.

When I was alone in the carriage from Nancy to Strasbourg, I no longer felt the dust and heat, all this part of the journey was delightful.

My cousin[1] was waiting for me at the station. We were very glad to see one another again.

Sunday, 3 August

About seven o'clock we went to the Orangerie driving through thick clouds of dust, but I felt well rewarded by seeing the town, which is enchanting. We have nothing like this in Paris, and what is more there were very few people about.

Everything here is different. The outskirts of the town, where fields and meadows lie beside the avenues and intermingle with them, give it a peaceful, countrified air. The inhabitants do not look flighty and impudent as our own people so often do. They positively seem to belong to a different race. This is the kind of place to live in when one is growing old.

Nancy, Saturday, 8 August

Left Strasbourg and my good cousin. I have lost the cane he gave me. The journey began badly. Disagreeable people in the carriage; however it was soon over.

Arrived in Nancy at three o'clock. Met Jenny as we had arranged. Stayed in all the evening.

Sunday, 9 August

Went out before Luncheon. *Place* Stanislas and cathedral. I admired the unity of style in the architecture of the building.

Then to the Museum, where they have hung my picture[2] too high, and in a bad light. But all the same I did not feel too much dissatisfied with it.

Nancy is a fine large city, although somewhat dismal and monotonous, but I find the wide, straight streets most depressing; you can

[1] Delacroix visited his cousin Lamey on his way to Plombières, where he (and Jenny) were to take the waters.

[2] 'The Battle of Nancy' exhibited at the Salon in 1834, presented by the State to the town of Nancy.

see the object of your walk three miles off in a dead straight line. I know only one duller place, the West End of London, where the houses are all alike and the streets are even wider and seem even more interminable. I prefer Strasbourg a thousand times, with its narrow but clean streets; it has an atmosphere of quiet family life and order, and a peaceful, untroubled existence.

Plombières, Monday, 10 August

Left Nancy at five in the morning. I was called at four and thought there would be plenty of time, but the omnibus was at the door long before I was ready. However, I tumbled my things together and found seats in the train for myself and Jenny. Delightful journey as far as Épinal. Every time I watch the dawn I glow with pleasure, I imagine that I am seeing it for the first time, and feel miserable at not enjoying it more often.

We arrived in Plombières at about eleven o'clock. I called on the good Dr. Laguerre, who took me to see M. Sibille and has arranged for me to take my first bath.

Dr. Laguerre came to see me and I consulted him about Jenny. I owe him for a visit to Joseph.

21 August

Rose early and did a sketch in perfect conditions, from the Promenade des Dames beside a delicious little stream; the slopes were covered with dew, and the sun was shining through the trees. Afterwards I climbed a long way up the hill to the left. Views admirable in the morning. Made two sketches.

Rather tired when I got back, but very well on the whole.

29 August

Took my leave of the church at Plombières. I like churches, I like being alone in them, and sitting down quietly, and having a good long meditation. They want to build a new church but if I come back to Plombières, I shall not often go into it. It is the ancientness of churches that makes them venerable; they seem to be hung with a tapestry woven of all the prayers which suffering hearts have breathed. Who would replace the inscriptions and memorial tablets, the pavement of half-obliterated tombstones, the altars, the steps, worn down by the feet and knees of generations who have suffered in this place, and over whom the ancient church has murmured its final benediction? In

short, I prefer the smallest village church, as time has made it, to *Saint-Ouen*, in Rouen, after its restoration. *Saint-Ouen*, that was so majestic, so sombre, so sublime in its ancient obscurity, and today is all glittering after its scraping down, and the new windows, etc.

I caught cold today, when I was taking the last of my baths. In the evening I went for one last walk along the road to Saint-Loup. I can hardly bear to tear myself away from so much beauty. There are reapers and haymakers everywhere, and laden hay-wagons pulled by teams of fine oxen.

31 August

Left Plombières at seven in the morning. Travelled in the same carriage as four nuns; one of them had a charming face. Felt unwell the whole of the way to Épinal.

Arrived about ten o'clock. Went to see the church; dark and rather primitive Gothic; much restored.

Paris, 3 September

I have written to my good cousin:

'In spite of the solitary life I am leading here, as solitary, I mean, as one can be in Paris, I often think regretfully of our peaceful life in Strasbourg, and of all the good it did me, especially to my shattered health and tired and worried mind. In your peaceful town everything seemed to breathe tranquillity; here, all I see in people's faces is a restless fever; even the town itself seems to be given over to perpetual change. This new world which, for good or ill, is struggling to emerge from our ruins is like a volcano beneath our feet. It allows no breathing space, save for those who, like myself, begin to regard themselves as strangers to all that is happening, and limit their hopes to making good use of each day as it comes. So far, I have only once been out into the streets of Paris; I was horrified by the faces of all those schemers and prostitutes.'

Augerville, Friday, 16 October

Superiority of music; absence of reasoning (not of logic). I was thinking of this as I listened to the simple piece for organ and cello which Batta played for us this evening, after having played it over before dinner. The intense delight which music gives me—it seems that the intellect has no share in the pleasure. That is why pedants class music as a lower form of art.

Paris, Thursday, 29 October

On Charlet. It is useless to ask at the Bibliothèque de la Nation for the works of Charlet or the works of Géricault. Their very meagre funds are used to complete collections of the works of masters who often have nothing to recommend them but their rarity. It is the same with the works of Prud'hon and Géricault. These glories which are so near to us, these men, whom many people still alive have seen and known, do not have the glamour of the old Italian and Flemish painters. The works of Michelangelo are better represented than those of our own admirable contemporaries.

If we cannot find enough marble to make statues of them, I should like to see busts of these men placed in the entrance halls of the academies which failed to elect them when they were alive.

I deliberately connect the two names (Charlet and Géricault), not so much because they lived and worked at the same time, as because a mutual admiration made them passionately interested in one another (describe this).

Charlet ranked Gros and Géricault above all others. Géricault called Charlet the *La Fontaine of painting* after he had discovered him in Meudon, where he was painting the signboard outside a tavern, and indeed, he resembles the immortal portrayer of nature in more than one respect. Like La Fontaine, Charlet painted man, not as sentimentalists would like him to be, but as he really is, with all his absurdities and even his vices. Charlet was one of the great caricaturists of the age. He delighted to take for his models the naïve figures whose tricks and oddities he mocked in his painting. He seems to have been able to identify himself with them in a spirit of admirable seriousness.

There was no gradual awakening of his talent. From the very first, marvellous facility was at the service of an inexhaustible imagination. In that way he was like Bonington, whose charming talent perished all too soon. But his facility was the very opposite of what was needed to maintain him permanently at the high level of his early works.

It would seem that talents which develop more slowly, or should I say, more painfully, are destined to live longer at the height of their strength and fullness.

In his later works, Charlet's great facility seems to have become a habit, or rather the enthusiasm which guided his hand made itself too much felt.

With him thought and execution were simultaneous. He rarely

made a separate sketch before beginning on his stone, and completed each detail as he went along.

In a drawing which is intended as a sketch, etc. . . . but in a picture it is absolutely essential that the relationships should be better balanced, more carefully studied.

Charlet is Gallic, like La Fontaine, like Rabelais himself, who seems to be the father of this whole line of jesters.

Those who have written or painted usually know what to make of a first draft. It is without form; in four pages there may be only four lines worth preserving.

I believe that a simple drawing is sufficient to allow one to brood over an idea, so to speak, and at the same time to bring it to birth. Within its small compass, and with a rather summary execution, one can attain the loftiest feeling as well as one can with the complex execution of a picture, where it is impossible to grasp the composition and the rendering at the same moment. Material execution. The laws governing it in painting; time is as indispensable as training and manual skill.

But after all, is it not one of Minerva's privileges to create a complete work of art with a single gesture? And how delightful they are, those paintings, which seem to cost their authors nothing, in which we find no trace of fatigue, nor of the effort needed to maintain unity in every part of a long and exacting task.

Happy artists, whom a kindly Deity inclines to produce works of this kind! Who will realize their good fortune better than that great majority of their fellow artists who give birth to their creations in anguish and fever?

Grétry tells us that he never composed an opera without spitting blood! Who would ever believe, as they listen to those light arias and those melodies which seem to flow so naturally from his pen, that they cost the composer sleepless nights and laborious effort?

Charlet has one remarkable characteristic, which is probably unique among painters. His earliest manner is the one that shows the greatest breadth. As he grew older his style became wittier and his skill rather too obvious. He brought himself within range of the public by using a precise, clean touch—sometimes, it must be confessed, a little too precise and clean—that gives to some parts only a surface rendering, although others are rendered in the fullest possible way. The further he went from the early period when his finest work was produced, the more he was inclined to fall into what I call the *French defect* of using *line everywhere*. And indeed this may be considered the greatest

weakness of the French, compared with other schools. The slightest and most insignificant details are equally elaborated, and are presented without any sacrifices or regard for the evil effect of such clumsy scrupulousness. In French painting, generally speaking, you never find those happy negligences that have the virtue of attracting interest to the parts on which it should be concentrated. Flemish painters were past-masters in this art, to say nothing of Rembrandt, with whom it was almost as much a matter of deliberate calculation as of instinct, and who did not require his swiftly moving point to give a heavy rendering even in essential passages. In the works of the Dutch and Flemish masters (paintings as well as engravings) you notice this same ease of execution, this art of concealing sacrifices made for the delight of the imagination—a faculty that quickly grasps an artist's meaning and understands even what he does not make manifest.

How strange that this absence of lightness, this tense execution, so repellent because it is so laboured, that destroys the charm of our pictures and engravings, should be the very quality we most dislike in all forms of literature. Grace and lightness are the greatest charms of our poetry and prose, but not for foreigners, I should say, who are incapable of appreciating this precious quality. La Fontaine, Racine, Voltaire, and not only in light verse, but even, etc.

This art of skimming off the cream, and not wearying the reader with trifling details, the art of being concise, that corresponds to the art of showing nothing but the essentials in painting, is the very quality that most delights us. Other works, full of good things, are spoiled for us when they lack this quality. They confuse the imagination and allow us no breathing space because the arrangement is muddled and above all because there are too many details.

Paris, 4 November

The other morning as I was standing on my balcony in the sunshine, I noticed the prismatic effect of the thousands of tiny hairs in the cloth of my grey jacket. They were sparkling with all the colours of the rainbow, like little pieces of crystal or diamond. Each separate hair being glossy, it reflected the most brilliant colours, which changed whenever I moved. We only notice this effect in sunshine . . .

9 November

On the word Distraction. A long while ago I made some notes similar to these on the use of the word *distraction* to express pleasures

and pastimes. It comes from the Latin word *distrahere*, to detach or pluck away. When a man says that he proposes to give himself a little distraction, he does not realize that the expression is completely negative. It describes the first stage in the operation of pleasure-seeking, the act of dragging oneself out of a state of boredom or ill-health. Thus, *I am going to seek some distraction* means 'I am going to detach my thoughts from present cares and forget my sorrows, if I can, with a chance of finding pleasure into the bargain'. Every man needs distraction, and would like to seek it all the time. Perhaps only stolid Moslems (at least, they appear stolid to us) can be content to sit on their carpets for days on end with only a hookah for company but after all, even that may be a form of distraction. It is a lazy occupation which serves to pass the time.

As for our own forms of distraction, we find them in reading and the theatre, in going for walks and card-playing. Some men amuse themselves and while away the interminable hours with occupations of the mind, but these are the kind of people who can make even prison tolerable by imaginings which take them far from their present state, and distract them from the contemplation of themselves. Can we then never manage to live with ourselves without the aid of such more or less frivolous pastimes, without appealing for the society of some other human being, a fellow-sufferer and as bored as we are ourselves, or going out to entertainments, where we enjoy the inventions of other men who, in creating the works which give us so many pleasant hours, are also seeking an answer to this problem of living with themselves?

Pythagoras compares the world to the Olympic Games. Some men keep shops and think only of their profit, others risk their lives and aspire to glory, and others again are content merely to watch the Games.

Friday, 13 November

It is difficult to say what colours men like Titian and Rubens used to produce such brilliant and permanent flesh tints, and especially those half-tints, where the transparency of the blood can be felt through the skin, in spite of the greyness characteristic of every half-tint. Personally, I am convinced that they used a mixture of the most brilliant colours. When the tradition was broken with David, who like his followers introduced other mistaken ideas, it became a matter of principle that sobriety was one of the elements of the Beautiful.

Let me explain this. After the intemperate drawing and wild outbursts of colour which led the decadent schools to outrage truth and good taste in every way, a return to simplicity was needed in all branches of art. Drawing was re-tempered at the source of the Antique with the result that a completely new field was opened for truth and nobility of feeling. Colour shared in the reformation, which in this case was injudicious, since it was thought that colour should always remain attenuated and should revert to what many considered it should be—a simplicity that does not exist in nature. In David's work (for example in the 'Sabine Women' which is the prototype of his reforms) you find colour that is relatively true, but he and his school imagine they are recapturing the tones which Rubens produced with strong, fresh colours, such as brilliant *greens*, *ultramarines*, etc., when they use *black* and *white* to make blue, *black* and *yellow* for *green*, *red ochre* and *black* for *violet*, and so on. And again, David uses earth colours, *umber* or *Cassel earths*, *ochres*, etc. Each of these near-greens and near-blues plays its part in this attenuated scale of colour, especially when the picture is seen in a strong light which penetrates the molecules of paint and brings out all the brilliance of which they are capable. If the picture is in shadow however, or placed in oblique lighting, the earth colours become earthy once more, and the tones *no longer play*, so to speak. Above all, if you hang it next to a picture that is full of colour, a Titian or a Rubens, for example, it shows up for what it really is—earthy, bleak and lifeless. *Dust thou art, and to dust shalt thou return.*

Vandyke used more earth colours than Rubens; *ochre, red-brown, black*, etc.

30 November

Ask the nurseryman for hollyhocks, syringa, lilies, zinnias, honeysuckle, nasturtiums, sunflowers, hyacinths, narcissi, tulips, ranunculus, morning-glory.

9 December

I'm always apt to think too well of people when I meet them for the first time: I always imagine them to be superior.

Sunday, 20 December

I am staying indoors. I am letting my beard grow; now I think I am beginning a cold and it gives me an excuse for remaining

where I am. Since the beginning of the month I have begun to work again.

The studio is completely empty,[1] who would ever believe it? Even now that it's all bare and deserted, I still love this place where I used to be surrounded by all kinds of pictures, many of which I enjoyed for their variety and all of them evoking some special memory or feeling. The studio seems twice as big. I still have about ten small pictures to finish and am enjoying the work very much. As soon as I get up, I hurry upstairs to the studio, hardly waiting to comb my hair, and I stay here until dark without one empty moment or desire for the distractions of paying visits, or other so-called entertainments. All my ambition is bounded by these walls. In these last moments I am enjoying the feeling of still being in this room which has known me for so many years, and where I spent so much of the last part of my late youth. I say this, because although I am now an old man, my imagination and some other faculty (I don't quite know what to call it) still gives me the thrills and longings and enthusiasms of the best years of my life. My faculties have never been slaves to uncontrollable ambition, and therefore I am not forced to sacrifice my enjoyment of them and of myself in a vain desire to be envied in some public position. What a futile bauble for a man to play with in his old age! A stupid thing to give his heart and mind to at a time when he should be withdrawing into his memories, or finding some healthy intellectual occupation to console him for all he is losing! He should try to fill his last hours in some other way than with those tedious public affairs over which the ambitious waste so much time merely for the sake of appearing for a few moments in the limelight. I cannot leave this humble place, these rooms, where for so many years I have been alternately melancholy and happy, without feeling deeply moved.

Thursday, 24 December

While the move was going on I worked all day just as usual. In the evening I learned of the death of poor Devéria.[2] He only died today, and they're burying him tomorrow.

[1] This was the famous studio in rue Notre-Dame de Lorette.

[2] Achille Devéria (1800–57), painter and lithographer, was one of the liveliest of the Romantic group. Delacroix was a frequent visitor about 1828 when the house of the Devéria brothers was a meeting-place for Victor Hugo's circle.

Monday, 28 December

Moved into the new studio today, in a great hurry. In the morning, worked on the 'Fighting Horses'.

My new home is really charming.[1] I felt rather depressed, after dinner, at finding myself transplanted, but I gradually became reconciled and went to bed quite happy.

I awoke next morning to find the sun shining in the most welcoming way on the houses opposite my window. The view on to the little garden, and the cheerful look of the studio continue to give me great pleasure.

1858

Paris, 23 February

The ancients achieved perfection in their sculpture: Raphaël in his art did not. This reflection is caused by the small picture 'Apollo and Marsyas';[2] an admirable work, from which one can scarcely turn away one's eyes. No doubt this is a masterpiece, but of an art which has not yet reached perfection. What we see is perfection in the talent of an individual artist, and ignorance due to the period when the picture was painted. The figure of Apollo looks as though it were glued to the background, and the background itself, with its little factory buildings, is puerile. The only excuse for it is the naïve imitation and the scanty knowledge of aerial perspective at that time. The Apollo's legs are too thin and the modelling is weak—the feet are like pieces of wood stuck on to the ends of the legs; the neck and collarbones are unsuccessful, or rather, they are not felt. The same applies to the left arm holding the staff. I repeat, the chief attraction of this picture is the personal feeling of the artist, and the charm that belongs to talent of the rarest kind.

One feels nothing like this about the small plaster casts which were arranged beside the picture in the owner's house and were probably

[1] Delacroix had chosen this house at 6 rue de Furstenberg with a studio in the garden, in order to be closer to his work in the church of St. Sulpice. It is now kept as a National Monument, open to the public.

[2] This picture is no longer definitely attributed to Raphaël. Delacroix had seen it in the collection of John Morris Moore, the English connoisseur, whose portrait was painted by Alfred Stevens at Rome, in 1840. The painting had Raphaelesque qualities of design which sufficed for the very general nature of Delacroix's comparisons.

casts made from antique bronzes. Certain passages were neglected, or less finished than others, but the spirit animating the whole could not exist without a complete understanding of art. Raphaël is halting and graceful: the Antique is full of the unaffected grace we see in nature. Nothing is disturbing, nothing regrettable, nothing missing, nothing superfluous. Modern artists can show no examples of an art like this. In Raphaël we see an art struggling in swaddling clothes. His sublime passages carry us over the ignorant parts, the childish naïveties that are but promises of a more complete art. Rubens is exuberant; his knowledge of the technical means of art, and above all his facility in using them, instinctively betrays his skilful hand into creating extravagant effects and conventional practices designed to make the impression more striking. Puget has marvellous passages, surpassing both the ancients and Rubens in truth and vigour, but he has no unity—lapses everywhere, defective parts fitted together with obvious difficulty, the ignoble and the commonplace at every turn.

The Antique is always even, always serene, complete in every detail and irreproachable in the general effect. All the works seem to have been created by one artist. The style varies slightly in different periods but, nevertheless, each individual example of antique art retains the peculiar value which all owe to that unity of doctrine, that sustained strength and simplicity, which modern artists have never attained in the art of drawing, nor perhaps in any other art.

Greek art was the offspring of the art of Egypt. All the marvellous gifts of the Greek people were needed to reach such perfection in their sculpture, while following a kind of hierarchical tradition like that of Egyptian art. It was the *liberality*, the creative freedom of the Greek spirit that animated and brought fertility to cold idols, consecrated by a different art and bound by an inflexible tradition. But when we compare them with modern art, obsessed as it is by all the new things which the centuries have brought in their train, by Christianity, by scientific discoveries that have encouraged boldness of imagination, and finally, by that inevitable revolution in human affairs which prevents one period from resembling any that have gone before . . .

The extreme daring of the greatest men has been responsible for much bad taste in others. But such audacities in the work of great artists have broken down barriers for those who come after and resemble them. Just as Homer appears to be the source from which everything flowed in Ancient Greece, so in modern art certain geniuses, tremendous geniuses I venture to say (the word is intended

to describe both their greatness and the impossibility of restricting them within limits), have, each in his own characteristic way, opened all the roads which others have covered since their time. Not one great mind coming after them but owes them tribute, and finds in them the prototype of his own inspiration.

The example of such innovators is dangerous for the weak or inexperienced. Fine talents, even in their early stages, are prone to mistake their own impulses or flights of imagination for the effects of genius equal to that of the most exceptional men. It is to other great men, like themselves but coming at a later date, that their example is beneficial. Lesser natures may find it easy to imitate Virgil and Mozart . . .

Change is natural to men, we find examples of it even among the ancients, whose grandeur seems so monotonous from a distance. The great tragic writers follow, but do not resemble one another. Euripides has not the simplicity of Aeschylus; he is more satirical; he seeks after effects and contrasts. Plots become more complicated as men feel the need to appeal to the new sources of interest which are being discovered in the human soul.

We find the same thing taking place in modern art. Michelangelo, when he wishes to increase the effect of his sculptures, cannot call upon backgrounds and landscape, which enhance the effect of figures in a painting. His consuming desire is for expression, pathos of gesture, and fine balancing of planes. Great admirers of Corneille and Racine (and they are few today) fully realize that modern plays based on the model of these masters would leave us cold. We lack creative geniuses. Our poverty-stricken poets cannot give us the tragedies of our own times; they have produced nothing so far but imitations of Shakespeare mingled with what we call melodrama. But Shakespeare is too much of an individualist, his beauties and effusions spring from too inventive a mind for us to be completely satisfied when modern writers try to produce plays based on the Shakespearian model. He is not a man who can be plundered; his works cannot be compressed. His genius is not only completely his own, unlike anything else, but he is an Englishman. His fine passages are more lovely to the English, and his defects may not seem like faults in their eyes. How much less so must they have appeared to his own contemporaries, who delighted in many of the things that shock us. The sailors and fish-hawkers who filled the gallery in Shakespeare's theatre were probably not moved to applaud the immortal beauties that shine out here and there in his plays, and the gentlemen of Elizabeth's court are not

likely to have had much better taste. They would have preferred the plays upon words and the laboured witticisms.

Lyrical composition, realism, all the fine new inventions are supposed to have originated in Shakespeare. From the fact that his servants talk as well as their masters and that he makes Caesar question a shoemaker in a leather apron, who answers him in the jargon of the streets, many people conclude that our own plays must be lacking in realism because they do not contain this new form of humour. In the same way, when people see a lover alone with his mistress spouting two pages of extravagant eulogies to nature and to the moon, or a man in a paroxysm of rage stopping to indulge in endless philosophizing, they think they have found an element of interest in what is nothing but a fearful bore.

What contradictions there are in one man's mind! The variety of opinions held by different men is astonishing enough, but a man with a sound intellect can conceive every possibility, and can make his own or understand every different point of view. This explains why a man frequently changes his opinions, and no one should be surprised at him, except those who are incapable of making up their own minds.

26 February

I had a conversation with J . . . about the unsatisfactory leg of the 'Medea'. When men of talent are inspired with an idea everything else has to be subordinated, that is the reason for the weak passages in their work; they are sacrificed of necessity. It is all to the good if the idea comes clearly from the beginning and develops of its own accord. For men of real talent, the only difficulty lies in passing over such weak passages. The lapses are less noticeable with artists of weak talent, because everything else in their work is weak.

14 March

Artists who seek for perfection in everything achieve it in nothing.

3 April 1858

I have been re-reading some of my old note-books in a search after the recipe for quinquina wine, which good old Boissel gave me. They brought the past back to me with a gentle and not too melancholy pleasure.

Since it costs me so little effort, why have I been neglecting this task of jotting down, from time to time, in these note-books a record of what is happening in my life and above all, in my mind? Of course, in such hurriedly scribbled notes, there are bound to be many things which one would prefer not to find when one reads them later. Everyday happenings are not easily described, and it is only natural to feel nervous of the use that might be made in the future of many things that have no general interest and are carelessly written.[1]

13 April

Went to see Huet at half-past three. I was greatly impressed with his pictures. They are uncommonly vigorous. There are still some vague passages, but that is characteristic of his talent. One cannot admire anything without also finding something to regret. Altogether, great progress in his good qualities. And that is enough with pictures that stick in the memory as his do in mine. All this evening I have been thinking about them with pleasure.

After dinner I walked round my little garden. It is a great help to me. I badly need to get my strength back completely.

Champrosay, 11 May

Left for Champrosay at eleven o'clock. I feel very glad to be here again. I met my poor neighbours; their grief is heart-rending.

I always find some change. Now they have built a great shed on the plain in front of my window and the roof hides part of my view of the river. They are pulling down Villot's wall. Everything comes to an end, and so do we.

24 May

Mme Villot invited me to spend the evening to meet a mysterious young lady, a friend of Mme Sand. I went there in spite of my cold and in torrents of rain. There I found Mme Plessis, a charming young lady who made me promise to write to Mme Sand on her behalf. She was just about to kiss me before the whole company, when I told her that I did not believe in that small attribute called a *soul*, which we are supposed to be blessed with.

[1] The Journal had been kept going when Delacroix could spare time from his main vocation of painting, i.e. on holidays and during illnesses. The last sentence suggests that he is now concerned about the use that might be made of his notes in the future.

26 May

When I was doing the lay-in for my 'Christ lowered into the Tomb', I remembered a similar composition by Baroccio, which one sees everywhere, and I thought of what Boileau says about all the arts: 'Nothing is beautiful but the truth'. There is nothing truthful in this wretched composition; the gestures are contorted, the draperies wave about without rhyme or reason. Reminiscences of the various styles of the masters.

The masters (here I am speaking of the greatest among them, the ones whose style is very pronounced) express the truth through their use of style, if it were not so, they would not be beautiful. Raphaël's gestures are naïve in spite of the strangeness of his style. What is odious is when fools imitate his strangeness, and are false in gesture and intention into the bargain.

Ingres, who has never learned to compose a subject as nature shows it, believes that he resembles Raphaël because he apes certain of his gestures, certain forms which are characteristic of the master. These do actually give his work a kind of grace, reminiscent of Raphaël, but with the latter you are very conscious that they come naturally and are not deliberately cultivated.

Paris, 3 July

First day at the church,[1] with Andrieu.

On accessories. Mercey says a very good thing in his book on the Exhibition: *the beautiful in the arts is truth idealized.* He has cut clean through the argument between the pedants and the genuine artists. He has put an end to the ambiguity which allowed partisans of *the beautiful* to conceal their incapacity for finding *the true.*

On accessories. They have an immense influence on the effect, yet they must always be sacrificed. In a well-ordered picture, there is an infinite number of what I call accessories, for not only are furniture, small details and backgrounds, accessories, but also draperies and figures and even parts of the principal figures themselves. In a portrait where the hands are shown, the hands are accessories; in the first place, they have to be subordinated to the head and often a hand must attract less attention than part of the clothing or background, etc. Why bad painters can never attain to the *beautiful*—that *truth idealized,* of which Mercey speaks—is because, apart from their lack of a general

[1] St. Sulpice, to work in the Chapelle des Saints-Anges.

conception of their work with regard to *the truth*, they almost invariably strive to bring out details which should be subordinated, with the result that their accessories distract attention from the general effect instead of enhancing it. There are many ways of arriving at this bad result, for instance, excessive care taken to emphasize details so as to display the artist's ability, the prevailing custom of making an exact copy from nature of all the accessories intended to enhance the effect. When a painter copies such fragments from actual objects, just as they are, without modification, how can he add or subtract and give to these objects, which in themselves are lifeless, the power needed to enforce the impression?

14 July

This afternoon I went for a walk along the road to Épinal. I made some enchanting discoveries; rocks and woods and best of all, water—water of which I never grow tired; I feel a continual longing to plunge into it, to be a bird, a tree whose roots are steeped in it, to be anything, except an unhappy, sick, bored old man.

27 July

For the last three or four days I have been reading *Les Paysans*, by Balzac. I was forced to give up Dumas's *Ange Pitou*, its incredible badness defeated me. *Le Collier de la Reine* had the same faults and the same lack of restraint, but there were at least some interesting passages.

At the beginning I was interested in *Les Paysans* but as it goes on it becomes almost as tiresome as Dumas's chatter. He always gives the same microscopic details by which he hopes to make something striking of all his characters. What a muddle, and what minuteness! What is the use of giving full-length portraits of so many secondary characters that all the interest of the book disappears? As Mocquart said the other day, that isn't literature. It is like everything else that they do nowadays, they underline everything, they exhaust their material, and worst of all, they exhaust the reader's curiosity.

The other day, in the *Débats*, I read an article on Rubens by a certain M. Taine. I had already decided, from other things he has written, that he was a thorough-going pedant and full of the faults of which I have just been speaking. He, too, says everything, and then he says it all over again.

Champrosay, 12 August

Went out into the country at six o'clock in the morning. A delicious walk. I went down to the river and did a sketch looking towards Degoty's hut. Brought home an armful of water-lilies and bulrushes; I spent nearly an hour, plunging about on the slippery clay at the edge of the river and enjoyed myself enormously capturing my poor flowers. This escapade reminded me of Charenton, and of going out fishing when I was a boy. I was quite sunburnt by the time I reached home.

13 August

Started out at the same early hour as yesterday, and stopped for a while in front of the fountain at Baÿvet to make a sketch which I regretted not having done the day before. It is one of the best in the little sketch-book which I brought with me from Plombières. They were busy waxing the floor when I got home, so I stayed out of doors as long as I could and sat under a tree near the river, not far from the little bridge over the gully. I was sitting under my sunshade at the top of the river bank, not down among the reeds, and opposite to the little island of reeds which appears when the river is low.

Spent the rest of the day sitting in a shady corner of the garden in my armchair, which they brought downstairs while we waited for the floor to dry.

In the evening after dinner, I went out into the fields with Jenny; poor woman, she is feeling ill again, just as she was in Bordeaux. She stayed only a moment with me, but I did not come home until it was nearly dark.

19 August

A man does not work only for the sake of producing, but to set a value on his time. We feel more satisfied with ourselves and with our day if we have stirred up our minds and made a good start, or have finished a piece of work.

Reading memoirs and history is a consolation in ordinary troubles; they draw a picture of human suffering and mistakes.

3 September

I have been feeling ill since Tuesday evening. All through the weekend I have been interrupting my painting to read Saint-Simon. He makes everyday events seem extraordinarily interesting. All these

deaths and misfortunes, so long past and forgotten, comfort us for the emptiness with which we feel ourselves to be surrounded.

I have also been reading Lamartine's *Commentaries on the Iliad*, from which I mean to make some extracts. They have revived my admiration for everything resembling Homer, including Shakespeare and Dante. It must be acknowledged that our modern authors (men like Racine and Voltaire) have not achieved this type of the *sublime*, this astonishing naïvety, which makes poetry of commonplace details and transforms them into *paintings* for the delight of the imagination. These people seem to think themselves too aristocratic to speak to us as man to man of sweating or the natural movements of our bodies.

6 September

Wrote as follows to M. Berryer: 'And so I have finally taken refuge here, and have begun to recover my health, but that is not all. This is what I found lying in wait for me at Champrosay. I had hardly arrived before the man who used to rent this little house to me told me that he proposed to sell it, and that I must make other arrangements as soon as possible. So I found myself with all my old habits upset; not that I was particularly comfortable before, but at least I was established; I have been coming to the district for the past fifteen years, seeing the same people and the same woods and hills. What would you have done in my place, my dear cousin, you who have allowed yourself to be walled up in your apartment for the last forty years rather than hunt for another? Probably just what I did. I have bought the house. It was not very dear, and with a few alterations over and above the purchase price, it will make a little home for me in keeping with my small means. All this means that I shall have to go back to Paris in a couple of days' time and settle down to a month's work on things which I have been continually putting off, but must still find time to come down here occasionally to supervise the arrangements I have just mentioned.'

1859

On the flyleaf is written:

Addresses of models given to me by Corot:

Madame Hirsch, rue Lamée, No. 6. Superb head, brunette, same type as la Ristori.

Adèle Rosenfeld, rue du Marché-Sainte-Catherine, No. 5. Reclining pose seemed to me superb.

Joséphine Leclaire, rue de Calais, No. 4. Very elegant, beautiful figure, thin arms.

Rosine Gimpel, rue du Petit-Carreau, No. 17.

Paris, 1 March

DICTIONARY

Picture. To produce a picture; the art of carrying it through from the first sketch to the finished work. This is both a science and an art, and to acquit oneself in a really masterly manner long years of experience are absolutely necessary.

Art is so big that a whole lifetime is needed to master the organization of certain fundamental principles which govern every branch of it. Men who are born painters know by instinct how to find a means of expressing their ideas; they bring the idea to light through a mingling of sudden impulses and tentative gropings, and perhaps with a more special charm than that offered by the production of a consummate master.

There is something naïve, and at the same time daring, about the dawn of an artist's talent, not unlike the graces of childhood and just as happily careless of the conventions that govern grown-up people. This is what renders still more astounding the daring which the greatest masters displayed towards the end of their careers. To be bold when one has a reputation to lose is the surest sign of strength.

I believe that Napoleon rated Turenne above all his commanders because he noticed that as he grew older his plans became more audacious. Napoleon himself is a supreme example of this rare quality.

In the arts especially, a man needs to possess very deep feeling if he is to maintain his originality of thought in spite of habits which even talented artists are fatally prone to acquire. After spending a large part of his life in making the public familiar with his genius, an artist finds it very hard to avoid repetition—to renew his talent, as it were. Yet he must do so if he wishes to escape those errors of triteness and banality so characteristic of artists and schools in their old age.

Gluck has given us a remarkable example of the strength of will that was in truth the strength of his genius. Rossini was continually renewing himself, up to that last great masterpiece which brought his illustrious succession of masterpieces to a premature end. So it was with Raphaël, Mozart, etc., etc.

Daring. Yet it would be wrong to attribute that daring, the mark of all great artists, solely to a gift for renewing and rejuvenating their talent by means of new effects. There are some men who show their full powers from the beginning, and whose greatest quality is a sublime monotony. Michelangelo never varied the character of that awful talent which has given new life to every modern school and charged it with an irresistible momentum.

Rubens was Rubens from the beginning. It is noteworthy that he never varied his execution, and only modified it very little after taking it from his master. When he copied Leonardo da Vinci, Michelangelo, or Titian—and he copied continually—he seems more typically Rubens than in his original works.

Imitation. One always begins by imitating.

It is generally acknowledged that what is known as *creation* in the great painters is only a special manner in which each of them saw, co-ordinated, and rendered nature. But not only did these great men create nothing in the proper sense of the word, which means making *something* out of *nothing*, but in order to form their talent, or prevent it from getting rusty, they had to imitate their predecessors and, consciously or unconsciously, to imitate them almost unceasingly.

Raphaël, the greatest of all painters, was also the most diligent of copyists. He imitated his master, which left a permanent mark on his style; he imitated the Antique and the masters who preceded him, but gradually freed himself from the swaddling clothes in which he found them wrapped; finally, he imitated his own contemporaries such as Albrecht Dürer, Titian, Michelangelo, etc.

Strasbourg, 23 August[1]

Letter to Mme de Forget:

'I am writing to tell you about my journey and my visit. I managed to arrive here without getting too hot and dusty, and indeed, without too much difficulty, in spite of the crowds flocking into Paris from the Provinces to admire our celebrations which, for my part, I have been avoiding as much as possible. Travel and distraction have not quite succeeded in making me well again, but I hope that the complete rest I am enjoying with my good cousin will cure me. However one feels in oneself it is a great joy to have a change of scene in the absence of livelier amusements. The town seems very primitive or,

[1] This was the last round of family visits that Delacroix was able to make. There are few entries in the Journal at this period.

if you prefer it, very backward compared with Paris. I hear nothing but German spoken, and find it rather reassuring as it lessens my dread of being interrupted by tiresome acquaintances when I go for my walks. But can one anywhere escape from bores? I read and sleep a great deal, I take little walks, and I greatly enjoy being alone with my cousin, a man whose mind and judgement I admire and who has exactly the same tastes as myself. We shall continue in this way until I go to spend a few days with my cousin in Champagne on my way back to Paris. This will take me until about the tenth of September when, please God, I shall have regained enough strength to settle down again to my work, as I earnestly hope to do this autumn.

'How are you? Are you ruling your imagination? That is the important thing; we are happy when we believe ourselves to be so, and if our minds are set on the opposite extreme all the diversions in the world will not give us any pleasure. I am sure this lovely country would do you good, and the delightful walks, which begin as soon as you are outside the walls. No noise, very little traffic, and nobody dresses; in short, they are a hundred years behind the times, which should be enough to drive anyone away—but I find it enchanting.'

Strasbourg, 1 September

The most confirmed realist, when he attempts to render nature in a painting, is compelled to use certain conventions of composition or of execution. If it is a question of composition he cannot take an isolated fragment, or even a series of fragments, and make a picture out of them. He is bound to set some limit to the idea if the beholder's mind is not to hover uncertainly over an area, which has unavoidably been cut out from a larger whole; if it were not so, there would be no art. In a photograph of a view you see no more than a portion cut from a panorama; the edges are as interesting as the centre of the picture and you have to guess at the scene of which you are shown merely a fragment, apparently chosen at random. In such a fragment, the details have as much importance as the principal object and, more often than not, obstruct the view because they occur in the fore-ground. You need to make more concessions to faults of reproduction in photographs than in works of the imagination. The most striking photographs are those in which certain gaps are left, owing to the failure of the process itself to give a complete rendering. Such gaps bring relief to the eyes which are thereby concentrated on only a limited number of objects. Photography would be unbearable if our

eyes were as accurate as a magnifying glass; we should see every leaf on a tree, every tile on a roof, and on each tile, the moss, the insects, etc. And what shall we say of the disturbing effects produced by actual perspective, especially where human figures are concerned? In a landscape, where parts of the foreground may be magnified out of all proportion without offending the eye of the beholder, the defect is less noticeable. The confirmed realist corrects this inflexible perspective which, because of its very accuracy, falsifies our view of objects.

Even when we look at nature, our imagination constructs the picture; we do not see blades of grass in a landscape, nor minute blemishes in the skin of a charming face. Our eyes are fortunately incapable of perceiving such infinitesimal details and only inform the mind what it needs to see. Again, the mind itself has a special task to perform without our knowledge; it does not take into account all that the eye offers, but connects the impressions it receives with others that have gone before, and depends for its enjoyment on conditions present at the time. This is so true, that the same view will not produce the same impression when seen from a different angle.

What makes modern literature inferior is the attempt to reproduce everything; cohesion disappears under a flood of detail, and the result is boredom. In certain romances, for example those of Cooper, you have to read through an entire volume of conversation and description in order to find one interesting passage. The same defect greatly spoils the novels of Walter Scott and makes them exceedingly difficult to read; the mind wanders dully over pages of emptiness and monotony where the author seems perfectly happy to be talking to himself. Lucky painting, that requires only a glance to attract and arrest the attention!

12 October

True beauty in the arts is eternal and would be acceptable in every period, but it wears the dress of its own century; something of the period clings to it. Alas for works of art that appear at times when public taste is depraved!

They say that truth is naked. I cannot admit this for any but abstract truths; in the arts, all truths are produced by methods which show the hand of the artist, and are therefore clothed in the accepted forms of the period during which he lived.

The works of a poet are coloured by the everyday speech of his times. This is so true that it is impossible to give any exact idea of a

poem in a translation made at a much later date. For instance, in spite of all the more or less successful attempts to translate him, Dante will never be rendered in his natural beauty by the language of Racine and Voltaire. This is also true of Homer. Virgil, who lived in a more sophisticated period, more nearly akin to our own times, and even Horace, despite his concise style, can more easily be rendered in French. The Abbé Delille translated Virgil, Boileau might well have translated Horace. The chief obstacles to any exact translation would therefore seem not to be so much difficulties arising from differences of language, as the difference in spirit between the ages. Dante's Italian is not the Italian of our own times; ancient ideas are best suited to an ancient language. We call the old authors unsophisticated, but it was their period that was unsophisticated, and only in comparison with our own.

The usages of every period are completely different; the various ways of showing sentiment, of being humorous, and of self-expression, are in harmony with the mental attitude of the age. We only see the men of fourteenth-century Italy through the Divine Comedy; they laughed just as we do, but they laughed at things which seemed humorous in their day.

1860

Paris, 15 January

DICTIONARY

Audacity. It needs great audacity to dare to be oneself, and this quality is particularly rare in a period of decadence like the present. The primitives were bold by nature, almost without being conscious of it, but it really needs the greatest possible audacity to break away from habits and conventions. The men who came first had no conventions to fear, the field was open to them, no tradition fettered their inspiration. In the modern schools, depraved and intimidated as they are by precedents well contrived to curb presumptuous impulses, nothing is so rare as the confidence which alone can beget great masterpieces.

16 January

For the preface to the Dictionary

A dictionary of this type would amount to very little, relatively speaking, if it were the work of only one man of talent. It would be far better, indeed it would be the best possible, if it were compiled

by several gifted artists, but only on condition that each treated his separate subjects without the assistance of his collaborators. Working together, they would relapse into commonplaces, and fail to rise much above the level of a work jointly compiled by mediocre artists. If each article were to be amended by all the collaborators in turn it would lose its originality under a load of corrections, and take on a dull uniformity without instructional value.

In a work of this kind, what we should look for is the fruit of experience, but whereas experience is always fruitful with men who are blessed with originality, in second-rate artists it is merely a matter of a somewhat longer training in hackneyed recipes.

In this handbook the reader will find articles on several famous painters, but not a discussion of their lives and characters. He will find instead, long or short analyses of their characteristic styles and of the way in which each artist adapted the technical side of his art to suit his particular manner.

What is important in a Dictionary of the Fine Arts is not so much to learn whether Michelangelo was a great citizen (the story of his driving a spear into the porter so as to study the agony of a crucified man) as well as the greatest of artists, but to discover how his style evolved out of a succession of tentative gropings by schools hardly free from the swaddling clothes of timid infancy, and what influence this stupendous style has had on everything that came later.

The reader will also be spared a repetition for the thousandth time of the ridiculous story of Correggio, but he may perhaps be glad to learn what numerous biographers of the great masters have never sufficiently stressed, namely, how astonishing the influence of this great artist has been on the art of painting, and how in this respect he resembles Michelangelo himself and has an equal right to the admiration of the centuries.

The chief aim of a Dictionary of the Fine Arts is not recreation, but instruction. To establish certain basic principles or to elucidate them, to enlighten the ignorant more or less successfully, to point out the road, to give warning of pitfalls on roads that are dangerous or which taste condemns; this is the right course for a work of this kind, and where can one find principles better applied than in the example of the great masters who brought the different branches of art to perfection? What can be more instructive than even the errors of such men? For we must not allow ourselves to have a blind admiration for those privileged artists who appeared first on the scene. To adore them in every part of their work would be fatal, especially for young

students. The majority of artists, even including those who are capable of bringing their work to some degree of perfection, are inclined to establish themselves on the weaknesses of the great masters and to quote their authority. Such weaknesses in men of genius are usually an exaggeration of their personal feeling; in the hands of feeble imitators they become the most flagrant blunders. Entire schools have been founded on misinterpretations of certain aspects of the masters. Lamentable mistakes have resulted from the thoughtless enthusiasm with which men have sought inspiration from the worst qualities of remarkable artists because they are unable to reproduce the sublime elements in their work.

Unfortunately, no man is equal to more than a limited task. It is possible that many who are capable of writing excellent things on painting and the arts in general (once again, I am not referring to mere critics, but to practising artists, able to give genuine instruction) have been discouraged by the thought of the inadequacy of any one man—especially one who is busy with the practice of his profession—to compile a work on matters that are so little understood.

Writing a book is so respectable, yet at the same time so formidable a task that it has chilled the enthusiasm of more than one artist prepared to devote part of his leisure to the enlightenment of those less advanced in their careers. A book has many advantages, no doubt; it has a sequence of ideas, it deduces principles, it develops a theme, it recapitulates, it is in short, a lasting memorial and, regarded as such, is as flattering to the self-esteem of the writer as it is instructive to the reader. But a book needs a plan and transitional passages, and its author binds himself to the duty of omitting nothing that relates to his subject.

A dictionary, on the other hand avoids a great deal . . . it may not be so serious a matter as a book but it is less tiring to read, because it does not oblige the breathless reader to follow it through its progress and development. Although it is usually the work of compilers, as they are rightly called, it does not exclude original ideas and observations; for example, the man would need to be very uninspired who saw in Bayle's dictionary nothing more than a hotchpotch of other people's ideas. Such a dictionary is restful to a mind that finds it hard to plough through long developments of a theme and follow them with proper attention, or to classify and divide the material. One may take it up and lay it down at will, and after reading one or two fragments one may well find the excuse for a long and fruitful meditation.

There appeared a man like Michelangelo, a man who was painter, architect, poet and sculptor. If such a man had been a great poet as well as the greatest of sculptors and painters he would have been the most prodigious phenomenon, but mercifully for the artists who lag far behind him, and perhaps to comfort them for being so much his inferiors, nature did not allow him to be the greatest of poets. He did write no doubt, when he was tired of painting or carving, but his true vocation was to give life to bronze and marble, not to vie with Dante and Virgil, or with Petrarch. He wrote short poems, as befits a man who has other things to do than to spend a long time pondering over rhymes. Had he only written his sonnets, posterity would probably have ignored him. His consuming imagination needed something to feed on every moment of his time and although he was, as his life-story proves again and again, a constant prey to melancholy and even to discouragement, he felt compelled to appeal to men's imaginations even when he avoided their society. The only people whom he could bear to have around him were people of no account, his assistants and workmen, whom he could brush aside whenever he chose, men whose company he enjoyed at times and was glad to see when he tired of having to associate with the great, who wasted his time and compelled him to observe the usages of polite society.

The practice of an art demands a man's whole self. Self-dedication is a duty for those who are genuinely in love with their art. Painting and sculpture were almost one art in the centuries of renewal, when public encouragement went out to meet men of talent, and the host of mediocre artists had not yet destroyed the goodwill of the great patrons, nor yet confused public taste. But now that there are so many schools, and an overwhelming number of second-rate artists demanding a share in public grants or the munificence of patrons, who will be allowed to fill the place of several men and practise his art alone?

27 January

Architecture. Architecture is utterly degraded at the present time; the art has lost its way. Something new is wanted, and there are no new men. Eccentricity takes the place of the novelty that is so much sought after, and is stale and unoriginal precisely for this reason. The ancients reached the summit of perfection by degrees, not suddenly; not by telling themselves that they must be astonishing at all costs,

but by rising slowly, almost unconsciously, to a perfection which was the fruit of genius based on tradition.

What do architects hope to achieve by breaking with tradition? They say that people have grown tired of Greek architecture, which even the Romans respected, great as they were, with a few modifications adapted to suit their different customs. After the darkness of the Middle Ages, the Renaissance, which was genuinely a rebirth of taste, or good sense (which is to say the *beautiful* in every field of art), brought a return to those admirable proportions, whose supreme authority must always be recognized in spite of all pretensions to originality. Our modern way of living, although in many ways different from that of the ancient Greeks, is admirably suited to these proportions. Light and air, room for large numbers of people to move about freely, and magnificent façades become more and more in keeping with the gradual enlargement of our towns and buildings. The anxious, restricted lives of our forefathers, constantly occupied with the problem of defending their homes and spying on the enemy through their narrow slits of windows, with their narrow streets that prevented the development of those broad sweeping lines characteristic of the Antique, were well suited to an oppressed society, forced to be constantly on the alert.

But what connexion with our lives have these constructors of buildings after the fashion of fifteenth-century Paris? One expects to see a man with a harquebus behind each of the arrow-slits which they call windows, or to hear a portcullis crash down behind those formidable nail-studded doors.

Architects have abdicated. Some, without faith in themselves or their colleagues, tell you quite candidly that there are no longer any inventors, and that invention itself is impossible in our time. A return to the past is therefore necessary, and since according to them, the taste for the Antique has had its day, they turn to the Gothic style which, when they revive it, seems to them almost like a new style because it has been out of fashion for so long. So they plunge headlong into Gothic in order to appear innovators. But what Gothic, and what newness! Some naïvely admit that the circle is closed, that they are bored by the monotony of Greek proportions, and that there is nothing to fall back on, save the proportions of the buildings of the dark ages. If only they would use the proportions of the art that was believed to be buried and add a gleam or two of genuine invention! But they do not invent, they merely make tracings from the Gothic.

30 January

<div align="center">DICTIONARY</div>

Subjects of pictures. Some artists can choose their subjects only from foreign works that lend themselves to vagueness.

Our own authors are too perfect for us. The beholder is continually returning in imagination to their impression of these things, presented so finely and executed to such perfection.

Perhaps the English feel more at ease with subjects taken from Racine and Molière than from Shakespeare and Lord Byron.

The more perfect the work that inspires a picture, the less opportunity an allied art will have of producing a comparable effect on the imagination. Cervantes, Molière, Racine, etc.

31 January

On the Soul: Jacques found it hard to believe that what we call *the soul*, that intangible *being*—if the word *being* may properly be applied to that which has no body, that is not self-evident, nor even like the wind that . . . Can this *being*, whose existence he feels and may not question, continue to live when its habitation of bone and flesh, in which the blood circulates and the nerves perform their functions, has ceased to be the active workshop, the laboratory of life that maintains itself amidst opposing elements and despite many accidents and vicissitudes?

When the eyes have ceased to see, what becomes of the sensations that reach the poor soul, sheltered I know not where, through these windows on to the outside world? You will say that the soul remembers what it has seen, and lives and consoles itself by its memories, but if memory itself should die, memory which does, after a fashion, replace sound and hearing and the other senses which we lose one after another, what then will keep alive the invisible flame? What becomes of the soul when paralysis or imbecility have driven it to its last refuge, and it is at length compelled by the final extinction of life and its eternal exile to separate itself from a body that is now no more than clay? And once finally banished from that body which some call its prison, is the soul present at the final scene of mortal decomposition, when priests come with ceremony to murmur prayers over the lifeless lump of clay, or when perhaps, some voice is raised to bid a last farewell? As the tomb is closed, does the soul linger beside it to receive its share of the funereal mummeries? What becomes of it at that supreme moment when it is forced into complete separation from

that body to which it gave, or from which it received, life? What is its condition in that widowhood of the senses when the blood contracts and congeals, ceasing to give momentum to this strange composition of flesh and spirit, rather as the pendulum of a clock, when it ceases to move, halts the activity of the movement and of all the wheels?

Jacques was afflicted by this mortal doubt, and yet he sacrificed to fame. He spent days and nights polishing the works which he hoped would perpetuate his name. The strange contradiction of working for an empty reputation of which his ashes would be unconscious, could neither cure him of his researches, nor give him hope of survival, nor even that of knowing himself to be admired when he was no longer alive.

Jacques had a friend, a complete materialist, a man who had ransacked and dug deeply into every corner of the realm of science. He used to wonder sadly whence this immortal soul, alone of all that we see around us, could have secured the privilege of immortality. For unless one were determined to consider the soul a particle or emanation of a supreme being, he believed that it must share the common destiny; be born—if something that is nothing can be born—develop according to its nature, and finally perish. Why, he reflected, should it ever have begun, if it were not to end? Are we to believe that the innumerable souls of all human beings, including idiots, Hottentots, and millions of men no different from brute-beasts, have existed from all eternity? For after all, this is the case with all matter; it is all subject to its successive changes. Therefore from this eternal succession of nothing, which was destined to give understanding to this particular nothing, it was necessary . . .

Why, if the spirit endures, do the creations of great souls not share the same privilege? A great work seems to contain some of the spirit of its author. A fine picture, which is a material thing, is beautiful only because it is quickened by a breath of life that has no more power to preserve it from destruction than our feeble souls have power to preserve our feeble bodies. Indeed it is often our mad, intemperate, unruly souls that whirl their companion bodies—I almost said their inseparable companions—into a thousand risks and perils.

8 February

Balzac says in *Le Petit Bourgeois*:

'There comes a point of perfection in the arts which talent lies below and to which only genius can attain. There is so little difference

between the work of genius and the work of talent, etc. There is
more in it than this; the vulgar are deceived. The stamp of a genius
is a certain appearance of facility. Indeed, his work may well seem no
more than average at first glance because it is always perfectly
natural, even in the loftiest themes.'

Draw a deduction from the above on the works of Decamp, Dupré,
and in fact, of all artists who use extravagant means. It is very rare for
great men to exaggerate in their works. Consider this question.

Lawrence, Turner, Reynolds and generally speaking, all the great
English painters have this defect of exaggeration, especially in the
general effect, a fault that prevents their being ranked among the
greatest masters. The cloudy and variable skies of their country lead
them to produce these extravagant effects, these sudden contrasts of
light and darkness, but they greatly exaggerate them, revealing defects
caused by fashion or personal bias that speak louder than their fine
qualities. They have painted magnificent pictures, which, however,
do not show that quality of eternal youth characteristic of the great
masterpieces, all of which, I venture to say, are free from over-
emphasis and a sense of effort.

22 February

Realism. Realism should be described as the antipodes of art. It is
perhaps even more detestable in painting and sculpture than in history
and literature. I say nothing of poetry, if only because the poet's
instrument is a pure convention, an ordered language which im-
mediately sets the reader above the earthly plane of everyday life. To
speak of 'realistic poetry' would be a contradiction in terms even if
such a monstrosity were conceivable. But what would the term
'realistic art' mean in sculpture, for example?

A mere cast taken from nature will always be more real than the
best copy a man can produce, for can anyone conceive that an artist's
hand is not guided by his mind, or think that however exactly he
attempts to imitate, his strange task will not be tinged with the colour
of his spirit? Unless, of course, we believe that eye and hand alone will
suffice to produce, I will not say exact imitations only, but any work
whatsoever?

For the word *realism* to have any meaning all men would need to
be of the same mind and to conceive things in the same way.

For what is the supreme purpose of every form of art if it be not
the effect? Does the artist's mission consist only in arranging his
material, and allowing the beholders to extract from it whatever

enjoyment they may, each in his own way? Apart from the interest which the mind discovers in the clear and simple development of a composition and the charm of a skilfully handled subject, is there not a moral attached even to a fable? Who should reveal this better than the artist, who plans every part of the composition beforehand in order that the reader or beholder may unconsciously be led to understand and enjoy it.

The first of all principles is the need to make sacrifices.

Isolated portraits, however perfect, cannot form a picture. Personal feeling alone can give unity, and the one way of achieving this is to show only what deserves to be seen.

Art and poetry live on fiction. Ask a professional realist to paint supernatural beings, those gods, nymphs, monsters and furies, all those entrancing creatures of the imagination!

The Flemish painters (with the exception of Rubens, of course), who rendered the familiar scenes of everyday life so admirably and, strangely enough, brought to them the idealization required by this style of painting as by any other, generally failed with mythological subjects, or even with simple historical or heroic themes, or stories taken from the fables. They tricked out the figures which they painted from life—ordinary Flemish models—in all kinds of draperies and mythological accessories and with all the regard for accuracy which they gave to tavern scenes in their other pictures. The result was the extraordinary incongruity of making a Jupiter or a Venus out of one of the citizens of Brussels or Antwerp rigged out in fancy dress, etc. (Remember the tomb of the Maréchal de Saxe.)

Realism is the grand expedient which innovators use to revive the interest of an indifferent public, at periods when schools that are listless and inclined to mannerism do nothing but repeat the round of the same inventions. Suddenly a return to nature is proclaimed by a man who claims to be inspired . . .

The Carracci (they are the most illustrious example one can use) believed that they were rejuvenating the school of Raphaël. They thought they could discern a weakness in the master's imitation of the human figure. And indeed it is not very hard to perceive that the works of Raphaël, like those of Michelangelo, Correggio, and their most famous contemporaries, owe their principal charm to imagination, and that the imitation of the model was a secondary concern with them and often completely disregarded. The Carracci, who, it cannot be denied, were men of very superior quality, learned, and gifted with a great feeling for art, decided to take it upon themselves to

capture what had eluded their great predecessors, or rather, the thing which they had scorned. The very fact of their scorning it may have seemed to the Carracci to show an inability to combine the diverse qualities in nature which appeared to them to form an integral part of painting. They founded schools; indeed, it is true to say that schools as we know them today began with the Carracci—those schools, I mean, in which a careful study of the living model came first and almost entirely replaced the unremitting study of every branch of art, of which the study of the model is only part.

The Carracci doubtless imagined that without losing anything of the breadth and deep sentiment of the composition they could introduce a more perfect representation of details into their pictures, and thus rise above the level of the great masters who preceded them. Before long they had led their pupils, and they themselves had lapsed, into a form of imitation which was certainly more exact, but which distracted the mind from more vital parts of pictures that were conceived with the primary object of pleasing the imagination. No sooner had artists come to believe that the way to achieve perfection was to build a picture out of a combination of faithfully imitated fragments . . .

David's work is an extraordinary mixture of realism and the ideal. The followers of Vanloo had ceased to copy the model, and although their forms were trivial to the last degree, they drew upon their memory and experience for everything. It was an art sufficient for its day. Meretricious charms and emasculated forms devoid of any touch of nature sufficed for pictures that were cast in the same mould, without original invention, and without any of the simple graces by which the works of the primitive schools endure. David began by painting a large number of pictures in this manner; it was the manner of the school in which he was trained. I do not think that he possessed very much originality, but he was blessed with plenty of good sense; above all, he was born at the time when this school was declining and a rather thoughtless admiration for antique art was taking its place. Thanks to this fact, and to such moderate geniuses as Mengs and Winckelmann, he fortunately became aware of the dullness and weakness of the shameful productions of the period. No doubt the philosophical ideas in the air at that time, the new ideas of greatness and liberty for the people, were mingled with his feeling of disgust for the school from which he had emerged. This revulsion, which does great honour to his genius and is his chief claim to fame, led him to the study of the Antique. He had the courage completely to reform his

ideas. He shut himself up, so to speak, with the Laocoön, the Antinoüs, the Gladiator, and the other great male conceptions of the spirit of antique art, and was courageous enough to fashion a new talent for himself—like the immortal Gluck, who in his old age abandoned his Italian manner and renewed himself at fresher, purer springs. He was the father of the whole modern school of painting and sculpture. His reforms extended even to architecture and to the very furniture in everyday use. It was through his influence that the style of Herculaneum and Pompeii replaced the bastard Pompadour style, and his principles gained such a hold over men's minds that his school was not inferior to him, and produced some pupils who became his equals. In some respects he is still supreme, and in spite of certain changes that have appeared in the taste of what forms his school at the present day, it is plain that everything still derives from him and from his principles. But what were these principles, and how far did he confine himself within them, and was he always faithful to them?

The Antique was undoubtedly the foundation and corner-stone of his edifice. The simplicity and majesty of antique art, the restraint on composition—the restraint in draperies carried still further than with Poussin, but in the imitation of the various parts . . .

To a certain extent, David was responsible for bringing sculpture to a standstill, for his influence over this beautiful art was as supreme as over the art of painting.

1 March

Buy water-colours in tubes; use them to suggest the effect and thus make your researches beforehand.

3 March

I went out yesterday for the third time and spent a good half-hour sitting in the Luxembourg gardens. It was bitterly cold today, and I came home sooner.

How is it that the gravest literature belongs to a people who are supposed to be the most frivolous nation on earth? Even the ancients themselves, who laid down the laws for works of the imagination in every field of art, can show no examples of so sustained a sense of order, clarity, and discretion as the French. There is a certain looseness in the works of the finest writers of antiquity; they are apt to digress. Because we owe them the utmost homage we allow them every latitude; but we are not so easy-going with our own writers. A book that

is badly composed and badly written cannot be saved by the excellence of its details, nor by the brilliance of the conception taken as a whole. We insist that each separate part, however brilliant, should contribute its quota to the general scheme, and on the other hand, in a well-arranged and logically thought-out book the details must never mar the grand conception. When a play draws an audience to the theatre the author's task is only half done; the work must also 'read well', as they say.

Shakespeare was probably only mildly concerned with this second part of his duty towards the public. When the performance produced the result he desired and the audience, especially the gallery, was satisfied, he probably did not worry overmuch about the effect on the purists. To begin with, the great majority of his public could not read, and even had they been able, would they have had the leisure? They were either young dandies of the court, more interested in their pleasures than in literature, or else costermongers and whelk-sellers, who would have been little inclined to pull a work of art to pieces.

Who knows what became of the original manuscripts, the canvases on which Shakespeare set his scene? Fragments of them were carelessly distributed to the actors learning their parts, and were snapped up haphazard by impecunious printers who had full liberty to piece them together and to fill in the gaps as they thought fit. Surely these fantastical plays (I mean what Shakespeare called his comedies), or these sensational melodramas—the tragedies—with their alternating effects of melancholy and absurdity, wherein heroes and their valets intermingle, each talking his own language, and the action unaccountably takes place in a dozen different places at once, and over an unlimited space of time—surely, I say, such lovely and defective works of art can only please wayward minds, and the nation that clings to them must be more frivolous than deep-thinking.

For my own part, I believe that a nation's taste, its characteristic turn of mind, is strangely dependent upon that of its famous men who first wrote, or printed, or produced works of art of any kind whatsoever. If Shakespeare had been born at Gonesse instead of at Stratford-on-Avon, and at a period in our history before the time of Rabelais, Montaigne, Malherbe, or Corneille, we might have seen the development of a very different theatre (witness Calderón, in Spain) as well as a different form of literature. I am very willing to believe that the English temperament added something of its own toughness to such works. As to the savagery which the English are

supposed to have shown at various periods in their history, and to which people ascribe Shakespeare's tendency to drench the stage in blood, I cannot believe, as I consider our own history, that we owe much in the way of cruelty to our English neighbours, or that the actual tragedies which cast so dark a shadow over the reigns of the Valois, for instance, could have given us the kind of education likely to soften our manners.

The fact that we abolished massacres in our Theatre, and that it first began to shine in a gentler period, does not make the history of our nation more humane than that of the English. Recent events of fearful memory have shown that cruelty, even savagery, continue to reside in civilized man, and that gay works of art may go hand in hand with distinctly aggressive behaviour. The social instinct, which is possibly more highly developed among us Frenchmen, may have helped to put a finer polish on our literature. It is far more likely that the masterpieces of our great writers came in the nick of time to discredit the eccentric or bombastic efforts of earlier periods, and inclined us to obey certain rules of taste and propriety, which underlie any genuine social life no less than works of the mind. We are often told that Molière, for example, could only have existed in France. I should think so indeed! Was he not the heir of Rabelais, not to mention others?

8 March

It is always right and appropriate to set down ideas as they come to you, even if you have no consecutive work on hand into which they can immediately be incorporated. But all such notes take on the form of the moment. When the day comes for them to be fitted into a work of any length, you must be careful not to pay too much attention to the form which you originally gave to them. You notice this sort of patchwork very much in mediocre works. Voltaire must have noted down his ideas; in fact, his secretary tells us that he did so. Pascal left us proof of the same thing in his *Pensées*, which are the raw materials of a book. But when such writers poured their ideas into the melting-pot they took whatever form they could, and were far more concerned with the sequence of their ideas than with their shape. One thing is certain, they did not inflict upon themselves the wearisome task of looking up ideas which they had noted down, and of enshrining them in their original form.

One should not be too difficult. An artist should not treat himself like an enemy. He ought to believe that there is value in what his

inspiration has given him. The man who re-reads his work and takes up his pen to make corrections is always to some extent a different man from the one who wrote the first draft. Experience ought to teach us two things; first, that we should do a great deal of correcting; secondly, that we must not correct too much.

14 March

I have been to the exhibition on the boulevard and have come home in a black mood. It was very cold. The pictures by Dupré and Rousseau delighted me, but I did not care for any of the Decamps; it is antiquated stuff, harsh and diffuse; he still has imagination, but no drawing whatsoever. Nothing is more annoying than this insistence on careful finish in weak drawing. He is as yellow as old ivory, with black shadows.

6 April

Went to Saint-Sulpice, today. Boulangé had done nothing, and had not understood one word of what I wanted. I seized a paintbrush and, in a fury, gave him the idea for the grisaille frames and the festoon. It is most extraordinary; although I was tired when I reached home, my nerves were not on edge. I believe that this is the first real sign of returning health after so many set-backs.

7 April

Went to Saint-Sulpice. Boulangé was not there to meet me. The unspeakable rascal never turns up, does no work, and puts down the delays to my changeableness. He actually was not there! I came home in a rage and have written to him about it.

My evening walks are doing me good.

12 April

I have come across the following passage, which I wrote down in a note-book when I was staying at Augerville, in July 1855 (Mme Jaubert was there at the time): 'I have just seen some blue and green and yellow dragonflies darting over the turf by the edge of the river. As I watched these butterflies that are not butterflies, although their bodies are somewhat similar, these creatures, whose wings unfold like those of grasshoppers, although they are not grasshoppers, I thought of the inexhaustible variety of nature, always consistent yet

always different, assuming the most varied shapes, yet using the same organs. And then I thought of old Shakespeare, who created with whatever he found lying ready to hand. Each of his characters in their different circumstances seems to come to him perfectly rounded, with its special temperament and appearance. Using the same human data he adds or subtracts, adapting his material to suit his purpose, and giving you people created out of his imagination, but real men for all that . . . This is a sure sign of genius. Molière is an example of it, and Cervantes—Rossini, too, with all his bad qualities. If he falls short of the others, it is through his careless execution. By some strange quirk which you do not often find in men of genius, he is lazy. He uses formulas and has a way of patching together his compositions that gives him a long-winded quality; this is always apparent in his handling, but does not bear the stamp of strength and truth. As to his inventiveness, it is inexhaustible, and when he wishes, he knows how to combine the *true* with the *ideal*.'

14 April

Yesterday, Friday 13th, in spite of the omens, I went back to the studio after my long convalescence.

(Later.) It is incredible the amount of work that I have been able to do in the last three weeks, or just over a month, down to today, June 14th. I have finished for Estienne, the 'Horses fighting in a Stable', the 'Horses coming out of the Sea', 'Ugolin'; have nearly finished the sketch for the 'Heliodorus', intended for Dutilleux; I have done the lay-in and advanced the two battle pictures for Estienne; the 'Arab Encampment by Night'; the 'Arab Chief at the Head of his Troops and the Women offering him Milk'; also the 'Drinking-trough in Morocco'; and have made great headway with the four pictures of the 'Seasons' for Hartmann, etc., etc. I have also taken up again the sketch for the Saint Stephen, and have finished it.

15 April

On human nature at a time of political revolution. (Augerville, 21 October 1859.)

All revolutions invariably encourage bad characters and potential criminals. Traitors throw off the mask; they cannot contain themselves amidst the general confusion that seems to promise easy victims. Nothing restrains them; these blackguards in sheep's clothing care as little for the disapproval of their benefactors—whom a short

while ago they were flattering in the hope of receiving new favours—as they do for the contempt of honest men, or the fear of being known for what they are. They feel that the world exists only for rascals. They are at their ease amidst the silence of decent people and flatter themselves that no one is left to judge them, or to bring them to the disgrace which they so richly deserve.

Dieppe, 18 July

Left Paris for Dieppe, after a disappointment which forced me to change my time-table. I had originally intended to catch the half-past eight train, but when I arrived at the station, I found I should have to wait for the one o'clock express. Went home again and idled away the time there until the train left, except for going to the Café du Chemin de Fer, in the rue Saint-Lazare, to get some luncheon. Jenny left for Champrosay at midday. At the station I met Mme de Salvandy, Rivet's youngest daughter.

Arrived at five o'clock. Met Mme Grimbelot at the station; I had been admiring her imposing crinoline as I walked behind her, before I realized who she was. She is now living permanently in Dieppe, but I did not ask her reasons for taking such a serious step.

19 July

Spent nearly the whole day on the jetty. Saw the English yacht go out. I was watching her when that unfortunate man fell overboard, whom they found drowned on the following day.

Went to Saint-Remy in the evening; wonderful effect of that strange architecture lit by two or three smoking candles, planted here and there so that the shadows were made visible. I never saw a more imposing sight.

I like being here alone, pottering about and keeping myself to myself.

20 July

Sat for a long time on the jetty; the sea was magnificent, but the sun was rather hot in spite of the wind, and I went back to Saint Rémy.

In the evening the weather was very fine and I returned to the jetty. The sea was superb, although it was low tide. I saw all the effects that I need for my 'Christ walking on the Waters'.

Saturday, 21 July

It has been raining all day. After trying to reproduce the effect of the sunset which I saw yesterday evening I went for a walk in the rain, under the arcades. When it had cleared up a little I risked going down to the jetty, where I met the Rivet ladies and their husbands. I was driven away by torrents of rain and came home drenched at one o'clock.

22 July

I have caught cold, there is no doubt about it. I have moments when I feel profoundly bored and want to leave for Paris. At night I feel desperate. You must admit that it is rather hard to be shivering in one's bedroom in the month of July. I asked for a fire the day before yesterday, but Mme Gibbon, my landlady, was afraid for her fireplaces, which were never intended for the purpose; however she has given me a footwarmer instead, so that I can now read in my room in comparative comfort.

I have borrowed Balzac's *Ursule Mirouet* from the lending library. Still the same elaborate portraits of pygmies, all described in minute detail, whether they are principal or merely secondary characters. In spite of the generally overrated opinion of his talent I still think that he has a wrong conception of the novel and that his characters are not true to life. Like Henri Monnier, he creates his people through the jargon of their trades, in other words, from the outside. He knows how janitors and shop-assistants talk, and all kinds of professional slang, but nothing could be less true than these too neat and wholly consistent characters. Take for instance the doctor and his friends, and Chaperon, the virtuous priest, his whole appearance breathing virtue, down to the very shape of his cassock—we are not even spared that touch—and Ursule Mirouet herself, a miracle of innocence in her white dress and blue sash, converting her unbelieving uncle in church.

Champrosay, 27 July

I left Dieppe at a quarter to twelve and arrived in Paris at twenty minutes past four. By hurrying, I just had time to catch the quarter past five train to Corbeil.

There was a young lady in the carriage whom I took to be under the escort of a silent, disagreeable-looking man in the opposite corner. Imagine my surprise when in the customs house this young person opened her lips and addressed me in the most agreeable way imaginable.

Only my age and the train for Corbeil prevented my following up this delightful encounter. She reminded me of Mme D . . .

6 August

I must now make amends to Balzac. His description of the post-master's remorse in *Ursule Mirouet* (it comes towards the end of the book) has touches of intense truth. I am writing this at Champrosay after the tragic death of old Mme Bertin. I noticed one of her heirs behaving in an agitated way which reminded me of certain actions of Balzac's *Mirouet*, and strangely enough, made me reflect more than ever before on the advantages of being honourable, in other words of having a clear conscience, although to a gentleman, this must always come second to not degrading himself by stooping to self-interest.

One should have reservations, however. Balzac's book is false in a great many ways and in those respects it is bad; it is good because of its true description of that type of coarse-natured man who, although utterly devoid of natural delicacy, cannot bear the weight of remorse.

21 October

Admirable Rubens! What a magician! I grow angry with him at times; I quarrel with his heavy forms and his lack of refinement and elegance. But how superior he is to the collection of small qualities that make up the whole stock of other painters! He, at least, had the courage to be himself; he compels you to accept his so-called defects, that come from the impetus with which he is swept along, and wins you over, in spite of precepts that hold good for everyone but himself. Beyle [Stendhal] professed to admire Rossini's early works more than those of his last period, which most people think superior, and he gives as the reason that Rossini did not attempt to write *great music* when he was a young man, which is true. Rubens did not correct himself, and he was right. By permitting himself every liberty he carries you to heights which the greatest painters barely attain. He dominates, he overwhelms you with so much liberty and audacity.

I also note that his greatest quality (if you can imagine having to choose one quality in particular) is the astounding relief of his figures, that is to say their astonishing vitality. Without this gift there is no great artist. Moreover, only the greatest succeed in solving this problem of relief and solidity. I think I have said elsewhere that even

in sculpture there were some men who possessed the secret of failing to achieve relief, as will be obvious to any man with a feeling for art, who compares Puget's work with all other sculpture, not excepting even the Antique. Puget achieves life through relief as no other sculptor has succeeded in doing, and the same is true of Rubens, among painters. Titian and Veronese are flat compared with him, but let me note in passing that Raphaël, in spite of his lack of colour and aerial perspective, usually gave plenty of relief to his figures. No one could say as much for his present-day imitators. Indeed one could make an amusing thing of the search after flatness, which is so much in fashion today in all the arts, architecture included.

22 October

The gift of powerful invention; in other words, of genius.

Paris, 25 November

I keep steadily at my work; my willpower and my health keep one another going. How thankful I shall be in a month or six weeks' time when, according to my reckoning, I shall have finished my work in the church!

Yesterday, we elected that insipid Signol to the Institute. Meissonier got as many as sixteen votes, and thus the only people left to compete with him were Signol and that antiquated old Hesse, both of them representatives, or offspring, of the École. But shuddering at the idea of seeing an original talent enter the Academy, these two groups joined forces to destroy him. This was done at the price of Signol's election. The result will be far more deadly than if they'd decided on Hesse, an old man who will leave no pupils to perpetuate the taste of the school of David. In any case, I prefer that to the mixture of the Antique and bastard Raphaëlism of Ingres and his followers.

I have written to Mme Sand:

'My dear friend, you must realize that the few extra years which release certain springs in our intellects, also make those that help us to move and digest considerably more rusty. I do indeed believe that one of the effects of growing old is to perfect our mental capacity— I am speaking of good minds, naturally healthy and, above all, well-balanced. But it is a hard bargain which ruthless nature drives! Soon there is no body, nor any circulation left to assist the mind. As Themistocles said: *man decays and departs just when he is beginning to work well.*

'But to be brief, here you are, out of your troubles and restored to health once more. As you truly say, what happiness to see around one everything one loves, and to return to the daylight that shows us such exquisite things! What shall we find beyond? The night, the dreadful night. We can expect nothing better, at least such is my sad foreboding. That gloomy limbo where Achilles roamed, a mere shade, regretting not merely that he was no longer a hero, but not even a peasant's slave to endure the cold and the heat of the sun which, thank God, we can still enjoy—when it is not raining.'

1861

Paris, 1 January

I began the New Year by going on with my work at Saint-Sulpice, as usual. I have paid no visits—except by leaving cards, which is no trouble to me—and I have been working all day long. What a good life! What a divine compensation for my solitary state, as they call it! Brothers and fathers, relations, and friends of all kinds live together, quarrelling and hating, and scarcely able to say a sincere word to one another. Painting, it's true, like the most exacting of mistresses, harasses and torments me in a hundred ways. For the last four months I have been getting up at dawn, and hurrying off to this enchanting work as though I were rushing to throw myself at the feet of a beloved mistress. What seemed so easy at a distance, has now become dreadfully and unceasingly difficult. But how is it that this unending struggle revives instead of destroying me and, far from discouraging, comforts me and occupies my mind when I leave it? A blessed compensation for all that has gone with my youth! A noble occupation for the old age that is already assailing me in so many ways, but still leaves me strength to overcome bodily suffering and the ills of the spirit!

On the yellowish high lights on flesh. In the note-book for 1852, 11 October, I see that I made the following experiment: on some figures in the Hôtel de Ville that were reddish or purplish in colour, I risked some high lights of *Naples yellow*, and although this went against the law that demands cold high lights, the contrast of the yellow on the violet tone produced the effect satisfactorily.

7 January

Part of my answer to a letter from Grzymala:

' . . . I will let you know as soon as I have finished, and shall look

forward to seeing you again with all the pleasure and warmth of feeling that your kind letter has revived. With whom else can I speak of that incomparable genius[1] whom heaven grudged to us on earth, and of whom I think so often, now that I can no longer see him in this world, nor hear his divine melodies?

'If you should see charming Princess Marcelline—another person for whom I have a great regard—give her my compliments, as from a poor man who has never forgotten her kindness, nor his admiration for her talent—another bond with the seraph whom we have lost, and who is now charming the heavenly spheres.'

12 January

I enjoy copying the following letter, which I wrote to Mme Sand *currente calamo*:

'My dear friend,

'I have learned, although I forget through whom, that you were quite well again and intending to spend the winter somewhere (I don't know where) to make your recovery complete. Everything you do is right, but I cannot say that I am much impressed with the idea of staying in inns as a health-cure. To leave one's comfortable bed in the corner where one has been planted by providence is like being deprived of one's mother's milk. My own health, thank God, has been very good up to the present, although I find, as I feared, that after spending two winters by my fireside I have to avoid running risks and laying myself open to chances of catching a chill. For the last four months I have been doing a job which has given me back the health I thought lost for ever. I get up very early and hurry off to my work. I return home as late as possible and begin again next day. This never-ending hobby of mine, and the zest I bring to working like a cab-horse, makes me feel that I have returned to that delicious age when one is always running after something or other, and especially after those fair deceivers who charm us even as they destroy! Nothing gives me more pleasure than painting and now it is giving me the health of a man of thirty into the bargain. It occupies my whole mind, and the only intrigue I carry on is to give myself entirely over to it. In other words, I am buried in my work, like Newton (who, incidentally, died a virgin) in his famous discovery of the law of gravity (I think that was it).

[1] He was referring, of course, to Chopin.

'I have only space left to tell you that I shall always love you dearly . . .'

15 January

Among other things which I wrote to M. Berryer: *To Finish* requires a heart of steel. You have to make decisions all the time, and I am finding difficulties where I thought there would be none. The only way I can keep up this life is to go to bed early and do nothing whatsoever outside my work, and I am sustained in my resolution to give up every pleasure, and most of all that of seeing the people I love, only by the hope of carrying the work through to completion. I think it will kill me. It is at times like these that one realizes one's weakness and how many incomplete or uncompletable passages there are, in what a man calls a *finished* or *complete* work.

1862

Augerville, Thursday, 9 October

Arrived here on Tuesday.

We must not do our nation an injustice. In our own times, France has produced a phenomenon in the arts which I think is unparalleled. After the marvels of the Renaissance, when, especially in sculpture, we equalled and even surpassed the Italians, France did, it is true, pass through a period of decadence, once again following the example set by Italy, just as she had followed the example of her great master-pieces. The still-glorious reign of the Carracci led to a series of degenerate schools both in Italy and France, with Vanloo supplying the last word. But it was reserved for our country to bring back, in due course, the taste for the simple and the beautiful. The works of the French philosophers reawakened a feeling for nature and the cult of Ancient Greece. David, in his painting, summarized the results of both. It is hard to imagine what such novel and audacious ideas would have become in his hands had he possessed the extraordinary genius of Michelangelo or Raphaël; however that may be, they had im-mense influence amid the general reformation of ideas and political theories. Great artists continued the work of David, and when the heritage, falling into less able hands, seemed to be stricken with the listlessness that has attacked the finest schools one after the other, a second renewal, as fruitful of ideas as the one which David brought about, showed phases of art quite new in the history of painting.

Gros, the offspring of David but original in so many ways, was followed first by Prud'hon, who combined the nobility of antique art with the grace of Leonardo and Correggio, and later by Géricault, more romantic than Gros, and at the same time more influenced by the vigour of the Florentines. These men have revealed boundless horizons and paved the way for every kind of new development in art.

Today, 12 October 1862

Augerville.

God is within us. He is the inner presence that causes us to admire the *beautiful*, that makes us glad when we do right, and consoles us for having no share in the happiness of the wicked. It is he, no doubt, who breathes inspiration into men of genius, and warms their hearts at the sight of their own productions. Some men are virtuous as others are geniuses and both are inspired and favoured by God. Therefore the reverse should be true; there must be natures in whom the divine afflatus takes no effect; men who commit crimes cold-bloodedly, and never rejoice in the sight of the *true* and the *beautiful*. Thus, the Eternal Being has his favourites. Happily, these great-hearted men do not sink under the misfortunes which all too often seem to dog them in their short passage through life. The sight of the wicked laden with the gifts of fortune should not discourage them—but what am I saying? They are often comforted by seeing the anxieties and fears that assail evil men and make their prosperity a bitterness to them. They often witness the punishment of the wicked in this world. The inward satisfaction of obeying divine inspiration is sufficient reward; the despair of the wicked when they are frustrated in their wrongful pleasures is . . .

1863

Paris, 26 March

Carrier, who came to call on me, has promised me some Alken prints.[1]

14 April

On the Beautiful. This is always a vexed question; the word is quite indefinite—of course, I am only considering the Beautiful in

[1] Samuel Alken, the English engraver, whose prints Delacroix admired.

the arts. Fundamentally, the Beautiful in painting and in every other art (as I think it should be understood) amounts to the same thing, but still . . .

I have found in my note-books, the following definition, by Mercey, that cuts clean across the ambiguity between the beauty which consists only in pure lines, and the beauty which consists in the impression on the imagination caused by other means: *The Beautiful is truth idealized.*

23 April

Dined with Bertin and enjoyed myself, as always. Found Antony Deschamps there; he is the only man to whom I enjoy talking music. because he likes Cimarosa as much as I do. I was saying to him that the great drawback to music is the absence of any element of surprise. because one learns to know the various pieces so well. One's pleasure in the finest passages is lessened by the lack of anything unforeseen. Expectation of the weak and boring passages, which we know equally well, can make it a kind of martyrdom to listen to music that delighted us at a first hearing, when the careless passages merged in with the rest and almost served as links in the composition. Painting has not this disadvantage; it does not grip you by the throat as music does; you can turn your eyes away whenever you choose. Besides, everything can be seen at once, and when you like a picture you get into the habit of looking only at the beautiful parts, of which you never grow tired.

A certain M. Trélat with a delightful voice was also there But why do people with good voices never think of singing good music? Antony says that all modern music is alike. It is all slight and frivolous. We are snowed under with trivialities in music, as in everything else for that matter—painting, literature, and the theatre.

A composer writes a *Faust* and puts in everything except *Hell*. He has no conception of the principal character—the terror mingling with the comedy.

Don Juan was differently conceived. I always feel the talons of Mephistopheles outstretched above the libertine, waiting to seize him.

4 May

One may hold what views one likes of the system of mixing comedy with tragedy after the manner of Shakespeare, which was so much extolled by the romantics. Genius of Shakespeare's quality is

justified in making us accept it, because of the power and freedom of the ideas and the grandeur of the design. But I believe that this style should be forbidden to minor geniuses; we owe a great many bad plays and novels to such unfortunate misconceptions. The best novels of the last thirty years have been ruined by it; Dumas, for example, and Mme Sand.

But this is not the only drawback to modern literature. Nobody, nowadays, can write a sermon or a book of travels, or even the report of some ordinary event, without going through the whole gamut of different styles. Even Thiers, steeped as he is in tradition and in the great works of French literature, could not refrain from padding out his fine history with perorations, chapter-endings, and reflections in a maudlin and sentimental style. If a man writes about a journey, he has to describe each sunset and landscape with a kind of humorous tenderness which he imagines will win over his reader. You find this mixture of styles in every piece of writing now and very nearly in every line. 'Today,' Voltaire says, 'they write history after the manner of comic opera,' etc. *It is good for everything to be in its place.* When that astonishing man wrote *La Pucelle*, he never took his reader out of a light and playful style and never varied this humorous tone. On the other hand, when he devoted a page to writing eloquently on the Maid of Orleans, in his *Essai sur les Mœurs*, he showed nothing but admiration and sorrow, and yet managed to avoid a style of pompous apologia or funeral oration.

One cannot read a comedy or a farce nowadays, without having a handkerchief out, ready to mop one's eyes at the passages where the author tries to appeal to one's finer feelings.

Friday, 8 May

I have written to Dutilleux:

'My dear old friend, when I saw you looking at the little sketch of "Tobias" the day before yesterday and holding it in your hands, I thought it very poor, although I had enjoyed doing it. At any rate, after you had gone, I remembered that you seemed to like the little picture of the lion, on one of the easels. I hope I am not mistaken in thinking that you took a fancy to it. I would have sent it to you there and then, but it needed one or two finishing touches, which I added yesterday. If you will accept it with all the pleasure I feel in sending it to you, you will make me very happy.

'It is still wet in places; keep it free from dust for a day or two.'

Champrosay, 16 June

Returned to Champrosay after two weeks of illness.

22 June

[*Written in pencil in a small notebook.*] The first quality in a picture is to be a delight for the eyes. This does not mean that there need be no sense in it; it is like poetry which, if it offend the ear, all the sense in the world will not save from being bad. They speak of *having an ear* for music: not every eye is fit to taste the subtle joys of painting. The eyes of many people are dull or false; they see objects literally, of the exquisite they see nothing.

END OF THE JOURNAL

[Delacroix died on 13 August of the same year.]

THE PLATES

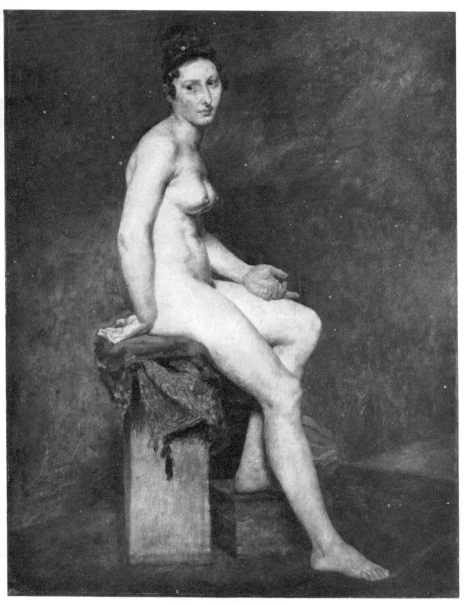

I. NUDE FIGURE STUDY, MLLE ROSE

2. GÉRICAULT: THE RAFT OF THE 'MEDUSA'

3. DANTE AND VIRGIL IN THE INFERNAL REGIONS

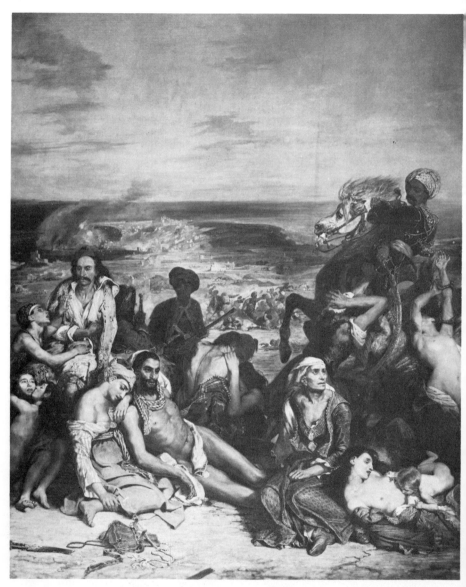

4. THE MASSACRE AT SCIO

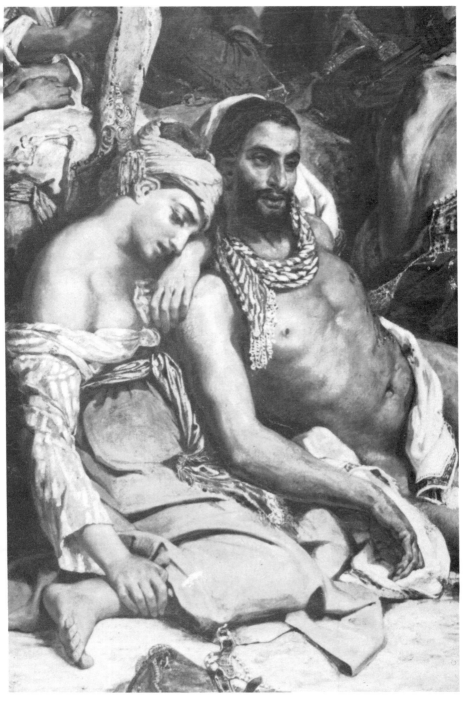

5. Detail from Plate 4

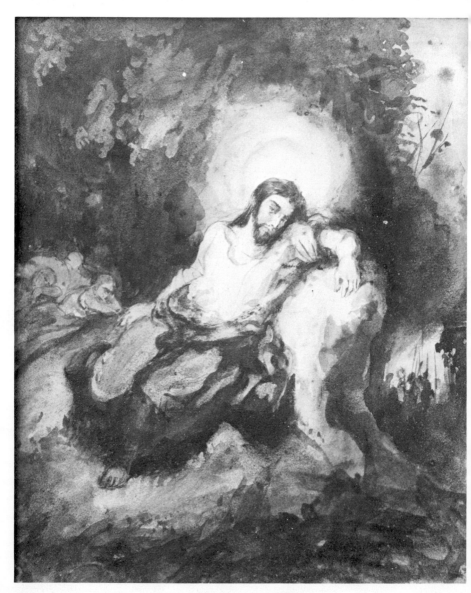

6. THE AGONY IN THE GARDEN

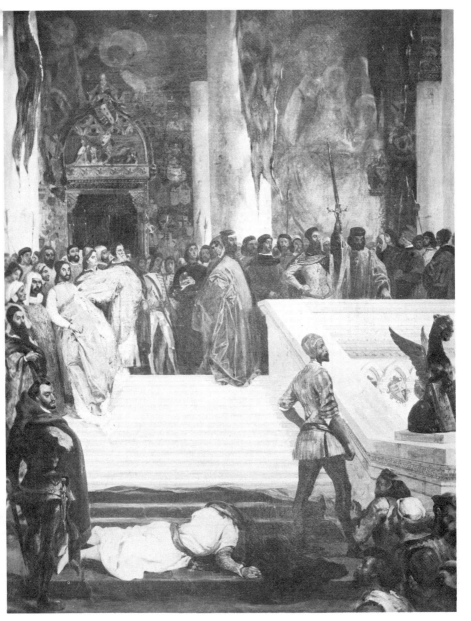

7. THE EXECUTION OF DOGE MARINO FALIERO

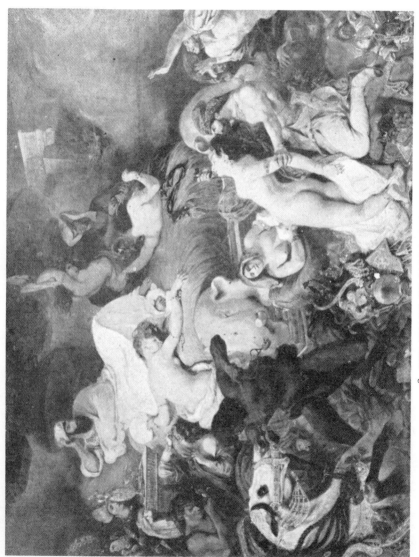

8. THE DEATH OF SARDANAPALUS

9. Detail from Plate 8

11. WOMAN WITH A PARROT

12. THE MURDER OF THE BISHOP OF LIÉGE

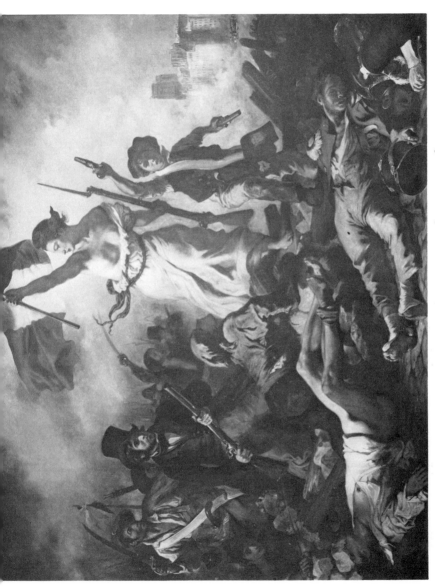

13. LIBERTY GUIDING THE PEOPLE: THE 28TH JULY, 1830

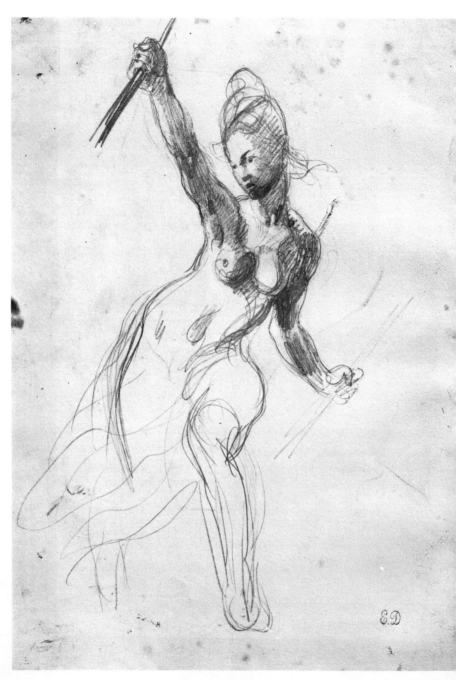

14. LIBERTY
Drawing for Plate 13

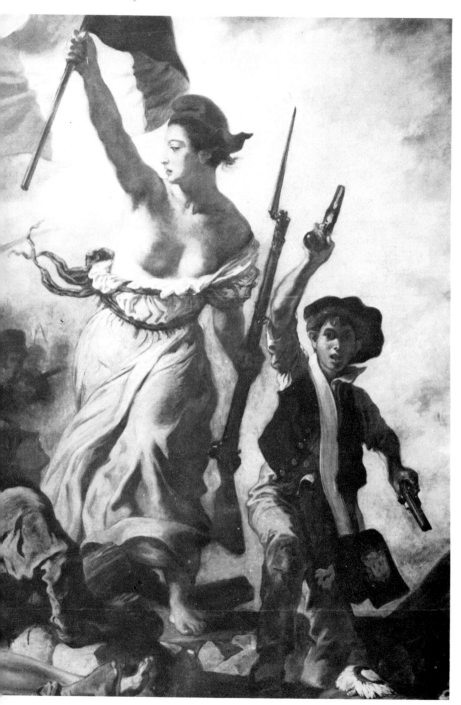

15. Detail from Plate 13

17. WOMEN OF ALGIERS

18. CHESS PLAYERS IN JERUSALEM

19. THE BATTLE OF TAILLEBOURG

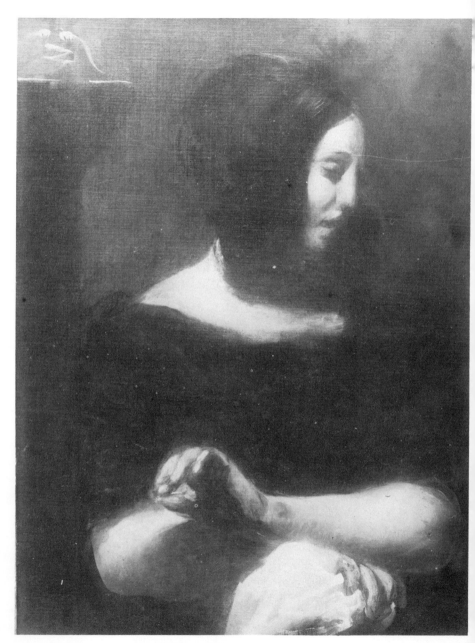

20. PORTRAIT OF GEORGE SAND

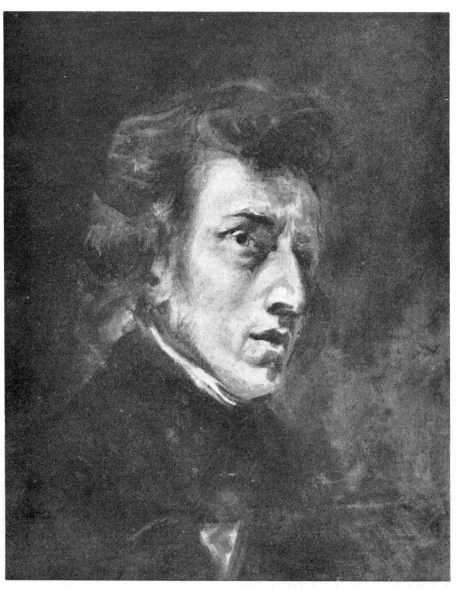

21. PORTRAIT OF FRÉDÉRIC CHOPIN

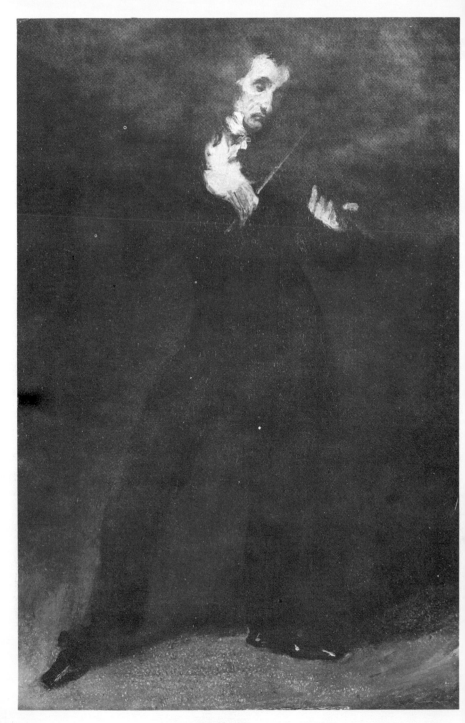

22. PORTRAIT OF PAGANINI

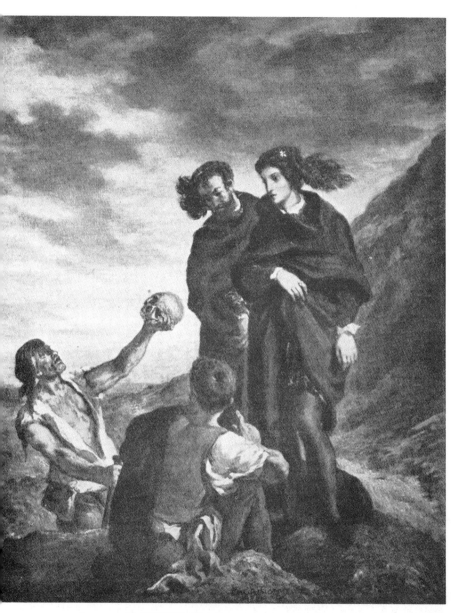

23. HAMLET AND THE GRAVE-DIGGER

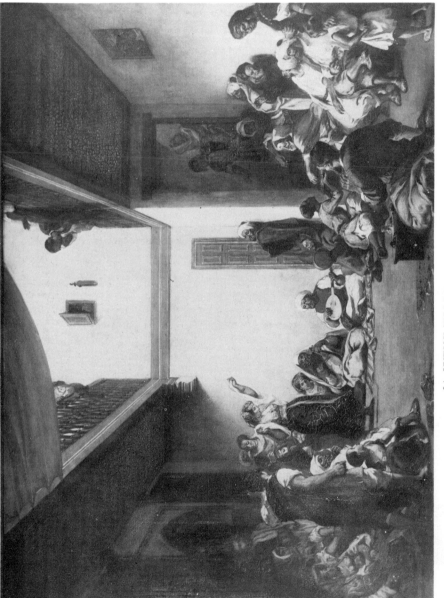

24 JEWISH WEDDING IN MOROCCO

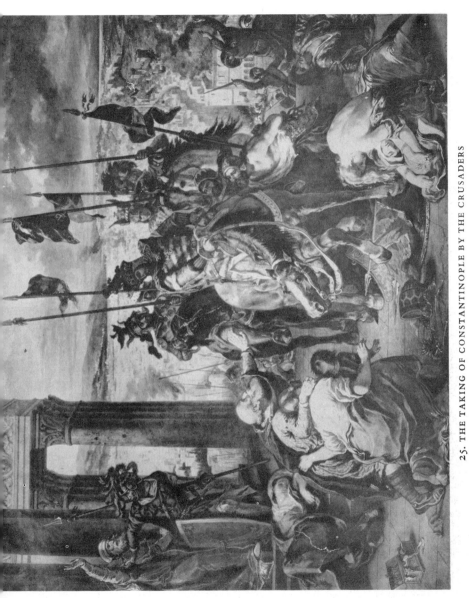

25. THE TAKING OF CONSTANTINOPLE BY THE CRUSADERS

26. Detail from Plate 25

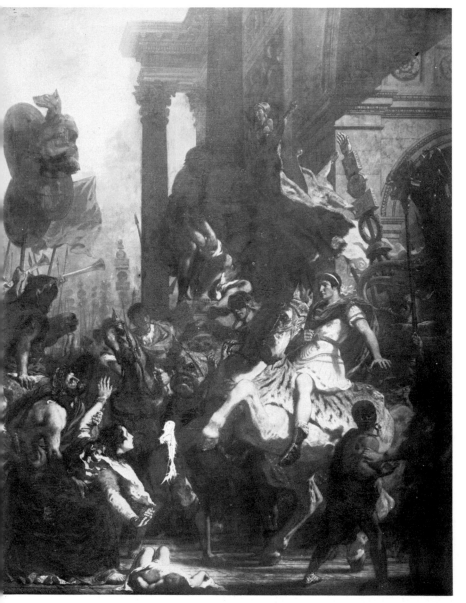

27. THE JUSTICE OF TRAJAN

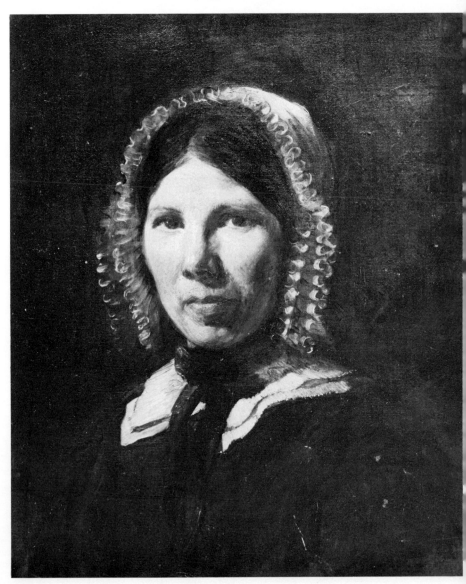

28. PORTRAIT OF JENNY LE GUILLOU

29. 'L'AMOUREUSE AU PIANO'

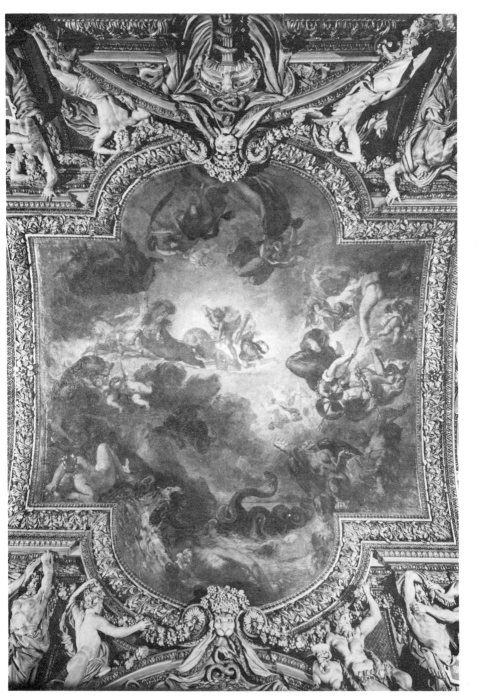

33. APOLLO VICTORIOUS OVER THE SERPENT PYTHON

34a. THE EDUCATION OF ACHILLES
Study for Plate 35

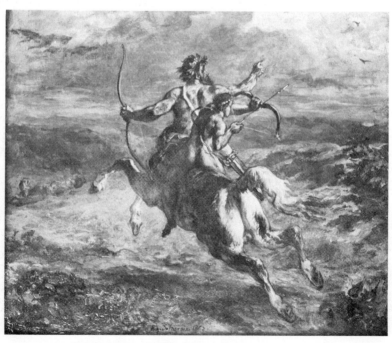

34b. THE EDUCATION OF ACHILLES
Variant of Plate 35

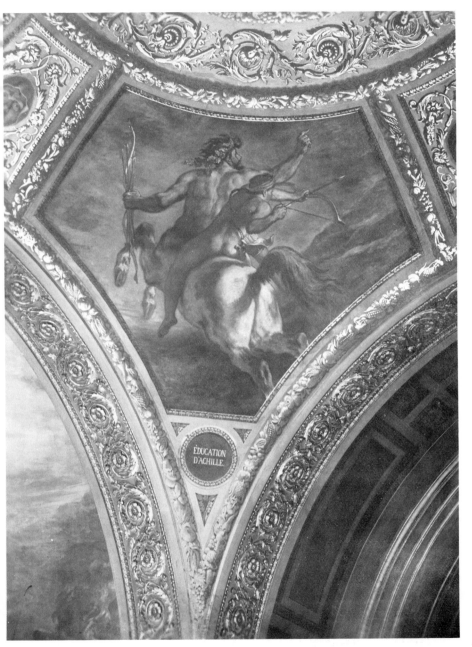

35. THE EDUCATION OF ACHILLES

36a. VIRGIL PRESENTING DANTE TO HOMER

36b. VIRGIL PRESENTING DANTE TO HOMER
Study for Plate 36a

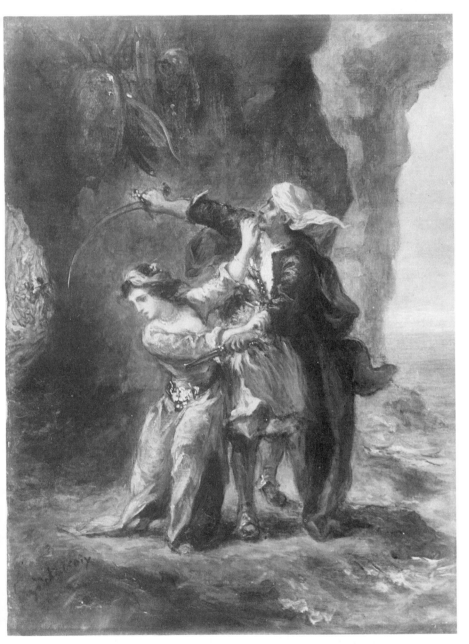

37. THE BRIDE OF ABYDOS

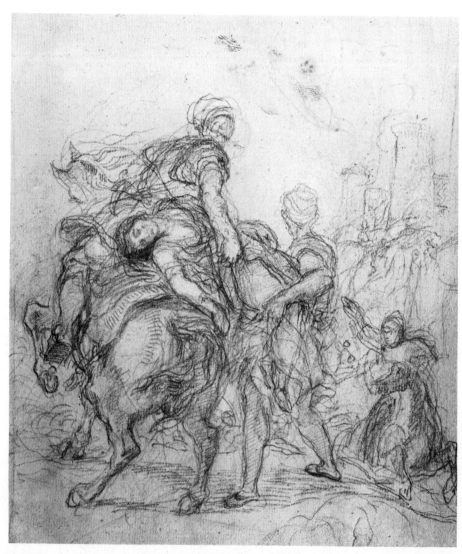

38. THE ABDUCTION OF REBECCA
Study for Plate 39

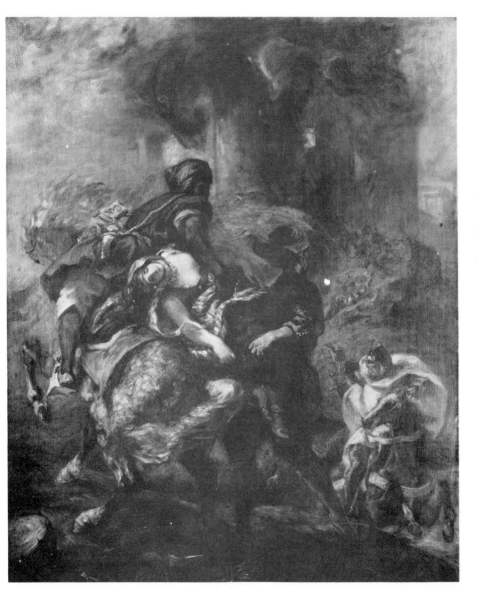

39. THE ABDUCTION OF REBECCA

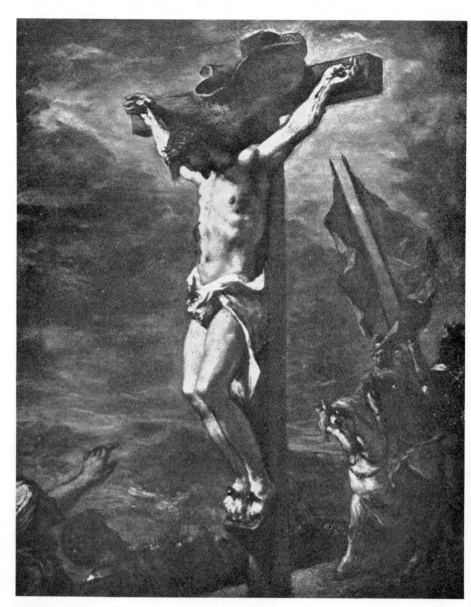

40. CHRIST ON THE CROSS

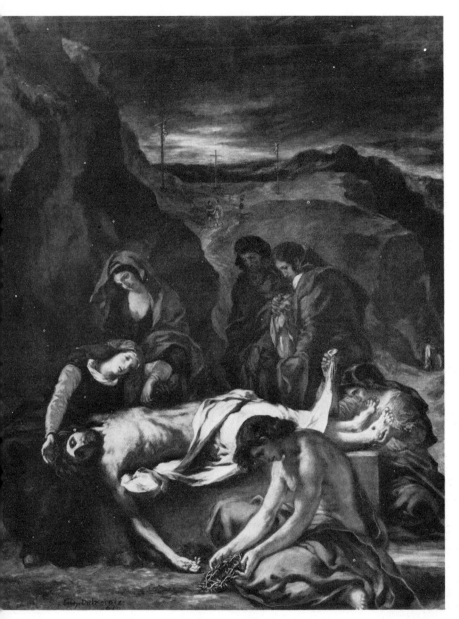

4I. THE ENTOMBMENT

42. RUBENS: Detail from 'The landing of Marie de Médicis'

43. STUDY OF A TORSO
Copy of the Water-nymph in Plate 42

44. Souvenir of Rubens's 'Coup de lance'

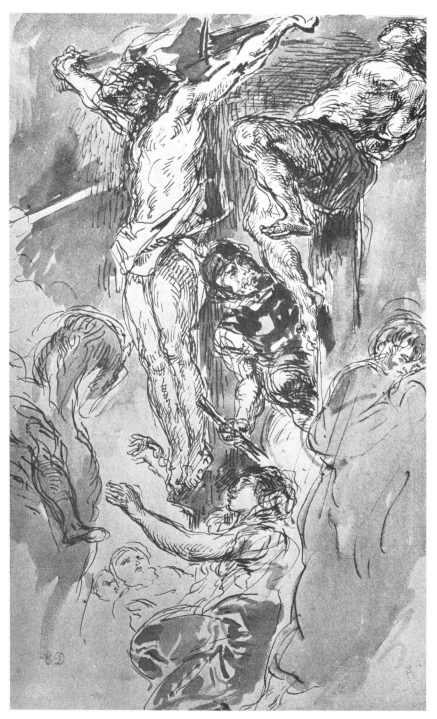

45. THE CRUCIFIXION

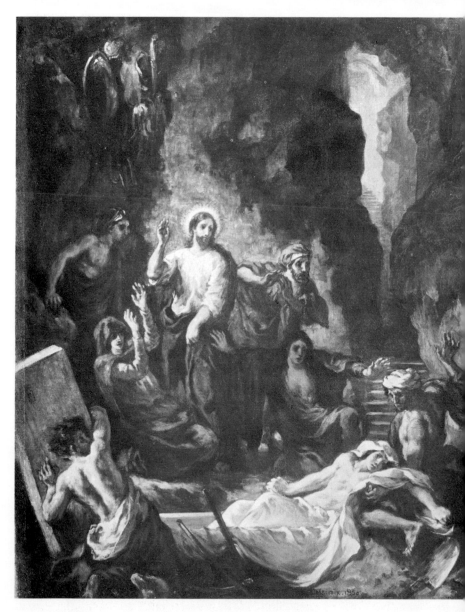

46. THE RAISING OF LAZARUS

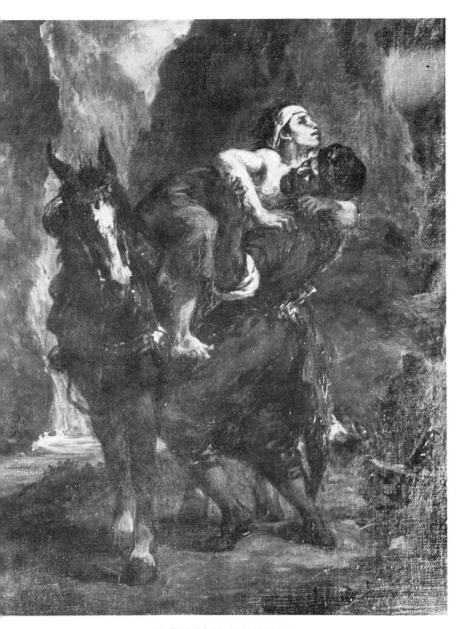

47. THE GOOD SAMARITAN

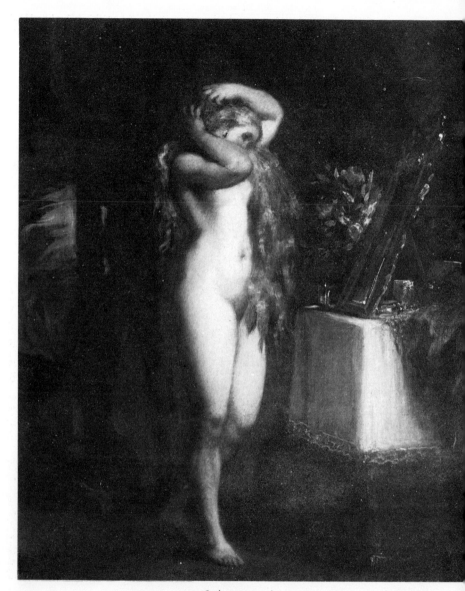

48. 'LE LEVER'

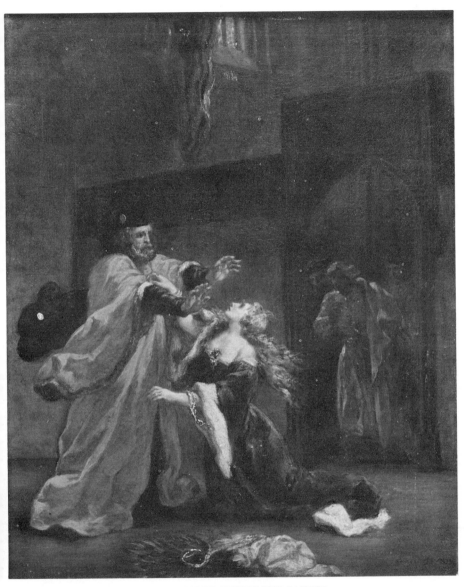

49. DESDEMONA BEFORE HER FATHER

50. THE SEA AT DIEPPE

51. THE QUAI DUQUESNE, DIEPPE

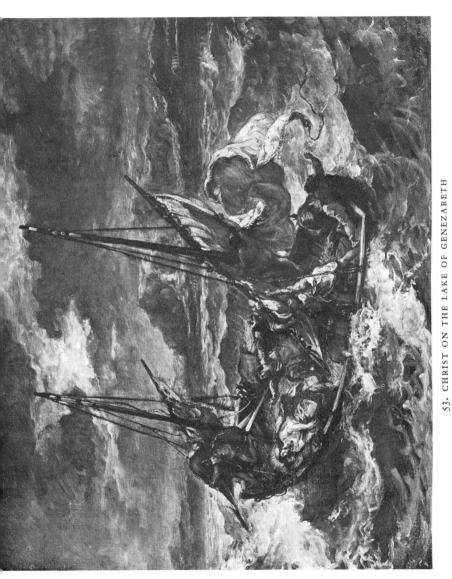

53. CHRIST ON THE LAKE OF GENEZARETH

54. LION DEVOURING A CROCODILE

55. LION HUNT

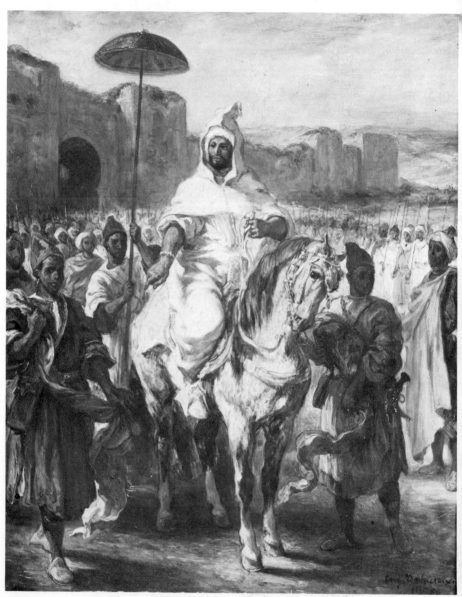

56. THE SULTAN OF MOROCCO WITH HIS BODYGUARD

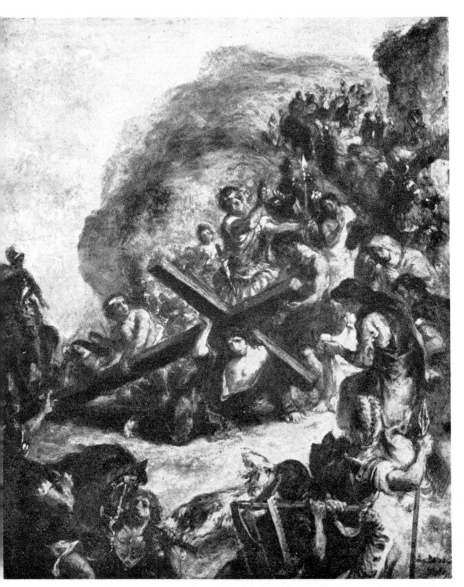

57. CHRIST FALLING UNDER THE CROSS

58. OVID IN EXILE WITH THE SCYTHES

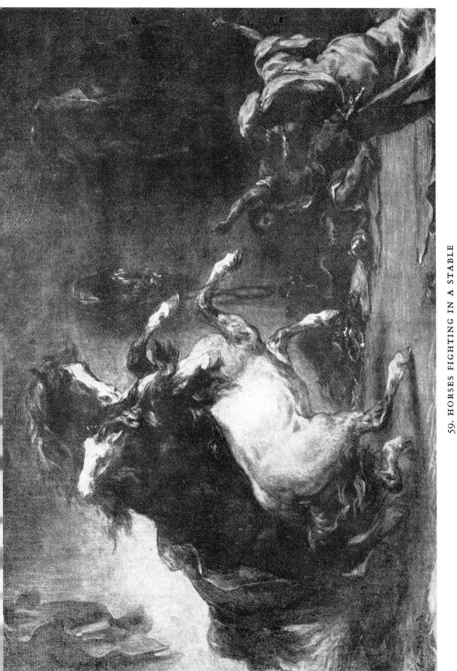

59. HORSES FIGHTING IN A STABLE

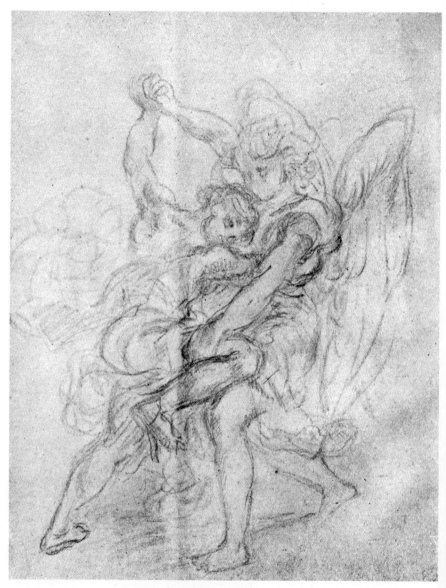

60. JACOB WRESTLING WITH THE ANGEL
Study for Plate 62

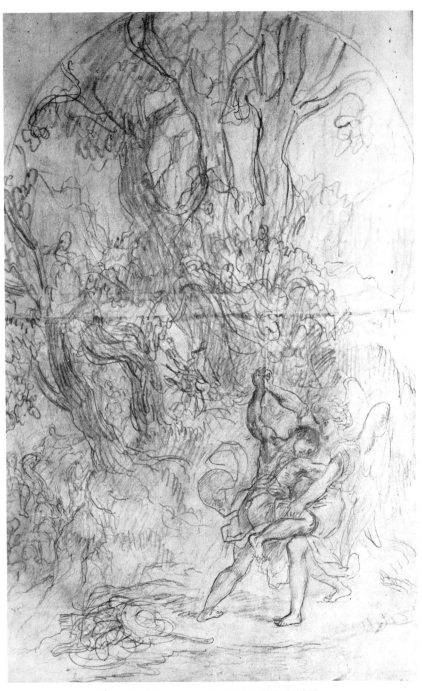

61. JACOB WRESTLING WITH THE ANGEL
Study for Plate 62

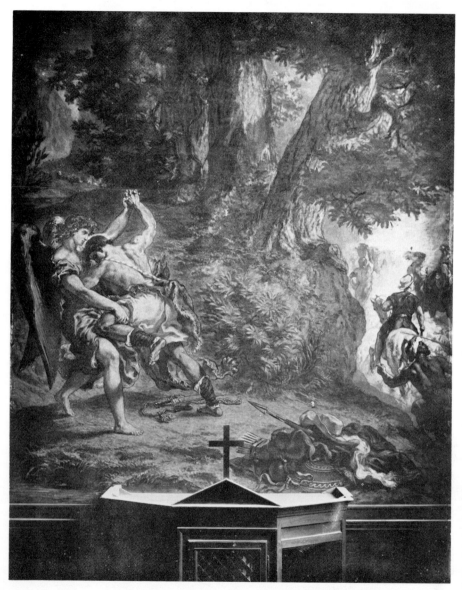

62. JACOB WRESTLING WITH THE ANGEL

NOTES ON THE PLATES

1. NUDE FIGURE STUDY, MLLE ROSE. *c.* 1821–3. PARIS, LOUVRE

One of two academic studies of a favourite model, Rose, which show the admirable technical equipment which Delacroix had developed in the studio of Guérin.

2. GÉRICAULT: THE RAFT OF THE 'MEDUSA'. 1819. PARIS, LOUVRE

Criticized violently when first exhibited in Paris, this picture moved Delacroix profoundly (Introduction, p. xi). Géricault's work and personality were the most potent influences on the younger painter's formation.

3. DANTE AND VIRGIL IN THE INFERNAL REGIONS. 1822. PARIS, LOUVRE

Dante and his guide are rowed by the boatman Phlegyas across the turbulent lake which surrounds the flaming city of Dis, amid writhing figures of the damned. This first large work was abused by critics for its violence of gesture and colour, but a famous article by Adolphe Thiers declared that the painter showed the mark of genius. Now a sombre painting in colour, it still exhales power and dramatic grandeur.

Delacroix began his Journal in September 1822, and page 2 records the news that this picture had been bought by the State and hung in the Luxembourg.

4. THE MASSACRE AT SCIO. 1824. PARIS, LOUVRE

Delacroix chose the subject for his Salon picture of 1824 from an actual event in the Greek War of Independence rather than from poetry or legend (Journal of May 1823, page 15). The grandeur of Michelangelo still occupied his mind, but the new subject demanded a new realism in style and detail. Delacroix gathered evidence from eye-witnesses (cf. Géricault and the Raft), made many studies, and began the picture on 12 January 1824, working often directly on the canvas from friends and models.He was copying a painting said to be by Velázquez at this time, and was intent on dramatic expression in individual heads. Then there was the influence of Constable and Bonington (Journal, 9 November 1823 and 19 June 1824: and a letter to Th. Silvestre: 'Constable impressed me greatly at the time when I was painting the "Massacre at Scio".') Tradition says that he took down his canvas after it was hung on the Salon walls and worked on the sky and landscape in the gallery.

5. DETAIL FROM PLATE 4.

In spite of the enmity of the classical school and the comment from Baron Gros—'a massacre of painting'—the picture was bought by the State for 6,000 francs.

6. THE AGONY IN THE GARDEN. WATER-COLOUR, 1826. PARIS, LOUVRE

One of the studies for the large painting of 1826 for the church of St. Paul-St. Louis, though very different from the final picture.

7. THE EXECUTION OF DOGE MARINO FALIERO. 1827. LONDON, WALLACE COLLECTION

Painted soon after his trip to England. Delacroix sent this with some other pictures to be exhibited in this country, where it was particularly admired by Sir Thomas Lawrence, who considered buying it.

8. THE DEATH OF SARDANAPALUS. 1827. PARIS, LOUVRE

The king lying on a superb bed, surmounting a funeral pyre, orders the execution of his favourites—women, pages, horses and dogs; the subject from Byron. This vast canvas, 13 ft. by 20 ft., caused enormous scandal and proved a severe if temporary check in his recognition by the State authorities. Delacroix was himself dissatisfied but decided that it contained good qualities as well as faults.

9. DETAIL FROM PLATE 8

This lovely blonde girl leaning against the couch is an excellent example of the influence of Flemish and English technique on Delacroix at this period.

10. HORSE FRIGHTENED BY A STORM. 1824. BUDAPEST, MUSEUM

Delacroix followed Géricault in his love of horses in action and was himself a horseman. This intensely imagined and romantic water-colour was given by him to his friend Baron Schwiter, whose portrait by Delacroix is in the National Gallery, London.

11. WOMAN WITH A PARROT. 1827. LYONS, MUSEUM

One of a number of small nudes of the same period as the 'Sardanapalus' (Plate 8).

12. THE MURDER OF THE BISHOP OF LIÉGE. SKETCH, 1829. LYONS, MUSEUM

Sketch for a larger painting. The subject, taken from Scott's *Quentin Durward*, is typical of the Romantic movement, and of Delacroix's association with Victor Hugo at this time. The bishop in his sacred vestments is brought in and murdered at an orgy of William of the March.

13. LIBERTY GUIDING THE PEOPLE: THE 28TH JULY, 1830. DATED 1830. PARIS, LOUVRE.

Commissioned for a battle theme of Valmy or Jemappes, Delacroix chose to paint the barricades of contemporary history, and fused realistic detail with imaginative symbolism.

14. STUDY FOR THE FIGURE OF LIBERTY IN PLATE 13. PARIS, LOUVRE. FORMERLY COLLECTION E. DEGAS

15. DETAIL FROM PLATE 13.

16. ARAB LYING ON A DIVAN. WATER-COLOUR. 1832. PARIS, LOUVRE

17. WOMEN OF ALGIERS. 1834. PARIS, LOUVRE

Painted two years after his return from Africa, this calm un-emotional picture is a rare oasis in Delacroix's dramatic subjects and compositions.

It seems to embody interests and experiments in colour contrasts and harmonies, expressed in oriental traditional patterns, and was to have a great effect on his own and later French painting. Delacroix gives prominent place to this picture in his written applications for admission to the Institute. The reference in the Journal, 7 February 1849, is apparently to the smaller version, now at Montpellier Museum.

18. CHESS PLAYERS IN JERUSALEM. 1835. CHICAGO, ART INSTITUTE

19. THE BATTLE OF TAILLEBOURG. 1837. VERSAILLES, MUSEUM

Delacroix had painted the 'Battle of Poitiers' in 1829 and 'of Nancy' in 1831. 'Taillebourg' was commissioned for the Gallery of Battles at Versailles. The 15 ft. by 18 ft. picture was shown at the Salon of 1837, and represents King St. Louis forcing the bridge over the Charente defended by an English army. The 'pink' white horse which domi-nates the painting became famous, in this most vigorously imagined of all Delacroix's battle-pictures.

20. PORTRAIT OF GEORGE SAND. 1838. COPENHAGEN, COLLECTION HANSEN

This and the portrait of Chopin (Plate 21) originally formed parts of one picture. Chopin was seated, improvising at the piano, George Sand standing behind him listening. The canvas remained in Dela-croix's studio until his death.

21. PORTRAIT OF FRÉDÉRIC CHOPIN. 1838. PARIS, LOUVRE

This, the more complete of the two portraits, is said to have been detached in 1889.

22. PORTRAIT OF PAGANINI. 1838. WASHINGTON, PHILIPPS GALLERY

Sketch, on cardboard.

23. HAMLET AND THE GRAVEDIGGER. 1839. PARIS, LOUVRE

Two other versions of this subject and fifteen imaginative composi-tions in lithography show the hold that Shakespeare's play had on

Delacroix's imagination. Indeed, a small picture of himself in the costume of Hamlet in 1821 suggests some identification of the painter with the Shakespearian figure at this time.

24. JEWISH WEDDING IN MOROCCO. 1839. PARIS, LOUVRE

A sharply observed description is given in the Moroccan Journal, 21 February 1832. The discovery of ancient traditions in the customs of contemporary Morocco stirred Delacroix deeply.

25. THE TAKING OF CONSTANTINOPLE BY THE CRUSADERS. 1840. PARIS, LOUVRE

'Baudouin, Count of Flanders, and other leaders pass through the various quarters of the town and weeping families implore their mercy.' In conception it is noteworthy that an expression of pity is evoked in the victors which is quite absent in earlier 'massacres'. Tragedy is conveyed by a powerful vinous range of colour as well as by what Baudelaire called 'the emphatic truth of gesture in the great events of life'.

26. DETAIL FROM PLATE 25

This expressive group is also one of the most masterly examples of Delacroix's ripe technical method of hatching strokes of primary colours across a chosen local tint.

27. THE JUSTICE OF TRAJAN. 1840. ROUEN, MUSEUM

After a visit to the Museum Delacroix wrote in the Journal (30 October 1849): 'I cannot remember ever being so pleased by one of my pictures . . .' It is now badly cracked, but its power of design bears out his verdict.

28. PORTRAIT OF JENNY LE GUILLOU. c. 1840. FORMERLY COLLECTION MME LA COMTESSE NOURYE-ROHOZINSKA. PARIS, LOUVRE

Left in the painter's will to his famous housekeeper, she willed it to a M. Duriez, and until the exhibition of 1930 it was regarded as a lost work.

29. 'L'AMOUREUSE AU PIANO.' WATER-COLOUR. 1843. COLLECTION J. L. VAUDOYER

Once regarded as a portrait of La Malibran, but this is no longer believed.

30. THE SHIPWRECK OF DON JUAN. 1840. PARIS, LOUVRE

The subject of the casting of lots is from Byron, and the mood of tragedy is again expressed by colour.

31. ROGER AND ANGELICA. 1847. PARIS, LOUVRE

The subject has been sometimes described as 'St. George and the Dragon', and as 'Perseus and Andromeda'. But the title, from Ariosto, is given in Robaut's catalogue, and confirmed by M. L. Hourticq. The mediaeval armour scarcely recalls a Greek hero.

32. APOLLO IN HIS CHARIOT. DRAWING. PARIS, LOUVRE

Study for the ceiling in the Louvre, see Plate 33.
Apparently a pencil tracing from another drawing, not a first idea for the composition.

33. APOLLO VICTORIOUS OVER THE SERPENT PYTHON. 1850. BRUSSELS, MUSEUM

A sketch of the whole painting (with suggestions of ornamental borders) for the ceiling of the Galérie d'Apollon, Louvre, 1849–52.

34a. THE EDUCATION OF ACHILLES. DRAWING. PARIS, LOUVRE

Study for the mural decoration at the Palais Bourbon, Plate 35.

34b. THE EDUCATION OF ACHILLES. COLLECTION MME DE GANAY

Variant of Plate 35.

35. THE EDUCATION OF ACHILLES

Decoration for second pendentive of the first dome in the Library of the Palais Bourbon, 1838–47.

36a. VIRGIL PRESENTING DANTE TO HOMER. 1840–7. PARIS, LIBRARY OF THE SENATE, PALAIS DU LUXEMBOURG

36b. STUDY FOR PLATE 36a. COLLECTION GOBIN

37. THE BRIDE OF ABYDOS. 1843. PARIS, LOUVRE

Subject from Byron: Selim prepares to defend his betrothed against the approaching enemy.

38. THE ABDUCTION OF REBECCA. DRAWING. 1846. NEW YORK, METROPOLITAN MUSEUM

Study for Plate 39.

39. THE ABDUCTION OF REBECCA. 1846. NEW YORK, METROPOLITAN MUSEUM

The subject from *Ivanhoe*, by Sir Walter Scott. Another version, dated 1858, is in the Louvre.

40. CHRIST ON THE CROSS. *c.* 1845. COLLECTION MME CLEMENCEAU-MAURICE

This small tragic picture shows how much Delacroix absorbed from Prudhon, on whom he wrote an article in the *Revue des Deux Mondes* in 1846. The Journal of 27 April 1847 has a glowing note on Prudhon's portrait of Josephine.

41. THE ENTOMBMENT. 1848. BOSTON, MUSEUM

Although he grew up in surroundings very alien to religion, and was himself a great reader of Voltaire and Diderot, Delacroix executed a great number of pictures—some of them commissions for churches, others chosen at will—which express his profound sense of the grandeur and tragedy of Christian history. In Baudelaire's view 'he alone, in our unbelieving age, conceived religious pictures which were neither without meaning nor cold, like the result of struggles for commissions'. Journal, 15 February and 1 March 1847.

42. DETAIL FROM RUBENS'S 'LANDING OF MARIE DE MÉDICIS'. PARIS, LOUVRE

See Journal, 1 June 1849, and footnote.

43. STUDY OF A TORSO. EX COLLECTION G. AUBRY

Copy by Delacroix of the water-nymph in Plate 42.

44. SOUVENIR OF RUBENS'S 'COUP DE LANCE' (ANTWERP). 1850. PARIS, LOUVRE

In religious pictures as in all his work Rubens was the great exemplar of Delacroix. This small note in pastel dates from his visit to Belgium in 1850. See Journal, 10 August 1850, for a verbal analysis of the painting.

45. THE CRUCIFIXION. 1850. WASHINGTON, COLLECTION J. S. THACKER

Drawing in pen and wash, a study of Rubens's 'Coup de lance'.

46. THE RAISING OF LAZARUS. 1850.

47. THE GOOD SAMARITAN. 1850. COLLECTION MME ESNAULT-PELTERIE

Predominantly a picture of intense colour, to be later re-orchestrated by Van Gogh, in his transposition from an engraving.

48. 'LE LEVER'. 1850. COLLECTION DAVID-WEILL

See Journal, 14 February 1850, and footnote.

49. DESDEMONA BEFORE HER FATHER. 1852. RHEIMS, MUSEUM

Appealing against his curse on her secret marriage with Othello, who is seen in the doorway.

50. THE SEA AT DIEPPE. 1852. EX COLLECTION BEURDELEY.

See Journal, 14 September 1852.

51. THE QUAI DUQUESNE, DIEPPE. DRAWING, 1854. PARIS, LOUVRE

Delacroix stayed at No. 6, Quai Duquesne. See Journal, 18 August to 26 September 1854.

52. CHRIST ON THE LAKE OF GENEZARETH. 1853

53. CHRIST ON THE LAKE OF GENEZARETH. 1853, NEW YORK, METRO-POLITAN MUSEUM

There are no fewer than seven versions of this subject. Delacroix was always fascinated by the sea at Dieppe. On 11 or 12 September 1852, the Journal shows him staying at the pier for four hours to watch the waves breaking with splendid fury.

54. LION DEVOURING A CROCODILE. 1855. PARIS, LOUVRE

55. LION HUNT. 1855. BORDEAUX, MUSEUM

Between 1854 and 1861 Delacroix produced four large Lion Hunts, or Combats between men and wild beasts. They seem to be the product of reminiscences of the Morocco journey, the emulation of Rubens, and his natural love of wild animals. The Journal of 19 and 25 January 1847 is illuminating. The Bordeaux picture is ruined in design by the loss of its upper portion with two horsemen, through a fire in 1870.

56. THE SULTAN OF MOROCCO WITH HIS BODYGUARD. 1856. COLLECTION EUGÈNE MIR

A more animated version of a picture of 1845, at Toulouse. The subject is described in detail in the Moroccan Journal of 22 March 1832.

57. CHRIST FALLING UNDER THE CROSS. 1859. METZ, MUSEUM

A small picture, 23 in. by 19 in., intended to be executed on the scale of the St. Sulpice walls. The elaborate spiral composition seems to recall Tintoretto.

58. OVID IN EXILE WITH THE SCYTHES. 1859. PRIVATE COLLECTION

A particularly calm and harmonious picture, based on Moroccan memories.

59. HORSES FIGHTING IN A STABLE. 1860. PARIS, LOUVRE.

A small picture of great unity and eloquence; the source is to be found in the Moroccan Journal of 29 January 1832.

60. JACOB WRESTLING WITH THE ANGEL. 1857. COLLECTION CLAUDE ROGER-MARX

61. JACOB WRESTLING WITH THE ANGEL. 1857. COLLECTION G. AUBRY

Two studies for Pl. 62, the composition reversed.

62. JACOB WRESTLING WITH THE ANGEL. PARIS, CHURCH OF ST. SULPICE

Commissioned in 1840, after many delays. The walls of the *Chapelle des Anges* were prepared in 1855 and the two great pictures were painted with the aid of assistants between 1856 and 1861. They constituted the culminating effort of the painter's career.

63. THE EXPULSION OF HELIODORUS FROM THE TEMPLE. PARIS, ST. SULPICE

The wall facing 'Jacob and the Angel' shows Heliodorus, about to carry off the Treasures of the Temple, struck down suddenly by a mysterious horseman, and furiously beaten by two heavenly beings, until he is cast from the holy place.

It is interesting to see the strong influence of Raphael's Vatican fresco of the subject on Delacroix's late monumental painting. Taking much from Raphael's grouping and noble humanistic realism, he invests it with a splendid and elaborately related colour composition characteristically his own.

64. BACCHUS AND ARIADNE. 1862–3. FORMERLY COLLECTION GALLATIN

One of four allegorical panels of the Seasons commissioned to decorate the salon of M. Frédéric Hartmann, but never completely carried out. These luminous, graceful inventions on classical themes display a ripe mastery and ease far from the violence of his early work, and perhaps suggest the relaxation that Delacroix felt after the strain and tension of the wall-paintings at St. Sulpice.

NOTES ON THE ILLUSTRATIONS IN THE TEXT

I. SELF-PORTRAIT. *c.* 1830. PARIS, LOUVRE

Delacroix retained this, the most characteristic portrait of him in the great period of the Romantic movement. He left it in his will, 'the one with the green Scottish waistcoat', to Jenny Le Guillou, who bequeathed it to the Louvre in 1872.

II. EUGÈNE DELACROIX IN 1862

Photograph by Pierre Petit.

III. HENRIETTE DELACROIX, LATER MME DE VERNINAC, BY DAVID. PARIS, LOUVRE.

Eugène thought highly of this portrait of his sister, and intended it to hang ultimately in the Louvre.

IV. CORNER OF A STUDIO. *c.* 1830. PARIS, LOUVRE

V. DELACROIX (in centre group, with Alfred de Musset on left) AT A SOIRÉE. Water-colour by Eugène Lami.

VI. MADAME DALTON. *c.* 1827. PARIS, LOUVRE

This sketch is now taken to be a portrait of the young French dancer, married to an Englishman, who sat to Bonington and to Delacroix, who was greatly attached to her for several years. She herself was something of a painter.

VII. CONSTABLE: THE HAYWAIN. LONDON, NATIONAL GALLERY

Exhibited with another Constable landscape in Paris in 1823, and awarded a Gold Medal at the Salon of 1824. It greatly stimulated Delacroix (Journal, 9 November 1823, and 19 June 1824), who especially noticed the varied unbroken greens, which gave brilliance to the meadows shown in this detail. See Note on Plate 4.

VIII. COROT: THE BAPTISM OF CHRIST. CHURCH OF ST. NICOLAS-DU-CHARDONNET

Delacroix admired Corot and his work and asked his advice on painting trees (Journal, 14 March 1847).

IX. HOLMAN HUNT: STRAYED SHEEP. LONDON, TATE GALLERY.

Delacroix was impressed by the truth of individual observation in pictures by the Pre-Raphaelite Group (see Journal, 17 June 1855), and enthusiastic about the 'Strayed Sheep' (Journal, 30 June 1855). Hunt, whose work indeed seems the antithesis of Delacroix's, in intention and practice, abused it when Rossetti professed his admiration during their visit to Paris in 1849.

X. LEAF FROM A SKETCH BOOK used during the Moroccan Journey.

XI. RUBENS: THE RAISING OF THE CROSS. 1610–11. ANTWERP, CATHEDRAL

XII. RUBENS: CHRIST ON THE CROSS ('LE COUP DE LANCE'). 1620. ANTWERP, MUSEUM

On his second journey to Belgium in 1850 Delacroix revelled in this opportunity for repeated examination and study of Rubens's work. The Journal of 10 August 1850 analyses the technique of the above two pictures as only a painter can do. But he does not overlook the initial conception of the subject, nor the additional significance given to its expression by the actual performance of painting. In these most characteristic passages he still feels the magnificent power of the earlier work whilst realizing the richer quality of the later one.

XIII. RUBENS: THE LION HUNT. MUNICH, ALTE PINAKOTHEK

A reading of the Journal, 25 January 1849, leaves no doubt as to the stimulus which stirred Delacroix to paint his Lion Hunts. He revels in the ferocity of Rubens's beasts and men and finds all the details 'calculated to stir the imagination and the handling is admirable'— two of the most cherished aims of his own painting. His criticism that 'confusion results and the eye does not know where to rest' might apply to his own Bordeaux picture, Plate 55: but he is discussing an etching from Rubens, without colour, and it is the brilliant *tours de force* of colour and execution which save the Delacroix painting.

XIV. TIGER ATTACKING A WILD HORSE. LITHOGRAPH, 1828

Studies of animals at the Jardin des Plantes gave the knowledge of form but the drama of the design is entirely the result of imagination. Contrasts of texture and tone in the nameless background emphasize the violence and spirit of the whole, and even suggest colour.

XV. COURBET: THE PAINTER'S STUDIO. PARIS, LOUVRE

Delacroix detested the matter and manner of Courbet's realism, the vulgarity and futility of idea he saw in 'The Bathers' (Journal, 15 April 1853), but he recognized the vigour of execution. He visited the exhibition of Courbet's work (Journal, 3 August 1855) and could not tear himself away. The painter in him responded to the astonishing 'Studio' and found it a masterpiece. It is a great tribute to Delacroix's integrity of judgement on work so different from his own.

XVI. H. FANTIN-LATOUR: 'HOMMAGE A DELACROIX'. 1864. PARIS, MUSÉE DE L'IMPRESSIONNISME

Reading from left to right, the persons represented are: standing, Cordier, Alphonse Legros, Whistler, E. Manet, Braquemond, Balleroy; sitting, Duranty, Fantin-Latour, Champfleury, Baudelaire.

INDEX